Architecture of England, Scotland, and Wales

Recent Titles in
Reference Guides to National Architecture

Architecture of Greece
Janina K. Darling

Architecture of England, Scotland, and Wales

NIGEL R. JONES

Reference Guides to National Architecture

David A. Hanser, Series Adviser

Greenwood Press

Westport, Connecticut • London

Library of Congress Cataloging-in-Publication Data

Jones, Nigel R.
 Architecture of England, Scotland, and Wales / Nigel R. Jones.
 p. cm.—(Reference guides to national architecture, ISSN 1550–8315)
 Includes bibliographical references and index.
 ISBN 0–313–31850–6 (alk. paper)
 1. Architecture—Great Britain. I. Title. II. Series.
 NA961.J64 2005
 720'.941—dc22 2005006190

British Library Cataloguing in Publication Data is available.

Library of Congress Catalog Card Number: 2005006190
ISBN 0–313–31850–6
ISSN: 1550–8315

First published in 2005

Greenwood Press, 88 Post Road West, Westport, CT 06881
An imprint of Greenwood Publishing Group, Inc.
www.greenwood.com

Printed in the United States of America

The paper used in this book complies with the
Permanent Paper Standard issued by the National
Information Standards Organization (Z39.48–1984).

10 9 8 7 6 5 4 3 2 1

For
Ann Jones
&
Donald H. Kimball
In Memorium
Robin E. Jones
F. Cuthbert Salmon
&
Patty.

Contents

Entries by Location xi
Entries by Architectural Style xv
Entries by Architects, Engineers, and Designers xix
Simplified Summary of British Architectural Styles xxv
Timeline of British Rulers and Architecture xxix
Preface xxxiii
Acknowledgments xxxvii
Introduction xxxix

ARCHITECTURE OF ENGLAND, SCOTLAND, AND WALES

Alnwick Castle, Northumberland, England 1
Balmoral Castle, Aberdeenshire, Scotland 6
The Banqueting House, Whitehall, London 7
Bath, Avon, England 13
Belton House, Lincolnshire, England 19
Blenheim Palace, Oxfordshire, England 24
The British Museum, Bloomsbury, London 32
Broadleys, Cumbria, England 35
Buckingham Palace, London 38
Caernarfon Castle, Gwynedd, Wales 44
Cardiff Castle, Cardiff, South Glamorgan, Wales 48
The Cathedral Church of Christ, St. Peter's Mount, and
 The Metropolitan Cathedral of Christ the King, Liverpool,
 Merseyside, England 53
The Cenotaph, Whitehall, London 58

Charters and the Modern Movement, Berkshire, England 63
Chatsworth House, Derbyshire, England 66
Chester, Cheshire, England 70
Chiswick House, Chiswick, London 73
The Church of St. John the Baptist, Huntley, Gloucestershire,
 England 77
Coventry Cathedral, Coventry, West Midlands, England 82
Craigievar Castle, Aberdeenshire, Scotland 85
The Crystal Palace, Hyde Park, London 88
Ditherington Flax Mill, Shrewsbury, Shropshire, England 92
The Durham Cathedral Church of Christ and Blessed
 Mary the Virgin, Durham, England 94
Eaton Hall, Cheshire, England 98
Erddig Hall, Wrexham, Wales 104
Fonthill Abbey, Wiltshire, England 107
Glasgow School of Art, Glasgow, Lanarkshire, Scotland 112
Haddon Hall, Derbyshire, England 116
Hadrian's Wall, Bowness-on-Solway to Wallsend-on-Tyne,
 Cumbria, Northumberland, and Tyne and Wear, England 119
Hampton Court Palace, London 122
Hardwick Hall, Derbyshire, England 128
Harewood House, Yorkshire, England 132
Highgrove, Tetbury, Gloucestershire, England 136
Holkham Hall, Norfolk, England 138
The Houses of Parliament (Palace of Westminster),
 Westminster, London 146
The Iron Bridge, Ironbridge, Coalbrookedale, Shropshire, England 151
King's College Chapel, Cambridge, England 155
Little Moreton Hall, Cheshire, England 159
Lloyd's of London, London 162
London Bridge, London 166
London City Hall, The Queen's Walk, London 169
The "London Eye," The South Bank, London 173
Lutyens Country Houses, various sites 176
The Millennium Bridge, London 179
The Millennium Dome, Greenwich, London 183
Number 10 Downing Street, Whitehall, London 186
The Parish Church of St. Giles, Wrexham, Wales 190
Portmeirion, Gwynedd, Wales 195
Poundbury, Dorchester, Dorset, England 200
Public Telephone Kiosks, various sites 204

The Queen's House and The Royal Naval Hospital,
 Greenwich, London 208
Red House, Bexleyheath, Kent, England 212
Regent's Park and Regent Street, London 215
The Royal Albert Hall, South Kensington, London 220
The Royal Pavilion, Brighton, Sussex, England 224
The Royal State Coach, The Royal Mews,
 Buckingham Palace, London 228
St. James's Palace, Pall Mall, London 231
St. Martin-in-the-Fields, Trafalgar Square, London 236
St. Paul's Cathedral, London 240
Sandringham House, Norfolk, England 247
The Soane Museum, London 251
Somerset House, The Strand, London 256
Spencer House, Green Park, London 259
Stonehenge, Wiltshire, England 263
Stourhead, Wiltshire, England 267
Suburban Semi-Detached Houses, various sites 269
Syon House, Middlesex, England 273
Terraced Houses, various sites 276
Tower Bridge, London 283
The Tower of London, London 286
Trafalgar Square, London 291
Tyntesfield, Somerset, England 296
Westminster Abbey, The Collegiate Church of St. Peter at
 Westminster, Westminster, London 299
Windsor Castle, Berkshire, England 304
Wrotham Park, Barnet, Hertfordshire, England 308

Appendix: The Monarchy, the Peerage, and the Parliament 315
Glossary 321
Bibliography 329
Index 335

Entries by Location

ENGLAND

Avon

Bath

Berkshire

Charters
Windsor Castle

Cambridge

King's College Chapel

Cheshire

Chester
Eaton Hall
Little Moreton Hall

Cumbria

Broadleys
Hadrian's Wall

Derbyshire

Chatsworth House
Haddon Hall
Hardwick Hall

Dorset

Poundbury, Dorchester

Durham

The Durham Cathedral Church of
 Christ and Blessed Mary the
 Virgin

Gloucestershire

The Church of St. John the Baptist,
 Huntley
Highgrove, Tetbury

Hertfordshire

Wrotham Park, Barnet

Kent

Red House, Bexleyheath

Lincolnshire

Belton House

London

The Banqueting House (Whitehall)
The British Museum (Bloomsbury)
Buckingham Palace
The Cenotaph (Whitehall)
Chiswick House
The Crystal Palace (Hyde Park)
Hampton Court Palace

The Houses of Parliament
 (Westminster)
Lloyd's of London
London Bridge
London City Hall (The Queen's
 Walk)
The "London Eye" (The South
 Bank)
The Millennium Bridge
The Millennium Dome
 (Greenwich)
Number 10 Downing Street
 (Whitehall)
The Queen's House and The
 Royal Naval Hospital
 (Greenwich)
Regent's Park and Regent Street
The Royal Albert Hall (South
 Kensington)
St. James's Palace (Pall Mall)
St. Martin-in-the-Fields (Trafalgar
 Square)
St. Paul's Cathedral
The Soane Museum
Somerset House (The Strand)
Spencer House (Green Park)
Tower Bridge
The Tower of London
Trafalgar Square
Westminster Abbey, The
 Collegiate Church of St. Peter
 at Westminster (Westminster)

Merseyside

The Cathedral Church of Christ,
 St. Peter's Mount, and The
 Metropolitan Cathedral of
 Christ the King, Liverpool

Middlesex

Syon House

Norfolk

Holkham Hall
Sandringham House

Northumberland

Alnwick Castle
Hadrian's Wall

Oxfordshire

Blenheim Palace

Shropshire

Ditherington Flax Mill, Shrewsbury
The Iron Bridge, Ironbridge,
 Coalbrookdale

Somerset

Tyntesfield

Sussex

The Royal Pavilion, Brighton

Tyne and Wear

Hadrian's Wall

West Midlands

Coventry Cathedral

Wiltshire

Fonthill Abbey
Stonehenge
Stourhead

Yorkshire

Harewood House

SCOTLAND

Aberdeenshire

Balmoral Castle
Craigievar Castle

Lanarkshire

Glasgow School of Art, Glasgow

WALES

Gwynedd

Caernarfon Castle
Portmeirion

South Glamorgan

Cardiff Castle

Wrexham

Erddig Hall
The Parish Church of St. Giles

Entries by Architectural Style

See the Introduction for descriptions of major architectural styles and periods in British history.

Prehistoric (2500–1300 B.C.E.)

Stonehenge

Roman (43–circa 450)

Bath
Cardiff Castle
Chester
Hadrian's Wall
London Bridge

Anglo-Saxon (Circa 450–11th century)

Westminster Abbey

Norman/Romanesque (11th/12th centuries)

Durham Cathedral
The Tower of London
Westminster Abbey
Windsor Castle

Gothic

Early English Style (12th century)
Alnwick Castle

Decorated Style (12th/13th centuries)
Alnwick Castle
Caernarfon Castle
Coventry Cathedral
Haddon Hall
London Bridge
The Parish Church of St. Giles
Westminster Abbey
Windsor Castle

Perpendicular Style (14th/15th centuries)
King's College Chapel
The Parish Church of St. Giles
Westminster Abbey

Tudor (late 15th/early 16th centuries)
Hampton Court Palace
Little Moreton Hall
St. James's Palace

Renaissance

Tudor (16th century)
Somerset House
Syon House

Elizabethan (late 16th century)
Chatsworth House
Hardwick Hall
Little Moreton Hall

Jacobean (early 17th century)
Craigievar Castle

Stuart (17th century)
The Banqueting House
Coleshill House
The Queen's House
St. James's Palace

Restoration (late 17th century)
Belton House
Clarendon House
Eaton Hall
Erddig Hall
Number 10 Downing Street
Terraced Houses

Baroque (late 17th/early 18th centuries)
Blenheim Palace
Buckingham Palace
Chatsworth House
Hampton Court Palace
St. Paul's Cathedral
Windsor Castle

Georgian

Palladian (18th century)
Bath
Chiswick House
Holkham Hall
St. Martin-in-the-Fields
Spencer House
Stourhead
Westminster Abbey
Wrotham Park

Picturesque/Romantic (late 18th/early 19th centuries)
Alnwick Castle
Eaton Hall
Fonthill Abbey
The Royal Pavilion
Stourhead
Windsor Castle

Neoclassical (late 18th/early 19th centuries)
The British Museum
Buckingham Palace
Erddig Hall
Harewood House
Highgrove
London Bridge
Regent's Park/Regent Street
The Royal State Coach
The Soane Museum
Spencer House
Somerset House
Syon House
Terraced Houses
Trafalgar Square

Industrial Revolution (late 18th/19th centuries)
The Crystal Palace
Ditherington Flax Mill
The Iron Bridge

Victorian (19th century)
Balmoral Castle
The British Museum
Broadleys
Cardiff Castle
Castell Coch
Chatsworth House
The Church of St. John the Baptist
The Crystal Palace
Eaton Hall
Glasgow School of Art
Harewood House
Red House
The Royal Albert Hall

Sandringham House
Terraced Houses
Tower Bridge
Trafalgar Square
Tyntesfield

Twentieth Century

Edwardian (early 20th century)
Lutyens Country Houses

Inter-War (20th century)
The Cenotaph
The Cathedral Church of Christ,
　St. Peter's Mount and The
　Metropolitan Cathedral of
　Christ the King
Charters
Portmeirion
Public Telephone Kiosks
Suburban Semi-Detached
　Houses

*Modern (late 20th/early
21st centuries)*
The British Museum
The Cathedral Church of Christ,
　St. Peter's Mount and The
　Metropolitan Cathedral of
　Christ the King
Coventry Cathedral
Eaton Hall
Lloyd's of London
London Bridge
London City Hall
The "London Eye"
The Millennium Bridge
The Millennium Dome
Number 10 Downing Street
Poundbury
Suburban Semi-Detached
　Houses
Trafalgar Square
Windsor Castle

Entries by Architects, Engineers, and Designers

L isted below are the most important architects, engineers, and designers mentioned in this book along with their life dates and the structures described in this book with which they are associated.

Robert Adam (1728–1792)

Alnwick Castle
Bath (Pulteney Bridge)
Harewood House
Lloyd's of London
Terraced Houses (Wynn House)
Syon House

George M. Adie (1901–1989)

Charters

**HRH The Prince Albert
(1800–1861)**

Balmoral Castle
Crystal Palace

**Thomas Archer
(Circa 1668–1743)**

Chatsworth House

Arup (A firm)

Millennium Bridge

Charles Bage (1752–1822)

Ditherington Flax Mill

Julia Barfield (Living)

The London Eye

**Sir Charles Barry
(1795–1860)**

Harewood House
The Houses of Parliament (Palace
 of Westminster)
Trafalgar Square

**Edward Middleton Barry
(1830–1880)**

The Houses of Parliament (Palace
 of Westminster)
Trafalgar Square

**Sir John Wolfe Barry
(1836–1918)**

Tower Bridge

**Robert of Beverley (mason)
(Dates unknown)**

Westminster Abbey

**Sir Arthur W. Blomfield
(1829–1899)**

Tyntesfield

Edward Blore (1787–1879)

Buckingham Palace

**Richard Boyle, Lord Burlington
(1694–1753)**

Chiswick House
Holkham Hall

**Matthew Brettingham
(1699–1769)**

Holkham Hall

**Lancelot "Capability" Brown
(1716–1783)**

Alnwick Castle
Blenheim Palace
Chatsworth House
Harewood House
Syon House

William Burges (1827–1881)

Cardiff Castle and Castell Coch

William Burn (1789–1870)

Eaton Hall

**Frederick P. Button
(Dates unknown)**

Charters

Colen Campbell (1676–1729)

Stourhead

Sir Anthony Caro (1924–)

The Millennium Bridge

John Carr (1723–1807)

Harewood House

**Sir William Chambers
(1723–1796)**

Buckingham Palace
Somerset House
The Royal State Coach

Simon Clerk (Dates unknown)

King's College Chapel, Cambridge

**Thomas Coke, Lord Leicester
(1697–1759)**

Holkham Hall

Kenton Couse (1721–1790)

Number 10 Downing Street

Thomas Cundy Snr. (1765–1825)

Syon House

Abraham Darby III (1750–1791)

The Iron Bridge

Peter de Colechurch (Died 1205)

London Bridge

**Henry de Reyns (mason)
(Dates unknown)**

Westminster Abbey

**John E. Dennys (Dates
unknown)**

Eaton Hall

Giles Downes (Living)

Windsor Castle

**Achille Duchêne (Dates
unknown)**

Blenheim Palace

**Colonel Sir Robert W. Edis
(1839–1927)**

Sandringham House

Reginald Ely (Died 1471)

King's College Chapel, Cambridge

Raymond Erith (1904–1973)

Number 10 Downing Street

Richard of Farnham (Dates unknown)

The Durham Cathedral Church of Christ and Blessed Mary the Virgin

Henry Flitcroft (1697–1769)

Stourhead

Norman Foster (1935–)

The British Museum
London City Hall
The Millenium Bridge
Trafalgar Square

Captain Francis Fowke (1823–1865)

The Royal Albert Hall

Charles Fowler (1792–1867)

Syon House

James Gandon (1743–1823)

Terraced Houses (Wynn House)

Sir Frederick Gibberd (1908–1984)

The Metropolitan Cathedral of Christ the King

James Gibbs (1682–1754)

St. Martin-in-the-Fields

John of Gloucester (mason) (Dates unknown)

Westminster Abbey

Sir George Gray (Died 1773)

Spencer House

Nicholas Grimshaw (Living)

Bath (Bath Spa)

Benjamin Gummow (Dates unknown)

Eaton Hall

Gundulf, Bishop of Rochester (Dates unknown)

The Tower of London

Buro Happold (A firm)

The British Museum
The Millenium Dome

Hart of Bristol (Dates unknown)

The Parish Church of St. Giles, Wrexham

Nicholas Hawksmoor (Circa 1661–1736)

Blenheim Palace
The Queen's House and The Royal Naval Hospital
Westminster Abbey

Hugh Herland (carpenter) (Dates unknown)

The Houses of Parliament (Westminster Hall)

William Hoare (Dates unknown)

Fonthill Abbey

Henry Hoare II (1705–1785)

Stourhead

Henry Holland (1745–1806)

The Royal Pavilion, Brighton
Spencer House

Albert Jenkins Humbert (1822–1877)

Sandringham House

Sir Horace Jones (1819–1887)

Tower Bridge

Inigo Jones (1573–1652)

The Banqueting House
The Queen's House and The Royal
 Naval Hospital
St. Paul's Cathedral
St. James's Palace

Rolfe Judd (A firm)

Spencer House

Anthony Keck (1726–1797)

Highgrove

William Kent (Circa 1685–1748)

Chiswick House
Holkham Hall
Number 10 Downing Street
St. James's Palace

Ralph Knott (1878–1929)

London City Hall

Leon Krier (Living)

Poundbury

**Sir Edwin Landseer Lutyens
(1869–1944)**

The Metropolitan Cathedral of
 Christ the King
The Cenotaph
Lutyens Country Houses

**Charles Rennie Mackintosh
(1868–1928)**

Glasgow School of Art

David Marks (Living)

The London Eye

Hugh May (1621–1684)

Windsor Castle

David Mlinaric (Living)

Spencer House

John Nash (1752–1835)

Buckingham Palace
Regent's Park and Regent Street
The Royal Pavilion
St. James's Palace (Clarence House)
Trafalgar Square

John Norton (1823–1904)

Tyntesfield

James Paine (1717–1789)

Alnwick Castle
Chatsworth House

Sir Joseph Paxton (1803–1865)

Chatsworth House
The Crystal Palace

**Sir James Pennethorne
(1801–1871)**

Buckingham Palace

John Russell Pope (1874–1937)

The British Museum

**William Porden (Circa
1755–1822)**

Eaton Hall

Sir Roger Pratt (1620–1685)

Belton House, Clarendon House,
 Coleshill House

**Thomas Farnolls Pritchard
(1723–1777)**

The Iron Bridge

**Augustus W. N. Pugin
(1812–1852)**

The Houses of Parliament (Palace
 of Westminster)

John Rennie (1761–1821)

London Bridge

Sir John Rennie (1794–1874)

London Bridge

Richard Rogers (Living)

Lloyd's of London
The Millennium Dome

James St. George (Circa 1235–1308)

Caernarfon Castle

Anthony Salvin (1799–1881)

Alnwick Castle

William Samwell (1628–1676)

Eaton Hall

Sir Giles Gilbert Scott (1880–1960)

The Cathedral Church of Christ, St. Peter's Mount
Public Telephone Kiosks

Colonel H. Y. Darracott Scott (Dates unknown)

The Royal Albert Hall

Vincent Shepherd (Circa 1750–1812)

Alnwick Castle

John Simpson (Living)

Buckingham Palace

Sir Robert Smirke (1780–1867)

The British Museum

Sydney Smirke (1797–1877)

The British Museum

William Smith (1817–1891)

Balmoral Castle

Robert Smythson (Circa 1535–1614)

Hardwick Hall

Sir John Soane (1753–1837)

Number 10 Downing Street
Houses of Parliament (Palace of Westminster)
The Soane Museum (13, Lincoln's Inn Fields)

Sir Basil Spence (1907–1976)

Coventry Cathedral

William Stanton (1639–1705)

Belton House

James Stuart (1713–1788)

Spencer House

William Talman (1650–1719)

Buckingham Palace
Chatsworth House

Sir Robert Taylor (1714–1788)

Number 10 Downing Street

Quinlan Terry (1937–)

Number 10 Downing Street

Samuel Sanders Teulon (1812–1873)

The Church of St. John the Baptist, Huntley
Sandringham House
Suburban Semi-Detached Houses

Joseph Turner (Circa 1729–1807)

Erddig Hall

Sir John Vanbrugh (1664–1726)

Blenheim Palace
St. James's Palace
The Queen's House and The Royal Naval Hospital

John Vardy (Died 1765)

St. James's Palace
Spencer House

Charles F. A. Voysey (1857–1941)

Broadleys

Isaac Ware (Circa 1707–1766)

Wrotham Park

John Wastell (Dates unknown)

King's College Chapel, Cambridge

Alfred Waterhouse (1830–1905)

Eaton Hall

Sir Aston Webb (1849–1930)

Buckingham Palace

John Webb (1611–1672)

The Queen's House and The Royal
 Naval Hospital
Syon House

Philip Webb (1831–1915)

Red House

Thomas Webb (Dates unknown)

Erddig Hall

**Sir Clough Williams-Ellis
(1883–1978)**

Portmeirion

William Winde (Died 1722)

Belton House
Buckingham Palace

Henry Wise (1653–1738)

Blenheim Palace

John Wolrich (Dates unknown)

King's College Chapel, Cambridge

**John Wood the Elder
(1704–1754)**

Bath (Queen Square, The Circus)

**John Wood the Younger
(1728–1801)**

Bath (The Royal Crescent)

**Sir Christopher Wren
(1632–1723)**

Hampton Court Palace
St. James's Palace
St. Paul's Cathedral
The Queen's House and The Royal
 Naval Hospital

James Wyatt (1746–1813)

Belton House
Erddig Hall
Fonthill Abbey
Syon House

Sir Jeffry Wyatville (1766–1840)

Chatsworth House
St. James's Palace
Windsor Castle

**William of Wykeham (mason)
(Dates unknown)**

Windsor Castle

**Henry Yevele (mason)
(Circa 1320–1400)**

The Durham Cathedral Church of
 Christ and Blessed Mary the
 Virgin
The Houses of Parliament
 (Westminster Hall)

Simplified Summary of British Architectural Styles

Listed below are the defining characteristics and approximate periods of popularity of the most important architectural styles of Britain. Note that architectural styles do not conveniently fit historic periods; also, they overlap, often by many years. For definitions of architectural terms, please refer to the Glossary.

Prehistoric Period

Style	Chief Characteristics
Prehistoric—Bronze Age (2500–1300 B.C.E.)	Massive, simple stone structures

Roman Period

Style	Chief Characteristics
Classical (43–450 C.E.)	Simpler version of Greco-Roman Classical Militaristic Formal, axial

Anglo-Saxon Period

Style	Chief Characteristics
Saxon (450–1066)	Simple structures of timber or stone

Mediaeval Period

Style	Chief Characteristics
Norman/Romanesque (1066–1200)	Massive walls and columns Round arches and barrel vaults Small, round-headed windows Simple, decorative motifs
Gothic—Early English (1150–1300)	Buttressed walls Pointed arches and simple ribbed vaults Larger windows with simple plate tracery
Gothic—Decorated (1250–1400)	Buttressed walls Flying buttresses and pinnacles Pointed arches and complex ribbed vaults Big windows with decorative tracery Decorative carvings on column capitals, corbels, etc.
Gothic—Perpendicular (1375–1510)	Deeply buttressed walls Flying buttresses and pinnacles Four-centered "flat" arches and elaborate fan vaults Massive windows with horizontal/vertical stone ribs and tracery Carved decoration on every surface Shallow pitched roofs

Renaissance Period

Style	Chief Characteristics
Tudor (1510–1580)	Mediaeval/Gothic forms Crude use of Classical details on porches, fireplaces, tombs, etc.
Elizabethan (1560–1603)	Symmetrical Large windows More learned interpretation of Classical details
Jacobean (1603–1625)	As Elizabethan but richer, more extravagant
Stuart (1610–1660)	Symmetrical and proportioned Correct use of Classical details British interpretation of Palladio

Restoration (1660–1700)	As Stuart but more refined
Baroque (1675–1725)	Symmetrical, formal, theatrical, richly decorated, and massive

Georgian Period

Style	*Chief Characteristics*
Palladian (1725–1775)	Symmetrical, proportioned, aloof
	Externally austere, internally extravagant
	Return to Palladian ideals
Picturesque/Romantic (1740–1840)	Interpretations of various styles, e.g., Gothic, Mediaeval castle, Greek, Hindu/Chinese
Neoclassical (1760–1837)	British interpretations of archaeologically correct Classical details
	Spatially complex
Industrial Revolution (1777–1914)	New technologies/materials

Victorian Period

Style	*Chief Characteristics*
Gothic Revival/Classical (1837–1901)	Traditional styles changed by use of new technologies/materials of the Industrial Revolution
	Overdecorated and multicolored
	Confident, bravura architecture
Arts and Crafts (1860–1914)	Vernacular, traditional, and comfortable

Twentieth Century

Style	*Chief Characteristics*
Edwardian (1901–1914)	Imperial celebratory Classical
Inter-War (1918–1939)	Art Deco and streamlined Modern Movement
	White walls, flat roofs, and abstracted decoration
	Simplified, minimalist Classicism

Modern (1945–)

Traditional/historical vs. "High-Tech" minimalism

Daring structural experimentation and material use

Sustainable and environmentally intelligent buildings

Timeline of British Rulers and Architecture

Prehistoric–Bronze Age circa 2500 B.C.E.–circa 1300 B.C.E.

Stonehenge

Roman Empire

Roman Emperors (43–circa 450)
Bath
Cardiff Castle
Chester
Hadrian's Wall
London Bridge

Anglo-Saxon

Saxon Kings (c. 450–1016)

Skjoldings ("of Denmark")

Canute (1016–1035)

Harthacanute & Harold I (1035–1042)

Edward the Confessor (1042–1066)
Westminster Abbey
Houses or Parliament

Harold II Goodwinson (1066)

Norman and Plantagenet

William I (1066–1087)
The Tower of London
Westminster Abbey
Windsor Castle

William II (1087–1100)
Durham Cathedral

Henry I (1100–1135)

Stephen (1135–1154)
Alnwick Castle

Henry II (1154–1189)

Richard I (1189–1199)

John (1199–1216)
London Bridge

Henry III (1216–1272)
Haddon Hall
Westminster Abbey

Edward I (1272–1307)
Caernarfon Castle

Edward II (1307–1327)

Edward III (1327–1377)
Alnwick Castle

Chester
Coventry Cathedral
Haddon Hall
Parish Church of St. Giles,
　Wrexham
Westminster Abbey
Windsor Castle

Richard II (1377–1399)

Henry IV (1399–1413)

Henry V (1413–1422)

Henry VI (1422–1461)
King's College Chapel, Cambridge

Edward IV (1461–1470)

Henry VI (1470–1471)

Edward IV (1471–1483)
Little Moreton Hall
Parish Church of St. Giles,
　Wrexham

Edward V (1483)

Richard III (1483–1485)

Tudor

Henry VII (1485–1509)
Parish Church of St. Giles,
　Wrexham
Westminster Abbey

Henry VIII (1509–1547)
Hampton Court Palace
St. James's Palace
Syon House

Edward VI (1547–1553)
Somerset House

Mary I (1553–1558)

Elizabeth I (1558–1603)
Chatsworth House
Hardwick Hall
Little Moreton Hall

Stuart

James I (1603–1625)
The Banqueting House
Craigievar Castle
The Queen's House

Charles I (1625–1649)
St. James's Palace
St. Paul's Cathedral

Commonwealth (1649–1660)
Coleshill House

Charles II (1660–1685)
Belton House
Clarendon House
Number 10 Downing Street
Eaton Hall
Erddig Hall
Windsor Castle
St. Paul's Cathedral
The Terraced House
Windsor Castle

James II (1685–1688)
Chatsworth House

William III & Mary II (1689–1702)
Chatsworth House
Hampton Court Palace
The Queen's House and The Royal
　Naval Hospital

Anne (1702–1714)
Blenheim Palace
Buckingham House (Palace)

Hanover

George I (1714–1727)
Chiswick House
St. Martin-in-the-Fields

George II (1727–1760)
Bath
Holkham Hall
Spencer House
Stourhead

Westminster Abbey
Wrotham Park

George III (1760–1820)
Alnwick Castle
Bath
Ditherington Flax Mill
Eaton Hall
Erddig Hall
Fonthill Abbey
Harewood House
Highgrove
The Iron Bridge
The Royal State Coach
Spencer House
Somerset House
Syon House
The Terraced House

Regency (1811–1820)
Regent's Park and Regent Street
The Royal Pavilion
The Soane Museum
Trafalgar Square

George IV (1820–1830)
The British Museum
Buckingham Palace
Windsor Castle

William IV (1830–1837)
London Bridge

Victoria (1837–1901)
Alnwick Castle
Balmoral Castle
The British Museum
Broadleys
Cardiff Castle
Castell Coch
Chatsworth House
The Crystal Palace
Eaton Hall
Glasgow School of Art
Harewood House
The Houses of Parliament
The Church of St. John the Baptist,
 Huntley

The Red House
The Royal Albert Hall
Sandringham House
The Terraced House
Tower Bridge
Tyntesfield

Saxe-Coburg & Gotha

Edward VII (1901–1910)
The Lutyens Country House

Windsor

George V (1910–1936)
The Cenotaph
The Cathedral Church of Christ,
 St. Peter's Mount and The
 Metropolitan Cathedral of
 Christ the King
The Public Telephone Kiosk

Edward VIII (1936)

George VI (1936–1952)
Charters and the Modern
 Movement
Poertmeirion
The Suburban Semi-detached House

Elizabeth II (1952–)
The British Museum
Coventry Cathedral
Number 10 Downing Street
Eaton Hall
The Cathedral Church of Christ,
 St. Peter's Mount and The
 Metropolitan Cathedral of
 Christ the King
Lloyd's of London
London Bridge
London City Hall
The London Eye
The Milennium Bridge
The Milennium Dome
Poundbury
The Terraced House
Trafalgar Square
Windsor Castle

Preface

*T*he *Architecture of England, Scotland, and Wales,* one of the Greenwood Reference Guides to National Architecture, is intended to provide an introduction to the architecture of mainland Britain. Readers who want to know more about the architecture of Britain and how it relates to the history, the monarchy, and the society will find many answers in the book's entries. Changes in architecture are the result of political, social, cultural, and technological changes and in each entry I endeavor to include the appropriate background information. I do assume some knowledge of British and European history, but very little of architecture and architectural terminology.

In all but a few of the seventy-five entries, the buildings are still extant, although in many cases considerable changes have occurred over the years. Roman buildings fell into ruin or were quarried for their materials by later builders. Anglo-Saxon churches were incorporated into larger Norman (Romanesque) and Gothic structures. Gothic cathedrals were "improved" by overzealous architects during the nineteenth century and monasteries fell into ruin after the Dissolution of the sixteenth century or became the country houses of the new elite. Their new mansions were rebuilt as taste changed from Jacobean to Restoration to Baroque to Palladian to Neoclassical to Gothic Revival; many country houses are an archaeological jigsaw of periods and styles. Religious, civic, and industrial architecture contribute to the appearance of cities and towns but are also susceptible to social, economic, and political forces.

Britain does not have an extreme climate—notwithstanding its reputation for fog and continual rain—nor does it suffer severe earthquakes, typhoons, or tornadoes. Buildings succumb to fire, war, and abandonment. The monarchy has ruled, with only one short break, for over 1,000 years; parliamentary government, while continually adapting, has ruled for several hundred years; the aristocracy, although its power has recently waned, still wields great in-

fluence and wealth; and the last successful invasion was that of William the Conqueror in 1066. Therefore, buildings survive and records often date back hundreds of years; also, diaries, travelogues, biographies, and reminiscences give vivid descriptions of the owners, architects, construction, appearance, and functioning of many of the buildings described. Nevertheless, records are often incomplete and architectural historians disagree over attribution (which architect? which client?), dates, and details, and I have usually mentioned opposing arguments.

The entries, whether buildings (e.g., "Chatsworth House," "The Tower of London), or cities (e.g., "Bath," "Chester"), architectural types (e.g., "Lutyens Country Houses," "Terraced Houses"), or other design types (e.g., "Public Telephone Kiosks," "The Royal State Coach"), are arranged in alphabetical order by building, city, or design name. Each entry begins by listing the architectural style; construction, reconstruction, or remodeling dates; and the architects or designers (if known) of the entry subject. The opening paragraph places the subject within its historical and geographical context and explains why it is worthy of notice. There then follows a more detailed description of the entry subject, its history, architect(s), owner(s), and particular features. Some entries include general descriptions about a particular architectural style or plan type. Each entry then concludes by bringing the reader up to date with the current appearance and condition of the subject and by providing a list of further information sources in both print and electronic formats.

Entries are also carefully cross-referenced to other related entries and to architectural terms defined in the Glossary. Entry cross-references are set in **boldface** type while Glossary references are set in *italic* type. Although architectural terminology is often explained in the text, fuller descriptions can be found in the Glossary. Measurements, where given, are in feet and inches, but are often converted from metric dimensions and therefore, while close, must be seen as approximate. The British currency is the Pound Sterling, designated by the symbol £; today the conversion is approximately $1.80 to the pound. I often quote the cost of a building when it was built centuries ago, but remember, the cost of living and purchasing power of any currency changes over time. Therefore, understanding costs relative to today's money is difficult because the difference between two periods can be vast. For instance, a domestic servant working in a house in the late nineteenth century would earn £10 to £25 annually, depending upon rank; while fewer servants are employed in private houses today, their salary could be a 1,000 times greater than their counterparts earned a century ago. The entries sometimes give a translation into modern costs in pounds and dollars, but the reader should realize that this changes almost daily and truly is an approximation.

As further aids to making connections between entries and to finding basic related information, the *Architecture of England, Scotland, and Wales* includes a detailed subject index and lists of entries by location; architectural style; and architects, designers, and engineers. The Simplified Summary of British

Architectural Styles is a quick guide to the chief characteristics of the most important British styles. Because the monarchy is an important thread that weaves through any British history, a Timeline of British Architecture connects entries to royal dynasties and reigns as well as to architectural styles and important events in British history. Dates beside the name of a monarch refer to the reign, not to the individual's dates of birth and death. The monarchy, the peerage, and the government of Britain are explained more thoroughly in an appendix.

Although Britain and the United States both use the English language, there are differences of spelling and usage. For example, the British "theatre" is the American "theater"; a "terrace house" in Britain is a "row house" in the United States; and when referring to the stories in a building the British would start at the basement (or cellar) and move up through the ground floor, first floor, and so on, to the attic, while Americans would move from basement to first floor—thus the British third floor is the fourth floor to an American. I have used American spelling and usage except where naming a particular building or using a direct quotation.

I encourage readers to consult the books and Web sites in the Bibliography or appended as "Further Reading" to each entry. Web sites listed are official sites run by the British government, various city councils, or building owners and the addresses are correct as of Fall 2004. Internet search engines, such as Yahoo! or Google, will lead to updated sites and additional information or images. However, as a word of caution, such sources can vary widely in quality, from extremely informative to downright misleading.

Acknowledgments

My first and heartfelt thanks go to Dr. David A. Hanser, my colleague and friend at the School of Architecture at Oklahoma State University, who invited me to write this volume of the *Reference Guides to National Architecture* series. He has long been a source of inspiration for me, setting an example of a great teacher of architectural history and providing encouragement and commiseration during the writing of this book. My interest in architectural history began during lectures at the University of Newcastle-upon-Tyne, in the north of England, given by Dr. Geoffrey Baker and Dr. Peter Willis, and I thank them for setting me on the path that has led to this book.

At the OSU School of Architecture, I thank also the other members of the faculty, the students, and the staff for their interest and support. Particularly, I mention Professor J. Randall Seitsinger, the Head of the School, and my fellow teachers and best friends, Professors Mohammed and Suzanne Bilbeisi.

Over the four years it has taken to write this book I have been supported by friends in Stillwater: I thank the members of the Tuesday International Lunch Group and the Dinner Group. Other friends who have provided sustenance, mental or otherwise, include L. B., K. C., D. K., N. K., N. M., and the Kimball family.

There have been several changes in my life during the writing of this book, not the least being the construction and move to a new house. That process was made easier thanks to the late F. Cuthbert Salmon, Emeritus Head of the School of Architecture at Oklahoma State University, who invited me to stay in his home while my house was being built. Our many evenings of conversation added to my thoughts about architecture but did extend the time it took to write the book. Cuth's daughters, Libby Rhodes and Mary Ramnes, provided good company, food, and wine at opportune moments.

John Wagner and the other editors and staff at Greenwood Press have shown great patience as I have prevaricated and complained. Thanks should also be sent to the author of the first volume in the series, Janina K. Darling, whose volume *Architecture of Greece* paved the way and answered many questions on format and illustrations for all series authors.

A good part of this book was written with the assistance of a large black cat, Patty, who insisted that her place was the in-tray beside the keyboard on my desk, from where, if not sleeping, she would oversee my work. Patty died in June 2004 as the final pages were being written; her role as overseer has been taken up by the less insistent Two.

Finally, thank you to my parents, my late father Robin, and my mother Ann—for everything.

Introduction

This royal throne of kings, this sceptered isle,
This earth of majesty, this seat of Mars,
This other Eden, demi-paradise,
This fortress built by nature for herself
Against infection and the hand of war,
This happy breed of men, this little world,
This precious stone set in the silver sea,
Which serves it in the office of a wall,
Or as a moat defensive to a house,
Against the envy of less happier lands.
This blessed plot, this earth, this realm, this England.

William Shakespeare. *Richard II*

The British Isles comprise the two countries of the United Kingdom and Northern Ireland and the Republic of Ireland (Eire). The United Kingdom is a union of the countries of England, Scotland, Wales, and Northern Ireland currently ruled over by Her Majesty Queen Elizabeth II. Geographically, England occupies the largest portion of the island of Great Britain and contains large areas of rich agricultural land, gently rolling landscapes, and moorlands in the southwest and north. To the west is Wales, a rugged and mountainous region, and to the north is Scotland, equally rugged in its mountainous northern Highlands, gentler in the rolling Lowlands to the south. The climate is not, as it is reputed to be, continuous rain interspersed by periods of dense fog, but rather consists of four distinct seasons: spring, summer, autumn (fall), and winter, although gloriously warm, sunny, summer days can unpredictably be followed by dreary, wet days of drizzly rain such that the weather is a national obsession. The people of Britain, until re-

cent years, were the descendents of Celts, Anglo-Saxons, and Norman-French; recent immigration has added citizens from the West Indies, Africa, and the Indian subcontinent: modern Britain is a multiracial society and, with its membership in the European Community, truly multicultural. Even Shakespeare's defensive moat has been breached by the Chunnel—Channel Tunnel—connecting southeast England to northern France beneath the twenty-two-mile wide English Channel.

Prehistoric and Roman

A history of Britain and British architecture begins with the tribes that lived on the islands in the prehistoric stone, iron, and bronze ages, the builders of **Stonehenge**. The Celts who arrived later, c. 800 B.C.E., followed the Druidic religion, whose high priests promoted resistance to the expanding Roman Empire throughout northern Europe; in 55 B.C.E., Julius Caesar crossed the English Channel from Gaul (modern France) to make a brief reconnoiter that subdued the Celtic tribes for a while. The Roman Emperor Claudius made Britannia a part of his empire in 43 C.E. after ruthlessly subjugating the Celtic tribes. The Druids were finally destroyed at their last redoubt, the Island of Anglesey off the northwest coast of Wales in 60 C.E. The *Pax Romanum*, Roman Peace, which brought prosperity to England and Wales (southern Scotland was only briefly under Roman dominance) for the next three centuries, was assured by a strong military presence housed in fortress cities, many today recalling their ancient past in names ending in caster, cester, or chester. **Bath**, **Chester** and London, where the first **London Bridge** crossed over the River Thames, all date from Roman times and were vibrant, rich cities as fine as any in the Roman provinces. In the far north the Celtic tribes, the Scots and Picts, were kept at bay by **Hadrian's Wall** stretching from coast to coast. This peaceful existence, under the rule of remote emperors in Rome, came to an end c. 400 C.E., when the Roman Legions abandoned Britannia, leaving it a tempting target for new invasions. The arrival of the Saxons, and of such related peoples as the Angles and the Jutes, heralded the beginning of the so-called Dark Ages in Britain.

Mediaeval—Norman (Romanesque) and Gothic

The Dark Ages, a disputed term for the period of political and social realignment and limited architectural/artistic activity that followed the fall of the Roman Empire in western Europe, effectively ended with the reign of the last Saxon king, Edward the Confessor (1042–1066), the builder of the first **Westminster Abbey** and Palace of Westminster (later to become the **Houses of Parliament**).

Social, political, or natural upheavals always affect the course of architec-

ture and change was inevitable when, in 1066, the Duke of Normandy invaded England to become King William I. The Norman Conquest was the last successful invasion of Britain behind its natural moat, Shakespeare's "fortress built by nature for herself." To establish his rule, William built emphatic statements across the country: **The Tower of London**, **Windsor Castle**, Westminster Abbey, and **Durham Cathedral** are proof of the Norman domination and their control of the state and the church. Architecture evolves in phases. At first a style is tentative and exploratory; then, when the style is accepted and established, rules are applied that restrain the designers within bounds; finally, there is a period when the rules are pushed or broken. In the Italian architecture this evolution is seen in the Early Renaissance, the High Renaissance, and finally the Baroque (Late Renaissance). In mediaeval Britain, church and cathedral architecture evolved from the simple Norman or Romanesque through Early English, Decorated (High) and Perpendicular (Late) styles as seen at Westminster Abbey, **Durham Cathedral**, the **Parish Church of St. Giles** at Wrexham in Wales, and **King's College Chapel** at Cambridge. Castle architecture saw a similar development accelerated as ideas seen in the Holy Land by the Crusaders were brought back home to result in formidable structures such as **Caernarfon Castle** built by Edward I after the conquest of Wales.

Renaissance—Tudor and Elizabethan

The mediaeval period closed with the War of the Roses (1455–1485), the Civil War between the rival Lancaster and York branches of the royal family that ended when Henry Tudor defeated King Richard III at the Battle of Bosworth Field. Crowned as Henry VII, the new king, a Lancastrian, married Elizabeth of York and established the Tudor dynasty, which ruled England until 1603. The Tudors brought stability, prosperity, conflict, and upheaval in equal measure, changing forever the religious and secular faces of the country. Most important were the consequences of the failure of Henry VIII's wife, Catherine of Aragon, to produce a male heir. Henry demanded an annulment; the pope, leader of the Catholic Church, would not agree and, influenced by the Reformation in northern Europe and the king's covetous eye on the wealth of the church, the split with Rome occurred and the Church of England (Episcopalian) was established. The King divorced Catherine and married Anne Boleyn, the second of his six wives; he became Supreme Head of the Church of England in 1534; and from 1536 to 1540 the lands and riches of the church were confiscated during the Dissolution of the Monasteries. **Hampton Court Palace**, built by Henry's chief minister Cardinal Wolsey before the religious upheavals, and given to the King in the hope of saving the situation, is the first Renaissance building in England closely followed by **Somerset House**, the London mansion of Thomas Seymour, regent during the minority of Edward VI. Henry VIII had died in

1547 and his successors—Edward VI, Mary I, and Elizabeth I—struggled to resolve the conflicts that he had unleashed between Catholicism and Protestantism. This culminated in the 1588 defeat of the Spanish Armada, a great fleet of ships packed with soldiers sent by King Phillip II of Spain to conquer England and return the country to the Catholic faith. The era of Elizabeth eventually saw a great flowering of literature—this is the time of Marlowe and Shakespeare—and the arts expressed architecturally in such great houses as **Chatsworth House** and **Hardwick Hall**, both built by Elisabeth of Hardwick, Countess of Shrewsbury, a representative of the new aristocracy promoted by the Tudors.

Renaissance—Jacobean, Stuart, Restoration, and Baroque

The death of Elizabeth I in 1603 saw a change of dynasty. The throne passed to Scotland's King James VI of the House of Stuart, who, as a great-grandson of Margaret Tudor, daughter of Henry VII, became James I of England. James I and his son Charles I, although Protestants, had Catholic tendencies and both believed in the Divine Right of Kings, concluding that God had chosen them to rule, and rule autocratically. Their courts were extravagant and luxurious and royal demands for money brought them into conflict with the increasingly Puritan-dominated Parliament. One extravagance was the masque, an elaborate musical play that later developed into opera. Inigo Jones, a self-taught architect who had traveled to Italy and there seen the buildings of architect Andreas Palladio, designed the complicated scenery and costumes. Jones introduced Palladianism to England, astounding the king and the people with such correctly Classical and beautifully proportioned gems as **The Banqueting House**, Whitehall and **The Queen's House** at Greenwich. The Banqueting House was but a small part of a huge palace intended to be the grandest in Europe, and such expensive designs and demands for increased taxes led, in part, to the Civil War of 1642–1649, which set the Royalists against the Puritans. The Royalists, supporters of the king, fought against the Roundheads or Parliamentarians, who were eventually led by Oliver Cromwell. The Royalists lost and in 1649, Charles I was executed, beheaded on a scaffold set in front of The Banqueting House. Oliver Cromwell ruled for almost a decade as Lord Protector, but his death in 1658 and increasing discontent with the harsh Puritan government led to the Restoration of the Stuart monarchy in 1660 in the person of Charles II. Although Cromwell's regime destroyed many castles, houses, and churches that had survived from mediaeval times, there were architectural developments that continued into the Restoration period. In particular, the Palladian ideas fostered by Inigo Jones were further developed with a characteristically English look. The houses of Sir Roger Pratt, Coleshill House and Clarendon House (see **Belton House**), and imitations such as **Eaton Hall**, **Erddig Hall**, and **Belton House** were the first of many well-

proportioned, symmetrical, middle-sized houses that became the standard during the Georgian period of the following century and were much copied in the North American colonies. These houses are still considered to be the ideal English house and are much copied, as at The Salutation of 1911 by Sir Edwin Lutyens (see **Lutyens Country Houses**).

The restored monarchy of Charles II was restrained in its dealings with Parliament but still extravagant in its spending, and there was an architectural boom, especially after the Great Fire of London in 1666. The fire necessitated the rebuilding of over fifty parish churches and also of **St. Paul's Cathedral**. The genius of Sir Christopher Wren, an astronomer and scientist turned architect, rebuilt London and evolved the restrained Palladianism of Jones and Webb into the English Baroque that reached its height in the works of Sir John Vanbrugh and Nicholas Hawksmoor. Charles II was called the "Merry Monarch" for his good living and many mistresses, but he was also wily and wise, knowing to keep his Catholicism hidden and thus Parliament quiet. His brother and successor, James II, a devout and outspoken Catholic, was not so clever, and in the three years following his succession in 1685 he so riled the Whig aristocracy (the Whigs were a fervently Protestant political party, the other party being the Tories) that the Glorious Revolution of 1688 forced him into exile. William III, a cousin, and his wife Mary II, James II's safely Protestant daughter, were invited to reign as joint monarchs and were followed by Queen Anne, James II's other daughter. That they were *invited* to ascend the throne further reduced the power of the monarchy and increased that of the aristocracy. The leading aristocratic families, who were rewarded with earldoms and dukedoms, set out to build huge country houses to show off their power and wealth. **Blenheim Palace** and **Chatsworth House** are examples of ducal mansions that make the royal family's own rebuilding at **Hampton Court Palace** look quite plain. The baroque church of **St. Martin-in-the-Fields**, designed by James Gibbs, developed Wren's principles and was to have a profound influence on the design of churches in North America even to the present day.

Georgian—Palladianism, Picturesque and Romantic, Neoclassicism, and the Industrial Revolution

The death of the childless Queen Anne in 1714 saw a redirection for both the monarchy and architecture. Wanting to avoid the Stuarts, Parliament looked to a distant branch of the family, the Electors (Princes) of Hanover. The first four Hanoverian monarchs, all named George, ruled England until 1830. They were followed by William IV, who died in 1837, and by Victoria, who ruled for over sixty years, until 1901. Architectural critics led by Lord Burlington looked askance at the extreme and, to them, unlearned Classicism of Blenheim and St. Paul's and called for a change that heralded the second Palladian movement, looking to Palladio and Jones for inspiration and a

stricter interpretation of the rules of classical design. **Chiswick House** and **Holkham Hall** designed by Burlington and William Kent, are particularly complete and influential examples of Palladianism. Georgian Palladianism had a strict hold on architectural design for nearly fifty years, although planning evolved from the axial formalism of Holkham and Buckingham House (**Buckingham Palace**) to the more relaxed circuit plan of **Wrotham Park** and **Harewood House**. Later in the century the rational thinking of the Enlightenment, archaeological discoveries at Pompeii, and travel in southern Italy and Greece brought the realization that Palladian Classicism had veered from its ancient Greek and Roman roots and ushered in the Neoclassicism of Robert Adam, Sir William Chambers, and Sir John Soane. Adam's interiors at **Syon House** and **Harewood House**, decorated by the greatest craftsmen of the period, are the apogee of British design while Chambers's **Somerset House** and Soane's own house in Lincoln's Inn Fields (now **The Soane Museum**) have been studied by every subsequent generation of architects.

The aesthetic movements of the mid-eighteenth century, the Picturesque and the Romantic, had changed the landscape of England, sweeping away the formal gardens that surrounded country houses and, as designed by Lancelot "Capability" Brown, reformed the landscape into carefully designed naturalistic vistas that rolled from the drawing room windows to the horizon. Picturesque adornments—follies—such as mediaeval ruins (real or fake), Classical temples, or rustic cottages made for polite conversational topics soon influenced the very design of the houses: **Fonthill Abbey** was built, and **Eaton Hall** was rebuilt, as Gothic fantasies, while **Alnwick Castle** and **Windsor Castle** were apparently residences for knights in armor rather than silk-bedecked Regency dandies. Most amazing of all was the Prince Regent's Anglo-Hindu-Chinese **Royal Pavilion** at Brighton, a building influenced by trade and colonization in the Far East.

Revolutions changed this world of royal and aristocratic good taste and dilettantism. The American Revolution of 1776 temporarily stopped the expansion of the British Empire and although the bloodthirsty Terror that followed the French Revolution of 1789 did not come to Britain, the political draft led to the Great Reform Acts of 1832 and the beginning of the end of aristocratic dominance of government. The Industrial Revolution, heralded by the first **Iron Bridge** at Ironbridge in Coalbrookdale, changed Britain from a rural, agricultural economy to an urban, industrial economy. Canals, and later railways, carried goods and people across the country; large factories demanded housing for workers covering vast acreages with **Terraced Houses**; and large cities demanded civic buildings such as town halls, museums, and concert halls.

Victorian

The Industrial Revolution that began in the late eighteenth century is a phenomenon of the Victorian Era, named for Queen Victoria who reigned from

1837 to 1901. During Victoria's reign Britain was the richest country in the world, the most productive industrial nation, and the center of the largest and last colonial empire. The diminutive Queen, dressed after the 1861 death of her husband Prince Albert in funereal black, was Empress of India, Great Queen, and Mother to half the world. From her self-enforced retreat in the Scottish Highlands at **Balmoral Castle** she dominated a country bound by rigid class distinctions, social conventions, prudery, and religious conviction. Victorian architecture begins with the Battle of the Styles, the argument over an appropriate architectural style for the rebuilding of **The Houses of Parliament**, which burned in 1834. After much discussion the palace was rebuilt in a suitably British Tudor-Gothic style thereby besting the proponents of a Classical Italianate style. The fantasy Gothic of **Fonthill Abbey** was now socially acceptable and Gothic Revival became the style most associated with the nineteenth century: **The Church of St. John the Baptist** at Huntley, **Eaton Hall**, **Tyntesfield**, and even **Tower Bridge** exhibit the muscular Christian fervency of the High Victorian Gothic Revival encouraged by the influential and interfering Ecclesiological Society. The Classical style was not totally doomed and can be seen at the rebuilding of **The British Museum**, the recasting of **Harewood House**, and **The Royal Albert Hall**. Aristocratic eccentricity continued as seen at the Marquess of Bute's **Cardiff Castle** and **Castell Coch**.

The extreme confidence of the Victorians in their engineering prowess, seen beneath the Gothic Revival dress of **Tower Bridge**, was seen unadorned at **The Crystal Palace**, designed by Sir Joseph Paxton for the 1851 Great Exhibition championed by Prince Albert, the Queen's husband. Paxton, facing a near impossible timetable and budget, accepted the challenge and by the factory production of prefabricated assemblages and a rolling construction program erected a 750,000-square-foot building in a few months—the first building of the modern era. But the many poorly designed, mass-produced pieces exhibited inside **The Crystal Palace** raised the ire of traditionalists concerned that ancient crafts and skills were being lost. The Arts and Crafts Movement was born and architecturally resulted in such houses as **The Red House** and **Broadleys** and led to the **Lutyens Country Houses** of the Edwardian era, which was named for Queen Victoria's successor Edward VII (r. 1901–1910). In Scotland, Charles Rennie Mackintosh idiosyncratically developed his own Arts and Crafts/Art Nouveau style based on historic Scottish buildings such as seventeenth-century **Craigievar Castle**; the result was the architectural gems at Hill House, the Willow Tea Rooms, and **The Glasgow School of Art**.

Twentieth Century

The world that Queen Victoria knew was destroyed by The Great War of 1914–1918, the cataclysm that brought down the monarchies of Austria, Germany, and Russia. British society changed forever—women released from

being domestic servants to replace the men in factories refused to go back; death duties (inheritance taxes) forced the sales of aristocratic estates; a loss of national confidence began the decline of the Empire; and new inventions—the automobile, the airplane, the telephone—again changed the appearance of towns and cities, changed business practice, and revolutionized architecture. Pavements (sidewalks) sprouted **Public Telephone Kiosks**; newly rich industrialists built streamlined modern houses, as at **Charters**; an eccentric aristocrat-architect continued the tradition of gentlemanly patronage at the eclectic **Portmeirion**; and the newly mobile lower middle classes in their Morris Minor cars moved to **Suburban Semi-detached Houses**, fleeing the slums and pollution of the Victorian cities.

The Second World War of 1939–1945 brought bombing and destruction to cities, but in spite of the rigors of war the peace of the 1950s was exuberantly celebrated in the Festival of Britain held on the South Bank of the River Thames in London, 100 years after the Victorian Great Exhibition at **The Crystal Palace**. The new modernism of postwar British architecture, as seen at Sir Basil Spence's **Coventry Cathedral**, paved the way for an architectural revival led by Norman Foster and Richard Rogers with their "High-Tech" creations—**Lloyd's of London**, **The Millennium Dome**, and **The Millennium Bridge**, and the Queen Elizabeth Great Court at **The British Museum**, all in London. As usual, there was criticism and reaction against the architecture and city planning of the late twentieth century led by His Royal Highness The Prince of Wales who, in 1984, railed at the members of the Royal Institute of British Architects (R.I.B.A.) assembled to celebrate the one-hundred-and-fiftieth anniversary of their foundation. The prince's solutions at **Poundbury** and his own house, **Highgrove**, have in turn been criticized as backward looking, even kitsch, but his comments raised public awareness of architecture and the environment. British architects are still capable of designing the most innovative and experimental buildings, most recently illustrated by Norman Foster's **London City Hall** and The Swiss Re Building in the City of London, both of which feature sustainable and intelligent building technology. They continue a tradition of innovation that stretches back through **The Crystal Palace**, **Ditherington Flax Mill**, and **Iron Bridge**, to the first ribbed vaults high above the nave of **Durham Cathedral**, still, in the twenty-first century, considered to be one of the great masterpieces of architecture.

Architecture of England, Scotland, and Wales

ALNWICK CASTLE, NORTHUMBERLAND, ENGLAND

Styles: Mediaeval, Georgian, and Victorian
Dates: Circa 1134; circa 1310; circa 1350; 1754–1768;
1854–1865
Architects: Robert Adam; James Paine and Vincent Shepherd
(eighteenth century); Anthony Salvin (nineteenth century)

The present border between England and Scotland runs in a northwest-erly direction from the Solway Firth on the west coast to Berwick-upon-Tweed on the east coast. In Roman times the border effectively ran due east from the Solway Firth to Wallsend at the mouth of the River Tyne. Wallsend is so called because it is the end of the great wall that the Emperor Hadrian caused to be built in 122–130 c.e. **Hadrian's Wall** was built to keep the bar-barian peoples of unconquered northern Britain from attacking and pillag-ing the peaceful Romanized lands to the south. Circumstances had not changed a thousand years later when the English lands bordering the dan-gerous Scottish border were called The Northern Marches. Border conflicts were a regular occurrence and William the Conqueror and his successors gave large landed estates in this area to their richest, most powerful barons, the strategy being that these rivals for power would spend their wealth and energies protecting the border and their estates rather than conspiring against the king. Alnwick Castle, guarding the crossing of the River Aln on the main eastern road between England and Scotland, was the stronghold of the Lord Warden of the Marches, a position usually held from 1309 by the Percy family, earls of Northumberland. The present, and 12th, Duke of Northumberland, Ralph Percy, can trace his line of descent back to Henry, 1st Lord Percy of Alnwick and further to William de Percy, one of William the Conqueror's companions at the Battle of Hastings in 1066. His home, Alnwick Castle, now the administrative center of a vast, well-managed, landed estate, has all the appearance of being a mediaeval castle: glimpsed across the *park* from the highway the view of the castle, with its great *keep*, *battlemented* towers, and high defensive walls, takes the imagination back to the time of knights in armor and their distressed damsels.

The strategic importance of the site of Alnwick had been recognized soon after the Norman Conquest of 1066. Around 1134, when controlled by the

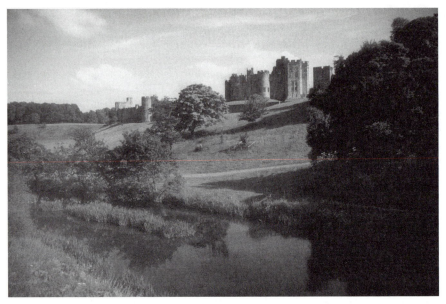

Alnwick Castle. The keep, remodeled by Anthony Salvin, seen across Capability Brown's park. *Photo by Ian Britton (FreeFoto.com).*

de Vescy family, the site was described as "very strongly fortified." By the late twelfth century the castle followed closely the form we see today with a central circular keep of several towers clustered around a small courtyard with two *"baileys"* or outer courtyards, demonstrating the transition from the "keep and courtyard" castle to the "concentric" castle of the thirteenth century. Most of the walls visible today contain evidence of twelfth-century masonry, although most have been rebuilt over the subsequent 700 years. The de Vescy Barons of Alnwick were very much involved in English national politics and border conflicts with Scotland. The castle was briefly occupied by King David of Scotland in 1138 and besieged by the Scots in 1172 and 1174. Eustace de Vescy was one of the leading barons in the revolt against King John (r. 1199–1216) and he was one of the twenty-five barons who, in 1215, forced the King to sign the Magna Carta. The legitimate de Vescy line ended in 1297 and a bastard son inherited but signed over the castle and Barony of Alnwick to the Bishop of Durham, who sold them on November 19, 1309 to Henry de Percy. The Percys were already a wealthy and powerful family with estates in Yorkshire, Lincolnshire, and Sussex, but the acquisition of Alnwick made them one of the most important in the country, a position they maintained until the twentieth-century curtailment of aristocratic power.

Until 1603 and the union of the English and Scottish crowns under James I (James VI of Scotland), the borders were continually dangerous and often at war—the Percys were at the center of these conflicts, often lead-

ing armies to repel Scottish invasions or make incursions north of the border. The most famous Percy of this time is Henry Percy (1364–1403), eldest son of the 1st Percy Earl of Northumberland, who was so renowned a fighter he earned the nickname of "Hotspur." The Percys were also deeply involved in domestic politics. "Hotspur" was killed at the Battle of Shrewsbury while leading a rebellion against Henry IV (r. 1399–1413). Henry Percy, 2nd Earl of Northumberland (1394–1455), was killed at the Battle of St. Albans, the first battle of the War of the Roses, and his son Henry, the 3rd Earl (1421–1461), died six years later at the Battle of Towton. A later earl, another Henry, made the mistake of falling in love with Anne Boleyn, for whom Henry VIII (r. 1509–1547) was also falling and who later became the king's second wife. The earldom survived even the Civil War in the seventeenth century until the death of the 11th Earl, whose heiress was Elizabeth, Baroness Percy.

The castle at Alnwick, as built by the de Vescys, had been improved by the Percys, who in the early fourteenth century rebuilt many of the towers of the keep and the curtain walls surrounding the two baileys. The twin octagonal towers of the gatehouse facing the town were built around 1350 and are still decorated with life-size stone figures of soldiers (mistakenly thought to be decoys to confuse the enemy as to the size of the garrison). However, by the time of Elizabeth Percy in the late seventeenth century, the family lived closer to London and the castle was considerably decayed. The Civil War had seen the destruction of many castles, "slighted" on Cromwell's orders, but Alnwick Castle far in the north was saved from that fate only to fall down through neglect.

Elizabeth, the Percy heiress, married well, becoming Duchess of Somerset upon her marriage to Charles Seymour, 6th Duke of Somerset, who was popularly known as "The Proud Duke." Deeply involved in the politics of the time, the duke was one of the leaders of the Glorious Revolution of 1688 that expelled James II, and the accession of the Hanoverian dynasty in 1714. His duchess was Mistress of the Robes to Queen Anne (r. 1702–1714), at that time a very influential and important court appointment. The Percy estates separated again when another Elizabeth succeeded to the barony and entailed lands in Northumberland in 1750. Although recognized as a great heiress this Elizabeth had married a minor Yorkshire baronet, Sir Hugh Smithson who, in recognition of his wife's ancestry, changed his surname to Percy. Ambitious and pushy, Sir Hugh used his new wealth to solicit titles and honors and in 1766 he was created Duke of Northumberland.

There is humor in the duke's rush to change his name from the homely Smithson to the ancient Percy. His illegitimate son, James Smithson, a scientist of great fame for whom the "Smithsonite" carbonite of zinc is named, was also a radical who supported the ideas of republicanism. He left his fortune "to the United States of America, to be formed at Washington, under the name of the Smithsonian Institution, an establishment for the increase and diffusion of knowledge among men."

The new duke and duchess, for all his ambition and her ancient ancestry, were seen by many in society as nouveau and vulgar. They were, however, the rescuers of the long-neglected Alnwick Castle. By the 1750s the "picturesque" was the height of fashion and aristocratic landowners were creating "Sham Castles," having the appearance of mediaeval ruins, as follies and conversation topics visible from the windows of their correct *Palladian* houses. The Northumberlands went to the extreme and rebuilt their genuine mediaeval ruin as a great country mansion. They first commissioned James Paine (1717–1789), whose work included the main staircase and the State Bedroom. The newly fashionable architect Robert Adam, who was responsible for the Saloon, Drawing Room, and Library, succeeded Paine and is most closely associated with the work at Alnwick at this time. It is not often that we know the local architect responsible for executing famous architects' designs but at Alnwick it is known that the duke's representative was Vincent Shepherd (c. 1750–1812). The decoration and furniture—most of which survives—was hailed as a great success but the exterior, with large Gothic windows, *quatrefoil* decorations, and extraneous turrets and statuary, was condemned as out of keeping with the mediaeval origins of the castle. Alnwick Castle was dressed up in the fake "Strawberry Hill" Gothic (named for a famous Gothic Revival house built for Horace Walpole at Twickenham, Middlesex, 1748–1784) of the fake eighteenth-century castle follies that looked like a caterer had iced the decoration onto the *façades*.

The 1st Duke died in 1786, remembered as a proud and ambitious if slightly ridiculous man, and was succeeded by a line of dukes who have given to their country through royal, military, and political service. Hugh, 10th Duke of Northumberland, who died in 1988, served in the Second World War, was a university chancellor, chairman of the Medical Research Council, president of the Royal Agricultural Society, and Lord Steward of The Queen's Household as well as Master of the Percy Foxhounds! In 1946 he married Lady Elizabeth Montagu Douglas Scott, uniting the Percy and Douglas families who had for centuries been enemies across the border.

The Alnwick Castle that the 10th Duke and his Douglas Duchess lived in was very different from the castle designed by Paine and Adam for the 1st Duke and Duchess. In 1854, Algernon, 4th Duke of Northumberland had commissioned the learned mediaevalist architect Anthony Salvin to re-create a genuine feel to the castle. Sir Walter Scott, the author of *Ivanhoe*, on a visit had suggested that the castle needed a taller central tower to unify the composition, and this Salvin provided in the form of the Prudhoe Tower as a part of a major reconstruction of the keep. The castle was deceptively compact, especially for a ducal mansion; Salvin ingeniously contrived to install a suite of magnificent state rooms on the second floor of the keep that were decorated by a team of Italian plasterers and craftsmen led by Commendatore Canina. The contrast between the rugged feudal exterior and the lavishly rich interior was a specific request of the duke, who did not intend to live in mediaeval discomfort. "Would you wish us to only sit on benches upon a

floor strewn with rushes?" he would chide those who complained at the discrepancy.

Salvin had studied many genuine castles and his restoration, with few exceptions, took Alnwick back, close to its appearance in the fourteenth century. Inside, the Italian craftsmen created a setting for the Northumberland treasures of furniture and fine art including a pair of massive cabinets from the private apartments of Louis XIV of France. The most astonishing room is the Library, which occupies two floors of the Prudhoe Tower. Lined with bookshelves of oak inlaid with maple, the upper tier is accessed from a delicate gilded balcony that runs around three sides, and is topped by a deeply coffered gilded and painted ceiling. The room is rich in color and atmosphere—one of the most magnificent rooms in the country.

The castle overlooks the 3,000-acre Hulne Park (named for a nearby mediaeval Carmelite Priory), landscaped in the eighteenth century by Capability Brown and adorned with bridges, towers, and follies by Robert and James Adam. This, in turn is at the center of the 120,000-acre agricultural estate inherited by the current 12th Duke in 1995. Jane, the latest duchess, has recently created the "Versailles of the north," a new water garden in the abandoned 12-acre walled garden that features fountains, cascades, waterfalls and canals, and 65,000 plants. Built at a cost of $21 million, the new garden has been described by Prince Charles as "imaginative, modern and internationally renowned rivaling the greatest gardens in the world. When complete it will inspire, educate and capture the imagination of young and old alike. It will recreate the garden's glory of the eighteenth and nineteenth centuries, but it will also look to the future." While the duchess's new garden at Alnwick will bring long-term fame in addition to the splendors of the castle and park, recent interest has been sparked by the movie of J. K. Rowling's *Harry Potter and the Sorcerer's Stone*. Alnwick Castle was the setting for "Hogwarts School of Witchcraft and Wizardry."

Further Reading

Alnwick Castle. www.alnwickcastle.com.
Alnwick Gardens. www.alnwickgarden.com.

AVEBURY HENGE. *See* Stonehenge.

BALMORAL CASTLE, ABERDEENSHIRE, SCOTLAND

Style: Victorian
Dates: 1853–1856
Architects: William Smith with HRH the Prince Albert

If George IV (r. 1820–1830) was the monarch of the House of Hanover with the best architectural taste—expressed in the extravagant creation of **The Royal Pavilion** at Brighton, Carlton House in London, **Buckingham Palace**, and **Windsor Castle**—then Queen Victoria (r. 1837–1901), the last Hanoverian, is certainly the one with the worst. All of the buildings she and her husband, Prince Albert, the Prince Consort, commissioned are unmitigatingly bad even by the standards of that era. The ugly and poorly constructed East Wing of Buckingham Palace was refaced in 1913. The Italianate palazzo of Osborne House on the Isle of Wight (1845–1848), designed by Prince Albert and Thomas Cubitt (a developer); contained too many memories of the autocratic widowed Queen and was given to the Royal Naval College within months of her death by her son Edward VII (r. 1901–1910). And, while Balmoral Castle, her retreat in the Scottish Highlands, is still a favorite home of the royal family, this is more because of its remote privacy than any aesthetic appeal. The wholesome, perfect family image of the royal family cultivated during the reigns of George V (r. 1910–1936), George VI (1936–1952), and Elizabeth II (1952–), which spectacularly fell apart in the 1990s, has been referred to as "Balmorality."

Queen Victoria's doctor, Sir James Clark, was a Scot and a proponent of the healthy qualities of pure mountain air. Therefore, in 1842 the Queen and Prince Albert stayed at Lord Breadalbane's Taymouth Castle and were enchanted with the country and its people. "Scotland has made a most favourable impression upon us both. The country is full of beauty, of a severe and grand character; perfect for sports of all kinds, and the air is remarkably pure and light. . . ." wrote the Prince. Another expedition in 1844 was not so successful as rain kept the party indoors, and a cruise of the Western Isles was similarly ruined by the weather. Sir James persevered and his researches showed that the valley of the River Dee on the east side of the country was just as healthy—and much drier! The prime minister had recently inherited the lease on a Deeside property called Balmoral and he sold it to the Queen. Victoria and Albert made their first visit in 1848 and fell in love with the isolation but not the small old castle, which could not accommodate the royal household. The freehold—outright ownership—to the property, which extended to some 11,000 acres, was purchased in 1852 and

in 1853 the foundation stone was laid for the new Balmoral Castle. Although the Queen wrote that the new house was "My dearest Albert's own creation, own work, own building, own laying out, as at Osborne," he was assisted by another unknown architect, of even less ability than Thomas Cubitt, William Smith of Aberdeen (1817–1891).

Balmoral Castle is a typical and rather ordinary country house of the mid-Victorian era in the "Scottish Baronial" style to which it gave some popularity. The two particular features characteristic of this style are a tall tower—at Balmoral rising seven stories—and a profusion of pepper-pot *turrets*. The former derived from the defensive tower houses of mediaeval times and the latter from sixteenth-century French *chateaux*. Before the union with England, Scotland and its monarchs had close ties with France and were much influenced by French taste. Add to the design mix several crow-stepped (stair-like) gables, *dormer windows*, and a massive battlemented *porte cochere* and you have the essence of the Scottish Baronial style. The interior suffered, as one government minister complained, from "tartanitis," a surfeit of tartan (plaid) design, which was used for wallpapers, carpets, curtains, and upholstery fabrics.

Remote and secure, this vast house has been a favorite home of all monarchs since Victoria, although often disliked by their families, courtiers, and ministers. After the death of Prince Albert in 1861 the Queen spent long periods of time at Balmoral forcing her many prime ministers and their associates to make the long journey to her northern stronghold to confer on matters of the empire. Recent monarchs have been more considerate, but each September the prime minister of the day is invited to Balmoral for a long weekend that effectively marks the end of the summer vacation for the royal family.

Further Reading

British Government Balmoral Castle. www.royal.gov.uk/outputs-page560.asp.

Strong, Roy. *Royal Gardens*. New York: Pocket Books (Simon and Schuster Inc.), 1992.

Woodham-Smith, Cecil. *Queen Victoria, from Her Birth to the Death of the Prince Consort*. New York: Alfred A. Knopf, Inc., 1972.

THE BANQUETING HOUSE, WHITEHALL, LONDON

Style: Renaissance—Stuart
Dates: 1619–1622
Architect: Inigo Jones

Whitehall is a street of ponderous government buildings: the Treasury, the Foreign Office, and the Defense Ministry all add to the gravitas of this processional route, which leads from **Trafalgar Square** to Parliament Square and the **Houses of Parliament**. It is hard to conceive that this was once the site of the largest royal palace in Europe: Whitehall Palace, the official residence of English kings from 1530 until 1698. There is one hint: approximately halfway along Whitehall, opposite the gates to the Horse Guards (1750–1759, by William Kent), is a small building that stands out for its exquisite detailing and proportions. This is Inigo Jones's Banqueting House; so different from everything built before that it can be considered to be one of the most revolutionary buildings in Britain. It was built for King James I (r. 1603–1625) as the setting for court entertainments called masques, elaborate and costly productions that featured acting, music, and ballet and were the forerunner of opera.

Whitehall Palace began as York Place, the town house of the Archbishops of York who, after the Archbishops of Canterbury, were the most important religious figures in the country. Their high positions in the church (at this time England was a Catholic country) brought appointments to state offices and, with their religious and political power, they acquired great wealth and influence. York Place, conveniently located a short distance from the principal royal residence, the Palace of Westminster, was begun in the fourteenth century. In 1514, Thomas Wolsey (c.1475–1530) was appointed Archbishop of York. He immediately began work to improve York Place, building a new Great Hall, Chapel, and *apartments* for his own use. The Venetian ambassador, writing in 1519, described York Place as "a very fine palace, where one traverses eight rooms before reaching his (Wolsey's) audience chamber" (see **Blenheim Palace** for a description of the development and use of such multiroomed apartments). Wolsey, the son of a butcher who rose to be Cardinal, Archbishop, and Lord Chancellor, was the trusted advisor of King Henry VIII (r. 1509–1547), but when he was unable to arrange for Pope Clement VII to annul Henry's marriage to Catherine of Aragon (the first of the six wives of Henry VIII) their relationship soured. The breakup of the royal marriage led to a schism with the Catholic Church, the establishment of the Protestant Church of England (Episcopalian in the United States), and the Dissolution of the Monasteries. During the latter, monasteries, abbeys, and nunneries were closed, their property confiscated. While the church was much in need of reform, its wealth was also a potential valuable source of income and patronage for the king. Henry was very jealous and visits to Wolsey's sumptuous new palaces at York Place and **Hampton Court** raised the King's ire because he was living in borrowed accommodation, his apartments at the Palace of Westminster having burned in 1512. Upon Wolsey's fall in 1529, Henry took Hampton Court and York Place into his possession. Immediately renovating and enlarging both structures, Henry renamed the latter Whitehall, which became the principal London residence of the King and his new wife, Anne Boleyn.

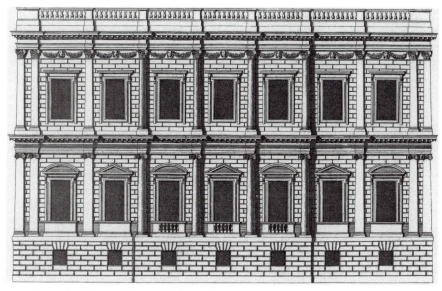

The Banqueting Hall at Whitehall Palace. *Vitruvius Brittanicus.*

York Place was confined by the River Thames to the east (at this time the river was the safest and smoothest transportation route and all important buildings and houses had docks) and by the road connecting Charing Cross (now Trafalgar Square) to Westminster. To enlarge the house to create Whitehall Palace, Henry acquired more land to the south and west. Unable to close the highway, he renamed it King's Street and built two gatehouses that allowed the road to pass below and a passage from the palace to St. James's Park crossover above. On the west, St. James's Park side of the street were a Tennis Court (for "Real Tennis," a game that combines tennis with racquetball), a Tilt Yard for jousting, and a Cockpit for cock fighting. The two gatehouses were architecturally very interesting. The Holbein Gate at the north end was a typical example of late Gothic/Tudor design in stone, checkered brick, and flint (hard, shiny, round stones) with large, multipaned windows and terracotta roundels of Roman emperors. The King's Street Gate at the south end was architecturally the more innovative, being the first example of the new Classical ideas of the Renaissance that were just reaching England from Italy and France. With its Classical *Ionic pilasters*, *pediments*, and decorative "busts à l'antique" it dates from 1545 predating Old Somerset House, the first Renaissance building in London, by two years. (Unfortunately, the architectural importance of the King's Gate was not realized in the eighteenth century and it was demolished in 1723; the architect Sir John Vanbrugh saved the Holbein Gate from destruction in 1719 but it also was demolished in 1755.) Henry continued to expand and embellish Whitehall and at his death in 1547 it extended over twenty-three acres, the largest royal palace in Europe.

The palace was not to be substantially altered by later monarchs, mostly because they lacked the money, but in the case of Elizabeth I (r. 1558–1603) it was because she was parsimonious. During Henry VIII's time at Whitehall temporary buildings would occasionally be erected for special events that would not fit or be appropriate in the Great Hall or Chapel. His daughter Elizabeth I (daughter of Anne Boleyn) also built a temporary banqueting house in 1581 in which to hold entertainments for the visiting Duke of Alençon, who hoped to marry the Queen (obviously a political alliance as Elizabeth was in her late forties and was never to marry). Built just beside the King's Gate, the temporary banqueting house proved convenient and, although built only of timber and painted canvas, survived until 1606. King James I had it replaced with a more permanent structure specifically designed as a setting for the twice-yearly masques that had just been introduced to the court from Italy. This second banqueting house burned in 1619 and the King immediately decided to rebuild. Inigo Jones, since 1615 the Surveyor of the King's Works (official architect), was ordered to produce designs for a new banqueting house with the proviso that it be completed by Christmas 1620, Christmas being one of the most important royal celebrations. Although not finished until 1622, costing the vast sum of £15,618 14s, the King was delighted with Inigo Jones's new Banqueting House.

Inigo Jones (1573–1652), the son of a London clothworker of Welsh origin, is first acknowledged in 1603 in the service of the Earl of Rutland as "Henygo Jones, a picture maker" (i.e., an artist). Using his contacts with aristocratic patrons, Jones was able to travel extensively in Europe and by 1605 was employed by James I's wife, Anne of Denmark, as an Italian-trained designer. Between 1605 and 1640 he staged over fifty masques, often in collaboration with the poet Ben Johnson (both men being "difficult," having "artistic temperaments," their relationship was uneasy). As early as 1606, Jones was dallying with architecture and in 1608 he drew up proposals for the New Exchange in the Strand and the completion of the tower of **St. Paul's Cathedral**. In the words of Sir John Summerson, these designs "are obviously the work of somebody who had had little to do with architecture and nothing with building." However, on further trips to Italy in about 1606, 1609, and 1613–1614 he was able to study the buildings of Andrea Palladio (1508–1580) and Vincenzo Scamozzi (1552–1616) and collect many architectural books and treatises. In London, Jones received various royal appointments culminating in the Surveyorship at a time when James I had plans for lavish expenditure on several palaces. The designs Jones produced for the King show him to be a "careful student of Palladio and Scamozzi, a mature architectural designer whose skill in composition was controlled by an intellectual grasp of the principles of Renaissance architecture." Nothing before had been seen in England like these buildings: The Banqueting House at Whitehall; **The Queen's House**, Greenwich (1616–1619 and 1630–1635); and The Queen's Chapel at **St. James's Palace** (1623–1625). Rising, pristinely austere, above the mediaeval and Tudor buildings of Whitehall

Palace, the Banqueting House was astonishing to English eyes. Unfortunately, to the increasingly Puritan population it was a symbol of royal excess.

Internally, the Banqueting House is a double cube 110 feet long, 55 feet wide, and 55 feet high. Based on the ancient Roman basilica as interpreted by Palladio from Vitruvius (first-century Roman architect, engineer, and writer), Jones imaginatively adapted the plan moving the columns that usually created side aisles against the walls where they appear to support a balcony. Semi-circular half-columns, below the balcony, are in the *Ionic order*; above are *Corinthian pilasters*. At the south end was a semi-circular recess, an *apse*, with a coffered *semi-dome* (removed 1625–1626) that gave the room a strong axis and termination. Elaborately carved beams divide the ceiling into to nine rectangular panels with an oval in the center; in 1636 paintings by the Flemish artist Sir Peter Paul Rubens (1577–1640) were installed. These huge canvasses—the largest is over 40 feet long—depict the Apotheosis of James I, The King, shown being raised to heaven by Justice. At this time it was usual for palaces to be decorated with paintings and sculptures that showed the majesty and dignity of kings and emphasizing the "Divine Right" of their rule. The strong belief of James's son, Charles I (r. 1625–1649), in his God-given rights led to conflict with Parliament and the Civil War of 1642–1649. The stately Banqueting House was used for many court ceremonies and entertainments including the masques devised by Inigo Jones, but these were curtailed after 1636 as it was feared the special effects might damage the ceiling paintings.

On the outside the main room is raised above a *basement* of *rusticated* stone (masonry with deeply cut v-shaped joints between each block). Above this Ionic and Corinthian half-columns and pilasters frame the two levels of windows. Jones based his design on one by Palladio for a townhouse where the three central *bays* of the seven-bay *façade* project slightly and support a triangular *pediment*. As this would have unduly emphasized the central axis where the entrance door was usually placed, Jones, as his design developed, removed the pediment. Unusually, although not without precedent, the whole façade is rusticated, emphasizing the smooth stone of the columns, pilasters, and window surrounds. Originally, this contrast was enhanced by different-colored stone: brown Oxfordshire for the basement, light-tan Northamptonshire for the upper walls, and white Portland for the details and balustrade. Unfortunately, Jones's subtle color scheme was eliminated in 1829 when Sir John Soane refaced the building using only Portland stone; fortunately, the details were re-created exactly.

James I, Charles I, and their architect Inigo Jones considered the Banqueting House to be the mere beginning of a much larger palace that would replace the outdated Whitehall Palace. The unfinished end walls and the temporary staircase at the north end show they had ambitious ideas: plans by Inigo Jones and his pupil John Webb indicate a massive palace 1,280 feet by 950 feet that would have extended from the river far into St. James's Park.

The Banqueting House would have been a minor component in the corner of the Grand Court.

Charles I left Whitehall in 1642 to lead his Royalist troops against the Parliamentarian armies—called the Roundheads for their simple helmets—who were eventually led by Oliver Cromwell. After the decisive defeat of the Royalists at the Battle of Naseby on June 14, 1645, Charles I's fate was inevitable. Declared to be a "Tyrant, Traitor, Murderer and Public Enemy," the King was charged with treason and tried at Westminster Hall (see entry for **The Houses of Parliament**). Condemned to death, he walked through the center window of the Banqueting House to the scaffold where he was beheaded on January 30, 1649.

Cromwell, the Lord Protector; lived at Whitehall Palace and used the Banqueting House to receive ambassadors. On Cromwell's death in 1658 his regime crumbled and in 1660 the monarchy was restored; Charles II (r. 1660–1685) returned to Whitehall and it once again became the focus of lavish court ritual. James II (r. 1685–1688) was the last monarch to live at Whitehall. After he fled the country his successors William III (r. 1689–1702) and Mary II (r. 1689–1694) (they reigned as joint monarchs) preferred St. James's Palace, Kensington Palace, and Hampton Court. They were not upset when, in 1698, clothes drying by a fire caught light and within five hours the whole palace was destroyed. Only the two gates built by Henry VIII and the Banqueting House survived. Sir Roy Strong quotes an anonymous observer: "It is a dismal sight to behold such a glorious, famous, and much renowned palace reduced to a heap of rubbish and ashes, which the day before might justly contend with any palace in the world for riches, nobility, honour and grandeur."

The Banqueting House was immediately fitted up as the Chapel Royal, by Sir Christopher Wren, replacing the Tudor chapel lost in the fire, a function it kept until 1890 when it became a museum attached to the Royal United Services Institute. In 1962 the museum closed and the Banqueting House has since been restored. In 2003 it was the setting for a speech by U.S. President George W. Bush during the state visit to the United Kingdom.

Further Reading

Historic Royal Palaces. www.hrp.org.uk/webcode/banquet_home.asp.

Strong, Roy. *Lost Treasures of Britain*. London: Penguin Books Ltd., 1990.

Summerson, Sir John. *Inigo Jones*. London: Penguin Books Ltd., 1966.

BATH, AVON, ENGLAND

Styles: Roman, Mediaeval, Georgian, and Modern
Dates: 43 C.E. to present day
Architects: John Wood the Elder and John Wood the Younger
(18th century)

Bath is arguably the most beautiful city in the United Kingdom. As its name suggests it is a spa town that originated in Roman times because of the healing hot springs that daily gush a quarter of a million gallons at a temperature of 115 degrees. The Romans developed Bath, then called Aquae Sulis, as a resort and it similarly became the destination of eighteenth-century society who came to the fast-developing city to "take the waters" and be at the center of fashion. Jane Austen (1775–1817) writes of Bath in two of her books—*Persuasion* and *Northanger Abbey*—and she lived in Bath for four years. It is the eighteenth-century development of elegant streets, plazas, and gardens that made Bath such a beautiful city, a city that largely survives to the present day and is the model for many town-planning ideas. In the *Daily Telegraph* newspaper in February 2004, George Trefayne wrote an article under the headline "The economy could use another Bath." His argument was that the problems of housing and land shortage that now affect Britain could be overcome if the grand terraces of densely packed but beautiful row houses (**Terraced Houses**) of Bath were copied in new housing developments.

Legend has it that c. 500 B.C.E. Prince Bladud, the father of King Lear of Shakespeare's tragic play, returned from distant travels with the disease of leprosy. Cast out by his father, he became a swineherd at a farm called Swainswick where he noticed that the unusually healthy pigs liked to wallow in mud that was unusually warm. Reasoning that the hot spring water was good for the pigs, he tried it himself and was cured of his leprosy. Bladud retuned to his father's court, eventually succeeded to his inheritance, and founded the city of Bath so that others might try the healthy waters; the spring was dedicated to the pagan god, Sul. Some of this story is confirmed by what is definitely known, particularly the Roman name for the city they built after 43 C.E. Aquae Sulis incorporates the Celtic god's name even though the Romans dedicated the actual springs to their own goddess of health and healing, Minerva.

Bath is situated on the banks of the River Avon between the hills of the Cotswolds to the north and the Mendips to the south. One of the major highways of Roman Britain, the Fosse Way, which stretched from Exeter in the far southwest to the Humber estuary on the east coast, passed though Aquae Sulis giving easy access from all over the island to the spa resort that developed around the hot springs. The Romans built several baths and most

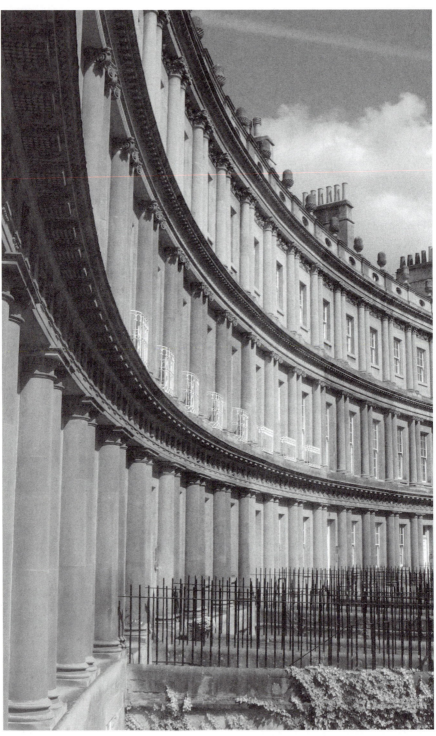

Bath. The Circus by John Wood the Elder. *Photo by Ian Britton (FreeFoto.com).*

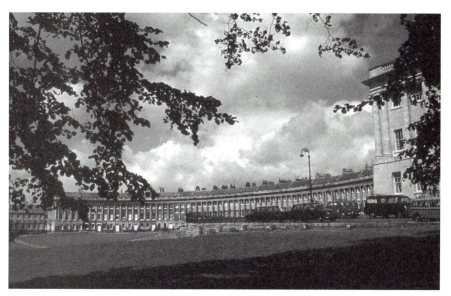

Bath. The Royal Crescent by John Wood the Younger. *Photo by author.*

of these survive to the present day, although the buildings that once enclosed them have now disappeared. The Great Bath, 80 feet long by 40 feet wide and six feet deep, built in 70 C.E., was originally roofed over and surrounded by dressing rooms, massage rooms, and the ancient equivalent of a Turkish bath. Lead pipes installed by Roman plumbers still supply hot mineral-spring water to the Great Bath. In one corner of the bath a cast bronze head of Minerva, which must have once looked down upon the bathers, was found. Beside the baths the Romans built a temple dedicated to Minerva, and from the *pediment* has survived a carved stone head of Medusa complete with snakes, but strangely mustached, that is believed to be part of a larger sculpture referring to the healing and evil-averting powers of Sulis (Sul)-Minerva (it was part of the Roman success that as their empire expanded local gods were acknowledged and incorporated into the Roman pantheon thus somewhat appeasing conquered peoples).

In 577 C.E., almost two centuries after the Romans had left Britain, a battle at Dyrham, just north of Bath, saw the triumph of the invading Saxons over the Britons and Bath was looted and destroyed. A hundred years later the Saxons established a monastery at Bath on a site close beside the ruined bath buildings, although the main baths and the temple were hidden beneath fallen rubble. The abbey became very important and in 973 C.E. was the site of the coronation of King Edgar, the first king of a united England. But it had declined by the eleventh century when it was sold to Bishop John of Tours for £60 and a new, larger cathedral was built. In the last year of the fifteenth century Bishop Oliver King had a vision of angels climbing ladders

reaching from heaven assisting in the building of a great cathedral and he directed the building of the third and final Bath Abbey in the Perpendicular style with its fine fan vaulting, stained glass, and allegorical carvings.

The hot springs were still recognized for their healing properties and The King's Bath was built in the eleventh century over the site of the Temple of Minerva, while in the twelfth century the St. John's Hospital was founded, earning the place this description by the chronicler Henry of Huntingdon: "Where the hot springs . . . supply the warm baths which stand in the middle of the place, most delightful to see and beneficial to health . . . infirm people resort to it from all parts of England, for the purpose of washing themselves in these salubrious waters; and persons in health also assemble there, to see the curious bubbling up of the warm springs, and to use the baths." Three hundred years later, in 1449, a local correspondent named Banwell wrote, "a report has reached the ears of the bishop that the heavenly gift of warm and healing waters with which the City of Bath has been endowed from of old is turned into an abuse by the shamelessness of the people of that city." This was to be a common complaint cited against Bath over the coming centuries, as it became a city of fashion and leisure.

The wool industry had been the source of local wealth in mediaeval times but as this declined the baths were developed with three—the King's Bath, Cross Bath, and Hot Bath—in use throughout the sixteenth century and the Queen's Bath, built beside the King's Bath, added in 1576. Queen Elizabeth I visited Bath in 1574 and in 1590 granted a Charter of Incorporation of the City of Bath that entrusted control of the hot springs to the city council so that they should be accessible to the public in perpetuity. Later monarchs to take the waters at Bath included, in 1663, Charles II (r. 1660–1685) and his barren wife, Katherine of Braganza; in 1687, James II (r. 1685–1688) and his wife Mary of Modena, who soon after became pregnant and bore a son, a Catholic heir (whose existence led to the Protestant uprising and the Glorious Revolution of 1688); and, in 1692, 1702, and 1703, Princess, later Queen, Anne (r. 1702–1714) made visits that prompted comments that Bath was the "premier resort of frivolity and fashion." These royal visits assured the success of Bath and as the aristocracy and gentry flocked to the city a great rebuilding took place that completely changed its look—in 1700 Bath was essentially a mediaeval city, but by 1800 it was a splendid city of Classical architecture and elegant streets.

This transformation is due to the foresight of three men: Ralph Allen, Beau Nash, and John Wood the Elder. Ralph Allen (1693–1764) had made a fortune revolutionizing the national postal services, which until his intervention had all gone via London whatever a letter's origination and destination. He was Mayor of Bath in 1742 and, as the inspiration for the redevelopment of the city was not to act altruistically, he owned the Combe Down quarries that supplied all the stone for the new buildings. Allen's great house, Prior Park, designed by John Wood the Elder, spreads over a hill overlooking the city he created.

Richard Beau Nash (1674–1761) arrived in Bath in 1703 from London where he had been a professional gambler. Nevertheless, he was accepted by Bath society and upon the death (in a duel) of Captain Webster, the "Master of Ceremonies," Nash succeeded as the arbiter of social mores in the city. As the "King of Bath" Nash regulated society and the city, even devising a set of rules regulating sedan chair owners that is the basis of modern regulations for taxicabs. Nash ruled over the fashionable, dictating when and how entertainments took place and establishing a strict etiquette for visitors. Far from stifling, Bath became a polite place to which people flocked, but beneath the manners simmered all the romance of many a novel, as can be seen by reading the works of Jane Austen.

John Wood the Elder (1704–1754) was Allen's architect and with his son, John Wood the Younger (1728–1801) was responsible for designing most of the new city of Bath. Wood's career began in Yorkshire where he worked on a formal landscape of tree-lined avenues at Bramham Park. From 1725 to 1727, Wood was in London working for the Duke of Chandos who also owned land in Bath contiguous with an area owned by Robert Gay. Wood, seeing the possibility of making a lot of money, proposed a plan to develop the Chandos–Gay estates and became the architect, the leaseholder, and the contractor—a huge financial risk, but one that paid off. The elder Wood's other contribution to British architecture was to apply an idea developed by the French architect J. H. Mansart in 1698 at the Place Vendome in Paris. Until this time terraced or row houses had been built side-by-side but still retained their individual appearance. Mansart created long, unified façades behind which the individual houses were built. This idea came to England with the partly built design of Grosvenor Square, London of 1725–1735 but was fully realized with Wood the Elder's Queen Square, Bath of 1729–1736 and Circus (1754) and Wood the Younger's Royal Crescent (1767–1775) creating "the most spectacular example of eighteenth century urban development" (Banister Fletcher).

Queen Square closely followed the latest urban developments Wood the Elder had seen in London with its unified *façades*, central attached *porticoes*, *Corinthian* half-columns and *pilasters*, *rusticated* first floor and prominent end *pavilions*. It is only careful scrutiny that reveals that the grand palaces overlooking the gardens of Queen Square are actually terraces of row houses. The trick is only given away by the multiple discreet front doors and the regularly spaced chimney stacks and firewalls above the *parapet*. Wood, however, knew of Bath's Roman existence and he determined to give his new city the Classical grandeur of its predecessor with a "Forum, Circus and an Imperial Gymnasium," presumably a reference to the thermae (baths) of ancient Rome. From Queen Square to the north leads Gay Street, a comparatively narrow uphill connection that suddenly bursts into the spectacular Circus. Wood originally conceived of this 320-foot diameter space as "for the exhibition of sports" but quickly realizing the impracticality of this, created an "outside-in" colosseum again lined with row houses. The three equal tiers of

coupled columns, *Doric* on the first floor, *Ionic* on the second, and Corinthian on the third, rhythmically line the circle concealing the thirty-three houses. The sweeping circle is broken three times: for Gay Street, Brock Street, and a short street leading to the Assembly Rooms (1769, by Wood the Younger), the social center of Bath. The Circus was originally designed as a paved plaza for the parade of fashionable ladies and their beaux but the monumental grandeur of Wood's conception has been diluted by the creation of a central circular, tree-filled garden, which blocks appreciation of the whole space.

Brock Street, like Gay Street, is comparatively narrow, a rest after the visual excitement of the Circus that appears to lead to a park. It is only when one reaches the end of Brock Street that one realizes that the grand design the Woods, father and son, had for Bath continues exploding into the Royal Crescent. Wood the Elder died in 1754 while the Circus was under construction and it was his son John Wood the Younger who bought land to the west and built one of the most important urban forms in English architecture: the crescent, whether elliptical as in Bath or semi-circular as at Buxton and Brighton, was repeated many times throughout Britain until the end of the nineteenth century. Unlike Queen Square with its palace façades clearly defined by central and end pavilions, the Royal Crescent is a continuous rhythmic parade of giant order Ionic columns rising through the second and third floors over a plain ashlar first floor; the monumental scale—over five hundred feet—and repetition is breathtaking in its audacious simplicity and is considered one of the architectural set-pieces of Europe. How Wood the Younger came to this design is not known, but Summerson surmises his original concept was for a larger version of his father's Circus using the elliptical proportions of the Roman Colosseum; this "conception was split into two demi-colosseums by the need for a road passing through the structure. The omission of one of the demi-colosseums leaves the Crescent." Whatever, the result was and is architecturally and spatially splendid and its thirty houses command astronomical prices.

The sequence of architectural spaces from Queen Square to the Royal Crescent lead away from the center of Bath out into the countryside. Together they "form a highly original complex of urban architecture. Nowhere in Europe had anything with quite this same freedom and invention been executed" (Summerson). Bath in the eighteenth century was as influential as London as a center of fashion and the idea of palace façades and monumental blocks fronting row houses became the accepted norm as seen at Bedford Square, London, and John Nash's **Regent's Park and Regent Street**, also in London.

The houses of Bath beyond the formality of the Woods' designs became more romantic, straggling and curving terraces of row houses—Camden Crescent, Lansdown Crescent, and Somerset Place (all c. 1788) lead up the hill to Beckford's Tower, the last folly and burial place of William Beckford of **Fonthill Abbey**. East of the city lay the Bathwick estate and this was opened up for development after the construction of Robert Adam's Pulteney

Bridge crossing the River Avon. Based on the Ponte Vecchio in Florence, Italy, this elegant bridge was lined with fashionable stores and led to Great Pulteney Street, impressively large (1,100 feet long by 100 feet wide) but, compared to the work of the Woods west of the city center, rather sterile. In the city center the bath buildings were rebuilt several times and in the 1790s during the building of the Pump Room, where the mineral water could be drunk, the Roman Great Bath was discovered and incorporated into the new building.

During the nineteenth century Bath declined as a place of fashion but it was still much visited as a health spa and for its elegant, genteel atmosphere. In 1976 the National Health Service (the equivalent of Medicare/Medicaid) withdrew support and the Spa Medical facility closed; other health concerns closed several of the baths to public use. In 2004 the renovated and rebuilt Bath Spa was nearing completion and when it opens to the public will allow users to once again bathe in the pools and drink the hot mineral waters that have bubbled up from below for thousands of years. The dramatic new buildings inserted into the old fabric are to the designs of Nicholas Grimshaw and Partners, and from the roof terraces views over the city's 2,000-year architectural heritage will be possible: the remains of the Roman City; the mediaeval splendor of Bath Abbey; the urban grandeur of the Woods' development to the west; and Adam's elegant Pulteney Bridge to the east. Despite wartime bombing and the ravages of insensitive planners in the twentieth century, Bath survives and in 1987 was created a World Heritage City by UNESCO.

Further Reading

Roman Baths, Bath. www.romanbaths.co.uk.
Summerson, John. *Architecture in Britain 1530–1830*. New Haven, Conn.: Yale University Press, 1993.

BELTON HOUSE, LINCOLNSHIRE, ENGLAND

Style: Renaissance—Restoration
Dates: Circa 1684–1688
Architect: William Winde

Belton House is the home of the Earls Brownlow, whose family has owned the property since 1609 when Richard Brownlow, Chief Prothonotary of the Court of Common Pleas (i.e., a very successful lawyer), started to acquire

land in Lincolnshire to establish a country estate. The Earl of Lincoln was upset to see land he coveted bought by this upstart Londoner and described him as "a villayne . . . that purchased land every day from under my nose, and . . . would purchase my house if were suffered." Richard Brownlow's eldest son, "Old" Sir John, married an heiress but died childless, leaving his fortune and lands to his great-nephew, also John Brownlow, and great-niece Alice Sherard, whom he had brought together "in case they shall affect one the other." They married in 1676, both aged sixteen. Inheriting the then prodigious income of £9,000 and with even more in the bank, they soon decided to build a new house at Belton. Sadly, the "Young" Sir John died of a self-inflicted but accidental gun shot in July 1697, and Belton again passed to another branch of the family.

The importance of Belton is not so much the house itself, although it is very fine, but that in its design it closely follows two very influential houses that have been lost: Coleshill House, Berkshire (c. 1650–1662), which burned in 1952, and Clarendon House, Piccadilly, London (1664–1667), which was demolished in 1683. Their architect was Sir Roger Pratt (1620–1685) and their revolutionary planning and form, and the principles they incorporated, were to have a permanent impact on country house design. The importance of these two houses is Sir Roger's introduction of what he called the "double pile" in which two ranges of rooms were set back-to-back with a service corridor in between. This represented a further development in the evolution from the communal households of the mediaeval and Tudor periods where all activity focused on the great hall. At **Hardwick Hall** the importance of the hall is reduced but at Coleshill it becomes merely a grand entrance hall with no pretense at being a banqueting hall; Pratt places the staircases in this ornate space. The hall at Coleshill forms half of what became known as the "state centre" where the most important rooms of the house were placed. Behind the hall on the first floor is the Great Parlour (the equivalent of the Low Great Chamber at Hardwick) and on the second floor is the Salon (High Great Chamber). To each side of the "state centre" are four apartments (bedroom suites) for the family and important guests, each comprising a chamber and adjoining closets.

Pratt kept two notebooks that he titled "Rules for the Guidance of Architects" and "Notes on the Building of Country Houses," and in these he explains his thoughts about planning, proportion, and servants. By this time the makeup of households of the nobility had changed markedly from that in mediaeval times when there was a feeling that they were a community, with the lord at the apex, all working and living together. The houses that Pratt designed demonstrated a great change in that servants were now lowly employees, paid to serve but otherwise not to be acknowledged, and certainly not to be allowed to sit at table in the Great Hall and partake of a banquet with the lord and his guests; the servants had their own dining room. Pratt's innovative plan placed the service rooms in a semi-*basement*, back stairs at each end of the house, and servants' sleeping quarters in the attic lit by *dormer*

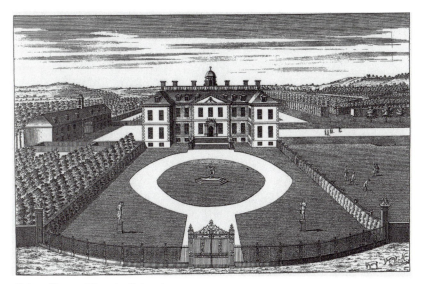

Belton House. *Vitruvius Brittanicus.*

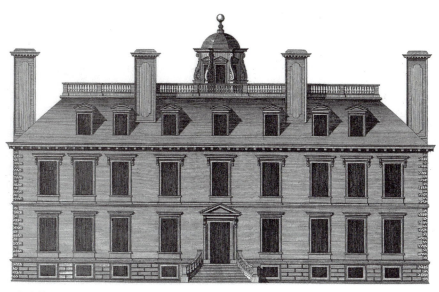

Coleshill House. The precursor of Belton house, designed by Sir Roger Pratt. *Vitruvius Brittanicus.*

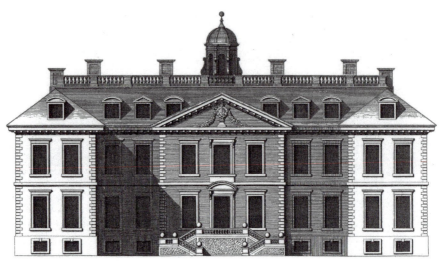

Belton House. *Vitruvius Brittanicus.*

windows. The crucial development is the back stairs; this enabled servants to reach most rooms in a house without passing through the hall or as Mark Girouard put it, "gentry walking up the stairs no longer met their last night's faeces (in the chamber pot) coming down!" This was the beginning of the rigorously enforced hierarchy of servants that reached its apogee in the late nineteenth century: butler, housekeeper, steward, cook, footmen, maids, and so on down to the lowliest boot boy and scullery maid (see **Wrotham Park**).

At Coleshill, Pratt designed a house that was to be copied many times, although not as elegantly. A house that reinforced the ideas of Palladio, Inigo Jones, and his pupil John Webb (the latter two were probably consulted) while developing a particularly English style that was to be continued by such great architects as Wren but also by every minor provincial architect and mason. It was symmetrical, ordered, and subtle and had great presence. At first glance rather ordinary, Coleshill was symmetrical and ordered with a subtle variation in the window spacing that indicates the hierarchy of the rooms inside. Unlike Hardwick Hall, where the symmetry is sham achieved by many fake windows, at Coleshill the symmetry and order carries through into the interior of the building. Coleshill is the precursor of the Georgian architecture that was to become the accepted style of the eighteenth century in Britain and the United States.

Clarendon House, also designed by Pratt, was built on the western edge of the city of London for Edward Hyde, Earl of Clarendon (1609–1674), who was Lord Chancellor under Charles II (r. 1660–1685). John Evelyn, the diarist, called Clarendon House "without hyperbolies, the best contriv'd, the most usefull, gracefull, and magnificent house in England." Pratt developed the idea of Coleshill, reinforcing the "state centre" with a *pediment* and ex-

panding the plan with four projecting wings to form an H-shape. As at Coleshill the steep dormered roof was capped by a *balustrade* that allowed for a roof terrace (somewhat like a widow's walk) reached via the central *lantern* (this idea Pratt possibly took from Balleroy, a *chateau* in France by Mansart). Clarendon House was a victim of Clarendon's fall from power in 1667, when he was forced to flee to France and much of his fortune was confiscated. His heirs sold the house for its materials and the land for development and it was demolished in 1683 after standing for only seventeen years. Although nothing remains of Clarendon, its importance to the development of English architecture cannot be overlooked and a hint of its beauty can be seen at Belton House, which closely follows its design.

The architect of Belton is not precisely known. Sir Roger Pratt kept good records and therefore he can be eliminated. It is known that it was built by the master-mason William Stanton (1639–1705) as the Belton archives show payments for more than £5,000 over the years 1684–1686. Stanton was a first-class mason, an officer and Master of the Mason's Company (professional organization), capable of leading a team to produce the exquisite craftsmanship seen at Belton but not of the sophistication of its design. The clue to the architect is a letter of February 1690 from Captain William Winde to Lady Bridgeman recommending a plasterer "now looked on as the beste master in Ingland in his profession, as his work at Coombe, Hamstead and Sir John Brownloe's will evidence." Combe Abbey, Warwickshire, and Hampstead Marshall, Berkshire, were both designed by Winde with Combe in particular being based on Clarendon House. It is therefore virtually certain that William Winde who, additionally, was also a friend of Sir Roger Pratt's, is the architect of Belton House.

Belton House has many of the features of Clarendon House although it is slightly smaller, being eleven *bays* wide as opposed to fifteen. The plan is H-shaped and has two main floors over a semi-basement with a steep roof and attics lit by pedimented dormers. As at Coleshill there is a "state centre" with apartments, four on each main floor, to either side. One of the four wings contained *apartments* while the other three contained the nurseries and schoolroom, the kitchen, and the Chapel. The balustraded flat (roof terrace named for the lead "flats") is accessed via the glazed *lantern* that dominates the center, vying for attention with the six tall chimneys. Built of golden Ancaster stone with lighter Ketton stone used for window and door surrounds, keystones, and quoins (protruding corner stones), the two main *façades* are emphasized by central pediments containing armorial devices. The "state centre" of the house is entered through the central doorway into the 30-foot by 40-foot Marble Hall. On axis but on the garden side of the house is the Great Parlour while above are the Great Dining Room and the best bedchamber with its adjoining closets. All of the major apartments have an adjoining withdrawing room or dressing room (the latter a sitting room, not as private as its name suggests). There is an inventory of 1688 that names and describes each room and its contents, even indicating the person residing in

each of the apartments; Sir John and Lady Alice Brownlow's rooms are to the west of the "state centre" with Madam Sherard's (Lady Brownlow's mother) in one of the wings and Sir John Sherard's (Lady Brownlow's grandfather) on the ground floor. (Sir Roger Pratt, in his "Notes on the Building of Country Houses," recommends "one bedchamber at least upon the first floor for those who are sick, weak, old, etc.") The Chapel is a two-story space reaching through the basement and first floors with the servants on the lower level and the family overlooking from a balcony. The altar is backed by a huge *reredos* (backdrop to the altar) with *Corinthian* columns and a segmented pediment of carved wood painted to look like marble.

There have been changes over the years, most significantly in 1776 when architect James Wyatt moved fireplaces and paneling while reconfiguring the plan and redecorating several of the rooms: the Great Dining Room became a Neoclassical drawing room. Wyatt's decision to remove the lantern and balustrade from the roof was luckily reversed in 1872–1893. In the 1930s, Peregrine Cust Brownlow, the 6th Baron and a devoted friend of King Edward VIII (r. 1936), and his mistress Wallis Warfield Simpson had the second floor nurseries redecorated as a bedroom suite for them and these are now called the Windsor Rooms. All these changes have had little effect on the overall composition and most of William Winde's concept is still clearly discernible as is the debt he owed to those earlier houses by Sir Roger Pratt, Coleshill and Clarendon House.

Further Reading

National Trust Web site for Belton House. www.nationaltrust.org.uk/scripts/nthand book.dll?ACTION=PROPERTY&PROPERTYID=77.

BLENHEIM PALACE, OXFORDSHIRE, ENGLAND

Style: Renaissance—Baroque
Dates: 1705–1722; 1722–1725; 1764; 1892–1930
Architects: Sir John Vanbrugh; Nicholas Hawksmoor; Henry Wise and Lancelot "Capability" Brown (eighteenth century); Achille Duchêne (twentieth century)

In 1874, the American heiress Jennie Jerome married Lord Randolph Spencer-Churchill, second son of the 7th Duke of Marlborough; their eldest son, Sir Winston Churchill (1874–1965), was born at Blenheim Palace.

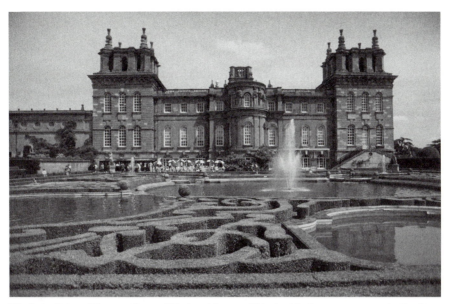

Blenheim Palace. The west front of Vanbrugh's central block with the water terraces by Duchêne in the foreground. *Harcourt Index.*

Lady Randolph Churchill (it is usual for the wife to use her husband's name) wrote of her first visit to the vast palace that has been the country home of the Dukes of Marlborough since the early eighteenth century: "As we passed through the entrance archway and the lovely scenery burst upon me Randolph said with pardonable pride 'This is the finest view in England.' Looking at the lake, the bridge, the miles of magnificent park studded with old oaks . . . and the huge and stately palace, I confess I felt awed. But my American pride forbade the admission."

Lady Randolph's journey had brought her through the Oxfordshire countryside to the small town of Woodstock with its genteel eighteenth-century houses. At the end of the street, where one would expect to find fields and meadows, a triumphal arch and heavy wooden gates block the way. The triumphal arch (1722–1723 by Nicholas Hawksmoor) gives a hint of the wonders that are beyond: the lake by Capability Brown, the park by Wise and Brown, and the great palace by Sir John Vanbrugh.

Blenheim was built to reward Sir John Churchill (1650–1722, created Duke of Marlborough in 1702), a military genius who led the allied armies that defeated Louis XIV of France in the War of the Spanish Succession (1701–1714). One of the early battles of the war in 1704 was at Blenheim, a small village on the north bank of the River Danube. Marlborough's victory over the French led by Marshall Tallard saved Vienna and was a turning point in the war. Queen Anne was so grateful that she granted to Marlborough the Royal Manor of Woodstock with the promise to build, at her own expense,

a house to be called Blenheim. It helped that Sarah, the duke's wife (1660–1744), was the closest friend and confidant of Queen Anne (r. 1702–1714); they addressed each other by the pet names Mrs. Freeman (Sarah) and Mrs. Morley (The Queen). On the East Gate is an inscription that reads:

> Under the auspices of a munificent sovereign this house was built for John Duke of Marlborough, and his Duchess Sarah, by Sir John Vanbrugh between the years 1705 and 1722. And this Royal manor of Woodstock together with a grant of £240,000, towards the building of Blenheim was given by Her Majesty Queen Anne and confirmed by Act of Parliament . . . to the said John Duke of Marlborough and to all his issue male and female lineally descending.

Marlborough and his duchess fell from royal favor in 1710 and had to find more than £60,000 to complete the building. Nevertheless, the Marlboroughs still pay "rent" to the Sovereign for their estate: a standard (flag) featuring the three gilded fleur-de-lys (lily flowers) of the Corps de Roi is presented every August 13th, the anniversary of the Battle of Blenheim.

As his architect Marlborough had chosen Sir John Vanbrugh, the extrovert soldier, spy, playwright turned architect who was designing some of the most extravagant houses ever to be built in the country: Castle Howard, Yorkshire; Seaton Delaval, Northumberland; Kings Weston, Gloucestershire, and so on. Vanbrugh based his architecture on the work of Palladio and Wren but added such theatricality and bravura that neither of those purists would wish to praise his designs. Vanbrugh marks the high point of the English Baroque.

The scale of Blenheim is difficult to comprehend. The main *façade* is nearly 1,000 feet wide and the whole complex of buildings and courtyards covers an area of over seven acres. Compositionally simple, the main block is connected by curved quadrants to the side wings; colonnades connect these to the service courts, the kitchen court to the east and the stable court to the west— basically an elaboration of the *Palladian* villa. Wren wrote of Vanbrugh that "he designed in perspective" and no view of Blenheim is unresolved or boring. Vanbrugh used a huge *Corinthian portico* as the center of the design topped by another unexpected *pediment* dramatically broken and recessed. Carved stone trophies, many by the sculptor Grinling Gibbons, depict England's victory over France and praise the Queen and Marlborough. To either side the *Doric Order* provides appropriately muscular strength to the quadrants and colonnades reinforced by the use of deeply incised, *rusticated* (with deep v-shaped joints) stonework of the four corner towers. Vanbrugh wrote of another of his houses that he "thought it absolutely best to give it something of the castle air" and at Blenheim he also created a military atmosphere—appropriate for a memorial to a great victory and a great general but not necessarily for a home. Alexander Pope expressed a common opinion:

See, Sir here's the grand Approach
This way is for his Grace's Coach;
There lies the Bridge, and there's the clock,
Observe the Lyon and the Cock,
The spacious Court, the Colonade,
And mark how wide the Hall is made?
The chimneys are so well designed,
They never smoke in any wind.
The gallery's contrived for walking,
The windows to retire and talk in;
The council chamber for debate,
And all the rest are rooms of state,
Thanks, sir, cried I 'tis very fine,
But where d'ye sleep, or where d'ye dine?
I find, by all you have been telling,
That 'tis a house, but not a dwelling.

Vanbrugh's own thought was that the house "ought in short to be considered as both a Royal and national monument with the appropriate qualities viz. beauty, magnificence, duration." Sarah, Duchess of Marlborough (a difficult woman at best), hated the house for its size and discomfort— "that wild unmerciful house. Vanbrugh's madness."—and condemned Vanbrugh for his extravagance, finally firing him in 1716 and hiring his associate Nicholas Hawksmoor to complete the house. Hawksmoor, a pupil of Wren's, worked beside Vanbrugh through most of his career and it has been said that "though Blenheim as a whole is Vanbrugh's yet there is not one detail of which one could say with certainty that Hawksmoor had not designed it."

Internally, the house is as spectacular as the exterior. The central axis of the house leads into the Great Hall that rises 67 feet to the ceiling, painted in 1716 by Sir James Thornhill with a scene from the Victory at Blenheim. Spatially complex, the hall is visually larger than it first appears with arcades to each side opening to staircase halls and a huge archway leading to the door of the Saloon or State Dining Room. This is another massive room, its walls and ceilings painted by Louis Laguerre and its doorways designed by Gibbons and featuring the double-headed eagle crest of the duke as a Prince of the Holy Roman Empire. To either side of the Saloon are the State Apartments; in the East Wing, the Private Apartments; and, in the West Wing, the 180-foot-long Gallery.

Visitors to the house today wonder why the first duke and duchess needed so many interconnecting rooms: two drawing rooms (Red and Green), a Green Writing Room, and the three *State Rooms*. The house seems to be nothing but elaborately decorated sitting rooms, but this was not the original function of these rooms. Blenheim Palace is one of a series of "formal houses," the final and most developed form of a plan that appeared in the

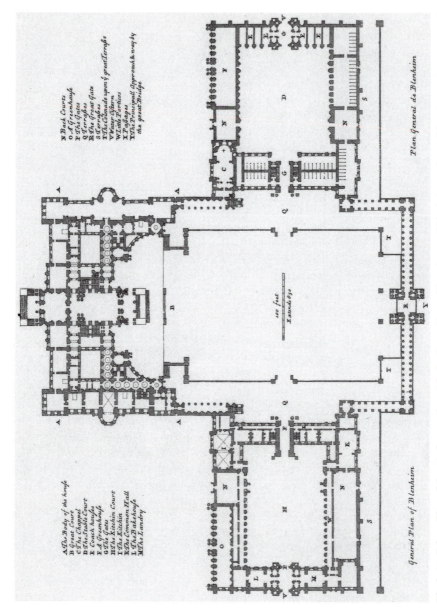

A The Body of the house
B Great Court
C The Chappel
D The Stable Court
E Coach house
F A Greenhouse
G The Gate
H The Kitchin Court
I The Kitchin
K The Common Hall
L The Bakehouse
M The Laundry

N Back Courts
O A Greenhouse
P The Gates
Q Terrasses
R The Great Gate
S Terrasses
T The Colonade upon ye great Terrasse
V Water Ciftern
W Little Porticos
X Passages
Y The Principall Approach & way by the great Bridge

General Plan of Blenheim.

Plan general de Blenheim.

100 feet
Extends 850

Blenheim Palace. Plan of the whole complex with the Great Court (B) and central block (A) in the middle, the Kitchen Court (H) to the left, and the Stable Court (D) to the right. *Vitruvius Brittanicus.*

28

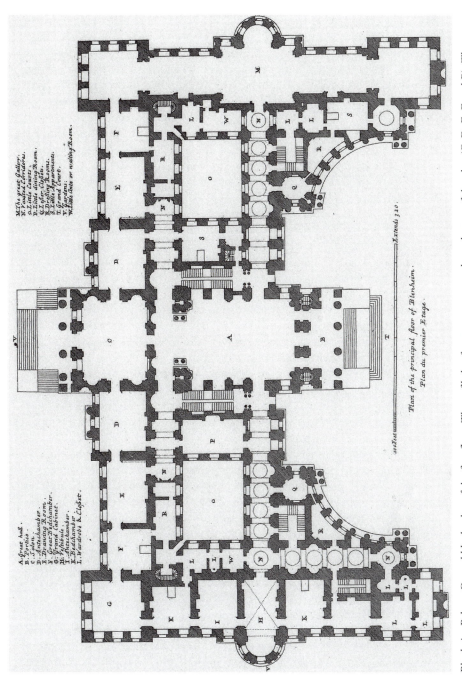

A. Great hall.
B. Portico.
C. Salon.
D. Antichamber.
E. Drawing Room.
F. Great Bedchamber.
G. Grand Cabinet.
H. Alcobe.
I. Antichamber.
K. Bedchamber.
L. Wardrobe & Closet.

M. The great Gallery.
N. Vaulted Corridors.
O. Little Courts.
P. Little dining Room.
Q. Light Closets.
R. Drefsing Rooms.
S. Lodging apartments.
T. Grand Court.
V. Gardens.
W. Little Gate or waiting Room.

Plan of the principal floor of Blenheim.
Plan du premier Etage.

Extends 3 10.

Blenheim Palace. Central block, plan of the first floor. The enflade of state rooms runs along the top of the plan (C, D, E, F, and R). The apartments of the duke and duchess are to the left (H, I, K, and L). The monarch's apartment and the duke's apartment connect at the Grand Cabinet (G). *Vitruvius Brittanicus.*

mediaeval period. The original nobleman's "hall house" consisted essentially of one large room where the whole household ate and slept; there was little privacy except as provided by curtained alcoves. In this great hall the lord feasted in great state with rituals devised to honor and enhance his standing. Over the years privacy became a consideration and a parlor or chamber was added with the consequence that retainers closest to the lord wanted entrée. Another room was added with the same consequence until a whole apartment was created with a sequence of increasingly private rooms. At **Hardwick Hall**, beyond the Great Hall, the staircase leads to *apartments* comprising a great chamber, a withdrawing room, a bedroom, and a closet or cabinet. This last and smallest room gives us the term for the inner group of ministers or advisors to a monarch or president—the Cabinet. At the time of the building of Blenheim the rituals surrounding monarchs and great noblemen such as the Duke of Marlborough had reached an extreme, partly modeled on the ceremonial seen at Louis XIV's court at Versailles, France.

Study the plan of Blenheim Palace and it becomes evident that there are four distinct apartments each arranged as an *enfilade* (sequence) of rooms. Two, the State Apartments for the monarch and his or her consort, open off the Saloon and comprise an ante room, a drawing room, a bedroom, and (facing inner courtyards) a dressing room and a closet. In the East Wing a central parlor (now the family dining room) marked externally by a *bow window*, led to the apartments of the duke and duchess; each comprising a drawing room, bedroom, dressing room and a closet. Realize also that at this time bedrooms and dressing rooms were not particularly private with servants, retainers, visitors, and even petitioners allowed to enter at the whim of the king or nobleman; in some cases a *balustraded* barrier, in effect a fence, would keep people away from the bed! At Blenheim, an unusual deviation allows for a large cabinet at the southwest corner that can be entered from both the monarch's and the duke's apartments.

Blenheim Palace and similar "formal houses" allowed for an elaborate ritual of visiting apartments that expressed a person's relative importance in society. For example, a nobleman of equal status to the duke would be personally greeted in the Great Hall and escorted all the way through the sequence of rooms to the cabinet or closet. A "nobody" might be given access but would be greeted by a servant and would perhaps only be permitted access as far as the drawing room where his petition (letter requesting redress, assistance, employment) would be conveyed to the duke's secretary. On extremely important occasions the residents of the apartments might formally visit each other, each resident—even husband and wife—visiting and receiving the others with much bowing and kissing of hands. The ritual of the "formal house" (royal palaces worked in the same way) allowed all kinds of social messages to be passed as to a person's consequence and worth; were they rising or falling? Within a few years of the completion of Blenheim the ceremonial that led to its design changed and in the nineteenth century the bedrooms were moved upstairs resulting in the multitude of sitting rooms.

Outside the palace Queen Anne's gardener Henry Wise created, to the south of the house, a Great Parterre (formal garden of hedges, gravel, and flowers), surrounded by a walkway, that resembled the defenses of a city. To the north of the Great Court led an *avenue* planted with trees in groups said to represent the battalions of troops lined up for the battle of Blenheim. The 2,100-acre *park* is surrounded by a dry stone (built without mortar) wall, eight feet high and over eight miles long. Immediately north of the house the River Glyme ran in a narrow deep valley and this was crossed by a bridge designed by Vanbrugh that was the cause of the final rift with the duchess. Sir Christopher Wren, consulted by the duchess, had proposed a simple bridge with a curving road rising up to the level of the Great Court, but Vanbrugh built a huge bridge to the full height of the valley creating a level road. The duchess was astonished to find thirty-three rooms within the bridge and "a house at each corner." Vanbrugh denied this but certainly there are rooms within the piers and abutments, some with fireplaces, and one large chamber was fitted up like a theater with a proscenium arch. The bridge was completed except for an arcaded superstructure and various military trophies and finials in 1710, but by November 1716, Vanbrugh and the duchess were totally estranged and he was dismissed—he calling her a "BBBBB old B." Sir John and Lady Vanbrugh with the Earl of Carlisle tried to visit Blenheim Palace in 1725 but they were refused admission and Vanbrugh only got a distant view of his greatest creation; he died the following year. One suggested epitaph for his gravestone read:

> Under this stone, reader survey
> Dear Sir John Vanbrugh's house of clay.
> Lie heavy on him earth, for he
> Laid many a heavy load on thee.

There is little change apparent at Blenheim; the first duke's immense wealth was dissipated by later generations and they could not afford to remodel or rebuild. The biggest change was outside, where Lancelot "Capability" Brown created the great lake that forms a worthy setting for Vanbrugh's bridge and removed the parterres and formal avenues creating the naturalistic *park* with its great oaks and dense woodlands. The 9th Duke succeeded in 1892 and, having two rich American wives—Consuelo Vanderbilt and Gladys Deacon—set about restoring the gardens. With the assistance of Achille Duchêne, a French landscape architect, he re-created the north avenue, with its trees in battle formation, and the formal gardens to the east and west of the house, the latter—The Water Terraces—incorporating a fountain of river gods by Bernini.

Today Blenheim Palace is the home of John George Vanderbilt Henry Spencer-Churchill, 11th Duke of Marlborough. "Whilst Blenheim was given to my ancestor and is still owned by my family, my role today is virtually that of a trustee and custodian . . . for all those who cherish the historical and

artistic tradition that Blenheim represents." In 1988, Blenheim Palace was included in the World Heritage List.

Further Reading

Balsan, Consuelo Vanderbilt. *The Glitter and the Gold.* New York: Harper and Brothers, 1952.

Blenheim Palace. www.blenheimpalace.com.

Hibbert, Christopher. *The Marlboroughs, John and Sarah Churchill, 1650–1744.* London: Penguin Books Ltd., 2001.

Montgomery-Massingberd, Hugh, and Sykes, Christopher Simon. *Great Houses of England & Wales.* New York: Rizzoli International Publications, Inc., 1994.

BRITISH AIRWAYS LONDON EYE. *See* The "London Eye."

THE BRITISH MUSEUM, BLOOMSBURY, LONDON

Styles: Georgian, Victorian, and Twentieth Century—Modern
Dates: 1823–1847; 1854–1857; 1996–2001
Architects: Sir Robert Smirke; Sydney Smirke (nineteenth century); John Russell Pope and Sir Norman Foster (twentieth century)

The British Museum is one of the great museums of the world, ranking with the Louvre in Paris and the Smithsonian in Washington, D.C., as the depository of a national collection of antiquities; coins, medals, and paper money; ethnography; and prints and drawings. Its most famous holdings are the Rosetta Stone acquired in 1801, a carved black monolith covered with texts in several ancient languages that provided the key to the understanding of Egyptian hieroglyphics; and the so-called Elgin Marbles, acquired in 1816. The latter are the British Museum's most controversial possessions, the sculptures that once graced the *pediments* and *friezes* of the Parthenon, the Temple of Athena Parthenos atop the Acropolis in Athens, Greece. They were acquired by Lord Elgin, British Ambassador in Constantinople, which was the capital of the Ottoman Empire that ruled Greece at that time. In-

deed, it could be said that Lord Elgin rescued the sculptures as the Parthenon was in a ruinous state and the carvings would otherwise have been lost. That these ancient Greek sculptures now reside in the British Museum is a cause of much argument between the two governments.

The British Museum is housed in one of London's grandest buildings situated off Great Russell Street on land originally owned by the Earls of Southampton. The 4th Earl took advantage of the growing city's need for housing to develop grand, wide streets and spacious squares. On one prime site was built the earl's own Southampton House and close by stood the Duke of Montagu's London residence. Montagu House was the most splendid house built in London in the late seventeenth century. The duke built two houses on the same site as the first, burned to the ground in 1686, was replaced by an even more magnificent building reputedly designed by a French architect "Monsieur Poujet" (either Pierre Puget or his son François). J. Strype, editor of *Stow's Survey of London* of 1720, wrote that "for stateliness of Building and curious Gardens, Montagu House hath the Preeminence, as indeed of all Houses within the cities of London and Westminster." By 1733 the Montagu family was short of money and abandoned their house; in 1753 the government bought it for the newly created British Museum.

The core of the new museum's holdings was the antiquarian collections of Sir Hans Sloane; the Harleian collection of manuscripts; and the library of Sir Robert Cotton. King George II (r. 1727–1760) added to this in 1757 when he donated the 9,000-volume Royal Library, founded by Edward IV (r. 1461–1470, 1471–1483) in 1471. King George III (r. 1760–1820) was a book collector on a grand scale and by the time of his death in 1820 he had amassed a library of 67,000 volumes housed in a series of magnificent rooms at Buckingham House. Donated to the British Museum in 1823 as "The King's Library," this magnificent addition heightened the space problems the rapidly growing museum faced—an 1845 watercolor painting by G. Scharf depicts visitors to the museum admiring three stuffed giraffes incongruously displayed on the landing of the Montagu House staircase just before its demolition. In 1823, Sir Robert Smirke (1780–1867), an architect with the Office of Works (a government department that oversaw the building of major public buildings), had been commissioned to design a scheme to rebuild and expand the museum. Completed in 1852, Smirke's scheme is in the *Neoclassical* Greek Revival style on a huge scale comparable with the grand public buildings of German architect Karl Friedrich von Schinkel (1781–1841), particularly the Altes Museum in Berlin of 1823–1830. Facing Great Russell Street across a wide forecourt, the main *façade* features an octastyle (eight-columned) projecting *portico* while to each side extend L-shaped colonnaded wings. The *Ionic order* used for the forty-four colossal columns is based on that found at the ancient Temple of Athene Polias at Priene. Passing through the portico into the museum the galleries were arranged around a vast central square courtyard entered from each wing through smaller, but equally impressive, Ionic porticoes.

Although the completion of Sir Robert Smirke's designs for the British Museum greatly expanded the area for exhibition galleries and libraries to 600,00 square feet, the museum was soon under pressure to expand again. In 1857, in the center of Sir Robert Smirke's great courtyard, the magnificent and architecturally progressive Reading Room was built to the designs of his youngest brother, Sydney Smirke (1797–1877). This spectacular circular space lined with tiers of bookcases is crowned by a domed ceiling of papiermâché suspended from a cast iron supporting structure as innovative in its day as **The Millennium Dome** of 2000. Access to this famous room was possible only with a Reader's Ticket and in its hushed splendor many great works were researched, perhaps most notably Karl Marx's *Das Kapital*.

Over the next 150 years the museum saw many changes. Paintings had already been moved to the new National Gallery in Trafalgar Square and in the 1880s the Natural History section moved to its own museum, designed by Sir Alfred Waterhouse, in South Kensington, London. The Duveen Galleries, designed by American architect John Russell Pope for the Elgin Marbles, were completed in 1939, damaged by German bombs in 1940, and finally reopened to the public in 1962. In 1973 the British Museum Library became the British Library Reference Division and prepared to move to a new building at St. Pancras. This was finally accomplished in 1997 when the Reading Room closed to prepare for the major restoration that is a part of the most radical development at the museum since its founding.

As envisaged by Sir Robert Smirke the central, two-acre courtyard was to be a grand, open public space. The construction of the Reading Room marred this vision and soon after the remaining area was filled with ramshackle storage buildings—this was all to change under the direction of architect Norman Foster. On December 7, 2000, the Queen opened the "Queen Elizabeth II Great Court," which received public and critical acclaim—an "Ace courtyard with British Museum attached," one of the few architectural successes of the millennium year. The courtyard had been cleared; the Reading Room's deteriorated brick exterior clad in stone; the destroyed southern portico rebuilt; and, most spectacularly, the whole vast space—the size of a football field—covered by a high-tech steel and glass roof designed with engineers Buro Happold. The roof is a technological marvel, a gently arched square toroid (donut) of delicate steel triangles that hovers above the stone walls. Attached directly to the steel are 3,312 triangular panels of *fritted* and tinted glass, seemingly a taught skin some 120,000 square feet in area. In the same way that I. M. Pei's glass pyramid gave organization to the Louvre Museum in Paris, Foster's Great Court provides a focus for the disparate parts of the British Museum while subtly introducing the expected educational, sales, and restaurant facilities expected in a modern museum. The project cost approximately $150,000,000 of which $45,000,000 was a grant from the Millennium Commission.

Inevitably, there had to be a problem: the rebuilt south portico was constructed using inferior Anstrude Roche Clair stone from France rather than

the superior British Portland Stone specified by the architects and used to construct the original by Sir Robert Smirke. The portico has been the cause of allegations and recriminations; calls for investigations, resignations; and accusations of fraud and a cover-up. Although it does not look quite right, starkly white beside the weathered mellow stone of the older walls, the portico does not take away from the success of Foster and Partners/Buro Happold's magnificent Great Court—a worthy setting for the British Museum's 250th anniversary in 2003.

Further Reading

British Museum. www.thebritishmuseum.ac.uk.

Foster and Partners (architects). www.fosterandpartners.com.

Goldberger, Paul. "The Supreme Court: Modernism Coexists with Classicism in the New Courtyard of the British Museum." *The New Yorker*, January 8, 2001.

Hart, Sarah. "Queen Elizabeth II Great Court, British Museum, London." *Architectural Record*, March 2001.

BROADLEYS, CUMBRIA, ENGLAND

Style: Victorian—Arts and Crafts
Dates: 1898–1899
Architect: Charles Francis Annesley Voysey

Broadleys, situated on a stunning site commanding views of Lake Windermere, Cumbria, is one of Charles Voysey's best houses demonstrating the personal principles of design he brought to the Arts and Crafts Movement that had emerged during the second half of the nineteenth century. The Great Exhibition of 1851 and its pioneering building, **The Crystal Palace**, demonstrated the triumph of the Industrial Revolution over traditional cottage industries and the rural economy. The factories of the new industries, surrounded by the rows of **terraced houses** (row houses) of the workers, turned out the mass-produced products that were then distributed by the railways and canals that reached all corners of the country. At the Crystal Palace visitors saw the results of industrialization, which in many cases were crude, mass-produced copies of artifacts previously made lovingly by hand with artistry and craftsmanship. In reaction many horrified observers began the Arts and Crafts Movement espousing the quality of traditional crafts. The Arts and Crafts Movement became an important artistic force in the 1880s but it is presaged architecturally by **Red House**, Bexleyheath, Kent, of 1859–1860, designed for William Morris by Philip Webb. Red

House's Puginesque (following the principles of architect A.W.N. Pugin) *Gothic Revival* exterior contained an interior featuring remarkable decoration and furniture, all lovingly handcrafted. Architects of the Arts and Crafts Movement include, among many great designers, R. Norman Shaw (1831–1912), Charles Rennie Mackintosh (1868–1928) in Scotland, Sir Edwin Lutyens (1869–1944), and C.F.A. Voysey (1857–1941).

Voysey considered that a successful house should be welcoming and comfortable, provide calm in a storm, and have no dark corridors. This was in reaction to the many excessively large Victorian houses with their huge rooms and wastefully complex plans, particularly in the servants' quarters. He achieved his aim by designing houses with comfortably high and enveloping steep roofs, large prominent chimneys, and often used L-shaped plans with the rooms on the outside of the form and the connecting hallways on the inside, suitably light, with windows overlooking an entrance courtyard. This was the basic plan of Broadleys.

Where Voysey differs from many of the other, and usually earlier, Arts and Crafts architects is that while his designs owe much to traditional *vernacular* English houses he did not studiously try to re-create them. Rather, he developed his own distinctive architectural vocabulary: emphatically horizontal hipped roofs; continuous ranges of mullioned windows with those on the second floor being immediately below the eaves; the outside walls finished with a white roughcast (a pebbly plaster) often with sloping *buttresses* at the corners; and wide doors with prominent strap hinges sometimes ending in his trademark heart shape. Internally, his rooms were usually low with *ingle-nook fireplaces*, built-in benches, furniture, and screens, all simply detailed of unpolished oak with exposed metal connections, hinges, and latches. While his work can be compared to that of Lutyens, Baillie Scott, and Mackintosh it is distinctively Voysey.

The client for Broadleys was A. Currer Briggs, a wealthy owner of Yorkshire coalmines. The Lake District had become popular as a vacation destination through the writings of John Ruskin, William Wordsworth, and Alfred, Lord Tennyson. Broadleys was one of several houses built for wealthy upper-middle-class clients who could afford to spend their summers away from the industrial source of their wealth. It is ironic that many of the clients of the Arts and Crafts architects were the newly rich industrialists whose products were the cause of the movement's founding. As a colliery owner Currer Briggs was one of Voysey's wealthiest clients and the house has an atypical degree of formality, a presence that belies its relatively small size. It not only commands, it takes possession of the magnificent views westward over lake and mountains.

The house is sited on a narrow shelf of flat land between a country lane and a steep slope down to the east shore of Lake Windermere. The drive sweeps in from the gateway, passing the protective lodge and carriage house, to arrive in the forecourt with the main block of the house first visible and then the long horizontal service wing. The house and hedges conceal the

lake, saving the view until one is inside the house. The plan uses Voysey's favorite L-shape with only the staircase, the front door, cloakroom, kitchen, and two bedrooms (at the extreme ends), other than corridors, overlooking the courtyard. A gabled porch welcomes arrivals and the visitor then passes through a lobby into the Hall, a two-story room used as the main living room and large enough to contain a full-size billiard table. A huge semi-circular *bay* window draws occupants to look at the view. South of the Hall is the Drawing Room, a lower room that also features a semi-circular window, and which used to lead to to an open *verandah* (porch) overlooking a formal rose garden. This has since been glassed in to provide a card room for the Yacht Club that now occupies the house. Across the Hall, to the north is the Dining Room with a third semi-circular bay. Off the Hall, overlooking the forecourt through a continuous band of windows, is the staircase. Here Voysey's woodwork is almost *art nouveau* with thin columns extending to the ceiling and fretwork balusters with inset metal hearts. A long hallway with windows looking over the forecourt and down into the Hall leads to the main bedrooms, with their adjoining dressing rooms, over the Drawing and Dining Rooms. Attached at the northeast corner of the house is the long arm of the L, the service wing, which is nearly as big as the main part of the house. This comprises the kitchen, larders, and utility rooms downstairs, and guest or servant bedrooms upstairs.

Observed from Lake Windermere, Broadleys appears to be symmetrical with the three semi-circular windows thrusting out toward, almost into, the view but protected by the stone bastion (retaining wall) of a wide terrace. In the center is the double height bay of the Hall while to either side are the bays of the Drawing Room, Dining Room, and the main bedrooms. Upon closer inspection one realizes that the elevation is not symmetrical. The bays are not centered on the house, there is a large chimney to the right of the Drawing Room bay, and a round "porthole" window (a favorite feature often used by Voysey) between the Hall and Drawing Room bays. It is a friendly house, warm and welcoming, yet proud and imposing as appropriate for such a family. One can imagine that for the Briggs family, assured Victorians, confident of their place in society, Broadleys was a wonderful summer home.

Study of the houses of Voysey, Lutyens, and other Arts and Crafts architects will provide an understanding of the derivation of the "English Cottage" style favored by developers and realtors in the United States of the late twentieth century.

Further Reading

Durant, Stuart. *Architectural Monographs No. 19: CFA Voysey.* London: Academy Editions, 1992.

Hitchmough, Wendy. *CFA Voysey.* London: Phaidon Press Ltd., 1995.

Muthesius, Hermann. *The English House.* St. Albans, U.K.: Granada Publishing Ltd., 1979.

BUCKINGHAM PALACE, LONDON

Style: Georgian—Neoclassical
Dates: 1703–1705; 1762–1774; 1825–1829; 1846–1847; 1913; 1997–2002
Architects: William Talman; William Winde and Sir William Chambers (eighteenth century); John Nash; Edward Blore and Sir James Pennethorne (nineteenth century); Sir Aston Webb and John Simpson (John Simpson and Partners) (twentieth century)

The focal point of British ceremony and patriotic fervor is Buckingham Palace, the official residence of the monarch, the Head of State. In the twentieth century every great event—be it the declaration of war in 1914, VE Day in 1945, or the wedding of the Prince and Princess of Wales in 1981—culminated with the royal family appearing on the balcony, acknowledging the crowds. Beneath the fluttering Royal Standard on the flagstaff atop the palace, separated from the cheering mass in the Mall beyond the ornate gates by the forecourt where the Guard parades and the band plays, the monarch gives a final characteristic wave and disappears into the palace. The famous *façade*, immediately recognizable to every "Brit," was completed in 1913 at the height of the British Empire. Behind this imposing, and, to some, pompous façade, is concealed another, older, building: the most splendid *Neoclassical* palace of its time, built to celebrate the defeat of Napoleon—at the Battle of Waterloo in 1815—the victory of traditional monarchy over revolution.

The history of the palace dates back to the early seventeenth century when James I granted a lease to one William Stallinge for an area to the west of St. James's Park. Here, an experimental mulberry garden was planted where the king hoped silk worms would provide him the raw material for fine fabric. The garden failed but in 1633, on an adjoining site, Lord Goring built a "fair house." This burned in 1675 and was rebuilt in the latest fashion by Lord Arlington, Lord Chamberlain to James II (r. 1685–1688). In 1702, Lord Arlington's heirs sold the house to John Sheffield, Duke of Buckingham. The duke did not consider his purchase grand enough for his position and cleared the site for a new house built slightly to the north with its main façade facing east aligned with The Mall, an avenue of trees in St. James's Park created by Charles II (r. 1660–1685). The new house, named Buckingham House and built 1703–1705, was probably designed by William Talman (1650–1719) and completed by Captain William Winde (d. 1722), but the attribution cannot be assured. Whoever the designer, Buckingham House was very different and became the fashionable model for new houses such as

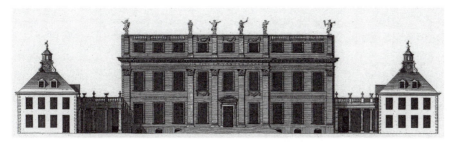

Buckingham House, London. The Duke of Buckingham's house as it appeared in the early eighteenth century. The central block was later incorporated into Buckingham Palace, and now contains the Grand Hall and Staircase, the Guard Room, the Green Drawing Room, and the Throne Room. *Vitruvius Brittanicus. Harcourt Index.*

Wotton House and Chicheley House, both in Buckinghamshire. The design, with a central block connected to flanking service *pavilions* by curved colonnades, was essentially *Palladian*. However, the solidly square central block of two stories and an attic with the roof hidden behind a *balustraded parapet* introduced a new and peculiarly English innovation. The exterior featured *Corinthian pilasters* and many lead statues while the forecourt was enclosed by an ornate wrought iron *grille* which curved out into St. James's Park. Inside, the duke commissioned Sebastiano Ricci from Venice and Louis Laguerre from Versailles to complete the sumptuous halls and *state rooms*. Virtually surrounded by royal parks, with an incomparable view of the City of London and **St. Paul's Cathedral** to the east, Buckingham House was a Baroque town palace *and* a country house. The Duke of Buckingham's pride in his creation can be judged from the inscription carved into the entablature: "Sic situ LaetanturLares" (The Household Gods delight in such a situation).

Unfortunately for the heirs to this delightful property, while most of the site was freehold (owned outright), a small and vital area, actually part of St. James's Park, was leased (rented) from the Crown. In 1761 difficulties in renewing the lease led to the sale of the whole property to George III (r. 1760–1820). Recently married to a German Princess, Charlotte of Mecklenburg-Strelitz, the King wanted a family home away from the formality of the court, which would continue to reside at the nearby **St. James's Palace**. To this day foreign ambassadors to Britain are accredited to the Court of St. James. George III had studied architecture and, disliking the duke's Baroque excesses, commissioned Sir William Chambers to remodel the house in a simpler *Neoclassical style* more suited to his unpretentious tastes. Retaining the basic plan of the duke's house, the revised house comprised an entrance hall and grand staircase on the east side of the first floor with the King's apartment to the west overlooking the garden. On the second floor the Queen's apartment, above the King's, was much more richly decorated and was approached though the Saloon, the largest room in the house which

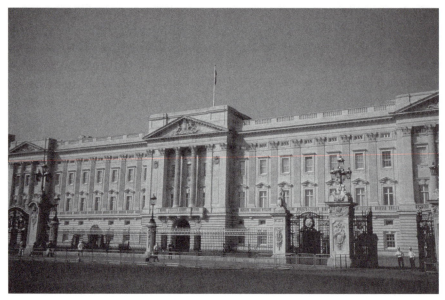

Buckingham Palace. The east front facing the Mall by Sir Aston Webb completed in 1913.

formed the center of the east façade. Extensions to north and south accommodated the growing royal family and, in a continually expanding suite of grand rooms, the King's 67,000-volume library.

Buckingham House—during this period often called The Queen's House—was the private home of the King and his family until his "madness"—now thought to have been an inherited chemical imbalance known as porphyria—led to his incarceration at Windsor Castle. Following the establishment of the Regency in 1811, the house was redecorated in a more formal manner to accommodate the court functions that Queen Charlotte preferred to hold there, rather than at St. James's Palace where her son, The Prince Regent, now ruled. The Queen died in 1818 predeceasing her husband, King George III, by two years.

In 1820, the Prince Regent became King George IV (r. 1820–1830), but even before his parents died he was considering Buckingham House as his own residence to replace the sumptuous but cramped Carlton House. Having already poured hundreds of thousands of pounds into the prince's residences—Carlton House, London, the **Royal Pavilion, Brighton**, and Royal Lodge in Windsor Great Park—the government was wary of allowing the king to spend more on architectural extravagance. The King, however, consulted his favorite architect, John Nash (1752–1835) and plans were put in hand to substantially remodel Buckingham House. The King's ideas were grandiose and by 1825 when work began (although parliamentary approval only followed several months later), the new palace was to be not only his residence but also a national memorial celebrating the recent defeat of

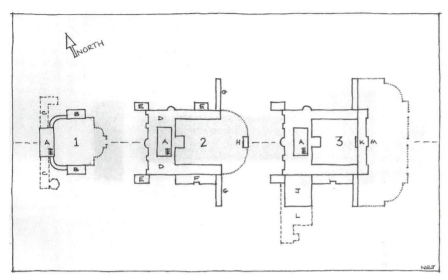

Buckingham Palace. These three diagrammatic plans show the evolution of the building. Draw-ing 1 shows Buckingham House, as completed in 1705 for the Duke of Buckingham, with the main block (A) and the two service wings (B). After George III bought the house, extra ac-commodation was added to the north and south of the main block, approximated by the dashed lines (C), including the king's octagonal library. Drawing 2 shows Buckingham Palace as de-signed by John Nash for George IV after 1820. The main block of the old house (A) is com-pletely enveloped by Nash's new additions (D). Temple like pavilions (E), used as conservatories, framed the north and west elevations; offices for the king's household formed the south façade (F); single storey gatehouses (G) protected the entrances to the gardens; and the expanded fore-court is entered through the Marble Arch (H). Drawing 3 shows the palace as it is today. Nash's building extended by Pennethorne's Ballroom (J) and Blore's east wing (K) was refaced by Webb in 1913. The royal balcony (M) overlooks the huge forecourt where the ceremony of the Chang-ing of the Guard takes place. The location of the main staircase, in the southeast corner of the original Buckingham House, has not changed over the centuries. Only two of Nash's conserva-tory pavilions survive; that to the northwest now houses the palace swimming pool, and the one to the southwest is a part of the Queen's Gallery, which also occupies the most recent addition to the palace approximated by the dashed line (L). *Diagrams by author.*

Napoleon. Nash had already designed and substantially completed a cere-monial route beginning at **Regent's Park** on the north edge of the city. Lined with magnificent buildings this terminated at Carlton House, which was de-molished and the route continued into St. James's Park to approach the King's new house where the main entrance was marked by a triumphal arch—the Marble Arch—covered with celebratory sculptures.

While celebrating the defeat of the French, the new house was also a cel-ebration of French Neoclassicism owing much to Napoleon's favorite de-signers, Percier and Fontaine. The Marble Arch was similar to the Arc du Carousel, which stood at the entrance to Napoleon's Tuileries Palace while the house itself references the Hotel de Salm in Paris with its central domed *bow window*. On the interior Nash created the most magnificent suite of *state*

rooms in Europe. Exquisitely and richly designed, these rooms were the apogee of the craftsmanship of the late Georgian period displaying astounding examples of the art of the plasterers, carvers, painters, furniture makers, and upholsterers whose skills were largely to be lost with the advent of the Industrial Revolution. Furniture not specifically made for these rooms came from Carlton House and from the King's collection of French furniture which he had his agents buy following the 1789 Revolution—many of the greatest pieces of French eighteenth-century furniture are at Buckingham Palace. The King had also collected, or inherited, many significant paintings, sculptures, and objets d'art that the rooms were designed to display.

Nash's plan was quite simple. Retaining the core of the Duke of Buckingham's house of 1703 and keeping the entrance hall and stairs in the same locations, he converted George III's *apartment* on the first floor into a sculpture gallery and Queen Charlotte's apartment above into a picture gallery lit by glass skylights. To the west of these Nash extended the house forming a new garden front with the King's apartment on the ground floor and the state rooms above. The center of Nash's new façade was formed by the bow window of the Music Room which was topped by a shallow dome while *conservatories* designed as *Ionic* temples framed the composition. On the east side Nash refaced the old Buckingham House with Bath stone to match the new work creating a bold central double *portico* based on Claude Perrault's Louvre façade in Paris. The carving in the *pediment* above the portico continued the heroic theme of the Marble Arch across the forecourt.

To either side of the forecourt, Nash designed single-story service wings but in 1826 the King changed his mind and, to Nash's consternation, declared that Buckingham House would be the new state palace—Buckingham Palace. Nash explained that the house did not have enough space to house the whole court with its many officers and functionaries let alone the proper line of interconnecting state rooms—the *enfilade*—necessary for a palace of that time. The King prevailed and the two flanking wings were rebuilt to the full height of the main block creating a U-shaped courtyard. The interior was slightly reconfigured, with Nash's genius demonstrated in the Grand Staircase that initially rises to a broad half-landing. From here two flights return to enter an abridged enfilade culminating in the Throne Room or a flight straight ahead leads to a gallery which connects to the State Drawing Rooms on the west side overlooking the gardens.

The palace was a huge project built at a time of postwar recession and Parliament kept a close eye on its progress. In 1828, Nash was forced to present himself before a Select Committee of the House of Commons to explain the massive cost overruns (which it has to be said were mainly the fault of the King). The King, seeing such criticism as a personal affront, protected his architect. Upon the King's death in 1830, however, Nash was exposed to further attack focusing not only on the finances of the construction but on the actual design. His design did have some shortcomings, most notably the way the dome above the Music Room on the west peeked over the roof and

was seen, strangely truncated, from The Mall on the east. Nash, the most successful architect of his time, already the subject of many critical articles and caricatures, admitted defeat and retired in disgrace.

The palace was completed during the reign of William IV (r. 1830–1837) under the supervision of Edward Blore who had a reputation as a "cheap architect of unutterably dreary work." To his credit, he did recognize the genius of Nash and attempted to follow his designs while making the economies and improvements demanded by the Select Committee. William IV did not live long enough to move into Buckingham Palace, as it was now officially called, but in 1837 his successor, Victoria (r. 1837–1901), became the first monarch to inhabit the new palace. It was for Queen Victoria and her growing family that Blore added the east wing of the palace in 1847–1850, removing the Marble Arch and closing the courtyard. Blore's banal and much-derided design was refaced by Sir Aston Webb in 1913, creating the building we know today. The Ballroom wing, also for Queen Victoria (of 1852–1855), and extending the palace to the southwest, was designed by Nash's pupil Sir James Pennethorne (1801–1871).

Queen Victoria's reign pivots on the death in 1861 of her husband Albert, the Prince Consort after which, while dedicated to her duties as Queen, she became a virtual recluse at her country residences. Calls to abolish the monarchy and establish a republic were rampant—satirical "For Rent" signs were hung on the palace gates—and were only dispelled in the patriotic furor of the Golden and Diamond Jubilees of 1887 and 1897. These celebrated the fiftieth and sixtieth anniversaries of Victoria's accession to the throne and her reign over a huge and wealthy empire. In 1901, when Edward VII (r. 1901–1910) succeeded to the throne, the palace was in a sorry state of disrepair and he had many rooms redecorated in the white and gold "Ritz style" popular at the time, much reducing the impact and splendor of the Nash design. The twentieth century saw little change to the palace apart from the new east façade of 1913 designed by Sir Aston Webb. Queen Mary, the wife of George V (r. 1910–1936), oversaw a more logical reorganization of the contents and during the reigns of George VI (r. 1936–1952) and Elizabeth II (1952–), other than repair of damage incurred during World War II, little was done besides required maintenance. Nash's southwest conservatory, destroyed by wartime bombs, has been rebuilt as the Queen's Gallery for the exhibition of items from The Royal Collection. In celebration of Queen Elizabeth II's Golden Jubilee in 2002, The Queen's Gallery was completely rebuilt and expanded. A limited competition in 1997 had chosen John Simpson and Partners as architects and the resulting galleries, approached though a polychromatic (multicolored) *Doric* portico, opened in May 2002 with an exhibition of 450 of the most important pieces from The Royal Collection. Simpson's $30-million design, the most significant change at the palace in 150 years, pays homage to the architecture of John Nash and raises the thought that the next great royal project should be the restoration of the Nash interiors at Buckingham Palace.

Further Reading

British Government Web site for Buckingham Palace. www.royal.gov.uk/output/page
 555.asp.
Davis, Terence. *John Nash: The Prince Regent's Architect.* Newton Abbot, U.K.: David
 and Charles Ltd., 1973.
Mansbridge, Michael. *John Nash: A Complete Catalogue, 1752–1835.* Oxford: Phaidon
 Press Ltd., 1991.
Morton, Andrew. *Inside Buckingham Palace.* New York: Summit Books, 1991.
Robinson, John Martin. *Buckingham Palace.* London: Michael Joseph Ltd. and Royal
 Collection Enterprises Ltd., 1995.
Strong, Roy. *Royal Gardens.* New York: Pocket Books (Simon and Schuster Inc.), 1992.
Watkin, David. *The Royal Interiors of Regency England.* London: The Vendome Press,
 1984.
Wessex, Edward (The Earl of Wessex). *Crown and Country: A Personal Guide to Royal
 London.* New York: Universe Publishing, 2000.

CAERNARFON CASTLE, GWYNEDD, WALES

Style: Mediaeval
Dates: 1283–1327
Mason: James St. George

Prince Charles, the eldest son and heir of Queen Elizabeth II (r. 1952–), is
known by his title of Prince of Wales. On July 1, 1969 the Investiture, a cere-
mony formally conferring the title on the prince, took place at Caernarfon
Castle. Caernarfon, with its great castle and city walls dating from the thir-
teenth century, is the most complete example of mediaeval defenses in the
country, rivaling Carcassone in France.

 The title of Prince of Wales has been awarded to male heirs apparent since
the first Prince of Wales was named in 1284 (females are "heirs presump-
tive," there being the chance a male heir might be born). Edward I (r.
1272–1307) was in the middle of a military campaign to conquer the Prin-
cipality of Wales whose people, annoyingly independent, harassed the En-
glish western border. Soon after the Norman Conquest of England (1066)
by William I (r. 1066–1087), the new rulers decided that Wales needed to be
under their control. Robert of Rhuddlan in 1073 and the Earl of Chester in
1090 attempted to the take over North Wales, establishing castles at Rhud-
dlan, Aberlleiniog (Anglesey), Caernarfon, and further south in Merionydd.
By 1115 the Welsh princes had regained most of their lost lands and Caernar-

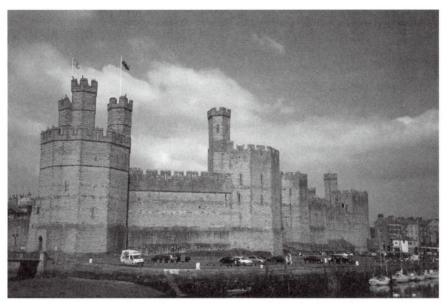

Caernarfon Castle. The castle from the river with the Eagle Tower where the king's apartments were located to the left. Just visible at the far left of the picture is the beginning of the town wall. *Photo by David G. Britton (FreeFoto.com).*

fon became their stronghold through the reigns of Llewelyn the Great (1173–1240) and Llewelyn Ap (son of) Gruffud (d. 1282). Edward I's first campaign of 1276–1277 was not successful, but he again declared war on Palm Sunday (March 22) 1282 and by 1283, with Prince Llewelyn dead, had control of most of Wales with three armies—Southern, Central, and Northern—penetrating deep into the country and splitting all opposition. To cement his control Edward immediately set about building a series of castles that would dominate the country and cower the Welsh populace. He personally built Flint, Rhuddlan, Conwy (Conway), Caernarfon, Harlech, Aberystwyth, and Builth; had his lords build Holt, Denbigh, Ruthin, and Harwarden; and repaired the Welsh castles of Hope, Dolwyddan, Criccieth, and Castell-y-Bere. At all these locations substantial and fascinating ruins remain although none is now inhabitable (only at Hawarden is there a nearby house, the home of the Gladstone family).

The work on the castles advanced quickly and with the country safe, Edward's wife, Queen Eleanor, accompanied him on a tour of the conquered territory in the summer of 1283; they returned to Caernarfon for Easter in 1284. It was during this stay that, on April 25, 1284, a son was born whom, tradition says, Edward presented to the people of Wales from the castle's Queen's Gate saying, "here is a Prince of Wales, one who can speak neither English or Welsh." That the King and his court spoke French and that the newborn could not speak beyond gurgles and burps is overlooked—either

Edward took the Welsh for fools or the story is just that, a romantic story. Nevertheless, the boy, Edward of Caernarfon, was confirmed in his title of Prince of Wales in 1301 and endowed with all revenues from Crown land in Wales. Prince Charles is the nineteenth heir apparent to hold the title of Prince of Wales.

Edward's reason for building Caernarfon was the establishment of a nucleus of English influence at a site famous in Welsh mythology. Situated on the coast at the southern end of the Menai Strait, between the mouths of the rivers Seiont and Cadnant, Caernarfon was naturally protected and had easy access for ships to trade with the town, supply the castle, and, if necessary, provide the garrison with a means of escape. The town charter of privileges was issued in 1284 and the castle and town were built at the same time; the castle as a center of royal power administering the judicial and financial affairs of the principality, the town as a thriving community whose attractions would pacify the surrounding countryside. The town was the effective capital of North Wales for the next 400 years. Caernarfon Castle's relative importance is shown in its elaborate towers and multicolored stonework, which set it apart from the other castles of the period.

The architect, or at this period the master mason, was James St. George, a skilled military engineer whose services Edward had secured from Count Phillip of Savoy (Italy) in 1278. Master James controlled an army of quarriers, stonecutters, masons, smiths, carpenters, plumbers, and laborers summoned from all over England and had direct control of, or was consulted on, the construction of all of the castles built in North Wales by Edward I. The first phase of building took place in the years 1283–1292. The castle, town walls and gates, and quay (dock) were seen as a single building operation and the materials that arrived by ship were directed to all these construction sites. Documents still survive from the period and one of June 24, 1284, mentions work on the ditch that separates the castle from the town. A protective wooden stockade was built around the whole site and trenches were cut down to the natural rock on which the twenty-foot-thick walls were built. Some Welsh houses had to be moved for which compensation was paid and large timber-framed buildings were built to house the King and Queen and the new administration. It is probable that the Eagle Tower at the western end of the castle was substantially complete by mid-1284. The town walls were completed in 1285 and the south walls of the castle with the elaborate towers by 1288. The accounts show considerable expenditure during the early years but this was reduced to a negligible amount by 1292 when the circuit of town walls and the west, south, and east castle walls provided a defended enclosure. The north wall of the castle inside the defensive ring of walls was not built at this time and the only separation was the ditch and the beginnings of stone walls.

In 1294, the Welsh, led by Madog ap Llewelyn, revolted and, managing to breach the town walls, had easy access to town and castle. Everything combustible was set alight and the sheriff assassinated. Rapid English action saw

the insurrection put down and a second building phase in which the town walls were repaired, the castle walls and towers heightened, and the castle's north walls and the King's Gate (the main gate) built. The sense of insecurity can be seen by the very elaborate defenses incorporated into the King's Gate: two drawbridges, five doors, and six portcullises (sliding gratings that could be let down from the room above the passageway). The walls to either side of the passageway and to each side of the gatehouse were punctured by slits through which defenders could fire at attackers. Work on the castle continued until 1330 with 70 to 100 men being employed in winter, 150 to 200 in summer, at an annual expenditure of approximately £700. In 1317, the stone eagles were placed atop the *turrets* of the Eagle Tower and a statue of Edward of Caernarfon, the 1st Prince of Wales, now King Edward II (r. 1307–1327), was placed above the outer arch of the King's Gate. Nevertheless, despite massive expenditure and years of building the castle was never completed; for example, the Queen's Gate is only a *façade* that looks complete from the outside but has no back wall; its rooms open to the courtyard.

Caernarfon began as a Roman settlement and the remains of the rectangular walled fortress of Segontium can still be seen east of the town. The traditional story is that Magnus Maximus, Roman Emperor from 383 to 388, died at Segontium; he was the father of the Emperor Constantine and Caernarfon Castle, with its faceted towers and horizontally banded multicolored stonework, resembles the walls of the city of Constantinople.

The plan of the castle is like a large figure eight (approximately 450 feet by 120 feet), formed by two courtyards, with the King's Gate at the neck. The two courtyards, the Lower and Upper Wards occupy the site of the Norman *motte and bailey* (mound and enclosure) castle built during the first Norman attempt at conquest—the motte, although much reduced, was only completely removed from the Upper Ward in the 1870s. The main entrance was through the King's Gate, which led into the Lower Ward. Here were found the kitchens (against the north wall) and the Great Hall (against the south wall) while the towers are named the Well Tower, the Eagle Tower (for the King), the Queen's Tower, and the Chamberlain Tower. The latter is opposite the King's Gate at the neck of the figure eight and beyond them in the Upper Ward are the Black Tower, the Cistern Tower, the (incomplete) Queen's Gate, the Watch Tower, the North-East Tower, and the Granary Tower. The various names of the towers indicate their intended occupants or their service function. Each tower has walls fifteen to twenty feet thick although these are punctured by recesses, garderobes (toilets), oratories (chapels), and window embrasures. At this time castle design did not focus on one main tower or "*keep*" as seen in the motte and bailey castle (see **The Tower of London** or **Windsor Castle**). Each tower was designed as an independent fortress that contributed to the strength of the whole castle but whose fall was not the end of the defense. Inside some of the towers, in which all the floors and roof have collapsed, it is possible to see the construction methods used with recesses to receive the great supporting beams—in other

towers the floors and roof were restored around 1900. The walls between the towers contain connecting passageways with multiple arrow slits, some with multiple-angled slits allowing an archer to fire in several directions. Unusually, at Caernarfon there are two levels of wall-passages.

The town walls, about 800 yards long, attach to the castle at the northeast and northwest corners at the North-East and Eagle Towers. Eight towers and two twin-towered gateways are spaced at intervals of approximately 210 feet. One E-W street, connecting the two gateways, and three parallel N-S streets subdivide the town on a grid. Most of the houses, some built against the walls, are eighteenth or nineteenth century. The west gate, which led to the quayside, is now the Royal Welsh Yacht Club.

Caernarfon is now a bustling market town, a favorite destination for tourists who come to see the castle and walk the town walls. The Investiture ceremony for a new Prince of Wales that occasionally takes place in the castle is, for all its mediaeval appearance, of recent invention devised in 1911 for Prince Edward the son of George V (r. 1910–1936), and later King Edward VIII (r. 1936). The last Investiture of a Prince of Wales was that of Prince Charles in 1969 and the next will presumably be that of Prince William.

Further Reading

British Government Welsh Assembly Web site for Caernarfon Castle. www.cadw. wales.gov.uk/cadw/sites/site018.html.

CAERNARVON CASTLE. *See* Caernarfon Castle.

CARDIFF CASTLE, CARDIFF, SOUTH GLAMORGAN, WALES

Style: Victorian
Dates: 1866–1928
Architect: William Burges

Cardiff Castle and Castell Coch were both designed by William Burges (1827–1881) for John, 3rd Marquess of Bute (1848–1900), a fabulously

wealthy aristocrat whose wealth came from land, coal, and the development of Cardiff as a major port. Indeed, 200 years ago Cardiff was little more than a coastal village and it is completely due to the investments of succeeding Lords Bute that it is now the capital city of the Principality of Wales, a major seaport and industrial center, and a university city. To oversee their domains the Butes lived at Cardiff Castle in the very center of the city and to escape the noise and grime they had created they could travel a few miles northwest to the valley of the Taff River and Castell Coch. Although very different in scale—Castell Coch is a miniature, fairy-tale castle while Cardiff Castle is an enormous mansion—they have many things in common beyond the same owner and the same architect. Both are built on the ancient foundations of earlier fortifications; both are attempts to re-create the atmosphere of medi-aeval times; and both are the most fantastic creations of the Victorian ro-mantic imagination, rivaling, if not exceeding, in their elaboration, mad King Ludwig's Neuchwanstein Castle in southern Germany (the castle featured in the movie *Chitty-Chitty-Bang-Bang*).

The beginnings of Cardiff Castle date back to the Roman occupation of Britain and Wales. The earliest fortifications date to the reign of the Em-peror Nero (54–68 c.e.) when the Roman Army defeated King Caractacus. Around 75 c.e., a small fort with stone defensive walls was built and c. 250 this was expanded to the size of the present castle with stronger walls, ten feet thick, backed by an earth bank. Abandoned when the Romans left Britain in the fifth century, Cardiff's strategic value was recognized by Robert Fitzha-mon, a follower of William the Conqueror (r. 1066–1087). In 1091, he re-stored the ancient defensive walls, raised a forty-foot-high *motte* (mound) in the northwest quadrant of the enclosure which was split in half, east and west, to create outer and inner *baileys* (courtyards). Fitzhamon's work hid the re-mains of Roman walls, which were only revealed in the nineteenth century and now can be seen separated from the later mediaeval masonry by a line of darker red stones. Cardiff was an important castle and administrative cen-ter and it was often attacked by the recalcitrant Welsh—sometimes with suc-cess. Therefore the defenses of the castle were constantly being improved with a stone *keep* built atop the motte connected to a strong south gate by a barbican wall (a projecting wall allowing defenders to fire to both sides). In the early fifteenth century new lodgings for the Earl of Warwick were built against the west walls and it is this building that forms the basis for the nineteenth-century mansion. Cardiff continued to be important and was at-tacked during the War of the Roses, the accession of the Tudors, and the Civil War.

In 1550, Edward VI (r. 1547–1553) awarded Cardiff Castle to William Herbert, Earl of Pembroke, and in 1766 it passed by marriage to John Stu-art, heir of the Earl of Bute, first Prime Minister of George III (r. 1760–1820). Stuart was raised a level in the peerage becoming Marquess of Bute and his great-grandson, also John, inherited in 1848 at the age of six months. John Patrick Crichton-Stuart, 3rd Marquess of Bute was an unusual

Cardiff Castle. The fairy tale nineteenth century castle created by William Burges for the Marquis of Bute. *Photo by Ian Britton (FreeFoto.com).*

man: shy, scholarly, deeply religious (Roman Catholic), the possessor of vast wealth, and with a fascination for all things mediaeval. It was this fascination that led to a sixteen-year partnership with William Burges and the transformations at Cardiff Castle and Castell Coch.

Castell Coch is situated on a platform overlooking the gorge of the River Taff on one of the main routes from Cardiff to inland Wales. Probably first built by a Welsh lord c. 1240, Castell Coch—Red Castle, named for the color of its stonework—was improved by the Norman Baron Gilbert de Clare, c.1270, of Cardiff Castle. Small, able to fit inside a 110-foot square, Castell Coch comprised three towers—a keep and two lesser towers—at three corners with a curved connecting wall on the northwest side. By 1540, Castell Coch was described as "al in ruine" (John Leland, Antiquarian) and in the 1850s Robert Drane, a Cardiff chemist, describes it as overgrown, surrounded by "evil-smelling wild garlic flowers"—they still flower every summer. Like Cardiff, Castell Coch came to the Butes through the marriage of John Stuart.

William Burges (1827–1881) was regarded as the most brilliant architect-designer of his generation. J. Mordaunt Crook wrote of Burges: "Brilliant but eccentric, unstable and extravagant Burges was a Pre-Raphaelite [a late nineteenth-century art movement] architect in all but name, and like his Pre-Raphaelite friends he sought an artistic Holy Grail in a Victorian vision of the Middle Ages." He rivals, if not exceeds, the best architects and designers of furniture, stained glass, jewelry, and metalwork of the nineteenth cen-

tury with the possible exception of his hero A.W.N. Pugin and the French architect Viollet-le-Duc, of whom Burges said, "We all copied from Viollet-le-Duc." Born to a wealthy family "Billy" Burges was able to travel throughout Europe and Turkey becoming a mediaeval archaeologist of international repute. As an architect he trained with Edward Blore (**Buckingham Palace**) and Matthew Digby Wyatt and for a time was in partnership with Henry Clutton, a fellow enthusiast for Gothic architecture.

In 1865, Burges was asked by the Marquess of Bute to prepare an extensive report on the state of Cardiff Castle and later a similar report was prepared for Castell Coch. In each case Burges studiously investigated the history of the building producing measured drawings of the existing structures. Castell Coch was a ruin, barely rising above its foundations, but at Cardiff the castle walls were well preserved, the keep on its motte complete if roofless, and the fifteenth-century Warwick Lodging, remodeled in the eighteenth century, was the home of the young Marquess. Burges, with his scholarly background and mediaeval fervor, included detailed proposals for rebuilding or remodeling each building and the marquess was easily persuaded to proceed with the suggested work. Burges assembled a team of masons, sculptors, carpenters, and artists who were to work on Cardiff Castle and Castell Coch for over thirty years.

At Cardiff Castle, Burges, working within the existing walls, burrowed into the mediaeval walls to create passages and built or remodeled several towers. Externally, the castle was reformed as a scholarly but romantic interpretation of a mediaeval building with *battlements*, machicolations (overhanging walkways to pour boiling oil on attackers below), *turrets* and *spires* topped by finials, weathervanes, and flags. Within this framework he created a series of fantastic rooms decorated with elaborate multicolored murals, carved fireplaces and *coffered* ceilings (complex tray ceilings). Themes for the decoration include "The Triumph of Virtue over Vice," the "Vision of St. Gertrude," and Geoffrey Chaucer's *The Legend of Good Women* and *The Canterbury Tales*. It is impossible to describe the richness, the quality, the extravagance of these rooms that overawe, but not overpower, and even fascinate and amuse through their spatial complexity and details. Architecturally, the most successful aspect of the Burges work at Cardiff Castle is the Clock Tower that forms a detached, multistory bachelor suite for Lord Bute (although he was happily married) of Summer and Winter Smoking Rooms, a bedroom, and an elaborate bathroom. The most extravagant room Burges designed for Cardiff Castle was the Grand Entrance Hall and staircase. This was unfinished when Burges died in 1881 and although other work continued, supervised by his assistant William Frame, the Grand Entrance Hall was never completed, and in 1927 it was demolished and replaced by the present small Entrance Hall, a new Drawing Room, and several bedrooms. Much of the elaborate carved and inlaid furniture designed by Burges still remains in the rooms as envisaged by the architect and the marquess.

The 1875 report on Castell Coch included a series of wonderful drawings

by Burges showing the ruined walls of the castle (some fifteen feet thick) with a complete suggestion of a restoration superimposed. Although originally intending only to record the ruins Lord Bute was entranced by Burges's vision of a miniature mediaeval castle perched high on the wooded mountainside and work on Castell Coch began beside that at Cardiff. With its high-pitched conical roofs, cantilevered wooden walkways, tall chimneys, and spiky finials, Castell Coch looks more like a continental castle such as Chinon on Lake Geneva, but Burges was convinced that British castles also had steep roofs. The three round towers rising out of square pyramidal bases date from the mediaeval castle but everything above is essentially the creation of Burges's imagination. The castle is entered across a wooden bridge over a dry moat and through a gateway with a working portcullis (gate that raises up to allow passage) into the courtyard from where the Banqueting Hall is accessed. Castell Coch is not a mansion; it is very small with bedrooms for Lord and Lady Bute only, but the rooms are as ornately decorated as those at Cardiff, although maybe more whimsically as befits this occasional retreat. The Banqueting Hall, Drawing Room, Lady's Bedroom, and Lord's Bedroom are decorated in a colorful eclectic mix of designs inspired by Gothic and Oriental precedents; at Castell Coch, Burges was less pedantic about the scholarly correctness of the interior than he was at Cardiff. The "Official Handbook" written for "Her Majesty's Stationery Office" describes Castell Coch as a "gigantic sham, a costly folly erected by an eccentric Victorian architect to satisfy the antiquarian yearnings of a wealthy nobleman," although the author does faintly praise it as successfully reproducing "the appearance of a thirteenth century Welsh castle of which no authentic example survives intact, and its interior is a particularly striking example of Victorian imaginative decoration at its most original and exuberant." Burges concluded his report on Castell Coch:

> This concludes the survey of the ruins and my conjectural restoration. As for the latter I must claim your indulgence; for the knowledge of the military architecture of the Middle Ages is a long way from being as advanced as the knowledge of either domestic or ecclesiastical architecture. It is true that Viollet le Duc (a French nineteenth-century architect) and Mr. G. T. Clark (a British nineteenth century antiquarian) have taught us a great deal, but we are still very far behind hand and the restoration I have attempted will I hope be judged according to the measure of what is known and not what ought to be known.

It is not to be doubted that Burges was granted whatever indulgence he wished as at both Castell Coch and Cardiff Castle he created buildings that amaze and astonish, whatever their antiquarian shortcomings.

The twentieth century was not kind to families like the Butes: taxes and death duties (inheritance taxes) eroded their great wealth. In 1947, Cardiff Castle was given to the city of Cardiff and Castell Coch to the government.

The Butes retreated from their ancient Welsh estates to their ancestral home, Mount Stuart, on the Isle of Bute off the west coast of Scotland, where they still live.

William Burges was stocky, shortsighted, and untidy; he was called Ugly Burges to distinguish him from the painter J. B. "Pretty" Burgess. That he was admired by his colleagues and clients is demonstrated by the words of Lord Bute, who called him "soul-inspiring one" and Lady Bute, who wrote "Ugly Burges who designs lovely things. Isn't he a duck" [upper-class slang of that period for a dear or a "neat" guy].

Further Reading

British Government Welsh Assembly. www.cadw.wales.gov.uk/cadw/sites/site032. htm.

Cardiff City Council. www.cardiffcastle.com.

Crook, J. Mordaunt. *William Burges and the High Victorian Dream*. London: John Murray, 1981.

CASTELL COCH. *See* Cardiff Castle.

THE CATHEDRAL CHURCH OF CHRIST, ST. PETER'S MOUNT, AND THE METROPOLITAN CATHEDRAL OF CHRIST THE KING, LIVERPOOL, MERSEYSIDE, ENGLAND

Styles: Twentieth Century, Gothic Revival, and Modern
Dates: 1904–1990; 1962–1967
Architects: Sir Giles Gilbert Scott and Sir Frederick Gibberd

The city of Liverpool dates back to 1207 and King John (r. 1199–1216); its situation at the mouth of the River Mersey provided a natural port that looked westward to Ireland and in later centuries to the New World. Wealth came to Liverpool in the eighteenth century when its merchants traded in cotton, sugar, rum, tobacco, and slaves. A century later, still a major

port, the passengers were emigrants heading to the United States (over nine million between 1830 and 1930). Many of these people, instead of taking ship, decided to stay in Liverpool and the city acquired a cosmopolitan population including a particularly large Irish Catholic contingent who had arrived in Liverpool while escaping the potato famine of 1845–1850. In the twentieth century, following the Second World War, Liverpool declined as its industries and port trade moved elsewhere, but it has recently seen a revival; that The Beatles came form Liverpool has helped attract many tourists. Looking at the city from one of the famous Mersey ferry boats, two architectural set-pieces are discerned: on the water front three massive Classical buildings give evidence of Liverpool's prosperous past—the Liver Building (housing an insurance company named for the mythical, phoenix-like bird that gave the city its name), the Cunard Building (once the headquarters of the shipping line), and the Mersey Docks and Harbour Board Building (from where the port was administered). Farther away, beyond the city center, two buildings dominate the skyline: the Cathedral Church of Christ, the Anglican (Protestant) Church of England (Episcopalian) Cathedral, and the Metropolitan Cathedral of Christ the King, the Roman Catholic Cathedral—they stand at opposing ends of Hope Street.

The requirement for an Anglican cathedral was established in 1880 with the appointment of the first Bishop of Liverpool; a cathedral is the focal church of a diocese where a bishop presides. The Rector of Liverpool described the most important church in the city, St. Peter's, and until that time much liked, as "ugly and hideous." It took twenty years and one failed attempt to make the decision, but in 1902 a second competition was announced for designs for a worthy cathedral for the City of Liverpool, "something to speak for God." Giles Gilbert Scott (1880–1960), the son and grandson of famous architects, and at that time articled (apprenticed) to architect Temple Moore, submitted a design titled "Design for a Twentieth Century Cathedral." Scott, surprised and pleased to make the final five under consideration, was astonished when it was announced by judges R. Norman Shaw and George F. Bodley that his design was the winner. The Liverpool Cathedral Committee was dismayed, for Scott was inexperienced, twenty-two years old, and a Roman Catholic. A compromise was reached with Scott and the much older Bodley declared as joint architects for the project. Their collaboration was not happy and Scott was about to resign from the job in 1907 when Bodley died. By this time the committee had more confidence in Scott and he continued as architect until his own death in 1960.

King Edward VII (r. 1901–1910) laid the foundation stone on July 19, 1904, to the accompaniment of a choir of 1,000 voices singing Handel's "Hallelujah Chorus." In 1910 the Lady Chapel at the southwest corner of the complex was completed in a conventional Gothic Revival style, showing the influence of Bodley over Scott at this early stage of the project. (Site considerations forced the orientation of the cathedral to be north–south, rather than east–west, with the High Altar at the south end instead of the more ac-

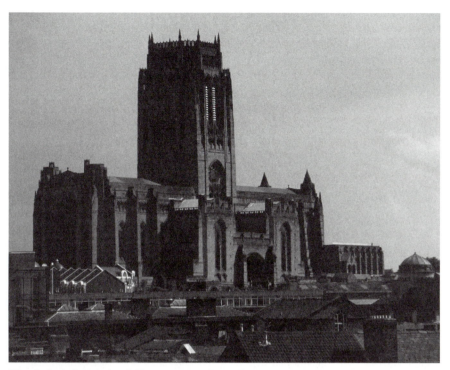

The Cathedral Church of Christ. Liverpool's Anglican (Episcopalian) Cathedral. *Photo by Ian Britton (FreeFoto.com).*

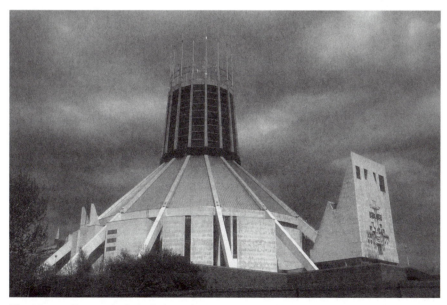

The Metropolitan Cathedral of Christ the King. Liverpool's Roman Catholic Cathedral. *Photo by Ian Britton (FreeFoto.com).*

cepted east end; many descriptions use the liturgical orientations placing the altar at the "east" end.) It was in 1910, with Bodley now deceased, that Scott approached the Cathedral Committee proposing a major redesign of the rest of the building and this was approved after considerable discussion. Scott's original design had been of a safe Gothic Revival, English Decorated style, somewhat simplified (see **The Parish Church of St. Giles** for a description of the styles of English Gothic architecture). His new design is much more monumental and sublime, simplified to abstraction owing, in its free adaptation of Gothic forms, to European, particularly Spanish, influences. Symmetrical about two axes that cross at the great central space, the plan is almost Classical in feeling. In plan unlike other English Gothic cathedrals, there is a long processional space running from the main entry at the north end to the Chancel and High Altar to the south; a gallery, the Dulverton Bridge, crossing over between two major piers, visually separates the northern quarter of the 619-foot overall length of the building. In the very center, under the tower, is a great space with the seating for the congregation. To east and west huge porches cut deeply into the mass of the building, opening directly into the central space, between double transepts housing subsidiary chapels. Scott's original design featured twin towers, obviously inspired by **Durham Cathedral**, but these were replaced by the single more massive tower over the central space we see today. Internally, the vaults inside rise to 120 feet above the floor, 175 feet to the vault under the tower that externally rises to 331 feet; Scott placed the last, topmost, stone of the tower in 1942.

Liverpool Cathedral was built of red sandstone using traditional techniques and therefore construction was slow and laborious. By 1924, with some delay during the First World War of 1914–1918, the High Altar, the *Chancel*, and southern transepts were complete and were consecrated at a service attended by King George V (r. 1910–1936) and Queen Mary, where Scott received a knighthood. In 1942, at the height of the Second World War the tower was finished, the Dulverton Bridge in 1961, a year after Scott's death, and on October 25, 1978, Queen Elizabeth II (r. 1952–) attended a service of thanksgiving celebrating the completion of the cathedral. It had taken only seventy-four years to build the third-largest church in the world after St. Peter's in Rome and Milan Cathedral.

At the other end of Hope Street the Catholic Metropolitan Cathedral of Christ the King has a similar history, although the end result was a very modern building constructed on the foundation of a building planned earlier. This is known locally as "Paddy's Wigwam," in reference to the largely Irish Catholic congregation who caused it to be built and the shape that has been likened to an Indian teepee.

Until the enactment of Catholic emancipation in 1829, the open practice of Roman Catholicism had been proscribed. Catholic emancipation allowed adherents of the Roman faith to worship legally and by 1850 the full hierarchy of archbishop and bishops, diocese and parishes had been reestablished; the first Bishop of Liverpool oversaw the commission of a new cathedral in

1853, to be designed by Edward Welby Pugin (1833–1875), the son of Augustus W. N. Pugin, who had worked beside Sir Charles Barry on the **Houses of Parliament**. The Lady Chapel was the only part of the planned cathedral that was built and unfortunately this had to be demolished in the 1980s.

Sixty-six years later, in 1922, the idea of a cathedral was once again raised and fund-raising began. A site was found on Brownlow Hill, where the Poor Law Institution or Work House (a home for destitute people) stood until 1928; the nine acres was bought in 1930. The chosen architect was Sir Edwin Lutyens (1869–1944) famous for his design of **The Cenotaph** in London and numerous country houses (see **Lutyens Country Houses**). Lutyens planned a huge building, austerely and massively Romanesque, in contrast to Scott's minimal Gothic to the south, topped by a 168-foot-diameter dome rising to a height of 520 feet. The foundation stone was laid in 1931, the name ordained by Pope Pius XI; building continued until 1941 when the war caused construction to be stopped. The lower level, The Crypt, that formed a *plinth* for the actual building was finished after the war but it was realized that the funds available were totally inadequate when faced with the inflated postwar prices, and the church itself was never built. The decision to abandon Lutyens's design was made in 1953; a new domed design by Adrian Gilbert Scott, brother of Giles, did not meet approval, and in 1960 the Archbishop of Liverpool announced an international competition for a new cathedral to be built atop The Crypt.

The winner, out of 300 entries, was Sir Frederick Gibberd (1908–1984) and his controversial design was built in a mere five years, from October 1962 to May 1967, when the Anglican cathedral still had eleven years to go of seventy-four years under construction. Following the line of the circular space below Lutyens's proposed dome the Gibberd design features a ring of cranked concrete structural members that slope up from the base and then soar vertically into a circular *lantern* filled with stained glass; the spikiness of this is a reference to the Crown of Thorns but the whole has been likened to a crown roast. Beneath this structure is the nave, a circular space capable of seating 2,300 worshippers, who all focus on the altar at the very center. The archbishop's chair, the cathedra, is close by so he is also at the center of worship. Around the outside of the nave, between the sloping legs of the concrete structure, are inserted small concrete walled chapels of different shapes and sizes. Beneath, in The Crypt, the rooms designed by Lutyens are used for meetings, concerts, banquets; the Chapel of Relics contains the tombs of three late archbishops and is accessed through a six-ton marble door that rolls to one side, alluding to the stone that sealed Christ's tomb.

Liverpool, the city of the Beatles and the Royal Liverpool Philharmonic, a city of wealth and poverty, elegant Georgian houses and derelict slums, is a city of contrasts. The two cathedrals, both built with pride and dedication, representing the Anglican and Catholic Churches, contrast architecturally: one the last of the Ecclesiastical Gothic Revival, the other a product of the

brash modernism of the 1960s; one gloomy and atmospheric, the other full of light and color; both part of Liverpool's past while contributing to its future when the city will be the 2008 European Capital of Culture.

Further Reading

Kennerley, Peter. *The Building of Liverpool Cathedral.* Lancaster, U.K.: Carnegie Publishing, 2004.
Liverpool Cathedral. www.liverpoolcathedral.org.uk.
Liverpool Roman Catholic Cathedral. www.liverpool-rc-cathedral.org.uk.
Wilkinson and Kennerley. *The Cathedral Church of Christ in Liverpool.* Liverpool: Bluecoat Press, 2003.

CATHEDRAL CHURCH OF ST. MICHAEL. *See* Coventry Cathedral.

THE CENOTAPH, WHITEHALL, LONDON

Style: Twentieth Century
Dates: 1919–1920
Architect: Sir Edwin Lutyens

The First World War, the Great War, the 1914–1918 War was, however one refers to it, arguably the most traumatic conflict of the twentieth century. For each generation, for each group of veterans, the war they experienced personally has the most importance, whether World War II (1939–1945), Korea, Vietnam, Bosnia, the Persian Gulf, or Iraq. However, in terms of its social and political impact, the war that blew apart Europe in 1914–1918 had the most ramifications as it swept away the past and opened up the future. And for each generation it is important that those who died be remembered not just individually by each family but nationally with a memorial that focuses grief and memories and ensures future generations do not forget. In the words of the British writer Rudyard Kipling, "Their Name Liveth for Evermore." In London, in the middle of the broad street Whitehall, which leads from **Trafalgar Square** to **The Houses of Parliament** and close to **The Banqueting House**, stands the Cenotaph, a simple, tall stone

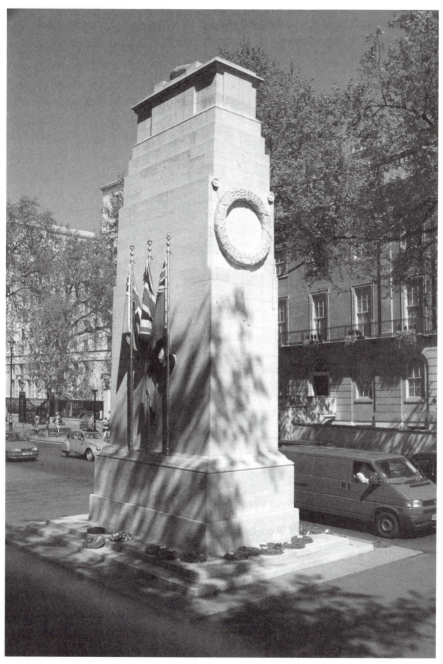

The Cenotaph. Lutyens's simple monument to the dead of World War I sits in the middle of Whitehall, the busy thoroughfare at the center of the government district of London. *Photo by Ian Britton (FreeFoto.com).*

memorial that in its day had as much impact on a national psyche as did Maya Lin's Vietnam Wall in Washington, D.C.—the architect was Sir Edwin Lutyens, the finest British architect of the twentieth century.

At the time of the outbreak of the war in August 1914, Lutyens had a successful practice designing country houses for upper-middle-class clients, houses that embodied the ideal of the smaller English country house based on traditional materials and vernacular precedents with an overlay of Classicism (see **Lutyens Country Houses**). He was also working on his greatest commission, New Delhi, India, and its focal point, The Viceroy's House. In 1917 work on New Delhi was suspended and Lutyens was instead invited to work with the Imperial War Graves Commission charged with overseeing the design of cemeteries and memorials at the sites of the battles of the still raging war. Lutyens, with fellow architects Sir Reginald Blomfield and Sir Herbert Baker, was responsible for the simple design that marked the character of the many sites: fields of regularly spaced small stones or crosses with a central building to shelter a register and visiting mourners. At all but the smallest cemeteries Lutyens placed a large stone, "a great fair stone of fine proportions, twelve feet in length, lying raised upon three steps, of which the first and third shall be twice the width of the second . . . This stone should be, wherever circumstances permit, on the east side of each cemetery, and the graves lie before it, facing east, as the army faces now [as it battled into Germany further to the east]." The design of the Stone of Remembrance, as it came to be called, looks back to the heroic altar tombs of ancient Greece and Lutyens incorporated the ideas of proportion and entasis seen in the Parthenon in Athens. Entasis corrects for the misreading of the human eye when looking at an object; for example, when looking at a tall vertical line, such as the side of a column, the eye will not see a straight line but a slight curve. Architects use entasis to correct this by incorporating a counter curvature that visually straightens out the line. Lutyens's Stone of Remembrance uses entasis in such a way that all its nominally horizontal surfaces are parts of circle 1,801 feet, 8 inches in diameter, and all the verticals converge to a point 900 feet, 10 inches (half the circle's diameter) above the ground. The first time the design for the Stone was used was in a Great War Shrine in Hyde Park which, while the ceremonies were considered "an outburst of national vulgarity" and "one of our insults to the dead," led to a call for a national memorial. It was Lutyens's work with the Imperial War Graves Commission and the Great War Shrine that was to lead to the Cenotaph.

The peace treaty finally ending the Great War was signed on June 28, 1919, and a Peace Celebrations Committee planned appropriate festivities including a Victory Parade of troops from all the victorious nations that would march past King George V (r. 1910–1936) taking the salute on a dais outside **Buckingham Palace,** down The Mall and along Whitehall to Parliament Square and **Westminster Abbey**. Prime Minister David Lloyd George attended similar events in Paris and noted a temporary catafalque (place to rest a coffin) beside the Arc de Triomphe that was the focal point

for the soldiers as they marched past along the Champs-Élysées. The Victory Parade was to take place in August on the fifth anniversary of the declaration of war, and on July 19, 1919, Lloyd George called Lutyens to see him at **Number 10 Downing Street** and requested a catafalque similar to the one he had seen in France. Lutyens had already sketched some ideas for memorials and one, which he had called "Sketch for Cenotaph," he developed further. The word cenotaph derives from the Greek words *kenos* meaning empty, and *taphos* meaning tomb, and for Lutyens the name came from a large stone seat, referred to as the "Cenotaph of Sigismunda," in the garden of Munstead Wood, the house he had designed for his patron and friend Gertrude Jeckyll. Built of wood and plaster in two weeks, the Cenotaph incorporated the quest for perfection using proportion and entasis seen in the Stone with the pragmatic of needing an object visible above a mass of marching soldiers mundanely situated in the middle of six lanes of traffic.

Thirty-five feet tall and fifteen feet by eight feet, six inches at the base, the Cenotaph comprised a tall, stepped pylon supporting a catafalque; the pylon was adorned with two wreaths on the narrow north and south ends, three flags along each of the sides, and the words THE GLORIOUS DEAD on the west side and the dates MCMXIV (1914) and MCMXIX (1919) above the two wreaths. The form derives from ancient and Renaissance examples of tombs and Lutyens refined the entasis such that the verticals all meet at a theoretical point 1,000 feet above the ground and all the horizontals are arcs of circles theoretically centered 900 feet below. The Cenotaph was only one of several temporary structures along the parade route and played only a brief part in the celebrations, but somehow it caught the veterans' and public's imagination, an understated, abstract expression of the nation's grief. A letter to *The Times* newspaper stated: "The Cenotaph in Whitehall is so simple and dignified that it would be a pity to consider it merely as an ephemeral structure" and a subsequent editorial said: "The new Cenotaph erected in Whitehall to the memory of 'the glorious dead' was the centre of what was perhaps the most moving portion of Saturday's triumphal ceremony. The Cenotaph is only a temporary structure made to look like stone; but Sir Edwin Lutyens's design is so grave, severe and beautiful that one might well wish it were indeed of stone and permanent."

The idea was planted for a permanent memorial and a quick decision was necessary as the temporary structure was rapidly deteriorating. Government committees up to the level of the Cabinet approved and the General Purposes Committee of Westminster City Council met to deliberate with a major issue being the situation of the Cenotaph in the middle of a busy street; The Mall or Parliament Square were suggested as alternative locations. Sir Alfred Mond, the First Commissioner of the Board of Works wrote to the Mayor of Westminster: "Before the Council come to a final decision on this question I should like them to bear in mind that the erection of the permanent Memorial is the declared decision of the Cabinet supported by the House of Commons and public opinion. With regard to the Committee's

suggestion that the Cenotaph should be erected in Parliament Square or else-where, I think it should be remembered that it was specially designed by Sir Edwin Lutyens for the position in which it stands and with the most careful regard for its surroundings. The spot on which it stands is now consecrated to the Memory of all those, whether belonging to the Empire or our Allies, who fell in the Great War, and it will thus be remembered for all time the spot containing the Memorial to the 'Glorious Dead' which was saluted by the representatives of the troops of the Empire and of our Allies on the day when Peace in the Greatest War in the World's history was celebrated in London." Westminster Council approved without further demur.

Lutyens submitted final drawings on November 1, 1919, and the permanent memorial was completed at the considerable cost of £7,325 by the firm of Holland, Hannen and Cubitts Ltd. The proportions and lines had been refined and the blocks of stone carefully placed with rubbed joints so thin as to be virtually invisible—hence the great expense. The Cenotaph was unveiled on Armistice Day, November 11, 1920 (the second anniversary of the ceasefire that ended the Great War) by King George V, beginning the tradition of an annual ceremony remembering the British people's war dead at which the monarch leads the laying of wreaths of red poppies. The only change to the Cenotaph since its completion has been the addition of two more dates to the east and west faces, MCMXXXIX (1939) and MCMXLV (1945): the dates of World War II.

For Lutyens the Cenotaph was to bring many more commissions from the Imperial War Graves Commission and other councils totaling ninety war memorials and cemeteries including the massive and moving interlocking arches of the "Memorial to the 73,357 Missing of the Somme" at Thiepval, France. Knighted by George V in January 1918, Lutyens was to receive the highest awards of the architectural profession of both Britain and the United States: the Gold Medal of the Royal Institute of British Architects in 1921 and the Gold Medal of the American Institute of Architects in 1924.

Further Reading

Brown, Jane. *Lutyens and the Edwardians. An English Architect and His Clients.* London: Penguin Viking, 1996.

Wilhide, Elizabeth. *Sir Edwin Lutyens: Designing in the English Tradition.* London: Pavilion Books Ltd., 2000.

CHARTERS AND THE MODERN MOVEMENT, BERKSHIRE, ENGLAND

Style: Twentieth Century—Inter-War, Modern Movement
Date: 1938
Architects: George M. Adie and Frederick C. Button (Adie, Button and Partners)

The Modern Movement and Art Deco (derived from the French Arts Decoratif) styles of architecture of the 1920s and 1930s did not have the same impact on British architecture as they did in the rest of Europe, particularly Germany, or the United States. Indeed, London was a stepping-stone for many Modern Movement architects on their way from the oppressive Nazi regime in Germany to the friendlier shores of America. They stayed for a short time in Britain, designed a few buildings, influenced a few British architects, and headed west across the Atlantic where they revolutionized American architecture. In Britain, Bertold Lubetkin of the Tecton Group (an architectural firm), Welles Coates, and Wallis Gilbert were the leading Modern Movement architects. They designed factories, office buildings, public buildings, and housing developments—Coates's "Isokon" Flats (apartments) in Hampstead, north London were recently restored to their 1933 appearance, demonstrating a revival of interest for these often neglected buildings. Most towns, in their 1930s suburbs, feature some startlingly different Modern Movement houses with their gleaming white walls, flat roofs, and horizontal bands of steel-framed windows. Favored by the avant-garde, middle-class intelligentsia, the Modern and Art Deco styles were rarely chosen for the design of a country house. However, in the late 1930s Frank Parkinson, the chairman of Crompton Parkinson of Chelmsford, a manufacturer of electrical goods, built Charters.

Parkinson's estate in Berkshire to the west of London featured a landscaped *park* that had been laid out for an earlier house. This had been demolished but its site, facing south over the park, enjoyed views to the distant hills and in particular one of distinctive shape known as the "Hog's Back." Architects Adie and Button were commissioned by Parkinson to design a house "that would combine many of the attributes of a traditional country seat (estate) with all the conveniences that modern technology could offer." Viewed form a distance across the park, Charters has an almost Georgian severity and symmetry but a closer inspection reveals that the *portico* is actually an abstraction of the *Palladian* motif incorporated into a very modern building. In Evelyn Waugh's *Decline and Fall*, a character named Margot Best

Chestwynde builds a "clean and square" house called King's Thursday. The fictional architect is Professor Silenus, a German best known for his chewing gum factory. Charters could be the model for King's Thursday and, while there is not a German connection, Frederick Button's mentor, Wallis Gilbert, had designed the Wrigley's chewing gum factory. Featuring all the requisites of a Modern Movement building—cubic forms, flat roofs used for sun terraces, large, steel-framed windows (in Britain made by Crittal), and gleaming white walls—on closer inspection Charters is found to veer from the doctrinaire dictums of Modernism. Rather than being truthful and just painting the concrete walls and structure white, at Charters the whole of the exterior is covered in gleaming white Portland stone—a material favored for important buildings for centuries. In other ways Charters, for all its twentieth-century optimism, looks back by reinterpreting traditional forms: the "portico" on the south front; the "great hall" at the center of the house even features a "minstrel's gallery."

In his book *The Last Country Houses*, Clive Aslet calls Charters "the perfect example of Good Taste triumphant." This is because of Mrs. Parkinson who, being "nouveau riche" (new rich), did not have the confidence to face the established local gentry in a house that did not feature antiques and swagged drapes. While the bathrooms are among the most luxurious examples of Art Deco design in the country (temples of chrome and marble), the living rooms and bedrooms of the house are an odd mix of modern and traditional. With concealed lighting and simple moldings, Mrs. Parkinson's interior designer, Mrs. G. R. Mount, contrived to make the Dining Room Chinoiserie (Chinese), and the Drawing Room neo-Georgian (eighteenth century). In the Great Hall *Corinthian* columns, chandeliers, and murals were introduced as a suitable backdrop for seventeenth- and eighteenth-century furniture. Only in the Morning Room did Modernism reassert itself with pale walls, sleek Australian walnut cabinets, and boxy sofas and armchairs covered in "brown and greenish weaves." Amazing to see is the huge *basement* furnace room, looking like a ship's engine room, white tiled and sparklingly clean, the hub of this Modern Movement house that does not quite adhere to Le Corbusier's idea that a house is a "machine for living." Charters was owned, until 2002, by DeBeers Diamond Company.

Other houses designed in the Modern style include Jolwynds, Surrey, by Oliver Hill (1930–1932). A pure, stark interpretation of the style and much praised, Jolwynds was unfortunately structurally flawed and therefore replaced after only seven years by The Wilderness, Jolwynds, Surrey, by Margaret Lubetkin of the Tecton Group (Aslet describes The Wilderness as "committed Modern Movement with a pitched roof"). "High and Over," a spectacular design by Amyas Connell in Amersham, Buckinghamshire (1929), features a Y-shaped plan, cantilevered flat roofs, and a hall with a black marble floor, a central pool and fountain. And, in the 1930s, at Eltham Palace, designers Rolf Engströmer and Peter Malcrida transformed an undistinguished house of little merit, for Mr. and Mrs. Stephen Courtauld, into a "hedonistic tour de force." Recently restored at a cost of $3.3 million, Eltham

Palace is the best known Art Deco house in Britain—"the quintessential 1930s interior."

Moving up in scale, one of the most striking examples of Modern Movement architecture in Britain is the De La Warr Pavilion on the promenade overlooking the sea at Bexhill, Surrey. Designed by German architect Erich Mendelsohn and built in 1933–1936, the De La Warr Pavilion was given to the town by the philanthropic 9th Earl De La Warr as a center for the arts and art education. In 1989, the building having barely escaped demolition, the Pavilion Trust was established to raise funds for the restoration and refurbishment that was completed in 2000. Recently voted one of the best buildings in Britain, by *The Independent* newspaper, the judges commented that "this Modernist masterpiece has a sinuous elegance that has rarely been surpassed."

Sadly, many of the larger Modernist and Art Deco buildings have been demolished. Flat roofs and white walls require continual maintenance and many of the factories and office buildings built in the style did not survive the economies of late twentieth-century recessions. Only at the end of the century did an appreciation for 1930s architecture develop and several buildings have been rescued and restored for use as offices or loft apartments. Many of the largest factories were built on the so-called arterial highways that connected major cities and encouraged "ribbon development" out into the countryside. The Hoover Factory of 1931–1935 was built on London's Western Avenue and is one of the grandest buildings of this genre. Designed by Wallis, Gilbert and Partners for the Hoover vacuum cleaner manufacturer, the composition is reminiscent of a great palace, with a long, central colonnaded block, flanking wings, and punctuating towers. Thomas Wallis was the British representative for the American firm Trussed Concrete Steel Company (Truscon), which brought the innovative ideas of Albert Kahn, who designed many of the automobile factories of Detroit, to Europe. Wallis's designs, efficiently arranged with good lighting and ventilation, were "the antithesis of the dreary nineteenth century factory."

Part of the revival of interest in Modern Movement and Art Deco architecture can be attributed to a television series. The mystery writer Agatha Christie lived for a time in the Isokon flats and she gave one of her creations, detective Hercules Poirot, an almost obsessive appreciation of the purity of Modernist design. In the television series *Poirot* (c. 1999–2001), most of the film locations are houses, apartment buildings, and factories from the period and it is possible to understand their appearance and, when compared to the cars and clothes, to realize how modern these buildings were to the people of the time.

Further Reading

Aslet, Clive. *The Last Country Houses.* New Haven, Conn.; London: Yale University Press, 1982.

De La Warr Pavilion. www.dlwp.com.

Doordan, Dennis P. *Twentieth-Century Architecture.* Englewood Cliffs, N.J.: Prentice Hall, 2002.

Hall, Michael. *The English Country House—From the Archives of Country Life, 1897–1939.* London: Mitchell Beazley, 1994.

CHATSWORTH HOUSE, DERBYSHIRE, ENGLAND

Styles: Renaissance—Elizabethan and Baroque, and Victorian
Dates: 1552–1570; 1687–1707; 1756–1764; 1820–1841
Architects: William Talman and Thomas Archer (seventeenth and early eighteenth centuries); James Paine (eighteenth century); Sir Jeffry Wyatville and Sir Joseph Paxton (nineteenth century)

Chatsworth House is possibly the finest property in the British Isles, the *beau ideal* of the English country house. It is still lived in by the descendants of its builders, filled with priceless treasures, its architectural splendor surrounded by wonderful gardens and extensive deer parks. Sometime called the "Palace of the Peak," it is situated in a pastoral valley hidden in the remote fastness of the Derbyshire Peak District where the great house nestles against a protective west-facing slope with the River Derwent meandering below. The house was begun in 1552 for the redoubtable Bess of Hardwick who at that time was married to her second husband (as his third wife), Sir William Cavendish. The Cavendishes had six surviving children and through them Bess was determined to establish a great dynasty that would enjoy continued wealth and prominence, with Chatsworth as their main property and residence. Sir William came from Cavendish, a small Suffolk village, and had acquired wealth and land as a commissioner of the Dissolution of the Monasteries. An adroit politician, he was able to navigate through the turbulent times of Henry VIII (r. 1509–1547), Edward VI (r. 1547–1553), and Mary I (1553–1558), keeping position and possessions. Bess was nearly his undoing. She had grown up at Hardwick some miles to the east of Chatsworth and upon their marriage in 1547 she persuaded him to sell all his inherited and newly acquired lands and buy an estate and further adjoining lands at Chatsworth. There they began the construction of a huge new house. Bess's profligacy led to failure, for while she spent money on land, building, and a lavish lifestyle, Sir William, to keep up with her, embezzled money from his position of Treasurer to the Royal Chamber. An audit revealed a shortfall of £5,000 and it was only the timely death of Sir William that rescued Bess and the Cavendish heirs from ruin. Everything was in her

name, and while she repaid a token amount, the bulk of the estate was safe and continued to rapidly grow. Two more marriages led to increased wealth and status and in 1590 Bess retired to Hardwick as Countess of Shrewsbury where she built her final house: **Hardwick Hall**. Chatsworth eventually passed to her second son, William Cavendish, who was created 1st Earl of Devonshire in 1618.

The Cavendishes were astute politically and through the dramas of the Civil War and the Restoration managed to back all sides and keep their position and riches. However, in the late seventeenth century the 4th Earl (also William) became increasingly at odds with the professed Catholicism and absolutism of the Stuart monarch James II (r. 1685–1688). The country and the Cavendish family had not suffered through the turbulent times of the Tudors and the Interregnum (the period when the monarchy was abolished—it lasted from the beheading of Charles I in 1649 to the Restoration of Charles II in 1660) only to see their power and influence stripped away. The earl had visited France and seen how Louis XIV had rendered the ancient aristocracy politically impotent puppets, feckless creatures fawning on the monarch at Versailles. The great hope for Cavendish and his co-conspirators was Mary, the Protestant daughter of James II, who was married to the equally Protestant William of Orange (of Holland). However, in 1688, a son was born to James II and his second wife Mary of Modena and the threat of a Catholic heir hastened the Glorious Revolution that brought William and Mary to the throne as joint rulers in 1689: a glorious revolution because there was no bloodshed, James having fled to France at the first sign of trouble. The new regime rewarded the earl with a promotion, creating him Duke of Devonshire in 1694.

By this time the house at Chatsworth was distinctly old-fashioned, showing signs of considerable dilapidation. Bess had built a fine square house around a large courtyard, three stories high with the most important rooms on the top floor enjoying the views. Entered from the west through a gateway framed by octagonal towers, the corners of the house were emphasized by small square towers. Filling the east side facing into the courtyard was a traditional Great Hall. Chatsworth was not a revolutionary house as Hardwick was to be thirty years later. The 4th Earl, self-exiled from London in 1687, started to work on the rebuilding of his forebears' great house, creating by 1707 a palace symbolic of the prestige and power that had come to the families at the heart of the Glorious Revolution who now effectively ruled the country.

The first parts of the house that were rebuilt were the east and south wings containing the Great Hall, the *State Rooms*, and the Chapel. William Talman (1650–1719) was the chosen architect; popular with the new leaders of the country, he worked on several important houses and was probably the architect of Buckingham House (see **Buckingham Palace**, London) that was to be so influential as model for several country houses. Talman is reputed to have been a difficult man—as was the duke—and he was dismissed in 1696

Chatsworth House, Derbyshire. The west and south fronts. *Vitruvius Brittanicus.*

with the remodeling of Chatsworth only half completed. The south front is Talman's finest work at Chatsworth, a long, twelve-bay *façade* with three *bays* at each end enhanced with *Ionic* giant *order pilasters* between the windows. Often compared to Bernini's design for the Louvre in Paris, the south front at Chatsworth also resembles Le Vau's Vaux-le-Vicomte, particularly the window treatment with the emphatic protruding keystones. The monumental appearance of the house is reinforced by the absence of a visible roof with only lead flats behind *balustrades* punctuated by bases carrying urns.

A detailed study of the south façade raises questions about the plan of the house behind. Unusually, the façade, while symmetrical, does not center on an elaborate doorway. This is because the façade in reality represents half a house. The three windows to the right on the second and third floors contain the Low and High Great Chambers, the entry rooms to suites of *apartments* that proceed (to the left as viewed from outside) with withdrawing rooms, bedrooms, and closets. In a grand house of this period there should be "his and hers" apartments to either side of the great chambers, but Chatsworth was built too close to the hillside to allow for expansion eastward and, also, the duke had determined to build within the shell of Bess's original house. The other apartments had to be elsewhere in the house but to maintain the illusion a huge mirror fills a doorway in the High Great Chamber at the point of entry to the missing apartment and reflects the *enfilade* of rooms opposite. Therefore, the center of the south front is not the most important room; it is actually the wall between two rooms and does not need to be emphasized. The rooms behind the south façade were designed by Talman and exhibit the finest craftsmanship available with carvings by Cibber, ironwork by Tijou, and ceiling paintings by Verrio—the duke had diverted the royal decorating team from **Hampton Court Palace** to his own palace! Louis Laguerre decorated the Great Hall, completely rebuilt by the

duke as a monumental entrance hall, with scenes from the life of Julius Caesar. It is apparent from the house he created that while the duke was wary of the French king's despotism, he admired French architecture and artists.

Since Talman was dismissed, the rather pedestrian *pedimented* west front, completed in 1696, is by an unknown hand and is unfortunately the house's most visible façade. The north front with its prominent bowed centerpiece was built during 1704–1707 by Thomas Archer (c. 1688–1743), who also designed the Cascade House of 1702 that sits atop the ornamental water staircase east of the house.

James Paine was brought in to build the stables in 1758–1763, the bridge over the River Derwent (1760–1764), and an office (service) wing attached to the northeast corner of the main block (1756–1760). The latter was demolished in 1820 and rebuilt, for the 6th Duke, to the designs of Sir Jeffry Wyatville, who included new kitchens and servants' accommodations on the lowest level with a new dining room, sculpture gallery, orangery, and a theater above. The fly tower for scenery of the latter justifies the tower at the north end of the new wing. Apart from minor changes to make the house more manageable, Chatsworth is little changed since 1840.

Lancelot (Capability) Brown had been employed during the 1760s to transform the *park* into the naturalistic landscape that still exists, although he intended the pasture to come right up to the west windows of the house. It was in the nineteenth century, during the time of the 6th Duke, that the gardens were created much as we see them today. The major loss has been the Great Stove, a massive greenhouse, over half an acre of steel and glass, designed by Joseph Paxton (with Decimus Burton, who was later to design the Palm House at Kew). This displayed the tropical plants that the duke had sent to him from all over the world. This pioneering structure led Paxton to the design of **The Crystal Palace** in Hyde Park, London, for the Great Exhibition of 1851. Unfortunately, it was very expensive to maintain and having fallen into disrepair during the First World War was blown up in 1920 on the orders of Evelyn, Duchess of Devonshire.

Chatsworth continued to be the center of British political life until the 1960s. Prime Minister Harold Macmillan was the duke's uncle, having married a Cavendish, and an important connection with the United States is often overlooked: William Cavendish, the 10th Duke's eldest son, married Kathleen Kennedy in 1944 only to be killed a few months later fighting in France. If he had lived and succeeded, President Kennedy's sister would have been Duchess of Devonshire. However, as it worked out, it was the younger son Andrew, and his wife Deborah Mitford, who became 11th Duke and Duchess of Devonshire in 1950. They were faced with 80 percent death duties on the estate and a dilapidated Chatsworth House that had been used by a girls' school during the war years. Retrenchment was required and land-holdings shrank from 120,000 acres to 72,000 while eventually Hardwick Hall and several of the most important works of art including paintings by Memlich, Rembrandt, and Lorrain were handed over to the government. It

is a demonstration of inflation and increased values that the estate valued for probate in 1950 at approximately $9 million (and assessed for over $7 million in taxes) is now valued at over $2 billion. Chatsworth House under the care of the current Devonshires—the 12th Duke inherited it in 2004—is everything that Bess Cavendish hoped for over 500 years ago: the great house of a lasting respected dynasty, filled with great art and artifacts, and surrounded by profitable estates.

Further Reading

Cavendish, Deborah, Duchess of Devonshire. *The House, a Portrait of Chatsworth.* London: Macmillan Ltd., 1982.

Chatsworth Estate. www.chatworth-house.co.uk.

Montgomery-Massingberd, Hugh, and Sykes, Christopher Simon. *Great Houses of England & Wales.* New York: Rizzoli International Publications, Inc., 1994.

Pearson, John. *The Serpent and the Stag.* New York: Holt, Rinehart and Winston, 1983.

CHESTER, CHESHIRE, ENGLAND

Styles: Roman, Mediaeval, and Victorian
Dates: Circa 70 C.E. to present day
Architects: Unknown

Chester, in the County Palatine of Cheshire in northwest England, is worthy of notice for two reasons: (1) it is one of only a few European cities where the defensive walls are still extant, with walls built during the Roman Empire c. 70 C.E.; (2) it features The Rows, a fourteenth-century shopping mall unique to the city.

Cheshire is situated in the western Marches, the region of England that borders on Wales. It is a plain of rich agricultural land distantly bordered by the Pennine Mountains to the east and the mountains of Wales to the west. Wales, with its narrow valleys and high peaks, was a defensive retreat for the Druid cult during Roman times and for some of the Celtic tribes after the Angle and Saxon invasions that followed the Roman retreat. Chester, on a defendable bluff above the River Dee, provided a place of protection and a base for incursions into Wales. During the early mediaeval period the Earls of Chester were among the most important barons in England, charged with protecting the western border and subduing the Welsh. The last Norman Earl of Chester died in 1237 and the heir to the throne, currently Prince Charles, has since held the title.

The first Roman expedition to Britain took place in 55 B.C.E. under Julius

Caesar, but no settlements followed. In 43 c.e., under the emperor Claudius, the Romans invaded again and with the defeat of Cassivellaunus, the British Chieftain and King Caractucus (another tribal chieftain who fled to Wales), established control of the south of Britain. During the years 70–84 c.e., the Romans expanded their control farther north and attempted to conquer Wales where they discovered valuable reserves of gold and lead. The XXth (twentieth) Legion, ordered to march into north Wales, built a fortress called Deva, which we now know as Chester. Many Roman settlements in Britain can be identified by the inclusion of the word "chester" or "cester," which derives from "castrum" meaning a fortress, in their name; for example Winchester, Gloucester, Leicester, or Worcester.

The disciplined Roman army was capable of marching great distances at incredible speed and building defensive wooden stockades when they camped for the night. Fortresses were built as permanent bases, usually for a particular legion; they were designed with military precision and efficiency and followed the same plan as temporary encampments. Each legion numbered ten cohorts and each cohort six centuries of eighty men (originally one hundred, this was found to be too many for the centurion to command and was reduced). The camps and fortresses were laid out on a regular grid by centuries with the commanding officers' and generals' quarters at the center. Two main streets, at right angles to each other, which led from the entrance gates to a central plaza, divided the rectangular plan. This plan became the model for the cities that were established as the Pax Romanum (Roman peace) encouraged trade and commerce to flourish throughout the empire. The fortress at Deva, one of these, was located on a bend of the River Dee; the rectangular layout was oriented north/south and surrounded by a stone wall some two miles in total length. At the center of each side a gateway led in to the two main streets, the Cardo (NS) and the Decamanus (EW). At Chester, standing at The Cross, it is possible to look in four directions: north up Northgate Street; east along Eastgate Street; west down Watergate Street; and south down Bridge Street. The names of the streets give an idea of where these streets led in Roman and mediaeval times. The Roman fortress developed into a prosperous city mostly contained within the defensive walls, although the *amphitheater*, the largest in Britain (314 feet by 286 feet with an arena 190 feet by 162 feet), was just outside the east gate.

After the Romans withdrew from Britain c. 400 c.e., the city that had developed under the protection of the XXth Legion was attacked by the Danes and Saxons. By 900 it was abandoned and derelict. In 1070, soon after their invasion, the Norman conquerors established Chester as a garrison city under the rule of Hugh Lupus, Earl of Chester. The Roman walls, still substantially intact, were repaired, a castle built in the southwest corner protected by the river below, and the abbey (now the cathedral) of St. Werburgh established in the northeast corner. Important as a trading center and the base for Edward I's (r. 1272–1307) invasion of Wales, Chester became a prosper-

ous port city with ships arriving at the quay outside the Watergate from Scotland, Ireland, France, and Spain.

In the fourteenth century the famous double-tiered shops (stores), known as The Rows, were built along the four main streets. At street level (at this time unpaved, muddy, and probably virtually an open sewer) were stores that sold "dirtier" produce or that required daily deliveries. Above these lower stores and recessed into the buildings was a covered walkway ten to fifteen feet wide that allowed access to upper-level stores of "cleaner" trades such as tailors, milliners, and jewelers. Each building lot is fifteen or twenty feet wide and the covered walkways connect each building making it possible to window shop the length of each street only descending to the ground level to cross over. The merchants had their homes in the two or three floors built above the stores. Most construction was timber-framed with an infill of brick or "wattle and daub" (stucco on woven sticks). Each level *jettied* or cantilevered out further over the street such that the upper levels of the buildings got closer the higher they were built. This was not a problem on the wider, main streets but on narrow side streets the houses could be so close one could lean out of an upstairs window and shake hands with a neighbor. It was this dense, close-built timber construction that allowed the Great Fire of London (1666) to spread so rapidly and be so destructive. Some semblance of how these narrow streets looked can be seen in the area of the city of York called The Shambles. The Rows in Chester were rebuilt over the years and many of the buildings date from the Tudor, Elizabethan, and Stuart periods, one of the finest being the ornately carved and decorated Bishop Lloyd House of 1604–1615. However, it is easy to be deceived as many houses were rebuilt during the nineteenth century and are convincingly picturesque.

Fourteenth-century Chester became famous for its religious Mystery Plays and pageants and in 1541 Henry VIII (r. 1509–1547) granted a civic charter and made the city the seat of a Bishopric. However, the river silted up and in consequence trade was much reduced and the city became little more than a market town and center of county administration. In 1645, during the English Civil War, Charles I (r. 1625–1649) stood on the walls of Chester and watched his army beaten by the Parliamentarian Roundheads at the Battle of Rowton Heath. In the nineteenth century the Grosvenor family of **Eaton Hall** (five miles south of Chester), who own most of the city, renovated The Rows and developed houses and parks. The Grosvenors, Dukes of Westminster, are still the ground landlords of much of Chester. Most property is leased, and in recent years they have invested considerably in the city. It is now a major regional shopping center and the location of several high-tech and finance companies. But it is as a tourist destination that Chester is famous with throngs walking the city walls and The Rows, diverting to visit the cathedral, the castle, and the archaeological remains of its Roman beginnings.

Further Reading

Chester Portal, Chester City Council. www.chestercc.gov.uk/chester-portal/main_
portal_04_history.htm.

CHISWICK HOUSE,
CHISWICK, LONDON

Style: Georgian—Palladian
Date: 1725
Architects: Richard Boyle (Lord Burlington) and William Kent

West of London, upriver on the Thames, close enough to the city to be easily reached by boat or carriage, eighteenth-century aristocrats built themselves villas, small houses where they could retreat from the bustle and heat for a few days or even invite friends for an evening party. They had mansions on their country estates, they had their palatial London townhouses, but here they had their less formal houses. One such aristocrat was Richard Boyle, 3rd Earl of Burlington and 4th Earl of Cork; he had a country estate at Londesborough in the East Riding of Yorkshire, further country estates in Ireland at Lismore, the huge London townhouse of Burlington House, Piccadilly (now the Royal Academy), and a suburban riverside estate at Chiswick (pronounced Chis'ick). At Chiswick there already stood a substantial Jacobean house of c. 1610 purchased by the first Lord Burlington in 1682. This was a courtyard house with fanciful Dutch gables, an elaborate Classical porch, and a later L-shaped stable block to the east. To the west of the house was to be built the most extravagant of the Thames villas; the most intellectually pure design of the burgeoning *Palladian* revival that Burlington was leading; and an homage to one of his architectural heroes, the Italian architect Andrea Palladio. Indeed Chiswick House is the product of three minds: Andrea Palladio, Lord Burlington, and William Kent.

Andrea Palladio (1508–1580) was an Italian, born in Vicenza where he practiced designing buildings throughout the Veneto, the area of northern Italy ruled by the city of Venice. Considered a late Italian Renaissance architect, of the Baroque era, his work is strongly based on his interpretations of the *Ten Books on Architecture* by Marcus Vitruvius Pollio, the first-century Roman architect-engineer. The writings of Vitruvius had survived the fall of the Roman Empire and the Dark Ages to surface in the monastic libraries where his practical advice on drains and building was followed and his essays

Chiswick House. The entrance front with its portico from William Kent's *Designs of Inigo Jones.*

on the design of pagan temples conveniently overlooked. The only architectural book to survive from the age of Classical architecture was to become very influential, one of the most influential books of all time. Renaissance architects and scholars wrote their own translations with explanatory illustrations (Vitruvius can be somewhat vague and confusing at times); the *Ten Books* have been a source for architects since the fourteenth century to the present day, the latest translation being published in 1999. Palladio, seeing that architects had strayed from the ideas of Vitruvius, endeavored to more closely interpret his writings in his own designs, producing a series of country houses—villas—as well as churches and public buildings. His most famous buildings are the Church of the Redentore, Venice, 1576–1580; S. Giorgio Maggiore, Venice, 1564–1580; the Teatro Olympica, Vicenza, 1580–1585; and the Villas Barbaro, Maser, 1550–1558; Foscari or Malcontenta, c.1558–1560; Almerico-Capra or Rotonda, begun 1565/66. It is the last, the Villa Rotonda, that is Palladio's most recognizable building, sitting on a low hill facing extended views, completely symmetrical with four identical elevations addressing the landscape with six-columned *Ionic porticoes* while the central circular salon is capped by a dome. Rotonda was to be much copied even immediately after its completion by Palladio's follower Vincenzo Scamozzi (1552–1616) at the Rocca Pisani at Lonigo, 1576, which closely followed the plan though with an octagonal rather than a circular salon and only one portico. Palladio's designs were not only to be copied in Italy but were to influ-

ence architects throughout Europe and particularly Britain, and hence the United States: Jefferson's Monticello, in Virginia, owes much to the writings of Palladio (and Vitruvius).

Lord Burlington, even by the somewhat lax moral standards of the early eighteenth century, was viewed warily. His ancestor, also named Richard Boyle (1566–1643), was an adventurer who made his name and fortune in sixteenth-century Ireland becoming successively Lord Boyle, Viscount Dungarvan, and Earl of Cork as he was promoted up the Peerage. One of his sons, Robert, was the scientist of Boyle's Law while his heir, another Richard, added the title Earl of Burlington in 1663. Richard Boyle, 3rd Earl of Burlington succeeded to his titles and fortune at the age of nine. Even before he came of age in 1715 he was recognized as having an appreciation of the arts; in 1713, Handel's opera *Teseo* was dedicated to the earl. In 1714, Burlington left on a Grand Tour of Europe journeying through France and Italy where, possibly in July 1715, he met William Kent and began a friendship that was to last until Kent's death in 1748. The contrast between the two could not have been greater; one a refined, educated aristocrat, the other a talented painter of low birth and little education. So close was their friendship that rumors spread and in 1748 when Lord Hartington, heir to the Duke of Devonshire and **Chatsworth House**, proposed to marry Burlington's daughter, Charlotte, the duchess was so upset she retired to the country and was only reconciled with her son and daughter-in-law many years later.

Lord Burlington had already employed some of the major architects of the day at Burlington House where the ordinary red brick *hip-roofed* mansion was changed into a model Classical hotel (hotel is derived from the French word for an aristocrat's city mansion) in the Parisian manner. The brick of the main block was clad in stone while new service wings to each side connected to curved colonnades framing a columned and *rusticated* gateway leading to the street of Piccadilly. The first architect employed was James Gibbs (see **St. Martin-in-the-Fields**), followed by Colen Campbell (see **Stourhead**) but Burlington, as his own architectural knowledge increased—he had bought Inigo Jones's library and papers—was increasingly unhappy with their work, feeling that their English Baroque style was straying from the ideals of Palladio, Scamozzi, and Inigo Jones, who had introduced the work of Palladio to England (see **The Banqueting House** and **The Queen's House**). Burlington became his own architect beginning with small garden buildings at Chiswick but eventually leading to private commissions such as Tottenham Park, 1721, and the York Assembly Rooms, 1731–1732. He encouraged Kent as an architect and together they were to heavily influence the design of **Holkham Hall**, 1734–1759. Kent became a successful architect, landscape architect, and painter in his own right, responsible for such buildings as Badminton House, Gloucestershire, c.1740; and The Horse Guards, Whitehall, London, 1750–1759, his last design, built after his death. At Chiswick, Burlington, with Kent's assistance, was to build England's purest example of Palladian design.

The new villa was built to one side of the old mansion, which, although

damaged by fire in 1725, was retained with a new Burlington-designed front. It is possible that it was the fire that instigated the building of the new villa and the old house just stayed longer than intended originally. Sitting close to a public road, a gateway allowed entry to a forecourt with the new house on the far side. Based on Palladio's Rotonda with some influences from Scamozzi's Rocca Pisani, the new house is not a slavish copy of either but rather shows Burlington to be a creative architect working within the principles of Palladio. Seventy feet square, two stories high, with the main floor raised to the second floor above a *basement*, the design exhibits mathematical proportions, axes, symmetry, and strict adherence to a conceptual idea over practicalities. From the forecourt elaborate stairs lead up to the six-columned *Corinthian* portico and the front door. Entering, a passage leads to the central, octagonal Tribunal or Saloon with its clerestory lunette windows and coffered dome. Doors opening from the Tribunal open up axes from front to back and side to side of the whole house. Proceed ahead and the Gallery is entered running the full length of the back of the house and divided into three spaces—circular, rectangular with *apses*, and octagonal. The circular and octagonal spaces are in effect the anterooms to two drawing rooms, the Red Velvet Room and the Green Velvet Room, at the center of each side of the house, that connect to two bedrooms with closets that each overlook the forecourt. One of these bedroom suites comprises the Blue Velvet Room and the Red Closet. Burlington, in miniature, created the *enfilade apartments* of the great formal houses such as **Blenheim Palace** while at the same time predicting the less formal circuit houses of later in the century such as Holkham and **Wrotham Park**. The interiors are richly decorated with, as suggested by their names, velvet wall hangings, and elaborate gilded ceilings, door cases, and fireplace over-mantles.

Externally, Burlington did not closely follow Palladio's Rotonda; only the entrance *façade* features a portico. The side elevations feature central *Venetian windows* (sometimes called Palladian or Serlian windows and composed of three windows close together, the central one wider and with an arched top) and four unusual obelisk chimneys while the rear elevation has three Venetian windows, each recessed within an arched opening. The façades are meant to be seen in isolation, not together from an angle, and wing walls emphasize this, extending the front and rear elevations twelve feet each side. To advertise his inspirations Burlington placed statues of Andrea Palladio and Inigo Jones in front of the wing walls to the forecourt.

Contemporary reaction to Lord Burlington's new villa was generally critical: Lord Hervey wrote that "the house is too small to inhabit, and too large to hang on one's watch;" Sir John Clerk commented, "this house is rather curious than convenient" while William Aikman, a Scottish painter, said "(Lord Burlington's) house at Chiswick is near finish'd and is a very beauty." Later in the eighteenth century Horace Walpole and Lord Chesterfield agreed that Burlington's "too strict adherence to rules and symmetry" spoiled his architecture.

Chiswick was used as a retreat from London and Burlington's duties at court but in 1733, overlooked for a promotion, he quit all his positions, abandoned Burlington House, and moved to Chiswick where the Link Building and Summer Parlour were built to connect the villa to the old house. The gardens were continuously developed with many garden buildings, a gate designed by Inigo Jones, water features, statues and follies; it became a great attraction for visitors. Burlington died in 1753 and all his property passed though his daughter Charlotte to the Dukes of Devonshire. In 1788 the Jacobean house was demolished and symmetrical wings were added to the villa to compensate for the lost accommodation, changing the compact villa into a great house. The Devonshires maintained Chiswick House until 1929 when it was sold to the Borough of Brentford and Chiswick. In 1948 it was taken over by the Ministry of Works, the forerunner of English Heritage, who had the 1788 wings demolished and restored the villa to its appearance in 1753, even rebuilding the Link Building that now only leads to the Summer Parlour. Restoration of the interior and the gardens continues and Chiswick is now close in appearance to the ideal that Burlington intended for his homage to Andrea Palladio and Inigo Jones.

Further Reading

Chiswick House Friends (charity). www.chfriends.org.uk.

English Heritage. www.english-heritage.org.uk/filestore/visitsevents/asp/visits/De tails.asp?Property_Id=100.

Harris, John. *The Palladian Revival: Lord Burlington, His Villa and Garden at Chiswick*. New Haven, Conn.; London: Yale University Press, 1994.

Pearson, John. *The Serpent and the Stag*. New York: Holt, Rinehart and Winston, 1983.

Rowland, Ingrid D., and Howe, Thomas Noble (translator and commentator/illustrator). *Vitruvius: Ten Books on Architecture*. Cambridge: Cambridge University Press, 1999.

Tavernor, Robert. *Palladio and Palladianism*. London; New York: Thames and Hudson, 1991.

THE CHURCH OF ST. JOHN THE BAPTIST, HUNTLEY, GLOUCESTERSHIRE, ENGLAND

Style: Victorian—Gothic Revival
Dates: 1861–1863
Architect: Samuel Sanders Teulon

There were two great periods of church building in Britain: the medi-aeval period before the break with the Roman Catholic Church and the establishment of the Church of England (Episcopalian) under Henry VIII (r. 1509–1547) in the sixteenth century; and the Victorian era of the nine-teenth century. Although the Victorian era, named after Queen Victoria (r. 1837–1901), ended just a century ago, it is still a mysterious period in many ways. Socially, the country was changing; the industrial revolution was see-ing manufacturing expand with a consequent increase in urban populations and major changes to the appearance of cities and towns. The British Em-pire was rapidly expanding, reaching its apogee in 1897 with the Diamond Jubilee of the Queen-Empress, Victoria. Vast wealth created by the spread of the empire and the rise in manufacturing was concentrated in the hands of an upper class supported by a huge population of workers: factory work-ers, laborers, and domestic servants whose wages were a pittance compared to the incomes of the rich. The Duke of Westminster (see **Eaton Hall**) had an annual income of £150,000 at a time when a good cook made £50 and a scullery maid £10. During the late eighteenth century and early nineteenth century the rich lived luxuriously, little caring for the life of the lower classes, but the shock of the French Revolution of 1789, the Napoleonic Wars of 1803–1815, and the social reforms of the 1830s (the Great Reform Act began the transition to a modern democracy in 1832 and slavery was abolished in 1833) changed attitudes and the rich gained a social conscience. One result was a religious revival seen in the many churches built in the mid- and late nineteenth century. The Church of St. John the Baptist at Huntley is just such a church, one of the most richly decorated of its time, and has been described as "one of the most interesting buildings in England" (Sir Harry Stuart Goodhart-Rendell, Past President, Royal Institute of British Architects).

Many of our impressions of the Victorian era come to us from its litera-ture, from the works of such authors as the Brontë sisters, Frances Hodgson Burnett, Charles Dickens, or George Elliot. The client for Huntley Church could be a character from one of Anthony Trollope's Barchester Chronicles. The Reverend Daniel Capper was an enormously wealthy landowner with estates in Herefordshire, County Durham, and Gloucestershire. He com-missioned extensive renovations at his main residence near Hereford; the new Parish Church of St. James and many cottages at Hunstanworth, County Durham; and at Huntley, Gloucestershire, the enlargement of the rectory and, apart from the tower, the complete rebuilding of the parish church. Ap-pointment to be a vicar (parish priest), usually called a "living" at that time, was usually in the patronage of the local landowner but the living at Hunt-ley was unusual in that it was independent, a so-called discharged living. A living was much desired in the nineteenth century, as there was an associated income from parish tithes; at Huntley the living was worth £280 annually. The Reverend Capper apparently inherited his estates in the late 1850s and in a fit of good works rebuilt churches, farms, and cottages and made sig-

Church of St. John the Baptist, Huntley, Gloucestershire. The south porch and nave viewed across the gravestones in the churchyard. Teulon's extravagant imagination is hinted at by the elaborate tracery to the window of the transept to the right. The tower just visible to the left dates from circa 1100. *Photo by author.*

nificant alterations to his own houses. His chosen architect was Samuel Sanders Teulon (1812–1872), one of the most outrageous and intriguing architects of the High Victorian Gothic Revival.

Teulon, of French Huguenot descent, was born in Greenwich and lived a life of Victorian respectability in Hampstead with an office in Gray's Court off Whitehall, London. As an architect he quickly developed as one of the most imaginative designers of the 1850s and 1860s, taking the ideas of Pugin for complicated massing and of Ruskin for color to such extremes that Goodhart-Rendell included him in an essay entitled "Rogue Architects of the Victorian Era." In 1862, *The Civil Engineer and Architect's Journal* warned: "the mention of Mr. Teulon's name is quite sufficient to prepare one for seeing some curious achievement, in the way of novelty . . .", and Matthew Saunders, in an essay in *The Architectural Outsiders*, writes, "He was, and has remained, an Architectural Outsider, adopting the Victorian rediscovery of polychromy (multicolor), asymmetry and Romantic drama, but with such liberality that, at best, his buildings remain amongst the most extraordinary of English architectural experiences." It would be supposed that his clientele were among the newly wealthy industrialists but surprisingly, he worked almost exclusively for well-established, old-money aristocracy who, however, did share his evangelical Low Church fervor: the Calthorpes of Elvetham and Edgbaston; Lord Ducie of Tortworth Court; the Buxtons of Shadwell Court; the Dukes of Bedford and Marlborough all commissioned designs

from Teulon and passed his name to friends and church committees within their influence assuring him a busy and successful practice.

The connection that brought Capper to him as a client is not known but there is an interesting thread that the 2nd Earl of Ducie, for whom Teulon had built Tortworth Court (1849–1853), was a friend of Henry Probyn of Huntley Manor (Gothicized by Teulon in 1862), a close neighbor to Capper at Huntley Rectory. (Tortworth Court, an enormous house, receives guests with the word "Welcome" carved three feet high in the parapet wall of the gatehouse—the house was later used as a prison!).

The three projects for the Reverend Capper in Herefordshire, Gloucestershire, and County Durham were all commissioned concurrently, the last to be completed being the cottages at Hunstanworth in 1865. The Church of St. John the Baptist at Huntley was rebuilt in 1861–1863 and involved the demolition of a much older, c. 1100, church with only the mediaeval tower being retained. Teulon's plan takes the usual components of a smaller parish church and puts them together in a complicated manner resulting in a plan comprising a nave entered from a south porch, a slightly lower *chancel* to the east, a north aisle that perversely extends half the length of the chancel, and a south transept. At the northeast corner, in the angle of the aisle and chancel is a shed-roofed vestry that is entered through a small, *turreted* porch that grows out of the adjoining walls. The new church was built of a rough rubble red sandstone with white Painswick (local) limestone used for details and for the new spire that nearly doubled the height of the tower. Externally, St. James's is one of Teulon's more restrained designs, although one gets a hint of the richness within from the window of the transept that features convoluted *tracery* unlike any mediaeval precedent enhanced with carved sculptures and bas-reliefs that give the whole a "decidedly Moorish quality" (Smart).

Internally, the colors of the stone reverse with the white limestone dominating, horizontally banded with the red sandstone. Cluster columns (like a bunch of pencils) feature multicolored marble shafts and capitals of deeply carved foliage by Thomas Earp (1828–1893), a renowned Victorian artist. Above is a heavily timbered roof, below an elaborately patterned tile floor. The chancel becomes a festival of color with stone, marble, and timber-carved, *stenciled*, colored, or gilded into a riotous finale focused on the High Altar, the alabaster *reredos*, and the stained glass east window. The reredos, carved to represent the Last Supper; the pulpit, beside the chancel arch; and the font were all carved by Thomas Earp of alabaster and marble, and were exhibited at the Great International Exhibition of 1862. Even the organ in the transept is painted with geometric patterns. The whole is breathtaking, overpowering even, but somehow works and is a prime example of the confidence of the High Victorian church design.

The Victorian Era is considered to be a period of great confidence, moral correctness, and piety. The obverse is that it is also seen as a time of great hypocrisy as exemplified in such stories as Charlotte Brontë's *Jane Eyre*. The contrasts and hypocrisy of the era are seen in the life of Samuel Sanders Teu-

lon, who worked for the richest, most pious, leaders of society; clients who commissioned churches, schools, alms houses, and cottages as well as mansions. Clients and architect were fervent followers of the Low Church evangelical movement yet Teulon's death in 1873 reveals another side to his character, for the certificate lists the cause as "paralysis insanorum," indicative of a coma brought on during the final throes of tertiary syphilis. But an architect capable of producing such buildings as the Church at St. John the Baptist, Huntley, is a great artist.

Further Reading

Brown, Roderick, ed. *The Architectural Outsiders.* London: Waterstone, 1985.
Smart, C. Murray, Jr. *Muscular Churches: Ecclesiastical Architecture of the High Victorian Period.* Fayetteville: University of Arkansas Press, 1989.

CLARENCE HOUSE. *See* St. James's Palace.

CLARENDON HOUSE. *See* Belton House.

COLESHILL HOUSE. *See* Belton House.

THE COLLEGIATE CHURCH OF ST. PETER AT WESTMINSTER. *See* Westminster Abbey.

COVENTRY CATHEDRAL, COVENTRY, WEST MIDLANDS, ENGLAND

Styles: Mediaeval and Twentieth Century—Modern
Dates: Fourteenth & Fifteenth centuries and 1955–1962
Architect: Sir Basil Spence (twentieth century)

During the Second World War, at the height of the Battle of Britain, the German air forces launched a massive attack on the city of Coventry in the industrial heartland of England—it was the night of November 14, 1940. As lines of planes passed over the city they released their bombs and ignited a firestorm of destruction below. The Cathedral of St. Michael, which dated form the early mediaeval prosperity of the city, was in the path of the fire-bombs and could not be saved. By the next morning the cathedral was a burned-out smoldering shell, but rather than feeling bitterness or hatred the people of Coventry wanted a "sign of faith, trust and hope for the future of the world," and decided to rebuild. The new Coventry Cathedral is one of the most memorable twentieth-century buildings in the country.

St. Michael's was originally a cathedral, built on a huge scale indicating the wealth and importance of Coventry in the mediaeval period. The first cathedral was founded in 1043 as part of a Benedictine monastery by Leofric, Earl of Mercia and his wife Godiva (Lady Godiva is famous for her naked ride through the streets of Coventry, only her long hair maintaining her modesty). Rebuilt in the fourteenth century on an even larger scale with a unique pentagonal east end and a magnificent wooden roof, the old cathedral was entered at the west end and the long nave led to the *chancel* and altar at the east end. The last part to be completed was the tower at the southwest corner beside the main entrance. The square lower stages of the tower, built 1373–1394, become an octagonal *lantern* supported by *flying buttresses*, while the tower is topped by a *spire* added in 1433. The whole structure rises over 300 feet, the third tallest spire in the country after Salisbury and Norwich. In 1539, at the Dissolution of the Monasteries, the amalgamated See (area ruled by a Bishop) of Coventry and Litchfield moved to Litchfield and the cathedral fell into decay, demoted to the level of a parish church. In 1918, reflecting the increased importance of the industrial Midlands, the Diocese (modern name for a See) of Coventry was created and St. Michael's was once again a cathedral. Twenty-two years later all that remained standing were the outer walls and the tower.

Soon after the end of the war a competition was held to choose an architect for the new cathedral. The winner was Basil Spence (later Sir Basil Spence), a modernist whose work, by the choice of materials and details, ex-

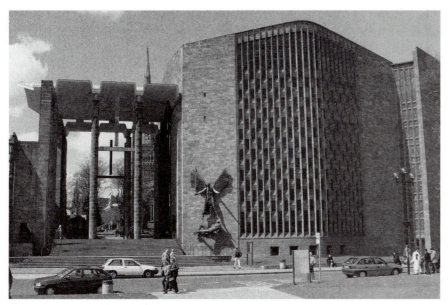

Coventry Cathedral. The Porch connects the ruins of the old cathedral to the left to the new building clad in red sandstone. The sculpture represents St. Michael and the Devil. *Photo by Ian Britton (FreeFoto.com).*

hibited a warmth and richness. The designs submitted ranged from the extremes of Modernism and traditionalism but the Spence design managed to be both without being extreme; a modern appearance on a traditional axial plan that defied calls by "trendy" liturgical scholars for a centralized plan.

Spence used the old and new cathedrals to symbolize death and resurrection and the indestructibility of Christianity by strongly linking the ruins to the new construction. Its paving renewed, the old cathedral forms a spectacular plaza focusing on a rubble altar supporting the "Charred Cross," a large wooden cross made from charred roof beams. Carved on the wall behind the altar are the words "Father Forgive."

While in the ruins of the old cathedral it is impossible not to feel the presence of the new building, which is seen to the north of the chancel. The site dictated that Spence's plan, to achieve the length he wanted, had to run north–south, an unusual but not forbidden orientation. Leaving the ruins through the center window on the north side of the chancel a wide flight of steps—The Queen's Steps—leads down to the porch that forms the new main entrance. Immediately in front is the glass wall enclosing the end of the new cathedral, while to either side tall columns support the thin "folded plate" concrete roof. (Spence liked to exploit the possibilities of thin shell concrete, reinforced concrete that when folded or curved achieved great strength.) The glass wall, hidden from the streets and protected by the porch, allows a clear view of the interior of the new cathedral and its chancel and altar from the

ruins of the old, while allowing the reverse view from new to old when the congregation turns to leave. The glass, designed by artist John Hutton, is incised with figures of angels, saints, apostles, prophets, and patriarchs "expressing the connection between the life of the Christian in the world and the heavenly world, which surrounds us."

Passing inside, the eye is immediately drawn to the tapestry at the far end above the High Altar. Designed by the artist Graham Sutherland to represent reconciliation with Christ, this massive, and controversial, tapestry measures 72 feet high by 38 feet wide and weighs nearly one ton; it was woven by Pinton Frères at Felletin near Aubusson in France. The seated Christ figure on a vivid green background dominates the cathedral by its scale and portrayal.

The nave and chancel form a rectangle approximately three times as long as it is wide. The first third is usually kept free of seating (except for large services) forming a narthex (entrance area) with the Baptistry to the right and one of several subsidiary chapels, the Chapel of Unity, to the left. The Baptistry window, 81 feet high and 51 feet wide, represents the Holy Spirit and comprises 195 separate lights (individual windows/panels); it was designed by John Piper. The sidewalls of the other two thirds are in a sawtooth pattern such that the windows are hidden from view but cast a glow toward the chancel. Best seen from the High Altar the ten windows, five each side, represent the Destiny of Man and the Revelation of God. These windows were designed by Einar Forseth and were a gift from the people of Sweden. Soaring high overhead, supported on slender cruciform pillars, is a ceiling of *tracery* ribs, recalling the Gothic architecture of more ancient cathedrals, with an infill of stained wood.

Unlike mediaeval cathedrals, where a *Rood Screen* conceals the chancel, at Coventry the choir, Bishop's Throne, and seating for other church officers are open to view, although traditionally oriented in two halves facing across the central axis. The choir stalls, pulpit, and lectern were designed by Spence and made of afromosia wood and bronze. Geoffrey Clarke, whose inspiration was the "Charred Cross" in the old cathedral's ruins, designed the cross on the High Altar. (Throughout Coventry Cathedral, beyond those specifically mentioned, are sculptures, windows, and other artifacts designed by the leading artists of the day.) So dominant is the Sutherland tapestry that it appears as the backdrop of the High Altar. It is only after some time that the observer realizes that there is something beyond and below and taking steps to each side reaches the Lady Chapel where the tapestry continues with a second smaller representation of Christ, this time the Crucifixion. To the east of the Lady Chapel are two small chapels: the Chapel of Christ the Servant, also known as the Chapel of Industry, and the Chapel of Christ in Gethsemane. Each of these minor chapels is an exquisite design in itself, exhibiting a sparse modernity that is nonetheless very eloquent.

Externally, the cathedral is finished in a pink Hollington sandstone and a copper-covered roof crowned by a slender, airy flèche (a spire surmounting

a roof rather than a tower). Guarding the entrance porch is Sir Jacob Epstein's last religious sculpture, a massive representation of St. Michael and the Devil.

Queen Elizabeth II (r. 1952–) laid the foundation stone of the new Coventry Cathedral on March 23, 1956, and she returned on May 25, 1962, for the consecration and opening. One of the most important modern buildings in Britain, Coventry Cathedral has influenced the design of many new churches in the country and throughout the world. An example in the United States is the Episcopalian Church of St. Andrew's in Stillwater, Oklahoma, by architects Salmon and Salmon (F. Cuthbert Salmon and Christine Salmon).

Further Reading

Coventry cathedral. www.coventrycathedral.org/history.htm.

CRAIGIEVAR CASTLE, ABERDEENSHIRE, SCOTLAND

Style: Renaissance—Jacobean (Scottish Tower House)
Dates: Circa 1610–1626
Architect: Unknown

Queen Victoria's (r. 1837–1901) favorite home was **Balmoral Castle**, the huge house she and her beloved husband built beside the River Dee in the remoteness of Aberdeenshire in northern Scotland. Balmoral Castle is built in what is termed the Scottish Baronial style that resurrected the architectural features of the sixteenth and early seventeenth centuries, particularly a tall tower crowned with an ornate skyline of *turrets* and gables. Victoria and Albert did not have far to travel to see a perfect example of a genuine tower house, as a few miles from Balmoral, in the even more remote valley of the River Don, stands Craigievar Castle, the home of the Forbes-Stemphill family from the year 1610 when the estate was purchased by a rich merchant named William Forbes. That Craigievar survives virtually unchanged since its completion is due to two circumstances: first, the family had another property at Fintray nearer to the city of Aberdeen and second, the family had many generations of spendthrifts and did not have the money. Thus it was that Oliver Hill, writing in the 1950s, could write that Craigievar "was incomparably lovely. The first impression is overwhelming: the tower, as it comes into view looks like a great white galleon in full sail." It is no surprise therefore that Craigievar Castle is considered to be Scotland's finest and, in these days of opinion polls, finest tower house.

Craigievar, for all the praise, is a simple building, constructed at a time when defense was still a consideration with thick stone walls, a single entrance, and small windows high up its seven stories. The exterior is covered with harl, a form of render mixed with small stones that formed a thick waterproof finish. Stone details adorn the doorway, some window surrounds, the topmost *balustrade*, and the *corbels* (cantilevered stones like an upside-down staircase) that allow the top of the castle to break out into a fantasy skyline of many turrets.

The plan is also very simple and like most tower houses is an L-shape with a square tower within the protected, re-entrant angle (some tower houses had a slightly more complicated Z-shaped plan). The L-shape of Craigievar is formed of a main block that contains the Great Hall on the second floor, a wing that completes the L-shape, and the small tower. The entrance door leads into a small lobby off which open storage cellars and the kitchen—Craigievar is not a grand house and the master and servants shared the one entrance and mingled on the stairs. A straight staircase leads up to the second floor where the Great Hall is to the left in the main block, the ladies' Drawing Room in the wing, and the small Prophet Chamber in the tower that was originally used by visiting preachers and later became the laird's (lord's) study. The Great Hall is entered though a low-ceilinged, wood-paneled lobby similar to the screens passage in a mediaeval hall (see **Haddon Hall**) with a minstrels' gallery above. Two turnpike or spiral staircases, one at the top of the main stairs and the other at the opposite corner of the Great Hall, ascend to the upper floors where there are family and guest bedrooms (third and fourth floors), children's nurseries (fifth floor), and servants' quarters (sixth and seventh floors), with a final spiral staircase leading to the balustraded viewing platform on top of the tower. There was possibly originally a long gallery on the sixth floor running the length of the wing and across half of the main block but this was divided up to form cubicles for servants in the eighteenth century and restored as the Long Room in the 1950s. At the corners of the main block and the wing on the fifth and sixth floors the corbels support round turrets that finish with steeply pitched conical roofs (sometimes referred to as pepper-pots).

The bald description of the plain exterior and the plan does not allow for the wonder that is Craigievar Castle: the rich plasterwork that adorns the ceilings of all the major rooms. The Great Hall, two stories high, has a plastered vault covered with convoluted strap-like carvings decorated with heraldry, foliage, and biblical characters surrounding the arms of William Forbes and his wife Margaret Woodward. The carved decorations writhe across the ceiling coming together in three "drops," curving downward to hold carved wooden pendants and on the central, more elaborate one, a simple lantern (hanging lamp). Above the fireplace is a huge representation of the arms of the United Kingdom designed to make a grand political gesture—England and Scotland had come to be ruled by one monarch in 1603. James I of England (r. 1603–1625) had been James VI of Scotland since 1567. Forbes is

making clear he supports the king and the union with England. The Drawing Room and several of the bedrooms have equally splendid plaster ceilings, but all feature only carved foliage decoration without any political or religious allegories.

In the early nineteenth century Sir John Forbes had inherited from one of the spendthrift Forbes, his elder brother Arthur, and wondering whether to consolidate by focusing on Fintray House while demolishing Craigievar Castle, he consulted the Aberdeen architect John Smith, who reported: "I beg leave to add that the Castle is well worth being preserved as it is one of the finest specimens of architecture in this Country of the age and style in which it is built." This very early and surprising concern for the past saved Craigievar and until the 1890s the castle was used for summer vacations, but once again a spendthrift Forbes headed the family. William Forbes, who had also inherited the ancient title of Lord Semphill, managed to overspend by £30,000, a vast sum in those days and so Fintray was rented and Craigievar became the family home. Only a few changes had been made to the castle over the years, the most obvious being the lowering of the windows in the Great Hall to allow a view out and the consequent adjustment to the paneling so, apart from some discreet bathrooms and electricity, the castle is much as William Forbes finished it in 1626. Outside, even the surroundings escaped the improving eye of the eighteenth century and the barmkin wall surrounding the courtyard in which the castle was centered largely remains with one circular corner tower converted at some time for use as a dog kennel. There are no lodge gates, no surrounding *park*, no terraced *parterres*; just the farmland of the Don valley rolling up to the walls of the castle.

During World War II, Fintray House was requisitioned for use by the government and was in such a poor state after the war that it was demolished in 1952. The Forbes-Semphill family continued to live at Craigievar until 1963 when, beset once again by financial problems, the castle was sold to the National Trust for Scotland.

Another house very similar to Craigievar Castle but on a much larger scale and much changed and extended over the years is Glamis Castle in Forfarshire. At the heart of Glamis is an L-shaped, seven-storey, turret-bedecked building with a circular tower in its angle, but the extensions zigzag to each side producing a vast spread of building. Glamis Castle was the supposed redoubt of Shakespeare's Macbeth, Thane of Glamis, and more reliably is the home of the Bowes-Lyon family, Earls of Strathmore. Elizabeth Bowes-Lyon, the future Queen Elizabeth the Queen Mother (1900–2002) was born at Glamis, as was her younger daughter, Princess Margaret Rose (1930–2002).

Further Reading

Gow, Ian. *Scottish Houses and Gardens from the Archives of Country Life*. London: Aurum Press Limited, 1997.

THE CRYSTAL PALACE, HYDE PARK, LONDON

Style: Victorian—Industrial Revolution
Date: 1851
Architect: Sir Joseph Paxton

One of the most amazing Victorians was the husband of Queen Victoria (r. 1837–1901) herself, Prince Albert (1819–1861). Intelligent, well read, cultured, and astute, the prince and the disciplined Queen made a powerful couple exerting more influence over government than any monarch since the reign of Elizabeth I (r. 1558–1603). The prince was from a minor German principality, looked down upon by most European monarchs, but the young Queen Victoria was infatuated and they married in 1840; for the next twenty-one years he acted as her private secretary conversant with all affairs of state. Publicly, he stayed somewhat in the background; his German ancestry was viewed with suspicion by his wife's subjects, but in one instance he came very much to the fore. This was the Great Exhibition of 1851, for which one of the most important buildings of modern times was built: The Crystal Palace.

In 1843, Albert had become the president of the Society for the Encouragement of Arts, Manufactures and Commerce (known as the Society, soon to be the Royal Society), stressing that "the main object of its existence must be the application of science and art to industrial purposes." The Industrial Revolution had begun at Ironbridge in 1777 and in a short time had changed Britain from a rural economy to an industrial economy, leading the world. Under the prince's direction the Society began to flourish with competitions and annual exhibitions and it is this energy coupled with rapid economic growth and rivalry with the French that led in 1848 to the idea of an international exhibition. On June 30, 1849, the prince gave his backing, endorsing a suggestion that Hyde Park be the site (Hyde Park is a 350-acre Royal Park close to the center of London). "The Exhibition of 1851 is to give us a true test and a living picture of the point of development at which the whole world of mankind has arrived; (it will be an image of) peace, love and ready assistance between individuals and between nations."

At New Year 1850 a Royal Commission of twenty-four worthy gentlemen—manufacturers, engineers, artists, bankers, even an architect (Charles Barry, designer of **The Houses of Parliament**)—led by the prince began work organizing the exhibition with the date to open designated to be May 1, 1851. A subcommittee, the Building Committee, was quickly formed and announced a competition, although Richard Turner, the designer of the Kew Gardens Palm House, had already sent in a design. By the deadline of April 8, 1850,

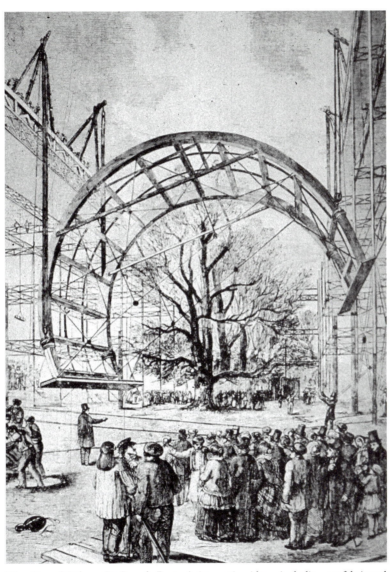

The Crystal Palace. Sir Joseph Paxton's innovative ideas, including prefabricated components, fascinated nineteenth-century Londoners as seen in this engraving of the building under construction from the December 1850 edition of *The Illustrated London News*.

233 submissions were received (plus twelve received late). A revised scheme by Richard Turner and one by French architect Hector Horeau were considered the outstanding designs but both were estimated to cost at least £300,000, three times the budgeted amount. With doubts concerning costs and also about the timetable for constructing such complicated designs, the Building Committee began to panic and decided to conduct a second "stage two" competition with a much more detailed brief stating, in justification of their action, "We have arrived at the unanimous conclusion that there was yet no single (design) so accordant with the object in view . . . as to warrant us in recommending it for adoption." At this point Joseph Paxton entered the scene.

Joseph Paxton (1803–1865) was the head gardener at the Duke of Devonshire's **Chatsworth House**, appointed at the age of twenty-three. Not only a knowledgeable horticulturalist, he was an innovative engineer and an efficient manager: He managed the duke's estates and consulted on projects as diverse as Kew Gardens and the growing railroad network. At Chatsworth two buildings were the precursors to the Crystal Palace: the Victoria Regia house of 1850, built to contain a pond for a giant water lily; and the Great Stove, a massive tropical plant greenhouse 277 feet long, 123 feet wide, and arching to a height of 67 feet, built 1836–1840. The Great Stove was built on a cast iron structure of columns and beams wrapped in a "tablecloth" (Paxton's description) of thin timber trusses and glazing bars supporting 49-inch by 10-inch sheets of glass. Paxton had evolved his design over several years building of different greenhouses at Chatsworth with one innovation being the top member of the timber truss that was cut in a special machine to include an external rain water gutter and internal condensation drains that directed the water to the inside of the cast iron columns and hence to a drainage system.

Paxton visited London in early June 1850 and, assured that he would receive a hearing from the Building Committee, paced the site and went to work. Attending a meeting for the Midland Railway, he seemed distracted drawing on his blotter what he later held up as the "design for the Great Industrial Exhibition to be held in Hyde Park." The myth is that Paxton designed the Crystal Palace on the piece of blotting paper but in reality he was bringing together over twenty years of experimentation and design already achieved—on a much larger scale. Paxton, frantically working with Charles Fox of contracting engineers Fox Henderson & Co., spent long hours preparing a design and budget, submitting a cost of £85,800 and a completion date of January 1, 1851—less than six months away. There was opposition, but Paxton's design was accepted as being the only possible means of saving the exhibition—and face!

The design submitted by Paxton, based on the ideas developed at Chatsworth, took the Victoria Regia house, a building less than 30 feet square, and expanded it to 1,848 feet long by 408 feet wide, tiered somewhat like a large three-level wedding cake. Structurally, Paxton and Fox had developed a cast iron frame over which the "tablecloth" of timber and glass was stretched and the effect was very long and horizontal. The characteristic

semi-circular vault, reminiscent of the Great Stove, was only added later when Colonel Sibthorp, a Member of Parliament, tried to sabotage the scheme by demanding that none of the trees of Hyde Park could be removed or clipped: the solution, the vault, cleared the affected trees, bringing them within the envelop of the building. Partly in criticism and partly in jest, *Punch* magazine named the design the "Crystal Palace."

What makes the Crystal Palace so important is not just the design but also the construction techniques that allowed completion in a very short time: mass production, prefabrication, on-time delivery (to use a modern phrase), and efficient methods—the main structure supported the winches that hoisted up smaller components; glaziers sat in carts that ran along Paxton's gutters; and even the wooden planks of the site fence were sized to become the flooring. Today we expect such techniques of our architects, contractors, and construction managers, but in 1850 this was new and amazing. Erection of the iron structure began at one end of the site and before it was even halfway complete the timber and glass enclosure was being placed. Over the winter of 1850–1851, over 2,000 workmen were camped in Hyde Park working near sixty-hour weeks for at most six pence an hour. The work was completed on February 1, 1851, when the exhibits began to be installed. Queen Victoria opened the Great Exhibition on May 1, 1851, exactly as planned. The world was amazed, not just by the exhibits, but also by the building itself with its astounding and innovative design exemplifying the Industrial Revolution and the British Empire's leading role in commerce and industry. The Great Exhibition succeeded beyond all hopes with over 100,000 visitors on many days, double the estimated daily attendance. Queen Victoria was so enthralled by her husband's creation that she visited it thirty-four times.

The exhibition closed to the public on October 11, 1851, with a formal ceremony four days later before an estimated 50,000 attendees. After some discussion on whether to retain the building in Hyde Park, it was demolished and rebuilt in south London at Sydenham in an area that came to be called Crystal Palace. It burned to the ground in November 1936.

Further Reading

Ferriday, Peter, ed. *Victorian Architecture*. London: Jonathan Cape Ltd., 1963.

McKean, John. *Architecture in Detail: Crystal Palace*. London: Phaidon Press Ltd., 1994.

DEANERY GARDEN. *See* Lutyens Country Houses.

DITHERINGTON FLAX MILL, SHREWSBURY, SHROPSHIRE, ENGLAND

Style: Georgian—Industrial Revolution
Dates: 1796–1797
Architect: Charles Bage

Shropshire, in the west of England on the border with Wales, is an overlooked corner of the country. Rich agricultural land, neat farms, prosperous villages focus on the county town of Shrewsbury, a pleasant but not particularly memorable place situated within a loop of the River Severn. Northeast of the town center stands a forlorn, derelict building distinguished by a squat pyramid-roofed block, a tall, narrow tower with an ogee-roofed cupola, and a long, multigabled wing. It is the latter that makes Ditherington Flax Mill important for it is the first iron-framed building constructed in the world and is thus the forerunner of most modern buildings including the tallest of skyscrapers.

Flax is a tough, fibrous plant that originally came from the borders of Eurasia. Through a complicated process flax produces a fiber used to make linen; linseed oil, used as a thinner and the basis of linoleum floor covering; and linseed cake, which is used as cattle fodder. In the late eighteenth century the flax industry was very important, cotton was not readily available, whether from the southern states of the United States or from Egypt, and linen was a common and relatively cheap fabric. The soldiers and sailors who fought the wars against Napoleon's France (1803–1815) were uniformed in linen. To extract the fibers used to make the linen, plant stems, stripped of their leaves, are soaked in water, allowed to ferment to break down the toughest parts, dried, beaten, and finally combed. One problem is that a lot of dust is created and in the same way that midwestern grain silos are prone to explosion, flax mills were prone to spontaneous and disastrous fires. Therefore, when Marshall, Benyon and Bage, a manufacturing firm from Leeds, Yorkshire, decided to build a new flax mill, the senior partner, John Marshall, turned to his business partner Charles Bage (1752–1822), who had developed a means of designing cast iron beams using a series of tests and Galileo's bending theories. Bage was a friend of Thomas Telford, another pioneering engineer, and was aware of the work of Abraham Darby III and Thomas Pritchard, who had built the first cast iron structure the **Iron Bridge**, also in Shropshire (1777–1779). The quiet and rural appearance of today's Shropshire belies its history as the birthplace of the Industrial Revolution, and in

the 1790s Shrewsbury was an obvious place for Bage to build the new flax mill: the Shrewsbury canal brought raw flax from across the country and as far away as Ireland to the site and close by were all the materials needed for the innovative construction he planned.

Until Bage built his revolutionary mill, large buildings consisted of load-bearing walls of masonry—brick or stone—with timber beams spanning from exterior to interior walls; the size of buildings was limited by the size of suitable timber beams and joists. Bage wanted to avoid all use of timber in his building, to create a fireproof building, and he devised the concept of starting with an iron frame that supported brick arched vaulted ceilings and floors all clothed in a brick outer skin. Thus was born the iron, later steel, framed building with its infill of floor panels and its thin outer curtain wall.

Looking at the 1797 wing of the Ditherington Flax Mill, the exterior appears to be conventional load-bearing construction but that wall only has to hold up its own weight, because behind the five levels of regularly spaced windows is an equally regular grid of cast iron columns and beams interlocked together to create a strong structural frame. The rather dour exterior was once much more open as Bage's design featured large cast iron framed windows that would have filled the interior with light; these were changed after the building ceased to be a flax mill. Inside there are only the delicate tapered cruciform columns that also have the advantage of producing large open floors unbroken by intervening support walls. The columns support the cast iron cross beams that were cast in two pieces and bolted together where they abut at the center of the span. The multiple gables of the roof line—eighteen in number—reflect the shape of the *vaults* that were not filled and leveled as on the floors below but rather were used to form a shallow-pitched but weather-tight roof. Bage's design, the first of its kind, nevertheless reflects the efficient austerity that became a trademark of nineteenth-century industrial buildings and led to the principles of twentieth-century Modernism.

After ninety years as a flax mill the building was converted into a maltings, a building where barley is processed as part of the production of beer. At its peak, over 17,000 tons of barley were processed annually at the Ditherington Maltings. It was for the malting process that the tower and the adjoining pyramidal roofed dye house were added and these are interesting in themselves as pieces of industrial archaeology. The 1797 wing has the highest *conservation rating* of Grade 1 while the tower and dye house are the slightly less worthy Grade 2.

In 1987 the maltings ceased production and since then Ditherington Mill has fallen into disrepair, although owned by Maltings Development Ltd., who have plans to spend $20 million converting the building for use as an arts center and gallery with stores and offices. Both English Heritage, the national conservation organization, and Shrewsbury and Atcham Borough Council, the local authority, have pledged that the building will be conserved. John Yates, of English Heritage, said of Ditherington Flax Mill: "This is a

building of global importance . . . this is the grandmother of every skyscraper in every city. While this is now sleepy Shropshire, you have to think back 200 years to the Georgian industrial revolution when this was the 'Silicon Valley' of the world."

Further Reading

Deane, Phyllis. *The First Industrial Revolution*. Cambridge: Cambridge University Press, 1980.

DOWNING STREET. *See* Number 10 Downing Street.

THE DURHAM CATHEDRAL CHURCH OF CHRIST AND BLESSED MARY THE VIRGIN, DURHAM, ENGLAND

Styles: Mediaeval—Norman/Romanesque and Gothic—Early English
Dates: 1093–1220; 1465–1490
Mason: Richard of Farnham

Readers of Anthony Trollope's *Barchester Chronicles*, those fascinating novels set in a nineteenth-century cathedral city, well know the importance of the cathedral, the palace (most bishops' residences were designated palaces), and the deanery to English society at that time. Society has changed and Britain is now a much more secular society. There are still fifty-three diocese (areas administered by a bishop) covering the country but the social, political, and civic importance of the bishops has declined as has their lifestyle: Many palaces have been reduced in size or sold, and smaller, less imposing residences bought. But the cathedrals, the seats of the bishop's throne or cathedra, still regally dominate the cities over which they have soared, most for nearly 1,000 years. At least thirty cities could be named where the cathedral dominates the skyline, indeed gives the skyline its characteristic shape: Canterbury, the most French in style; Salisbury with its soaring pointed spire; Lincoln, high on its hill, extended to almost reach the clouds by three great towers; Ely, seen across the misty fenland, with its huge

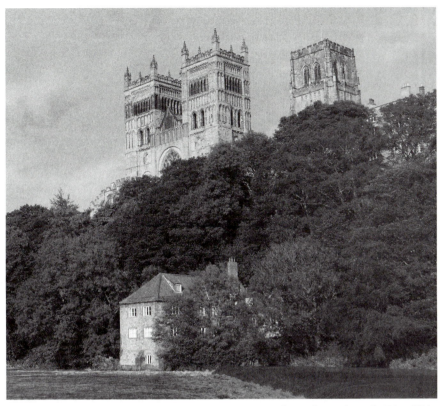

Durham Cathedral. The west towers with the crossing tower beyond soar above the River Weir. *Photo by Ian Britton (FreeFoto.com).*

west tower and squatter, two-tiered, octagonal central tower; Wells, its unfinished west façade carved with hundreds of biblical scenes—the "poor man's bible"; and York, growing out of The Shambles, the mediaeval streets and houses that still cluster close to its walls like chicks to a mother hen. Every one of these, and more, are wonderful buildings, but for many the Durham Cathedral Church of Christ and Blessed Mary the Virgin is the finest cathedral in England. Bill Bryson, in his book *Notes from a Small Island*, wrote of Durham, the city: "Why, it's wonderful—a perfect little city . . . if you have never been . . . go there at once"; and of the cathedral: "it's the best Cathedral on planet earth." Architecturally, it is the most complete example of a Romanesque style cathedral in Britain and it was the first building in Europe to have stone ribbed vaults throughout.

The site of Durham Cathedral is dramatic, enhancing the grandeur of the architectural ensemble. The River Wear flows through a narrow wooded valley in an elongated oxbow that almost meets itself. The near island thus formed, edged by sandstone bluffs, is only accessible across the narrow neck

at the north end. The site, early recognized for its security, became, after the Norman Conquest of 1066, the stronghold of the Prince-Bishops of Durham (the Bishops of Durham were so powerful—politically and within the church—and wealthy that this double title was given). A castle, dominated by an octagonal *keep* atop a *motte* (see **Windsor Castle**) protects the site especially from the north and the menacing Scots. On the highest point, nearly reaching from side to side of the peninsula, the cathedral was built, its west towers seeming to grow from the sandstone cliffs. The site of Durham Cathedral, majestic, high above the River Wear, dominating the countryside for miles, is one of the most memorable in England.

Legend has it that the guardians of the remains of St. Cuthbert, an early English saint who had brought Christianity to the north, built the first church in the tenth century C.E. They were brought to the site by a peasant girl searching for a lost cow. The remains of St. Cuthbert are buried in a shrine to the east of the High Altar. Late in the following century, William the Conqueror (r. 1066–1087) ordered the building of the castle and the cathedral followed soon after, beginning in 1093. The Nave, Transepts, and Choir were completed by 1133; the Galilee Chapel, a porch at the west end, was built between 1173 and 1189; the western towers were built between 1217 and 1226; the Chapel of the Nine Altars, a rebuilding of the earlier east end, was built between 1242 and 1274; and the last major construction to occur, the rebuilding of the Central Tower after it was struck by lightning, took place between 1465 and 1490. In plan the building is typically English, long and narrow (as opposed to French cathedrals that tended to be much broader), with the aisled nave and choir separated by a crossing beneath a central tower oriented east–west: North and south of the crossing are two transepts.

The mason of the Norman part of the cathedral is unknown but he is very important to the history of architecture because of the use of the stone ribbed *vault*—thin panels reinforced by ribs—that had developed in Italy a few years earlier, which he applied to a whole cathedral—architecturally a structural innovation of tremendous significance. Because the site is restricted, Durham cathedral is entered through the North Door into the west end of the nave. Looking eastward, the 300-foot length of the cathedral is revealed. The nave and choir are separated from aisles by an arcade of alternating compound columns (large columns with several smaller ones attached) and round columns, both of the massive proportions of the Norman/Romanesque style (for a description of the styles of mediaeval architecture see **The Parish Church of St. Giles**). The round columns are decorated with deeply incised patterns of spirals, zigzags, chevrons, and diamonds. Above this arcade is the triforium, another arcade opening into the roof space above the aisles and at Durham containing bracing half-arches, early flying buttresses; and above this the windows of the clerestory draw in light sixty feet above the floor. The three levels of arcading of the nave and choir feature semi-circular arches but the *vault* above solves one of the major problems faced by early

mediaeval masons. The use of round arches worked well if all the spaces to be spanned were of the same width, the arches would be of the same height; if different widths were encountered problems arose, sometimes resulting in stilted arches where the narrow arch is raided on higher columns. Whatever solution was tried the result was visually unsatisfactory. The introduction of the pointed arch formed of two arcs meeting at a point at the top resolved the problem as the width could easily be adjusted while maintaining the levels of not only the spring point (where the arch "springs" from the column), but also the top of the arch; the design freedom that resulted from this apparently simple development generated the finest Gothic buildings. Durham is one of the earliest cathedrals in Europe to use pointed transverse arches crossing the nave and choir. The diagonal ribs of the vaults do, however, form pure semicircles and it is interesting to try to understand the mason's thinking as he developed this ceiling, the first large-scale use of rib vaulting in Europe.

At the back of the High Altar at the east end of the Choir is the Neville Screen (named for an important local family) comprising the *reredos* and flanking sedilia (seats for the clergy); above are 107 niches for statues of saints removed at the time of the Reformation. The screen is carved from Caen Stone quarried in Normandy, France; shipped to London; carved under the direction of Henry Yevele the architect of Westminster Hall at **The Houses of Parliament**; shipped to Newcastle and brought to Durham by ox-wagon; and erected in 1380. It has survived relatively unscathed apart from the lost statues; the other mediaeval fittings suffered at the Reformation in the sixteenth century and during the Commonwealth in the seventeenth century when Oliver Cromwell (1599–1658) housed 3,000 Scots prisoners in the cathedral. The replacement High Altar, choir screen and stalls, font cover, and so on, date from the seventeenth and nineteenth centuries. One interesting survival from mediaeval times is a line of marble set in the nave floor that demarked the eastern boundary where women could be within the church during the time it was a monastery.

The east end, beyond the High Altar, originally had three semi-circular *apses* containing small chapels but these fell into disrepair and were replaced by the Early English style Chapel of the Nine Altars (the cathedral was originally part of a Benedictine monastery and multiple altars were needed for the many monks to pray before), designed by Richard of Farnham (probably assisted by Elias of Dereham, the architect of Salisbury Cathedral). The Chapel of the Nine Altars forms a hammerhead at the east end of the cathedral, being almost three times the width of the Choir immediately to the west.

The late Romanesque Galilee Chapel is squeezed into the space between the Norman *façade* and the sheer drop to the river. Almost Moorish in character, it is filled with light and delicate columns and arches in contrast to the ponderously massive quality of the nave. It serves as the Lady Chapel and by tradition was built here as St. Cuthbert, apparently a misogynist, would ap-

pear in spirit and destroy any building work near his tomb at the east end. The Galilee Chapel is so named because a great procession, signifying the return of Christ to Galilee, beginning at the High Altar would end here. The tomb of the Venerable Bede, an Anglo-Saxon scholar and saint, is in the Galilee Chapel.

The Prince-Bishops of Durham no longer wield great power; a mere Bishop of Durham lives at Auckland Castle while Durham Castle is now part of Durham University. In 1986, UNESCO declared Durham Cathedral and Castle a World Heritage Site.

Further Reading

Bryson, Bill. *Notes from a Small Island.* New York: HarperCollins Publishers, 1995.

Norwich, John Julius. *Great Architecture of the World.* London: Mitchell Beazley Publishers Limited, 1975.

Virtual tour of Durham Cathedral. Durham University. www.dur.ac.uk/~dla0www/ c_tour/cathedral.html.

EATON HALL, CHESHIRE, ENGLAND

Styles: Renaissance—Restoration, Georgian—Picturesque/Romantic, Victorian—Gothic Revival, and Twentieth Century—Modern
Dates: 1675–1682; 1804–1812; 1823–1825; 1846–1851; 1870–1882; 1971–1973
Architects: William Samwell (seventeenth century); William Porden, Benjamin Gummow, William Burn, Alfred Waterhouse (nineteenth century); John Dennys (twentieth century)

American visitors to Britain are often nonplussed by the names of places and streets. In London the U.S. Embassy is located in Grosvenor Square, a verdant green park surrounded by impressive buildings; its name is readily explained, being the family name of the owners of the land. Gerald Grosvenor, 6th Duke of Westminster is one of the wealthiest men in the country, with an estimated fortune of over $6 billion. The basis for the duke's great wealth is a 300-acre estate that encompasses the most exclusive streets of central London, in the districts of Mayfair and Belgravia. The latter is a contrived name; in the nineteenth century a postal official returned a letter addressed to a house in the new district of Belgravia with an attached note snobbishly querying if Belgravia were some eastern European princely state. Belgravia rapidly became *the* place to have a London residence and the Grosvenors grew richer

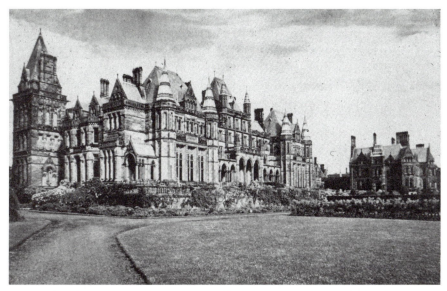

Eaton Hall. The fourth house designed by Sir Alfred Waterhouse photographed in the late nine-teenth century. The arcade at the center fronts the nine-bay seventeenth-century house buried within later remodelings. To the right is the Grosvenor Wing, private to the duke and his family.

on the rents. Belgravia is named for a tiny hamlet called Belgrave consisting of a few cottages clustered at the gates to the Grosvenor country house, Eaton Hall, one of the most extravagant houses in the country.

The Grosvenor family is of ancient lineage; their preferred interpretation of the name is the "great hunter," referring to an ancestor, Hugh Lupus, Earl of Chester, who was a nephew of William the Conqueror. Less kind persons, mindful of the Grosvenors' great pride in their ancestry, translate the name as the "Fat Hunter." They had acquired the Eaton estate in the fifteenth century and by the late seventeenth century were wealthy enough to build a fashionable new mansion. The owner was Sir Thomas Grosvenor, 3rd Bt. (Baronet) who in 1677 had married a great heiress whose fortune included those 300 London acres that were to be so profitable for later generations of the family. The architect of this house, the first Eaton Hall (built 1675–1682), was William Samwell (1628–1676), one of the gentlemen architects of the Restoration period (after the monarchy was restored in 1660). Samwell's design closely followed the ideas of Sir Roger Pratt's Coleshill and Clarendon (see **Belton House**) and was a symmetrical "double pile" (two rooms deep) block, nine *bays* (windows) wide, with a central *pediment* and a *hipped roof* rising to a *balustraded* flat (roof terrace) with a central *lantern*. The plan was of considerable sophistication, a development of Pratt's concept, featuring a "state centre" and four apartments. Two detached service wings to either side of the west entrance front created a large forecourt closed off by curved rail-

Eaton Hall. The fifth house, designed by John Dennys and completed in 1973, occupies the site of the first Eaton Hall. The statue depicts Hugh Lupus, a nephew of William the Conqueror and the "great hunter" from whom the Grosvenors claim descent. *Photo by author.*

ings and elaborate wrought iron gates by the Davies brothers of Wrexham (who had worked with the great smith Tijou). Elaborately wrought and gilded, these gates, known as the "Golden Gates," still guard the forecourt. Beyond the gates the Belgrave Avenue stretched for two miles reaching out toward the distant mountains of North Wales where the family had further estates and profitable lead mines. To the east of the house an elaborate garden of terraces, *parterres*, and allées stepped down to the River Dee.

Remarkably little was done to the house for 120 years. Capability Brown improved the park in 1769, removing the formal east gardens but surprisingly keeping the Belgrave Avenue. In 1802, the 2nd Earl Grosvenor (later 1st Marquess of Westminster) inherited the estate and an astronomical income of £50,000 from the Welsh lead mines that enabled him to build a grand London house, form a celebrated collection of pictures, and rebuild Eaton Hall. The second Eaton Hall was designed by William Porden (1755–1822) and built 1804–1812 in the fashionable Gothic style, the architect having convinced the proud earl that Gothic would remind visitors of the family's long history. Samwell's service wings were demolished but the main house was retained and extended with new drawing and dining rooms connected externally by a *loggia* on the garden front. A *porte cochere* (carriage porch) projected from the west front facing the Belgrave Avenue. The whole building was clad in light stone with cast plaster *buttresses, pinnacles, battlements,* and *turrets,* while the *tracery* of the windows was of cast iron, bronze, and copper. The interior was one of the most elaborate of its time, rivaling those created for the Prince Regent at **The Royal Pavilion**, Brighton and Carlton House, the Prince's famed London house (see **Buckingham Palace**). Lacy plaster *vaults* soared overhead, billowing drapes framed huge Gothic stained glass windows and spurious sculptures of Grosvenor ancestors graced niches and pedestals. Por-

den died in 1822 and his supervising (site) architect Benjamin Gummow was responsible for the library and chapel wings of 1823–1825 that further extended the great length of the house. Porden and Gummow's Eaton Hall was recorded in a series of watercolors and lithographs by J. & J. C. Buckler whose illustrations made Eaton Hall one of the great sights of its day, so familiar that it was prominently featured in the satirical book of verse *Dr. Syntax's Second Tour*, of 1820. In 1831, Harriet, Countess Gower (a relative), staying with the Grosvenors at their second country house (Classical Moor Park, Hertfordshire), commented, "they must feel it is a relief to be out of the eternal gothic of Eaton." The second Eaton Hall, for all its magnificence, has the quality of a decorated cake with its relentless and repetitive unscholarly Gothic detail, a "vast pile of mongrel Gothick which cost some hundred of thousands and is a monument of wealth, ignorance and bad taste" wrote Charles Greville, another visitor.

Maybe the Grosvenors would have ignored such snide remarks if the house had been comfortable, but unfortunately it was not. In the winter of 1826, despite all best efforts to keep the house warm, all the water pipes froze and a few years later Lady Belgrave (the wife of the marquess's heir) wrote that Eaton was "cold and comfortless as usual." In 1845, William Burn (1789–1870) was brought in to remodel the house. Burn was one of the most prolific architects of the nineteenth century and in his country houses was the master of efficient design of the increasingly complex service quarters—Eaton needed nearly 100 indoor servants. His architecture, while brilliantly planned and stylistically more correct than that of Porden and Gummow, was rather pedestrian and his late mediaeval/early Tudor–style third Eaton was to last less than twenty years.

In 1869, Hugh Lupus Grosvenor inherited as 3rd Marquess of Westminster. The London estates had been developed and the Grosvenors were the wealthiest family in the nation with an annual income of well over £150,000; this at a time when there was no income tax and a good cook earned £50, and a maid £10, annually. So wealthy was the marquess that in 1874, Queen Victoria (r. 1837–1901) made him 1st Duke of Westminster. Hugh Grosvenor saw his great inheritance and its consequent privileges as God-given destiny; it was his duty to maintain the standards and elaborate lifestyle of a duke of Victoria's empire but not to forget those less well off by giving generously to many charities. "Gone, one of Britain's noblest gentlemen" read the headlines on the front page of the *Manchester Guardian* on his death in 1899, while *The Times* called him "a great example of the great noble who, while following the same pursuits and other amusements as other Englishmen of wealth and leisure, devotes a great part of his time to the service of those less fortunate than himself." In 1869, Alfred Waterhouse was consulted with the intent of making Eaton Hall architecturally worthy of such a nobleman and in 1870–1882 the fourth Eaton was built.

Waterhouse had a thorough knowledge of European Gothic and was at the height of his success, having just completed the Manchester Assize Courts

and recently won the Manchester Town Hall competition. The new Eaton Hall was a polychromatic (multicolored) essay in the thirteenth-century French "early pointed" Gothic style with high pitched roofs and pointed turrets giving it a spiky silhouette; the massing was bolder and the detailing more substantial, more confident. Surprisingly, Samwell's nine-*bay* symmetrical block was still discernible after all this time, although by the time Waterhouse had finished it provided little more than the entrance hall and ante rooms to great rooms beyond. Waterhouse followed some of the Porden/Gummow plan but totally rebuilt the library wing on the south side, adding a tall, pyramid-roofed, tower. This balanced the clock tower of the new chapel to the north that is visible for miles around across the expanse of the Cheshire plain—*here* is Eaton Hall, home of the Dukes of Westminster. North of the main house but projected into the garden was the "Grosvenor Wing"; a private wing—a small mansion itself—for the duke and his family, well away from the public rooms and visitors in the main house. (The wife of the second duke loved this arrangement because she could relax here reading a book while the sixty or more guests entertained themselves in the main house, each thinking she was with some other guest.) Waterhouse's Eaton is massive and ponderous, more urban than rural, more civic than residential, and even the duke found it oppressive, writing in 1881, "Now that I have built a palace, I wish I lived in a cottage." Later he was heard to say that if his heir had any sense he would pull the house down and build another. He had spent £603,000 6s 11d on the building.

The heir did not carry out the duke's request and the house survived until 1961–1963 when, having suffered army occupation during the Second World War, it was demolished, the fittings and materials sold at an auction that lasted for five days. It was thought that the great days of the Grosvenors were over, massive death duties were owed and the 3rd, 4th, and 5th Dukes were all older, inheriting in rapid succession and apparently without a successor. But an heir was born and the energies of the dukes and their advisors were directed to preserving the Grosvenor inheritance for the young Gerald, who was to become the 6th Duke of Westminster.

After the death of the second duke in 1953, the family, when in Cheshire, lived at Saighton Grange, another house on the estate. In the early 1970s, however, they determined to move back to Eaton, at first living in a temporary wooden house built on the north side of the gardens. The private Grosvenor Wing was probably the finest residential design by Waterhouse but unfortunately, the trustees had demolished it along with the main house; only the chapel and stables remained with "a hole in the sky where the Wagnerian bulk of the house had filled the central axis" (a reference comparing the house to the mighty operas of the nineteenth-century German composer Wagner). The 5th Duke's brother-in-law, John Dennys, was an architect and he was commissioned to design the new house that was to rise on the historic site in 1971–1973. Unabashedly modern, the travertine-covered fifth Eaton Hall, sparkling white and boldly horizontal, struggled to fill that

"Wagnerian" space. By the wish of the duke the new house was on the same site as Samwell's house of 1675–1682, the core of the later houses, and has a *porte cochere* on the west entrance front that looks across the forecourt, through the Davies' "Golden Gates" to the Belgrave Avenue and the distant mountains. To give the house some height it was raised up on a semi-*basement* that contains service rooms and an indoor swimming pool. On the first floor a large Hall, Dining Room, Drawing Room, Library, and Study look east and south over the restored gardens while upstairs are twelve bedrooms, two dressing rooms, and two private sitting rooms. The roof was flat but a curved wall conceals the elevator motor room, water tanks, and an access stairway. The design, with its piloti (columns), smooth white walls, and horizontal bands of windows, obviously owed a considerable debt to Le Corbusier's Villa Savoye at Poissy, France (1929–1930). The duke's peers were not impressed; the Duke of Bedford wrote, "I was interested to see . . . a sketch model of Eaton Hall. It seems to me one of the virtues of the Grosvenor family is that they frequently demolish their stately home. I trust future generations will continue this tradition if this present edifice, that would make a fine office block for a factory on a by-pass, is constructed."

Gerald Grosvenor inherited in 1979, becoming the 6th Duke of Westminster, and it is under his direction that the Grosvenor Estates have become global developers with properties in Europe, North America, and Australia. Not including the 300 acres in London, the British estate now extends to 144,500 acres in Cheshire, Lancashire, and Scotland and is the only aristocratic estate (except that owned by the Queen) that grew in the twentieth century.

The Duke of Bedford's wish came true in part in the early 1990s when the house was once again remodeled. An attic floor, providing additional guest and servant bedrooms, was added and the whole building recast in neo-Georgian style through which the modern 1970s house, unfortunately, still shows its presence.

Further Reading

de Figueiredo, Peter, and Treuherz, Julian. *Cheshire Country Houses*. Chichester, U.K.: Phillimore & Co. Ltd., 1988.

Field, Leslie. *Bendor, the Golden Duke of Westminster*. London: Weidenfeld and Nicolson, 1983.

Robinson, John Martin. *The Latest Country Houses*. London: The Bodley Head Ltd., 1983.

EDNASTON MANOR. *See* Lutyens Country Houses.

ERDDIG HALL, WREXHAM, WALES

Styles: Renaissance—Restoration and Georgian—Neoclassical
Dates: 1683; circa 1716; 1773–1774
Architects: Thomas Webb (seventeenth century) and James Wyatt
(eighteenth century)

The unlovely town of Wrexham, spoiled by unfortunate nineteenth- and twentieth-century redevelopment, once could have been the model for Jane Austen's fictional town of Highbury in her novel *Emma*. At the turn of the nineteenth century Wrexham was a bustling market town with a handsome High Street of Georgian appearance but with many of the buildings dating back to mediaeval times. The skyline was (and still is) dominated by the tower of the stunning Gothic tower of **The Parish Church of St. Giles**. The Watkins-Wynns of Wynnstay Hall, the Cunliffes of Acton Park, and the Yorkes of Erddig Hall led polite society. Today Wynnstay is divided into apartments, much of its park built over. Acton Park was demolished in the 1950s and its park replaced by council (city-owned) housing. Erddig survives, saved by the National Trust, a charitable organization dedicated to the preservation of historic landmarks, landscapes, and buildings.

The original house at Erddig was built between 1684 and 1689 to the designs of Thomas Webb of Middlewich, Cheshire. In a contract of November 1683, Webb agreed to "entertake and perform the care and oversight of the contriving building & finishing of a case or body of a new house for the said Joshua Edsbury at Erthigge aforesaid . . . according to the designs, compass, manner & methode of draughts (drawings) already given by the said Thomas Webb." Subcontracts were made in March 1684 with Edward Price, mason and William Carter of Chester, bricklayer. The house was completed some three years later. The "said Joshua Edsbury" was actually Joshua Edisbury, a wealthy landowner who unfortunately lost all his money to speculation and in 1716 was forced to sell Erddig, having already sold most of the contents. The purchaser was John Meller, a wealthy London lawyer, who added north and south wings, tripling the size of the house and extending its length to 200 feet: The architect is not known. Meller also furnished the house by ordering sumptuous suites of sofas and chairs and a magnificent tester bed for the State Bedroom. [A tester bed has a canopy like a four-poster but the two posts at the foot are omitted and the tester or canopy has to be suspended from the ceiling.] The silks of the bed coverings were imported from China and are woven with gold thread and patterned with exotic birds and plants. Meller died a bachelor in 1733, leaving the estate to his nephew Simon Yorke in whose family it remained for 240 years. The

Yorkes used only two names for their eldest children and thus Phillip suc-
ceeded Simon and Simon Phillip for several generations, the confusion being
mitigated by the use of Roman numerals, like kings. The last Yorke, Phillip
III, gave Erddig to the National Trust in 1973.

The house built by Webb was of brick with stone detailing similar to the
contemporary **Belton House** or **Eaton Hall**. The 1716 wings were also of
brick but in 1772–1773 the entrance front, which faces west and the pre-
vailing winds, was refaced in stone producing a severe, even dull, *façade*, its
insipidity relieved by a *pediment* and an elegant double horseshoe staircase.
The architect was probably James Wyatt (1746–1813); letters indicate he was
consulted, although Joseph Turner of Whitchurch (c. 1729–1807) appears to
have been the architect on site. The opposite garden front, protected from
climatic extremes, still retains the brick and stone and is much pleasanter, the
façade of a comfortable and unpretentious provincial country house. Some
whimsy is introduced by the oval windows, akin to Wren's at **Hampton
Court**, in each wing and the little five-columned *balustrade* at the center of
the roof *parapet*. Old prints showing the house as it was originally built in-
dicate a *lantern* atop the roof very similar to those at Coleshill, Clarendon,
or Belton—Erddig was at the height of fashion when first completed—and
its loss is an unfortunate degradation of the composition.

Looking west from the front door across the *park*, the view of the distant
mountains of North Wales is foreshortened by the bulk of the spoil-heap at
Bersham Colliery. Coal mining was to destroy much of the beauty of Wrex-
ham and its surrounding estates, although it produced much wealth; it was
nearly the cause of the destruction of Erddig. While the Yorkes, the Squires
of Erddig, were still influential, they protected the house by leaving a "col-
umn" of coal unmined immediately underneath. After the Second World War
when the coal mines were nationalized (bought by the socialist government),
the new managers had no sympathy for such houses and ordered the column
of coal to be removed. The inevitable happened, the house "broke its back"
with one wing subsiding three feet and the other five feet, opening up cracks
in walls and the roof and letting rain water seep in to run from attic to base-
ment. By 1970 the magnificent state bed was constantly sodden, and the ceil-
ing held up by pit props acquired from the colliery. The gardens, long
abandoned, were given over to pasture and sheep wandered up the steps to
the garden door and into the Saloon. This is the house that Phillip Yorke of-
fered to the National Trust.

At first the trust was skeptical but the more it looked the more it realized
that while Erddig was not an architectural gem, it was a phenomenon wor-
thy of conservation. Individual pieces of furniture such as the state bed would
readily find a place in a museum, but what made Erddig special was the
"pack-rat" habits of the Yorkes: they had acquired possessions over the years
but had never thrown anything away; it was all there in a state of suspended
animation as if time had stopped in 1914 (the outbreak of the First World
War). And it is not just the contents of the family rooms with the original

Meller furniture added to by each generation of Yorkes that still remained, but every domestic appliance or tool used to keep such a house going. The laundry was still there with its copper hot water tubs and its huge mangle of wooden rollers weighted down by a box filled with stones; the kitchens, the bake-house, the brewery, the carpenter's shop, the sawmill, the slaughter-house, the gardener's sheds were all there. In the coach house still stood the family coach, landau, and governess cart while in the corner lurked an early automobile. The Yorkes had kept records of all expenditures and acquisitions and their account books formed an invaluable insight into the running of a large country house. The National Trust realized it had a piece of social history and set about its restoration. Phillip Yorke had also given the Trust 2,000 acres of park and farmland and a small area of this, adjoining the town of Wrexham, was sold for housing to raise money for an endowment. Ironically, the National Coal Board was forced to pay compensation for the damage it had so cavalierly caused twenty-five years previously. The state bed was sent to the Victoria and Albert Museum for restoration and now sits in a climate-controlled glass enclosure in the splendid State Bedroom.

Visitors to Erddig enter not as grand guests but as tradespeople having business with the steward or the housekeeper and pass by all the restored service areas, many working again and producing bread or hand-finished timbers for other Trust projects. It is a fascinating insight into the life of a country house explaining how it worked, how it was to a large extent self-sufficient, and how it needed an army of servants to run. The Yorkes had an unusual attitude toward their servants, treating them with affection and esteem. In the eighteenth century they commissioned journeymen (traveling) artists to paint portraits that were hung in the servants' hall as proudly as the more expensive family portraits in the grand rooms upstairs. Later, after the invention of photography, the custom was continued, with portrait and group photographs, until the last servants left the house.

Erddig Hall has a connection to the United States. Elihu Yale, the founder of Yale University at New Haven, Connecticut, was a near neighbor and business partner of Joshua Edisbury, the original owner of Erddig. Indeed it was Yale who called in the mortgages that caused Edisbury's bankruptcy—Yale was an astute businessman who did not let sentiment interfere with profit. A letter of 1682 from Yale to Edisbury offers thanks for a gift of "four roundletts of sandpatch ale" shipped to Fort St. George, Madras, India, and promising a japanned screen and oriental clothe. There is some speculation that the Chinese lacquer screen in the State Bedroom and the fantastic silk of the state bed are the gifts referred to, which have survived in the house despite Edisbury's ruin.

For the author Erddig has distinct memories, for it was in 1968, having followed the sheep into the house, that I was chased out by an irate Squire Yorke. In my haste to escape I came off my bicycle and broke a front tooth—the porcelain cap is a constant reminder of this teenage prank.

Further Reading

Pritchard, T. W. *Elihu Yale, the Great Welsh American*. Wrexham, U.K.: Wrexham Area
Civic Society, 1991.

FONTHILL ABBEY,
WILTSHIRE, ENGLAND

Styles: Georgian—Picturesque/Romantic
Dates: 1796–1812 (mostly demolished after 1825)
Architect: James Wyatt

When it was built at the turn of the nineteenth century, Fonthill Abbey
was the most sensational house in the country. Achieving the goal of
its owner, it was a sublime interpretation of Gothic architecture. During its
short existence it was the visited by the rich, the discerning, and the cele-
brated; it was depicted in a series of paintings by J.M.W. Turner; and it was
the subject of several best-selling booklets describing its architecture and the
wonders it contained. If Fonthill Abbey had survived—the great tower fell
down in 1825 and all but a small portion was subsequently demolished—it
would have been one of the architectural and artistic wonders of Britain. This
fantastic house was built for William Beckford, at that time Britain's richest
man and with an ego to suit the scale and character of his wondrous creation.
In California, in the twentieth century, William Randolph Hearst built his
San Simeon; in Wiltshire, a century earlier, William Beckford built Fonthill
Abbey.

William Thomas Beckford (1760–1844), even without Fonthill, was a
larger-than-life character whose reputation had been destroyed in 1784,
when he was twenty-four, by an infatuation for William Courtney, the young
heir to Powderham Castle. Although he was quickly married to his cousin
Lady Margaret Gordon (who died after three years of marriage, leaving him
with two daughters, one of whom became Duchess of Hamilton), it was the
homosexual affair with Courtney that defined his life. Ostracized by polite
society, Beckford initially exiled himself in Europe—first in Switzerland, then
France, and then Portugal and Spain in 1787–1788—where he began his
mania for collecting and writing. He authored *Vathek* (published 1787), one
of the earliest of the so-called "gothic" novels, a horror story combining
"Gothic romanticism with the vivacity of *The Arabian Nights.*" The gothic
novel was literature's interpretation of the Romantic, reveling "in the horri-
ble and the supernatural, in suspense and exotic settings"; the most famous

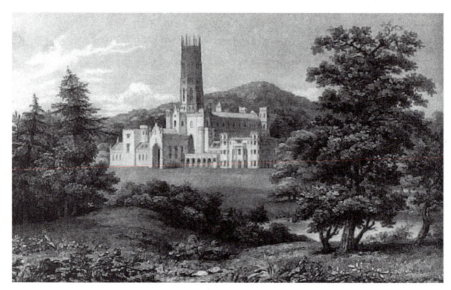

Fonthill Abbey. Beckford's fantastic house, protected behind high walls, fascinated the British public and many views were published such as this early nineteenth-century print.

gothic novel is Mary Shelley's *Frankenstein* published in 1818. It was the Napoleonic Wars that forced Beckford to return to England in 1796, when he went back to his estate, Fonthill, where work was already in hand to transform the estate he had inherited from his father into a Romantic fantasy that could have been the setting for a gothic novel.

The Fonthill estate had been mentioned in the Doomsday Book, the great census of population and property commissioned by King William I (r. 1066–1087) in 1086, in which it was called Fontel. The family who owned Fonthill was the Giffords and their name came to be associated with the estate, for many years called Fonthill Gifford, even though the property was inherited or sold. Sir Francis, later Lord, Cottingham (died 1652), ambassador to Spain and Chancellor of the Exchequer (Treasury), owned Fonthill in the seventeenth century and it was his heirs who sold the estate and mansion to William Beckford (senior), a very wealthy London Alderman, Member of Parliament and Lord Mayor of London (1763 and 1769–1770). The Beckford fortune was based on Jamaican sugar plantations, which made the family among the richest in Europe. The house at Fonthill burned down and Alderman Beckford called in William Hoare (dates unknown), a relatively obscure architect who nevertheless designed the massive and very competent *Palladian* mansion—built c. 1757–1770—which was so magnificent it was dubbed Fonthill Splendens. William Beckford (junior) inherited this great estate in 1770, when only eleven years old, but was soon living the life of a young rich aristocrat of those pre-revolutionary times. Beckford's massive wealth could not protect him from the consequences of the Courtney affair

and, with all hope of a public life like his father's lost, he became increasingly reclusive and eccentric. In preparation for his return to England in 1796 he had the *park* at Fonthill surrounded by a wall, nearly eight miles long, twelve feet high, and topped by iron spikes, called The Barrier, to keep neighbors and the hunt off his property (he disliked all bloodsports, particularly fox hunting).

Also in 1796, Beckford wrote to James Wyatt (1746–1813), a fashionable and prolific architect capable of working in the Neoclassical or Gothic styles and responsible for some of the most influential buildings of the Picturesque as well as some more questionable restorations at the cathedrals of Salisbury, Hereford, Durham, and Lichfield (these earned him the nickname "The Destroyer" among those interested in religious architecture). Beckford's letter requested a tower to be built on the highest point of the Fonthill estate to obtain distant views, including that of Salisbury Cathedral. Unable to settle on an idea and enamored of the ideas of Romanticism, Beckford changed to thoughts of a ruined convent, still with a tower, but containing rooms where he could stay for a few days as a retreat from his father's mansion across the park. This folly was the beginning idea for Fonthill Abbey, the massive house that replaced Fonthill Splendens (demolished 1807), inspired by the Swiss monastery of Grande Chartreuse where Beckford had been kindly received on first leaving England. The Abbey became Beckford's obsession and he insisted it be built as quickly as possible employing, at times, over 500 workmen who worked night and day as the site became a Romantic vision in itself: "It is really stupendous the spectacle here at night, the number of people at work, lit up by lads, the innumerable torches suspended everywhere, the immense and endless spaces, the gulph below, above the gigantic spider's web of scaffolding—especially when standing under the finished and numberless arches of the galleries, I listen to the reverberating voices of the night, and see immense buckets of plaster and water ascending, as if they were drawn up from the bowels of a mine, amid shouts from subterranean depths, oaths from Hell itself . . ." (letter from Beckford quoted by Strong).

In December 1800, Admiral Horatio Nelson (see **Trafalgar Square**) was invited to inspect the partially completed Abbey and a description of the visit was published in *The Gentleman's Magazine*. The party left Fonthill Splendens in a cavalcade of carriages and following "a road winding through thick woods of pine and fir, brightly illuminated by innumerable lamps hung in the trees, and by flambeaus moving with the carriages, they proceeded between two divisions of the Fonthill volunteers, accompanied by their band playing solemn marches, the effect of which was heightened by the continued roll of drums placed at different distances on the hills. The company on their arrival at the Abbey could not fail to be struck with the increasing splendour of lights and their effects, contrasted with the deep shades which fell on the walls, battlements, and turrets, of the different groups of the edifice. Some parts of the light struck on the walls and arches of the great tower, till it vanished by degrees into an awful gloom at its summit. . . . The parties

alighting . . . from their carriages, entered a groined Gothic hall. . . ." This was the Great Western Hall, a huge room (68 feet long, 28 feet wide, and 78 feet high) dominated by a flight of stairs leading to the Western Vestibule and the main part of the house. The entrance doors were over 33 feet tall opened by a gorgeously dressed dwarf employed to increase the impact of their size. To one side a recess held a statue of Alderman Beckford while high above the doors was a musicians' gallery. Passing from the Great Western Hall, through the vestibule, the next room was the Octagon. This room was below the central tower and while only thirty or so feet across was over one hundred feet high composed, like a church, of aisle, triforium (gallery), and clerestory (upper windows) crowned by delicate fan *vaulting* and an octagonal *lantern*. Externally, the tower was nearly 300 feet high to the top of the eight pinnacles adorning the topmost *parapet*. The tower collapsed several times during construction but Beckford was unconcerned and ordered it rebuilt, only complaining that on every occasion he was absent, thus missing the dramatic fall.

From the Octagon the plan of Fonthill Abbey was readily discerned. Essentially a cross, a long north–south axis and a shorter east–west axis crossed at the Octagon beneath the central tower. The west arm contained the Great Western Hall and the Western Vestibule. Across the Octagon a matching Eastern Vestibule led to the eastern arm where the Great Dining Room, Crimson Drawing Room, and the Grand Drawing Room were intended but never completely fitted out. The north–south axis was effectively one immense vista of connected vaulted galleries, approximately 300 feet long, with St. Michael's Gallery in the southern arm, vestibules to either side of the Octagon, and, in the north arm, King Edward's Gallery, the Vaulted Corridor, the Sanctuary, and finally the Oratory, where a statue of St. Anthony by Rossi stood on an altar. The dark and mysterious interiors were deliberately kept dimly lit except for the Oratory where a blaze of candles in silver-gilt lanterns and candelabra focused attention on the statue of St. Anthony. At the south end of St. Michael's Gallery doors led to the Yellow Withdrawing Rooms (two connected rooms) and Beckford's private apartment looking back toward the Great Western Hall across a private courtyard—the Fountain Court. Other bedroom suites were located on upper floors of the tower, the east wing, and above the Vaulted Corridor where a state bedroom—the Lancaster Suite—extended up into a four-story tower. Beckford was an inveterate collector of the curious, the rare, the beautiful, and the expensive and the house was furnished with carved and inlaid pieces, jewel-encrusted objects, and a superb collection of fine art (some pieces from the collection remain the property of the Dukes of Hamilton, Beckford's descendents, while most are in major art galleries in Britain and the United States).

A *basement* service floor extended beneath the whole house and multiple small staircases allowed quiet and discreet servants to readily access every room. Elaborate gardens surrounded the house and there was even a tunnel beneath a public road allowing Beckford to pass unobserved by the curious.

There is one story of Beckford's eccentricity and a curious interloper: a young gentleman, wanting to see Fonthill Abbey, was able to get into the grounds when the gates were opened to admit a cart. Approaching the house he was challenged by a gardener who, hearing his request, showed him around. On entering the house the gardener revealed himself to be Beckford himself and the visitor was treated to a tour of the house and a fine dinner. At 11:00 PM his host disappeared and a footman showed the young man out of a door saying, "Mr. Beckford ordered me to present his compliments to you sir and I am to say that as you found your way into Fonthill Abbey without assistance, you may find your way out again as best you can, and he hopes that you will take care to avoid the bloodhounds that are let loose in the gardens every night. I wish you good evening, sir." The young gentleman spent a worried night up a tree as the hounds circled below.

Wyatt was one of the most gifted architects of the period, capable of work on a par with Robert Adam, William Chambers, or John Soane. At Fonthill Abbey he demonstrated his ability to compose a dramatic silhouette and create theatrical spaces. The layout of the plan is, at first, illogical, being neither based on religious or residential precedents, but comparison with the plan of the old Palace of Westminster (destroyed 1834) shows where Wyatt got his inspiration and in turn Fonthill Abbey was the source for the plan of the new Palace of Westminster, **The Houses of Parliament**, by Sir Charles Barry. Wyatt was, however, also a dishonest drunkard, forever promising what he could not achieve, leaving in his wake numerous frustrated and angry clients. Beckford called him "Bagasse"—Whoremonger—but nonetheless, as Strong writes, "the combination of these two impossible people [Beckford and Wyatt] gave birth to the most bizarre and original building in Western Europe at the time." Wyatt was killed in a carriage accident on September 4, 1813, while overseeing construction of his Neoclassical masterpiece, Dodington Hall in Gloucestershire, and soon afterward, Beckford's dream world was to come to an end. He had spent his fortune on his collections and Fonthill Abbey and a slump in sugar prices drastically reduced his income. By the early 1820s he was deeply in debt and in 1822 sold some pieces from the art collection and opened the house for public viewing—Beckford with his scandalous past and mysterious house hidden behind The Barrier had intrigued a whole generation. Later, in 1822, Fonthill itself was sold for £300,000 and a year later most of the collection was sold, Beckford taking the best pieces to his new house in **Bath** where he soon built another, though much smaller, tower beside which his daughter, the Duchess of Hamilton, placed his tomb. Beckford died in 1844, having spent his last years as a curiosity, a relic of a distant age, pointed out as he drove by in his carriage.

John Farquar, the new owner of Fonthill Abbey, had made his fortune manufacturing gunpowder during the Napoleonic Wars, but he did not enjoy his new house for very long. On the night of December 21, 1825, the tower collapsed again. The contractor had admitted that the foundations had been scrimped, so fast did Beckford want the walls to rise—and Wyatt had not no-

ticed anything amiss. The 300-foot tower collapsed across the Fountain Court, destroying most of the Great Western Hall and Beckford's private apartment—the statue of Alderman Beckford stared out across the ruined walls. Fonthill Abbey had become the folly Beckford had originally intended: a ruined convent—"Would to God it were more substantially built! But, as it is, its ruins will tell a tale of wonder" (C. F. Porden). All that remains of the great house of Fonthill Abbey is the northern end of the great axis: the Vaulted Corridor, the Sanctuary, and the Oratory with the Lancaster Suite above, all stripped of their contents and used as a farmer's storeroom. The estate was divided and sold. In 1856, close to the remains of the Abbey, the Marquess of Westminster (see **Eaton Hall**) had Fonthill House built to the designs of William Burn (1789–1879), rather improbably in the Scottish Baronial style (see **Balmoral Castle**); close to the site of Fonthill Splendens stood Lord Margadale's Little Ridge, built in 1904 to the designs of Detmar Blow (1867–1936)—both these houses have been demolished and behind its gate lodges Fonthill Park is now disappointingly empty.

Today Beckford and Fonthill Abbey still capture the imagination. Beckford's tomb in Bath and the remains of the Abbey are sought out by intrigued pilgrims intent on finding out more about this amazing character and the world he created, a world that "had it survived intact, would have been England's supreme example of the Romantic imagination expressed through architecture."

Further Reading

Fairclough, Peter, ed. *Three Gothic Novels* (including Beckford's *Vathek*). Harmondsworth, U.K.: Penguin Books Ltd., 1983.

Strong, Roy. *Lost Treasures of Britain*. London: Penguin, 1990.

GLASGOW SCHOOL OF ART, GLASGOW, LANARKSHIRE, SCOTLAND

Style: Victorian (Art Nouveau)
Dates: 1897–1909
Architect: Charles Rennie Mackintosh

Scotland is divided into two regions: to the north the Highlands, to the south the Lowlands. The Firth of Clyde on the west coast and the Firth of Forth on the west coast mark the dividing line, approximately a third of

the way up the country from the border with England. The Clyde and Forth rivers virtually cut Scotland in half leaving only a narrow land bridge, a few miles long, where the Romans built the Antonine Wall (see **Hadrian's Wall**). Scotland's two greatest cities are Edinburgh, the capital city, on the Firth of Forth, and Glasgow on the Firth of Clyde. In the nineteenth century Glasgow was one of Britain's major industrial centers and the consequent wealth generated led to a vibrant cultural life patronized by the newly rich middle and upper classes. In the twentieth century Glasgow suffered the decline of many of its industries and much unemployment and dereliction; it has experienced a revival and is now a bustling modern city. One of the results of the early industrial wealth was the establishment, in 1845, of the Glasgow School of Art; at the end of the century the school moved into its own, purpose-built premises designed by Scotland's most famous architect, Charles Rennie Mackintosh (1868–1928).

Mackintosh trained at the Glasgow School of Art, which has always had an architecture program, and in 1889 he was working for Honeyman & Keppie, Glasgow's leading architectural firm. Mackintosh's work with Honeyman & Keppie demonstrates a keen interest in Scotland's architectural heritage, the ancient tower houses (see **Craigievar Castle**), the Scottish baronial style (see **Balmoral Castle**), and the tenements (apartment buildings) of Glasgow and Edinburgh. Glasgow had been the home of one of Britain's most creative Neoclassical designers, Alexander "Greek" Thomson (1817–1875), and his influence still pervaded the city's architects. Mackintosh is perhaps most famous for his furniture of black lacquered wood featuring close-spaced vertical bars, which remains fashionable to the present day. The Glasgow School of Art is his largest and best-known building, but he is also remembered for the Willow Tea Rooms of 1904, still open at 217 Sauchiehall Street and 97 Buchanan Street and Hill House of 1903 in the Glasgow suburb of Helensburgh. The tea rooms feature some of Mackintosh's most intricate interiors and Hill House, built for the publisher Walter W. Blackie, is currently being restored with its light pastel and silver interiors that were such a contrast to the dark Victorian décor of the time. Mackintosh's designs, with their extenuated verticals, naturalistic decorations, and unexpected colors, fit the style known as the Art Nouveau, exemplified by the work of Belgian architect Victor Horta but in a particularly idiosyncratic way.

From 1845 to 1869 the Glasgow School of Art was based in a commercial building on Ingram Street. It then moved to rooms in the McLellan Galleries, the city's art gallery, but these were woefully inadequate, described as "ill adapted for the purposes of a school of art . . . with the aggravation of the grey dull atmosphere prevailing here for half the year the students labour under positive disadvantages" (from a report by an examiner from the government's Science and Art Department). In 1885 the director resigned "in consequence of the apathy that is shown towards the institution" and was replaced by English painter Francis H. Newbery (1855–1946). Newbery was the energetic spirit that led to the move to the new premises in 1897.

As early as 1882 plans for a new school, part of a museum and art gallery, were proposed but had come to nothing. Ten years later, Mackintosh, working at Honeyman & Keppie, put forward a design for a new School of Art that in its plan and massing owed something to Leeds Town Hall but detailed in the style of Thomson. The idea for the new building, pushed by Newbery, was developed and an approach to the Bellahouston Trust provided the promise of funds up to £10,000, matching private donations. A few months later a half-block site on Renfrew Street, between Scott and Dalhousie Streets, was purchased and plans for the new building continued apace with plans for a design competition limited to twelve local firms. The competition brief, written by Newbery, required plans, a longitudinal section, two cross sections, and three elevations—north, east, and south (presumably considering that the building would be symmetrical and the two side elevations identical). The brief stated that the south elevation "may not have any lights (windows) in its walls (because of neighboring buildings) . . . except perhaps in the upper floor which would contain the Director's room, in a central position, with his studio on the north side where the spaces should be, as far as possible rigidly kept for classrooms with the windows free from mullions and small panes, and should be the length of the room. The school museum need not be a special room, but might be a feature in connection with the staircase." In addition there needed to be a library, two lecture theaters, and studios for multiple arts including one for still life and painting adjoining "a conservatory, with an exposure to the sun, in which plants and flowers, when not in use, may be kept." The selected architects all submitted a joint letter saying the proposed building could not be built for the £14,000 available (the site had cost £6,000) so an addendum asked that each submission show a phased construction. On January 13, 1987, the firm of Honeyman & Keppie with Charles Rennie Mackintosh were announced as the winners; some claim there was a fix but the resulting building is nevertheless outstanding.

Mackintosh closely followed the given brief providing four floors of north-facing studios (artists studios are best facing north as the light from that direction does not change with the sun) in a nearly symmetrical building; three *bays* to the left, four to the right of a complex central feature comprising the main entrance and the director's office and studio. The building's cross section is very complex; between the sidewalk railings and the main wall of the building sloping glass skylights admit north light into the *basement* studios; the first floor features studios in relatively conventional rooms with large north windows. Above, on the second floor are the painting studios, two stories high with vast north windows and skylights created by setting back the top floor where the director and professors had their studios. Long hallways running the length of the building divide the north studios from the support rooms on the south side. The site slopes steeply from front to back, north to south, and therefore there is a sub-basement in the southern half and, relative to the high rooms on the north side, several more floors for bathrooms and storerooms. The desired phasing was achieved by allowing the library, a

large component of the design, to be built later and this was done in 1907–1909 when additional funds had been raised.

Mackintosh's decorative iron railings and window cleaners' guards, based on Japanese heraldic devices, enliven the north elevation, with its huge windows and castle-like central entrance. On the east side the hierarchy of spaces is evident from the Board Room with its tall *bow windows* above the smaller windows of offices and the caretaker's flat (apartment). The north elevation could almost be that of an ancient Scottish castle; the expanses of blank wall, the variety of forms and window sizes, the multiple levels lead to a dourness only enlivened by the unexpected bays of the *loggia* high up toward the west end, and the cantilevered *conservatory* on the top corner of the library tower providing that required home for flowering plants requested in Newbery's brief. The library tower, on the southwest corner, was built as part of the second phase and Mackintosh revised the elevations compared to the competition submission. He had traveled south to England and seen the tall bay windows at such houses as Montacute, Somerset and these led to the elongated bays on the west elevation of the School of Art that rise through three floors of the library. The west elevation, particularly that of the library tower, is much more plastic with rounded stone projections between the windows: a development in Mackintosh as a designer is evident.

Inside, much that Mackintosh designed has remained or been restored: furniture, wall finishes and colors, ironwork, leaded glass (different motifs in the doors identify the different studios), and colored tiles. Some of the brick-vaulted circulation spaces—the lobby and upper corridors—have been whitewashed but most are still as designed by Mackintosh, lined with recessed wooden seats separated by niches for plaster cass of statues. Even the smallest or most insignificant rooms are enlivened by careful details, but outstanding are the Director's Office, one of Mackintosh's first white rooms; the Mackintosh Room, the original Board Room; the dark-paneled new Board Room of 1907 with its fluted *Ionic pilasters*; and the galleried Library, the books behind leaded glass, so richly dark the upper reaches become mysterious though enlivened by the jewel-like glisten of the metal central light fixtures inset with colored glass. The Library, with its tall bays, complexly detailed gallery, furniture, and metal lights is Mackintosh's tour de force, his greatest achievement.

The Glasgow School of Art continues as one of the few remaining independent art schools in the United Kingdom with 1,500 students studying in ten fine art and design departments and the Mackintosh School of Architecture.

Further Reading

Charles Rennie Mackintosh Society. www.crmsociety.com.
Glasgow School of Art and Mackintosh School of Architecture. www.gsa.ac.uk.
Macauley, Dr. James. *Glasgow School of Art*. London: Phaidon Press Ltd., 1993.
Willow Tea Rooms. www.willowtearooms.co.uk.

HADDON HALL, DERBYSHIRE, ENGLAND

Style: Mediaeval
Dates: 1070–1624 (several periods of construction)
Architects: Unknown

The great ducal mansion of **Chatsworth**, home of the dukes of Devonshire, is known as the Palace of the Peak. Leaving Chatsworth, heading south following the River Derwent to the junction with the tributary River Wye, a turn to the west and a short distance brings one to another ducal mansion. This is Haddon Hall, the secondary home of the Dukes of Rutland, the "most romantic house in England," and certainly one of the best preserved mediaeval houses in the country.

The fact that this sleeping beauty of a house has survived is due to the elopement and marriage, c.1560, of the daughter of the then owner Sir George Vernon, known as the "King of the Peak." (The Peak District is a mountainous region in north-central England). Dorothy Vernon escaped from her notoriously bad-tempered father to meet her lover, John Manners, a younger son of the 1st Earl of Rutland of Belvoir Castle. While her father was distracted by entertaining guests at a banquet, Dorothy left Haddon through a side door off the Long Gallery and made her way across the gardens and down seventy-six stone steps to the bridge over the river where John Manners was waiting. Whether this romantic version of their marriage is true or nineteenth-century fiction cannot be determined, but the story is often told, the route of her escape preserved, and certainly it was this marriage that eventually brought Haddon Hall into the possession of the Manners family. Sir John and Lady Dorothy Manners inherited Haddon, passing it on to their son Sir George Manners and his son, another Sir John Manners. The latter inherited the earldom of Rutland in 1641 and the Manners family moved to Belvoir Castle in Rutland, which, after several rebuildings, resulted in the fairy-tale Gothic castle that dominates the Vale of Rutland. Haddon Hall was left to hibernate in its remote valley for 300 years.

The approach to Haddon Hall is not grand or impressive. A narrow country lane passes by farms, stone houses, and barns surrounded by fields bounded by dry-stone (no mortar) walls. The River Wye bubbles and froths over boulders and waterfalls; across the valley, through the trees, stone towers, *turrets*, and chimneys can be glimpsed. A short drive leads from the road to an open area of gravel and grass backed by a serviceable, barn-like building (now the ticket office and restaurant) from where a short, steep path leads to the gatehouse of Haddon Hall. The scale of the house is not discernable

from here as the gatehouse is on the very northwest corner. Haddon was never a castle; it was always a manor house never intended to resist a siege, and the *battlements* that top the gatehouse tower and much of the rest of the building are purely decorative. The high Gothic (pointed) archway contains the original, much-weathered and restored wooden gate that opens to reveal the Lower Court. The gate closes and the visitor, observing the worn paving and the irregular plan with the Chapel to the right and the Great Hall to the left, is taken back 600 years.

The original builder at Haddon was "Peverel of the Peak," an illegitimate son of William the Conqueror who is remembered by the Peverel Tower. By the early twelfth century the manor was owned by one William Avenel from whom it was inherited by the Vernons. A rectangular figure eight in plan formed by narrow ranges of rooms all around the sides and divided into two courtyards—the Lower and Upper Courts—by the Great Hall. Most of the walls except those of the Great Hall were in place by 1250. It is probable that there was a hall on the site of the Great Hall but this was rebuilt c.1370 by Sir Richard Vernon. Later improvements from around 1500 for Sir Henry Vernon, who was treasurer to Arthur, Prince of Wales, the short-lived elder brother of Henry VIII (r. 1509–1547), included a parlor and the Long Gallery.

The mediaeval great hall developed from the "hall house" in which the whole lordly household had lived, ate, and slept with privacy for the lord and his lady provided by curtains. The fireplace was a stone slab in the center of the room, the smoke escaping through a vent on the ridge of the roof. The function of the hall evolved so as to reinforce the importance of the lord whose successes politically or militarily assured the livelihood of the household. The elaborate ceremonial honoring the lord (or the most important visitor if a higher ranking baron or the king should arrive) survives to this day as the formal banquet. In its developed form the great hall was entered at one end of the long side though a porch into an area called the Screens Passage. To one side a wooden *screen* partly concealed the main hall and helped reduce some of the drafts. The screen usually had three sections of paneling, often richly carved, forming two openings into the great hall; the central part of the screen was usually fixed but sometimes moveable. The screen supported a minstrel's gallery, overlooking the hall, above the entrance passage. In the hall the central hearth moved to a side wall after the invention of the chimney and provided another opportunity for heraldic carvings. At the far end of the hall stood the high table, sometimes raised on a dais, and usually lit by a large *bay* window that also provided a quiet recess for courtly dalliances—the mediaeval nobleman's household was predominantly male with only a few female attendants for the lord's lady and daughters; the codes of chivalry and courtly love developed to curb unseemly behavior. In the very center of the high table, facing down the length of the hall, was the lord's chair, enhanced by a richly embroidered canopy of state that hung overhead. The daily dinner ritual was designed to demonstrate the importance of the lord to his household and visitors; he sat in his high chair with

the most important members of the household ranked in strict order of precedence to either side at the top table. Less important members of the household sat at the long tables that ran down the two sides of the hall with the lowliest scullion boy seated closest to the screens where it was coldest. (There is an expression indicative of relative importance that says a person sits above or below "salt." In mediaeval times salt was an expensive commodity used to enhance the flavor of the [generally poor] food; only the most important diners were allowed to take salt from the elaborately decorated "salt" that moved down the table to its specified limits on small wheels.)

The meal was served with great ceremony, trumpets heralding a procession of huge platters featuring whole suckling pigs or great sides of roast beef (which, to us, would have been very tough, full of fat and gristle). The lord would be offered the best pieces and then the platters passed down the table until it reached the least important diner. The huge kitchens needed to produce these daily banquets were on the opposite side of the screens passage beyond the buttery [from the French "boteille" (bottle) and where the wine or ale was stored] and the pantry [from the French "pain" (bread) where bread and pastries were cooked and stored]. The kitchen was sometimes in a separate building to protect the great hall from the danger of fire. Several houses have survived with the mediaeval hall, buttery, and pantry extant: Penshurst Place, Kent (1341–1348), still has the central hearth and roof vent; Stokcsay Castle, Shropshire (1285–1305), has an attached defensive tower; while at Haddon Hall the whole layout survives with the detached kitchen later connected via an enclosed passageway.

As the nobleman's household evolved the family demanded more privacy and at Haddon there is a parlor paneled with dark aged oak featuring carvings representing the family's alliances and loyalty to the king. This room is now the Dining Room but when it was first built it would have been a warm retreat from the noisome hall where the family took all or some courses of their meals leaving the top table empty. Up a floor is the Long Gallery that the first Sir John Manners paneled in the newly fashionable Classical style. This huge room (110 feet by 17 feet) is full of light, having windows on both sides that render the originally painted woodwork a glorious warm gray. The great bay windows of diamond leaded glass have sagged and buckled over the years and their multifaceted panels play with the light internally and particularly outside by moonlight from across the terraced gardens.

It was only in the 1920s when the future 9th Duke of Rutland came to Haddon Hall during vacations to sketch and paint that the family renewed interest in the house and carried out a thorough and sympathetic restoration. Although used for many years as a summer home, considered too cold to live in during winter months, the house is now the home of Lord Edward Manners, the brother of the 11th Duke of Rutland.

Further Reading

Haddon Hall. www.haddonhall.co.uk.

HADRIAN'S WALL, BOWNESS-ON-SOLWAY TO WALLSEND-ON-TYNE, CUMBRIA, NORTHUMBERLAND, AND TYNE AND WEAR, ENGLAND

Style: Roman (Military Engineering)
Date: 122 C.E.
Architects: Roman military engineers following the instructions
of the Emperor Hadrian

The first Roman to venture across the English Channel was Julius Caesar in 55 B.C.E. He found a country of little promise ruled by fiercely territorial tribal kings and dominated by Druidic religion. It was not until 43 C.E. that the Emperor Claudius decided to incorporate the islands called Britannia into the expanding Roman Empire. Britannia had resources of lead and gold and Claudius also wanted to quell the Druid priests who were fomenting trouble in northern Gaul (modern France). King Caractacus of the Belgic tribe and later Queen Boudicca of the Iceni put up fierce resistance, but eventually were defeated by the powerful Roman legions; the Druids retreated to the Island of Mona (Anglesey) or the northwestern coast of Wales where their influence soon waned. The Romans quickly took control of southern Britain and Wales but in the north two tribes, the Picts and the Scots—the latter raiders from Ireland—were particularly troublesome, attacking farms, villages, and travelers. In 122 C.E., the Emperor Hadrian, an emperor who visited all corners of his empire, decided that there were boundaries to his control and it would be better to just stop the Picts and Scots in their tracks rather than try to overcome and control them. His answer was a defensive wall stretching seventy-three miles from the western Solway Firth to the eastern North Sea that became known as Hadrian's Wall.

The four centuries of *Pax Romanum* (Roman Peace) that Britain enjoyed from the invasion of 43 C.E. to the early fifth century, when contact between Rome and Britain was severed, saw a society that rapidly advanced to the highest levels of civilization known, and then, just as quickly, slipped into the confusion and uncertainty of the Dark Ages that followed the collapse of the Roman Empire. Large cities were founded and although most were abandoned after about 450, their sites were well chosen and under nearly every modern city are found the remains of its Roman beginnings. London, **Bath**, **Chester**, York, and all the places whose names end with caster, chester, ces-

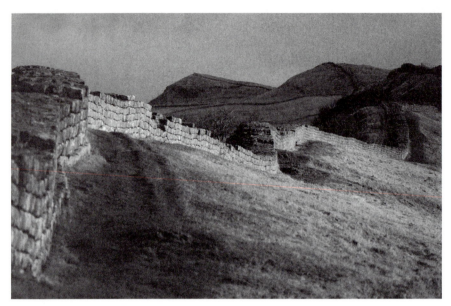

Hadrian's Wall. The wall snaked across the rugged landscape of northern Britannia. *Harcourt Index.*

ter (for example: Lancaster, Manchester, Leiccster, Worcester) began as Roman cities or fortresses. These cities were prosperous and luxurious with the requisite forum (central plaza), temples, basilicas (law courts), theaters, and amphitheaters seen in Roman cities across the empire. While interesting, none of the architecture of urban Roman Britain equaled that of more important provinces and it is generally overlooked in discussions of Roman architecture. Similarly, villas, the country houses at the center of large agricultural estates, have been discovered with frescoed walls, mosaic floors, and the intriguing hypocaust under-floor heating system, but compared to the villas of Italy and Gaul they are provincial and crude; an example of a large Roman villa can be seen at Fishbourne, near Chichester, Sussex. The contribution to Roman architecture and engineering that was built in Britain is Hadrian's Wall.

Hadrian's Wall is a massive feat of engineering crossing not only verdant valleys near the coasts but inhospitable, craggy mountains of inland Cumberland (now called Cumbria) and Northumberland. The original design featured a stone wall averaging sixteen feet high and ten feet wide with a walkway along the top. At approximately one-mile intervals a small fortress called a Milecastle protected a gate through the wall and between each of these were two manned observation turrets. The siting and distances of milecastles and *turrets* were carefully surveyed so that communication by flags or lamps could be maintained. As construction continued the plan changed and sixteen major forts were also added along the length of the wall, adding more

men to the control of the border. Thus, the final wall had the sixteen forts at approximately five-mile intervals, the milecastles at one-mile intervals, and the turrets at one-third-of-a-mile intervals. An attack on the wall at any point could be readily observed and soldiers rushed along the wall atop the walkway or along a parallel road—the Military Way—a short distance to the south of the wall. To protect the wall and more thoroughly control passage through the wall there was a deep v-shaped ditch, the glacis, on the north side that could only easily be crossed at the forts and milecastles. Earthworks, called the vallum, also protected the south side of the wall and were composed of two embankments running parallel to the wall with a flat-bottomed ditch in between. Thus, the section from north to south of the "wall" was composed of the v-shaped ditch, the stone wall, the vallum—embankment, ditch, embankment—and finally the road, the Military Way. Variations in geography meant some changes to this section occurred; for example, craggy cliffs allowed for the omission of the v-shaped ditch. Built by the soldiers of the 2nd, 6th, and 20th Legions (each legion consisted of about 5,500 men), and despite the changes to the design, it only took six years to complete Hadrian's Wall.

The forts were like small cities with the largest housing a garrison of over 1,000 soldiers. Close by, outside the walls of the fort, was a civilian town, called a vicus, which supported the fortress. The forts were laid out on the typical Roman plan of a rectangle with gateways in the center of each side leading to the main streets that crossed at the center where the main plaza would be overlooked by the headquarters building, the Principia. The east–west street, a continuation of the Military Way that paralleled the wall, is considered the most important and is called the Via Principalis or the Via Praetoria. Other buildings within the fort included several barracks divided into ten rooms each accommodating ten soldiers plus a larger room for the centurion, the battalion leader; a basilica (drill hall) where statues of the emperors were displayed; granaries (with enough food to last one year for the whole garrison); a hospital called the Valetudinarium that included a surgery; and the commander's house (usually with an adjoining private bath house). The walls of the fort were not very thick but were reinforced with a sloping rampart of clay and earth.

The wall was not the border between two countries with the gates acting as passport or customs control points. Rather, the wall was a convenient barrier that allowed the control of movement from Roman Britain to the area north of the wall that was under Roman military jurisdiction but vulnerable to attack from farther north. The wall meant that the movements of agitators could be observed and controlled; only occasionally was it used defensively to protect the lands to the south. In 143 c.e., a turf wall, the Antonine Wall, was built much farther north in modern Scotland, but this was abandoned in 185. Twelve years later the barbarians from the north managed to overrun the wall and caused major damage that was not repaired until 208 during the reign of the Emperor Septimius Severus. The troops who gar-

risoned the forts, milecastles, and turrets were usually auxiliary soldiers, mercenaries who volunteered for the Roman Army knowing that after twenty-five years of service they would be awarded citizenship of the Roman Empire. The wall was manned until the early fifth century when threats to the core of the Roman Empire caused the abandonment of distant Britannia; the legions just marched away and the island was left vulnerable to attacks from the Scots and Picts to the north and from the east the Angles and Saxons across the North Sea.

Abandoned, the wall and all its forts quickly fell into ruin. Later some towers and gatehouses were incorporated into farmhouses and many nearby farm buildings are built using stones from the wall. In 1745, the second Jacobite rebellion in support of the deposed royal House of Stuart threatened England with attack from Scotland. The wall would not be of use but the English commander, the Duke of York, caused the Military Way to be refurbished so that he could readily move his troops to the spot where the rebels crossed the border. The duke's road is still a major east–west highway called the Military Road, and from it the remains of Hadrian's Wall can be seen as it marches across the countryside.

Further Reading

Museums, Libraries and Archives Council Web site relating to Hadrian's Wall. http://museums.ncl.ac.uk/wallnet/.

Stierlin, Henri. *The Roman Empire, Volume 1: From the Etruscans to the Decline of the Roman Empire.* Cologne: Benedikt Taschen Verlag GmbH, 1996.

HAMPTON COURT PALACE, LONDON

Styles:—Renaissance—Tudor and Baroque
Dates: 1514–1536; 1689–1699
Architect: Sir Christopher Wren (seventeenth century)

Until the mid-nineteenth century the River Thames could be considered to be the main street of London. To the east the City of London and to the west the City of Westminster faced the river and although they were connected by The Strand, lined by the mansions of the nobility, the river was crowded and busy with boats, barges, and ferries. Therefore, the prime locations were beside the river where boatmen could be summoned to private docks or public quays and destinations quickly and easily approached. The rich had elaborately decorated private barges while poorer people paid a fare to an oarsman in a tiny skiff. Upriver, to the west, the rich had sub-

urban houses that were out of the smoke and pestilence of London yet still readily accessible by water. Thus developed such places as Chelsea, Richmond, and Chiswick. Traveling a little further on the north bank, as the river makes a curving bend, one sees first the great avenue of a huge formal park and then the red brick and white stone *façades* of a huge palace. This is Hampton Court Palace, the palace of kings and queens from Henry VIII (r. 1509–1547) to George II (1727–1760). Hidden within and behind the symmetrical ordered buildings that were designed by Sir Christopher Wren for William and Mary (r. 1689–1702) are the Great Hall, kitchens, and indoor tennis court of Henry VIII's fantastic palace that overwhelmed the house built by his Lord Chancellor, Cardinal Thomas Wolsey. In its three phases, Hampton Court was innovative and inspirational and we are lucky that George II so disliked the place that it has survived virtually unchanged from the mid-eighteenth century to the present day.

The earliest buildings at Hampton Court were storage and administrative buildings, erected after 1236 by the Knights Hospitallers of St. John of Jerusalem, a religious order, at the center of estates they owned in the area. The country air but convenient river situation was attractive, and in 1503 Henry VII (r. 1485–1509) and his wife Elizabeth of York visited the country house of the Abbot of the Order of St. John at Hampton Court. In 1505, Sir Giles Daubeney, the Lord Chamberlain, had leased the house for ninety-nine years and entertained on a grand scale (for an explanation of the lease system see **Terraced Houses**). The lease fell vacant on Sir Giles's death in 1508 and in 1514 a new ninety-nine-year lease was taken by Thomas Wolsey (c.1475–1530), the Chief Minister to the young King Henry VIII, and recently appointed Archbishop of York (see also **The Banqueting House**). Wolsey, from relatively obscure and humble beginnings, had risen fast in the hierarchy of the Roman Catholic Church, which religiously and politically dominated the country at this time. He was soon to reach the highest religious and secular positions of Cardinal and Lord Chancellor. Even before he reached this apogee Wolsey planned a new palace at Hampton Court fit for his position, consulting a book published in Rome in 1510 that included advice on the ideal cardinal's palace: *Paolo Cortese's de Cardinalatu.*

Hampton Court Palace occupies an area 700 by 400 feet with the long axis running east–west. The long south *façade* faces the river, the east façade the *park*, and the west façade the entrance courtyard. Within the palace are three main courtyards, from west to east the Base Court, the Clock Court, and the Fountain Court. Along the north side are service areas and smaller courtyards. Wolsey's Hampton Court remains as the Base Court, part of the Clock Court, and some of the north wing, while Henry VIII commissioned major changes, some of which can be seen in the Clock Court and north wing. Sir Christopher Wren's designs for William and Mary demolished Wolsey's and Henry VIII's *apartments* in the southeast quadrant; the plans called for the total demolition and rebuilding of the old palace but the money was (luckily) not available.

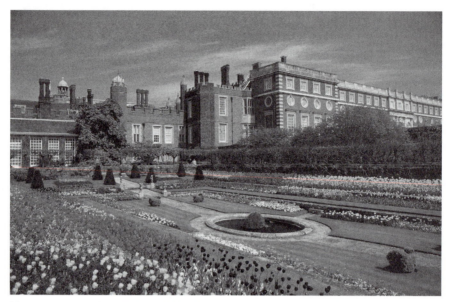

Hampton Court Palace. Tudor and Elizabethan to the left, Sir Christopher Wren's remodeling is to the right. *Harcourt Index.*

Cardinal Wolsey's Hampton Court had puzzled scholars with its idiosyncratic carvings and planning anomalies. It was only in 2001 that the design and its inspiration were understood. Careful measuring and archaeological digging confirmed a rational plan based on two eight-pointed stars placed side by side. The walls of the surviving, perfectly square, Base Court follow geometric lines and the digging discovered the foundations of demolished buildings that would have completed the design. Such careful and harmonious design was known in Italy at this time but not in England, where building was organic and additive with no overall plan. The research led to *Paolo Cortese's de Cardinalatu* and the answer to questions about even the smallest details: the series of round terra cotta bas-relief sculptures of Roman Emperors made for Wolsey in 1521 by the Italian sculptor Giovanni da Malano are suggested in the book. These discoveries confirm Wolsey's Hampton Court as the first Renaissance building in England.

The lavishness of Hampton Court attracted Henry VIII's attention, to which Wolsey responded, "To show how noble a place a subject may offer his sovereign." Words to be rued as a few years later when, unable to obtain permission from the Pope for the King's divorce from the first of his six wives, Catharine of Aragon (and in consequence prevent the collapse of Catholic power in England and the establishment of the Protestant Church of England), Wolsey saw his influence waning and he offered Hampton Court as a gift to Henry. The King confiscated all Wolsey's properties and the once powerful Cardinal died in 1530, escaping charges of treason and an inevitable execution.

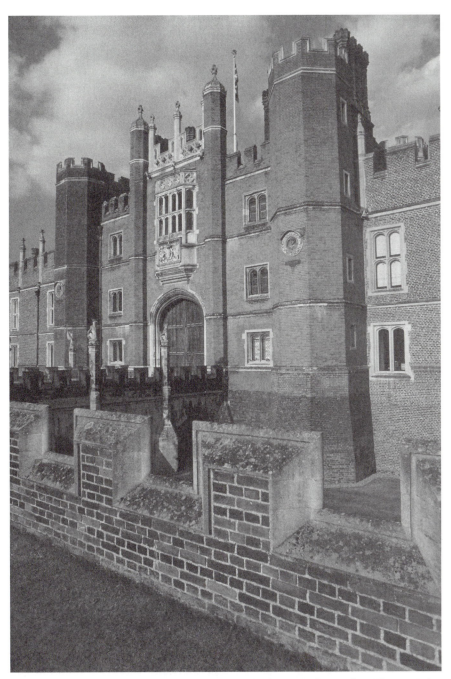

Hampton Court Palace. The entrance gate to Cardinal Thomas Wolsey's palace. *Harcourt Index.*

Henry commissioned major building work at Hampton Court, eventually spending £62,000 (approximately the equivalent of $40 million today) to rebuild the Great Hall, remodel the Chapel Royal—a sumptuous essay in late Gothic Perpendicular—and extend the kitchens to 36,000 square feet, capable of supplying food to 1,500 guests as in 1546 when the French ambassador and a retinue of 200 were entertained by Henry and the full court of 1,300 officials and attendants. The changes, however, while splendid, were carried out in the typical mediaeval haphazard way without an understanding of the grand plan of Wolsey's design and the clarity was lost until revealed 450 years later. At this time was built the indoor tennis court where the unusual game of Real Tennis, more like racquetball or squash, is still played. The south and east wings of the palace contained the king's apartments—remodeled at least six times—and those of the six wives. The screams of Catharine Howard, wife number five, are said to haunt a gallery near the Chapel Royal where she realized her fate was to be **The Tower of London** and an appointment with the executioner.

Hampton Court, at the time of the death of Henry VIII, was the most up-to-date and magnificent palace in the realm, far outshining Whitehall, Greenwich, or Richmond. Later monarchs did little to change the palace, occasionally enjoying its increasingly old-fashioned accommodations and the large adjoining hunting preserve. It was nearly 150 years later that Hampton Court attracted the attention of the recently crowned William III, who was co-monarch with his wife Mary II. The hunting and the fresh air were attractive and Sir Christopher Wren was commissioned to rebuild the palace. Sir Christopher Wren was England's most important architect, working on the rebuilding of **St. Paul's Cathedral** and many churches after the Great Fire of London in 1666. Wren had recently visited Paris and his original designs owe much to the south front of the Louvre as completed by Le Vau in 1664 for Louis XIV. But the final design owes more to Louis's other new palace at Versailles: the new Hampton Court with its strong horizontal lines, resembles the west façade of the Chateau of Versailles anglicized by the use of red brick with white stone details. With his designs for Hampton Court and other royal commissions, Wren established an architectural style, based on Classical precedents, which was to become known as Georgian and dominate the eighteenth century.

Wren's master plan for Hampton Court retained only Henry VIII's Great Hall of c. 1540 and would have removed all the sixteenth-century work. However, only two wings containing separate apartments for the King and Queen were built extending some 300 feet along the south and east fronts overlooking the Privy (private) Garden and the formal avenues of the *park*, respectively. Within and behind the new wings Wren created the Fountain Court that, with its repetitive elevations rising from an arcade, through a *piano nobile* (noble or main floor), a level of round windows to an attic of square windows overwhelm the relatively small courtyard. The exterior elevations are more successful if ponderous and massive; the contrast of the final

result to Wren's original design suggests to Summerson, "somebody was anxious to emulate at Hampton the regal monotony of the park front of Versailles." Maybe the usurpers William and Mary wanted to legitimize their reign by visual association with the grandest monarch in Europe. The formal arrangement of apartments for king and queen or even lord and lady reached its most elaborate at this period and in Britain can be seen at Hampton Court and at such houses as Castle Howard and **Blenheim Palace**.

Mary II died in 1694 and work on the new wings at Hampton Court was delayed and was still incomplete when William III died in 1702 following a hunting accident in the nearby park. Queen Anne also enjoyed the hunting but did little to alter or complete the palace and it was the Prince and Princess of Wales, later George II and Queen Caroline, who completed the royal apartments 1715–1718. The last work for the royal family at Hampton Court was the Duke of Cumberland's apartment completed in 1732 to the designs of William Kent. In July 1737, the last full court occupied the whole palace; a few months later Queen Caroline was dead and the King never returned. George III (r. 1760–1820) recalled too many family quarrels there and hated the place: "I should not be sorry if it had burnt down." The furniture was removed and the palace divided in to "grace-and-favour" apartments, rent-free accommodation awarded to those who had given service to the Crown or country.

In 1986 a fire began in a grace-and-favour apartment above the King's Apartments in the south Wren wing. The damage was extensive but was also seen as an opportunity, and when Queen Elizabeth II (r. 1952–) re-opened the King's Apartments in 1992 they had been restored to their appearance in 1700 as completed for William III, with most of the furniture, tapestries, paintings, and ornaments, still in the Royal Collection, returned from other palaces. The restoration of Hampton Court after the fire was a conservation success and saved several nearly lost arts as apprentices trained with old craftsmen to rebuild what was lost using old skills. It was many of these skilled craftsmen who were to work at **Windsor Castle** after the great fire there in 1992.

Further Reading

Historic Royal Palaces. www.hrp.org.uk.

Summerson, John. *Architecture in Britain 1530–1830*. New Haven, Conn.; London: Yale University Press, 1993.

Thurley, Simon. *Hampton Court: A Social and Architectural History*. New Haven and London: Yale University Press, 2003.

Wessex, Edward (The Earl of Wessex). *Crown and Country: A Personal Guide to Royal London*. New York: Universe Publishing, 2000.

HARDWICK HALL, DERBYSHIRE, ENGLAND

Style: Renaissance—Elizabethan
Dates: 1590–1597
Architect: Robert Smythson

In 1527, at the manor of Hardwick in the remote northern county of Derbyshire, Elizabeth Hardwick was born; the fourth child and third daughter of a farmer-squire whose meager landholding extended to only a few hundred acres. When she died in 1608, Bess of Hardwick (as she is usually called) was the titled Countess of Shrewsbury, the wealthiest person in the country (probably even including the king), the owner of over 100,000 acres of land, and the matriarch of a family—the Cavendishes—that was to be among the most important socially and politically until the present day. She oversaw the construction of two great houses both of which survive, **Chatsworth House**, much changed by later generations, and Hardwick Hall, which stands virtually unchanged since the day of her death in February 1608. Hardwick is a breathtaking house sited high on a hill surveying the countryside, its compact vertical form reaching up to the sky with six towers topped by a *balustrade* incorporating Bess's initials "ES" (Elizabeth Shrewsbury) in letters six feet high. The sun projects a dazzling rainbow of colors as it reflects off the huge multipaned windows that fill each *façade*, which inspired the old Derbyshire rhyme "Hardwick Hall, more glass than wall."

Bess's path to riches led the determined country girl from the obscurity of Derbyshire to the semi-feudal London house of the Zouche family where she and her first husband, Richard Barlow, served as lady-in-waiting and equerry (i.e., superior servants). Barlow (conveniently) died after only a few months of marriage and the young widow soon attracted the attention of the rich Sir William Cavendish, who had made his money as one of the commissioners of the Dissolution of the Monasteries under Henry VIII (r. 1509–1547). They married on August 20, 1547 at 2:00 AM, a time chosen by astrologers as propitious conjunction of the stars. Bess was Sir William's third wife; she gave him eight children (six survived childhood) and some grief as she spent money liberally to acquire estates in her home county of Derbyshire including Chatsworth and Hardwick, which was bought from her impoverished brother. Sir William, previously a careful, even miserly man, was so besotted with his young wife that he embezzled government money, and it was only his (convenient) death in 1557 that saved Bess from having to sell all the recently acquired estates to pay back the Crown. Luckily, the deeds

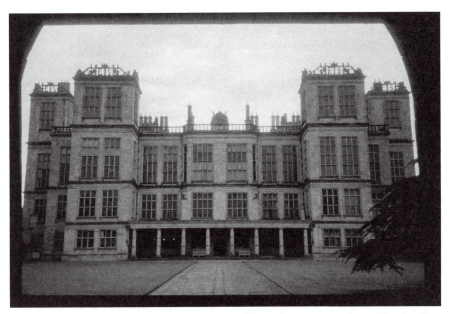

Hardwick Hall. The house seen across the courtyard from the entrance archway. The first floor contains service rooms, the second floor the private apartments, and the third floor the state apartments. The towers are topped by the giant initials ES for Elizabeth, Countess of Shrewsbury. *Photo by Erik Wallace.*

were in her name and not Sir William's. Bess was soon remarried, this time to Sir William St. Loe "of ancient knightly family," who was a favorite of Queen Elizabeth I (r. 1558–1603). They married in 1559 and by the time of his (convenient) death in 1565, Bess had contrived to get St. Loe to leave her his ancestral lands and fortune, completely cutting out his own brother. As Lady St. Loe, Bess had climbed the social ladder, leaving her humble beginning far behind, and she was now a woman of title, lands, money, and consequence, the perfect wife for the immensely wealthy George Talbot, Earl of Shrewsbury. Their marriage in 1567 can be likened to a merger of two hugely successful companies and the marriage contracts Bess negotiated so bamboozled the easygoing and obviously besotted earl that none of her wealth went to the Talbots, but considerable parts of the Talbot wealth went to the Cavendishes. The marriage was soon strained to the point of armed conflict between the retainers of the battling earl and countess. Mark Girouard, the architectural historian and biographer, described Bess as "capable, managing, acquisitive, a businesswoman, a money-maker, a land-amasser . . . she was capricious, rash, emotional, fond of intrigue and gossip, easily moved to tears, the best of company when things were going her way and spitting with spite and fury when crossed." Although not a great beauty, she must have had a sexual allure that captivated men and an intellect that overcame her difficult temperament. Curzio Malaparte, the Italian writer of

the 1930s, said of his spectacular house, Casa Malaparte, perched high on the cliffs of the Island of Capri, that it is a "house like me." Hardwick Hall can similarly be said to be like its creator, Bess of Hardwick, for it is commanding, confident, extravagant, indomitable, imperious, and ostentatious while at the same time beautiful, charming, friendly, and intriguing.

The architect Bess chose for her new house was Robert Smythson (c. 1535–1614), although his name does not show in Bess's careful accounts. He had worked for her in 1585 at nearby Worksop Manor when she was still living with the Earl of Shrewsbury and he had built houses for some of the most important men in the country: Longleat House, Wiltshire, for John Thynne; and Wollaton Hall, Nottinghamshire, for Sir Francis Willoughby. John Thynne was an amateur architect who had overseen the building of the new front to (old) **Somerset House**, London in the new Classical style, one of the earliest Renaissance building in England that incorporates symmetry, Classical detailing, and a horizontal roofline in a manner owing much to Italian and French ideas. Somerset House was a great influence on Longleat House where Thynne brought in Smythson to assist him. At Worksop and Hardwick, Smythson shows himself to be an independent designer, capable of working in the new Classical style yet not slavishly following the imported books of Serlio or Philibert de l'Orme, but capable of original thinking that brings together the new fashion with traditional English planning. Hardwick Hall is his greatest work.

At this time the wealthy, the old aristocratic families or the nouveau riche that aped them, lived in great formality and style. The focal point of great houses and castles was the great hall where the whole household would gather daily for meals served in the most stately fashion, to demonstrate the importance of the lord and his lady. During the sixteenth century the family had begun to retreat to a series of private rooms, leaving the hall to their senior retainers and only appearing for important banquets. Hardwick Hall is an important point in this transition from the great house being the home of a community headed by the lord and including the lowliest scullion boy to the home of a great lord and his servants; a transition from "us" to "us and them." At Hardwick Hall, Smythson cleverly indicates this change with some intriguing deviations from the usual plan. First, the Hall runs from front to back, rather than from side to side, and in place of the dais and lord's table at the far end there are only doors that lead to two broad, shallow staircases that thread their way up to the top floor of the house. Other than the Hall the first floor is given over to service rooms. On the second floor the staircases lead to the "Low Great Chamber" and Lady Shrewsbury's suite while on the third floor is the "High Great Chamber," the suite of *state rooms* and the Long Gallery. Note that each suite, or *apartment*, begins with a great chamber, then a withdrawing chamber, then a bedchamber and finishes with small, very private "closets" or "cabinets." (The highest officers of governments today are called "the Cabinet" because originally it was only the monarch's most trusted and wise ministers who had entrée to his private cabinet.)

This arrangement of rooms, which began in mediaeval times, reached its apogee with such formal houses as Castle Howard and **Blenheim Palace**.

Carved stone soldiers, symbolically reinforcing the real soldiers who would have rotated guard duty on the staircase landing, guard the entrance to Bess's apartment, which was richly decorated with tapestries and marble fireplaces and doorways. The State Apartment and Long Gallery, the show-piece rooms of Hardwick Hall, on the top floor were even more richly decorated, the High Great Chamber with a still extant set of Brussels tapestries depicting the *Story of Ulysses*. The most astonishing room of the house is the Long Gallery; 166 feet long and lined with tapestries where it doesn't have huge windows. Two massive stone and marble fireplaces feature statues of Justice and Mercy.

On occasions of great state Bess would have dined at a table in the High Great Chamber seated beneath a Canopy of State. The multiple courses would have been bought up the long staircase in elaborate processions of chamberlains, stewards, butlers, and servers (households, except for a few personal ladies' servants, were mostly male at this time) accompanied by the sound of trumpet fanfares. After dining Bess and her guests could be entertained by musicians and jugglers in the Long Gallery, or move to the rooftop terrace to exercise and admire the view. Here, dessert would be laid out in the top rooms of the towers—banquet houses (at this time the banquet was only the last course, not the whole meal). It was not unusual to place the most important rooms on the top floor of a house where they could enjoy the views of the countryside, and hunting, and where they were away from the cooking odors of the kitchens on the first floor. On a normal day Bess would have eaten in semi-state in the warmer, more intimate Low Great Chamber, which she reached by crossing over the gallery of the Hall acknowledging and blessing her retainers preparing to eat their own meal below.

Visitors approach Hardwick Hall up a long drive to the top of the hill. After passing the Old Hall (now ruinous), where many of the servants had their rooms, a small, narrow gateway leads into the forecourt and the house is fully revealed. The house is composed of a three-story central block 170 feet by 60 feet, to which the six four-story towers are attached, two toward the ends of each long side and one in the middle of each narrow side. The great windows tell exactly the function of each floor; the first-floor windows are two *lights* high, those in the private apartment on the second floor three lights high, and in the state apartment on the top floor four lights high. Apparently symmetrical, careful study of the plan reveals that the symmetry is only *façade* deep with several false windows concealing blank walls and varying floor levels. A long porch of *Doric* columns that stretches between two of the towers protects the main entrance. Otherwise the exterior is remarkably plain until the top of the towers is reached, where elaborate scrolling, decorative stonework frames those "ES" initials.

Bess of Hardwick's foresight and ambition for her family paid off. One

son, William, was created 1st Earl of Devonshire and another son, Charles, 1st Duke of Newcastle. The Devonshires advanced to a dukedom in 1694 and the current, 12th Duke lives at Chatsworth. The multiple Cavendish estates, with Chatsworth as their main residence, preserved Hardwick virtually unchanged since its completion in 1597—it was too powerful in its design and in its associations to attempt changes. Although they were recently listed as the tenth wealthiest family in the country (worth some $2,100,000,000), the Devonshires had to give Hardwick Hall and its contents to the nation in 1956 to pay death duties (inheritance taxes). This saved Chatsworth for the family but leaves Hardwick, although faultlessly maintained, a rather soulless museum stripped of the character that a resident family imparts.

Further Reading

Jackson-Stops, Gervase. *The English Country House in Perspective.* New York: Grove Weidenfeld, 1990.

Montgomery-Massingberd, Hugh, and Sykes, Christopher Simon. *Great Houses of England & Wales.* New York: Rizzoli International Publications, Inc., 1994.

Pearson, John. *The Serpent and the Stag.* New York: Holt, Rinehart and Winston, 1983.

HAREWOOD HOUSE, YORKSHIRE, ENGLAND

Styles: Georgian—Neoclassical and Victorian
Dates: 1759–1772; 1843–1850
Architects: John Carr and Robert Adam (eighteenth century); Sir Charles Barry (nineteenth century)

Yorkshire, in the north of England, is a vast county encompassing a variety of landscapes from the mountainous Pennines in the west to the flat coastal plains of the east. Divided into three "Ridings"—North, East, and West—its chief city is York with its stupendous Minster (Cathedral). Other cities such as Sheffield or Bradford developed during the Industrial Revolution and their names conjure images of steel works and woolen mills. The magnificent countryside of bleak moors and rich pasture is redolent of the eighteenth century when aristocratic families lived in great country houses at the center of vast estates. The estates may have diminished and the houses may be smaller, but many of those same families are still in residence: Sykes at Sledmere; Howard at Castle Howard; and Lascelles at Harewood. Situ-

ated north of the industrial city of Leeds, Harewood House is an eighteenth-century *Palladian*-style mansion designed by John Carr with interiors by Robert Adam, remodeled by Sir Charles Barry in the nineteenth century, set in a park designed by Lancelot "Capability" Brown. It is currently the home of George Lascelles, 7th Earl of Harewood.

The Lascelles claim to have accompanied William the Conqueror (r. 1066–1087) to England from Normandy in 1066. An ancestor is mentioned in the Domesday Book (a mediaeval census), and they were established in Yorkshire by 1315 as the "de Lascelles." Prosperous but not rich, the Lascelles were prominent in the military and served as members of Parliament. In the late seventeenth century the family acquired sugar plantations in Barbados and the increase in wealth these generated allowed the purchase of the Harewood estate by Henry Lascelles in 1738 and the building of a new house by his son Edwin. Edwin Lascelles was a careful man, his annual spending rarely exceeding his income, but nevertheless he considerably developed his estates, was a model landlord to his tenants, and at Harewood built one of the most exquisite houses of the period. "I would not exceed the limits of expense that I have always set myself. Let us do everything properly and well, mais pas trop," he wrote to Robert Adam.

As first Edwin Lascelles had consulted John Carr—"Carr of York" (1723–1807)—the foremost architect practicing in the north of England and the favorite of the Yorkshire landed gentry, many of whom were building new country houses. An architect of the Palladian school (the style that had been fashionable since its introduction by Lord Burlington in the 1720s), Carr, despite little formal architectural education and no foreign travel, became one of the most competent and successful architects of the Georgian period. At Harewood he designed a house that in plan appeared to be a long, rectangular building, but in elevation breaks into a two-story, nine-*bay* central block, with one-story wings ending in twin *pavilions* with central *Venetian windows* and niches for Classical sculptures. On the north front attached columns supported a *pediment*, while on the south front a *Corinthian portico* projected, from which the view down into the valley and across the lake could be enjoyed. Lascelles himself had thought to dam the stream and create the lake but he later commissioned Capability Brown to complete the landscape, reshaping the land and planting thousands of trees at a cost of £6,000 (approximately $3,600,000 today). On the estate Carr also designed the stable block and the model village that replaced the dilapidated one, which reputedly featured six public houses (bars).

As a country gentleman of means and influence Edwin Lascelles spent a part of each year in London where he was introduced to the young Robert Adam (1728–1792). Adam favored a lighter *Neoclassical style*, but upon inspecting Carr's plans for Harewood suggested only revisions to the internal courtyards in the linking wings. The plan is a transition from the courtly formal house/palace of earlier in the eighteenth century (as exemplified by Castle Howard or **Blenheim Palace**) to the more relaxed country house of the

Harewood House. The northwest front as designed by John Carr in 1759. It was remodeled by Sir Charles Barry in the nineteenth century. *Vitruvius Britannicus.*

nineteenth century. At the center of the house are the Entrance Hall and the Saloon—identified by the columns, pediment, and portico at the middle of each front. To the east a circuit of rooms forms two *apartments*, one for Edwin Lascelles includes his library and bedroom, one a State Apartment for VIP visitors—and show. To the west another circuit of drawing rooms, a gallery, a dining room, and a music room filled out the plan. The word "circuit" is deliberately chosen as such a house was for entertaining. For small groups only parts of the house would be used but for large events both circuits could be opened up with the guests passing through the rooms, admiring the contents and enjoying music, food, dancing, cards, gossip. Each circuit begins and ends at the central Hall/Saloon where the guests would be received and take their leave.

The foundation stone was laid in 1759, and the structure of the house was substantially completed by 1765 when Robert Adam's designs for the interiors were approved by Lascelles. Although there were later alterations, Harewood remains one of his finest creations. Carr had not fallen out of favor; he continued as Lascelles' architect for the estate—but presumably a fashionable Adam design was wanted for the interior of the new mansion. Adam brought with him not only incredible design skills and style but also a team of the best artisans and artists: plasterwork by Joseph Rose and William Collins; painted ceilings and wall panels by Angelica Kaufmann, Antonio Zucchi, and Biagio Rebecca; and furniture by Thomas Chippendale. Starting from the cool tones of the Entrance Hall, Adam's designs take us through a series of rich and complex rooms, varying in atmosphere, but appropriate to function, considered down to the minutest detail and finished with the highest level of craftsmanship. The most extravagant room is the Gallery, which occupies the whole of the west wing and has recently been restored to its appearance when completed in 1772.

In the 1840s, Sir Charles Barry (1795–1860), the architect of **The Houses of Parliament**, was employed to revise the plan and increase the accommodations—the 3rd Earl had thirteen children. Barry made some changes to the interior, the only major loss being Adam's dining room. Adding a second story to each of the two wings provided extra bedrooms. The most radical changes occurred on the outside where Barry removed the south portico and created a vast formal terrace with *parterres* and urns. The terrace and the re-

modeled house were all finished with elaborate *balustrades*, which give the house the appearance of an Italian palazzo. Victorian bravura replaced eighteenth-century good taste.

In 1922, Henry Lascelles, the future 6th Earl, married the Princess Royal, the daughter of King George V (r. 1910–1936) and Queen Mary, and it is through this marriage that the Lascelles are considered to be members of the royal family. Henry, always polite, one day took time to talk to his great-uncle, the Marquis of Clanricarde, a man so eccentric the rest of the family ignored him. The marquis remembered, and in his will left Henry a collection of Italian paintings now worth over $45 million and the equivalent of $150 million in cash! Taxation and death duties have substantially reduced the Harewood fortunes and their estate extends to only 4,000 acres—down from 25,000 acres. The current earl is an example of the British aristocrat who is "asset rich but cash poor." A recent newspaper article puts his fortune at over $200 million (not including the house and land, which are sheltered in trusts) but most of this is art and furniture. The value of paintings amounts to $165 million while the Chippendale furniture commissioned by Edwin Lascelles, designed by Robert Adam, and all still in place, is valued at $45 million, including a bed worth $6 million.

The future of the Harewood Estate and Harewood House with its rich and exquisite contents is assured. Careful planning and judicious gifts have made it safe for future generations of Lascelles while grants have paid for repairs and restored most of Adam's interiors. Much of the house and the gardens are open to the public while the earl and countess live in an upstairs apartment paying, for tax reasons, rent to the trust that owns and protects Harewood.

Further Reading

Harewood. www.harewood.org.

Montgomery-Massingberd, Hugh, and Sykes, Christopher Simon. *Great Houses of England & Wales*. New York: Rizzoli International Publications, Inc., 1994.

HEATHCOTE. *See* Lutyens Country Houses.

HIGHGROVE, TETBURY, GLOUCESTERSHIRE, ENGLAND

Style: Georgian—Neoclassical
Dates: 1796–1798
Architect: Attributed to Anthony Keck

Highgrove, a mile outside the village of Tetbury, Gloucestershire, was until 1980 a little known, unpretentious country house typical of many dating from the late eighteenth century. However, in that year HRH The Prince of Wales, Prince Charles, in need of a country retreat, viewed the estate and saw the potential of the house and its grounds. Over the subsequent years the prince has transformed the house into an Anglo-*Palladian* villa in the manner of Burlington or Campbell, creating around it one of the most significant gardens of the twentieth century. In the same way that in the late nineteenth century Marlborough House in London became synonymous with the life and social set of an earlier Prince of Wales (later Edward VII), so Highgrove has become closely associated with Charles and his search for a role as heir to the throne. In particular, during the conflicts of the disastrous marriage to Diana, Princess of Wales, Highgrove was viewed by the many as the headquarters of the anti-Di group. Following her death in 1997 and the recent resurgence of public support for Charles, Highgrove has been more happily associated with the prince's ideas on architecture, gardening, and organic farming. It is one of the country's showplaces, visited by many who come to see the extraordinary garden and experimental farm.

The original house at High Grove—as it was first named—was built for a landowner named John Paul Paul. The Paul family had settled in Gloucestershire in the early eighteenth century and had prospered through involvement in the cloth trade and judicious marriages, rapidly rising, in that class-conscious age, into the ranks of the gentry. In 1793, John Paul Paul married a rich heiress and his increased wealth led to the building of Highgrove, for its time a substantial but plain house. In his guide to country houses, *Delineations of Gloucestershire*, written 1825–1827, J. N. Brewer describes the house:

> The design is entirely free from ostentation, although some ornamental particulars are introduced. The principal efforts of the architect have been towards the interior, which presents many good apartments, of accurate proportions, well suited to the domestic and hospitable purposes of a family of high respectability. The situation is fine, and ex-

cellent views are obtained from the house and various parts of the at-
tached grounds.

The designer of Highgrove is reasonably assumed to be Anthony Keck
(1726–1797), an architect with a large practice in Gloucestershire and the
West Midlands. Keck lived in King's Stanley, Gloucestershire, where Paul
had business interests. In 1784, Keck considerably altered and extended Hill
House, in the nearby village of Rodborough, for another member of the
family, Sir George Paul. It is probable that Sir George recommended Keck
who designed some fifty houses during his career, including several of im-
portance: Moccas Court, Herefordshire (1776–1783) and Penrice Castle,
Glamorganshire (1773–1780). His most famous building is at Margam
Abbey, Glamorganshire, where the Orangery (an elaborate greenhouse) he
designed in 1787–1790 is 327 feet long—the largest in Britain. Keck worked
in the austere, restrained *Neoclassical style* of the late eighteenth century—a
provincial follower of Robert Adam. An engraving of Highgrove in Brewer's
Delineations of Gloucestershire shows the house to be a neat box, five *bays* wide,
three bays deep, and three stories high. A central *Venetian window*, under a
super arch—a favorite device of Keck's, enhances the east entrance *façade*.
Blind arcades frame the ground floor windows and *pilasters* of an unusual
Egyptian design separate the upper windows. Keck may have admired the
fashionable and expensive architects of his day, but his houses, elegant and
convenient at a reasonable cost, exhibit a country architect's independent
spirit.

Highgrove remained the home of the Paul family until 1860 when the es-
tate was sold. Four years later it was sold again, this time to William Yat-
man, a lawyer. Yatman rebuilt the tower and spire of St. Mary's Church in
nearby Tetbury, which Keck had made the focal point of the view when look-
ing east from the front of the house. A fire in 1893 gutted the interior and
damaged the west façade where the canted bay, a three-sided angled window,
collapsed onto the terrace bringing down the wall above. Dispirited by the
disaster, Yatman sold the estate and it was the new owners who rebuilt the
house. The interior plan was reconfigured, a large service wing added to the
north, and the roof concealed behind a high, solid *parapet* decorated with
small globes strangely out of proportion with the rest of the house. Although
very expensive, costing £6,000, the changes lacked any refinement and the
elegance of Keck's design was lost—along with the Venetian window—ren-
dering the house very plain and solid.

It was this house that Prince Charles saw in 1980 and which was bought
for him by the Duchy of Cornwall. One of the prince's titles is Duke of Corn-
wall and a large estate founded in 1337 for Edward, the Black Prince (d.
1376), now totaling over 130,000 acres in twenty-three counties, provides
the income of the heir to the throne. Thus, Highgrove is not the personal
property of the prince but is owned by the Duchy of Cornwall.

Little work was done on the house until the mid-1980s, when artist Felix

Kelly produced a painting showing how the house would look if the solid parapet were replaced by an airy *balustrade*; the unique Egyptian pilasters replaced with *Ionic* ones; and a *pediment* with a round window set above the main façade. The prince was inspired by Kelly's vision of a Neo-Palladian villa on the model of **Stourhead**, Wiltshire (Colen Campbell, c. 1721); Marble Hill, Middlesex (Lord Pembroke and Roger Morris, c. 1724); or **Chiswick House**, Middlesex (Lord Burlington, 1725). The work was carried out under the direction of architect Peter Falconer.

The original late eighteenth-century gate lodge, stables, and one-acre walled kitchen garden all survive and have been restored, the stables housing horses for fox hunting (a sport banned in 2005) and the garden providing produce for the house. Prince Charles and the leading landscape designers in the country have put considerable thought into the development of the garden and *park*. They are maintained organically without the use of chemical pesticides or fertilizers. Rare plants and flowers now grace the garden along with many old varieties long out of fashion and often thought lost. Areas of the park have been seeded with wildflowers in a mix called the "farmer's nightmare!" Several new buildings have been built using traditional materials and craftsmanship. These include the Holly Tree–house by architect William Bertram of Bath; the Arts and Crafts style Orchard Room—a banqueting room—by Charles Morris of Norfolk; and the delightful Column Bird, Rustic Temples, and Stumpery (an arrangement of tree stumps) by designers Julian and Isabel Bannerman. The column, temples, and other garden buildings and ornaments form part of a series of follies created in the spirit of the eighteenth-century Picturesque movement.

Further Reading

Wales, HRH The Prince of. *The Garden at Highgrove.* London: Weidenfeld & Nicolson, 2000.

Wales, HRH The Prince of, and Glover, Charles. *Highgrove, Portrait of an Estate.* London: Chapmans, 1993.

HOLKHAM HALL, NORFOLK, ENGLAND

Style: Georgian—Palladian
Dates: 1734–1759
Architects: Richard Boyle (Lord Burlington); Matthew Brettingham; Thomas Coke; William Kent

Eighteenth-century travelers to England from Germany or Denmark often landed at the east coast ports of Boston or King's Lynn, then bustling mercantile cities. The approaches to these ports brought ships along the north coast of East Anglia and the county of Norfolk. On clear days passengers would have seen the waves crashing onto golden sandy beaches and, beyond, a bleak, barren landscape of flat heath, the few trees visible bent by the winds off the North Sea. Then they would espy something that would make them ask to borrow a telescope, for amazingly, some half-mile from the shoreline, there appeared to be a great palace; a golden-colored *façade* of towers, *pediments*, and *porticoes* spreading some 400 feet across the landscape, the light glinting off the gilded glazing bars (muntins) of the many windows. Here was a palace to rival that of any margrave or elector (German princely titles). Enquiries would reveal that this was not the palace of the King of England or a royal duke but merely the house of one of his subjects: Holkham Hall, the home of Thomas Coke, Earl of Leicester.

The Cokes had risen to prominence, as had many aristocratic families, during the reigns of Queen Elizabeth I (r. 1558–1603) and King James I (r. 1603–1625). Sir Edward Coke (1552–1634) was Attorney-General to the first and Lord Chief Justice to the latter and is best known as the originator of the phrase, "An Englishman's home is his castle." His own castle was an unpretentious manor house on his windswept Norfolk estate—"a most unpleasant place," according to Lord Hervey writing in the eighteenth century—just a short distance from the site of his descendant's great mansion. During the seventeenth century the Cokes kept to their estates, avoiding the troubles of the Civil War and the Commonwealth (1649–1660), accumulating land and wealth; the Holkham estate presently extends to over 25,000 acres. Seventy years after the death of Sir Edward the young heir to this vast estate was Thomas Coke (1697–1759) and during his minority the income accumulated into a fortune that he inherited when he came of age. At that time it was usual for young aristocratic gentlemen to take a trip to Europe, particularly Italy, called the Grand Tour. This extended vacation—often lasting several years—was partly for pleasure and partly educational, completing the Classical education of a true gentleman. A huge entourage of servants, secretaries, and tutors traveling in a procession of carriages and baggage carts with outriders and armed guards would accompany a man as rich as Coke. Such rich tourists were welcomed at inns, mansions, and palaces all over Europe, and many artists worked primarily to provide works of art for the English "milords" to buy and send back to England—for example, most of the work of the Italian artist Canaletto is to be seen in collections in Britain. Coke's Grand Tour lasted for six years and while in Italy he met William Kent, the artist/architect and protégé of Richard Boyle, Earl of Burlington of Burlington House and **Chiswick House** who was the leading arbiter of taste in early eighteenth-century England and the leading proponent of the second *Palladian* movement in England.

Coke, for all his expensive education and long Grand Tour, was very much

Holkham Hall. The north, entrance front. *Vitruvius Brittanicus.*

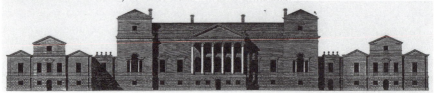

Holkham Hall. The south front. The three part composition is revealed with the larger porticoed central block linked to the Library or Family wing to the left and the Chapel wing to the right. The two link corridors have a flat roof decorated by four balls. *Vitruvius Brittanicus.*

the stereotypical bucolic English squire: hard drinking, hunting, shooting, fishing, and with an eye for the ladies. That he was a close friend of the dilettante Lord Burlington and his protégé William Kent seems unlikely as does the fact that he had a hand in the design of the austerely correct Classical façades of Holkham and the equally correct but richly decorated rooms inside. Coke, Burlington, and Kent were the architectural committee that oversaw the design of Holkham Hall.

Italy had inspired Coke and he determined from an early date to rebuild the manor house at Holkham in the Palladian style. While the planning of the house was under deliberation he began the planting of thousands of trees to create a less windswept and open situation. In 1720 financial disaster happened: Coke lost £79,000 (approximately $12 million today) in the "South Sea Bubble"—the Enron of its day—and plans for the new house were delayed. Coke's wife Margaret (Baroness de Clifford in her own right) then inherited £80,000 and restored their fortunes and in 1726 plans were drawn up by the architect Matthew Brettingham to the designs of William Kent with input from Burlington and Coke. Brettingham was to be employed by Coke from 1734 to 1759 at a salary of £50 for "taking care of his Lordship's buildings." (Coke had been created Baron Lovell and was later raised to the peerage as Earl of Leicester.) The financial worries over but still in mind, it was not until 1735 that Coke laid the foundation stone for the new house and construction began in earnest.

The drawings of 1726 showed a large square house with a *piano nobile* (noble or main floor) raised above a full *basement* floor (not sunk underground). A drawing by Kent dating from the early 1730s showed the house completely *rusticated* with wings added to the square central block. The final design simplifies the textures, removing all rustication from the upper floor

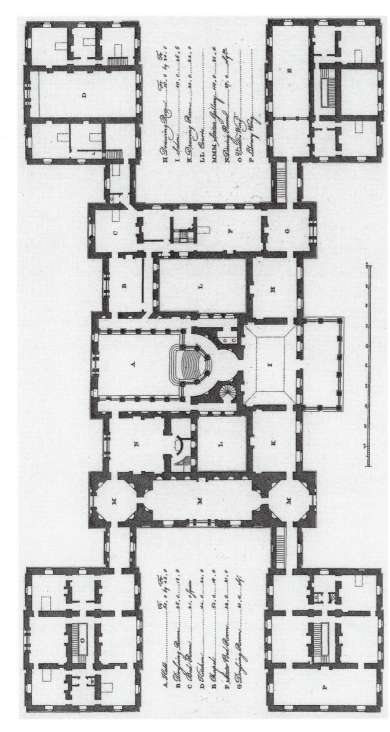

Holkam Hall. Plan of the main floor. The central axis of the hall (A) and Salon (I) leads to two circuits of state rooms in the central block. The four wings, clockwise from the bottom left, are the Library (P) or Family wing, the Guest or Visitors wing, the Kitchen (D) wing, and the Chapel (E) wing. *Vitruvius Brittanicus*.

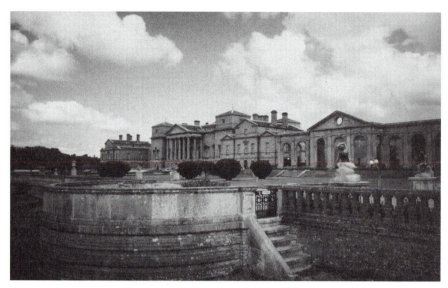

Holkham Hall. Viewed from the southeast with the Library or family wing to the left, the porticoed central block, and the balancing Chapel wing. The gutted building to the extreme right is a nineteenth-century conservatory. *Photo by Clark Ferguson.*

but adding back interest through the modulation of the façades and the varied heights of the component elements. The design team of Burlington, Kent, and Coke had studied the work of Palladio while in Italy and knew that, while his houses were much smaller, they were an apparently simple application of the principles of proportion with a direct relationship from inside to outside. Thus, carefully considered façade elements referred to rooms or suites within and the importance of the external features reflected the importance of the rooms behind. Looking at the south front of Holkham we find that the 400-foot-long façade is centered on a tetra-style (six-columned) portico behind which is the most important reception room of the house, the Saloon. To either side are the plainer walls of the two Drawing Rooms with, at the corners of the central block, slightly projecting elements, each with a *Venetian window*, that rise higher as pyramidal-roofed towers. These towers look back not only to similar features at Palladio's villas but also to Wilton House, which at that time was thought to have been designed by Inigo Jones, the architect who brought Palladianism to England 100 years previously (see **The Banqueting House** and **St. James's Palace**).

The towers form the corners of the rectangular central block. Attached at each tower, connected by insignificant link corridors, are four wings: the Private (family) Wing, the Chapel Wing, the Guest Wing, and the Kitchen Wing. Each wing is itself the size of a large house and they are identically treated with façades broken into three elements: the center, wider piece rising up to an open-base pediment. As with the main block the exterior articulation re-

flects the placement and usage of the rooms inside. The Private Wing was the first part of the house to be completed (in 1741) and it was attached, by a temporary corridor, to the old manor house, which was retained as a service building until the completion of the rest of the house. The north and south fronts are virtually identical, the major difference being that the south has the projecting portico overlooking the gardens while the north, entrance front is much plainer and has been marred by the addition of a projecting porch in 1860 (an unfortunate but necessary addition to combat the winds off the North Sea, which otherwise blew right into the house when the front door was opened).

Surprisingly for a house of this size and expense, Holkham is built of brick, of the same golden yellow color as the nearby beaches, made at Burnham Norton, a village on the estate. This choice was made not just to reduce the cost (stone would have had to have been brought a considerable distance at great cost as there are no local quarries) but was said to follow the ideas of Palladio—a rather spurious argument, as Palladio's villas, while built of brick, were covered in stucco, lined to look like stone. Whatever, the locally made brick seems to make Holkham part of its landscape, taking on the colors of the land as the seasons and weather change—exuberantly bright in summer sunlight, ominously somber during a winter rain. Coke had very clear and determined ideas of what he wanted his house to look like; he was a very hands-on client and it was at his instigation that the exterior was simplified to the aloof austerity we admire today.

The house was originally approached from the south through the Triumphal Arch designed by Kent, some distance away. The drive then went in a straight line on the axis of the portico on the south front pausing only to circle a great obelisk erected on the highest point in the new *park* before swinging around to the east to reach the north, entrance front. Today the drive has been simplified but the front door is still at the center of the north front. Passing through the 1860 porch one enters a house that has changed little from the day it was completed in 1762, and it is an awe-inspiring house of a richness and extravagance belied by the somewhat dour exterior.

The first room entered is perhaps the most dramatic: the Marble Hall rises up through three floors and occupies an area 80 feet by 45 feet. Originally designed as a cube, the final oblong shape was conceived in 1757 and is based on Burlington's Assembly Rooms in York and Palladio's design for an "Egyptian Hall" (it carried this name until quite recently). The redesign was due to a problem that had been created as the room is entered at the lower basement level and leads up to the main floor—the form of the staircase and the consequent shape of the room was a great problem and many options were considered. The final, as built, design has eighteen *Ionic* columns, based on those from the Temple of Fortuna Virilis in Rome, lining a rectangular space with an apsidal curved extension to contain the stairs that fluidly spread down onto the floor of the lower level. The deeply *coffered* and ribbed ceiling with ornately carved decorations is from a design by Inigo Jones. The lower walls and the columns are not of marble but of a richly veined Derbyshire alabaster; the plain walls be-

yond the columns are painted a pale yellow with simple curved niches holding Classical statuary—one could be in a temple in ancient Rome but instead of the statue to the god, at the top of the sweep of stairs would stand, before the doorway to the Saloon, Lord and Lady Leicester receiving their guests.

The central block of Holkham is for rooms "of parade and state," huge reception rooms meant to impress and awe visitors, a reminder of the wealth and power of such a landed aristocratic grandee in eighteenth-century England. Holkham, however, is not a "formal house" such as **Blenheim Palace** but is of the later more relaxed design where there are circuits of rooms that can readily accommodate varying numbers of guests—a few rooms for a small dinner; the full sequence of rooms for a huge political reception. At Holkham there are two circuits that branch off the Saloon: to the east a drawing room leads through two state bedroom suites (bedrooms and dressing rooms were public rooms at this time), while to the west a second drawing room leads to the 125-foot-long Sculpture Gallery and the Dining Room. Both circuits lead back to the Marble Hall such that guests could then enter the opposite loop or could pass down the stairs and take their leave. The rooms at Holkham are still very much as designed by William Kent, the Saloon and drawing rooms with cut velvet wall coverings and richly gilded, velvet-covered suites of furniture also designed by Kent, although the north-facing Dining Room, painted a pale green, is much more austere and cold.

The plan of Holkham allows for an *enfilade* of rooms to be opened up the full 400-foot length of the house. The Saloon is the center of a sequence of twelve rooms that reaches from the Library in the Private Wing to the west to the Chapel in its own wing to the east. When the doors are all open the full enfilade can be viewed and such was the high quality of the workmanship that it is said that when the doors were closed the light of a candle could be seen through the precisely aligned keyholes of the doors.

Thomas Coke died in 1759 and the house was completed by his long-suffering widow Margaret, Lady Clifford, who had really been in charge of overseeing the project while her husband enjoyed London. They had spent a total of £90,000 (approximately $13 million today) building the house; this also was the amount of debt left to their heirs and this encumbrance precluded any major changes to the house. Their son had died in 1753 and the heir was a great-nephew, also Thomas Coke (1754–1842). Lady Clifford disliked the second Thomas: "Young man, it is possible that one day you will be master of this house (Holkham) but understand that I will live as long as I can." The Leicester title died out with the son so Thomas Coke inherited as plain Mister Coke in 1775 at the age of twenty-one and he was to live at Holkham until 1842, for sixty-five years. He was a great agricultural reformer; he introduced crop rotation to English farming and held sheep-shearing contests that were the forerunner of the annual county agricultural shows (akin to a county fair in the United States). His careful husbandry not only improved his land but also paid off the debts incurred in building Holkham. He was known as Coke of Norfolk and resisted ennoblement, preferring to be "the first Commoner

of England." It was only in 1837 that he agreed to receive a peerage from the young Queen Victoria, becoming the Earl of Leicester of the second creation. Coke of Norfolk focused on agricultural improvements and thus made no changes to the house. His heir, confusingly again named Thomas (1822–1909), added the porch to the north front, a large conservatory to the southeast and the south *parterre* (formal garden) designed by William Nesfield in 1852. The Cokes were long lived and for 165 years from 1775 to 1909 there were only three owners of Holkham. Edward Coke, the 7th and present Earl of Leicester, has done much to restore Holkham Hall to its eighteenth-century appearance; for example, all the windows, replaced in the nineteenth century by large sheets of plate glass, have been restored with their glazing bars, adding a vital texture to the plain exterior. Holkham Hall is a memorial to the combined genius of Kent, Burlington, and the first Thomas Coke who conceived of this house in the Palladian manner, and they would find it little changed from their design; only the maturity of the trees in the surrounding park gives away the passage of years.

What became of the fourth architect involved with the design of Holkham Hall? Matthew Brettingham, a rather unscrupulous architect, went on to a successful national career. In 1761 he published a set of drawings of Holkham under the title *The Plans and Elevations of the late Earl of Leicester's House at Holkham* with his own name rather than Kent's as architect and, even more blatantly, a portrait of Brettingham shows him holding a drawing of the triumphal arch at Holkham, unequivocally designed by Kent. In 1758, he was commissioned by Sir Nathaniel Curzon to produce designs for the rebuilding of Kedleston Hall, Derbyshire. The design owed much to Holkham, being composed of a central block with four wings attached by curved linking corridors. Brettingham has been described by Colvin as "an orthodox, but unenterprising Palladian whose dull, well-bred façades betray neither the intellect of a Burlington nor the fancy of a Kent." Curzon seems to have recognized his architect's shortcomings, for Brettingham was replaced in 1759, (after only one wing was complete) by James Paine, who completed a second wing and began the central block (only two wings were completed). The brothers Robert and James Adam, who completed the central block with its Neoclassical south façade and interiors in turn replaced Paine. Holkham is the finest and most complete Palladian country house, but Kedleston shows the transition from the restraint and constraint of Palladianism to the creative inventiveness of the Neoclassical movement of the late eighteenth century.

Further Reading

Cook, Olive. *The English Country House*. London: Thames and Hudson, 1984.

Holkham Estate. www.holkham.co.uk.

Lloyd, Nathaniel. *History of the English House*. London: The Architectural Press, 1975.

Montgomery-Massingberd, Hugh, and Sykes, Christopher Simon. *Great Houses of England & Wales*. New York: Rizzoli International Publications, Inc., 1994.

THE HOUSES OF PARLIAMENT (PALACE OF WESTMINSTER), WESTMINSTER, LONDON

Style: Victorian—Gothic Revival
Dates: 1836–1868
Architects: Sir Charles Barry; Augustus W. N. Pugin; Edward Middleton Barry

When one sees reports from world capitals by news correspondents, the chosen background quickly tells one where the correspondent is reporting from: from Paris the Eiffel Tower will be in the background; from Athens, the Parthenon; or from Washington, D.C., the Capitol Building. When the news is from London the Houses of Parliament, the great Gothic style building with its distinctive clock tower, will be behind the television reporter. "Houses of Parliament" is the usual name for the Palace of Westminster that until 1512 was the main residence of English monarchs; only as late as 1965 did it cease to be a Royal Palace under the control of the monarch. The site, originally an island beside the River Thames, had been a royal residence since the time of King Canute (r. 1016–1035) and offered two advantages: It was beside the river for easy transportation and it was some distance from the City of London, whose citizens often disagreed with the king's decisions. Edward the Confessor (r. 1042–1066) rebuilt the palace and also founded nearby **Westminster Abbey**. William I (r. 1066–1087) built his great fortress-palace, **The Tower of London**, east of the City but later, feeling more secure, moved to Westminster, establishing it as the seat of government through to the present day.

The mediaeval palace and all its many additions and alterations were destroyed in a fire that swept through the complex on the night of October 16, 1834. The fire started in the offices of the Chancellor of the Exchequer, where for centuries notched wooden "tally sticks" had been used to record accounts—thousands, tied in bundles filled the cellars. Eventually, it was decided to get rid of them and they were being fed into a stove when the chimney overheated, setting fire to the building. Within hours nearly the whole palace was in flames, causing a great public spectacle the drama of which brought applause from the crowds, although not because of discontent with the government. Destroyed in the flames was St. Stephen's Chapel (1292–1365), the king's private chapel designed by Michael of Canterbury and said to rival the French kings' Sainte Chapelle in Paris. Also lost was the

Painted Chamber, originally the King's Great Chamber (multipurpose living/bedroom), lined with exquisite wall paintings dating from 1263 that depicted the stories of Old Testament wars. This room was one of the wonders of mediaeval Europe. A more recent alteration that also burned was Sir John Soane's new Royal Entrance and Gallery leading to the House of Lords of 1822–1827. The loss of such architectural masterpieces and the art they contained is somewhat offset by two great paintings depicting the disaster. Painter J.M.W. Turner recorded the scene of the fire in his sketchbooks as a prelude to two paintings, both entitled *The Burning of the House of Lords and Commons, 16th October, 1834*. Among his greatest works, these paintings, in the words of Sir Roy Strong, "portray the event . . . in an explosion of color whose radiant intensity turns the loss of the ancient palace of England's mediaeval kings into a golden apocalyptic glory."

At first the government called in Sir Robert Smirke (1780–1867) to design a new building but later it was decided to hold an architectural competition, the biggest of the nineteenth century. The new Houses of Parliament, according to the competition documents, should be "in the Gothic or Elizabethan styles" reflecting a nationalistic bias for English architecture. In opposition to this edict were architects, critics, and politicians who favored Classical architecture, believing it to be a more learned style that originated, with democracy, in ancient Greece. The "Battle of the Styles," Gothic versus Classical, occupied the minds of architects for the middle decades of the nineteenth century. At the Houses of Parliament the Goths won—it was the first public building of the Gothic Revival—but at the nearby Foreign Office of 1861–1873, Sir George Gilbert Scott, an ardent Gothicist, was required to design in the Classical style. Charles Barry (1795–1860), a successful London architect who had grown up in Westminster, was declared the winner of the competition for the new Houses of Parliament on February 29, 1836, a decision that infuriated the losers to the extent that an unsuccessful petition was submitted to Parliament to overturn the result. Ironically, Barry, while not averse to the Gothic style, much preferred Classical architecture and most of his buildings are Italianate (a nineteenth-century development of the Classical style in Britain and the United States). Indeed, while the outward appearance of the Houses of Parliament is Gothic, the plan is pure Classical with clear axes crossing at the Central Lobby. The shorter west to east axis connects the main entrance at St. Stephen's Porch, through St. Stephen's Hall (built above the crypt of the old chapel), to the great terrace overlooking the River Thames. The long, north–south axis runs from the Speaker's chair in the House of Commons, across Members' and Peers' (Lords) Lobbies, into the House of Lords to terminate at the monarch's throne some 450 feet distant. It was the clarity of this essentially simple plan, reflecting the parliamentary system and ceremonies of the time, which appealed to the jurors and won the competition for Barry. Possibly the plan owes something to another Gothic building designed by an architect who preferred to work in the Classical style: James Wyatt's **Fonthill Abbey** (1796–1812) has a similar axial plan and overall massing, although on a much smaller scale.

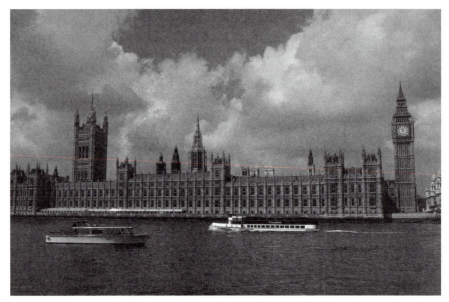

The Houses of Parliament. The east front seen across the River Thames. The Victoria Tower to the left, the Clock Tower that contains Big Ben to the right. The symmetrical façade indicates the classical axial plan behind the gothic decoration. *Harcourt Index.*

To complete the design in the late Gothic style chosen, Barry assembled a team of artisans led by Augustus Pugin, whom he admired for "his genius for Gothic detail, his draughtsmanship and his enthusiasm." Barry and Pugin were collaborators and the correct apportionment of credit is difficult to resolve: "Barry as architect in chief and originator of the whole concept; Pugin, the skilled Gothic decorator."

The building of the new palace began in 1840 and was sufficiently complete to be opened by Queen Victoria (r. 1837–1901) in 1852. Soon afterward she knighted Barry, making him Sir Charles Barry. Barry saw this as reward for all he had suffered during the design and construction including two Committees of Enquiry questioning whether he was carrying out the design originally selected. A second problem was the appointment of a Dr. Reid, an expert on heating and ventilation, whose system did not fit Barry's plan and had to be removed at great expense when it was discovered that dangerous fumes were being piped into the debating chambers. The Queen's husband, Prince Albert (d. 1861), was another problem: he was the president of a Fine Arts Commission that was to decide on the paintings and sculptures that decorated the building. Barry's intent was to make the Houses of Parliament "a treasure house of the visual arts and a sculptured memorial to our national history" and, while the commission was not in conflict with this idea, it was painful to Barry that he was excluded from their deliberations. Nevertheless the completed palace contains some of the finest examples of

the visual arts the nineteenth century produced, complementing the architectural setting designed by Barry and Pugin. Every detail was considered including every piece of furniture; even the doorknobs, pen sets, and wallpapers were specially designed and crafted. As taste changed and Victorian design became unfashionable, much of the decoration was changed and furniture dispersed; luckily, recent restorations have recovered or recreated much that was lost and the palace is substantially as originally designed.

Although essentially symmetrical in plan, when seen from across the River Thames, a Picturesque feel is created by the irregular composition of the towers that rise high above the building. Above the Central Lobby a tall, spired *lantern* rises 300 feet, while at each end are substantial towers: the massive Victoria Tower (336 feet) at the southwest corner signifies the Sovereign's Entrance, while at the northwest corner is the Clock Tower (300 feet). This is erroneously called "Big Ben" for the great bell that hangs inside the tower and chimes the hours. At each end of the river front are large houses for the Speaker of the House of Commons and the Lord Chancellor, the "chair" of the House of Lords.

In mediaeval times the monarchs would summon a Royal Council of bishops, noblemen, and ministers to advise on policy and this usually met at Westminster, drawing also the government bureaucracy and the courts to the palace and its precincts. The Royal Council evolved into the House of Lords (the Upper House similar to the U.S. Senate) while the House of Commons (the Lower House similar to the House of Representatives) began as a group of knights from the shires (rural areas) and burgesses from the towns, summoned to advise the King and Royal Council. At first these two groups would meet in various locations: Westminster Hall, St. Stephen's Chapel, the Chapter House of Westminster Abbey, even the King's private apartments but after 1512, when Henry VIII (r. 1509–1547) moved to the adjoining Whitehall Palace (see **The Banqueting House**), the Palace of Westminster became the permanent home of the English Parliament. Edward VI (r. 1547–1553) confirmed this informal agreement in 1547. The seating arrangement of the two Houses with the two parties, the government, and the opposition facing each other across "the floor" derives from their early meetings in St. Stephen's Chapel where they sat in the choir stalls.

Barry died in 1860 and, Pugin having died in 1852, Barry's son Edward Middleton Barry (1830–1880) oversaw the completion of the Palace of Westminster. A statue of Sir Charles Barry by J. H. Foley stands at the foot of the stairs leading to the Committee Floor. The only major change to the palace was the result of a German bomb that destroyed the House of Commons in 1940. This was rebuilt in a more austere style than the original but followed its basic size, form, and color scheme.

The Palace of Westminster, like the U.S. Capitol, is a historic building, but it is also a working building and when Parliament is in session it is a hive of activity as members and peers debate, meet in committee, and develop laws and regulations. The greatest ceremonial of the year is the State Opening of Parliament, usually held in early November, when the queen drives in

a carriage procession from **Buckingham Palace** to arrive at the Sovereign's Entrance. Ascending the Grand Staircase to the Royal Robing Room, where she dons ceremonial robes and the Imperial State Crown, the Queen then processes through the 100-foot-long Royal Gallery to the House of Lords. In front of her, but walking backwards, are the Earl Marshall and the Lord Chamberlain: hereditary offices held by the Dukes of Norfolk and the Marquesses of Cholmondely. Seated on the throne, the Queen can see the full length of the building to the Speaker of the House of Commons 450 feet away. The Queen's representative at Westminster, "Black Rod," is sent to summon the Commons to her presence, but as he approaches the doors of the House of Commons they are slammed closed. This represents the hard-won independence gained by the House of Commons over the centuries: the Queen's power is symbolic; it is really in the hands of the prime minister in the House of Commons. After three polite requests for admission the doors open and Black Rod delivers the Queen's invitation. Led by the prime minister the Members of the House of Commons proceed to the House of Lords where they stand just inside the door to hear the Queen's Speech. Not actually written by the Queen, but rather by the prime minister, the speech outlines the government's plans for the coming session. Its closest equivalent in the United States is the president's State of the Union address.

There are two important survivors from the mediaeval palace. One, the crypt of St. Stephen's Chapel (and its cloisters), used by the king's courtiers as their chapel, is now a private chapel for the use of members or peers. The other is Westminster Hall, the Great Hall of the mediaeval palace built for William II (r. 1087–1100), the son of William the Conqueror in 1097. Originally designed with two rows of pillars supporting the roof, these were removed during the reign of Richard II (r. 1377–1399) when the hall was substantially rebuilt and enclosed by the magnificent hammerbeam roof. This type of complex tiered-timber structure is capable of great spans; the Westminster Hall roof is one of the largest ever built. The mason/architect was Henry Yevele and the carpenter who designed the roof: Hugh Herland. Used for great state ceremonies, including Coronation Banquets, Westminster Hall once housed the courts of law and major trials, including those of Sir Thomas More (1535) and King Charles I (1649). Barry's rebuilding of the Palace of Westminster opened the south end of Westminster Hall to St. Stephen's Lobby where a great window brings a flood of light to the somber mediaeval interior. Westminster Hall is now used for public ceremonies including the "Lying in State" of monarchs, their consorts, and (rarely) politicians: George VI in 1952, Queen Mary in 1953, Sir Winston Churchill in 1965, and, most recently, Queen Elizabeth the Queen Mother in 2002.

Further Reading

Ferriday, Peter, ed. *Victorian Architecture*. London: Jonathon Cape Ltd., 1963.

Ross, Iain, ed. *The Houses of Parliament: History, Art, Architecture*. London: Merrell, 2000.

Strong, Roy. *Lost Treasures of Britain*. London: Penguin, 1990.

The United Kingdom Parliament. www.parliament.uk.

Wessex, Edward The Earl of. *Crown and Country: A Personal Guide to Royal London*. New York: Universe Publishing, 2000.

HUNTLEY PARISH CHURCH. *See* The Church of St. John the Baptist.

THE IRON BRIDGE, IRONBRIDGE, COALBROOKEDALE, SHROPSHIRE, ENGLAND

Style: Georgian—Industrial Revolution
Dates: 1777–1779
Engineers: Thomas Farnolls Pritchard and Abraham Darby III

In 1837, Charles Hulbert, in describing a scene at Coalbrookedale, wrote in his book, *A History and Description of the County of Salop* (Shropshire), that "the flaming furnaces and smoking limekilns [which] form a spectacle horribly sublime, while the stupendous iron arch, striding over the chasm presents to the mind an idea of that fatal bridge made by sin and death over chaos, from the boundaries of hell to the wall of this now defenseless world." That scene is hard to imagine today for in this peaceful, heavily wooded, steep-sided gorge of the River Severn the Industrial Revolution was born, and spanning the river the first great structure of that revolution—the Iron Bridge at Ironbridge—was constructed.

The potential of the Coalbrookedale area had been realized by Abraham Darby (1678–1717), the son of a Quaker farmer from Sedegely in nearby Staffordshire. His apprenticeship and early business opportunities took him to Birmingham and Bristol, but by 1709 he had moved to Shropshire. There supplies of low-sulphur coal, iron ore, and limestone and a location on the Severn, the second-busiest trading river in Europe at that time, made possible a thriving iron industry. By 1709, Darby was producing high-quality thin castings for pots and other "hollow ware" using coke-fired furnaces that were much larger and more efficient than the

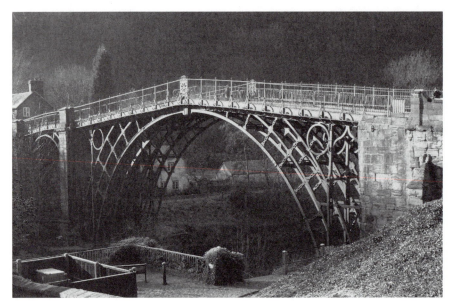

The Iron Bridge. The bridge spans the River Severn as it passes through a narrow gorge. *Photo by Ian Britton (FreeFoto.com).*

previous charcoal furnaces. (Coke is a derivative of coal; cast iron is a relatively brittle material, strong in compression but poor in tension and liable to shatter if dropped.) The business flourished under his son Abraham Darby II (1711–1763), who was the manufacturer of the Newcomen steam engine invented by Thomas Newcomen in 1712. Darby's grandson, Abraham Darby III (1750–1791), continued in the iron business and was the ironmaster responsible for the construction of the Iron Bridge.

Coalbrookedale was the center of a thriving iron industry but the very river that assisted with transportation and supplied water hindered as it flowed through the deep gorge with its steep rocky cliffs. A group of manufacturers met in the building that is now The Cumberland Hotel in Brosely and formed plans to build a bridge across the river. A subscription list of fifteen members agreed to fund the costs and Thomas Farnolls Pritchard (1723–1777), an architect from the county seat of Shrewsbury, was approached for a design. Even the ideas for the bridge excited interest; in 1776, J. M. Fisher wrote of the proposed bridge as "a Fabric which England or the whole Globe cannot equal. This is an Iron Bridge . . . the whole will be of Cast Iron without an ounce of any sort of material about it."

Pritchard, who had worked at the Darbys' house, Brosely Hall, was a respected architect in the county of Shropshire and in the West Midlands, responsible for several important country houses, churches, and public

buildings. In 1772 he assisted Payne Knight on the design for Downton Castle, one of the earliest houses of the Picturesque movement and of the castle style that was fashionable until the mid-nineteenth century. Bridges held a special fascination for Pritchard and he was thus to be the key figure in the building of the first iron bridge, one of the most important structures of the modern age. His first proposal for a bridge, to rebuild the English Bridge over the Severn in Shrewsbury, was rejected, but in 1773 his designs for a bridge across the Severn at Stourport went ahead. Originally, the bridge at Stourport was designed in timber with stone abutments, but Pritchard changed this to a single brick arch on an iron center (support while the brickwork is placed and setting) with large circular openings in the haunches of the arch to allow for flood conditions. The final bridge, completed in 1775, was not so revolutionary, being three-arched and of conventional stone construction; a flood destroyed it in 1794. Pritchard's work on the bridge at Stourport had allowed him to explore the possibilities of an all-iron bridge and his designs for the new bridge at Coalbrookedale were submitted to a receptive group of iron masters in 1775; with only a few modifications, Pritchard's design was built by Abraham Darby III beginning in 1777, completed in 1779, and officially opened on New Year's Day 1781. Unfortunately, Pritchard died on December 23, 1777 and did not see his creation completed, but he is remembered and his genius recognized.

Darby, the principal subscriber, determined that the new bridge would show how his company was years ahead of its rivals, chose a dramatic site where the gorge narrowed (but close to his furnaces) and local legend suggests it was he who determined the height of the bridge above the river so that when reflected in the water a full circle is formed. Until recently, it was not known how the bridge, which spans 100.5 feet in a single, graceful semicircular arch, was actually constructed. Written descriptions hinted at a timber structure—"a large scaffold"—leading to the supposition that towers supported a wooden span from which the iron members could be lowered into place. However, the recent discovery, in Sweden, of a painting has led to a more accurate understanding of the construction methods. The painting, by a Swedish professor of art, Elias Martin, who was traveling in England in 1777, shows the early stages of construction of the Iron Bridge. Unusually, the stone abutments have not yet been built, the painting shows three of the five parallel arched ribs in place, but freestanding, apparently placed using simple timber derricks (cranes) similar to the machines used on ships to load and unload cargo. To confirm the derricks could actually work, a half-size replica of the iron bridge was built a few miles north by the Royal Engineers 51 Field Squadron for a BBC television program (*Timewatch*, BBC2, 01/11/02).

Looking at the Iron Bridge in detail one sees a filigree of multiple arches each cast in two pieces. These arches are held apart to create a truss-like structure by elegant curvaceous radial members, also of cast iron, that are

joined to the arches by dovetail joints, a detail taken from carpentry. Indeed it is said by the guides at the visitor center that the bridge originally was wholly constructed using such joints—dovetail, *mortise and tenon*—slid together and made rigid with wedges; any bolts now seen are from later repairs. In the spandrel the triangle formed of the arch, the vertical abutment, and the horizontal roadway, an elegant but rather whimsical circle of iron recalls the flood openings in Pritchard's second design for the bridge at Stourport.

A local guide says, "Today's visitors enjoying the peace and beauty of the Ironbridge Gorge find it impossible to picture the same scene at the peak of the Industrial Revolution. The intense industrial activity of the 18th century has been replaced by an attractive urban landscape interspersed with reminders of the area's industrial past, set against a backdrop of wooded hillsides and at its heart, the River Severn and the famous Iron Bridge itself." Indeed in the eighteenth century there were more furnaces within two miles of the bridge than anywhere else in Europe and the gorge was filled with the noise, smoke, and pollution of iron production. Darby, who virtually bankrupted himself to build the bridge, achieved his goal of producing a renowned wonder and within months of its completion the Iron Bridge was a destination for artists, writers, and engineers who came from all over Europe to view the unique structure. To recoup their costs the subscribers charged a toll to cross the bridge with Darby, an egalitarian Quaker, insisting that the notice state the following: "This bridge is private property, every Officer or Soldier, whether on duty or not, is liable to pay toll for passing over, as well as any baggage wagon, Mail-coach or the Royal Family." On a visit to Coalbrookedale in July 2003, an amused Queen Elizabeth II duly handed over a penny to a toll keeper dressed in nineteenth-century garb. Today the Iron Bridge is a British National Monument and the Ironbridge Gorge a World Heritage Site. The bridge was closed to traffic in 1934 and the numbers of pedestrians are now controlled.

The Iron Bridge proved that cast iron was a viable structural material and it became a favored material for (supposedly) fireproof beams and columns. Its full potential was realized in the new urban building types of the early nineteenth century: warehouses, museums and railway stations, particularly the termini of London, and in **The Crystal Palace** of 1851.

Further Reading

Ironbridge Gorge Museums. www.ironbridge.org.uk.

KING'S COLLEGE CHAPEL, CAMBRIDGE, ENGLAND

Style: Mediaeval Gothic—Perpendicular
Dates: 1446–1515
Masons: Reginald Ely; John Wolrich; Simon Clerk; John Wastell

For the British community living in the United States, one of the annual events that many look forward to is the Festival of Nine Lessons and Carols broadcast from King's College Chapel a few days before Christmas. The service, the singing, the accents of the people reading the lessons are all very British and have a timelessness that makes one feel that such events have been occurring for centuries and will continue for many more. The chapel where the service takes place is at King's College, Cambridge, officially called The King's College of Our Lady and St. Nicholas in Cambridge, founded in 1441 by King Henry VI (r. 1422–1461; 1470–1471). Construction of the chapel, begun in 1446, was delayed by the War of the Roses (1455–1485) and not completed until 1515 during the reign of Henry VIII (r. 1509–1547). It is perhaps the finest late mediaeval Perpendicular-style building in the country, spectacular for its size and for its delicately decorated fan vaulting soaring high above the nave.

Henry VI gave his new college a generous endowment, providing for a provost and seventy scholars who by the rules of the Founder's Statutes had to be Etonians, selected from the pupils of Eton College, across the River Thames from **Windsor Castle**, which Henry had founded in 1440. The University of Cambridge itself had been founded in 1209 when a group of scholars met to study at Cambridge, beside the bridge over the River Cam, a site settled by the Romans. The Bishop of Ely founded the first college, Peterhouse, in 1284. Oxford University, the great rival of Cambridge, was ongoing in 1096, began to grow after 1167 when Henry II (r. 1154–1189) banned English students from attending the University of Paris. In 1201, a *magister scolarum Oxonie* ruled the university becoming chancellor in 1214. The first colleges at Oxford were University, Balliol, and Merton established between 1249 and 1264 as halls of residence to control the students who had been in conflict with the people of the town. Both Oxford and Cambridge universities are organized through a series of colleges that admit the students; here they live, dine in hall, and study. Each college was founded under different regulations and each has greater or lesser degrees of autonomy under the umbrella of the university. The rooms, or sets, provided to students can be quite spacious, especially in the older buildings, comprising a staircase rising through three or four floors with two one-person apartments off each land-

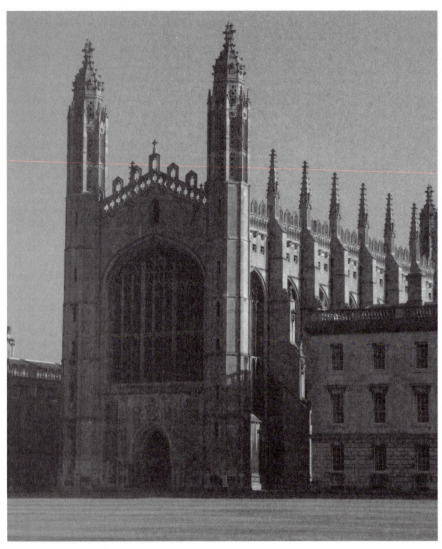

King's College Chapel. The west front with its large four-centered Perpendicular style window. The side walls, virtually all windows, are supported by stepped buttress that terminate with decorated pinnacles. *Photo by Ian Britton (FreeFoto.com).*

ing. Each set comprises a sitting room cum study plus a small bedroom. A bathroom and small kitchen is located off each landing. At King's College, Henry VI bought the land and cleared houses and a church for his new college with the intent of creating something akin to a monastery, with the Chapel on the north side and the living, study, and dining accommodation around a courtyard to the south (see **Westminster Abbey** for a description of a monastery). The concept was clearly explained in the Henry VI's "wille

and entent" written in 1448. The Chapel was to take nearly seventy years to build and the courtyard even longer, with the west side by James Gibbs (see **St. Martin-in-the-Fields**) built in 1724 and the screen wall and gatehouse by William Wilkins in 1828.

At both Eton and King's, Henry VI was most concerned with the Chapel and at King's he demanded that it be the largest of college chapels and of great beauty. The mason (architect), Reginald Ely, based his design for the new Chapel on a cathedral choir; the King laid the foundation stone on the feast of St. James, July 25, 1446. The War of the Roses broke out in 1455 when Richard, Duke of York, challenged the Lancastrian Henry's right to the throne. For the first few years of the war the King was able to send sporadic payments for construction but in 1461, upon hearing of his arrest, the workmen stopped work and went home. When construction ceased the foundations were complete and the walls rose to a height of 60 feet at the east end tapering to 6 feet at the west; the line where construction stopped can be clearly seen as, when building recommenced, the stone was changed from white magnesium limestone from Tadcaster in Yorkshire to a slightly differently hued sandstone from Northamptonshire. Henry VI was murdered in **The Tower of London** in 1471 and although his Yorkist successor, Edward IV (r. 1461–1470, 1471–1483), sent some money in 1476 and John Wolrich was appointed mason (succeeded by Simon Clerk in 1477), essentially nothing was done until 1483 when Richard III (r. 1483–1485) came to the throne. The new King encouraged building "with all possible dispatch" and threatened to "imprison anyone who opposed or delayed." Richard III lost his crown and his life at the Battle of Bosworth on August 22, 1485, to Henry Tudor who became King Henry VII (r. 1485–1509). By this time the eastern-most six *bays* were virtually complete with an oak and lead roof over the first five bays, allowing services to be held for the first time.

King's College petitioned the new King for the funds to complete the Chapel, stating, "the structure magnificently begun by royal munificence now stands shamefully abandoned to the sight." Completing the Chapel begun by his uncle had political advantages and in 1508, Henry VII paid for work to begin again; even though he died a year later his will provided money to "perfourme and end al the warkes that is not yet doon in the said chirche." The new mason was John Wastell, well known for his work in the east of England and at Canterbury Cathedral.

Henry VIII (r. 1509–1547) complied with his father's will and by 1512 the shell was complete and roofed. That left the vaulting, the glazing of the windows, and the woodwork to be done. Henry VII's executors found £500 for the vaulting and Henry VIII contributed the windows and woodwork. The Chapel was completed in 1515.

The Chapel is 40 feet wide, 289 feet long, divided into twelve bays, externally 94 feet high and internally 80 feet high to the *vault*. The plan features a nave, choir and chancel but without aisles; the spaces between the

buttresses provide for a series of chapels that at first glance at the plan suggest aisles but these are fully screened by pierced walls for most of the length of the Chapel. The Chapel is designed completely in the Perpendicular style (for a description of the styles of English Gothic architecture see **The Parish Church of St. Giles**): the walls are completely covered in a delicate paneled effect carved in the stone work; the huge windows that dominate the side and end walls are of the lower-profile, four-centered pointed arch and filled with delicate *tracery* supporting the glass (which miraculously has survived from the early sixteenth century); the four corners are dominated by towers so slender as to almost be designated *pinnacles* and the roof is hidden behind pierced *parapet* walls. Entering below the west window the eye is first drawn to the extreme length of the Chapel only partially obscured by the *rood screen*, with the organ hovering above, dividing the nave from the choir. The Nave occupies the first five bays from the west; the screen and organ most of the sixth bay; the Choir bays seven, eight, and nine; and the final three bays the *Chancel* and High Altar. The eye is next drawn to the overall decoration of every surface that seems to continue into the tracery of the windows and reaches up to the *vaults* that crown the Chapel from end to end.

It was always intended that the Chapel be vaulted but the design appears to have been changed from a simpler "lierne" style to the fantastic and complicated fan vaulting that was created by John Wastell from 1512–1515. The construction timetable demonstrates that the vaults of such chapels and cathedrals do not support the external roof; such vaults are an elaborate ceiling structurally free from the timber roof above that keeps out the weather. They are, however, because of their stone construction, extremely heavy and the mediaeval masons had to develop the use of *buttresses, flying buttresses*, and *pinnacles* to direct the loads safely to the ground. At King's College Chapel, buttresses and pinnacles ensure the stability of the internal vaults and add considerable richness to the side elevations. Wastell's fan vaulting has been called the "noblest stone ceiling in existence" by an anonymous admirer and it is a remarkable achievement for both the speed of construction and the beauty of the result.

Remarkably little has changed since the Chapel was completed in 1515, although different attitudes toward religion can be seen in the placement and decoration of the altar; even Cromwell's troops, the Roundheads, respected the building. The two most visible changes are the placement of the organ above the rood screen (c. 1660) and changes to the east wall made in 1968 to accept the placement of the painting *The Adoration of the Magi* by Sir Peter Paul Rubens, which had been donated by Major A. E. Allnatt, who purchased it at the sale following the death of the 2nd Duke of Westminster of **Eaton Hall**. Otherwise, King's College Chapel is very much as envisaged by King Henry VI when he laid the foundation stone over 550 years ago.

Further Reading

King's College, University of Cambridge. www.kings.cam.ac.uk/chapel/.

LANCASTER HOUSE. *See* St. James's Palace.

LIVERPOOL CATHEDRAL. *See* The Cathedral Church of Christ, St. Peter's Mount, and The Metropolitan Cathedral of Christ the King.

LITTLE MORETON HALL, CHESHIRE, ENGLAND

Styles: Mediaeval and Renaissance—Tudor and Elizabethan
Dates: Circa 1480–1598
Architect: Unknown

Buy a calendar showing pictures of historic or picturesque British scenes and it most likely will include an image of the dazzlingly patterned black-and-white Little Moreton Hall, its form twisted by age, apparently teetering on the edge of disaster as it leans over the reflective waters of its protective moat. Little Moreton Hall is one of the best examples of a half-timbered (timber framed) manor house in the country, the quintessential Tudor house built by the prosperous gentry of the period. It is not grand and imposing like **Chatsworth** or **Hardwick Hall** (both built by Bess of Hardwick in nearby Derbyshire), nor is it as ruggedly solid as **Haddon Hall** or Stokesay Castle; rather, for all its being a large house it is endearing and charming—a little old lady, not a *grande dame*. Owned by the same family, the Moretons,

from its beginnings in the fifteenth century until 1937, Little Moreton Hall was given into the care of the National Trust, the nonprofit organization that cares for many historic buildings and landscapes.

The construction that gives Little Moreton Hall its startling appearance is a timber framing technique often called half-timbered from the fact that the resulting structure is half wood and half infill. The history of the building (it was built in three phases) can be determined from the spacing of the major timbers of the structure. In the earliest part of the house they are close together but in the last part of the house to be built, approximately 100 years later, the spacing is larger resulting in bigger panels of infill. In all parts of the house the panels are broken up by diagonal braces that strengthen the structure. In some panels these braces are curved with added decorative pieces forming elaborately shaped *quatrefoils* that have been repeated as painted decorations on the coved eaves. The infill panels were made of *wattle and daub*—woven sapling branches or laths covered with mud or clay and then painted with a lime wash giving the characteristic white color. Later, for wealthier owners, brick was substituted for the wattle and daub. Another characteristic of half-timbered houses is that each floor steps out, literally cantilevers, a foot or two beyond the line of the wall below, such that the house gets bigger on its upper floors. This is called a *jettied* construction or jettying and while providing extra space, it was also a structural device to increase the efficiency of the floor beams. When the walls are built directly above each other the vertical loads go straight down to the foundations and do not affect the floor beams other than providing support; a heavy load placed in the rooms could cause the floor joists to sag. When the floor joists cantilever and have to support the outside wall there is a downward force pushing on the end of the joists; this is transferred over the pivot point of the supporting wall below into the main part of the beam as an upward force, which helps to counteract the weight of furniture and people in the room. If a house is jettied on more than two opposite sides, diagonal beams at the corners, called dragon beams, support the joists. Jettied construction is typical of half-timbered houses and can be seen in many country houses and cottages; it was very common in mediaeval cities where land was expensive and the extra space achieved was valuable, but in narrow streets it resulted in houses growing closer together such that at the top floors people could shake hands across the street. It was in the narrow streets lined with jettied houses only a few feet apart that the Great Fire of London of 1666 spread so readily. The area of York beside The Minster (Cathedral) known as the Shambles is a surviving mediaeval street and good examples of mediaeval jettied town houses can be seen in the city of **Chester**.

Little Moreton Hall began as a simple manor house comprising a Great Hall, with screens passage (see **Haddon Hall**), and a service wing to the east standing in a moated compound. Sometime around 1480 the arrangement was reversed by one William Moreton who built a new service wing on the west side of the Great Hall and a new family wing on the site of the origi-

nal kitchen, buttery, and pantry. The present entrance porch dates from this time and evidence for the changed plan is a blocked doorway at the opposite end of the hall. In the mid-sixteenth century the next owner of Little Moreton Hall, also William Moreton, divided the Great Hall into two floors (since reopened to its full height), and extended his father's family wing to provide three extra rooms on each floor and a private chapel. But William Moreton's most significant additions to the house are the two huge *bay* windows that light the Great Hall and the Withdrawing Room and the rooms above them. The *bay* windows are so close together that they create a small, almost hidden, space in the angle between them and as they jetty out their eaves collide and their roofs meld forming a very picturesque composition (copied in several nineteenth-century houses most convincingly at Bidston Court, Cheshire of 1891 by Edward Ould). On the bay windows at Little Moreton Hall is carved: "God is Al in Al Thing: This windous Whire mad by William Moreton in the yeare of our Lorde M.D.LIX. Richard Dale Carpeder made theis windous by the grac of God."

William Moreton had further extensions to his house in mind when he died in 1563, as his will instructed his executors to "make an ende and finishe in all poyntes such a frame as I have in hand." Therefore, William's son John Moreton completed the house as we see it today by building the south wing across the courtyard from the Great Hall that contained the gatehouse, guestrooms, and a garderobe (primitive toilet) projecting over the moat. Also built at this time was the Long Gallery, a third floor to the south wing, but this must have been an afterthought as there are various strengthening *buttresses* and braces added in the lower rooms. This last phase was completed before 1598, the year of John Moreton's death, and although the family continued to live here in varying degrees of prosperity and poverty, the house has hardly changed since the last years of the reign of Elizabeth I (r. 1558–1603).

The appearance of the house with its pattern of dark timber and light infill, carved details, and multiple gables is enhanced by the big windows filled with lattice lights—small pieces of glass held together with lead cames (strips)—in elaborate patterns. Most of the glass is very old with striations of color and texture and some windows feature painted and stained glass formed into heraldic shields and crests. Internally, the house features paneled walls and deeply coffered beamed ceilings while some of the less important rooms are painted to imitate paneling or marble. The Long Gallery is the most dramatic room in the house, long and narrow with windows on all sides; settlement has caused such deformation that the floor undulates and the walls lean at crazy angles. At each end of the Long Gallery, in the gable panels, are plaster reliefs copied from *The Castle of Knowledge*, a book first published in 1556, depicting Destiny and Fortune.

The fortunes of the Moreton family declined during the seventeenth century, hastened by their backing of the losing Royalist side in the seventeenth-century Civil War. The house was let to tenants in the eighteenth century and increasingly neglected, although sometime before 1800 the Great Hall

was restored to its full height. It was about this time that Little Moreton Hall began to be appreciated for its Picturesque qualities and it became a sight for appreciative tourists; in 1807 John Sell Cotman drew it for Britton's *Architectural Antiquities*. The last Moreton died in 1913 leaving Little Moreton Hall to a distant cousin, Charles Abraham, later Bishop of Derby, who did much to restore the house and assured its preservation by giving it to the National Trust. The Trust has done much to maintain and restore the house, for example, by removing unfortunate nineteenth-century painted decorations, but controversially, it has recolored the exterior in mellow dark brown and cream rather than the dramatic black and white people had become used to; this, the Trust assured the public, was how the house would have looked in the sixteenth century. Nevertheless, Little Moreton Hall is one of the most picturesque and memorable houses in the country.

Further Reading

Cooper, Nicholas. *Houses of the Gentry 1460–1680*. New Haven, Conn.; London: Yale University Press, 1999.

de Figueiredo, Peter, and Treuherz, Julian. *Cheshire Country Houses*. Chichester: Phillimore & Co. Ltd., 1988.

National Trust, Little Moreton Hall. www.nationaltrust.org.uk/scripts/nthandbook. dll?ACTION=PROPERTY&PROPERTYID=113.

LLOYD'S OF LONDON, LONDON

Style: Twentieth Century—Modern
Dates: 1978–1986
Architects: Richard Rogers Partnership (Lord Rogers of Riverside)

The City of London is the British equivalent of Wall Street in New York. The City is the center of trade and finance, while Westminster, a short distance west, is the location of the court (the monarchy), government, and high society. Also known as "The Square Mile" for its area, The City approximates the extent of the mediaeval city of London and, even further back, Roman Londinium. The Great Fire of London in 1666 destroyed most of the mediaeval buildings but the street plan is still evident in the maze of narrow streets and alleys that are lined with eighteenth- and nineteenth-century buildings interspersed with those of later years. Therefore, it is a surprise to come across the Lloyd's Building, the headquarters of Lloyd's of London, for it is an example of the "High-Tech" movement in architecture, a glittering confection of glass and stainless steel in extreme contrast to the brick and stone of the surrounding buildings.

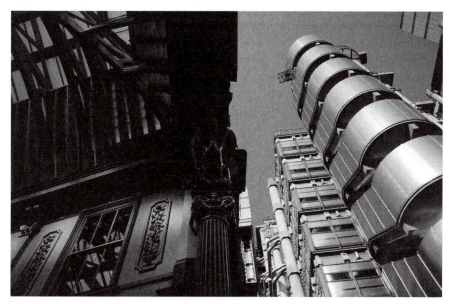

The Lloyd's Building. The shiny surfaces of the exposed service pods contrast sharply with the conservative classicism of the City of London. *Harcourt Index.*

Lloyd's is an insurance market where almost anything from fleets of ships to a dancer's legs can be insured. It is also a market for the reinsurance of policies taken with insurance companies. Known internationally, Lloyd's is the ultimate insurer for most disasters around the world; a homeowner's policy taken in the United States is probably eventually insured on the Lloyd's market. Not an insurance company, Lloyd's does not have shareholders and is not itself liable for any of the risks insured. Rather, it is a society of individual and corporate members—sometimes referred to as "members" or "names"—each of whom accepts insurance risks via membership in one or more underwriting syndicates. Individuals are liable to the full extent of their private wealth while corporate groups have limited liability—the profits, from premiums, can be enormous but so can the risks and the consequent liabilities.

The origins of insurance begin with shipping. In the sixteenth century, when England was becoming a maritime trading power, merchants invested fortunes in the ships and their cargo. The Lombards, a group of financially clever immigrants, began the idea of accepting the risk of the loss of a ship for a premium paid by the owner. To avoid being at risk for the whole cost of a ship and its cargo the broker would share the premium and the risk. By the late seventeenth century insurance was an accepted part of trading and began to be considered for other risks, for example, insurance against fire— the first fire brigades were paid for by the insurance companies, hoping to reduce their losses when buildings caught fire. In the 1680s the Royal Ex-

change was the traditional meeting place for merchants and insurance brokers but in those more informal times of gentleman's agreements, concluded by a handshake, the newly fashionable coffee houses were a more comfortable place for business transactions. Edward Lloyd, the owner of such a coffeehouse, had a reputation for accurate, trustworthy shipping news. Situated in Tower Street, Lloyd's Coffee House is where Lloyd's began and to this day retains the name of the enterprising host.

About 100 years later, in 1774, the coffeehouse was left behind. Because of the vastly increased insurance trade, and needing a regular place of business, Lloyd's moved to accommodations in the Royal Exchange. In 1871, an Act of Parliament established the legal basis that made Lloyd's a modern business and in 1928, Lloyd's moved into its own premises on Leadenhall Street. These, by 1958, proved too small and a move was made across the street to a new, but undistinguished, building. In 1978, again suffering from an overcrowded trading floor, the decision was made to build another new building on the Leadenhall Street site, which was still owned by Lloyd's. The 1928 building, designed by Sir Edwin Cooper, was demolished apart from the entrance *portico* that now stands to one side of the latest Lloyd's Building. Richard Rogers was the chosen architect and Queen Elizabeth II (r. 1952–) formally opened the new building in November 1986.

Rogers's most famous previous commission was the Centre Pompidou in Paris, designed in partnership with the Italian architect Renzo Piano. The Lloyd's Building continues the principles established in that building in that every component of the building is visibly expressed and part of a logical system. Thus, the structure, the heating and ventilation, or the circulation—the stairs, elevators, and escalators—can be readily understood as separate elements, as can how each fits into the totality of the building. Thus, apparently simple, the building is extremely complex involving the integration of elements that have rigorously been reduced to their most efficient and obvious. Rogers's work is Modernist but has diverged far from the white minimalism of Le Corbusier or the cold elegance of Mies van der Rohe, instead exhibiting the ideals of "Brutalism" (truthful expression of materials and structure) and "Bowelism" (visible expression of structure, pipes, and ductwork). Also once in partnership with Norman Foster, his rival as most prominent British architect of his time, Rogers says: "Norman has the wonderful magic of making everything look absolutely completed and wrapped" while characterizing his own work as "a more open-ended proposition between transformation and permanence." Certainly, while Foster concentrates on "single-mindedly devising the perfect object with Miesian elegance and restraint," Rogers "assumes a more ad hoc approach to a changeable kit of parts that gives his buildings a less finished look."

Lloyd's required a large trading floor—"The Room"—where the underwriters (numbering over 2,000) work from computerized stations called "boxes." To maximize the space for The Room, Rogers fitted the largest rectangle possible onto the site; this is five-and-two-half-structural-*bays* long and

three-and-two-half-bays wide. The only intrusion into this vast space is a bank of escalators that occupies one bay that is open to the entrance floor below. Above The Room the three central bays are open as an atrium, 240 feet high, which is capped by a semi-circular skylight reminiscent of Paxton's **Crystal Palace**. As the fourteen-story building rises, the size of each floor diminishes creating a stepped effect externally from which the atrium emerges with a seven-story-high south-facing window. The lower floor levels overlooking the atrium are open and several are now used for underwriting boxes, an expansion that Rogers expected and allowed for in the design. The upper levels, containing offices, are separated from the atrium (to meet fire codes) by aluminum fin-braced glass. The white marble floor of the atrium is kept clear except for the elaborate, ornately carved caller's rostrum crowned by a canopy and clock and within which hangs the Lutine Bell (the historic bell rung when a ship is lost). One of the most surprising elements of the Lloyd's Building is the eleventh floor Board Room that, rather incongruously, is a complete Robert Adam drawing room of 1761–1764, bought when the Great House at Bowood, Wiltshire, was demolished in 1956.

The rationale of Rogers's design is obvious from the viewpoint of the atrium. Round concrete columns, *cast in situ*, rise to the top of the building, precast collars and yokes support the floor system of inverted U-beams, all visible to the users of the building. The underside of each floor forms a grid of concrete within which aluminum shielded luminaires (lights) are recessed and through which the ductwork and fire sprinkler system can be seen. The bowels of the building are clearly visible.

The site of the Lloyd's Building is very irregular (as are most sites in the mediaeval city) and the areas left over beyond the rectangle of The Room, and the floors above it, are given over to all the services. Six satellite towers give the building what one critic described as a "rococo exuberance." Each is structurally independent of the main building and the three larger service towers comprise a lobby, four external glass-enclosed elevators, a bathroom module on each floor, and a fire escape staircase. Externally clad in stainless steel, the components were prefabricated in factories outside London (down to the marble wash basins), hoisted into place, and bolted together. Further enriching the exterior of these towers is a filigree of heating and air conditioning ductwork that snakes down and across the building from three-story-high mechanical rooms that perch atop the three main service towers. Again the system is readily understood and completely visible. Bright blue maintenance cranes are permanently placed on top of the mechanical rooms and from these yellow cradles can be lowered for cleaning and repairs. The three secondary service towers, similarly detailed, contain additional fire escape stairs and service elevators.

The Lloyd's Building, controversial when completed in 1986, continues to cause discussion although its presence in the historic confines of The City is now accepted. Rogers's work is not without its problems and the architect reached a settlement with Lloyd's for corrections to the external cladding.

Described as a high-tech architect, Rogers prefers to say, "There is no low or high technology, just appropriate technology."

Further Reading

Dietsch, Deborah K. "The Lloyd's Building." *Architectural Record*, November 1986.
Richard Rogers Partnership (architects). www.richardrogers.co.uk.
Society of Lloyd's. www.lloyds.com.

LONDON BRIDGE, LONDON

Styles: Mediaeval, Georgian—Neoclassical, and Twentieth Century—
Modern
Dates: 52 C.E.–c. 400; 1176–1209; 1825–1831; 1971–1973
Engineers: Peter de Colechurch (twelfth century); John Rennie and Sir
John Rennie (nineteenth century)

You can travel to Lake Havasu City, Arizona, in the southwestern United States to see London Bridge. This is the London Bridge completed in 1831 that, by 1967 was sinking under its own weight into the mud of the River Thames. It was dismantled stone by stone, transported to Arizona, and rebuilt to span an artificial lagoon beside Lake Havasu. The buyer was millionaire Robert McCulloch, who wanted the 140-year-old bridge as the centerpiece of a development he planned to build on a twenty-six-square-mile tract of land he owned on the Arizona/California border. There is no truth to the story that he was duped by the Lord Mayor of London into thinking he was buying **Tower Bridge**. The bridge he bought was replaced, in 1973, by an elegant structure of three gently arching, reinforced concrete spans; the bridge it had replaced in 1831 was much more interesting, having stood for over 600 years since its completion in 1209, observing English history cross the Thames from Southwark on the south bank to the City of London on the north bank.

The Romans invaded and conquered Britain in 43 C.E. and a few years later established Londinium at the lowest point on the Thames where it was possible to ford the river. Sometime around 90 C.E. a timber bridge was constructed that was maintained until the Romans abandoned Britain in the early fifth century. During the years of the so-called Dark Ages, Londinium was still inhabited, renamed Lundenwic, but the only means of crossing the river was by taking a small ferry boat. There are references to a London Bridge between 979 and 1014 when Viking raiders, led by Olaf the Norseman, pulled it down, an event that apparently led to the rhyme "London Bridge

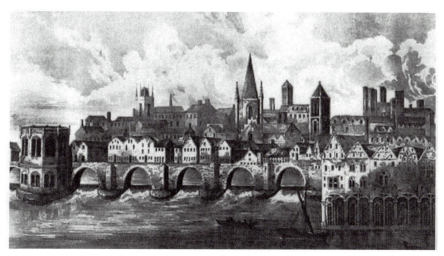

London Bridge. An early seventeenth-century Dutch print showing the chapel and houses built on the bridge and the dangerous water rushing through the arches caused by the bridge restricting the flow of the river.

is falling down, falling down, falling down. London Bridge is falling down, my fair lady!" The next London Bridge was built in 1087 by King William II (r. 1087–1100), who was known as Rufus—"red head." It lasted ten years until carried away by a flood. Squads of forced labor quickly rebuilt it, so important was the bridge to the prosperity of the city. All these bridges were built of timber and the last wooden bridge was completed in 1163, engineered by Peter de Colechurch, chaplain at St. Mary Colechurch in the City of London. Colechurch convinced Henry II (r. 1154–1189) that only a stone bridge would be strong enough to resist the flow of the Thames and the fires that had often destroyed the previous bridges. Already rentals from land adjoining the bridge paid for its upkeep and a tax on wool was imposed to pay for the new bridge. Peter de Colechurch began construction in 1176 but did not see its completion in 1209, having died in 1205: He was buried in the crypt of the Chapel of St. Thomas of Canterbury, built at the center of the bridge. In 1201, King John (r. 1199–1216) decreed that houses should be built on the bridge, on either side of the central passage, to generate extra maintenance income; thus the appearance of Old London Bridge, a "living bridge" lined with stores and residences, was established during its construction. Other features of note in 1209 were the Great Stone Gateway built on the third pier (counting from the south, Southwark, end); a drawbridge between piers six and seven with its mechanism in a gatehouse built on pier seven (the heads of traitors were impaled on long poles and displayed on top of this gatehouse until 1577 when they were instead hoisted above the Great Stone Gateway—a practice that only ended in 1678); and the chapel already referred to on pier eleven.

The starlings (foundations) built by Colechurch were constructed by driving elm pilings deep into the riverbed to enclose a boat-shaped space that was then filled with stone rubble. A second, outer line of pilings enclosed more rubble, the whole overlaid by oak beams, thus providing a platform upon which the actual piers and arches were built. The river therefore became very constricted and the flow of water became dangerously fast; the Thames boatmen were very skilled at "shooting the bridge" but nevertheless, many people lost their lives on the river (the flow was so fast that several waterwheels were installed under the arches close to each bank). The finished bridge, with its twenty arches, was approximately 940 feet long, 60 feet above the water, and 15 feet wide. Stores and houses lining the bridge reduced the width of the roadway but also cantilevered out over the water; above the second floor many of the houses were stabilized by haute-pas galleries, passageways that linked the houses.

The bridge structure suffered damage from floods, ice floes, and poor maintenance and the piers were constantly being repaired or rebuilt, but the bridge rarely closed for more than a few days. The chapel, rebuilt 1384–1397, was deconsecrated under orders from Henry VIII (r. 1509–1547) and by 1553 was serving as a house; the drawbridge gatehouse replaced in 1426 by the New Stone Gate was replaced in 1577–1579 by Nonesuch House, an amazing timber-framed building covered in gilded carvings, prefabricated in Holland, shipped to London, and erected on the bridge using only wooden pegs to hold it together. Disaster still affected the bridge. A fire in 1632–1633 destroyed all the houses from pier thirteen to the north end and they were no sooner rebuilt than the Great Fire of London in 1666 burned them again; the rest of the bridge was only saved by an open space called The Square.

Various attempts were made to architecturally unify the buildings on the bridge while also widening the roadway, but without much success, and in 1762, when all the leases expired, the buildings were cleared and London Bridge ceased to be a "living bridge"—a bridge lined with inhabited buildings. Pier nine was removed and replaced by the Great Arch, the width was increased to 46 feet, and the appearance updated with Classical *balustrades* and domed shelters, seven on each side. This bridge is recalled by Charles Dickens, who knew it in his youth: "I was wont to sit in one of the stone recesses watching the people going by, or to look over the balustrades at the sun shining in the water and lighting up the flame on top of the Monument (to the Great Fire)." Traffic, however, was increasing, even though other bridges crossing the river had opened, and by 1800 a new bridge was under consideration. John Rennie submitted designs on March 12, 1821; the committee instead organized a design competition, but after reviewing the results returned to Rennie's design. Although he died in October of 1821, the bridge was completed by his son, also John Rennie, and completed in 1831 when, on August 1, it was opened by King William IV (r. 1830–1837) and Queen Adelaide.

It is the Rennie bridge that eventually made its way to the banks of Lake Havasu where its success as a community focal point has led to the development of a city of 42,000 people, visited by 2.5 million tourists every year. Queen Elizabeth II (r. 1952–) opened the New London Bridge in 1973 and a London Bridge Museum is scheduled to open in 2009, the eight-hundredth anniversary of the completion of the Peter de Colechurch bridge in 1209.

Further Reading

Murray, Peter, and Stevens, MaryAnne. *Living Bridges: The Inhabited Bridge, Past, Present and Future*. London: Royal Academy of Arts; New York: Prestel Munich, 1996.

Pierce, Patricia. *Old London Bridge: The Story of the Longest Inhabited Bridge in Europe*. London: Headline Book Publishing, 2001.

LONDON CITY HALL, THE QUEEN'S WALK, LONDON

Style: Twentieth Century—Modern
Dates: 1998–2002
Architect: Norman Foster (Lord Foster of Riverside) and Partners

The late 1990s saw proposals for several exciting projects promising a combination of friendly modern architecture and distinctive forms that would transform the London skyline. One of these projects, the new City Hall, is the headquarters of the Greater London Authority (GLA), an elected body that has limited powers to administer the capital. Most decisions are still made by the government's Minister for London rather than the Mayor and London Assembly. Until the 1980s, London was administered by the Greater London Council from County Hall, the Edwardian Baroque building across the river from the Houses of Parliament, built 1912–1933 by architect Ralph Knott. The GLC so antagonized Prime Minister Margaret Thatcher (for example, by installing banners showing unemployment numbers across the *façade* of County Hall in full view of the terrace of the Houses of Parliament) that she abolished it. A decade later, when the GLA was proposed, County Hall was not available—it had been sold off to become a luxury hotel—and therefore, in 1999, Norman Foster won the commission to design a new building, to be named City Hall, representative of the new and open democracy that was to administer the city.

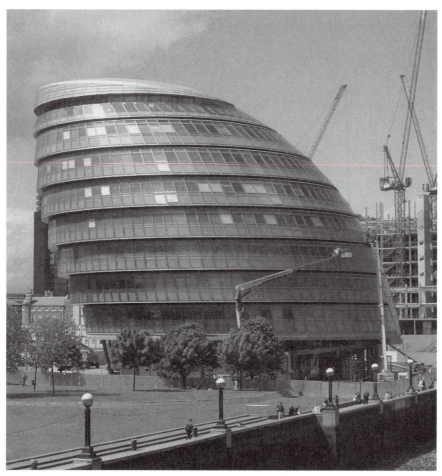

London City Hall. The headquarters of the Greater London Authority on the south bank of the River Thames viewed from **Tower Bridge**. *Photo by Ian Britton (FreeFoto.com).*

The City Hall commission was the result of a competition that received fifty-five submissions proposing possible sites and building designs. Seven sites and designs were chosen for public discussion; of these two were developed further, and on February 26, 1999, the Minister for London announced that the government would build the scheme at London Bridge City also known as "More London" designed by Foster. The site is not actually at London Bridge but farther east, on the south bank of the river at **Tower Bridge**, directly across from **The Tower of London**. It is a very prominent, high-visibility site calling for an outstanding design. The reaction of the critics to the finished building has been mixed. Giles Worsley, writing in the *Daily Telegraph*, said, "Looking like a glass-and-steel egg London's new City

Hall is bold but flawed . . . a building rippling with self importance . . . determined to be an icon . . . though, if truth be told strangely reminiscent of the comic-book hero Judge Dredd's helmet." The mayor, Ken Livingstone, described it as a "glass testicle." Foster and Partners have their offices in an elegant purpose-built building beside the River Thames and have completed several projects in London but City Hall is their first new public building to be built from the ground up.

The design brief given to the competition entrants was to create a building that would be a new landmark for London. Foster added his own symbolism determining that the building should express the "transparency of the democratic process and demonstrate the potential for a wholly *sustainable*, virtually non-polluting public building."

The transparency is achieved by the glass skin of the building and an internal public ramp spiraling upwards, allowing the citizens of London a view of the Assembly Hall—the debating chamber—and their elected officers in action. Committee Rooms, offices for the mayor and assembly members, and open-plan administrative support offices make up the rest of the official part of the building. The whole ten-story building totals approximately 185,000 square feet with usable floors ranging in size from 2,600 to 12,800 square feet. At the top of the building is "London's Living Room," a flexible, multipurpose room with glass walls and surrounding balconies that enjoy views across the city. At the base of the building underground access and service roads allow a large, traffic-free public piazza with cafés, seating, venues for outdoor events, and several water features as well as the always present river and glowering Tower of London.

The sustainable, virtually nonpolluting aspect of the design inspired the unusual and iconic form of the new City Hall. Giles Worsley's comment that it looks like a "glass-and-steel egg" is a good description. Foster describes the form as a "geometrically modified sphere (developed using computer modeling techniques)." The spherical form "achieves optimum energy performance by minimizing the surface area exposed to direct sunlight." The analysis of computer-generated sunlight and thermal maps of the building created the cladding treatment and the density of the fritting (reflective ceramic dots) on the glass. Facing north the glass is clear, but on the east and west sides where the sun can be a significant problem, the fritting is very dense, although it is still possible to see outside. (A material can be 90 percent solid but still be transparent if the observer is on the darker side looking through to the light. *Fritted* glass is one method of such sun screening; another is perforated metal external blinds or panels.) The geometric modification of the sphere assists in achieving further solar advantages. On the south side each floor plate steps out beyond that below so that the building appears to lean over. This shades the offices on this side of the building and reduces the cooling requirement for the building. Such techniques are known as active (the fritted glass) or passive (the shading) solar devices and are part

of a whole package of energy-saving technologies installed in the London City Hall that will make its energy consumption one-quarter that of comparably sized, traditionally designed buildings.

Thus, by its form and sustainability (the buzzword for energy and resource conservation) the new London City Hall has achieved the client's design brief and Foster's goals. It is certainly a spectacular building whose form and location, isolated on its great piazza beside the River Thames, make it stand out as a landmark in much the same way as Frank Lloyd Wright's Guggenheim Museum does in New York.

There is another connection to the Guggenheim in the circulation system that Foster chose to use: a ramp that reaches from the ground floor to the observation deck at the top of the building. It is Foster's hope that this ramp will be the "fulcrum around which the building revolves with staff and tourists using it to move from floor to floor." The critics have their doubts; they pessimistically suggest that the staff will find the distances excessive and only tourists will enjoy the ramp as it spirals up past the offices and around the Assembly Hall. The ramp is a spectacular structural tour de force that can be likened to holding one end of the peel of a skinned apple. Apparently without structure, the ramp is actually supported by the triangulated mesh that holds the glass wall that separates the public from the GLA spaces. Foster is not averse to copying his own work and a similar spiral ramp can be seen in his design for the Berlin Reichstag of a few years earlier, although without that building's spaciousness and elegance. To quote Worsley again: "As an architectural gesture, it [the ramp] smacks of the search for an iconic image, but, crammed into what is really quite a small building . . . it does not quite pull it off."

London City Hall comes close to realizing the tenet of high-tech architects such as Norman Foster and Richard Rodgers that aesthetics are irrelevant, the form of the building will "emerge directly from the practical demands placed upon it." In this they have developed Louis Sullivan's suggestion that "form follows function," but there is a flaw in their claims in that the general idea for the form—the aesthetic?—came first, and was then manipulated to meet the technical goals.

The GLA moved into the new London City Hall on July 15, 2002. Queen Elizabeth II (r. 1952–) officially opened the building on July 23, 2002, as one of the events celebrating her Golden Jubilee (50 years as queen). The building cost $65 million. As the queen looked across London from the "London Living Room" she saw a skyline that was about to change radically. If the mayor, Ken Livingstone, has his way the planning authorities will approve several new skyscrapers. In the City of London across the river from City Hall are: the Heron Tower by American architects Kohn Pedersen Fox; the Minerva Building by Sir Nicholas Grimshaw; the controversial Swiss Re Building by Norman Foster that critics have dubbed the "erotic gherkin (pickle);" and, along the south bank of the river from City Hall, London Bridge Tower by Renzo Piano. The developers say these new buildings are

essential to maintaining London's international standing as a financial center but the naysayers are worried about the impact these tall buildings will have on the historic city of London.

Further Reading

Foster and partners (architects). www.fosterandpartners.com.
Greater London Authority. www.london.gov.uk/gla/city_hall/index.jsp.

THE "LONDON EYE," THE SOUTH BANK, LONDON

Style: Twentieth Century—Modern
Date: 2000
Architects: David Marks and Julia Barfield

The Millennium Projects sponsored by the government through the Millennium Commission were, to varying degrees, major public embarrassments. Heading the list was **The Millennium Dome**, beside the Thames at Greenwich, the focus of political and financial scandal rather than national celebration. Upriver, and equally conspicuous, is **The Millennium Bridge**, which architecturally matches the bravura of the Dome but unfortunately closed after three days due to excessive swaying. It reopened only after the addition of expensive dampers that reduce the movement and took over a year to install. Within sight of pedestrians when they eventually were allowed to cross the Millennium Bridge is another project erected to celebrate the opening of the twenty-first century. This is the London Eye, a giant high-tech Ferris wheel that reaches 443 feet toward the sky from the south bank of the River Thames, close beside the former London County Hall and just a stone's throw from **The Houses of Parliament**.

The London Eye was commissioned by British Airways as its contribution to the millennium celebrations and, despite some initial technical problems, it has proved to be a great (and profitable) success with the paying public. In 1996 the then Secretary of State for the Environment, John Selwyn Gummer, gave planning permission for the Eye, stipulating that the permission was temporary and would last for five years—after that the Eye would have to be dismantled. It has been so successful that most Londoners hope that the Eye will follow the example of another famous temporary structure, the Eiffel Tower in Paris built in 1889.

The designers were the relatively unknown duo of David Marks and Julia Barfield who designed a beautifully elegant structure to rival the millennium

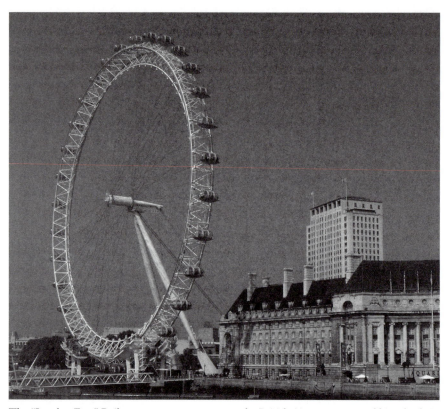

The "London Eye." Built as a temporary structure, the British Airways sponsored big wheel sits on the banks of the River Thames beside the old London County Hall that is now a hotel. *Photo by Ian Britton (FreeFoto.com).*

projects of the more famous architects Richard Rogers and Norman Foster. In many ways the Eye looks like a giant bicycle wheel, the rim is formed of a lacy network of structural steel that maintains the circle. Connecting to the hub are a series of tensioned cables; and, supporting the hub are two legs that lean over toward the river but are prevented from toppling by further tension cables that are held in check by massive ground anchors 200 feet away. W. F. Deedes wrote, in the *Daily Telegraph* of February 2, 2000, "For those of a mechanical turn of mind, the turning of the wheel offers fascination of its own. What appears to be two gigantic lorries (trucks) lying upside down with their tyred (tired) wheels in the air connect with the flanges of the wheel and turn it."

Instead of a tire the "bicycle wheel" has affixed to its rim thirty-two glass-enclosed capsules each capable of holding twenty-five people—the Eye can accommodate a maximum of 800 passengers at any one time, 15,000 a day. Each capsule is held within two ingeniously engineered hoops, held off the rim of the wheel by structural armatures—as the Eye turns the capsules ro-

tate within the hoops always maintaining a level floor. With a total height/diameter of 443 feet and moving at approximately two miles per hour, the Eye takes thirty minutes to complete a full circle. Moving so slowly, it is not necessary to stop the Eye to embark and disembark passengers and the wheel moves continuously from 9:00 AM until 10:00 PM.

Inside each capsule there is a central low table and seating for twelve but most passengers stand close to the curving convex glass skin out of which the most spectacular views of Britain's capital can be obtained. On cloudy days it is still possible to study the city from a novel viewpoint, while on clear days it is possible to see twenty-five miles to the edges of the city and beyond— south to the Downs (hilly countryside) or west to **Windsor Castle**. The height of the London Eye makes it the highest Ferris wheel in the world, twice the height of the Prater Wheel in Vienna, Austria, and ninety feet taller than the previous tallest in Yokohama Bay, Japan.

The construction of the Eye was not without problems and the project threatened to join the other millennium failures. The giant wheel was made of several prefabricated sections that were brought upriver on barges and assembled beside the site *on* the river. In the summer of 1999 the wheel lay on its side reaching over halfway to the opposite bank of the river. The first attempt to bring the wheel to its upright position failed and pessimists suggested that the project would fail at this stage. However, in October 1999 the wheel was raised. The second problem was less critical but certainly embarrassing. For the maiden voyage of the Eye, British Airways planned an extravagant champagne party for 250 prizewinners, special guests, and media representatives who would celebrate the new millennium riding the Eye, but it was not to be. The wheel could turn but the "clutch mechanisms" that allowed the capsules to rotate within their supporting hoops were faulty and safety concerns cancelled the celebratory ride. Instead, the partygoers watched the wheel turn and a Concorde fly past while drinking their champagne standing firmly on the ground. This disappointment was forgotten once the mechanism was corrected and passengers began to enjoy the wheel a month later. The first passengers boarded on February 1, 2000.

British Airways hoped that 2.2 million people would ride the Eye in its first year. After only seven months that number was exceeded by 400,000 and the target for the year was raised to 4 million passengers. The London Eye cost $50 million to build but British Airways will get its investment back. In these times of problems for the airline industry Deedes pithily suggests "This wheel will make more money than any of (their) aeroplanes."

Further Reading

British Airways London Eye. www.londoneye.com.
Hawkes, Jason. *London 360°, Views Inspired by British Airways London Eye*. London: HarperCollins Illustrated, 2000.
Rattenbury, Kester. *The Essential Eye*. London: HarperCollins Publishers, 2001.

LUTYENS COUNTRY HOUSES, VARIOUS SITES

Styles: Victorian—Arts and Crafts and Twentieth Century—
Edwardian and Inter-War
Dates: Circa 1890–1935
Architect: Sir Edwin Lutyens

Any encyclopedia of British architecture would be incomplete without reference to Sir Edwin Lutyens, arguably the greatest architect the country has produced, surpassing even Sir Christopher Wren and Sir John Vanbrugh. International architects of the twentieth century, when asked to name designers who have influenced their own work, will mention Lutyens: Study the works of James Stirling and Hugh Newell Jacobsen and the connection is obvious, even Michael Graves and Norman Foster admit their respect for Lutyens. The enigma of this reverence is that at first glance Lutyens's buildings do not appear to be that unusual. The early houses are in the vernacular style of southeast England akin to the Arts and Crafts designs of Shaw and Voysey. Later in his career he built either in a restrained "Queen Anne" or Georgian early eighteenth-century style or, for the grandest houses, he designed in the full-blown Classical manner. His greatest work is the Viceroy's House (never referred to as the palace it is) in New Delhi, India where he combined the Classical formality of European imperial architecture with the Moghul architecture of the sub-continent's prior rulers. It is a stupendous building conceived as the idea of Indian independence was beginning and completed only a few years before the independence ceremonies. In Britain, Lutyens was one of the most famous architects of his day and a century later his houses are much sought after, commanding a premium price far in excess of their statistical value.

Edwin Landseer Lutyens, the son of a retired soldier turned sporting artist, was named for the great Victorian artist Sir Edwin Landseer. Lutyens was a sickly child and he had little formal education while recuperating at the family home in Thursley, Surrey. As a teenager he met Gertrude Jeckyll, the revolutionary landscape designer who had reinvented the cottage garden to counter the forced, formal Victorian garden. It was with Jeckyll's encouragement that the young Lutyens spent many days bicycling around the country lanes of Surrey studying the local *vernacular* architecture and the craftsmanship of traditional masons and artisans. At the age of eighteen in 1887 he entered the office of the architect Sir Ernest George as an apprentice. Two years later he set up in practice for himself, concentrating at first

on residential architecture. In 1912 he received the commission for the Viceroy's House and this was to occupy most of his time until its completion in 1929. His practice during this time also became more commercial with several London office buildings (the headquarters for the magazine *Country Life* and the Midland Bank). For many Lutyens is best known for his work after the First World War (1914–1918) as principal architect to the Imperial War Graves Commission when he designed **The Cenotaph** (War Memorial) in Whitehall, London, and the massive Memorial to the Missing at Thiepval, France.

Lutyens was a round-bodied, round-faced ebullient individual, a good friend to most of his clients, although he was known to ride roughshod over some who questioned his ideas. At Heathcote (1905–1907), the Classical villa he designed in Ilkley, Yorkshire, for J. T. Hemingway, the client expressed a wish for an oak staircase. "What a pity," Lutyens responded. A few months later when they were inspecting progress the black marble staircase was noticed. "I told you I didn't want a marble staircase, I wanted oak" protested Mr. Hemingway to which Lutyens replied "I know, I said 'What a pity' didn't I?" Heathcote is the most Italianate of Lutyens's houses in deliberate contrast to the bleak North Yorkshire landscape and nearby Victorian houses. The elaborate elevations owe reference to Italian architects Palladio and Sanmicheli and to the English Baroque architect Sir John Vanbrugh. Lutyens was never afraid of using the past but always with his own particular twist. The plan of Heathcote is a prime example of Lutyens's play with axes; a lesser architect would have allowed a view right through the house but instead one enters to face a fireplace. This forces a turn to another axis and so on until, having passed though a series of intricately fascinating spaces, one returns to the original line to exit the house onto the terrace.

Study of the houses of Lutyens shows that with a few exceptions they follow a similar basic plan elaborated to meet the particular program. The complicated play with axes described at Heathcote is evident in all of Lutyens's designs, residential and commercial, and is the real delight of his buildings, a complexity that overrides their style be it vernacular or Classical. At Deanery Garden, Sonning, Berkshire of 1901, which he built for Edward Hudson, the creator of *Country Life* (a magazine enthusing about country pursuits and often featuring houses by Lutyens), multiple axes connect the main rooms and features of a house that has been described as "without overstatement a perfect architectural sonnet, compounded of brick and tile and timber forms, in which his handling of the masses and spaces serve as a rhythm: its theme, a romantic bachelor's idyllic afternoons beside a Thames backwater." Gavin Stamp wrote, "Deanery Garden may be regarded as the quintessential Lutyens house: a semi rural retreat which is a dream of old England, superbly built of the most sympathetic materials, and yet a pure formal conception of the utmost brilliance in which house and garden are integrated." As at many of his houses the garden here was designed in partnership with Gertrude Jeckyll; Lutyens would design an elaborate architec-

tural framework of terraces, pools, walls, and pergolas while Jeckyll would contribute the planting scheme.

One of Lutyens's first commissions was a new house for Jeckyll at Munstead Wood, Surrey (1896), soon followed by Deanery Garden (1899). At Little Thakeham, Sussex (1902–1904) he combines vernacular Tudor with Vanbrughian Baroque (in the manner of the early eighteenth-century English architect Sir John Vanbrugh), creating the fiction that the great hall of an Elizabethan manor house was in process of a renovation arrested in 1710. Lutyens would often create such stories for his designs or play stylistic and scale games. At Homewood, Knebworth, Hertfordshire (1901) a remnant of a grand-columned house appears to be in process of being enveloped by a vernacular gabled structure. While at Ednaston Manor, Derbyshire (1912–1913), the friendly but imposing red brick Classical house is in Lutyens's "Wrennaissance" style (a combination of Renaissance referring to the stylistic period, with Sir Christopher Wren the English architect of **St. Paul's Cathedral** and **Hampton Court Palace**); around the back, in the service court, the architect reverts to a vernacular style, as if an older house was buried within the larger, newer building. There are many other fascinating houses, too many to be listed but all worthy of study and praise.

One house though, is too good to omit—The Salutation. It was built in 1911 in Sandwich, Kent, on a site that by a quirk of ownership causes a road to divert around the south side of the garden. Where the road meets the site Lutyens created an extraordinary gatehouse of two lodges connected by a roof supported on a massive, curved white plaster cornice. When the high wooden gates are opened the house is not revealed; instead the axis of the road continues, and, marked by gateways and paths, passes through the gardens eventually emerging on the opposite side to regain the line of the road. The house is off to one side of this axis and, at first glance, appears to be an elegant Queen Anne style house of two tones of red brick, stone details, and regular symmetrical *façades*. The complexity of the plan, and the related garden of terraces, allees, and lawns, is completely un-eighteenth-century and is Lutyens at his very best. Every room—hall, library, drawing room, and dining room—is an axial, symmetrical, spatial tour de force coming together in an apparently simple, related whole. What appears to be a solid rectangular block from the three visible façades is actually a u-shape allowing the central staircase to have a large window bringing light into the heart of the house. Huge chimneys, in the manner of Pratt or Vanbrugh, dominate the skyline and on the west façade a central sundial brings a note of frivolity, of lazy Edwardian summer teas on the lawn, to an otherwise severe, even aloof, visage. As with many of Lutyens's houses The Salutation is not a country house at the center of a large estate; rather, it is a comfortable upper-middle-class country home, serene, confident, and assured in its elegant solidity. It is the perfect house that many in Britain aspire to own.

Further Reading

Brown, Jane. *Lutyens and the Edwardians. An English Architect and His Clients.* London: Viking/Penguin Group, 1996.

Dunster, David. *Architectural Monographs: Edwin Lutyens.* London: Academy Editions/St. Martin's Press, 1986.

The Lutyens Trust. www.lutyenstrust.org.uk.

Stamp, Gavin. *Edwin Lutyens Country Houses.* New York: The Monacelli Press, Inc., 2001.

Wilhide, Elizabeth. *Sir Edwin Lutyens: Designing in the English Tradition.* London: Pavilion Books Ltd., 2000.

MARLBOROUGH HOUSE. *See* St. James's Palace.

THE METROPOLITAN CATHEDRAL OF CHRIST THE KING. *See* The Cathedral Church of Christ, St. Peter's Mount, and The Metropolitan Cathedral of Christ the King.

THE MILLENNIUM BRIDGE, LONDON

Style: Twentieth Century—Modern

Date: 2000

Architect and Consultants: Foster and Partners (Norman Foster, Lord Foster of Thames Bank), with sculptor Sir Anthony Caro and engineers Arup

In the years leading up to 2000 the government of Britain, led by Prime Minister Tony Blair, decided that the country would celebrate the new millennium in spectacular style. A Millennium Commission was created, funded by the National Lottery and the government. It gave out money to events and projects throughout the country that were deemed appropriate and worthy. In London the major recipients of government largesse were **The Millennium Dome**, beside the Thames at Greenwich; the Great Court at **The British Museum**; the Tate Modern art gallery; and the Millennium Bridge, a new footbridge across the Thames connecting **St. Paul's Cathedral** and the Tate Modern. This would be the first new bridge in central London since **Tower Bridge** was opened in 1894 (not counting the rebuilding of **London Bridge** in the 1970s) and the first purely pedestrian bridge since Roman Londinium almost two millennia before.

While the best "spin" possible tried to rescue the millennium projects, nearly every one was a disaster or a scandal—or both. On the night of December 31, 1999, a "river of fire," a spectacular firework display, ignited by the Queen, lit the Thames from the Millennium Dome at Greenwich to Chelsea. Halfway along its journey it passed under the partially completed Millennium Bridge, a project that, as the year progressed, it was hoped would be a problem-free success. This was not to be.

The futuristic Millennium Bridge was conceived as a "ribbon of metal by day, and a blade of light by night" reaching across the Thames to the twenty-first century. The all-British team of designers included architect Norman Foster, sculptor Anthony Caro, and structural engineers Arup Engineering. Foster said they wanted "to push [suspension bridge] techniques as far as possible to create a uniquely thin bridge profile forming a slender blade across the Thames, an absolute statement of our capabilities at the beginning of the 21st century." The result was hailed in the *Evening Standard* newspaper as a "feat of architecture that combines form and function with stunning grace, a work of magical beauty." In a conventional suspension bridge such as New York's Brooklyn Bridge or San Francisco's Golden Gate Bridge the cables supporting the deck connect to the abutments on each shore via tall steel masts or masonry towers giving the characteristic curvy M-shaped profile. Foster and Caro's design, as engineered by Ove Arup, dispensed with the tall masts, using an innovative "lateral suspension" system that places all the cables virtually in a horizontal plane. By this means the profile of the bridge is very thin. Instead of tall masts extending high above the deck, Y-shaped supports project only a few feet higher than the handrails. The cables are connected by a series of cross members that cradle a pedestrian walkway 13 feet wide spanning 1,090 feet. Constructed of steel, stainless steel, and aluminium (as the material aluminum is called in Britain), the bridge weighs a mere 690 tons. The architectural critic for the newspaper *The Independent* wrote, "The Millennium Bridge is a striking example of a growing phenomenon in high-tech architecture—design crossover, in which engineers' structural solutions are increasingly dictating the form and detail of the buildings. The bridge is

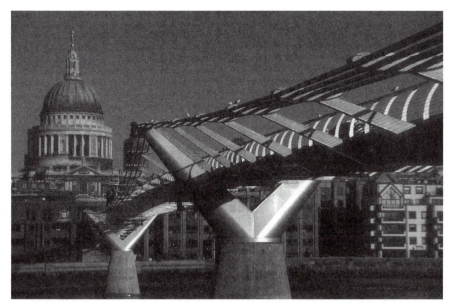

The Millennium Bridge. Norman Foster's new footbridge across the River Thames is on axis with the south façade of Sir Christopher Wren's **St. Paul's Cathedral**. *Photo by Ian Britton (FreeFoto.com).*

remarkable because there's very little of it, and in architecture, less usually means more—much more—in terms of calculations, selection of materials and risk." These were prophetic words.

In May 2000, Queen Elizabeth II (r. 1952–) cut the ribbon, walked halfway across, observed construction still under way, and hastily retreated to the north shore, thus officially inaugurating the Millennium Bridge. Her schedule is worked out months in advance and the bridge was unfinished on the chosen day, a minor embarrassment blamed on striking Finnish factory workers and French truck drivers. A month later on June 10, 2000, the Millennium Bridge was completed and opened to the general public with a charity walk in aid of Save the Children. Thousands of people walked over the bridge and it was immediately apparent that something was very wrong. The bridge swayed alarmingly with a rolling motion of three to four inches causing pedestrians to lurch drunkenly and reach out for the support of the handrails. After three days, to the major embarrassment of the designers, and the co-owners (The Millennium Bridge Trust, The London Corporation, and Southwark Council), the bridge was closed.

The problem was primarily the fault of the design that naturally started to sway as pedestrians walked across. The pedestrians in turn compensated for this slight movement by adjusting their walking gait, resulting in an equal pacing and a synchronized footfall rate that magnified the motion. This phenomenon is called "synchronous lateral excitation" and, while

known to engineers, is not well documented. It had been noted on other suspension bridges, most notably in 1987 when the Golden Gate Bridge was closed to traffic and 300,000 people walked over the bridge to celebrate its fiftieth anniversary. These cases, however, were vehicle bridges not usually expected to carry large numbers of pedestrians so the effect was not a problem—The Millennium Bridge is a footbridge for pedestrians only. Several solutions were proposed including stiffening the structure to decrease the bridge's natural movement, limiting the numbers of pedestrians on the bridge at any time, and using street furniture—benches and planters—to modify how people could walk cross the bridge. All were rejected in favor of an aesthetically and financially favorable "high-tech" solution that looked to car suspension and earthquake survival technology. Two types of "dampers"—viscous dampers, similar to a car shock absorber, and tuned mass dampers, large heavy masses connected by heavy-duty springs—were chosen to reduce and control the induced motion of the bridge. After the installation of ninety dampers, engineers asked for volunteers to participate in a test walk. On the evening of January 30, 2002, the solution was proclaimed a success as 2,000 walkers paced back and forth declaring the bridge felt "rock solid."

The London Millennium Bridge cost about $25 million to build, the "fix" cost another $7 million. At the inauguration ceremony, attended by the Queen, the chairman of the Millennium Commission, the Right Honourable Chris Smith, MP (Member of Parliament), said, "The Millennium Bridge is a real piece of landmark architecture and design which will undoubtedly be seen as a *symbol of the new millennium*" (italics added).

There is another Millennium Bridge in the far north of England. The Gateshead Millennium Bridge spans the River Tyne between the town of its name and Newcastle. Composed of two graceful arches, one of which lays horizontally to form the pedestrian deck while the supporting arch, connected by tension cables, leaps 160 feet overhead. To allow ships to pass up and down the river the two arches rotate such that both arches are at a forty-five-degree angle, leaving sufficient clearance. It cost approximately $30 million; it is also an unusual form of suspension bridge; it is supremely elegant; and, although ingenious, it works. Fondly known by its nickname "the Blinking Eye," the Gateshead Millennium Bridge won the 2002 Stirling Prize, Britain's most prestigious architectural award.

Further Reading

Arup (engineers). www.arup.com.
Foster and Partners (architects). www.fosterandpartners.com.
Gateshead Council. www.gateshead.gov.uk/bridge/bridged.htm.

THE MILLENNIUM DOME, GREENWICH, LONDON

Style: Twentieth Century—Modern
Dates: 1996–2000
Architects and Consultants: Richard Rogers Partnership
(Lord Rogers of Riverside), with engineers Buro Happold

Officially called The Millennium Experience—known to most people in Britain as "The Dome"—this vast high-tech structure, the focal point of national millennium celebrations, was opened by the Queen on the night of December 31, 1999, at a televised party. Queen Elizabeth II (r. 1952–) and Prime Minister Tony Blair led the singing of Robert Burns's "Auld Lang Syne." It was an astonishing sight for those watching the broadcast as the Queen gamely held Blair's hand and attempted to keep his enthusiasm in check, in sync with the traditional melody. Blair was trying to rescue the Millennium Dome, which, far from being the built representation of his reforming, forward-looking, government—"Cool Britannia" replacing "Rule Britannia" (that looked back to the time of the British Empire)—was rapidly becoming a political and financial scandal. That very evening was a disaster: thousands of guests were still stuck in lines at security checkpoints at Stratford Tube Station when the midnight hour struck and for those who made it to the Dome the champagne ran out!

The creation of the Dome was not the idea of Blair's Labour Party, which came to power in 1997, but rather of the previous Conservative government of John Major. The initial proposal came from the Deputy Prime Minister, Michael Heseltine, and the site at Greenwich, on the River Thames east of London, was chosen because it is on the Prime Meridian—zero longitude. It was also an area of industrial blight, a polluted wasteland once the site of a gas works. The Dome would be a catalyst for rejuvenation, encouraging developers to bring housing and industry to a desolated landscape.

The scandals surrounding the building cannot take away from the brilliance of the design. Richard Rogers (1933–) is one of the leading architects of the "High-Tech" movement whose career was made by the Centre Culturel d'Art Georges Pompidou in Paris (1971–1977), which he designed in collaboration with the Italian architect Renzo Piano. This building incorporates the tenets of two architectural ideologies: Brutalism, complete honesty in the use and finish of materials, and Bowelism, the undisguised display of the structure and mechanical systems of a building. These ideas had been promoted by the architectural group Archigram whose futuristic ideas—for

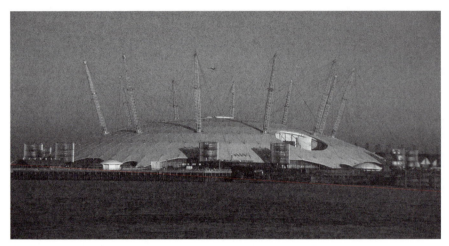

The Millennium Dome. Richard Rogers's spiky building with its yellow masts and detached ventilation pods as seen across the River Thames. *Photo by Ian Britton (FreeFoto.com).*

walking cities or plug-in buildings, for example—were largely unbuilt. Rogers continued to develop these ideas in his design for the **Lloyd's of London** building of 1979–1986 and the headquarters for Channel 4 Television, also in London, a few years later. His designs become increasingly refined and sophisticated taking the use of old and new materials to innovative and daring extremes. Rogers had long been a friend of Prime Minister Tony Blair—one of "Tony's cronies"—and an advisor on environmental and architectural issues. His rewards were the commission to design the Millennium Dome and a life peerage—Lord Rogers of Riverside.

As with all of his designs, Rogers's concept for the focal point of the millennium celebrations is very simple. A vast circular arena is covered by a hemispherical, tent-like membrane structure reaching a height of over 160 feet and spanning approximately 1,000 feet—the largest membrane structure in the world. Supporting and puncturing through the membrane are twelve steel lattice masts over 300 feet high from which an intricate net of tensioned steel cables attach to a 100-foot-diameter cable ring at the center and to a compression ring-beam at the edge. Vertical ground anchors around the perimeter resist the massive tension forces generated by the structure. To clad the structure 800,000 square feet of Teflon-coated glass-fiber panels attach to the tension net, appearing white and opaque during the day but translucent at night when the whole building glows mysteriously. Nestled up to the "mother-ship" of the Dome are the mechanical and service pods, red and blue cylindrical cages that sit on angled legs as if ready to walk under the welcoming arches of the Dome's sweeping roof. The only other element of color on the building is the use of Rogers's favorite bright yellow on the spiky crown of support masts. One of the consistent characteristics of the "High-Tech" movement is the essential

simplicity of the concept and the Millennium Dome is no exception—the impact of the building comes from its huge size but also from that simplicity and the exquisite detailing of the whole structure. The building is a new landmark for London, even clearly visible as a white dot from the Space Shuttle.

Inside the Dome were fourteen exhibition zones surrounding a central arena for dance and acrobatic performances. The zones, paid for by corporate sponsorship, were themed on such subjects as human biology, the environment, and commerce and religion, and were created by the foremost designers from around the world. The most noticeable exhibit was Nigel Coates's Body Zone, for which he created a huge humanoid form through whose tunnels visitors took a journey through the human body and our current understanding of its workings. Like a giant sculpture by Henry Moore, covered in brightly colored tiles, the Body towered over all the other zones, overseeing all the activities contained within the Dome.

The opening night was, as described, a disaster and throughout the year 2000 controversy plagued the Dome. During the first month visitor numbers were far below predictions, but still caused long lines at the most popular zones. The corporate sponsors rebelled, demanding improvements leading to the chief executive being sacked, replaced by a little-known ex–Disney Europe executive named Pierre-Yves Gerbaud, whose ebullient style did little to improve attendance or impress the public—a panel of Members of Parliament reported the Dome "lacked wow factor." Over the year the visitor target was cut several times, initially from 12 million to 10 million, finally to 4.5 million, and to compensate the government was forced to pour money into the project. By November 2000, the total cost of the Millennium Dome was put at $1.260 billion. Political scandals emerged that rocked the government, not least the allegations that the millionaire Hindujas brothers, from India, tried to obtain British citizenship by sponsoring part of the Dome. This led to the resignation of one of the government's senior ministers, Peter Mandelson, and further embarrassment for the prime minister. No longer did he boast that the Dome symbolized "New Labour." While there were sighs of relief when the Millennium Dome eventually closed on December 31, 2000, its future was uncertain and over four years later, stripped of its exhibit zones, it still awaited a buyer and a purpose.

Further Reading

Richard Rogers Partnership (architects). www.richardrogers.co.uk.

MODERN MOVEMENT. *See* Charters and the Modern Movement.

NELSON'S COLUMN. *See* Trafalgar Square.

NUMBER 10 DOWNING STREET, WHITEHALL, LONDON

Styles: Renaissance—Restoration, Georgian, and Twentieth Century
Dates: Circa 1682; 1732–1735; 1766–1775; circa 1780;
1825–1826; 1960–1963; 1988–1990
Architects: William Kent; Kenton Couse; Sir Robert Taylor
(eighteenth century); Sir John Soane (nineteenth century); Raymond
Erith; Quinlan Terry (twentieth century)

Number 10 Downing Street is the official residence of the British Prime Minister. Like the White House in Washington, D. C., it is referred to without qualification so familiar is its name: "a Downing Street spokesman" or "a meeting at Number 10" is sufficient for the world to know that it is the British government, and specifically the prime minister, that is being discussed. Also, like the White House it is a multipurpose building, being not only the home of the prime minister and his or her family but also a setting for grand official entertaining, containing the Cabinet Room, where ministers convene, and offices of the highest political functionaries. It is not, however, the home of the Head of State: the prime minister is the elected leader of the government but is constitutionally appointed by the monarch, currently Queen Elizabeth II (r. 1952–), who lives at **Buckingham Palace** across St. James's Park to the west. Until a few years ago, and heightened security measures, it was possible to walk through Downing Street, an insignificant narrow alley tucked against the north side of the Foreign Office, and wonder that such a plain, ordinary looking, building is the prime minister's residence.

The government area of London is known as Westminster (**The Houses of Parliament** is correctly called the Palace of Westminster) and for centuries was the home of the monarch either at the Palace of Westminster or at Whitehall Palace (see entry under **The Banqueting House**). Henry VIII (r. 1509–1547) gave up Westminster around 1520 and William and Mary (r. 1688–1702) abandoned Whitehall after a serious fire in 1698. The site of Downing Street was to the west of Whitehall Palace on the edge of St.

James's Park. Evidence of Roman and Saxon buildings have been found under Number 10 and it is known that in the fifteenth century it was the site of a brewery owned by the Abbey of Abingdon; their property was confiscated by Henry VIII during the Dissolution of the Monasteries. Now Crown land, the site was leased by Elizabeth I (r. 1558–1603) to Thomas Knyvet who built a large house "part with Bricke and part with Tymber and Flemish qualle [a lightweight infill between the timber framework] and covered with Tyle." Knyvet was a Member of Parliament and Justice of the Peace (Magistrate) for Westminster and he arrested Guy Fawkes for his part in the Gunpowder Plot of November 5, 1605, in which an attempt was made to blow up King James I (r. 1603–1625) and the House of Lords. Highly regarded by Elizabeth and James, Knyvet enjoyed his lease rent free and this perk was extended so that his heirs could hold the property, also without rent, for sixty years after his death. Thus it was that although Sir George Downing had acquired the freehold to the land in 1654 (during the Commonwealth when Oliver Cromwell sold many Crown properties), he did not get possession until 1682, sixty years after Sir James Knyvet had died in 1622.

Downing Street is named for Sir George Downing, a "rather shady character—a spy and a traitor." He was brought up in New England and was an early graduate of Harvard University. Returning to England during the Civil War between the Royalists and the Parliamentarians (Roundheads), he became Oliver Cromwell's Scoutmaster General, a position we would now describe as Intelligence Chief. A powerful and feared man within Cromwell's government, Downing quickly realized that the Commonwealth could not last after the death of its leader in 1658. He quickly approached King Charles II (r. 1660–1685) and offered his services—and knowledge—to the Crown. Charles readily understood the value of Downing's inside information and Downing survived even keeping the Crown land he had acquired beside Whitehall Palace. In 1682, once the legal issues of the Knyvet lease and the Crown "interest" were overcome, a row of fifteen terraced houses (row houses) were built on the north side of what became Downing Street. Until renumbering in 1779, Number 10 was Number 5, but house numbers were very misleading and houses tended to be known by the name or title of their occupants, the city being small enough that such directions were possible. The new houses were a cheaply built speculative development intended to make a quick profit and their shoddy construction led to many problems in later years.

The current Number 10 actually comprises two houses dating from the late seventeenth century. Behind Downing's terrace, separated by a high wall, stood Lichfield House, the home of the Countess of Lichfield, an illegitimate daughter of King Charles II (the King had many children, unfortunately none were legitimate and able to inherit the throne). Lichfield House, renamed Overkirk House in 1690 and Bothmar House in 1720, is a large brick house with an extensive garden that overlooks Horse Guards Parade (a military parade ground) and St. James's Park. In 1732, Count Bothmar died and

King George II (r. 1727–1760) presented Bothmar House and the Downing Street house to his principal minister, Sir Robert Walpole. The King intended this as a gift but Walpole refused, asking instead that the properties be his official residence as First Lord of the Treasury. Thus, Number 10 became the residence of British prime ministers, although that title, originally a term of abuse applied to Walpole, was not officially recognized until 1937. The letterbox on the door of Number 10 is still inscribed "First Lord of the Treasury."

The first task was to join the two houses together and William Kent, the favored architect of the Walpole faction, was commissioned to make the necessary modifications. The front door was in Downing Street, leading to a large entrance hall; beyond this Kent inserted a Grand Staircase that led to a corridor connecting to Bothmar House where a suite of Grand Reception Rooms was created that overlooked the gardens and the extensive view. Sir Robert and Lady Walpole moved into their new home in 1735.

Walpole resigned in 1742 and of later "First Lords" some lived at Number 10, but most lived in their own London houses and Number 10 was seen as a gift that could be awarded to other politicians or family members. Downing's poor construction and the strange plan led to many repairs and alterations. In 1766–1775 the Downing part of the house had to be rebuilt under the direction of Kenton Couse (1721–1790), the Clerk of Works at Whitehall, Westminster and St. James's. Couse is responsible for the elegant surround to the front door, the iron railings that sweep up over the entrance steps to support a lamp, and the famous lion's head door knocker. A few years later, c. 1780, Sir Robert Taylor carried out further repairs at a cost of over £20,000. The prime minister of the time, William Pitt the Younger, did not like Number 10, calling it "his vast, awkward house." It was for Pitt that the present Cabinet Room was created by knocking two smaller rooms together, the original division marked by two columns supporting the wall above.

In 1825–1826, Sir John Soane (1753–1837), one of Britain's most creative architects, worked at Number 10, and the adjoining Number 11, which was to become the official residence of the Chancellor of the Exchequer. At Number 10 he designed the State Dining Room, with its distinctive, minimally detailed, wood paneling and shallow-vaulted (curved) ceiling, and the adjoining Breakfast Room. As Number 10 became grander the neighborhood declined and there were numerous brothels and gin parlors (bars) in the adjacent streets. These were replaced in the 1860s by Sir George Gilbert Scott's massive Foreign Office, which faces Number 10 across Downing Street. Through the nineteenth century, as in the eighteenth century, Number 10 was not continuously lived in by the prime ministers, many having their own much grander residences in the fashionable squares of Mayfair or Belgravia. When the relatively poorer Arthur Balfour "kissed hands" with Edward VII (r. 1901–1910) in 1902, the tradition of Number 10 being the prime minis-

ter's residence was established and every succeeding holder of the office has lived there.

The twentieth century saw a major restoration of Number 10. Over the years more offices had been added even expanding into the garden; in 1937 the servant's attic rooms were converted into a private flat (apartment) for the prime minister and his family; and during the Second World War (1939–1945) most functions moved to safer locations and the house suffered severe bomb damage. Although Clement Attlee, the first postwar prime minister, moved into Number 10 in 1945, it was soon obvious that the house was in very poor condition with subsiding foundations and dry rot in the roof and floor timbers. A 1954 report concluded that the building might easily collapse or suffer an electrical fire and several options were proposed, including complete demolition and the building of a new official residence. However, the decision was taken to restore and preserve the historic houses at Numbers 10 and 11 while Number 12 would be demolished and rebuilt. The architect chosen was Raymond Erith, a leading proponent of traditional Classical design. Number 10, and most of Number 11, were completely gutted, with historic features removed and preserved to be reinstalled after the new steel structure and concrete floors were inserted within the old walls. The work was completed in 1963, one year late and at double the estimated cost of £500,000.

The last major work to be carried out at Number 10 was for Margaret Thatcher in the years 1988–1990. The three *State Rooms*, designed by William Kent when Number 10 was given to Sir Robert Walpole, had lost their original decoration except for the fireplaces. Quinlan Terry, Raymond Erith's partner, designed a Kentian restoration in which "the three orders were employed in new overmantles [elaborate picture surrounds above a fireplace]: *Ionic* for the Pillared Drawing Room; coupled *Doric* columns for the more formal central room where guests are received; and the more delicate *Corinthians* with a swan-neck (curvaceous) *pediment*, for the White Room." Heavily gilded ornamental ceilings, designed to Kentian principles, were installed featuring the national flowers of England, Wales, Scotland, and Ireland: the rose, daffodil, thistle, and shamrock. One decorative element that traditionally terminates with a carved figure of a man has, instead, been modified by the carver to be the figure of a thatcher complete with sheaves of straw; a witty reminder of the prime minister of the time.

Number 10 now contains three functions: the Cabinet Room and attendant offices of the prime minister; the suite of State Rooms, used for official entertaining; and the top attic floor, private flat for the incumbent (Prime Minister Tony Blair, because of his large family, swapped apartments with the Chancellor of the Exchequer and actually lives at Number 11—the two houses interconnect). The Downing Street *façade* with its plain brick and simple, though elegant, doorway gives little hint of the size or splendor of the house behind.

Further Reading

British Government. www.number-10.gov.uk/output/Page1.asp.
Papadakis, Andreas, ed. *Architectural Monographs No. 27: Quinlan Terry, Selected Works.*
London: Academy Editions, 1993.

NUMBER 13, LINCOLN'S INN FIELDS. *See* The Soane Museum.

PALACE OF WESTMINSTER. *See* The Houses of Parliament (Palace of Westminster).

THE PARISH CHURCH OF ST. GILES, WREXHAM, WALES

Style: Mediaeval Gothic—Perpendicular
Dates: Circa 1330–1331; 1463–1480; circa 1494–1525
Architects: Unknown masons and Hart of Bristol (sixteenth century)

The city of **Chester** looks westward to the mountains of Wales where, having crossed the border at Rossett and passed through the village of Gresford, the first major town reached is Wrexham. Important since at least the eleventh century, Wrexham flourished as the center of agricultural and coal mining communities and today it is a thriving regional focus supported by light industry. The town is situated in the center of a broad plain with the River Dee to the south, mountains to the west and north, and low hills to the east. From nearly all approaches the tall, tapering tower—147 feet high—of the Parish Church of St. Giles dominates the silhouette of the town. St. Giles's tower, indeed the whole church, is one of the best examples of the late mediaeval Gothic Perpendicular style.

In the late eighteenth century an anonymous writer penned a short rhyme listing the Seven Wonders of Wales, which reads as follows:

Pistyll Rhaeadr and Wrexham steeple,
Snowdon's mountain without its people,
Overton yew trees, St Winefride's Well,
Llangollen Bridge and Gresford bells.

All the wonders are in North Wales and therefore the list is suspect geographically, although all the landmarks, whether natural or manmade, are impressive. (Pistyll Rhaeadr is a spectacular waterfall; Snowdon is Wales's highest mountain; Overton churchyard is famous for its ancient yew trees; St. Winifrede's is a source of curative waters in a village also called Holywell; Llangollen bridge crosses the Dee at a point where rocky rapids make the river particularly dangerous; and at Gresford the church bells still melodiously peal.)

There is a connection that links Wrexham to the United States. Elihu Yale, the founder of Yale University, lived at Plas Grono, a country house near Wrexham, and is buried in St. Giles's churchyard (for more information about Elihu Yale see **Erddig Hall**). At Yale University's Saybrook College stands a copy of the tower at St. Giles's church that is known as Wrexham Tower. Although Elihu Yale would hardly recognize most of Wrexham, the approach to St. Giles's has changed little since his death in 1721. Turn off the High Street into Church Street and the magnificent black-and-gold wrought iron gates created in 1720 by Robert Davies of Croesfoel (who had trained with the French master Tijou) still block the way. Pass into the churchyard and the north side of the church comes into view. Ahead is the North Porch added in 1822; slightly to the right is the tower completed in 1525, while to the left stretches the main body of the church building with its large windows, *buttresses, battlements*, and crocketed *pinnacles* completed around 1500. Externally unified, exhibiting all the characteristics of the Perpendicular style, a complicated history beginning in the mid-thirteenth century is concealed.

English mediaeval architecture falls into several styles that conveniently approximate to the centuries. In the twelfth century, the Norman or Romanesque style was characterized by massive construction, thick walls, fat columns, round arches, and tiny windows. Decoration was limited to crude sculpture and simple carved zigzag or dogtooth patterns. A fine example of Romanesque style is **Durham Cathedral**.

The thirteenth century saw the transition to Gothic architecture with the introduction of the pointed arch, also at Durham. The structural system was refined through the use of buttresses: short, reinforcing walls at right angles to the main wall. Windows were bigger and if featuring pointed arch tops were called lancets or if very large were divided by a simple stone framework called plate *tracery*. Carved decoration became more competent and featured

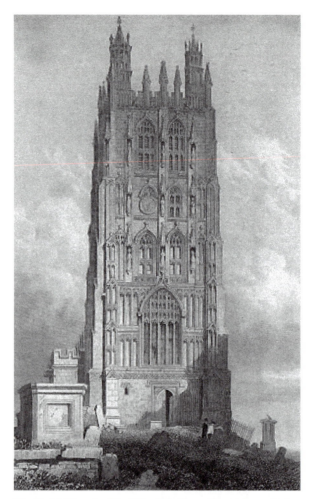

The Parish Church of St. Giles, Wrexham. The elaborately dec-
orated Perpendicular style sixteenth-century tower seen from
the west in a print by Henry Gastineau of c. 1830. The *buttresses*
at the corners, stepping back as they rise and the load is reduced,
terminate in tall *pinnacles*. The tomb of Elihu Yale, the founder
of Yale University in the United States, lies just outside the west
doors at the center of the picture. A copy of the tower was built
at Yale University in the early twentieth century.

plants, animals, and figures of saints, kings, and queens. This earliest Gothic
period is called Early English style and later in the century, as it became more
complicated, it is sometimes referred to as the Geometric style.

The fourteenth century features the middle Gothic period called the Dec-
orated style. As the name implies, the buildings became more elaborate with
rich carving and elaborately traceried windows with flowing patterns of stone

framework supporting large areas of stained glass. It was a goal of Gothic architects to build high and to capture light creating buildings that were a representation of heaven on earth filled with the presence of God. To achieve this they increased the size of the windows, which necessitated increasingly elaborate systems of buttresses and *flying buttresses* to support the stone *vaults* or timber roofs high above the floors. Salisbury Cathedral is a remarkably complete example of the Decorated style, unusual in that most of the building is in one style.

The final phase of Gothic architecture emerged in the fifteenth century, lasted well into the sixteenth, and is called the Perpendicular or sometimes the Flamboyant style. The windows became so big that the wall became insignificant and the tracery even more elaborately curvilinear. The pointed arches of the earlier Gothic periods were lowered in profile to be almost flat and are sometimes called four-centered from the geometric setup required. Every surface is covered with delicate carved decoration. It is this Perpendicular style that is featured on the exterior of St. Giles's at Wrexham, particularly the tower with its huge west window and overall panel decoration. Three of the best examples of the Perpendicular style are **King's College Chapel**, Cambridge, the Henry VII Chapel at **Westminster Abbey**, and St. George's Chapel at **Windsor Castle**.

Passing through the North Porch, added in 1822 but in an appropriate style, the interior of St. Giles's reveals the complicated history. The earliest records suggest a church existed on the site in 1186 under the control of the Abbot of Valle Crucis Abbey near Llangollen. In 1268, a dispute over control of Wrexham church between the Bishop of St. Asaph and the Abbot of Valle Crucis was settled in the latter's favor, but by 1291 the bishop was appointing the vicar to St. Giles. On November 25, 1330, the steeple of the church was blown down and this seems to have encouraged a major rebuilding, for the whole building was soon rebuilt in the Decorated style, comprising a large rectangle with nave and aisles separated by an arcade of octagonal columns and pointed arches. The typical section of larger churches and cathedrals has a central high nave with lower, narrower aisles to each side; smaller churches would not have aisles. The steeply pitched roof was supported on carved stone *corbels* projecting from the wall of the nave above each column.

In 1463 a fire swept through much of the town and badly damaged the church, but by 1480 the aisles had been rebuilt in the Perpendicular style, the clerestory with its upper-level windows raised the height of the nave and a new lower-pitched roof was installed—the corbels that supported the earlier roof are still visible halfway up the wall above the nave arcade. The new, flatter wooden ceiling features carved angels with gilded wings and one very scary red face of the Devil. At the west end the tower base was built but above was a timber structure, while at the east end, above the High Altar, was a magnificent traceried window. Stone carvings incorporated into the building show that Wrexham supported the up-and-coming Tudors, with one

corbel depicting Margaret Beaufort, Countess of Richmond, the mother of Henry Tudor, who became King Henry VII in 1485 and ruled until 1509.

The tower was completed 1518–1525, its splendid design ascribed to a mason named Hart of Bristol (a city in the southwest of England, at that time a very important port). About the same time that the tower was completed the *Chancel* was built. The huge east window was removed leaving stubs of its tracery, the sill lowered, and the five-sided light-filled Chancel for the clergy, choir, and High Altar built. As in the great cathedrals and abbeys, the Chancel was separated from the nave by a *rood screen*, an elaborately carved wooden filigree screen that kept the hoi-polloi out of the sacred area and visions of heaven after earth were conjured by contrasting the difference between the comparatively dark nave and glimpses of the bright colorful Chancel. At St. Giles's the plight of sinners was further depicted by a huge wall painting above the Chancel arch that depicts the Day of Judgment with, to one side, those refused by St. Peter being consumed by the flames of hell. Most worshippers were illiterate and such paintings were used to convince them of their fate if they strayed—and to keep the tithes coming in! The Judgment painting has survived largely intact because it was later whitewashed over and then further protected by a large wooden panel depicting the Royal Coat of Arms.

The completion of the Chancel was the last major change to St. Giles's, as soon after the Reformation occurred the power and importance of the church declined. In the mid-seventeenth century Oliver Cromwell's troops caused considerable damage and in later decades as congregations increased or decreased, galleries were added or removed from the aisles. As services changed the rood screen was removed and the pulpit moved to the center and then to the side beside the Chancel arch. More democratic open pews replaced the leased box pews, with their little doors, in the late nineteenth century. The organ was moved at least three times from above the rood screen to the west end beneath the tower before coming to rest in the south aisle. As is typical of most English parish churches, the interior contains many memorials, the oldest to members of prominent local families and those of the twentieth century to the regiments who served in the two world wars— here the Royal Welch Fusiliers and the Denbighshire Hussars Imperial Yeomanry.

The Parish Church of St. Giles is a magnificent building; it is large for a parish church but it is typical in that it features a complicated meld of architectural styles, and over the centuries the changes made convey a sense of the social history of its town and the country. The grave of Elihu Yale just to the west of the tower continues to bring visitors from Connecticut to Wrexham. His epitaph reads as follows:

Born in America, in Europe bred,
In Africa travell'd and in Asia wed,
Where long he liv'd and thriv'd; in London dead.

Much good, some ill, he did; so hope all's even
And that his soul thro' mercy's gone to Heaven.
You that survive and read this tale, take care,
For this most certain exit to prepare:
Where blest in peace, the actions of the just
Smell sweet, and blossom in the silent dust.

Further Reading

Clwyd Powys Archaeoligical Trust. www.cpat.demon.co.uk/projects/longer/churches/
 wrexham/106012.htm.
Penoyre, John, and Ryan, Michael. *The Observer's Book of Architecture*. London: Fred-
 erick Warne and Co. Ltd., 1975.
Williams, W. Alister. *The Parish Church of St. Giles, Wrexham*. Wrexham: Bridge
 Books, 2000.
Wrexham Borough Council. www.wrexham.gov.uk/english/heritage/wrexham_town_
 walk/st_giles.htm.

PORTMEIRION, GWYNEDD, WALES

Styles: Twentieth Century—Inter-War and Modern
Dates: Circa 1930–present
Architect: Sir Clough Williams-Ellis

As tourists crowd the *battlements* of Harlech Castle on the west coast of Wales trying to imagine what it was like to have been one of the garrison at this great mediaeval fortress, they look out over a changed landscape. When Edward I (r. 1272–1307) built Harlech (see **Caernarfon Castle**) atop its rocky promontory the sea lapped at its base and ships could deliver supplies to the water gate far below; now the sea has receded leaving sandy dunes and beaches to the west and north. Looking northeast, the eye, on a clear day, will pick out Snowdon, the highest mountain in Wales and, in the same direction but low down across the sand flats of the estuary, something else is visible that incongruously contrasts with the rugged strength of nature's Snowdon and man's Harlech. This is Portmeirion, the creation of the architect Clough Williams-Ellis who, in the early twentieth century, began this Italianate village as a living exhibition of architecture and landscape. His model was the Italian fishing village of Portofino that clings to a steep cliff overlooking the Mediterranean. A jumble of faded pastel-colored walls and multiangled, red-tiled roofs focus on a tall campanile (bell tower) set in a luscious landscape of rhododendrons and palm trees against the backdrop of the

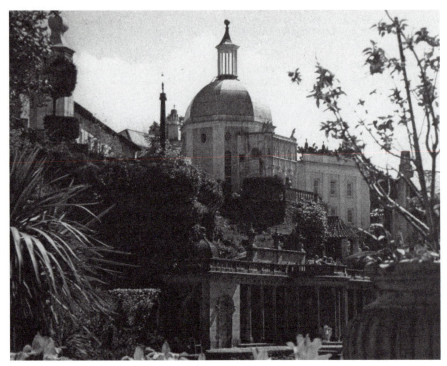

Portmeirion. The domed Pantheon's porch reused a nineteenth-century fireplace and the colonnade in the foreground is another example of architectural salvage and dates from c. 1760. *Photo by author.*

glowering mountains of Snowdonia—Portmeirion is the forerunner of the "New Urbanism" projects of the late twentieth century such as the Prince of Wales's **Poundbury Village** and Seaside, Florida (the resort community where the Jim Carrey movie *The Truman Show* was filmed), but it was built not as a social experiment, but as the toy of a rich and gifted architect.

Sir Clough Williams-Ellis (1883–1978, knighted 1972) has, largely on his work at Portmeirion, been relegated to the side stream of twentieth-century British architects, but during his early career and up to the outbreak of the Second World War in 1939 he was an architect of considerable repute and fame. Later, although still famous, he was rather considered to be a dilettante and an eccentric architect of fey, whimsical follies. He attended Trinity College, Cambridge, and then the Architectural Association School in London, beginning practice in 1903. His early work followed the tenets of the Arts and Crafts Movement of Voysey (see **Broadleys**) or Richard Norman Shaw, but in the late 1920s he veered into a modernistic style although at Portmeirion, which was building through most of his career, romantic Classicism is more in evidence. Williams-Ellis was the owner of a small estate at Plas Brondanw in North Wales, which he inherited in 1908, and seen

as a model landlord, other landowners consulted him to design estate buildings and farm laborers' cottages. His pioneering work led to commissions for housing and in 1945 he was made the first chairman of the Stevenage Development Corporation, the first postwar New Town. As with many British architects large country houses were a favorite commission and his most highly regarded are Llangoed Castle, Breconshire (1913); Bolesworth Castle, Cheshire (1921–1922); Nantclwyd Hall, Clwyd (1956–1970); Dalton Hall, Cumbria (1963–1969); and his own house at Plas Brondanw which was rebuilt over a twenty-five-year period after a devastating fire in 1951. Any of these houses are worthy of entry in a compendium of British architecture but in a more restricted format Portmeirion must be the chosen work of Williams-Ellis.

The story of Portmeirion begins with Williams-Ellis's decision to become an architect early in the century and his fascination with the relationship between architecture and the landscape (he was a founder of the Council for the Protection of Rural England in 1926 and the Campaign for the Protection of Rural Wales in 1928). He had a vision to build something that showed that "the development of a naturally beautiful site need not lead to its defilement and that architectural good manners could be good business." In his mind were visions of Italian hill towns and fishing villages with their appearance of growing out of the landscape and their romantic skylines and vistas. So enamored of this idea was Williams-Ellis that he spent vacations sailing the coast of Britain looking for a perfect site, little realizing that it was lying hidden on the estate of his uncle Sir Osmond Williams (whose many honors and sinecures included being constable of Harlech Castle) just a few miles from Plas Brondanw. The Castell Deudrath estate lies on a promontory between the estuaries of the rivers Glaslyn and Dwyryd which, in addition to the nineteenth-century main house, included a villa on the beach named Aber Iâ, the Welsh for "Glacial Estuary." This, renamed Portmeirion—Port because of the location on the coast and Merion for the Welsh for Merioneth, the county in which it is situated—was to be the site of his visionary development. Williams-Ellis knew the Castell, had designed a garden there in 1911, but so overgrown was the estate that he did not realize the steep valley down to the water's edge existed until the mid-1920s when, exploring near Aber Iâ, he found the "ideal site." He acquired the Castell Deudrath estate in 1925 from the trustees of his late uncle for less than £5,000 and immediately became "engaged upon plans and models for the laying out of an entire small township." The article in the *Architects Journal* of January 6, 1926, continued: "The results of his scheme will be significant and should do much to shake the current notion that although houses must be designed with due care, towns may grow by chance." This statement suggests, as do later statements by Williams-Ellis, that Portmeirion was unplanned, but the evidence of the drawings and models contradicts this, pointing to a defined concept that was largely adhered to over the next fifty years.

Broadly speaking, Portmeirion consists of the villa of Aber Iâ nestled between a cliff and the shore converted and extended for use as a hotel and the new village, which climbs up a narrow valley (complete with a babbling stream), encompasses a central green, and at the top, beneath the campanile, a small cobbled (paved) plaza where the arched gatehouse leads to the parking lot. (Williams-Ellis was very proud of his parking lot as he kept all the trees in that area and slotted small groups of cars in clusters among them, considerably reducing the impact of the shiny vehicles.) The village was built in two phases: 1925–1939 when the site was laid out and the most evocative buildings completed, and 1954–1976 when the "details were filled in." The earlier stage is essentially Arts and Crafts (although the extensions to the hotel are 1930s Modern—see **Charters**) while the later stage is Classical or *Palladian*. Williams-Ellis's means were not limitless and to pay for Portmeirion he conceived of the place as a resort with the villa as the main hotel and the other buildings as rental cottages, stores, restaurants, and banquet facilities. Now owned and maintained by a charitable foundation, Portmeirion is still available for vacation stays throughout the year, although it is also a popular day-trip destination, so popular that on some days access has to be controlled.

Of the many buildings designed by Clough Williams-Ellis at Portmeirion, the most significant is the Campanile. With its adjoining cottages, it is the most prominent building at Portmeirion and, with the additions to the villa to form the hotel, is among the earliest works designed and started on site in 1925. Williams-Ellis felt the tower was needed to draw attention to his ideas and to provide the focal point of the grouping of buildings he was envisaging in the same way that the Italian models he looked to cluster around their churches. The Campanile is seven stories high and rigorously Classical in its design. Williams-Ellis felt that towers belonged beside the sea and in 1935, beyond the hotel, he built the Observatory Tower, which, in its topmost room, houses a camera obscura that projects an image of the village onto a central table.

The Town Hall is a plain, rectangular building overlooking the Green, enlivened by Jacobean-style details and a central doorway and *bay* window at the termination of the main east–west axis. It has a spectacular second-floor room called the Hercules Hall with a seventeenth-century *barrel-vaulted*, sculptured ceiling salvaged from the demolition of Emral Hall in Flintshire. Williams-Ellis bought the whole ceiling for a mere £13 and from this gesture began his reputation as a savior of old buildings, providing a "Home for Fallen Buildings."

The Bristol Colonnade, at the top of the Green, is also a piece of architectural salvage; it is the c. 1760 front to the bathhouse at Arno's Court, Bristol, which fell into decay after damage in the Second World War. Classical in plan, the details are Gothic, and the building is a folly, a conversation piece in a picturesque garden. Rebuilt in 1959, the colonnade forms a covered meeting and sitting place and the backdrop to events on the Green.

The Pantheon is one of the later buildings and compensates for what Williams-Ellis described as a "severe dome deficiency in the Portmeirion ensemble." Williams-Ellis gave his master-joiner (carpenter) the outline of the dome he felt was necessary for the ensemble and left it to the crew to build, only keeping the gilding of the ball atop the *lantern* to his own hand—he was nearly eighty when he climbed the precarious ladders to apply the gold leaf. The *façade* of the Pantheon is yet another reused architectural fragment being, rather unbelievably, the upper part of the fireplace from the Music Room at Richard Norman Shaw's huge house at Dawpool in Cheshire, built in 1883 and demolished in 1925.

The Gloriette (1964) and the Gothick Pavilion also use reused architectural elements, Classical columns from Hooton Hall, Cheshire in the first and Gothic columns from Nerquis Hall, Flintshire in the latter. These elements are used as terminations of axes that span across the Green and lead the eye to various points framed by hedges or the residential cottages in their more restrained Arts and Crafts style. The cottages, as would be the case in an Italian village, are simpler structures that provide the cement that hold the other, more exuberant structures together as a composition. They are grouped in buildings that have evocative names such as the Angel, the Round House, Bridge House, and the Fountain.

Clough Williams-Ellis's fame and penchant for self-publicity soon placed Portmeirion on the map and it became famous architecturally as well as for being a luxurious resort hotel. Architects visited Portmeirion for its picturesque qualities, including Frank Lloyd Wright, who took the time to get to its remote location during his only trip to Britain, in 1956. The remoteness of Portmeirion made it an ideal retreat for celebrities of the 1930s and such mainly forgotten movie stars as Yvonne Arnaud, Alistair Sim, and Fabia Drake were regular guests. The playwright Noel Coward wrote his most famous play, *Blithe Spirit* here while enjoying one of many extended stays. However, Portmeirion's most famous claim to fame is the television series *The Prisoner*, an enigmatically mysterious show, starring Patrick McGoohan and Virginia Maskell, that has become a virtual cult. The contrast between the plot's "claustrophobic metaphysics" and the elegant buildings fascinates, but as far as Williams-Ellis was concerned Portmeirion "stole the show." *The Prisoner* has developed a following of fans, as fervent as any "Trekkies," who make pilgrimages to Portmeirion to relive the scenes from the series, particularly the human chess game played on the Green.

Sir Clough Williams-Ellis died in 1978 and his wife Amabel in 1984. Their only son Christopher had been killed at the battle for Montecassino in 1945, but it was their decision that, although they suffered great pain for their loss, they were alive and "we should try to be so properly, and to keep the wound to ourselves." The future was assured with their daughters and grandchildren, who administer the foundation that looks after Portmeirion and Plas Brondanw, and with the Portmeirion Pottery that has spread the name with outstanding designs on both sculptural and useful pottery.

In 1978, the year of Williams-Ellis's death, Portmeirion was protected as being of architectural distinction, listed as Grade II. It is ironic that if the listing system had been in place before the 1939–1945 war, most of Portmeirion would not have been built as we see it today, as so much of it depends on pieces from buildings which now would be high on the lists of those protected from destruction and change. Williams-Ellis enjoyed the joke in the same way as he "combined a wistful romanticism with a frothy sense of the absurd" (Keith Miller writing in the *Daily Telegraph*, September 21, 2002).

Further Reading

Haslam, Richard. *RIBA Drawings Monograph No 2: Clough Williams-Ellis.* London: Academy Editions, 1996.
Portmeirion Village. www.portmeirion-village.com.

POUNDBURY, DORCHESTER, DORSET, ENGLAND

Style: Twentieth Century—Modern (Traditional/Vernacular)
Date: 1987–date
Architect/Planner: Leon Krier (original master plan)

On the evening of May 30, 1984, Charles, Prince of Wales, was expected to make a typically bland royal speech expressing thanks and congratulations and, in this era of constitutional monarchy, actually say nothing approaching the controversial. His Royal Highness did quite the opposite, delivering one of the most blistering criticisms ever to be heard from a member of the royal family at a public event. The occasion was a banquet at **Hampton Court Palace** celebrating the 150th anniversary of the founding of the Royal Institute of British Architects (RIBA), the professional association of architects in Britain akin to the American Institute of Architects (AIA) in the United States. The prince's diatribe against the architectural and planning professions suggested they had lost touch with the real issues of where people lived, worked, shopped, and enjoyed their leisure time. Infuriating the architectural establishment, the speech opened up a discussion that continues to this day and drew support from a general public fed up with impersonal, imposed developments designed by architects and only appreciated by architects. One reaction was to say to the prince that he should "put his money where his mouth is" and become a patron of architecture. His response: Poundbury, a planned community that will eventually consist of

about 2,250 dwellings on the western edge of the Dorset County town of Dorchester.

Prince Charles's speech at Hampton Court is sometimes referred to as the "monstrous carbuncle" speech as he didn't just speak in general but also focused on particular projects, including the proposed extension of The National Gallery in **Trafalgar Square** by architect Peter Ahrends, describing the designs as "like a monstrous carbuncle on the face of a much loved and elegant friend." Ahrends's response was to accuse the prince of making "offensive, reactionary and ill-considered" remarks; of having "a rather nostalgic view of buildings"; and seeming to "look backwards rather than forward." This was a common reaction of architects to the speech and easily made as the prince commonly cited as examples of good architecture buildings from previous centuries rather than anything post–World War II. At a speech at the Mansion House in London three years later the prince, encouraged by general support for his thoughts, developed the wartime theme. To a group of architects and planners gathered to discuss proposals to develop the area around **St. Paul's Cathedral** he suggested that "You have, Ladies and Gentlemen, to give it to the Luftwaffe (Hitler's air force): when it knocked down our buildings, it didn't replace them with anything more offensive than rubble." The architects cried foul citing the prince's unfair advantage in using his position for a personal crusade, but the public was with him and the more open-minded concede that the "carbuncle" and "Luftwaffe" speeches and the television program and associated book, both titled *A Vision of Britain: A Personal View of Architecture*, were to have a huge impact on architecture and architectural thinking in Britain in the late twentieth century. The film and book refuted the idea of the prince as reactionary and backward looking, as while he uses as examples historic towns, villages, and buildings, he also cites modern buildings that contain the qualities he felt were largely forgotten by architects and planners. On pages 138 and 139 of *A Vision of Britain*, the prince introduced his plans for expanding the town of Dorchester and the development that was to become Poundbury.

Dorchester is a beautiful West Country town, celebrated as Casterbridge in the novels of Thomas Hardy, which lies below the Stone Age hill fort of Maiden Castle and dates back to the Roman town of Durnovaria. Although small as a county town and generally unspoiled by nineteenth- and twentieth-century redevelopment, Dorchester had become clogged by the cars of tourists passing through on their way to resorts on the Devon and Cornwall coasts. A ring road, bypassing the town center, relieved the traffic problem and attention then focused on the land between the ring road and the town. Here, some 350 acres of land seemed ripe for development and the West Dorset District Council had ideas of typical suburban houses built to designs from contractor's catalogs. However, since 1342 the land had been owned by the Duchy of Cornwall, the vast estate that provides income to the heir to the throne (see **Highgrove**), at this time Charles, Prince of Wales. And, while

the Duchy administrators at first envisaged conventional suburbia the Prince pressed for and achieved a new type of development that has become the model for the rest of the country "urban rather than a suburban . . . respecting the traditions of the past while also looking forward to the requirements of the 21st century."

The prince was very interested in the principles of New Urbanism espoused in the United States by such architects as Andres Duany and Elizabeth Plater-Zyberk and seen at Seaside, Florida, or Kentlands, Maryland. Duany and Plater-Zyberk were the architects of both Seaside and Kentlands but at the former the architectural theorist Leon Krier had cast a critical and influential eye leading to significant changes to the master planning. Prince Charles was impressed by Krier's theories and drawings of ideal (i.e., unbuilt) cities and asked him to provide a master plan for the Dorchester land. The prince's book contains a sketch view of a vision that is unlike any suburb seen before in Britain. Broad avenues, lined by trees, focus on grand-columned public buildings overlooking plazas while behind are denser streets leading to houses and apartment buildings designed to accommodate a rich mix of people of varied incomes, background, and outlook—the mix seen in any small community where rich and poor, laborer and professional, young, middle-aged, and old live together. Charles's words indicate a problem the Duchy faced with Krier's design: "hard economic calculations have to be made before any building can start, but vision and boldness are also needed if we are to produce something of real beauty in the English countryside." Considerable financial problems had to be overcome to get started and the whole scheme nearly was cancelled due to the economic recession, only to be saved by a commitment from the Guinness Housing Trust to finance and buy thirty-five of the sixty-two houses in the first phase.

In 1989 the master plan was discussed at a Planning Weekend chaired by the prince and attended by many people from Dorchester and Dorset. Their comments were incorporated into the final plan that succeeded in obtaining planning consent from the District Council and the first phase, one of four distinct quarters, began on site in October 1993 and was completed in 1995. The architectural and planning principles developed for Poundbury are not unlike the code Duany and Plater-Zyberk produced for Seaside, but written for a site in rural Britain:

- Buildings reflect the familiar English townscape with a hierarchy of scale and type of building.
- Houses are sited in squares, lanes, mews (narrow alleys—see **Terraced Houses**) and courtyards, are contextually related, and form a series of varied urban spaces.
- Cars are controlled by roads of irregular width and angles creating limited sight lines (reducing the need for speed bumps—called sleeping policemen in Britain—or excessive signage), and are visually suppressed

with small areas of parking, along the roads and in the courts and mews behind the houses.

- Walking is encouraged by careful attention to pavements (sidewalks) and a network of footpaths that allow residents to reach shops and schools and largely leave their cars unused.

- The buildings are traditional with references to seventeenth, eighteenth, and early nineteenth century classically influenced and vernacular architecture.

- The buildings are constructed using a range of traditional Dorset materials and techniques—stone, brick, slate, render (stucco) and no fake or modern materials such as vinyl or aluminum, although incorporating the latest energy-saving technology.

- The houses are fully serviced with wiring and cable hookups so that there are no overhead wires, television aerials, or satellite dishes visible. All utilities are at the rear of the houses in an easily accessed channel designed to prevent disruptive road works.

- Commercial buildings and appropriate manufacturing buildings are integrated among the housing although usually sited at the periphery to allow easier access.

The Duchy of Cornwall, as administrator of the development, makes sure that architects (at least fifteen firms have contributed designs to Poundbury), builders, and homeowners adhere to the Building Code and Building Agreements. At first skeptical builders said the stringent codes would make the houses too expensive but it was soon obvious that the public liked Poundbury and was prepared to pay a premium to live there that averaged about 10 percent over an equivalent house in the area. In 1995 the smallest two-bedroom units were selling for $90,000 while a larger, detached five-bedroom house sold for $200,000. (Realize that British/European houses are generally much smaller than American houses with less than 1,000 square feet considered more than adequate for a family house.)

Given the person who is the driving force behind Poundbury it is not surprising that many architects have been highly critical of its traditional historicist styles and contrived planning: "It looks like a stage set"; or "I cannot approve of new buildings which are going some way to deceive." But as the final form and intent becomes more evident praise is more typical: "I arrived a skeptic . . . I left a convert" and "We hate to say it, but Charles was right." John Prescott, the deputy prime minister queried, "Why shouldn't this be the average housing estate? What is being done here is very important work for this country's urban future"; while Giles Worsley, writing in the magazine *Country Life*, said, "Poundbury, a radical challenge to the conventions of modern town planning, to the dominance of the car, the cul-de-sac and the detached executive house."

Phase I of the development of Poundbury was completed in 2002; Phase II, with some 200 houses, is due for completion in 2005 while full completion of all 2,250 dwellings and all the other buildings is not expected until 2022. The skeptics still wonder whether the social experiment, the bringing together of a mix of classes and incomes, will work, but to date Poundbury has been a huge success leading to copycat developments and government initiatives to promote many of the ideas. The architectural establishment will never forgive Prince Charles for the "carbuncle" and "Luftwaffe" speeches, particularly as the results of the discussions provoked have proved that the prince was essentially correct to question what was being done to the cities, towns, and countryside he will one day reign over.

Further Reading

British Government, Prince of Wales. www.princeofwales.gov.uk/about/duc_poundbury.html.

Dimbleby, Jonathan. *The Prince of Wales: A Biography.* New York: William Morrow and Company, Inc., 1994.

Katz, Peter. *The New Urbanism.* New York: McGraw-Hill, Inc., 1994.

Leigh, Catesby. "All the King's Architects: The Surprising Success of Prince Charles's Anti-Modernist Crusade." *The Weekly Standard,* June 24, 2002.

Wales, HRH The Prince of. *A Vision of Britain: A Personal View of Architecture.* London: Doubleday, 1989.

PRIME MINISTER'S RESIDENCE. *See* Number 10 Downing Street.

PUBLIC TELEPHONE KIOSKS, VARIOUS SITES

Style: Twentieth Century—Inter-War
Dates: 1924; 1935
Architect: Sir Giles Gilbert Scott

What images say Britain? Is it the Queen? The Tower of Big Ben at **The Houses of Parliament**? Anne Hathaway's Cottage at Stratford-upon-Avon? Double-decker buses in **Trafalgar Square**? Or could it be that iconic

object the red telephone box? Thousands of telephone boxes were placed on street corners and outside post offices, police stations, or corner stores—in busy cities and towns rows of red telephone boxes stood at attention like the soldiers of a Guards regiment—and many just suddenly were there, around a corner of a country lane, tucked into the hedgerow. In these days of cell telephones, text messaging, and in-car satellite communication the public telephone is declining in usage—a 40 percent drop in pay phone use occurred between 2000 and 2001—but the old and familiar red telephone box is still a favorite object and removal is often a cause for battle between conservationists and British Telecom (more recently called simply BT).

The first telephone boxes appeared on British streets in 1884. The Postmaster-General allowed the telephone companies to establish "public call offices" thus opening up the telephone to all who could afford the penny or so it cost to place a call. There was not a standard design and there were cast iron boxes, rustic wooden arbors, and ornate wooden pavilions. By 1912 when the Post Office took over the telephone services (putting it under the supervision of the government) there were three favored designs for telephone boxes: the Wilson, the Norwich, and the Birmingham; the Post Office decided to have one design, based on the Birmingham.

However, the First World War (1914–1918) intervened and it was not until 1921 that a standard design for telephone boxes was reconsidered. K1—Kiosk Number 1—was produced in 1920 by Somerville & Company, but it quickly proved unsatisfactory so a competition was announced seeking designs for a new and grander kiosk (officially called telephone kiosks, they were mostly called telephone boxes). Several well-known architects submitted designs to the 1924 competition, which was judged by the recently formed Fine Arts Commission, and the declared winner was Giles Gilbert Scott.

Scott, the son of Sir George Gilbert Scott, architect of the Foreign Office (1861–1873), the Albert Memorial (1863–1872), and St. Pancras Station, was an architect of considerable skill himself, his most famous buildings being the Liverpool Anglican Cathedral (1903–1978) (see **The Cathedral Church of Christ, St. Peter's Mount, and The Metropolitan Cathedral of Christ the King**) and Bankside Power Station (now the Tate Modern art gallery). Scott's design, soon to be designated K2, was a simple and elegant box with multipaned glass on three sides—including the door—and a solid back on which the telephone equipment was placed; a convenient shelf accommodated ladies' handbags (purses) or gentlemen's hats. A shallow dome, sometimes called a "handkerchief dome," that dated from ancient Rome but had been a favorite device of British architect Sir John Soane (1753–1837), topped the Scott design; it was this dome that gave Scott's kiosk its distinctive recognizable form. At the corners of the box were slim *pilasters* and a band below the dome allowed for an illuminated sign announcing "TELEPHONE." A royal crown is cast into the metal of the spandrel panel beneath the dome. Scott had envisaged that his design would be made of mild steel

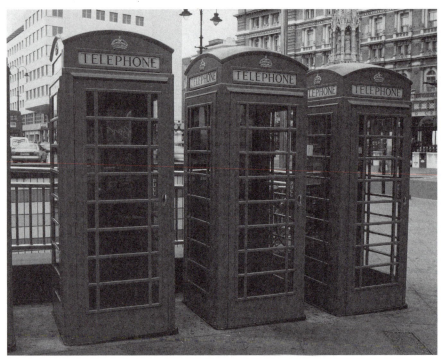

Public Telephone Kiosks. The K6 design introduced in 1935. *Harcourt Index.*

but the Post Office decided to change to the more resilient cast iron. K2 boxes were mainly installed in London from 1927 to 1935 when a revised design, the K6, also by Scott, was introduced commemorating the Silver Jubilee of King George V (r. 1910–1936).

The intervening K types were the K3, a concrete version of K2 intended for rural areas; K4, designed by the Post Office Engineering Department, incorporated machines to dispense postage stamps—only fifty of the K4 "Vermillion Giant" were put into service. K5 is even more rare being a collapsible plywood design for use at temporary locations such as exhibitions and fairs.

Scott's revisions to produce K6 simplified the K2 design. The pilasters, moldings, and recesses were removed and the glazing simplified, resulting in a much more streamlined design reflective of the Art Deco and "stripped" Classicism of the period. (In stripped Classicism the basic proportions of Classical design were retained but all decoration was removed or simplified.) Literally thousands of K6 telephone boxes went into service over the next thirty years and Scott's design became the icon, the familiar favorite on the streets of British cities, towns and villages. Ironically, when both K2 and K6 were introduced they were severely criticized as poor replacements for the previous supposedly superior design.

Scott had wanted his K2 design to be painted silver with a blue interior but the Post Office decided on the highly visible and familiar bright red, outside and inside. The K1 boxes had been painted to match their surroundings and the rural K3 boxes were painted cream with red glazing bars. The Post Office was resistant to complaints that the red boxes were an eyesore in country settings and it was only after 1954 that it allowed boxes in sensitive places—places of outstanding natural beauty—to be painted "battle-ship grey" with red glazing bars; most of these that survive in use have been repainted in the "historic" red color.

By the 1960s the K6 telephone box was considered to be out-of-date and several attempts to design a new box were considered: K7, designed by Neville Conder, only went as far as the prototype stage; K8, designed by Douglass Scott (no relation to G. G. Scott) and Bruce Martin replaced many K6 boxes and was a simpler, less substantial interpretation of K6—it was still painted red. Privatization of the telephone services creating British Telecom and later BT resulted in a wholesale replacement with poorly designed telephone boxes that provided little shelter from the elements, since they were little more than canopies with side screens above knee level. The old K6 boxes had been inefficient to maintain, inaccessible to the handicapped, and used for many purposes—mostly unseemly and often illegal—but their sudden removal caused an uproar likened to the disappearance of the elm tree (to Dutch elm disease). Prince Charles joined the fight for conservation of the remaining K2 and K6 telephone boxes while those already removed often found new homes as shower cabinets, liquor cabinets, or as telephone kiosks in the United States (Utica Square, an upscale shopping mall in Tulsa, Oklahoma, has several K6 telephone boxes. Tom Jones, an expatriate singer living in Hollywood, installed a K6 beside his swimming pool).

Now, most K2 or K6 telephone boxes are protected, having Grade II Preservation listing and renovated or new boxes—K6 has gone back into production—and are replacing their usurpers or being used where new boxes are needed. The advent of new communication systems has reduced the need for telephone boxes; they are not as ubiquitous as they formerly were, but some new boxes feature built-in video displays, keyboards, and a trackball mouse, allowing for e-mail and Internet usage.

Further Reading

BT (British Telecom). www.connected-earth.com/Journeys/ (follow the links: What about the workers—Buildings and places—Telephone kiosks—Sir Giles Gilbert Scott).

THE QUEEN'S HOUSE AND THE ROYAL NAVAL HOSPITAL, GREENWICH, LONDON

Styles: Renaissance—Stuart, Restoration, and Baroque
Dates: 1616–1635; 1660–1685; 1696–1752
Architects: Inigo Jones; John Webb; Sir Christopher Wren

Take a cruise on the River Thames downstream from **Tower Bridge** and the course first turns slightly northward before sweeping south into a great bend that nearly curves back on itself forming a narrow-necked peninsula known as the Isle of Dogs. The river is lined with docks and warehouses, often converted into fashionable loft apartments, but suddenly at the apex of the bend the view opens up and one is looking south through a set-piece composition of Classical buildings, a monumental Baroque stage-set, with, as the focal point, a small, plain, white rectangular building. The contrast between the seemingly insignificant center and the magnificence of the framing buildings, adorned with columns, colonnades, *porticoes*, *pediments*, and domes, could hardly be greater, but the architects of this ensemble have got it right for it is the Queen's House at the center that is the more important building: the four blocks, two to each side, for all their architectural finery make an obeisance to her cool haughtiness. Inigo Jones (1573–1652) designed the Queen's House adjacent to the Greenwich Palace, the Palace of Placentia; the four framing blocks—The Royal Naval Hospital—replaced that ancient palace and were built to the designs of John Webb (1611–1672) and Sir Christopher Wren (1632–1723).

The Duke of Gloucester, Regent of England had begun building Greenwich Palace in 1427 calling it Bella Court; twenty years later, renamed the Palace of Placentia (or Pleasaunce, essentially meaning pleasant place), it was the home of Margaret of Anjou, wife of King Henry VI (r. 1422–1461, 1470–1471), and it was to remain a favorite royal residence until the Commonwealth, 1649–1660, when it fell into disrepair. According to a story, King James I (r. 1603–1625) was upset when his wife, Anne of Denmark, accidentally shot a favorite dog while out hunting and he swore at her in public; in apology he gave her the Manor of Greenwich and its palace. At that time the main Deptford to Woolwich road ran close to the palace separating the palace from the deer *park*, a private royal hunting preserve, to the south. In 1616, Queen Anne commissioned Inigo Jones to design a building that would provide new royal *apartments* but would also allow her to reach the park, crossing the highway, without being seen by the public. Inigo Jones's solution was an H-shaped building with one arm in the palace gardens, the sec-

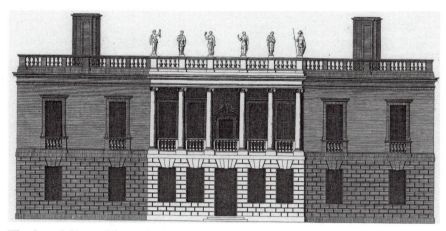

The Queen's House. The south elevation overlooking the park. *Vitruvius Brittanicus.*

ond arm in the park, and the crossbar being a second floor link that bridged over the highway. But the new building was much more than a mere convenience; as Summerson writes: "the idea of a Roman patrician villa brought to the Thames, subjected to the full rigor of Palladio and Scamozzi, and resolved into such a serene and simple statement that it might as easily belong to 1816 as 1616 . . . Jones as a prophet of neo-Classicism." As he was to do a few years later at **The Banqueting House** at Whitehall Palace, Jones created a revolutionary building that despite its relatively small size was to have immeasurable influence on English—and later American—architecture introducing the ideas of the Italian Renaissance architects Vincenzo Scamozzi (1552–1616) and particularly Andrea Palladio (1508–1580). Until this time English architecture was still essentially mediaeval, although some ideas of the Renaissance had crossed the English Channel from mainland Europe and could be seen in tombs, doorways, and some buildings—Old **Somerset House** and **Hardwick Hall**. At the Queen's House, Jones shows a complete classical building the equal of anything in Italy or France. (See The Banqueting House for a full description of Jones's career, education, and career as an architect, and importance to English architecture.) The queen died in 1619, her new house incomplete. It was finished by her successor Queen Henrietta Maria, wife of King Charles I (r. 1625–1649), in 1630–1635, when Jones refined and somewhat simplified the design.

Jones had absorbed everything he had seen in his travels across Europe to Italy and his designs can be seen as derivative, although they have the freshness of a new eye and a new interpretation taking on a character that is particularly English. The Queen's House H-plan is similar to that of Lorenzo de Medici's villa at Poggio a Caiano by Giuliano da Sangallo (finished 1485), though instead of the bridge the crossbar is a great hall. Also at the Medici villa is a second floor *loggia* recessed behind an open colonnade similar to

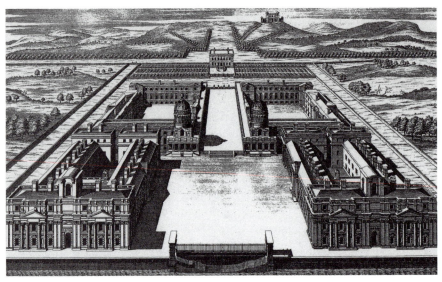

The Royal Naval Hospital, Greenwich. The buildings in the foreground by John Webb and Sir Christopher Wren with the Queen's House terminating the central axis. The building on the hill in the far distance is the Royal Observatory. *Vitruvius Brittanicus.*

Jones's on the south front of the Queen's House facing the *park*. Even the wide window spacing seems to derive from Caiano and the curved steps leading from the north terrace to the palace gardens are a direct copy. But, while owing much to the Medici villa, the Queen's House also owes a debt to Palladio and Scamozzi in its austere severity and the proportioning system that bases dimensions on cubes or multiples or subdivisions of cubes resulting in a building that has "the ineffable nobility of the absolute" (Summerson).

The north front of the Queen's House, facing toward the river, is seven *bays* wide with the center three projecting slightly; subtle variations of window size and detail and wall texture lend a richness not at first perceived, which carries round to the park *façade* where the center features the recessed loggia behind its *Ionic* colonnade. Internally, the most spectacular space is the forty-foot cube of the Hall at the center of the north wing.

After the restoration of the monarchy in 1660, King Charles II (r. 1660–1685) employed John Webb (1611–1672) to enlarge the Queen's House while the nearby palace was rebuilt. This resulted in a change from the original H-shaped plan to a more solid-appearing square, although there are two small courtyards within the structure. Charles II's intent was to build a new Palace of Placentia to replace the neglected, rundown building that dated back to mediaeval times. Webb was the architect of a vast, domed U-shaped building but the only part nearing completion by the time of the King's death was the block closest to the river on the west side, now known as the King Charles Block. William III (r. 1689–1702) and Mary II (r.

1689–1694) did not like Greenwich, preferring Kensington and **Hampton Court**, and in 1696, Sir Christopher Wren proposed plans to build a naval almshouse, a home for retired seamen, to be called the Royal Naval Hospital. The King Charles Block by Webb was to be retained and Wren designed a sequence of narrowing courtyards, perhaps derived from Versailles, France, that led to a domed centerpiece. But, according to some reports, Queen Mary insisted that the vistas to and from the Queen's House be maintained and certainly Wren changed his design to open up the center framing the central axis with two smaller domes marking the entrances to the Chapel to the east and the (dining) Hall to the west. The Queen's House, low, plain, and distant did not fit into Wren's grand composition but he and his assistant Nicholas Hawksmoor (c. 1661–1736) carefully worked out the lines of the ground plane and horizontal cornices so that the Queen's House deceptively achieves a scale appropriate as the center piece of the new buildings. Wren knew he was too old to see the scheme through to completion but cleverly, he had all the footings placed so that later architects would be reluctant to change the design. Hawksmoor continued an association with Greenwich until close to his death in 1736 and in letters hints that he felt the whole complex to be really his work. Wren, with all the City churches and **St. Paul's Cathedral** to oversee, may indeed have passed much of the work to his talented assistant; certainly some of the façades away from the central axis are definitely by Hawksmoor. Other architects who contributed to the Royal Naval Hospital were Sir John Vanbrugh (see **Blenheim Palace**), Colen Campbell, Thomas Ripley, and James "Athenian" Stuart.

The block facing the King Charles Block is the Queen Anne Block named for Queen Anne (r. 1702–1714) while the two blocks closer to the Queen's House are the King William Block (west) and the Queen Mary Block (east).

The buildings continued as the Royal Naval Hospital until 1869 when they were taken over by the Admiralty to be used by the Royal Naval College. In 1998 the Navy moved out, ending a 300-year association with Greenwich, and the site is now under the care of the Greenwich Foundation and used by the University of Greenwich and Trinity College of Music; some areas are retained as part of the National Maritime Museum. The Queen's House was fully restored 1984–1990 in the style of the 1660s and is also a museum.

South of the Queen's House on a hill in the park is the old Royal Observatory designed by Sir Christopher Wren in 1675 for King Charles II. It is here that the time pieces for Greenwich Mean Time were maintained and also beside the building can be seen the line of the Prime Meridian dividing east from west.

Further Reading

Greenwich Foundation. www.greenwichfoundation.org.uk.

Summerson, John. *Architecture in Britain, 1530–1830.* New Haven, Conn.; London: Yale University Press, 1993.

Summerson, Sir John. *Inigo Jones.* London: Penguin Books Ltd., 1966.
Tavernor, Robert. *Palladio and Palladianism.* London; New York: Thames and Hudson, 1991.
University of Greenwich. www.gre.ac.uk/about/campus/maritime.htm.

RED HOUSE, BEXLEYHEATH, KENT, ENGLAND

Style: Victorian—Gothic Revival
Dates: 1859–1860
Architect: Philip Webb

Bexleyheath is a suburb southeast of London recently of renown as the constituency (parliamentary district) of Sir Edward Heath, who was prime minister in the early 1970s. The Roman road called Watling Street passes through Bexleyheath and was also the path of the pilgrims traveling to Canterbury in Chaucer's *Pilgrim's Progress.* Wander off Watling Street today and one would find the meandering streets of banal suburbia lined with the type of houses described in **Suburban Semi-Detached Houses**, comfortable, respectable, and anonymous. But along one street called Red House Lane, a brick wall, overtopped by trees, screens the high roofs, gables, and chimneys of a substantial older house. Peek through the gates and one is taken back to 1860 and one of the most influential creations of the nineteenth century; a house that presaged the Arts and Crafts Movement of later decades into the twentieth century and was to affect many architects of the Modern era. In 1953, the architect Sir Hugh Casson described it as "suddenly rearing up like a miniature Camelot of turrets and steeply crested roofs above its surrounding wall." This is Red House, designed by Philip Webb (1831–1915) for William Morris and his wife Jane Burden. Red House is the solid expression of a romantic dream, a "palace of art" in Morris's words, that redefines Victorian architecture and in its honest expression of materials and function looks to the axiom of the Modern Movement: "form follows function."

William Morris (1834–1896) was an extraordinary character. The son of a rich businessman, he was educated at Marlborough (a private boys' school) and Exeter College, Oxford. At Oxford he fell in with a group—The Brotherhood—of devotees of the writers Carlyle, Ruskin, and Tennyson that included Edward Burne-Jones. Morris and Burne-Jones traveled to Europe and met the English artist Dante Gabriel Rossetti whose advice led to Burne-Jones also becoming a painter and Morris considering architecture. He there-

fore apprenticed himself to architect George Edmund Street, but as his motto *als ich kanne* (if I can) suggests, he knew his limitations and he changed to art and design. At Street's office he met Philip Webb and the two became lifelong friends as well as design collaborators.

While at Oxford, Morris had been introduced to Jane Burden, an unusually beautiful girl from a rough working-class background. Her striking angular face and luxuriant dark hair had drawn several artists and Morris was entranced by her romantically mediaeval appearance. In a story that could be the model for *My Fair Lady*, he gave her an education (which she readily absorbed, soon forgetting her humble beginnings) and married her in 1859. Many of the most famous pre-Raphaelite paintings of the late nineteenth century are of Jane Morris and the marriage was marred by her long affair with Rossetti.

Red House was built soon after the Morris's marriage but its genesis had begun on a boat trip down the Seine in France taken by Morris, Webb, and a third friend, Charles Faulkner, a year earlier. A sketch on the back of one of their maps shows a tower similar to the staircase tower at Red House. The idea germinated, and back in England a site was sought. Eventually, an old orchard in the hamlet of Upton on Bexleyheath was purchased in late 1858. Bexleyheath was ideal; in the country yet close to London, and served by the new North Kent railway line so friends could easily visit for the weekend. The closeness of Chaucer's pilgrimage route along Watling Street enhanced the appeal of the site, adding a romantically mediaeval spirit to the place. The house was quickly designed, construction began in 1859, and the Morrises moved into their new home in the summer of 1860 and welcomed their first guests, Edward and Georgina Burne-Jones.

The house that Webb had designed for the Morrises reflects his background as an architect of Gothic Revival vicarages but it is purified by the application of the theories of A.W.N. Pugin and John Ruskin. Pugin, in his book *Contrasts*, compared the falseness of current Gothic architecture with the honesty of mediaeval Gothic and Ruskin, in his book *The Stones of Venice*, declared, "Of the Nature of Gothic . . . a building has to be truthful before all." Red House is before all an honest and truthful house that expresses scale, hierarchy, and function like nothing before and it is this that was to make it so influential.

The plan is fairly straightforward; an L-shape with the protected inner angle facing southeast where a garden is centered on a well house with a steeply pitched, conical roof. The main entrance is from the north marked by a two-storey projecting gabled porch with a broad pointed arched opening to the porch. Within, a broad hall terminates in the staircase that rises in the tower, the roof expressed internally by the sloping ceilings. To the left of the hall a waiting room and a bedroom open off a broad corridor that led to the so-called Pilgrim's Porch and the garden. To the right is the dining room, used as the main living room, with a tall brick fireplace. Tucked under the stairs a doorway leads to the kitchens and sculleries. Morris was an early

convert to socialism but in all his houses he kept a large staff of a house-keeper, a cook, and maids. Upstairs over the dining room is a large drawing room with an even more elaborate and towering brick fireplace; the main bedroom is over the entrance porch and hall with an adjoining dressing room and, at the end of an upper broad corridor, Morris's studio. Off a landing of the stairs a minor corridor leads to the guest rooms and the staff quarters. The rooms look outward toward the grounds while the circulation of stair-cases (main and service) and corridors overlook the flower garden with its central well house. The whole house is constructed of red brick with a red tile roof from which came the name Red House.

The honesty and truth is evidenced in the roof, the windows, and the de-tails of the brickwork. For example, the drawing room, the most important room in the house, has the highest roof, the biggest windows including an *oriel (bay) window* looking west, and the tallest chimney. The descending hi-erarchy of room functions is reflected in the windows until the smallest store-room is noticed with its narrow slit windows. The house does not attempt to be purely Gothic and rather than mediaeval *tracery* windows a mix of sash and casements are used, chosen to best suit the room served. The different roofs indicate the components of the house: the Morrises' wing, the din-ing/drawing rooms, the guest and service areas; even the broad corridors, an important part of the house, receive their own roof, a decision that led to the one awkward part for the house where the drain for the valley gutter be-tween two roofs has to cross across the corridor ceiling forcing the contor-tion of a low archway from the staircase. The brickwork, on closer inspection, reveals various patterns, recesses, and arches which are used to reinforce the hierarchy already established by the form.

Internally, Morris, with his artist friends, completed a scheme of hand-made furniture and decoration that was a reaction to the fakery of much of the design at the Great Exhibition at **The Crystal Palace** and a return to craftsmanship and concern for materials that the success of the Industrial Revolution had largely overwhelmed. Remaining in the house are a settle (built-in bench seat) in the hall, a sideboard in the dining room, and an elab-orate settle/bookcase/minstrel's gallery in the drawing room. Morris and Burne-Jones decorated these with painted panels of scenes from mediaeval literature. The inside of the front door is patterned in bright colors in a de-sign conceived by Morris and many of the ceilings have delicate patterns that look to be wallpaper but are repetitive painted patterns. There were plans to paint elaborate murals of Classical and mediaeval legends in several of the rooms and the staircase but these were never begun.

So successful were Morris and his friends at the designs for the interior of Red House, the furniture, wall coverings, fabrics, and stained glass that they formed the manufacturing and decorating firm of Morris, Marshall, Faulkner & Co., with Rossetti, Burne-Jones, and Webb as additional direc-tors. This became one of the most successful and influential interior indus-trial design firms of the late nineteenth century and many of their designs

are still in production. Morris suggested moving the workshops from London to Bexleyheath and Webb drew up plans to extend the house to provide a wing for the Burne-Joneses, but health problems affected both them and the Morrises and in 1865 Red House was sold. Morris moved to London and was eventually to live at Kelmscott Manor near Oxford where he ran a publishing and printing enterprise; he never saw Red House again, saying, "The sight of it would be more than I could bear."

Subsequent owners made few changes to Red House; in the 1950s architect Edward Hollamby bought the house and oversaw a sensitive restoration. In 2003, Red House was sold to the National Trust and it is now safely preserved and open to the public.

Further Reading

Ferriday, Peter, ed. *Victorian Architecture.* London: Jonathon Cape Ltd., 1963.

Hollamby, Edward. *Red House.* London: Architecture Design and Technology Press, 1991.

London Borough of Waltham Forest Lifelong Learning Services. William Morris Gallery. www.lbwf.gov.uk/wmg/home.htm.

Miller, Keith. "Making the Grade: The Red House." *The Daily Telegraph* (London), July 26, 2003.

Muthesius, Hermann. *The English House.* St. Albans, U.K.: Granada Publishing Ltd., 1979.

William Morris Society. www.morrissociety.org.

REGENT'S PARK AND REGENT STREET, LONDON

Style: Georgian—Neoclassical
Dates: 1809–1832
Architect: John Nash

Until the completion of the Regent's Park and Regent Street developments London was not a grand city of vistas, plazas, and avenues. To the east the City of London destroyed in the Great Fire of 1666 had been rebuilt following the pattern of the mediaeval streets; Wren's **St. Paul's Cathedral** and his City churches were crammed on small sites with houses and businesses within feet of their walls. Westminster, connected to The City by The Strand, lined with the great mansions of the nobility, was equally confined, squashed between the River Thames and St. James's Park. Some newer developments did include open spaces, squares surrounded by terraced

Regent's Park. Cumberland Terrace is the most extravagant of Nash's palace façades. Through the arch can be seen the front door of the first house in this row of terraced houses. *Photo by author.*

houses (row houses, see **Terraced Houses**) and usually filled with gardens and trees, but these still led to narrow streets without grandeur or ceremony. John Nash devised a scheme so daring and innovative that the very character of London changed, making it an aristocratic city worthy of its role as the capital of a growing empire and the country that had defeated the Emperor Napoleon.

Regent's Park occupies the 550 acres that remained from Henry VIII's (r. 1509–1547) hunting preserve at Marleybone, land owned by the Crown and leased out for farming. In 1793, with the leases due to expire in a few years, the Surveyor-General of Land Revenue, John Fordyce, realized that, situated on the northern edge of the expanding city, Marleybone Park was ripe for a development that would provide a huge profit. Several reports were produced for the government to consider and it authorized a prize of £1,000 for the chosen design with Fordyce adding: "It is to be hoped that from the known

talents of some of the persons who have agreed to give their attention to this great National object, that this opportunity will not be lost and that something will be produced that will do credit not only to themselves but to the country." Fordyce's enthusiasm was not contagious and at his death in 1809 no schemes had been submitted. With time running out, Thomas Leverton (1743–1824) and Thomas Chawner (1774–1851), architects to the Land and Revenue Office, and John Nash, architect to the Chief Commissioner of Woods and Forests, were approached for ideas. Leverton and Chawner produced an unimaginative scheme that extended northward the grid of streets and squares of the recently built Grosvenor and Portland estates. Nash, however, produced a revolutionary plan that envisaged a picturesque *park* with a scattering of detached villas at its center surrounded on three sides by a great wall of terraced houses, the park to be open to the north, the countryside, and Hampstead Heath. Nash, a fashionable and prolific architect, was fast becoming the favorite of the Prince Regent. George, Prince of Wales, the future George IV (r. 1820–1830), was Regent for his mentally ill father, George III (r. 1760–1820), from 1811 to 1820. Whether it was princely influence or the evident merit of Nash's scheme that convinced the Crown Commissioners, it was his plan, somewhat simplified, that was recommended to the Treasury and approved in October 1811.

Fordyce had noted that the connection between redeveloped Marleybone Park and the city was important but it was Nash who realized the potential, offering a bold plan that extended southward across Marleybone Road, into the recently built Portland Place, and then carved a new route through the city, on the boundary between fashionable Mayfair and lower-class Soho. The Prince Regent's interest was piqued by this idea as Nash presented it as a street for grand ceremonial processions from the new park to the prince's London Palace, Carlton House. Add the idea of a summer palace—a *Guinguette*—in the park and the prince's support was assured for the building of Regent's Park and Regent Street. Nash worked unceasingly over the next twenty years to achieve his vision, dealing with property owners, leaseholders, speculators, architects, contractors, the government, and the prince. The government added an eastward expansion of the plan to connect Regent Street to The City; to this challenge Nash responded with **Trafalgar Square**. The prince, realizing the genius he had in Nash, commissioned **The Royal Pavilion** at Brighton and, to replace Carlton House, **Buckingham Palace,** and it was the latter which was to be Nash's downfall at the hands of jealous rivals and petty government ministers—the costs, admittedly, were vast.

At Regent's Park Nash created a naturalistic, picturesque landscape in the manner of Humphrey Repton (1752–1818), his partner in earlier years. A large lake visually held a circle drive around which the villas were to be sited (only eight of fifty-six villas planned were built, but the finances were balanced by the addition of two extra housing areas on the northeast corner of the park: Park Village East and Park Village West). The prince's summer palace would be in the middle of the park, facing west over a broad lawn bor-

dered by an arm of the lake. To provide a suitable setting for the proposed palace Nash conceived of the surrounding terraced houses as a group of stately mansions, palaces of noblemen, and the rows of houses—up to thirty-five houses in some terraces—are "concealed" behind single unified *façades*. It is only the individual doors and the regular spacing of firewalls and chimneys projecting through the roofs that give the game away. Each terrace of houses was given a name with appropriately royal connections, the most impressive are the following:

- **Chester Terrace (1825):** At nearly 1,000 feet long, this is the biggest terrace with three detached and two attached *Corinthian* porches to break up the length. At each end arched gateways, at right angles, connect to detached *pavilions* containing two houses. Chester Terrace with smaller, more manageable houses, is still residential.

- **Cumberland Terrace (1826):** The most elaborate, even spectacular, terrace designed to complement the prince's palace across the park and comprising three blocks connected by *Ionic* triumphal arches. The two side blocks have Ionic porches forming end pavilions while the center block has similar porches with an added projecting central porch, in front of the three middle houses, capped by a *pediment* and statuary.

- **Hanover Terrace (1822):** Considered the most scholarly terrace with a ground floor arcade concealing the front doors and supporting three Roman *Doric* pedimented *porticoes* connected by an elaborately carved continuous entablature.

- **Park Crescent (1812 and 1819–1821):** Built in two phases because the original builder went bankrupt, Park Crescent is Nash's brilliant device to connect the new park to the new ceremonial route. Two majestic, semi-circular terraces of houses allow Portland Place to broaden before exploding into the vastness of Regent's Park, while coming the opposite way they funnel the observer into the city. The terraces are very plain, only relieved by an Ionic colonnade at the ground level that wittily echoes the screen in front of Carlton House, the intended termination of the route. Park Crescent was destroyed during World War II and rebuilt as an office building omitting most of the house doorways.

- **Sussex Place (1822–1823):** The "oddest" of the terraces with its curved ends, the twenty-six houses broken into nine groups by canted bay windows capped with pointed hexagonal domes. Originally much criticized, it is now one of the most admired terraces and is occupied by a graduate college.

- **York Terrace (1822):** A pair of terraces of eighteen houses each designed in the Ionic order and framing a view, through York Gate (1821–1822), of St. Marleybone Church (1813–1817 by Thomas Hardwick).

Regent's Park was a massive development with many more terraces and detached houses, of different scales for all classes, plus markets, an orphanage (for the daughters of clergymen and officers), a barracks, and the terminal basin of the Regent's Canal—a commercial waterway. Some of these have been lost with most destruction taking place after rather than during the Second World War, in the 1950s, but much has been restored and enough remains that Nash's brilliant design can still be appreciated. Unfortunately, Regent Street has not fared so well.

Fordyce, Leverton, and Chawner had envisaged that the connection to the city would be a straight avenue cutting though established housing and commercial districts. Nash, realizing that the legal complexities would make such a scheme impossible, traced a route that followed the edges of landlords' estates, took advantage of land all ready owned by the Crown, or purchased land more readily available—a great landlord like the Duke of Portland was unlikely to sell part of a valuable estate but a single plot of land could be bought for a good price. The result was a street that curved and turned as it progressed south from Regent's Park to the front door of Carlton House—Nash's design made the whole sequence logical and coherent. Park Crescent formed the exit from Regent's Park and connected to an established street, Portland Place, designed a few years earlier by Robert Adam. At the south end of Portland Place, Nash encountered the first problem, a large mansion called Foley House immediately beyond the east side of Cavendish Square. Nash curved the street, creating Langham Place and, to distract the observer, designed a church at the junction, the pivot of this sharp elbow. All Souls Church, Langham Place (1822–1824) comprises a square, box-like building seating 1,820 worshippers on two levels. This box is largely concealed by an elaborate porch, formed of three stacked parts: a circular Ionic tempietto (circular temple), a solid drum (with clocks facing three directions) supporting a circular Corinthian colonnade, and a very tall *spire*. Architecturally, not only is the church a wonderful confection but, as a planning device to make this awkward turn, All Souls is brilliant. Nash's critics were not so positive and a famous caricature drawing shows Nash sitting very uncomfortably on the very sharp spire.

The turn at Langham Place brought the route into Regent Street proper and from here it proceeded south as an elegant street of fashionable shops (stores) with residences above, the elegant sweep broken by designed incidents at crossings or interrupted by more important buildings, all designed by Nash or under his supervision in a restrained Classical style. At the junction with Oxford Street, Nash created Oxford Circus, a circular plaza. Farther south, before entering Piccadilly Circus, Regent Street takes a full quarter-circle turn to the east with the Quadrant, one of the most dramatic streetscapes Nash created. At Piccadilly Circus the route turns southward again to reach Waterloo Place and eventually Carlton House. Most of Nash's Regent Street has been redeveloped with taller, grander buildings changing the scale of this wonderful creation now only preserved in drawings and

paintings. The future Emperor Napoleon III spent several years living in exile in London and Regent Street so inspired him that when he came to power he commissioned Baron Haussmann to create the boulevards and avenues of Paris.

The Prince Regent's summer palace was never built in the park; it quietly disappeared from the annual progress reports and Carlton House, one of the most extravagant and expensive palaces ever built, was demolished to be replaced by Carlton House Terrace (1827–1833), two terraces of massive houses separated by the Duke of York's column and steps that allowed access from Waterloo Place to St. James's Park and The Mall, a broad, tree-lined avenue, that led to the prince's—now King's—latest extravagance, **Buckingham Palace**.

Further Reading

Davis, Terence. *John Nash: The Prince Regent's Architect.* Newton Abbot, U.K.: David and Charles, 1973.

Mansbridge, Michael. *John Nash: A Complete Catalogue.* New York: Rizzoli International, 1991.

THE ROYAL ALBERT HALL, SOUTH KENSINGTON, LONDON

Style: Victorian—Classical
Dates: 1866–1871
Architects: Captain Francis Fowke and Colonel H. Y. Darracott Scott
of the Royal Engineers

The Great Exhibition closed in October 1851 after a successful run of some five months. Albert, Prince Consort, the husband of Queen Victoria (r. 1837–1901), was vindicated in his enthusiastic support of the idea of an international exhibition, which was proclaimed as "an intellectual festival of peaceful industry, a festival such as the world has never seen before." The building erected for the exhibition, **The Crystal Palace** designed by Sir Joseph Paxton, was an architectural masterpiece. But it was all temporary; the exhibits were removed soon after the exhibition closed and in 1852 the Crystal Palace was moved to a new site at Sydenham, south of London; now the problem was what to do with the profits of over £180,000. Eventually, it was decided that the money should be spent on a cultural district that came to be known by the nickname "Albertopolis," which ultimately contained the Natural History Museum; the Victoria and Albert Museum; the Geological

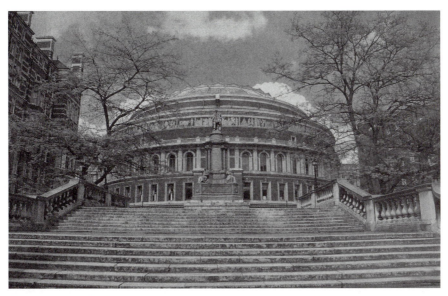

The Royal Albert Hall. The south façade. A new south porch, completed in 2003, was designed to match the existing building extends the public spaces, and overlooks the steps and plaza beneath which were constructed new service areas. *Harcourt Index.*

Museum; the Science Museum; the Imperial College of Science and Technology; the Royal College of Music; the Royal College of Mines; and a two-part memorial to Prince Albert, who died in 1861: the Albert Memorial and the Royal Albert Hall of Arts and Sciences.

The prince, from Saxe-Goburg-Gotha in Germany, was not popular in Britain but Queen Victoria was desolated by his death from typhoid in December 1861. She became a recluse, the Widow of Windsor, spending much of her time at the remote houses she and Albert had built at **Balmoral Castle** in Scotland and Osborne, on the Isle of Wight. She could, however, be induced to appear at events memorializing Prince Albert and on May 20, 1867, she laid the foundation stone for the Albert Hall, having signed the Royal Charter establishing its governance the previous month. The architect was Captain Francis Fowke of the Royal Engineers (1823–1865), who had completed several buildings in Edinburgh including the Royal Museum of Scotland of 1861. In London he designed the South Kensington Museum (V & A) of 1864–1869 and won the competition to design the Natural History Museum that was later built to the designs of Alfred Waterhouse (see **Eaton Hall**). The cause for the change of architect was the untimely death of Captain Fowke at an early age and at the point where his career was about to burgeon. The basic design for the Albert Hall had been decided at Fowke's death and the building was completed by the otherwise unknown Colonel H. H. Darracott Scott.

Fowke's concept saw the Albert Hall as a Roman amphitheater, an oval in shape measuring 272 feet by 238 feet (the Colosseum in Rome measures 620 by 513). To compensate for the unpredictable English weather Fowke proposed an iron-and-glass domed roof rising to a height of 135 feet. The hall as designed would seat 8,000 people. Built of bright orange-red brick and golden terra-cotta, the exterior is a typical coarsened version of Classical design of the Victorian Italianate style that impresses by its size but does not bear close inspection. High up beneath the cornice is a terra-cotta frieze, maybe ten feet high, depicting the "Triumph of the Arts and Sciences," referencing the building's dedication and official name. The roof structure was manufactured in Manchester where it was fully assembled and stress tested by loading it with sand bags. Dismantled and carted to London, it was reassembled in place but the engineers were so unsure of their calculations that all except a few volunteers were cleared from the site when the supporting scaffolding was removed: the roof settled by five-eighths of an inch.

Queen Victoria visited the nearly completed Albert Hall in December 1870 and said, "It looks like the British Constitution." What she meant by this obtuse remark can only be conjectured but as she was the Queen everybody nodded in agreement. The official opening was on March 29, 1871, in the presence of the Queen and the Prince of Wales. The Queen was so overcome that she could not make her speech and it was the prince who proclaimed, "The Queen declares this Hall is now open." The concert that followed revealed that the oval shape and domed roof were not acoustically efficient; so bad were the acoustics that it came to be said of the Royal Albert Hall that there a composer could be assured of hearing his work at least twice. It was not until nearly 100 years later, in 1969, that the acoustics were resolved by the addition of white fiberglass "flying saucers" high up beneath the dome.

The cost of the hall had been partly paid for by subscriptions with patrons buying seats and thus having the right to attend performances and events. The Royal Box on the north side comprises Queen Victoria's subscription seats. There is a story, which may be apocryphal, that two spinster ladies bought subscription seats in the lowest arena area. For some events such as balls or exhibitions a temporary floor would be built over the arena seats; the ladies refused to give permission for their seats to be obscured and accordingly a small opening with a safety railing was included; whether the ladies used their seats during such events is not told. The ownership of seats and boxes continues to this day and Box 70 recently sold for £250,000. Since the opening there have been over 150,000 events staged at the Royal Albert Hall from grand balls and pop concerts to wrestling matches. Two annual events are forever associated with the hall: the Festival of Remembrance recognizing those who fell in the wars of the twentieth century and the Henry Wood Promenade Concerts, which celebrated their one hundredth season in 1994. The Last Night of the Proms is a very British celebration of music and empire ending with spirited renditions of "Rule Britannia" and "Land of Hope and Glory."

The Victorians were good builders and knew how to move people in and out of buildings such as the Albert Hall so the introduction of fire codes did not really affect the building, but what did become outdated were the support areas, such as the bars and restaurants, changing rooms, and loading docks. A recently completed renovation included a restoration of the main hall, and the building of an underground services area beneath the plaza and steps to the south of the building. A completely new south porch complements those on the other three sides and features a contemporary abstract mosaic by artist Shelagh Wakely in the tympanum of the *pediment*.

The Royal Albert Hall has become a much-loved building to the British, referred to in many strange ways: in 2003 a government minister highlighting a problem claimed that Britain produces enough trash to fill the Royal Albert Hall every hour.

Not so loved for many years was the other half of the memorial to Prince Albert, the Albert Memorial, which stands across the road to the north close to the site of the Crystal Palace. Twentieth-century critics derided Sir George Gilbert Scott's spiky Gothic ciborium (canopy) built (1862–1872) as too gaudily Victorian, but a recent restoration has drawn renewed respect for a design that Scott considered "my masterpiece." A gilded bronze statue of Prince Albert sits within, reading the catalog to the Great Exhibition. The podium has a marble frieze of 178 figures from the arts and literature; at the four corners are allegorical groups representing Agriculture, Manufacturing, Commerce, and Engineering while further out at the corners of the steps are groups representing Europe, Asia, Africa, and America.

Further Reading

Cameron, Robert, and Cooke, Alistair. *Above London*. San Francisco: Cameron and Company, 1986.

McKean, John. *Architecture in Detail: Crystal Palace*. London: Phaidon Press Ltd., 1994.

The Royal Albert Hall. www.royalalberthall.com.

THE ROYAL NAVAL HOSPITAL. *See* The Queen's House and The Royal Naval Hospital.

THE ROYAL PAVILION, BRIGHTON, SUSSEX, ENGLAND

Styles: Georgian, Picturesque/Romantic
Dates: 1787; 1815–1823
Architects: Henry Holland and John Nash

George, Prince of Wales, the eldest son of King George III (r. 1760–1820), became de facto monarch as Prince Regent in 1811, when his father was declared mad. George, one of England's great builder monarchs, became King himself as George IV (r. 1820–1830) in 1820. According to John Morley, as quoted by Dinkel,

> King George IV was an extraordinary man who built extraordinary buildings: the key to the nature of his palaces is to be found in himself. He neither knew nor prized the proprieties and public accountability of his successors; he was of the *ancien regime*, and despite a customary affability and condescension, the two qualities most associated with the *ancien regime*, pride and frivolity, were conspicuous in his character. When the long-expected Regency came to him in 1811, and the Crown in 1820, what he relished were the greater means to pursue luxurious interests, especially his architectural visions. Though he was mercilessly criticized, even reviled, for this order of priorities as a time of social upheaval and the misery of the Industrial Revolution he added new dimension to the life of his country. In **Windsor Castle**, **Buckingham Palace** and Carlton House he created royal palaces truly worthy of a great power. He encouraged a new kind of London development, open, refreshing and grand. He inspired the establishment of the National Gallery. And for almost the whole of his adult life he directed architects and designers in the unfolding of a fantastic but stately dream at the edge of the ocean.

In 1783, George, Prince of Wales, visited his uncle, the dissolute Duke of Cumberland, at Brighton, which was in the process of changing from a sleepy fishing village named Brighthelmstone into a fashionable spa. Sea bathing had been declared healthy and many seaside villages were rapidly developing as resorts. Brighton, within reasonable distance of London and with the royal approval, became the most fashionable destination of the early nineteenth century. Prince George bought a small farmhouse separated from the beach by a grassy promenade called the Steyne and in 1786, Henry Holland was called in to create the Marine Pavilion. Holland retained the farmhouse

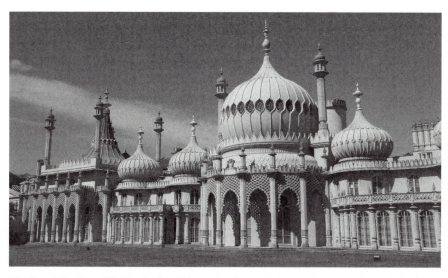

The Royal Pavilion. Within the fanciful exterior, beneath the smaller onion domes left of center, is the farmhouse bought by the Prince of Wales and remodeled over the years to create the extravagant royal marine residence. *Photo by Ian Britton (FreeFoto.com).*

as the south wing of a symmetrical Classical composition with a large circular saloon (reception room) behind a screen of columns and a balancing north wing, copying the original farmhouse. Underneath the later fantastic decorations Holland's Marine Pavilion, with its central circular element and *bow-*fronted wings, can be discerned, although it is hard to imagine his cool, restrained Classicism. The prince was always making changes at the Marine Pavilion and in 1803 the interior design firm Crace installed Chinese-style interiors in several of the main rooms, beginning the transition from Classicism to an exotic far-eastern style.

The next change, in 1803, was not to the house, but to provide stables for the prince's horses. A new building northwest of the pavilion accommodated eight carriages and stalls for sixty-two horses, forty arranged in a circle around an 80-foot-diameter circular domed interior courtyard so large that the building is now used as a concert hall. (A $33 million refit of the Dome Concert hall was completed in February 2002 preserving the spectacular Art Deco interiors designed by Robert Atkinson when the building was converted in 1935.) The architect for these extravagant stables was William Porden and he persuaded the prince to use the Indian style translated as multifoil arches and slender *turrets* topped by chattris (tiny gazebo-like structures). The prince was not unused to such buildings as his parents' garden at Kew featured Moorish, Turkish, and Chinese follies designed by Sir William Chambers and he is thought to have visited Sezincote (1803), the Indian-style house built for the "eminent servant of the East India Com-

pany," Sir Charles Cockerell, by his brother, the architect Samuel Cockerell. The acceptance of this exotic style encouraged Porden and Humphrey Repton to each propose designs for remodeling the pavilion in either Anglo-Chinese or Anglo-Indian styles. "Mr. Repton," said the prince on viewing the drawings "I consider the whole of this work as perfect, and will have every part of it carried into immediate execution; not a tittle shall be altered." The prince, however, was broke and unable to persuade the government to pay for a private residence. He could not afford to implement these intriguing plans and it was not until 1813 that the idea was taken up again and the chosen architect was Repton's erstwhile partner and consequently bitter rival, John Nash.

Nash had come to the prince's attention in 1811 when he presented his proposals for the design of **Regent's Park and Regent Street**. Soon Nash was the prince's confidential advisor on matters architectural and political, a position he was to retain until the prince, later King, died in 1830 when the enemies he had gained caused his downfall and disgrace—"make a hash of Nash" said the Duke of Wellington. At Brighton Nash and the prince were to produce the most fantastic of their creations, a building that, nearly 200 years later, still awes with its lavishness, extravagance and, set among staid lawns and terraces, its exotic style.

Taking Holland's Marine Pavilion, with its central circular saloon and two wings, as his starting point, Nash added two huge rooms at each end: to the north a Music Room and to the south a Banqueting Room. To the west to access this *enfilade* of rooms Nash used a favorite device, a broad corridor, the Gallery. West of this were a series of smaller rooms including at the north end the prince's private suite and rooms for the Private Secretaries, the Entrance Hall, visitors' rooms, and at the south end, discretely concealed behind a shrubbery, the service rooms including the King's Kitchen. A service corridor, concealed beside the spine of the Gallery, allowed servants to reach most of the palace without being seen by the prince or his guests. This relatively simple plan, essentially Classical in its axes and symmetry, was overlain by decorations internally and externally "so extravagant (they) defy detailed description" (Davis).

On the east front, facing the gardens, the central circular Saloon gained a large onion dome, the bow windows of the two wings gained their own smaller but more curvaceous onion domes, while at each end Nash's new rooms, essentially boxes, were roofed with pointed tent-like domes, the different elements punctuated by *turrets* and chattris similar to those on Porden's stables. The whole *façade* is tied together with a sinuous *verandah* (porch) that fronts all the rooms, composed of pinnacled columns and pierced trellis-work. The west, or entrance, front faces into a private forecourt protected by large gatehouses also designed by Nash and little is noticed of the main building, so richly decorated is the projecting *porte cochere* (carriage porch). The exterior is painted in cool blues and greens with stone and terra-cotta details.

Entering through the *porte cochere*, visitors passed through an octagonal vestibule into the relatively restrained green-and-grey Entrance Hall where there is a hint of the oriental decoration to follow in the cornice and painted wall patterns. A low doorway—the service corridor bridges overhead—leads into the Gallery. Decorated in pinks, reds, amber, and blue with a bamboo motif, the 162-foot-long Gallery is more a reception room than a corridor and it is here that the prince's guests would assemble before processing in to dinner in the Banqueting Hall. It is this room, and the similar Music Room that defy description. Nash provided a Classical rectangular space, the central square area covered by a dome rising to 42 feet held on *pendentives*. It is the decoration that Nash developed with interior designers Frederick Crace and Son and furniture designer Robert Jones that completely awes. Every surface is decorated with their interpretation of Chinese motifs: dragons, fretwork, murals of Chinese figures, and so on, but the eye is drawn to the dome where a three-dimensional giant plantain tree appears to block the sky. Under the leaves an enormous silver winged dragon clutches a "lighting device [chandelier] of unparalleled size and beauty" (description by E. W. Brayley published in 1838). Mythological *Fum* birds hold the four other chandeliers. In this magnificent room the prince would entertain thirty or forty guests, the butlers and footmen serving food from the technically advanced kitchens where Carême, the inventor of caramel, worked with a dozen other chefs. The oriental theme of the pavilion carries through to the kitchen where the columns have palm leaf capitals and the hoods above the ranges are shaped like tents.

After dinner the guests would move through to the drawing rooms and Saloon. The South Drawing Room is the original farmhouse and the ceiling is therefore rather low but this effectively contrasts with the high rooms to either side. Cast iron columns support the upper floor where Nash extended the room toward the garden. The decoration of this room, the Saloon, and the similar North Drawing Room, while sumptuous is relatively conventional, but the extravagance of the Banqueting Room is equaled, maybe surpassed by that of the Music Room, the "final dramatic gesture in the sequence of interiors" (Dinkel). Nash and Frederick Crace decorated the Music Room with crimson-and-gold walls rising into blue-and-gold cornices and coves reaching up into a dome of gilded scallop-shaped scales. Gasoliers, a new innovation, shaped like lotus flowers hang from the dome and cornice lighting the room and revealing gilded dragons, serpents, and other fantastic ornaments. In this room the King's seventy-member orchestra would entertain guests with music from Handel and Italian operas and at Christmas 1823, Rossini played for the assembled court.

Beneath the fabulous decoration the Brighton Pavilion is actually a very advanced building. Cast iron, a material only used since the **Iron Bridge** of 1776, is used extensively for columns, beams, and the structure of the domes, and even visibly for the treads and balusters of the staircases and the decorative cast columns in the two drawing rooms. The kitchen was the most up-

to-date of its time with hot plates, hot closets, and cold, warm, and hot water and steam supplied.

King George IV spent his last night at his beloved Royal Pavilion on March 6, 1827. By this time he was a no longer the handsome youth of 1783 but had become an overweight roué increasingly reluctant to face the public. He died at **Windsor Castle** on June 26, 1830. His successor, the sailor King, William IV (r. 1830–1837), continued to reside periodically at the Brighton Pavilion but his court was comparatively staid and respectable. George IV had made Brighton a popular resort and its success was the reason Queen Victoria (r. 1837–1901) and her husband Prince Albert shunned the place. After a couple of visits they found they could get no privacy; tourists were even looking in through their windows, and so in 1845 the royal family moved to Osborne House on the Isle of Wight for their vacations and the Brighton Pavilion was sold to pay for the new east wing of **Buckingham Palace**. The purchaser was the town of Brighton and when access was eventually gained it was found that all the furniture and fittings below the ceilings had been removed—there are some very incongruous Chinese-style rooms in the east wing of Buckingham Palace! However, over the years much has been restored, or returned by Queen Elizabeth II (r. 1952–), and today the Brighton Pavilion is close to its appearance during its heyday in the 1820s.

Further Reading

Davis, Terence. *John Nash: The Prince Regent's Architect.* Newton Abbot, U.K.: David and Charles, 1973.

Dinkel, John, with Morley, John. *The Royal Pavilion, Brighton.* Brighton Borough Council, 1990.

Mansbridge, Michael. *John Nash: A Complete Catalogue.* New York: Rizzoli International, 1991.

The Royal Pavilion, Brighton. www.royalpavilion.org.uk.

THE ROYAL STATE COACH, THE ROYAL MEWS, BUCKINGHAM PALACE, LONDON

Style: Georgian—Neoclassical
Dates: 1760–1762
Designer: Sir William Chambers

In the eighteenth century architects were expected to design all manner of objects, usually components of the buildings they were creating, and the commission to design a new state (official) vehicle for the monarch to be used for the most important royal events was not considered unusual. The Royal State Coach, sometimes called the Gold State Coach, was built for King George III (r. 1760–1820) and has carried each monarch since William IV (r. 1830–1837) to his or her coronation. Queen Elizabeth II (r. 1952–) has driven in the Royal State Coach on three occasions: to the coronation at Westminster Abbey on June 3, 1953; to the Silver Jubilee Thanksgiving Service at **St. Paul's Cathedral** in 1977; and most recently to the Golden Jubilee Service, also at St. Paul's Cathedral, on June 4, 2002. It is a magnificent sight, a rolling confection of gilded statuary and allegorical painted panels, 24 feet long. Weighing over four tons, it needs eight powerful horses to pull it at a slow walking pace.

George II (r. 1727–1760) died in 1760 and the accession of his grandson, the third George of the Hanoverian dynasty, was seen as an opportunity for increased royal patronage of British art, which had lapsed under the Germanic first two Georges. The new coach was the first significant commission of the new king who felt that the monarchy needed to be reinvigorated and that it was time to replace the outmoded, and increasingly dilapidated, Baroque state coach that had been made for Queen Anne (r. 1702–1714). Designs were invited and, according to the *Journals* of the Clerk of the Stables at the Royal Mews, several designs and drawings were received and "the approved parts thereof thrown into one by Mr. Chambers." That the final design is very similar to that submitted by Chambers and his co-designer Giovanni Battista Cipriani suggests that only ideas concerning the mechanics were taken from the other submissions. Joseph Wilton, a carver, who was to carry out the sculpture on the finished coach, was asked to make a model of the proposed coach. This still survives at the headquarters of The Worshipful Company of Coachmakers (one of the guilds that controlled apprenticeship and standards in the crafts) in London.

It is not surprising that William Chambers received this prestigious commission. The future King George III's education had been very thorough and rigorous, including lessons in art and architecture. In the late 1750s, Chambers, while working on several royal architectural commissions, was employed as the then Prince George's architectural tutor and his book, the *Treatise on Civil Architecture* of 1759, was originally written as a textbook for their lessons. Chambers remained a favorite of George III and designed the remodeling of Buckingham House, the royal family's private residence (now **Buckingham Palace**).

The year 1760 saw not only the accession of a new king but also successes for the British Navy and Army in the Seven Years' War of 1756–1763 against France. Thus the new state coach is a celebration of the monarchy and of military triumph. The approach of the monarch is signaled by two gilded tri-

tons (mythical sea creatures) beside the front wheels, apparently blowing a fanfare through conch shells. The body of the coach is adorned with eight golden palm trees that frame the panels and doors. The leaves of the palm trees curve over to form the edge of the roof while the trunks are decorated with military trophies. The union of England, Scotland, and Ireland (as the United Kingdom) is represented by the three putti (cherub-like statues) on the roof that hold up a crown and hold a scepter, a Sword of State, and the Ensign of Knighthood. At the rear of the coach two more tritons carry tridents (three-pronged spears) and fasces (weapons). The patriotic representation of the carving continues in the painted panels by Cipriani. On the front panel Victory presents laurels to an enthroned Britannia attended by Religion, Justice, Wisdom, Valor, Fortitude, Commerce, and Plenty. The door panels illustrate Industry and Ingenuity presenting a cornucopia to the Genius of England, and Mars, Minerva, and Mercury supporting the crown of Britain. Below the side windows are panels depicting the Liberal Arts and Sciences protected by History who records the reports of Fame while Peace burns the implements of War. Finally, on the rear panel, Cipriani painted representations of Neptune and Aphrodite emerging from their palace in a triumphal carriage attended by the Winds, Rivers, Tritons, and Naiads to bring the tribute of the world to Britain's shores. Thus, the coach is a proud celebration of the Britain of 1760.

So prolific is the carved decoration that it is hard to see the structure of the coach. The tritons sit atop the front and rear axles and support the leather straps that suspend the cab. A massive wooden chassis, also carved and gilded, connects the front and rear axles and provides the primary support for the cab. The crude suspension system allows the cab to rock backward and forward in a manner that can be discomforting to the occupants. The original design drawings by Chambers, and Wilson's model, show a seat perched above the forward tritons from which the coachman could control the horses. This is no longer in place and the eight horses are driven by four postilions (riders, each in charge of two horses) resplendent in red-and-gold livery. The vehicle needs plenty of room to maneuver although the smaller front wheels do turn.

The new Royal State Coach was made by the coachmaker Samuel Butler. On its completion it was so anticipated that when the King used it for the first time at the opening of Parliament in November 1762, people packed the streets and hired window space to get a glimpse. Used by George III and George IV (r. 1820–1830) for many important state occasions, the coach fell out of favor with Queen Victoria (r. 1837–1901), who complained of the "distressing oscillations." In the late 1940s, George VI (r. 1936–1952) had rubber strips, similar to tires, applied to the wheels to improve the comfort and the location of the cab was strengthened during a restoration in the 1970s.

This segment was written on the evening of June 4, 2002, the day that Queen Elizabeth II celebrated her Golden Jubilee (50 years as queen) by

driving from Buckingham Palace to a service of thanksgiving at St. Paul's Cathedral in the Royal State Coach.

Further Reading

British Government Royal Mews. www.royal.gov.uk/output/page556.asp
British Government Royal Transport. www.royal.gov.uk/output/page404.asp
Harris, John, and Snodin, Michael, eds. *Sir William Chambers, Architect to George III.* New Haven, Conn.; London: Yale University Press, 1996.

ST. GILES'S PARISH CHURCH. *See* The Parish Church of St. Giles.

ST. JAMES'S PALACE, PALL MALL, LONDON

Styles: Renaissance—Tudor and Stuart, Georgian, and Victorian
Dates: 1532–1540
Architects: Original architect/mason unknown but later work by many, including Inigo Jones and Sir Christopher Wren

Walking up The Mall, the great ceremonial avenue of central London, with **Buckingham Palace** and the Queen Victoria Memorial in the distance, St. James's Park is to one's left and to the right is a series of grand and imposing buildings: the two great blocks of Carlton House Terrace, Marlborough House, Clarence House, and Lancaster House. Tucked between Marlborough House and Clarence House a high brick wall all but hides the towers and courtyards of St. James's Palace. While Buckingham Palace is the London residence of the monarch and the setting for many royal ceremonies, it is to the Court of St. James's that ambassadors are accredited because, since 1698, St. James's Palace has been the senior palace of the Sovereign, the official residence. Taking Marlborough Road north to Pall Mall the palace still does not impress, but suddenly one espies a great gateway, five stories high, with flanking octagonal *turrets*, topped by a large clock face. Dark wooden gates are firmly closed but to either side stand the stiffly attentive red-jacketed guards indicative of a royal palace.

Why King Henry VIII (r. 1509–1547) decided to acquire St. James's is something of a mystery. A fire at the Palace of Westminster in 1512 had destroyed his private *apartments* but he had secured a replacement by confiscating York Place, the London home of the disgraced Cardinal Thomas Wolsey; this, much extended, became Whitehall Palace, the monarch's official residence until its destruction, also by fire, in 1698 (see **The Banqueting House** and **The Houses of Parliament**). Maybe it was the prospect of marriage to the second of his six wives, Anne Boleyn, that encouraged the king to build another palace, since it was a year before the wedding that he exchanged lands in Suffolk for "St. James's in the Fields," a nunnery and hospital for female lepers, and its surrounding fields. Draining the land created St. James's Park, which lies between Whitehall Palace and the new St. James's Palace. Of Henry VIII's palace very little remains but what does includes the great gatehouse, which bears the ciphers (entwined initials) of Henry and Anne dating its building to between 1533 and 1536—they married in 1533 and she was beheaded at **The Tower of London** in 1536. Henry rarely retuned to St. James's but his daughters Mary I (r. 1553–1558) and Elizabeth I (r. 1558–1603) regularly used the palace, in part because of the fresh air of its situation beyond the confines of London and Westminster. A description from the time of Elizabeth I suggests a comfortable rather than a splendid building "of a quadrate forme, erected of brick, the exterior shape whereof, although it appears without any sumptuous or superfluous devices, yet is the spot very princelye, and the same with art contrived within and without. It standeth from other buyldinges about two furlongs, having a farme house opposite to its north gate. But the situation is pleasant, indued with a good ayre and pleasant prospects. On the east London offereth itself in view; in the south, the stately buyldinges of Westminster with the pleasant park, and the delights thereof; in the north, the green fields."

Charles I (r. 1625–1649) made St. James's Palace his family home while court ceremony still took place at Whitehall. The Queen, Henrietta Maria, was French and in the newly Protestant England her Catholicism was suspect; St. James's Palace was a den of papists as far as the Puritans were concerned, especially after the construction of the Queen's Chapel on the east side of the palace. Designed by Inigo Jones and constructed in 1623, the Queen's Chapel now stands on the opposite side of Marlborough Road, which was cut through the palace precincts after a fire in 1809 destroyed the royal apartments. Like the Banqueting House at Whitehall, Jones's design for the Chapel was revolutionary in early seventeenth-century England. Based on Palladio's theoretical restoration of the ancient Temple of Venus and Rome, the Chapel is a double-cube space with a *barrel-vaulted* coffered ceiling. At the east end, above the elaborate *reredos* (the wall behind the altar) is a large *"Venetian" window* of three lights with an arch above the central opening. At the west end a low porch on the ground floor supports the Queen's Closet, Henrietta Maria's private gallery overlooking the Chapel, originally separated by a screen of *Corinthian* columns and carved festoons.

Outside the Chapel is coolly and simply Classical and the strangely foreign appearance of this very suspect building did not endear the King and Queen to their Puritan Protestant subjects. In January 1649, Charles I spent his last night at St. James's Palace before walking across the park to the Banqueting House at Whitehall Palace and his execution.

That the Queen's Chapel survived virtually unchanged through the Civil War of the 1640s, the Commonwealth of Oliver Cromwell in the 1650s, and Victorian meddling in the nineteenth century is amazing, for Henry VIII's Chapel Royal, just to the west of the gatehouse, was much altered in the nineteenth century. The Chapel Royal's Tudor Closet, a screened private gallery raised on thin columns, had long vanished when William IV (r. 1830–1837) and Queen Adelaide added the side galleries and a new ceiling, adding their ciphers to those of Henry VIII and Anne Boleyn; later Queen Victoria (r. 1837–1901) had new paneling and pews installed. The Chapel Royal has been the site of many significant events: Queen Victoria married Prince Albert here on February 10, 1840, and more recently the coffin of Princess Diana (died 1997) rested here before her funeral. The Chapel Royal is not just a building, but also an establishment of priests and singers who serve the spiritual needs of the monarch. As such music has always been very important at the Chapel Royal and its members have included Thomas Tallis, William Byrd, Orlando Gibbons, Henry Purcell, and George Frederick Handel, although the last, a German citizen, was not a member, but was instead appointed as "Composer of Musick of His Majesty's Chappel Royal."

The original "quadrate" palace was designed around four courtyards and these can be discerned when looking at the current layout from the air, although two courtyards are now incomplete and the other two are made much smaller by the various remodels and disasters that have occurred over the centuries. The King's and Queen's Apartments in the southeast corner overlooking St. James's Park were lost in the fire of 1809 but to the west the new apartment built for Queen Anne (r. 1702–1714) in 1703 by Sir Christopher Wren still exists although much altered. In 1716–1717, Nicholas Hawksmoor built the stable block with its brick arcades and terminating *pavilions*, while, at the same time, Sir John Vanbrugh was building a new kitchen for the Prince and Princess of Wales, the future George II (r. 1727–1760) and Queen Caroline. They fell out with George I (r. 1714–1727) and he took over use of the new kitchen to supply his own apartments. Queen Caroline later (1736–1737) commissioned William Kent to design a spectacular library at the far west end of the palace complex, but this was demolished in 1825 to make way for York House (now renamed Lancaster House). John Vardy worked on the north *façade* when some rooms were demolished in 1748 while Sir Jeffry Wyatville proposed major renovations for William IV and Queen Adelaide in 1831–1835.

During the eighteenth and early nineteenth centuries St. James's Palace was used for official royal ceremonies: levees, drawing rooms, and audiences (indeed levees—formal receptions—were held here until 1939), but the royal

family rarely lived in the palace as nearby Buckingham House (see Bucking-ham Palace) was the home of George III (r. 1760–1820) and Queen Char-lotte; the Prince Regent, later George IV (r. 1820–1830) lived at Carlton House; and William IV and Queen Adelaide at Clarence House. Apart from her own and other family marriages Queen Victoria rarely set foot in St. James's Palace and while apparently disregarded by reigning monarchs, St. James's Palace has provided homes for family members and this continues to this day. The Princess Royal (Princess Anne) and Princess Alexandra have apartments in the palace while the Prince of Wales has recently moved to Clarence House, which is technically within the precincts of St. James's Palace. In addition the offices of the Royal Collection, the Marshal of the Diplomatic Corps, the Central Chancery of the Orders of Knighthood, and the Chapel Royal are all housed in the palace.

There are three major houses within the precincts of St. James's Palace: Clarence House, Lancaster House, and Marlborough House. Clarence House attaches to the extreme west end of the Wren wing of 1703 and was originally built 1825–1827 for William Henry, Duke of Clarence, later William IV, and his wife Adelaide. The architect was John Nash who was then currently at work on Buckingham Palace although Clarence's house was much plainer and much cheaper than his brother's huge palace. In contrast to the red brick of the earlier buildings of St. James's Palace, Clarence House is of cream painted stucco much like Nash's work in **Regent's Park.** Much extended in 1874, although following the style of Nash's design, the result-ing mansion became the home of Queen Elizabeth, The Queen Mother in 1952 until her death, aged 101, in 2002. After major renovations Clarence House is now the London residence of the Prince of Wales, his sons Princes William, Harry, and the Duchess of Cornwall.

Lancaster House, which now serves as an opulent setting for government reception and conferences, has had three names, beginning as York House in 1825, becoming Stafford House in 1827, and gaining the Lancaster name in 1912. This enormous town palace was designed for the Duke of York, one of George III's disreputable sons, by Benjamin Wyatt and Philip Wyatt. York died in 1827 and the lease on the incomplete house was bought by the 2nd Marquess of Stafford (later created Duke of Sutherland) who commissioned the Wyatts, Sir Robert Smirke, and Sir Charles Barry to extend and com-plete the house. It was eventually finished in 1843 for the 2nd Duke of Sutherland and is so splendid that Queen Victoria, a frequent visitor, always quipped: "I have come from my house to your palace." There is a famous painting by Eugène Lami showing a reception at Stafford House in 1849; the central saloon, 80 feet square and 120 feet high to the glass skylights, is packed with gloriously dressed and bejeweled guests while from a narrow balcony close to the ceiling the duke's children and their attendants look down in wonder. This was the era of the aristocratic political hostess who, with wealth and a suitable house, could entertain and bring together the "right people" and alter the course of the empire; the Duchess of Sutherland

was one of the most powerful women after Queen Victoria. The great throng in Lami's painting was ascending twin staircases to the *state rooms* on the second floor that included an *enfilade* of drawing rooms, a ballroom, and the Orleans Gallery, the "most magnificent room in London" and so named because it once contained the art collection of the Duc d'Orleans that came to England after the French Revolution. In 1912, the Sutherlands, feeling the need to cut back on their expenses, sold Stafford House to a nouveau riche soap manufacturer, Sir William Lever, who renamed it Lancaster House for his native county in northwest England. The following year he donated the house to the nation to be used for government hospitality. Lancaster House sits at the southwest corner of the St. James's Palace complex, west of Clarence House on the other side of Stable Yard Road.

Marlborough House, at the eastern end of St. James's, is an equally impressive mansion and it has served as the home of three indomitable characters: Sarah, Duchess of Marlborough (d. 1745); Edward VII (r. 1901–1910) while he was Prince of Wales; and Queen Mary (1867–1953) during her widowhood. The original house was built by Sarah Churchill, Duchess of Marlborough, the wife of John Churchill, 1st Duke of Marlborough, the general who defeated the French at such battles as Ramilles, Malplaquet, and Blenheim (see **Blenheim Palace**). Sarah was the favorite of Queen Anne and she was thus able to obtain the lease on land from the Crown Estates in 1709. Sir Christopher Wren was commissioned to "make my house strong plain and convenient and that he must give me his word that this building should not have the least resemblance of anything in that called Blenheim which I have never liked. (The duchess hated the enormous and splendid Blenheim Palace and it was a cause of strife with the duke and its architect, Sir John Vanbrugh, whom she eventually barred from entering.) The house Wren designed, completed in 1711, was of red brick with stone details, two stories high and an H in plan. Several rooms were painted by Louis Laguerre with scenes of the duke's victories. The duchess was a very headstrong and outspoken woman who made many enemies including Sir Robert Walpole, who noticed that to obtain an access from Pall Mall and create an appropriately ducal forecourt she would need to buy some additional land. He was able to buy the four plots from under the duchess's nose and prevent the completion of her plans. To this day Marlborough House is approached through a narrow alley into a corner of its reduced forecourt. The lease reverted to the Crown in 1817 and in 1862 the house became the London home of Edward, Prince of Wales and his new bride, Princess Alexandra of Denmark (see **Sandringham House**). Major remodeling added two more stories destroying the proportions of Wren's design, but the Laguerre murals were preserved. From 1862 until his accession as King Edward VII in 1901, the prince made Marlborough House the center of London's social life, particularly the pleasure-seeking group who surrounded the prince and thus coined the phrase "Marlborough House Set" meaning the "in people" of the time. In contrast, in the twentieth century the house was twice the home of the very

upright and majestic Queen Mary, whom it is hard to imagine ever having let her hair down, and she died here in 1953, a few months before the coronation of her granddaughter, Queen Elizabeth II (r. 1952–). In 1959, Marlborough House became the headquarters of the Commonwealth Secretariat.

Further Reading

Commonwealth Secretariat. www.thecommonwealth.org/Templates/Internal.asp ?NodeID=34467.

Montague-Smith, Patrick, and Montgomery-Massingberd, Hugh. *The Country Life Book of Royal Palaces, Castles and Homes Including Vanished Palaces and Historic Houses with Royal Connections.* London: Antler Books Ltd., 1981.

Summerson, Sir John. *Inigo Jones.* London: Penguin Books Ltd., 1966.

Sykes, Christopher Simon. *Private Palaces: Life in the Great London Houses.* New York: Viking Penguin Inc., 1986.

Watkin, David. *The Royal Interiors of Regency England—From Watercolors First Published by W.H. Pyne in 1817–20.* London: The Vendome Press, 1984.

Wessex, Edward The Earl of. *Crown and Country: A Personal Guide to Royal London.* New York: Universe Publishing, 2000.

ST. MARTIN-IN-THE-FIELDS, TRAFALGAR SQUARE, LONDON

Styles: Renaissance—Baroque
Dates: 1720–1726
Architect: James Gibbs

Trafalgar Square sits at the heart of modern London at the point where The Strand coming from The City, the London of finance to the east, meets Whitehall, the London of politics to the south. From the southwest, through Admiralty Arch, can be seen The Mall and Royal London, terminating at **Buckingham Palace** while to the northwest Piccadilly leads to the aristocratic London of St. James's. Standing at the base of Nelson's Column where these vistas meet Trafalgar Square is completed along its north side by the bland *façade* of the National Gallery of Art and in the northeast corner the *portico*, tower, and *spire* of the church of St. Martin-in-the-Fields. Built in 1721–1726 to the designs of Scottish architect James Gibbs (1682–1754), it, through his folio *A Book of Architecture*, published in 1728 and 1739, became the basis for the American church design. In any New England town stands a church that is basically a box-like hall for the congrega-

tion to meet, with a columned west porch, topped by a tower/spire. Usually of white clapboard, sometimes of masonry the basic components of box, porch, and tower could be seen in the churches that spread across the United States as it expanded westward. The ancestor of all these churches is Gibbs's St. Martin-in-the-Fields.

The origins of the parish of St. Martin-in-the-Fields is obscure with references dating back to at least 1222 when a jurisdiction dispute recorded between the Bishop of London and the Abbot of Westminster highlights its pivotal position. Henry VIII (r. 1509–1547), after the Dissolution of the Monasteries of 1536–1540, took over St. Martin-in-the-Fields, rebuilt the church, and expanded the parish boundaries. His actions were not necessarily for the good of the church but rather to protect him and the court from the plague, as a new law prevented victims from being carried through the parish, forcing the funeral routes north away from the palaces of Westminster and Whitehall (see **The Houses of Parliament** and **The Banqueting House**). Henry's church was enlarged in 1607 but no other work appears to have been carried out and the church was in poor repair by the 1720s when a new building was commissioned.

James Gibbs had grown up in Scotland in a Catholic household. He studied for the priesthood in Rome but after a short time turned to architecture, studying under the leading Italian architect, Carlo Fontana. Rome at this time was the destination of many young English and Scottish aristocrats who completed their education by taking the Grand Tour. Thus, Gibbs made many contacts that stood him well when he returned to Britain in 1709 and began his career as an architect, obtaining private and public commissions from Tory (a political party) and Scottish clients. His being a Tory and a Scot went against him in 1714 when the government changed at the death of Queen Anne (r. 1702–1714) and the accession of George I (r. 1714–1727); but his undoubted skill as an architect brought many clients from the Tory aristocracy, who preferred his more florid style to the cold Palladianism favored by their Whig political opponents. To further his career Gibbs produced many books, including the two editions of *A Book of Architecture*, which included engraved plates of his designs, built and not built. Gibbs's books were the most popular design books of the eighteenth century; as pattern books they were used throughout Britain and made their way to the colonies of North America. Thus, through Gibbs's self-promotion, his work, particularly St. Martin-in-the-Fields, was among the most influential in British architecture.

The Commissioners for Rebuilding St. Martin's Church, Westminster City, solicited designs from architects Nicholas Dubois, John James, George Sampson, and Sir James Thornhill as well as James Gibbs. They chose Gibbs's design but soon realized that his proposal for a huge circular church with a domed interior would be far too expensive. Aspects of the design suggest Sir Christopher Wren's St. Stephen Walbrook in the City of London, and although it was rejected, Gibbs published it in his book and the design

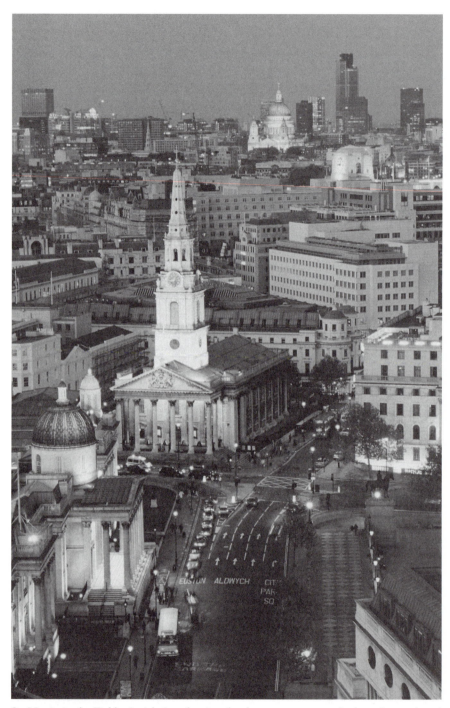

St. Martin-in-the-Fields. Aerial view showing the three components—the box, the porch and the spire—that became the "kit of parts" for many later churches in Britain and the United States. The National Gallery, the domed building to the left, overlooks **Trafalgar Square**. In the distance, surrounded by the skyscrapers of the City of London, is **St. Paul's Cathedral**. *Harcourt Index.*

was the basis for several later churches. His first design rejected, Gibbs then produced a second design with a simpler, five-bayed, rectangular-aisled nave. At each end similar bookend blocks provided for two vestries (offices) and the *Chancel* at the east end, and the entry lobby and staircases, leading to galleries above the aisles, at the west end. A tall hexastyle (six-columned) *portico* supporting a *pediment* displaying the Royal Arms of King George I completes the west *façade*. Externally and internally, Gibbs used the *Corinthian Order*, the most elaborate of the Greek Orders, using columns and *pilasters*. Wren, in his numerous church designs, always allowed the tower to rise from a visible base: the entrance lobby, baptistry, or vestry, but Gibbs places his tower above his west entrance lobby in such a position that it appears to grow out of the roof of the church, to some, incongruously thrusting through the temple-like church it dominates. Also criticized were Gibbs's window treatments: "The absurd rustication of the windows, and the heavy sills . . . are unpardonable blemishes," wrote fellow architect John Gwynn, but he added, "The portico is truly noble."

Inside St. Martin-in-the-Fields, escaping the noise of the traffic in Trafalgar Square, one is taken to an Italian world. Gibbs had brought with him from Italy two plasterers, Giuseppe Artari and Bagutti, and their exuberant filigree of rococo decoration, much colored and gilded, covers the *barrel vault* of the nave and the arches, *pendentives*, and domes of the aisles. The nave, as designed by Gibbs, was an open space uncluttered by pews although there was seating in the aisles and in the galleries above; the congregation in the nave would have stood or milled around during services. In 1887, Sir A. W. Blomfield altered the interior to incorporate pews across the full width of the nave.

St. Martin-in-the-Fields has reached out to the world not just through the influence of its design but also through the programs it has organized: a Lending Library founded in 1680; care of the homeless through the Social Care Unit dates from the First World War (1914–1918); and since 1959 the Academy of St. Martin-in-the-Fields under conductor Sir Neville Marriner has aired seventeenth- and eighteenth-century church and secular music on instruments contemporary to the period.

St. Martin-in-the-Fields is James Gibbs's masterpiece. In it he brings to complete fruition the experimentation of Wren in the City churches, rebuilt after the Great Fire of 1666, with the exuberance of the Italian Baroque learned in Rome. Through Gibb's *A Book of Architecture* the design for St. Martin-in-the-Fields was copied throughout Britain and in the colonies of North America, where it has become the basis of most church designs right up to the twenty-first century.

Further Reading

St. Martin-in-the-Fields. www.stmartin-in-the-fields.org.
Summerson, John. *Architecture in Britain, 1530–1830*. New Haven, Conn.; London: Yale University Press, 1993.

ST. PAUL'S CATHEDRAL, LONDON

Style: Renaissance—Baroque
Dates: 1675–1710
Architect: Sir Christopher Wren

There is a famous painting by Italian artist Antonio Canaletto that shows the City of London and the River Thames from the terrace of Old **Somerset House**. In the left foreground is the garden of Somerset House with steps leading down to the waters of the Thames; the sweeping bend of the river fills three-quarters of the width of the painting. The horizon is essentially a ragged horizontal line formed by the roofs of the houses of London that in those pre-elevator days reached only three of four stories high. But on closer inspection it can be seen that the horizon is spiky with the towers and *spires* of the numerous churches marking the many parishes that make up The City. And, just left of center, dominating the skyline, towers the great domed edifice of St. Paul's Cathedral like a mother hen with its brood of little chicks: the city churches. St. Paul's and many of the City churches are the work of one of Britain's greatest architects: Sir Christopher Wren. His greatest achievement is this stupendous cathedral, more impressive in that it was completed to the designs of this one architect in the short period of thirty-five years. St. Paul's is one of the symbols of London, of Britain, and the scene of great state events and memorials, including the wedding of the Prince of Wales to Lady Diana Spencer in 1981 and, in 2002, the Golden Jubilee Service of Thanksgiving celebrating Elizabeth II's (r. 1952–) fifty years as Queen.

There has been a church on the site of St. Paul's since 604 C.E., when Bishop Millitus had a wooden structure erected. Burned in 675, rebuilt in 685, destroyed by Vikings in 962, the cathedral's early history was a reflection of the turbulent times. The Norman Conquest of 1066 led by William, Duke of Normandy (see **The Tower of London**) led to plans to rebuild St. Paul's, plans hastened by a damaging fire in 1087. The plan was for the longest cathedral in Europe, built of stone with a timber roof structure in the Norman/Romanesque style, featuring huge round columns and semicircular arched openings. The new cathedral was finished in 1310. Over the next three centuries little work was done to the cathedral especially following the religious upheavals of the reign of Henry VIII (r. 1509–1547). By 1633, St. Paul's was very dilapidated, an embarrassment to the capital city; and Inigo Jones (see **The Banqueting House** and **The Queen's House and The Royal Naval Hospital**) was commissioned to update and repair the building. The work was carried out in 1633–1640 although designs had been produced as early as 1620. Jones renovated the Gothic choir but recased the

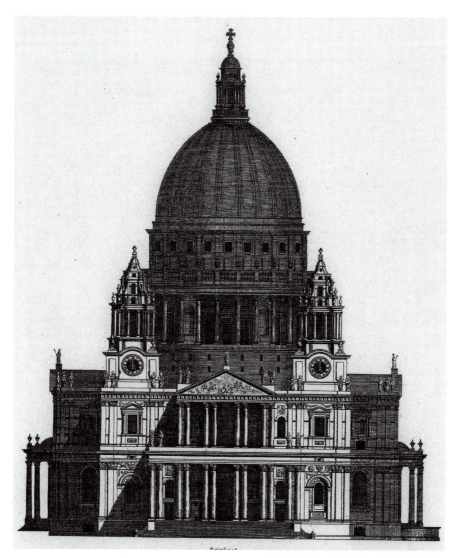

St. Paul's Cathedral. The west front. *Vitruvius Brittanicus.*

Norman/Romanesque nave and transepts in a Classical style based on the ideas of Italian architects Alberti and Palladio. The most successful element of Jones's design was a new *Ionic* west *portico*, ten columns wide and 56 feet high, framed by two towers, based on Palladio's reconstruction of the ancient Roman Temple of Venus and Roma in Rome. The completed west front by Jones was to have an influence on Wren's design fifty years later.

The reason for the rebuilding of St. Paul's in the late seventeenth century was the disaster that struck London in 1666: the Great Fire of London.

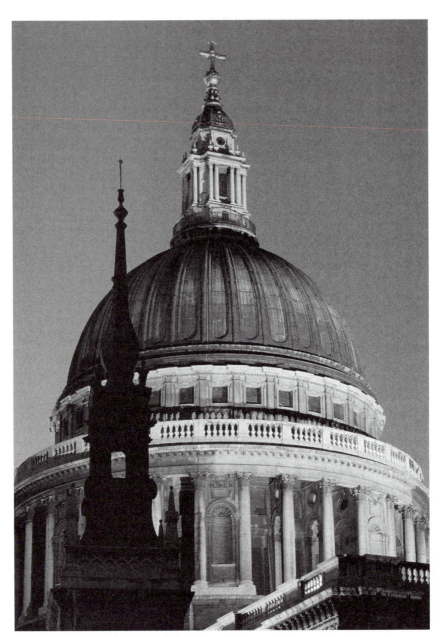

St. Paul's Cathedral. Detail of Wren's dome and lantern. *Harcourt Index.*

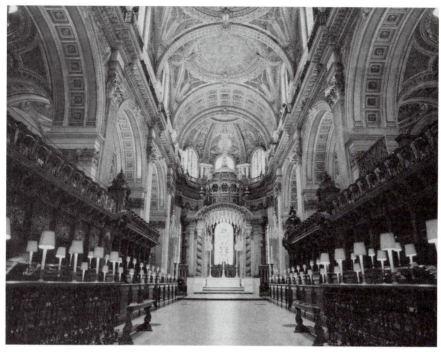

St. Paul's Cathedral. The Choir looking east towards the High Altar. *Harcourt Index.*

William I (r. 1066–1087)—the Conqueror—introduced a law requiring that all household fires be put out at night in an attempt to reduce fires in London houses that had straw on the floors and thatch roofs. Called the *couvre-feu* (cover fire) law, it led to the modern word *curfew*. The London of 1666 was essentially a mediaeval city of narrow streets lined with tall timber-framed houses *jettying*—cantilevering—over the street such that it was often possible to shake hands from upper windows on opposite sides (for a more detailed description of such houses see **Chester**). On the evening of September 1, 1666, Thomas Farynor, the King's baker, forgot to douse the oven fire in his bakery in Pudding Lane. The next morning Farynor's house was well alight; seven hours later **London Bridge** was burning, and by the time the fire was controlled, five days later, four-fifths of the City of London had been destroyed: 13,200 houses, 87 churches, and 50 Livery Halls. The only good thing about the fire was that the millions of rats that carried the bubonic plague died in the destruction, ending the Great Plague that had killed thousands the previous year. A tall column, topped by a gilded flaming torch, known as the Monument, marks the site of Farynor's house.

St. Paul's Cathedral also burned in the Great Fire with its stones exploding in the intense heat and the lead from the roofs running in a molten stream down the streets to the River Thames. Diarist John Evelyn wrote, "Thus lay

in ashes the most venerable Churche, one of the antientest Pieces of early Piety in the Christian World." The choir and tower were destroyed but the nave and west front were thought to be salvageable; it was soon realized that the damage was too great and the ruins were demolished 1668–1672. Dean Sancroft, in a letter to Christopher Wren, wrote that it was resolved to "frame a Design, handsome and noble, and suitable to all the Ends of it, and to the reputation of the City, and the Nation, and to take it for granted, that Money will be had to accomplish it." The leaders of the church had decided that a completely new cathedral was the only option.

Sir Christopher Wren (1632–1723, knighted 1673) would have been an extraordinary person without the architectural accomplishments he left. Born of an important church family (his father was Dean of Windsor, his uncle Bishop of Ely), educated at Westminster School and Wadham College, Oxford, he studied anatomy and mathematics and mixed with pioneering scientists who were to be the founding members of the Royal Society. In 1661, only twenty-nine years old, he was appointed Savilian Professor of Astronomy at Oxford with the accolade of the eminent scientist Robert Hooke that "there scarce ever met in one man, in so great a perfection, such a Mechanical Hand, and so Philosphical a Mind." But Wren was already thinking of architecture showing drawings of "new designs tending to strength, convenience and beauty in building." His uncle, the Bishop of Ely, commissioned his first building, a college chapel at Cambridge University, and he then designed several innovative buildings at Oxford University, including the Sheldonian Theatre, a large lecture theater with an unusual trussed roof spanning over a large oval space. Wren traveled to France in 1665, his only foreign trip, where he looked at "the most esteem'd Fabricks of Paris."

London's Great Fire of 1666 was Wren's big opportunity. Already known to King Charles II (r. 1660–1685), he obtained an audience within days to present a plan for a new city of broad avenues radiating from plazas or focused on major public buildings including a new St. Paul's Cathedral. The King was intrigued but Wren's plan came to naught as the citizens soon moved back to claim their property and rebuilt following the mediaeval street plan of the destroyed city. In October 1666, Wren was appointed one of the commissioners charged with surveying the damage and overseeing the rebuilding of the public buildings, including fifty-two new churches to be financed by a tax on coal. Wren therefore became the architect for many of the churches whose spires and towers can be seen in Canaletto's painting. Hemmed in on tight sites often abutting adjacent buildings, Wren's City churches are gems of architectural and interior design: St. Mary Abchurch; St. Lawrence Jewry; St. Martin Ludgate; St. Mary-le-Bow, Cheapside; and particularly St. Stephen, Walbrook, are fascinating exercises in geometric and spatial manipulation while their towers "display an astonishing variety of invention which is among his chief claims to greatness as an architect" (Colvin). Each tower became an identifiable symbol for its church, a marker or sign-

post enhancing community spirit that focused on the parish. The church rebuilding came first and it was not until 1675 that the rebuilding of St. Paul's Cathedral was contemplated, although Wren had been thinking about designs for some time, including the so-called Great Model of 1673, which can still be seen in the cathedral crypt. There were many designs, and as most of the drawings are undated the design process is conjectural.

The Great Model design features a centralized plan based on a Greek cross with a large domed central space leading to four equal spaces, that to the east for the choir and High Altar designated by a shallow *apse*, and that to the west extending into a smaller domed narthex (lobby) and a massive columned entrance portico that references Inigo Jones's west portico. The King liked the design, the church authorities did not, preferring a traditional Latin cross design that allowed for a processional entry up a long nave to the crossing and choir. Back at the drawing board, Wren, in 1675, produced the Warrant Design—the approved design—that closely follows the plan shape of Old St. Paul's and compared to earlier proposals reduces the dome to a shallow support to an octagonal tower capped by a smaller dome that terminates in a tall timber spire. The Warrant Design was Wren's answer to the clergy but he never intended to build it as presented, and with the King's approval he proceeded to build a cathedral closer to his own ideals though still based on the elongated Latin cross. High hoardings were erected behind which the cathedral rose and although speed was encouraged, time was on Wren's side as the high clergy were very elderly.

St. Paul's is essentially a Gothic cathedral clothed in Classical dress: nave, aisles, transepts, crossing, choir form the plan; in section there is an arcade and clerestory with saucer domes overhead; and that most Gothic of details, the *flying buttress*, supports the upper *vaults* of the nave. Wren's genius shows in the articulation of the piers (huge columns) at the crossing that support the dome; the structural details of the dome itself; and the realization that visually the stepped profile of the traditional section—aisles to each side of a much taller nave—would not work with the tall drum and soaring dome that he intended to tower above the crossing. Wren therefore raised the outside walls of the aisles to the full height of the nave, making the visual mass of the building much greater (and conveniently hiding those Gothic flying buttresses) and creating a boxier mass that forms a suitable base for the drum and dome. The exterior wall of St. Paul's is visually split into two levels reflecting the aisle (with windows) and the screen wall above (solid with apsidal niches); the wall surface is heavily *rusticated* punctuated by paired Corinthian *pilasters* giving an effect similar to Jones's Banqueting House. The west end also pays homage to Jones with a tall, double-tiered porch framed by towers that become exuberantly Baroque above the roofline.

It took thirty-five years to complete St. Paul's, an amazing feat for such a huge building and making it the only cathedral that was seen to completion by a single architect until modern times. Nevertheless, in 1697, Parliament was not happy with Wren and delayed payment of half his salary to encour-

age quicker progress. Essentially complete by 1710, some details were taken out of Wren's hands including, in 1717, the decision to place a *balustrade* all around the building's *parapets*. By this time Wren was an old man, considered an old-fashioned architect and the younger generation showed no reverence for the great architect, who had transformed the City of London. He resigned from the position of Surveyor-General in 1718.

Canaletto painted his view of London in 1750 and it clearly portrays Wren's vision for London with the many towers and spires indicating the parishes, the villages that make up The City with St. Paul's Cathedral its protective focal point. Over the years there have been many changes, not least those wrought by the Battle of Britain in 1940 during the Second World War. But the biggest changes followed the war in the years of prosperity of the late twentieth century with many high-rise office buildings changing the city's silhouette, submerging the churches, and virtually obliterating the view of the dome of St. Paul's. Prince Charles, in his book *A Vision of Britain*, decries the loss of Wren's skyline and the transformation of what was once beautiful to what is merely mediocre. St. Paul's, however, still awes with its sheer size and majesty and the genius of its architect, Sir Christopher Wren.

Further Reading

Beard, Geoffrey. *The Work of Christopher Wren.* London: Bloomsbury Books, 1982.

Fletcher, Sir Banister. *Sir Banister Fletcher's A History of Architecture*, 20th ed. Dan Cruikshank, ed. Oxford: Architectural Press, 1996.

Jardine, Lisa. *On a Grander Scale: The Outstanding Life and Tumultuous Times of Sir Christopher Wren.* New York: HarperCollins, 2002.

St. Paul's Cathedral. www.stpauls.co.uk.

Summerson, John. *Architecture in Britain, 1530–1830.* New Haven, Conn.; London: Yale University Press, 1993.

Tinniswood, Adrian. *His Invention So Fertile: A Life of Christopher Wren.* London: Jonathan Cape, 2001.

Tomalin, Claire. *Samuel Pepys: The Unequalled Self.* New York: Vintage Books, 2002.

Wales, HRH The Prince of. *A Vision of Britain: A Personal View of Architecture.* London: Doubleday, 1989.

THE SALUTATION. *See* Lutyens Country Houses.

SANDRINGHAM HOUSE, NORFOLK, ENGLAND

Style: Victorian
Dates: 1867–1870; 1881; 1891
Architects: Samuel Sanders Teulon; A. J. Humbert;
Colonel Sir R. W. Edis

The annual peregrinations of Queen Elizabeth II's (r. 1952–) court have certain specific destinations: June at **Windsor Castle** for the Garter ceremonies and horse racing at Ascot; July and August at **Balmoral Castle** in Scotland for the Highland Games and vacation; spring and fall at **Buckingham Palace** for state and government events including the State Opening of Parliament (akin to the State of the Union) in November, State Visits such as that made by George W. Bush in 2003, and diplomatic receptions, garden parties, and investitures. For Christmas and through most of January the Queen resides at Sandringham House in the remote flat vastness of Norfolk where arctic cold winds whip across the North Sea and hit the English coast—"Very flat, Norfolk," is an oft-quoted line form Noel Coward's play *Private Lives*. At Sandringham, over the past 150 years, the royal family has created a much-loved home. George VI (r. 1936–1952) wrote, "I have always been so happy here and I love the place," and his father, George V (r. 1910–1936), called it his "dear old Sandringham." Architecturally, like most buildings commissioned by the royal family in the nineteenth century, Sandringham is not outstanding; its interest and importance lies in its royal ownership and its survival, virtually unchanged, as an example of a country house estate of the Edwardian era—the heyday of the aristocratic lifestyle that effectively collapsed with the First World War of 1914–1918—and to this day Sandringham fascinates royal followers.

The recorded history of the Sandringham estate dates from 1686 when documents show its sale by the Cobbe family and acquisition by the Hostes: Sir William Hoste was one of Nelson's commanders at the Battle of the Nile against Napoleon. In 1771, the estate had passed by marriage to Cornish Henley who replaced a rambling sixteenth-century house with a plain, compact, rectangular Georgian building covered in white painted stucco enlivened by a gable above the front door and a bay window overlooking a lake to the west. Henley died before his new house was completed and, in 1836, his son sold the estate to a neighboring landowner, John Motteux. Motteaux, an eccentric bachelor of great wealth, died in 1843, leaving his estate to Charles Spencer Cowper, a younger son of the 5th Earl Cowper. As a

younger son his expectations were not high so this inheritance was a great windfall allowing Cowper to make a good marriage and, in 1852, to carry out alterations to Sandringham Hall, as the house was then known. Cowper's architect was Samuel Sanders Teulon, the wildest of the High Victorian Gothic Revivalists, who has been referred to as the "enfant terrible" of nineteenth-century architects (for further information on Teulon see **The Church of St. John the Baptist**). Renowned for his polychromatic (multi-color) materials and contorted forms, Teulon was relatively restrained at Sandringham where he added a two-storey entrance porch on the east front and a large conservatory attached to the southwest corner. Both feature red brick and several types of stone including a dark carstone obtained from a nearby quarry; the bright colors provided a startling contrast to the white stucco of the eighteenth-century house. Cowper did not really like Norfolk, preferring Paris, and when, in 1861, his stepfather, Prime Minister Lord Palmerston, arranged the sale of the estate to the royal family he was more than happy to oblige, especially as the price was outrageously high at £220,000.

Queen Victoria (r. 1837–1901) and her husband Albert, the Prince Consort, were having problems with their eldest son, the heir to the throne, Albert Edward, Prince of Wales, who later reigned as Edward VII (r. 1901–1910). The Prince Consort was a scholarly, dedicated, hardworking, somewhat puritanical character who diverted Victoria from the wayward and spendthrift path of her Hanoverian forbears (see, for instance, **The Royal Pavilion**, **Windsor Castle**, and **Regent's Park and Regent Street**). Unfortunately for the father, the son seemed to be a true Hanoverian, already at the age of twenty showing a propensity for the good life of gambling, food and wine, and women. It was decided that "Bertie," as his family called him, needed a wife and a country house far away from the distractions of London. In 1861, plans for both were in place—the wife was to be Princess Alexandra of Denmark and the country house, Sandringham Hall—but fate intervened. The Prince Consort contracted typhoid (probably from the poor drains at Windsor Castle) and died in December 1861, resulting in his widow, the relatively young Queen Victoria, becoming a virtual recluse at Balmoral Castle or Osborne House—the two houses they had built together. Victoria's future decisions were based on the principal of "what would Albert have done" and his having approved of Princess Alexandra and Sandringham, these decisions were enacted. Bertie visited Sandringham on February 3, 1862, to see what his father had decided for him, married Alexandra on March 10, 1862, and the newly married couple took up residence two weeks later; over the next forty-eight years they were to transform Sandringham, its estate, and its house.

At first they concentrated on the 8,000-acre estate (which has expanded over the years to the current 20,600 acres), including rebuilding farms and cottages, new roads, and a wall around the sixty acres of gardens surrounding the house with, north of the house, the famous Norwich Gates—a spectacular wrought iron screen and gates designed by Thomas Jeckyll, exhibited

at the Great Exhibition of 1851 and presented to the Prince and Princess of Wales, as a wedding present by the people of Norwich and Norfolk. It was soon realized that Sandringham Hall was too small for the prince and princess and their extensive retinues, especially as the family grew with the quick arrival of three sons and three daughters. The household also comprised a considerable number of servants, a number expanded by the lady's maids and valets of the many visitors the Waleses invited to stay at Sandringham. At first it was thought to extend the house, but soon a complete rebuilding was instituted. The architect was A.J. Humbert (Albert Jenkins Humbert, 1822–1877), who was presumably chosen for a quiet life as he was a favorite architect of the Queen; recommended by the contractor-developer Thomas Cubitt, he otherwise had no great merit as he was an architect of great mediocrity.

The new house Humbert designed, renamed Sandringham House, was built between 1867 and 1870. It sits on the same site as the older house but is much bigger in all dimensions. The style of the new house has been called "Jacobethan," a mix of the styles of the Elizabethan late sixteenth century and the Jacobean of the early seventeenth century. Vaguely historical in appearance, but without scholarly substance, Sandringham House is pure mid-Victorian with its *porte cochere*, gables, bay windows, towers, *turrets*, and tall chimneys, all built of red brick with pale Ketton stone details. The house is very long and thin with the long elevations facing east and west overlooking the entrance forecourt and the gardens, respectively. The prince and princess's private rooms faced north while at the south end the service areas rambled more than doubling the length of the house and encompassing Teulon's conservatory renovated to form a billiard room; the idea of retaining of Teulon's front porch had been contemplated but was eventually discarded as too costly and too out of keeping with Humbert's more restrained *façade*.

Internally, the main rooms comprised the Great Saloon modeled on a Jacobean great hall, the white-painted Great Drawing Room, and the pale-green Dining Room hung with tapestries based on Goya cartoons that were a gift from King Alfonso XII of Spain. Throughout the house everything was and still is late Victorian dark abundance, with no surface left undecorated, while the Edwardian aura comes from the occasional lighter-colored room and the built-in mirrored display cases in many rooms, containing exquisite china and carved gemstone objets d'art and bibelots (including Fabergé pieces received as presents from Alexandra's sister, the dowager Empress of Russia). Upstairs were literally dozens of suites and bedrooms for the royal couple, their retinue and guests and servants, while in a comparatively remote location were the nurseries for the children. In the grounds were built several substantial houses used for extra guests (especially bachelors who could not be trusted to behave if given rooms near to young ladies—or the maids!).

Above the front porch are carved the words "This house was built by Albert Edward and Alexandra his wife in the year of Our Lord 1870," and to

celebrate its completion they hosted a ball for 300 guests who drove up the drive in the bright light of gas lamps supplied from the estate gas plant. The new house was technically up-to-date with iron and concrete fireproof construction, gas lighting, and the latest kitchen equipment. Beyond the immediate grounds was created an immense kitchen garden that supplied not only Sandringham House but also the Wales's London home Marlborough House (see **St. James's Palace**). The estate was developed agriculturally but the main intent was to provide prime shooting for the prince and his guests. Pheasants and partridge were nurtured in specially formed woods and then "driven" by picturesquely dressed beaters toward a line of guns. Several drives would occur each day and the estate was so well managed that up to 30,000 birds were shot each season. Sandringham is still one of the most famous shoots in the country and the Queen is an expert at directing Labrador Retrievers using just a whistle and signals.

The new Sandringham House was still not big enough for the prince and in 1881 a large ballroom was added to the designs of Colonel Sir Robert W. Edis (1839–1927, knighted 1919). Edis was also the architect who oversaw the building of the long south wing and the reconstruction of the top floor of the house after a major fire in 1891; the fireproof construction saved the lower floors and the prince's fiftieth birthday party continued in the slightly damp house beneath a temporary roof of wood, tarpaulins, and corrugated iron. In the 1970s, Elizabeth II contemplated a major remodeling of Sandringham House even considering, with the encouragement of her husband Prince Phillip, complete demolition and rebuilding, but this was a time of economic hardship in the country and it was decided it was politic to reduce the expenditure, although the renovations, carried out in 1973–1975 resulted in a reduction of ninety rooms. However, the house is still very big.

If Sandringham House is not architecturally important its gardens are of great interest to historians of landscape design. The original lake immediately west of the house was moved south and west and expanded to include two lakes connected by a cascade. In revolt against the formality of the Victorian garden with its formalized *parterres* and regimented plantings the garden designer, William Broderick Thomas, laid out much more naturalistic, densely planted and colorful gardens meant to be at their best from November to February—the shooting season. These gardens nevertheless required a huge number of gardeners to maintain and in consequence have been simplified over the years—in 1939 fifty-eight gardeners were employed; by 1980 there were only twelve. George VI commissioned the most significant change to the appearance of Sandringham. The original main drive to the forecourt was from the Norwich Gates, northeast of the house, resulting in a virtually unobstructed view of the north *façade* of the house and the windows of the royal *apartments*. Geoffrey Jellicoe, the foremost landscape designer of the twentieth century, proposed realigning the drive swinging it further to the east and shielding the house with a swathe of evergreen trees and shrubs. Immediately north of the house he created a formal garden of

"rooms" formed of clipped box hedging further enclosed by pleached (square clipped) lime trees. To the west of the house beyond the gardens is the church of St. Mary Magdalene, the royal family's local church, where each year, on Christmas Day, hundreds of well-wishers gather to see the arrival of the Queen and her family for the morning service. South of the house, overlooking the lower lake, is York Cottage which, from 1910 until 1925, was the country home of King George V and Queen Mary and their large family while the widowed Queen Alexandra lived in the "big house": "It is my mother's house," said the King "my father built it for her." Queen Mary was not happy about having to live in the small, dark cottage.

Compared to other royal residences Sandringham has a short history but it has seen its many deaths: Prince Eddy (the Prince of Wales's eldest son) in 1892, Queen Alexandra in 1925, George V in 1936, and George VI in 1952. That they chose to die at Sandringham perhaps demonstrates the affection held for this house, which for all its architectural blandness is a comfortable home away from the expansive splendors of Buckingham Palace and Windsor Castle.

Further Reading

Montague-Smith, Patrick, and Montgomery-Massingberd, Hugh. *The Country Life Book of Royal Palaces, Castles and Homes Including Vanished Palaces and Historic Houses with Royal Connections*. London: Antler Books Ltd., 1981.

Strong, Roy. *Royal Gardens*. New York: Pocket Books (Simon and Schuster Inc.), 1992.

Sandringham Estate. www.sandringhamestate.co.uk.

Sandringham House. British Government. www.royal.gov.uk/output/page561.asp.

THE SOANE MUSEUM, LONDON

Style: Georgian—Neoclassical
Dates: 1792–1824
Architect: Sir John Soane

The squares of London, with their luxuriant gardens, have been called the lungs of London; these green oases provide places for relaxation away from the bustle of the modern city. Laid out by Inigo Jones (see **The Banqueting House** and **The Queen's House and The Royal Naval Hospital**), Lincoln's Inn Fields, at twelve acres, is the largest square in The City and in the seventeenth century it was the fashionable place to reside, home to King Charles II's (r. 1660–1685) mistress Nell Gwynne. By the mid-eighteenth century fashionable London had moved westward, to the squares and streets of Bloomsbury and Mayfair, and Lincoln's Inn Fields had become

The Soane Museum. The museum rooms of the house are filled with architectural fragments, urns, and busts dramatically lit from above. *Photo by author.*

home to lawyers and other professionals. The terraced (row) houses lining the square are of a dark brick of simple Georgian design (see **Terraced Houses**) but close to the middle of the north side, one house stands out. Number 13 projects from the line of the other house, proclaiming itself different, and the *façade* is built of Portland stone, a pure white limestone. It

was not unusual for some houses in a terrace to be treated differently, relieving the boredom of a long elevation and providing architectural punctuation, but here, instead of the usual columns and *pediment*, is found a simplified Classical design so abstractly minimal that one could suspect it to be the product of the late twentieth century. This is the Soane Museum, once the home of Sir John Soane (1753–1837), created between 1792 and his death when it served as his home, his office, and his private museum. In 1833, Soane negotiated an Act of Parliament that established, upon his death, the building as a museum for the benefit of "amateurs and students" in architecture, painting, and sculpture. The Soane Museum is not only an amazing architectural feat but the magpie collection of artifacts that fill it are also an amazing feast for the eye of the amateur and the scholar.

Soane was born in 1753 in Reading, Berkshire, west of London and in 1771 was admitted to the Royal Academy Schools where he was awarded the Silver Medal for a measured drawing of the Banqueting House and the gold medal for his design for a Triumphal Bridge. Initially, his architectural practice was modest, mostly with commissions in East Anglia, but sufficient enough to allow him to marry Elizabeth Smith in 1784. In 1788, through the influence of friends, he was awarded the surveyorship of the Bank of England, a great prize as it brought not only financial security but also one of the greatest commissions of that time. The Bank of England was rebuilt 1788–1833 and the demolition of Soane's building in the 1930s is one of Britain's greatest architectural tragedies. Essentially, externally a solid walled building with few openings, the interior was filled with light from courtyards and skylights that lit arched, vaulted, and domed spaces detailed in the most restrained Classical manner that is still to be seen at the Lincoln's Inn Fields house. The bank appointment led to other important royal and government commissions; Soane became one of the foremost architects in the country and in 1832 received a knighthood. In 1806 he was appointed Professor of Architecture at the Royal Academy in its new premises at **Somerset House** and in 1834 he was recognized as the father of the profession by the award of a Gold Medal by the 350 members of the newly formed Institute of British Architects. A difficult, even neurotic man, Soane's personal life was marred by tragedy; his wife died suddenly in 1815 and his sons refused to follow him in the architectural profession and were a constant source of regret.

In 1800, Soane had purchased Pitzhanger Manor at Ealing, west of London, with twenty-eight acres of land where he rebuilt the house, experimenting with external forms, interiors, and details that were a basis for Lincoln's Inn Fields. He had bought a house in the square, number 12, in 1792 and extended his London property with the purchase of number 13 in 1807. Realizing that neither of his sons appreciated Pitzhanger, he sold the house in 1810 and focused on redesigning the London house, which was to be constantly changing until just before his death.

Looked at from the square, the houses of Lincoln's Inn Fields appear to be very regular and one supposes the sites to be rectangular. However, be-

cause of an angled street behind the properties, the plots were anything but regular with number 12 narrowing considerably from front to back; number 13 widening by approximately a third of its front width; and number 14 (bought in 1823) being the closest to a rectangle. Originally the houses were of three stories above a basement with an attic set back and hidden from the street; in 1825 a brick wall was continued up above the front façades visually making the houses a story higher. The history of the design of the three houses can be somewhat simplified:

1792: number 12 purchased and totally rebuilt with a new house toward the square and at the rear of the site a two-storey architectural office replacing the original stables.

1807: number 13 purchased and the stables replaced by a museum and office extension connected to the office at number 12. The house was rented out.

1812: negotiated a swap with the tenant of the house at number 13, who moved to number 12, allowing Soane to take over the larger house, which was totally rebuilt within seven months and connected to the exiting museum and office.

1823: number 14 purchased and demolished; at the rear of the site the museum was further extended while at the front a new rental house was built.

The new façade of number 13 defies the rules of the London building code by projecting beyond the building line. The rules did allow for projecting balconies and these were usually delicate wrought iron attachments. Soane made his balconies of Portland stone, arcades of three arched openings on the first and second floors, and a smaller central temple-like structure on the third floor. It is this stone balcony that gives the Soane Museum its distinctive appearance especially as, at a later date, Soane expanded the internal rooms outward, absorbing the balconies and glazing the arcades.

What the bald listing above does not convey is the quality of the architecture that Soane achieved, the sheer creativity confined within the spaces available. In plan the houses are conventional terraced houses with the entrance to one side leading to the staircase. To the side on the first floor a dining room connected to a breakfast room overlooks an internal courtyard while on the second floor are the drawing rooms; the bedrooms are on the third and fourth floors, the kitchens in the *basement*.

The most evocative room is the breakfast room at number 13. Buried in the middle of the site, it is nevertheless filled with light from a large window to the internal courtyard and by skylights cunningly hidden above the edges of the room. The ceiling is a shallow saucer dome with *pendentives*; the structure does not reach the walls on all sides but appears to hover in the space with the light from above washing down the walls. One description likens

this ceiling to a handkerchief spread out, let go, and parachuting downward, so airy is the effect. The dome is decorated with an incised Greek meander pattern. The room is lined with bookcases and paintings against brilliant yellow walls; convex mirrors, strategically placed, provide all sorts of visual tricks and bounce the light around the room.

Standing in the breakfast room the observer begins to realize another architectural device used by Soane: the axis. This is not the simple alignment of doors as seen in the *enfilade* of the formal houses of the eighteenth century (see **Blenheim Palace** and **Holkham Hall**), but is rather a much cleverer, more intricate grid of parallel and crossing axes that lead, stop, turn, or reorient the observer as he or she is moved around the house. Soane even presages the modern idea of connecting inside to outside by throwing axes across the courtyards and visually drawing the eye through several spaces, blurring the definition of the spaces.

The interiors of the living areas astonish but they hardly prepare the visitor for what lies beyond in the museum and office wing that occupies the sites of the stables of the three houses. The museum is a tall narrow space, top lit from a skylight of colored glass, and open to the basement crypt. The architecture is grand; huge arches with simple, incised line decoration rise smoothly from columns without bases, capitals, or entablatures. Instead every surface and opening is covered or filled by antique architectural fragments, plaster casts, urns, and swags in a profusion that takes the breath away, all thrown into detail of shade and shadow by strategic lighting and guarded by a series of huge busts that line the rim of the skylight high above. The museum is a maze of physically and visually interconnecting spaces that intrigue at every turn and eventually lead to Soane's last creation, the Picture Room. Here "the small space of thirteen feet eight inches in length, twelve feet four inches in breadth and nineteen feet six inches in height, which are the actual dimensions of this room, is rendered capable of containing as many pictures as a gallery of the same height, twenty feet broad and forty-five feet long" (Soane's *Description* of 1835). Entering the room one sees walls lined with pictures but then the walls unfold, like huge doors, to reveal two more surfaces for the display of paintings: the backs of the doors and the now visible actual wall; ingenious and effective.

Soane sent a copy of his *Description*, his guide to the house and museum to Isaac D'Israeli, who wrote back a letter that concluded: "Your museum is permanently magical, for the enchantments of Art are eternal. Some in poems have raised fine architectural Edifices, but most rare have been those who have discovered when they had finished their House, if such a House can ever be said to be finished, that they had built a Poem. All this you have accomplished." The Soane Museum remains to this day virtually as Soane left it on the day he died in 1837.

Sir John Soane is one of Britain's greatest architects, on a par with Jones, Wren, Vanbrugh, Adam, or Lutyens. His influence can be seen in the work of modern architects such as Michael Graves, Philip Johnson, Sir Edwin Lu-

tyens, Rafael Moneo, Giles Gilbert Scott (see **Public Telephone Kiosks**), and Robert Venturi and Denise Scott Brown. The Bank of England, the Dulwich Picture Gallery, Pitzhanger Manor (recently restored), his country houses, and the Soane Museum are all studied by architects of today who try to understand the spatial and visual complexities of plan, section and mass, and of light and color that Soane so adeptly achieved in his work.

Further Reading

Richardson, Margaret, and Stevens, MaryAnne. *John Soane Architect.* London: Royal Academy of Arts, 1999.
Sir John Soane's Museum. www.soane.org.

SOMERSET HOUSE, THE STRAND, LONDON

Style: Georgian—Neoclassical
Dates: 1776–1780
Architect: Sir William Chambers

London has few grand public spaces that can be enjoyed by the public. **Trafalgar Square**, watched over by Nelson's Column, or The Mall leading to **Buckingham Palace** are grand spaces but most of the time, despite recent improvements, they are filled with the sound of traffic. Piccadilly Circus and Oxford Circus, intervals on John Nash's processional Regent Street (see **Regent's Park and Regent Street**) are choked by tourists and shoppers. However, on May 25, 2000, Her Majesty Queen Elizabeth The Queen Mother opened a new public plaza for the people of London, a space away from the busy streets of the capital where the openness, the quiet, the sky could be enjoyed against the backdrop of one of the most spectacularly grand buildings ever built in London. This is not a new plaza or a new building; it is the courtyard at Somerset House designed by Sir William Chambers in the late eighteenth century as a government office building—believed to be the world's first purpose-built office building.

The history and name of Somerset House goes back over 200 years before the Chambers building. The Strand is the street that connects **The Tower of London**, the Royal stronghold on the east side of the City of London, to Westminster (see **The Houses of Parliament** and **The Banqueting House**), the location of the royal palaces in mediaeval and Tudor times. The River Thames was the other main transportation route and the two ran parallel to each other. The plots of land between the river and the street were

favored by the rich and powerful to build town mansions convenient to both the riches of The City and the politics of Westminster. When Henry VIII (r. 1509–1547) died, his heir, Edward VI (r. 1547–1553), was only nine years old and Edward's uncle, Edward Seymour, Duke of Somerset, served as regent, taking the title Lord Protector of England. Protector Somerset decided he needed to build a house suiting his lofty position and, using his absolute powers he confiscated church land that fronted The Strand and the Thames and had constructed the most stylistically advanced building of its time. Like Cardinal Thomas Wolsey a generation earlier (see **Hampton Court Palace**), Somerset looked to Europe and his new palace exhibited the ideas of the Renaissance using symmetry, axes, and the Classical orders in a manner totally novel in England. Old Somerset House was one of the most influential buildings in the story of English architecture as it planted the seed of Classical architecture in the country. Somerset did not enjoy his new house for long; being so important he attracted many enemies. At his final downfall in 1551, he joined the long list of prisoners incarcerated in the Tower of London; he was executed in January 1552 and Somerset House passed into the ownership of the Crown.

The Stuart King James I (r. 1603–1625) was a strange character and his queen, Anne of Denmark, lived a separate and extravagant life at Somerset House, which was renamed Denmark House. Major renovations and some rebuilding was commissioned to the designs of Inigo Jones and these continued when Queen Henrietta Maria, the wife of Charles I (r. 1625–1649), took over the palace that was again called Somerset House. Henrietta Maria returned as Dowager Queen at the restoration of the monarchy in 1660 but returned to France in 1665 to escape the Great Plague—the Great Fire a year later stopped one block from Somerset House. The next, and last, royal occupant was Catharine of Braganza, wife of Charles II (r. 1660–1685), whose extreme Catholicism was seen as suspect, and she left for her home country of Portugal in 1693. For the next eighty years Somerset House, while occupied by court officials, a battalion of the Foot Guards, and the Royal Academy of Arts, fell into disrepair. In 1775, George III (r. 1760–1820) agreed to demolition and the building of a new Somerset House.

William Chambers had been architectural tutor to George III before he inherited the throne and, as Comptroller of the Office of Works, was one of the king's architects responsible for many royal works and for a series of innovative and intriguing Neoclassical buildings, the most interesting being the Casina at Clontarf, Co. Dublin of 1759. Therefore, he was surprised when he was not appointed and a lesser architect named William Robinson presented designs for the new building. The argument was whether the new Somerset House should be a functional pragmatic design or more elaborate and hence more expensive. In the end it was determined that it should be "an ornament to the metropolis and a monument to the taste and elegance of His Majesty's Reign." It was doubtful that Robinson was up to this task but he solved the problem by suddenly dying in 1775 and the commission

was awarded to Chambers. The program envisaged a building in which several government departments could efficiently coexist as well as provide accommodation for the Royal Academy of Arts, the Royal Society (for the Encouragement of Arts, Manufactures and Commerce), and the Society of Antiquaries. The largest and most difficult department to accommodate was the Navy Board, which added the complication of requiring docks and a bargehouse for the King's Bargemaster—the Thames was still the most viable means of moving between Westminster and The City and the docks at Greenwich. The second problem Chambers faced was the site; the garden and terraces of Old Somerset House sloped steeply down to the river.

The new Somerset House, with its courtyards, covers the whole six-acre site and extended into the river where the Embankment Building rose straight out of the waters of the Thames with a huge central arched opening leading to the boat dock and bargehouses. On top of this Chambers created a massive terrace, a promenade from which to view the sweeping bend of the river, while set back and behind rose the South Wing of his new building. The site has a narrow frontage to the street and here Chambers erected the Strand Block that housed the "learned societies" and also provided a magnificent multiarched and columned gateway into the huge courtyard. East, West, and South Wings, which provided accommodation for the various government departments, frame the courtyard. Today we would probably separate such entities by floor but Chambers placed each in separate but adjoining six-story buildings with two levels of *basement*, ground floor, *piano nobile*, attic, and garret (rooms within the roof). The basements are spectacular spaces, brick-vaulted feats of engineering, and now serve as superb art galleries though they must have been oppressive for pen-pushing clerks. The buildings above are externally detailed in a robust *Neoclassical style* owing much to French architecture of the time. Internally, Chambers created many beautiful rooms and spaces; particularly notable are the Royal Academy of Arts' Great Exhibition Room and several of the staircases; the Navy Stair is a magnificent double sweep with, suddenly, a flight soaring overhead crossing the sky-lit space.

The South Wing is six times the length of the Strand Block giving an indication of the odd shape of the site. To complete Somerset House the New Wing was built in 1849, designed by James Pennethorne, to the west facing Wellington Street and connected to Chambers's West Wing by graceful cast iron bridges. A second parallel eastern wing that housed King's College was completed in 1829.

The learned societies moved out of Somerset House in 1874, relocating to Burlington House, and the whole building was dedicated to government offices, particularly the Inland Revenue that came to occupy the East and West Wings and the New Wing; the Registry of Births, Marriages and Deaths occupied the Strand Block; and the Principal Probate Registry, where wills were recorded, the South Wing. The demands of late twentieth-century technology forced the occupants of the Strand Block and South Wing to

move to new premises and the Royal Academy spaces have been renovated to house the Courtauld Institute's art galleries. The great courtyard, long a barren parking lot, has been repaved and enlivened with a computerized "dancing" fountain making a space for people to relax or enjoy outdoor concerts described in the Queen Mother's speech as "an amazing space—London's finest open air living room."

One reference to the United States of America adorns Somerset House. High on the courtyard elevation of the Strand Block are carved female figures representing four of the continents. Three, representing Asia, Australasia, and Africa, where the empire was expanding, carry cornucopias full of the bounty streaming back to England. The figure representing the Americas is grim-faced and armed—the year they were put in place was 1776.

Further Reading

Harris, John, and Snodin, Michael, eds. *Sir William Chambers, Architect to George III.* New Haven, Conn.; London: Yale University Press, 1997.

Somerset House Trust. www.somerset-house.org.uk/history/.

Summerson, John. *Architecture in Britain, 1530–1830.* New Haven, Conn.; London: Yale University Press, 1993.

SPENCER HOUSE, GREEN PARK, LONDON

Styles: Georgian—Palladian and Neoclassical
Dates: 1756–1759; 1759–1765; 1785–1792; 1985–1990
Architects: Sir George Gray; John Vardy; James Stuart; Henry Holland (eighteenth century); Rolfe Judd (twentieth century)

In 1955, Nancy Mitford wrote, "Aristocrats no longer keep up any state in London, where family houses hardly exist now. Here many of them have shown a sad lack of civic responsibility, as we can see by looking at poor London today. At the beginning of this century practically all the residential part of the West End belonged to noblemen and the Crown. A more charming and elegant capital city would have been far to seek. To the Crown . . . and to two Dukes, Westminster and Bedford, we owe the fact that London is not exactly like Moscow, a conglomeration of dwellings. Other owners cheerfully sold their houses and 'developed' their property without thought for the visible result. Park Lane, most of Mayfair, and the Adelphi . . . bear witness to a barbarity which I, for one, cannot forgive." Nancy Mitford's opinion was biased by her class; she was the very aristocratic daughter of Lord Redesdale.

She was regretting the demise of the great London houses of her relatives and friends, of the small select group that made up London "Society" before the First World War. That great watershed for the aristocracy of Europe saw the deaths of many heirs to great estates, the increase in the rates of income tax and death duties, and the end of an era that resulted in the demolition of many London mansions—Spencer House is one of the few to survive.

The West End referred to is the area bounded by The City to the east, Oxford Street to the north, Hyde Park to the west, and Green Park and St. James's Park to the south. Developed in the late eighteenth century by the Crown and the ducal Westminster and Bedford families, the West End rapidly became the most fashionable part of London. Although great changes in society took place before 1955 and continue to the present day, the West End maintains its premier position and most of it is still owned and preserved by the Crown and ducal estates mentioned by Mitford. On the most prominent sites overlooking the parks and squares were built the largest houses, the town mansions of the richest, most aristocratic families. Devonshire House on Piccadilly; Grosvenor House and Londonderry House, both on Park Lane; Derby House in Grosvenor Square are a few of the many great houses that were demolished during the twentieth century to make way for mundane hotels or office buildings. Other houses that have survived are now office buildings for government departments or private companies, the luckiest being used for receptions and dinners and thus maintaining some of the splendor of their earlier function. Spencer House, overlooking Green Park, is an example of a great town mansion, no longer lived in by the aristocratic family it was built for, recently leased and completely restored by a private company—The J. Rothschild Group—as its London headquarters.

Spencer House was built for the 1st Earl Spencer, John Spencer, one of the heirs to the fabulously wealthy Sarah Churchill, Duchess of Marlborough (see **Blenheim Palace**). The Spencers could trace their ancestry back to a William Spencer of Defford, Worcestershire, in 1330. They had become important, and rich, early in the sixteenth century acquiring Althorp, Northamptonshire, which continues to be their country estate and is the home of the current 9th Earl Spencer, the brother of the late Diana, Princess of Wales. John Spencer was born in 1734 the second son of the 3rd Earl of Sunderland and his wife Ann, 2nd Duchess of Marlborough in her own right. This complex tangle of overlapping titles and fortunes allowed for John, unusually for a younger brother, to inherit a vast fortune, so large that he was created Earl in 1765. Also unusually, for such a rich and well-connected family, John married for love. His wife was not rich, not particularly beautiful, nor from a family of equal standing, but she was intelligent, well-educated, talented in the arts, music, and needlework; a linguist capable of brilliant conversation in several languages and an intrepidly daring horsewoman. Her name was Georgiana Poyntz, "a mere Miss Poyntz," according to the great arbiter Horace Walpole. They met in 1754, married on December 20, 1755, and Spencer House was begun soon after. "Indeed to a large extent the house

Spencer House. The elevation overlooking St. James's Park. *Vitruvius Brittanicus.*

was built for Georgiana and for the life which Spencer hoped to share with her. Spencer purchased the site a short time after their engagement and construction began in the period immediately following their marriage."

St. James's at this time was the most fashionable part of London. It adjoined **St. James's Palace**, the official London home of the monarch, and was described as "well replenished with fine open streets, which are graced with good buildings, and generally well inhabited [i.e. the owners were aristocratic]." The site for Spencer House, which had the great advantage of facing west over Green Park, adjoined an open area, almost a forecourt to the new house, at the end of St. James's Palace, a cul-de-sac street just north of St. James's Palace. John Spencer, with some judicious negotiations and a grant from the king allowing a terrace to encroach into Green Park, had a site suitably large for the house he envisaged, although the stables had to be built some distance away. There is some difficulty in attribution of the architect as the names of both Colonel Sir George Gray and John Vardy are associated with the house. It appears that Spencer acquired Vardy as his architect when he purchased the site and that Gray, a minor Scottish baronet with an interest in architecture, was employed as an architectural advisor. Gray, secretary of the Dilettante Society (a group of aristocrats with a common interest in the arts), a shadowy figure whose name is mentioned in connection with many buildings of the period, is the eminence behind the design of Spencer House. He apparently approved Vardy's appointment as architect and, after they fell out, advised that James Stuart be hired to complete the interior.

Colonel Gray was of the *Palladian* school, a follower of Lord Burlington and William Kent in their admiration of the work of the Italian architect Andrea Palladio (1508–1580). Indeed, Spencer House owes much to the work of Kent and has direct references to Palladio's Palazzo Chieracati, Vicenza and a Palladio design for a town house. This featured a *rusticated* lower floor

and a *piano nobile* (literally "noble floor"—the main floor level) of tall windows placed between tall attached columns supporting an elaborate decorative cornice. Sir John Summerson describes the west front of Spencer House as "a somewhat pretentious Palladian Hybrid, something between villa and palazzo." Summerson has a point, as the house with its columns and *pediment* tends to confuse as to its scale—is it a small palace or a large villa—and is overdecorated compared to the work of other Palladian architects, verging on Rococo in its exuberance. John Vardy's drawings for Spencer House are signed and dated 1759, although the basic design had been finalized in 1756 when construction began. The exterior of the house is faced with pure white Portland stone, the finest building material available, which made the house conspicuous among its brick neighbors.

While the outside of Spencer House excited notice and discussion it was the interior and the two suites of rooms designed by Vardy on the first floor, and Stuart on the second floor, that became the talk of fashionable London. Vardy designed a typically hard and cool entrance hall as a transition from the streets of the city, a small dining parlor, and, facing Green Park, a "Great Eating Room" flanked by two drawing rooms. The South Drawing Room is Vardy's masterpiece. The culmination of a sequence of increasingly complex decorative schemes, it is a square room separated by columns from an oval secondary space. Picking up on an unexecuted design by John Webb Vardy makes the columns appear to be gold palm trees whose fronds threaten to take over walls and ceilings. Even the furniture is decorated with palm leaves. It is a virtuoso play of white and gold on a green background and, recently restored, still astonishes. As Vardy completed the ground floor Gray was working against him, having James Stuart, a younger and newly fashionable practitioner of the *Neoclassical style* on hand to take over. Stuart, known by the sobriquet "Athenian," designed the second floor rooms that, in their references to ancient Rome and Greece rather than sixteenth-century Italy, are very different from those by Vardy. In their richness and intricate thoroughness they are the equal of those on the floor below, but more restrained and elegantly tasteful. The house officially opened for the reception of guests in the spring of 1766 to universal praise. Arthur Young, a writer of guide books for discerning travelers, wrote, "I do not apprehend there is a house in Europe of its size, better worth the view of the curious in its architecture, and the fitting up and furnishing of great houses, than Lord Spencer's in St. James's Palace. Nothing can be more pleasingly elegant than the park front, which is ornamented to an high degree, and yet not with profusion; I know not in England a more beautiful piece of architecture." He continues, even more fulsomely, to describe the interiors in great detail.

The 1st Earl died in 1783, his widow in 1814, although she had moved from the house created for her and lived in the country. The 2nd Earl brought in Henry Holland who made some changes to the floor plan and redecorated the Dining Room. During the nineteenth century a garden was formed beneath the west terrace within Green Park but only minor changes

were made to the house, which continued as the London home of the Spencer family. In the 1920s, the end of the great London house as a political and social force was evident and, although he held out for as long as possible, the 7th Earl had to move out in 1926, renting the house to the Ladies' Army and Navy Club. During World War II the earl, fearing the house might be bombed, had much of the interior stripped of its decoration, doors, and paneling. Only slightly damaged, Spencer House survived, but as an empty hulk that saw a series of unfriendly tenants until, in the 1980s, the J. Rothschild Group commissioned Rolfe Judd as architect for a complete restoration. The exterior was cleaned and renovated, the interior stripped of partitions and unfortunate light fittings and restored to its eighteenth-century glory using craftsmanship and materials of the appropriate and highest quality. Where the original fittings or furniture could not be bought or borrowed they were copied and recreated—for example, chairs and sofas from the Palm Room now in the Boston Museum of Fine Arts were carefully measured and exact copies made for the restored Vardy designed room. A stupendous and expensive project, the restoration was partly done in honor of Georgiana Spencer's great-great-great-great granddaughter, the late Diana, Princess of Wales.

Further Reading

Friedman, Joseph. *Spencer House: Chronicle of a Great London Mansion.* London: Zwemmer, 1993.

Pearce, David. *The Great Houses of London.* New York: The Vendome Press, 1986.

Spencer House. www.spencerhouse.co.uk.

Sykes, Christopher Simon. *Private Palaces: Life in the Great London Houses.* New York: Viking Penguin Inc., 1986.

STONEHENGE, WILTSHIRE, ENGLAND

Style: Prehistoric
Dates: Circa 3000 B.C.E.–circa 1600 B.C.E.
Architects: Unknown

Every Midsummer's Day, before dawn, hundreds of people gather at an isolated spot in the middle of Salisbury Plain to await the sunrise. Some 4,000 years ago the ancient inhabitants of Britain chose this site for a great temple or Henge. A Henge is an open-air ceremonial site and there are many such sites across Britain and northwest France. Little is known about their function although they are associated with the ancient pagan religions that evolved into the Celtic Druid religion. This powerful cult, which held to-

gether the small tribal kingdoms of northern Europe, was eventually destroyed at their last redoubt on the island of Anglesey off the coast of northern Wales. The ceremonial sites of the ancient tribes usually comprised earthen embankments and ditches enclosing a central oval or circular space defined by standing stones. Often there is an axial approach or causeway across the ditch also lined with standing stones. At some sites it is the axes that are more important than any defined space and it is the sophistication—and accuracy—of the ancients who aligned their designs to celebrate special days in the celestial calendar, which amazes and confounds today's observer. At Stonehenge at sunrise on Midsummer's Day the sun appears as a fiery red ball on the main axis observed through the central *trilithon*—a post-and-beam structure of two uprights supporting a connecting lintel.

The dates of such ancient structures are hard to determine accurately but the latest evidence suggests that work on the Stonehenge site began c. 3000–2600 B.C.E. when, during the Late Neolithic/Early Bronze Age, a ditch and low earth bank were dug—all well before the Druid religion emerged. The site created was approximately 300 feet in diameter. The main axis was also created at this time with the causeway leading from the northeast aligned with the midsummer sunrise. Within the circular earthworks there are indications of wooden posts and standing stones being carefully placed during the earliest phase of construction. Some 500 years later, during the Bronze Age, the next major development took place. Two concentric rings of standing stones were erected at the center of the enclosure. The inner ring was 74 feet in diameter, the outer ring 85 feet. Each ring contained thirty-eight standing stones, arranged in radially aligned pairs, of blue dolerite. Tests on these stones have determined the location of the quarry to be in the Prescelly Hills in Pembrokeshire, South Wales, some 150 miles away. Obviously, the blue dolerite was of considerable significance to the ancient Britons who dragged these huge stones from distant Wales, probably transporting them part of the way on wooden rafts along the coast, across the Bristol Channel and up the River Avon. Such an undertaking suggests great religious fervor, a ruthless and dedicated society and, possibly, a captive labor force of slaves.

The final phase of construction at Stonehenge dates from the middle and later Bronze Age c. 1800–1600 B.C.E., during the time of the pre-Celtic people known as the Beakers. At this time the concentric rings of blue stones were removed and replaced by the outer circle and inner horseshoe of "Sarsen Stones" seen to this day. Eighty-two of these massive stones were brought from the Marlborough Downs twenty miles to the north. The stones each averaged over 57,300 pounds in weight and had to be dragged over difficult terrain to the site where they were lifted upright as columns or placed on top of the columns as beams or lintels. The outer ring comprises sixty-six stones arranged as a ring of uprights supporting a continuous lintel while the inner horseshoe uses fifteen stones to make five independent trilithons. The central trilithon is sited slightly apart from the other four and straddles the axis aligned with the midsummer sunrise. The important blue stones were

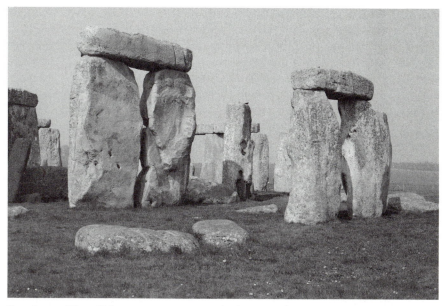

Stonehenge. The trilithon structures composed of two uprights supporting a single horizontal stone. *Harcourt Index.*

not forgotten or discarded but were repositioned to form an oval of standing stones inside the new ring of sarsen stones and a secondary horseshoe within the horseshoe formed by the trilithons. The inner horseshoe of blue stones was arranged with the height increasing to the tallest stone placed on the axis—this has since fallen over and is now called the "Altar Stone."

Stonehenge is obviously linked architecturally to other ancient sites such as Avebury, Wiltshire, but it is unique in its development and sophistication. The massive stones have been finely worked considering the tools available; the lintel stones are dovetailed together to form a continuous connected ring and are located on top of the upright stones using a modified *mortise and tenon joint.* Further, the designers understood that the eye can deceive and they carefully shaped the uprights to counter the distortion of perspective making the top appear larger than the base—the stones taper slightly. The circle of lintels is also shaped to be a continuous smooth ring rather than a series of straight stones; each lintel stone is curved to form a part of the larger circle. These refinements cannot have been thought of just for this structure and it is probable that the designers were "drawing on a well established architectural tradition," evidence of which has been lost. That this kind of thought and energy was put into Stonehenge indicates it was a major ceremonial site, possibly the most important in Europe; it is certainly the finest surviving Bronze Age structure in Europe.

How Stonehenge was used is not known, although imaginative invention

has created stories of bloody sacrifices of animals and humans led by white-clad priests, which may be true. A few burial sites have been found within the site but only one skeleton. Found in 1923, lost during the war, and only recently discovered and studied, it gives some evidence of ritual execution. Careful examination of the skull and neck vertebrae of the thirty-five-year-old man show he was executed with a single clean sword cut from behind. However, he died approximately 2,000 years ago, long after it is thought Stonehenge ceased to be a ceremonial site; but this discovery is leading archaeologists to reconsider the history of the site.

During mediaeval times Stonehenge was a place to be feared but not enough to prevent several of the stones from being "quarried" as building materials for other buildings. For many years Stonehenge stood uncared for in a field on a private estate, but recently it has come under the protection of English Heritage, the government's historic preservation office. So popular as a tourist attraction that the paths were eroding and the stones polished, it has been proposed that the site be secured, visible only from a distance, while the "experience" would be recreated in a nearby fiberglass replica.

Avebury, another henge, is twenty miles north of Stonehenge and although much larger it is not as sophisticated. It comprises an outer bank, 1,400 feet in diameter and 20 feet high. Within this is a massive ditch originally 30 feet deep and 45 feet wide that encloses a circular area 1,140 feet in diameter and over 28 acres in area. Two circles of standing stones are place within the site, one focusing on a nineteen-foot-high stone pillar, the other on three massive sarsen stones that form an open-roofed sanctuary. Avebury henge was entered over four causeways aligned to the cardinal points of the compass with that to the south extended by an avenue 1.5 miles long lined with 100 pairs of ten-foot-high sarsen stones.

Southwest of Avebury is Silbury Hill, the largest artificial mound in Europe. Dating from c. 2500 b.c.e. and once thought to be a barrow [burial site], Silbury is now known to have been another site for ritual ceremonies. Five hundred feet wide and 120 feet high when completed, the mound of sparkling white chalk—the local stone—comprised a spiral ramp leading up to a sacred platform. The surrounding ditch, from which the stone was quarried, was originally flooded to form a moat that reflected and visually increased the size of this already massive structure. Sitting in a valley with the sacred platform visible from nearby hilltops, the brilliant white mound surrounded by green meadows and forest must have been an awe-inspiring sight to the ancient people.

Further Reading

Derbyshire, David. "Secrets of Silbury Hill Uncovered." *Daily Telegraph*, February 20, 2002.

English Heritage. www.english-heritage.org.uk/stonehenge/.

Fletcher, Sir Banister. *Sir Banister Fletcher's A History of Architecture*, 20th ed. Dan Cruikshank, ed. Oxford: Architectural Press, 1996.

STOURHEAD, WILTSHIRE, ENGLAND

Styles: Georgian—Palladian and Picturesque/Romantic (Landscape)
Dates: 1720–1724; 1741–1772
Architects: Colen Campbell; Henry Flitcroft; Henry Hoare II (owner)

In the west of Wiltshire, on the border with Gloucestershire, the landscape features rolling hills lush with woodlands, hedgerows, and cottage gardens. Manor houses and mansions are surrounded by gardens and parkland that date to the eighteenth century when land ownership and usage was finally legalized and the remnants of feudal agriculture obliterated. The Enclosure laws allowed landowners to fence land that had for centuries been deemed common land or divided into inefficient strips; the face of the land was changed forever. At Stourhead, literally the head of the River Stour, stands a *Palladian* mansion of c.1720, designed by Colen Campbell (1676–1729), sitting in a large *park* that shows vestiges of an earlier formal landscape of tree-lined avenues. To the southwest of the house, hidden by a belt of trees, is the Stour valley and one of the most important gardens in a country of gardens: the first naturalistic landscape created in Britain, a landscape that was to have a huge influence on parks and gardens throughout the country and led to such landscapes as Central Park in New York City. This garden was created by the then owner of Stourhead, Henry Hoare II (1705–1785), with assistance from the architect Henry Flitcroft (1697–1769).

Henry Hoare I bought the Stourhead estate, owned for over 700 years by the Stourton family, in 1717. His father, Sir Richard Hoare (1648–1718), Lord Mayor of London in 1712, founded Hoare's Bank in 1672 and it remains today as the last surviving private deposit bank under the name C. Hoare & Co. Henry Hoare I, with a huge fortune, wanted a country estate and a new mansion. The mansion designed by Colen Campbell was really a large villa in the fashionable Palladian style (see **Chiswick House**): a near square in plan with the main front facing east leading to a thirty-foot cubic hall with two formal *apartments* running the depth of the house to each side (see **Blenheim Palace** for an explanation of the formal house). Campbell proposed a projecting, four-columned *Corinthian portico* but Hoare replaced this with an attached portico during construction. The Campbell portico was added in 1841 while, some years previously, in 1793–1795, wings to each side of the east front were built containing a library and a picture gallery. The main block of the house burned in 1902 but was faithfully restored to the original designs by the Henry Hoare of that time and it was he, without direct heirs, who gave the house and estate to the National Trust in 1947. Stourhead, the house by itself, would be well worth seeing because it is so fine an example of eighteenth-century Palladian design, but it is completely

outshone by the gardens created by the next owner, Henry Hoare II, beginning in 1741.

Describing the gardens at Stourhead, Marvin Trachtenberg and Isabelle Hyman wrote, "Stourhead was the perfect realization of the eighteenth-century yearning for a Vergilian and Claudian Arcady. The Stourhead park was created in a luxuriant valley, which Flitcroft made into a lake with a path around it that provided a sequence of Picturesque views and encounters with temples, statuary, springs and grotto, all involving layers of visual, literary, and even personal allusion. One of the principal Picturesque views at Stourhead is known to reflect Claude Lorrain's *Coast View of Delos with Aeneas* and the passage from Vergil on which it was based, relating Aeneas's account of his experience in the Temple of Apollo at Delos."

What Hoare and Flitcroft had done was revolutionary; it was probably the former who had the brilliant ideas and the latter who assisted in the realization. Taking a shady walk from the house, a wilderness walk through a wooded copse not unusual at that time, suddenly there is the bright reflection of water down below and the path emerges into an Arcadian landscape in a steeply sided valley of clumps of trees, a serpentine lake, and assorted Classical and Gothic structures. The genesis of this garden was probably the Italian landscapes seen on the Grand Tour, the educational tour of Europe, particularly Italy, taken by most rich young gentleman in the eighteenth century. They returned with their own memories, sketches, and watercolor paintings of these landscapes and also oil paintings by such artists as Poussin, Salvator Rosa, and Claude Lorrain (1600–1682). Hoare decided to recreate the Italian landscapes and paintings in his new garden and the path that forms a circuit around the lake reveals several set-piece views, the most famous being that with the bridge in the foreground, the Temple of Hercules across the lake, and the Temple of Apollo high on the hill to the left. Compare this view with Lorrain's *Coast View of Delos with Aeneas*, owned by Hoare and now in the National Gallery in London, and the painting comes to life. A further reference is found in the Temple of Hercules, with its statue by Rysbrack, where a Latin inscription alludes to Aeneas seeking a new home in Rome and Hoare building his new home in Wiltshire.

As Henry Hoare's guests, "polite society," walked around the circuit the sequence of living paintings was revealed with each stopping place indicated by one of the buildings or a very deliberate framing of trees. The view could be exclaimed upon, interpreted, and the allusions to antiquity or mediaeval times discussed; not only was the landscape "picturesque" in its composition, it was also "romantic" in its effect. Stourhead was the beginning of the "Picturesque" movement and predicts the "Romantic" movement of the late eighteenth century.

The buildings designed by Flitcroft at Stourhead include: the Temple of Flora (originally Ceres), a small *porticoed* rectangular structure of 1744–1745; the Grotto, an underground cave with a carved river god; the Temple of Hercules, a small-scale version of the Pantheon in Rome of 1754–1756; the five-

arched bridge of 1762; the Temple of Apollo of c.1765, high to one side of the valley overlooking the lake and based on the Round Temple at Baalbec; and Alfred's Tower designed c.1765 but not finished until 1772. Later additions include the Gothic Cottage of 1806. A real Gothic feature is the market cross, dated 1372, which Hoare brought from Bristol in 1768 to sit between the lake and the mediaeval parish church that had became part of his contrived landscape.

The original planting relied completely on trees so was essentially a texture of greens. Later owners, particularly the antiquarian Sir Richard Holt Hoare who inherited Stourhead in 1785, changed the planting forming an aboretum, a museum of trees and plants, including a collection of rhododendrons so that nowadays, depending upon the season, the valley is full of color.

So important was Stourhead that the King of Sweden sent artists to survey and record the garden so that he could build one similar; Hoare even built an inn just outside the garden to accommodate the many visitors. Some art critics have suggested that the naturalistic garden, the "Jardin Anglais" (English Garden) is England's greatest contribution to the arts of the Western world, whether it be a great landscape such as "Capability" Brown's at **Chatsworth** or Hoare and Flitcroft's smaller arcady here at Stourhead.

Further Reading

Coats, Peter. *Great Gardens of the Western World*. London: George Weidenfeld and Nicholson Ltd., 1963.

Trachtenburg, Marvin, and Hyman, Isabelle. *Architecture from Prehistory to Post-Modernism*. Englewood Cliffs, NJ: Prentice-Hall, 1986.

Williamson, Tom. *Polite Landscapes: Gardens and Society in Eighteenth Century England*. Baltimore, Md.: John Hopkins University Press, 1995.

SUBURBAN SEMI-DETACHED HOUSES, VARIOUS SITES

Styles: Twentieth Century—Inter-War and Modern
Date: Twentieth Century
Architects: Anonymous

In traveling around Britain one notices that the regional characteristics developed over the centuries are still obvious: Cheshire has its charming black-and-white half-timbered cottages; the Cotswolds towns their glowing

Suburban Semi-detached Houses. Diagrammatic plans of a typical "semi" such as the house in Gloucester Drive. Each house is approximately 24 feet wide. *Diagram by author.*

golden-yellow sandstone buildings, and even London its characteristic red brick or stuccoed terraced (row) houses (see **Terraced Houses**). But look at the houses of the twentieth century and one particular style stands out as appearing in every town; a type of house that was constructed all over the country; a type of house that can truly be said to be ubiquitous—the suburban semi-detached. The "semi" can also be said to be characteristic of the country as it manages to embody the class-conscious snobbishness and pretentiousness that continues to rule Britain.

At the turn of the twentieth century Britain was the world leader in the building of "garden suburbs" and new towns: Port Sunlight (begun 1888), Bourneville (1895), Letchworth (1903), Hampstead Garden Suburb (1906), and Welwyn Garden City (1920) are all examples of model communities providing healthy modern housing away from the disease and pollution of the city slums. Railway services provided rapid transportation into the cites where husbands worked as factory workers, clerks, or office assistants—upper-working-class or lower-middle-class jobs—while wives stayed at home raising the children. Architecturally and socially experimental, the new towns were slow to develop and often financially not viable. Speculative developers quickly noticed the potential of building on the edges of cities close to railway stations or along the newly built "arterial roads" that provided fast transportation for cars, buses, and trucks—creating the so called "ribbon developments." Not wanting expensive investment in elabo-

rate town plans or architecturally designed houses, the developers settled on a plan that had evolved from that of the row house in the nineteenth century and could often be seen in farm cottages on landed estates. The nineteenth-century architect Samuel Sanders Teulon (1812–1873) has been credited with designing several estate cottages at Sunk Island, East Yorkshire, in the 1850s that in their plan and appearance foreshadow the twentieth-century "semi."

What is the "semi?" The term "semi-detached" was coined to describe a house that, while not terraced and therefore associated with working-class areas, was not expensively detached: It shares one common wall with a neighboring house and the plans and elevations were a mirror image. The two houses nestle together under a single roof, usually *hipped* and at the very center all the fireplace flues came together in one large chimney. In the United States it would be called a duplex. Externally, the typical "semi" has large stacked *bay* or *bow windows* designating the main living room on the first floor and the main bedroom above while to one side an arched opening led into a small porch sheltering the front door. Usually of brick on the lower floor with the upper floor of stucco or pebble-dash (a render of cement with small stones embedded thus providing a rough finish), the developers would use every possible feature to make their design different and therefore marketable: stained glass in the front door; a circular window in the hall; half-timbered gables above the bay windows; or French doors leading to the rear garden from the dining room. Sometimes the Modern or Art Deco styles would be used but usually the "semi" is in a vaguely Tudor or Elizabethan style (though very far removed from the original). Georgian style was not popular as its simple red brick, white sash-windowed appearance was associated in purchasers' minds with "council housing"—rental projects developed by city councils.

Let us visit a typical semi-detached. Number 12 Gloucester Drive was built in the late 1930s just before the Second World War. It is situated at the end of a cul-de-sac of some twenty houses. Note the name of the street; not a common "street" but a "drive" and Gloucester has an imposing royal ring to it—the Dukedom of Gloucester being held by members of the royal family. The roadway is quite narrow (not many people owned cars in the 1930s) and is bordered by a pavement (sidewalk). A three- or four-foot-high brick wall separates the front garden (to the British a "yard" is a paved service area) of Number 12 from the street but privacy is assured by a further three feet of neatly trimmed privet hedge. Wrought iron gates open to a narrow drive that leads past the side of the house to a detached garage. The front garden is a formal square of lawn edged with borders filled with brightly flowering annuals and with a bed of regimented standard roses in the center. The semi-circular bow windows (actually multifaceted to avoid the expense of curved glass) are screened by net curtains; those next door quickly fall back into place indicating that your approach has been observed by at least one of the neighbors! Entering the porch, only a couple of feet

deep, the front door with its twin sidelights filled with stained glass is admired while searching for the bell push. Having rung the bell one can hear frenzied wrestling with bolts and locks and then the front door opens and one is invited to enter the house.

The first room in the house is the hall, a place of greeting and taking off overcoats (in Britain a hall is a room, an entry lobby, while the circulation space is called a corridor or a landing). At Number 12 the hall is small and dark with wood paneled walls; to one side rises the staircase while opposite are two doors leading to the sitting room at the front of the house and the dining room at the back. Opposite the front door, at the back of the hall, is another door leading to the kitchen while "under the stairs" is a coat cupboard (closet). The sitting room is only used for "best" and the dining room is therefore used as the main living room. Each is about fifteen feet square and both feature fireplaces with elaborate wooden surrounds into which gas log fires have later been installed. The kitchen is narrow and inconvenient with little counter space; a door at the back leads to a single-storey extension off the back of the house where there is a toilet (half-bath), and a "wash-house" (laundry/utility room).

Going up the stairs the treads wind to turn to a landing at the center of the house off which open four doors. The two main bedrooms are above the sitting and dining rooms below. Above the porch and hall is a third, very small bedroom while above the kitchen is the bathroom. One of the builder's options offered when Number 12 was built was to separate the toilet from the bath but here everything is in one bathroom. Off the bathroom is the airing cupboard—a large closet for towels and bedding kept warm by the "immersion heater," a large copper electric water heater. There are no walk-in closets; clothes storage is in chests of drawers and freestanding wooden wardrobes, pieces of furniture similar to a large armoire.

Number 12 comprises approximately 1,500 square feet and is very typical of the semi-detached type of house. There were innumerable variations to the size and details offered but the basic underlying plan and appearance remained the same; thousands of these houses were built. Today the "semi" is derided as representing the class-consciousness of the lower-middle classes who have made it out of the working classes but not far enough to afford a detached house—typical of the pretentiousness represented by Hyacinth Bucket in the television series *Keeping Up Appearances*. But, well built, well maintained, adaptable, and relatively affordable, they are still very popular, and a close look at the plan of current designs offered by developers, modern, spacious, and convenient, shows that the "semi," updated and modernized, continues to be the typical British house.

Further Reading

Muthesius, Stefan. *The English Terraced House*. New Haven, Conn.; London: Yale University Press, 1982.

SYON HOUSE, MIDDLESEX, ENGLAND

Styles: Renaissance—Tudor and Georgian—Neoclassical
Dates: Circa 1415; circa 1540; 1656; 1762–1769; 1819–1826.
Architects: John Webb (seventeenth century); Robert Adam (eighteenth century); Thomas Cundy (nineteenth century)

That a single family is the owner of two houses worthy of inclusion in a list of the most important buildings in the country is remarkable. That significant architectural developments in the history of these houses were commissioned by the same clients and of the same architect is unique. The two houses are **Alnwick Castle**, Northumberland and Syon House, Middlesex; the clients were Hugh, 1st Duke of Northumberland and his wife Elizabeth, heiress to the Percy estates; and the architect was the young and brilliant Scottish architect Robert Adam. Alnwick Castle, owned by the Percys since 1309, is in the far north of England close to the border with Scotland. Its history and that of the Percy family is discussed in another section of this book (see Alnwick Castle). Syon House has been in the possession of the Percys since they received it as a gift from Elizabeth I (r. 1558–1603) in the late sixteenth century. Situated on the western edge of London, across the River Thames from the Royal Botanical Gardens at Kew, it is now the London home of the 12th Duke and Duchess of Northumberland.

Syon House began as a Bridgettine Nunnery founded by Henry V (r. 1413–1422) in 1415, although the site, beside the Thames in the countryside west of London, had already seen a historical event: it was here that Julius Caesar's army crossed the river in 54 B.C.E. The nunnery was an important establishment and was an early casualty of the Dissolution of the Monasteries in 1534 that followed the divorce of Henry VIII (r. 1509–1547) from Catherine of Aragon, his marriage to Anne Boleyn, the split with the Catholic Church, and the establishment of the Protestant Church of England. Monasteries, abbeys, priories, and nunneries across the country were confiscated, along with their riches; their lands were distributed to Henry's followers. When Henry VIII died in 1547 his coffin rested overnight at Syon on its way from London to Windsor. Due probably to putrefaction of the body, the coffin split open during the night and the dogs worried the King's remains. This was seen by some as retribution for Henry's desecration of the Syon Nunnery and fulfilled the prophecy of a displaced Franciscan friar that "God's judgements were ready to fall upon his head . . . and that the dog's wold lick his blood as they had Ahab's." Syon was given to Edward Seymour, the Duke of Somerset, the brother of Henry's third wife, Jane Seymour. Somerset demolished the church buildings, retaining the nuns' living accommo-

dation around a large courtyard, which was converted into a great *castellated* mansion. It is this rather ordinary looking four-square building that has survived with its regular rows of windows, *battlements*, and corner *turrets*. Externally not an exiting building, it is the interior that amazes and overwhelms with its rich splendor. The poet and architectural critic Sir John Betjeman said, "You'd never guess that battlemented house contained such wonders as there are inside it."

Those wonders were created 200 years after Henry VIII; the Somersets had fallen from royal favor and the house was given to the Percys. In 1646, Algernon Percy, 10th Earl of Northumberland, employed John Webb (1611–1672) to make alterations in "my Lord's lodgings," but this work has not survived and is only known from documents in the Percy archives at Alnwick Castle. In 1750, Hugh Smithson inherited the Percy properties, including Syon and Alnwick, through his wife Elizabeth, Baroness Percy. The couple took the ancient name of Percy as their surname, assumed the titles of Earl and Countess of Northumberland, and in 1766 were created Duke and Duchess of Northumberland.

According to the Duchess they found Syon quite "ruinous." In 1762, Robert Adam, the brilliant Scottish architect they were already employing to transform Alnwick Castle, was asked to work equal wonders at Syon House. The plan of the house consisted of four narrow ranges of rooms arranged around a square courtyard: the Great Hall in the east wing, *state rooms* in the south, the Long Gallery in the west, and in the north the family's private rooms. Adam's brief was to remodel and redecorate all of the existing building and construct a circular ballroom in the courtyard. Syon was not their main London home, that was Northumberland House at Charing Cross, and with its situation a pleasant boat or carriage trip from the capital, Syon was intended to be a place for parties, routs, and fêtes. The Northumberlands were extremely wealthy but their extravagances curtailed their budget, so only three-quarters of the remodeling and redecoration was completed and the planned ballroom never got beyond the drawing board; Adam's design was for a half-scale version of the Roman Pantheon. Despite this reduction of the project, Syon House is considered to be one of Robert Adam's finest creations.

The Great Hall Adam devised as a cool entrance hall with a black-and-white marble checkered floor and off-white walls with stucco (plaster) decorative details picked out in blue and gray. Inspired by the atria (central halls) of ancient Roman houses, Adam furnished this hall with marble statues and busts. Adam had studied in Italy, seeing recently uncovered ancient Roman buildings in Rome and Pompeii. His designs, based on genuine Classical Roman examples, introduced the *Neoclassical style* to Britain. As is often the case when dealing with older buildings, the floor levels of adjoining rooms varied by several feet. Adam solved the problem between the Great Hall and the sequence of state rooms with dual curved flights of steps focused on a bronze statue of *The Dying Gaul* purchased in 1773 by the duchess for the enormous sum of £300. Eighteenth-century designs deliberately kept en-

trance halls cold and hard as a transition from the outside to the inside, so Adam was not particularly innovative, although his hall is exquisite. Guests, having divested themselves of cloaks and mufflers, would proceed up the short flight of stairs (their eyes drawn to the poignant statue) through a tall arched doorway, and be astonished by the contrast of the next room, the Anteroom. Here Adam introduced a riot of multicolored marble and gold set against walls of light and dark green featuring gilded *trophies* of Roman armor and weaponry. Around the walls are arranged twelve genuine ancient *scagliola* (fake marble) columns dredged up from the River Tiber in Rome and cleverly arranged to make a rectangular room appear to be a perfectly square. Again the furniture is sparse with only a few side tables and upright chairs as this splendid, richly decorated room is also a prelude, the Anteroom, to the main rooms beyond.

The next room is the Dining Room and again Adam provides contrast with a restrained cream-and-gold color scheme. Spatially, the room is interesting with columned *screens* and *apses* with *semi-domes*, all decorated and detailed to Adam's highest standard. At this time it was unusual to designate a room specifically for dining and Syon is transitional in having a room specifically designed as such, although there was never a permanent dining table. Instead temporary trestle tables would be set up as needed and the chairs set against the walls, thus enabling the room to be used for receptions and other entertainments. Beyond the Dining Room is the comparatively plain but richly colored Red Drawing Room, its walls still covered with the original Spitalfields [English] silk hangings and the floor with the original Moorfields [English] carpet designed by Adam and made by Thomas Moor in 1769. Adam's attention to detail is evident in these rooms with their elaborate ceilings reflected in complementary carpets and the decorative theme carried through to the carvings on cornices, doorframes, and furniture. Adam designed down to the smallest detail.

A drawing room was usually separated from a dining room by an intervening room, as it was the room of retreat for ladies after dinner when the gentlemen were left in the dining room to "*pass the port*" and talk politics (or exchange bawdy jokes!). At Syon there was no space for an intervening room so Adam conceived the final room of the suite of reception rooms, the room beyond the Red Drawing Room, as the ladies' drawing room. Originally the Long Gallery, the proportions measured a difficult 136 feet long, 14 feet wide, by 14 feet tall. Adam broke up the great length of the room by introducing *pilasters* to divide it into sections while a criss-cross ceiling pattern and mirrors between the windows contrived to widen the appearance of the room. Meanwhile, the eye was diverted by painted medallions and inset paintings of pastoral landscapes the whole arranged and furnished "in a style to afford variety and amusement." As with all the other rooms in the suite the decoration and furniture of the Long Gallery, with only a few additions, is exactly as Adam left it in 1769.

Adam also designed the screen, comprising a central gateway, ornamental

railings, and flanking gatekeepers' lodges, which closes the west side of the entrance forecourt. This was erected in 1773 and was Adam's last contribution at Syon.

It is well nigh impossible to describe in words the quality of the design and craftsmanship that went into the creation of the Adam rooms at Syon House and photographs do not do them justice. After the deaths of the 1st Duke and Duchess little was changed at Syon. The external stonework of the house was renewed to the designs of Thomas Cundy (1765–1825) in 1819–1826 and this architect is probably responsible for the remodeling of the north range's family rooms that Adam had not completed.

While Adam was working on the house the *park* was being redesigned by the landscape architect Lancelot "Capability" Brown (who was also working at Alnwick). The *castellated* stables north of the house were built 1789–1790 to the designs of Adam's successor in fashionable favor, James Wyatt, who also designed the iron bridge, constructed in 1790, in the park. In 1827–1830 a huge and innovative domed greenhouse was constructed north of the house to the designs of Charles Fowler (1792–1767). This was well before Decimus Burton's Palm House of 1845–1848 at Kew (across the river from Syon) and Sir Joseph Paxton's Great Stove (Conservatory) of 1836–1840 at **Chatsworth**, which was the forerunner of **The Crystal Palace**. The 200 acres of garden and parkland are an oasis of quiet within the western suburbs of London, where only the distant muted roar of traffic reminds the visitor that one is not in the eighteenth century.

Northumberland House, the ducal town house in central London, was purchased by the Metropolitan Board of Works in 1874 and demolished as part of a road improvement plan. This town palace, the last of the great noblemen's mansions that had lined the Thames from The City to Westminster, contributed furniture, paintings, and sculptures to Syon including the huge sculpted Percy Lion that now stands proudly atop the east front of the house.

Further Reading

Montgomery-Massingberd, Hugh, and Sykes, Christopher Simon. *Great Houses of England & Wales.* New York: Rizzoli International Publications, Inc., 1994.
Syon Park. www.syonpark.co.uk.

TERRACED HOUSES, VARIOUS SITES

Style: Renaissance—Restoration to Twentieth Century—Modern
Dates: Circa 1700–present day
Architects: Robert Adam (eighteenth century) and many others

Aerial photographs of British towns and cities show that the majority of homes are "terraced houses." This term encompasses houses of all sizes, from the meanest house of a factory worker to the grandest town house of an aristocratic grandee. In the early eighteenth century the terraced house, whatever the status of its tenant, tended to be rather plain externally, but from the 1770s the exteriors of houses for the upper and middle classes were more elaborately decorated. In the nineteenth century bay windows, porches, gables, and *dormers* added variety and richness while still retaining the same basic plan. In the twentieth century the terraced house was unfashionable for a while; associations with unhealthy inner-city slums made the semi-detached house the popular ideal (see **Suburban Semi-Detached Houses**), but as the demand for houses and land prices increased, the efficiency of the terraced house encouraged its revival. This revival was also caused by the failure of mass housing projects of tower blocks of the 1960s and 1970s that proved to be socially less attractive and statistically providing no more units per acre. According to Stefan Muthesius, in 1911 detached houses provided 10 percent of living units, flats (apartments) 3 percent, and some form of terraced houses the remaining 87 percent. Britain, England in particular, is unusual in Europe in that apartments were not popular for inner-city homes and, to this day, the British prefer that their houses, detached, semi-detached, or terraced, rest firmly on the ground.

The terraced house developed from a combination of the effect of the mediaeval city plan and London building codes introduced after the Great Fire of London of 1666. The mediaeval city was not planned, as can be seen by looking at such areas as the City of London (a particular area of central London) or The Shambles in York surrounding the ancient cathedral of York Minster. An evident characteristic is the narrow yet deep lots providing frontage to the main streets for as many owners as possible—only the richest people could afford a wide house on double or triple lots. Over the centuries prior to 1666 the houses of London, closely built side by side, were timber-framed, *jettying* (cantilevering) over the street to gain square footage. This dense mass of wood construction was the proverbial "accident waiting to happen" and on Sunday, September 1, 1666, in a narrow street called Pudding Lane, an accidental house fire got out of control resulting in the loss of 13,000 houses, eighty-seven churches, and of **St. Paul's Cathedral**. Within months plans were drawn up to create a grand new city with wide boulevards punctuated by new churches and public buildings. These came to naught as the landowners claimed the rights to their original lots and the government did not have the power or money to override them. One result, however, was the establishment of a set of building codes requiring such things as fireproof materials, firewalls between units, window spacing, and street widths. While the building lots were still as narrow as before the houses were very different, the codes—and the newly fashionable Classical style—produced tall, narrow houses with regularly spaced windows. A century later the 1774 Building Act listed four classes of terraced house: Class I being the tallest (5 or 6 floors) and widest (more than

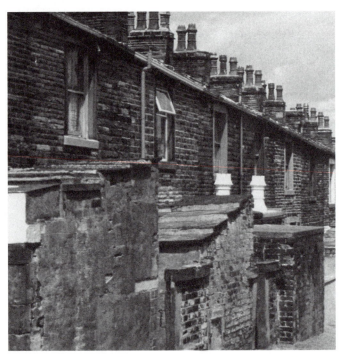

Terraced Houses. The alley at the back of nineteenth-century houses in Newcastle-upon-Tyne. The lower wings contained outhouses and coal holes; the small doorways giving access can still be made out. *Photo by author.*

30 feet), and Class IV, the smallest and narrowest (2 or 3 floors and less than 20 feet wide). In the nineteenth century, terraced houses built for the workers of the Industrial Revolution were even smaller (as described below) but only a few houses of the very rich exceeded the Class I specification.

Whatever the class specification of the terraced house and consequently the status of its tenant, the plans are remarkably similar. Lots were narrow, three to five times as deep, and usually backed onto a service alley called a "mews" if the houses were grand enough to have stables and coach houses attached. The typical plan divides the width into thirds; two-thirds to one side or the other are combined to provide space for the main rooms of the house while the remaining third is for circulation: the entrance hall, corridors, staircase(s), and smaller rooms. This arrangement would fill the front of the site, the depth determined by the class of the house but rarely exceeding forty feet (two large rooms with windows front and back). At the back of the house a wing, up to half the width of the lot, would reach out to the alley containing additional service and secondary rooms. This basic arrangement of a two-thirds to one-third split reflecting served and servant spaces is evident in all terraced houses and continues to the present day.

Another look at those aerial photographs would show that the terraced

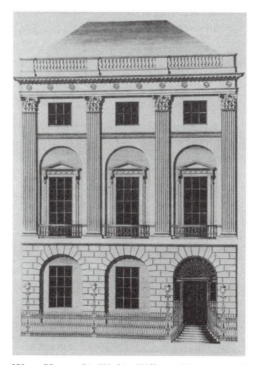

Wynn House. Sir Watkin Williams-Wynn's grand
London townhouse designed by Robert Adam from
an eighteenth-century print.

houses were grouped according to their class and thus the class of their ten-
ants. Class I houses faced out onto wide streets or at the very best addresses
overlooked a "square," an open space with a large central garden private to
the tenants—Grosvenor Square, Berkeley Square, Eaton Square, and so on.
These pockets of fresh air, with their lawns and trees, were once referred to
as the "lungs of London" although they could do little to alleviate the "pea-
souper" fogs that were caused by the thousands of flues from the coal-
burning fireplaces that heated every room. As the streets got narrower and
less salubrious the houses got smaller and denser until one reached the work-
ing-class streets that clustered around factories, mills, or docks.

Two examples of very different terraced houses will now be described in de-
tail. The first is in Liverpool, a city in northwest England famous as the birth-
place of the Beatles. Liverpool developed rapidly in the nineteenth century as
a port for ships trading with the United States and Canada. The Herculaneum
Docks were built in the 1860s to provide births for ships needing to transfer
goods to barges to be taken inland on the Manchester Ship Canal. East of the
docks, rows of streets of terraced houses were built to house the dockers who
labored in the Herculaneum Docks. The street is just wide enough for two
cars and is separated from the front step of the houses by a narrow pavement

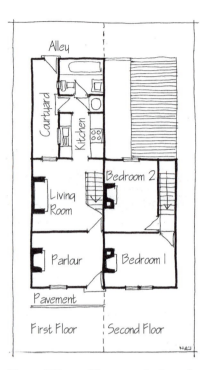

Terraced Houses. Diagrammatic plans of a smaller terraced house such as the one in Liverpool as remodeled in the 1970s by adding a kitchen and full bathroom. The living room was originally also the kitchen and the extra wide fireplace accommodated a coal-fired cooking range. The new kitchen was built in the courtyard while the new bathroom occupies the site of the "coal-hole" and toilet. The house is approximately 12 feet wide. *Diagram by author.*

(sidewalk); the houses open directly from the street, there is no front yard. Each house is about twelve feet wide, the front elevation comprising a door to one side with a window beside it with a single window above on the second floor. The house is too small to waste space on a porch or hall; open the front door and the front room, the parlour (parlor), is revealed. This room is about nine feet deep. A door opposite the front door leads into a slightly larger back room that was originally the kitchen/living room. A steep stair leads up to the two bedrooms. In the early 1970s grants were awarded to update these houses and the single-story wing at the back now contains a modern, if very narrow kitchen with a small bathroom beyond. The windows at the back of the house overlook a narrow, paved courtyard from where a gate leads to the alley. Careful study of the brickwork reveals traces of the original layout of the wing which would contain scullery (a sort of utility room off the kitchen); a "coal hole" for

the storage of fuel for the four fireplaces; and the toilet. There was no bathroom as such; baths were taken in a tin tub in the kitchen and the toilet was a wooden circular seat over a pit in which ashes from the fireplaces would be thrown to contain the odors. In the alley two small doors could be opened by the tradesman who delivered coal and by the unfortunate man who removed the "night soil" from the toilet. This terraced house sounds to be very minimal but it was not the smallest or meanest: Those would be the "back-to-backs," two-roomed houses with a living room/kitchen downstairs and a single bedroom upstairs (this is a family house!). Needing windows or doors in only one wall these could be placed back to back as well as in a terrace thus placing other families on three sides. "Necessary" facilities would be at the end of the street! Needless to say none of these houses have survived.

At the other end of the terraced house spectrum would be the London town house of an aristocratic landowner. The wealthiest people in the eighteenth and nineteenth centuries lived on their estates in vast country houses; in London, which they visited for the "Season" when Parliament was in session, they required an appropriately grand house but few families built anything on the scale of their country houses. Wynn House, Number 20 St. James's Square, is very grand, having been built for Sir Watkin Williams Wynn, one of the wealthiest landowners in North Wales. So extensive were his lands that he was referred to as the "real" Prince of Wales (Prince of Wales is the title of the heir to the throne, currently held by Prince Charles). In 1771, Sir Watkin bought the site in fashionable St. James's Square for the vast sum of £18,500 on the condition that he demolish the existing, very dilapidated house and rebuild.

James Gandon was the original architect chosen and, while he continued to work at Wynnstay, Sir Watkin's country house in Denbighshire, North Wales, in London he was supplanted by the most fashionable architect of the time, Robert Adam. The house that Robert Adam designed for Sir Watkin may be one of the most extravagant terraced houses built in the capital but nevertheless it has the same basic plan as that small dockworker's house in Liverpool. The site was 45 feet wide and nearly 200 feet deep; the front third of the site is occupied by the main house; the middle third by a wing and a paved courtyard; and the rear third by stables, a coach house for four carriages, and other service rooms. The front elevation, overlooking St. James's Square, comprises three *bays* with arched openings set in a boldly *rusticated* wall framing the ground floor windows and the front door. Above, *Corinthian pilasters* topped by a deep entablature and a *balustrade*, which hides the attic *dormer windows*, frame the windows of the drawing room and the bedrooms. The house is set back about ten feet from the pavement and the front door is approached by a sweeping flight of steps. A railing with attached lamps prevents pedestrians from falling in to the "area," the pit that provides access and light to the service *basement* that runs below the whole house.

Internally, the genius of Adam is obvious; he takes the basic terraced house plan and manages to provide a series of rooms and circulation spaces that are dramatic and varied in their form and decoration. A plain, cold entrance hall

leads to the grand staircase where a huge niche containing statues provides interest and extra width. To either side of this niche are doors to the dining room and the music room, both rooms enlivened by apsidal recesses and the former also by a columned *screen*. Upstairs the plan is similar with a suite of anteroom and two drawing rooms. The wing beyond the staircase that overlooks the courtyard provides elaborate *apartments* (suites) for Sir Watkin on the first floor and Lady Wynn above. The plan ingeniously provides all the ritual planning of the "formal house" (see **Blenheim Palace**) and its sequence of increasingly private rooms with the late eighteenth-century requirement for a circuit of rooms. Sir Watkin and Lady Wynn would entertain extensively during the Season consolidating political and financial alliances or negotiating advantageous marriages, and would invite hundreds of people to balls and concerts in the house. A circuit or loop of interconnected rooms allowed these large numbers of people to circulate relatively easily and, whether both floors were used, or all the rooms on a particular floor, allowed for flexibility. At the end of the three-month Season the Wynns, exhausted by so much activity and expense, would retreat to their country house to recover.

The interior of Wynn House is one of Adam's finest with each room ornately decorated and carefully detailed, every piece of furniture, fitting, or ornament designed or specifically chosen. The house is now the headquarters of an international company and much of the decoration has survived, although Adam's spectacular courtyard, filled with Classical statuary, and the stable building have disappeared.

The basic formula of the terraced house allowed the full range of house types as seen in the examples in Liverpool and London, which reflect near opposites. The efficiency of the plan has encouraged its continuity and even a revival as other high-density housing solutions have failed. Terraced houses are still built and older houses are being updated and remodeled—some of the most expensive addresses in London are terraced houses.

In the above description of the terraced house the term "tenant" has been used rather than "owner." In Britain much of the land is owned by private landowners. A tenant "leases" the land from the landowner, pays annual rent, and builds a house of a suitable required quality. The lease is for a specific period of time, usually ninety-nine years, and when it is up the whole property reverts to the landowner, who can lease the land and "sell" the house. Property advertisements will describe a house and end with the years left on the lease. Even the U.S. Embassy in London is held on a lease although the landowners, the Grosvenor family of **Eaton Hall**, were generous and granted a 999-year term. The smaller terraced houses were built by the industrial companies and rented to their workers, although those that survive now are usually owner-occupied.

Further Reading

Muthesius, Stefan. *The English Terraced House*. New Haven, Conn.; London: Yale University Press, 1982.

Pearce, David. *The Great Houses of London*. New York: The Vendome Press, 1986.

Rykwert, Joseph, and Rykwert, Anne. *Robert and James Adam*. New York: Rizzoli International Publications, Inc., 1985.

TOWER BRIDGE, LONDON

Style: Victorian

Dates: 1886–1894

Architect and Engineer: Sir Horace Jones and Sir John Wolfe Barry (engineer)

Every city has buildings that have become symbolic, relating to the place through historic association, fame, or form. Athens has the pure architectural perfection of the Parthenon atop the Acropolis; Paris has the Eiffel Tower with its tapering steel construction; Washington, D.C., has the great dome of the Capitol; and London has . . . ? London, possibly, has several buildings recognized worldwide: **The Houses of Parliament** and the Clock Tower of Big Ben; **Buckingham Palace**, the residence of Queen Elizabeth II (r. 1952–), with its imperious Classical façade; and, for the tourist brochures, there is another structure that symbolizes London: Tower Bridge spans the River Thames just to the east of The City with **The Tower of London** to the north and the new **London City Hall** to the south. What makes Tower Bridge symbolic is the familiar twin-towered silhouette and the fascination of the drawbridges that open to allow ships upriver to the Pool of London.

In the mid-nineteenth century London was fast becoming the busiest port in the world, the center of the still growing British Empire that was to reach its apogee when Queen Victoria (r. 1837–1901) celebrated her Diamond Jubilee, sixty years as queen, in 1897. **London Bridge** was the lowest bridge on the Thames; all other bridges had been built farther upriver, and below London Bridge the Pool of London was the main harbor for arriving and departing ships. Even when newer docks were built farther east, downriver, at the Isle of Dogs and Canary Wharf the lack of a bridge crossing caused huge traffic problems as horse drawn wagons laden with goods queued to get across the river. Also, as the city expanded workers' houses were built on both sides of the river and a more accessible pedestrian bridge was needed get to and from docks, warehouses, and offices. A public outcry demanded a new bridge and in 1876 the Corporation of London decided it needed to plan a new bridge across the river beside the Tower of London.

The problem facing the corporation was that while it acknowledged the necessity for a bridge, it also had to allow for the passage of ships into the Pool of London. At this time trading ships were very tall, three-masted tea clippers such as the *Cutty Sark*, that plied the routes to the Far East with sails

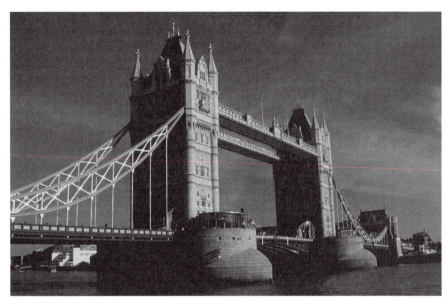

Tower Bridge. The two bascules (drawbridges) that carry the roadway open to a vertical position, allowing ships to pass between the two towers. Pedestrians can cross the river at all times via the high level walkways. *Harcourt Index.*

straining at speeds up to 17.5 knots (the *Cutty Sark* can be seen preserved in a dry dock at Greenwich). A "Special Bridge or Subway Committee" formed in 1876 solicited ideas through a public competition. As the name of the committee suggests, a tunnel under the river was contemplated but the engineering problems of cutting through the clay and under the river were thought to be insurmountable. The designs received, over fifty in number, ranged from the ordinary to the fantastic but none were thought appropriate or feasible, and it was not until 1884 that a design was received that met the requirements of the committee and was chosen to be built. The designer was London's City Architect Sir Horace Jones (1819–1887), who proposed a bascule or drawbridge solution, which would provide a roadway that could be raised to allow shipping traffic to pass. Jones had previously designed the London markets at Smithfield, Billingsgate, and Leadenhall, with their elaborate cast iron roofs, and the Guildhall Library and Museum of 1872. He therefore had experience with projects that required innovative engineering solutions and his design, with its simple mediaeval towers, suspension structures reaching out to the north and south banks, and the imaginative drawbridges acknowledged the presence of the nearby Tower of London. The basic idea accepted, the engineer Sir John Wolfe Barry (1836–1918) was brought in to assist Jones with the technical problems of his design. Construction began in 1886 but, unfortunately, Jones died in 1887 and it was Barry who oversaw the completion of Tower Bridge.

"Bascule" derived from the French word for "see-saw" or "teeter-totter" and is used to describe the roadway drawbridges that open up vertically, allowing passage of a ship. Such bridges were not uncommon where roads had to cross navigable rivers or canals, but were usually composed of only one section or bascule often operated using pulleys and counterweights. Tower Bridge was the largest and most advanced bascule bridge of its time, having two sections and steam-powered engines powering enormous hydraulic pump engines. The energy created did not directly move the bascules but was stored in six huge pressurized accumulators so that power was always available whatever the state of the fires below the boilers (furnaces) that produced the steam. Driving engines, fed by the accumulators, moved the bascules up and down like two flapping hands meeting at the fingertips. It took about one minute to raise the bascules to their fully open position at an angle of eighty-six degrees to the horizontal. In 1976 oil and electricity replaced steam in powering the hydraulic system but the original engines, accumulators, and pumps can be seen as part of a historic exhibition.

Sir John Wolfe Barry had a famous architectural and engineering heritage: his father was the architect Sir Charles Barry and his business partner was Henri Marc Brunel, the son of the famous and inventive engineer Isambard Kingdom Brunel. He was president of the Institution of Civil Engineers in 1896, received his knighthood in 1897, and was instrumental in establishing standards and codes for iron and steel sections. Barry was to design many other bridges in London and throughout Britain, the District Line of the London Underground railway system, and several docks in the developing port area downriver from Tower Bridge. But it was Tower Bridge that was his most important work and for which he is remembered while, it must be said, the real designer, Sir Horace Jones, is largely forgotten.

Construction of Tower Bridge began in 1886 and eight years later, in 1894, it was completed. During the planning stages a law was passed that forbade disruption of the river traffic during construction and Barry had to use innovative ideas when sinking the two massive piers supporting the two towers and when bringing in the 11,000 tons of steel and Cornish Granite and Portland Stone—Sir Horace Jones had described his idea as "steel skeletons clothed with stone." The width of the River Thames at this point is approximately 880 feet and the central opening spanned by the two bascules is about one-quarter that length, while the two approach ramps spanning from the river banks to the towers use a conventional suspension system.

Barry must have expected that the opening of Tower Bridge would have been met with universal acclaim but, while the engineering feat was acknowledged, the architectural style of the towers was condemned: "the most monstrous and preposterous architectural sham that we have ever known" thundered *The Builder* magazine. Jones's original design deferred to the nearby Tower of London with a very simple mediaeval appearance of massive planar walls and reticent details. Barry could not resist adding his own "improvements" to the design by using an unfortunate mix of French late

Gothic details, creating towers that would look at home attached to a Loire chateau. Over the years the furor died down and Tower Bridge is now a much-loved landmark: that symbol of London.

In the 1890s, soon after its completion, Tower Bridge would be raised and lowered over 1,000 times a year, but today few ships enter the Pool of London and the bridge is opened less than 100 times a year. Also, for the first fifteen years pedestrians could cross the river at Tower Bridge even if the bascules were open as each tower contained elevators and high above the water, above the ships' masts, two walkways connected the towers. Too many suicides caused this feature to be closed and the walkways have only recently reopened, glassed in as a historic museum of the bridge and its construction.

Dan Cruikshank wrote of Tower Bridge: "It encapsulates the struggle between the architect and the engineer, between a concern for history and the application of modern building technology . . . (that) is—in a very idiosyncratic way—a happy marriage of these potentially conflicting concerns, and perfectly encapsulates the topsy-turvy artistic tastes and values of late Victorian Britain." Tower Bridge represents the power, the prestige, the innovation, and the sheer bravura of the British Empire at its height; to the northwest glowers the fortress of the Tower of London representing the oppressive power of the Norman kings who had conquered England in 1066. To the southwest stands the new London City Hall, completed in 2002, its glassy transparency representing the power of the democratically elected socialist mayor of a London that is the capital of a realm not much larger than that of William the Conqueror (r. 1066–1087) nearly 950 years ago.

Further Reading

Tower Bridge Exhibition (Corporation of London). www.towerbridge.org.uk.
Weinreb, Matthew. *London Architecture, Features and Façades.* London: Phaidon Press Ltd., 1993.

THE TOWER OF LONDON, LONDON

Style: Mediaeval—Norman/Romanesque
Dates: 1078–1088
Architect: Gundulf, Bishop of Rochester

There are some places around the world that conjure feelings of fear, awe, loathing, or sheer power at the very mention of their name: the Forbidden City in Beijing, China; the *Chateau* of Versailles and the Bastille in pre-revolutionary France; and the Kremlin in Moscow during Tsarist and Communist rule of Russia are just a few examples. In London, from the

eleventh century until the mid-nineteenth century, the powerful presence of the Tower of London, on the eastern edge of the City of London, cast the shadow of royal power over the citizens and garnered its fearful reputation as the site of long imprisonment and many executions. A great castle built by William the Conqueror to impose his will on London, the Tower of London was last updated as a redoubt of the royal family in 1840 when the Chartist Movement (a group seeking major political and social change) fomented unrest and riots. As the symbol of royal power over the realm, the Tower still houses the Crown Jewels, the crowns, and coronation regalia of the British monarchs.

Edward the Confessor, so-called because of his extreme piety, ruled England from 1042 to 1066. Childless, his death led to four claims to the throne from the King of Norway, the Duke of Normandy, and Queen Edith's two brothers, Tostig, Earl of Northumbria and Harold Goodwinson. Tostig soon allied with the King of Norway but Harold dispatched them at the Battle of Stamford Bridge. Immediately, Harold had to march his weary army to the south coast to repel William of Normandy who had landed his army at Pevensey. The armies met on October 14, 1066, at Battle, north of Hastings, and by the end of the day Harold was dead, shot through the eye by a Norman archer, ending the reign of the Anglo-Saxon kings of England.

William's defeat of Harold and quick takeover of the country earned him the soubriquet "the Conqueror" but officially he is known as King William I (r. 1066–1087). To establish his rule over a people who did not appreciate their new Norman rulers, he began building a series of massive castles including **Windsor Castle** and the Tower of London. He rewarded his barons and knights with estates confiscated from the Saxon aristocracy, encouraging them to build their own castles to further impose Norman control. The legend of Robin Hood is thought to refer to the last resistance of a Saxon earl against the remorseless Normans who were harsh rulers of the peasants and serfs that worked the land.

London was the biggest city in England, the most important city in the country, and William needed to make sure it was firmly under his control. Windsor Castle was built to protect the western approach to London and in the city itself William decided to build a huge fortress to intimidate the surly populace. He chose the southeast corner of the walled city where the walls of Roman Londinium still stood and an area approximately 200 by 400 feet was cleared and construction began on a timber castle. Plans were soon in hand to replace this with a stronger, permanent stone building. The designer is thought to be Gundulf, a monk from the Abbey of Bec in Normandy who later became Bishop of Rochester. The most recognizable feature of the fortress designed by Gundulf, the White Tower, still dominates the Tower of London. This is a huge square *keep* or defensive tower approximately 92 feet high and 100 feet square with a semi-circular protrusion at the southeast corner and a circular tower at the northeast corner. It earned the name, the White Tower, not because of the color of the stone but because it was

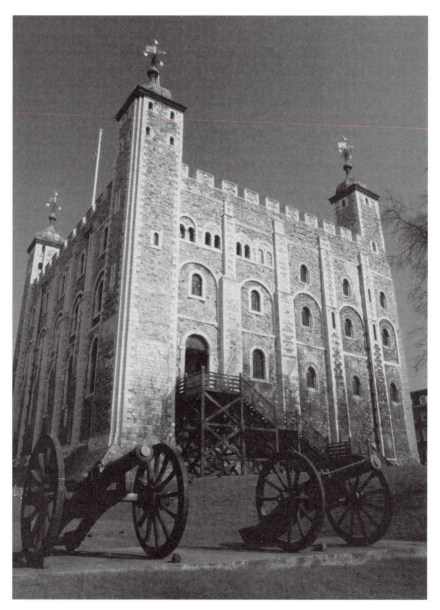

The Tower of London. The keep or White Tower at the center of the fortress. *Harcourt Index.*

usual for castles to be whitewashed at this time—a time-consuming routine designed to keep the garrison busy in quieter times. The White Tower housed the Royal Apartments on the third floor where larger windows were possible: the two-story Council Chamber (92 by 39 feet) connected through an arcade to the Presence Chamber (63 by 32), the king's room from which opened the private chapel—St. John's Chapel. It is in the Chapel that the majesty of the White Tower is most evident with the massive structure of broad columns and semi-circular arches marching down the two sides and around the apsidal east end that forms the semi-circular external protrusion. At the roof level at three corners rise square *turrets* while at the northeast corner the circular tower rises slightly higher allowing views across the city and beyond.

The White Tower sat in a walled enclosure or *bailey* formed of the renovated Roman wall to the east and new walls on the north and west sides that faced the city and the south side against the River Thames; the main gate was in the west wall and there was a secondary water gate to the river. A hundred years later the White Tower was little changed but to the west a second bailey with a much stronger gatehouse had been added, doubling the size of the fortress. The works overwhelmed the small city church of St. Peter ad Vincula and this became the Chapel Royal used by the community that lived within the walls of the Tower. The thirteenth century was a time of trouble in England with kings and barons in conflict. The Tower of London, controlling London and a symbol of royal power, was therefore very important and the defenses were expanded and strengthened: the inner bailey increased eastward placing the White Tower in the center of the compound, the outer walls were reinforced by a series of towers, and against the south wall were built new Royal Apartments and a new water gate. While the whole complex of buildings is often referred to as the "Bloody Tower," the inner water gate is also officially known as the Bloody Tower, for it is through here that prisoners were brought (having arrived by boat), taken to their cells, and dealt the usual fate—beheading on Tower Green. By c. 1300 the west gate leading from the city was protected by an outer barbican (outer gatehouse) and double drawbridges while the water gate had its own large barbican built in the river inside which boats could dock to securely deliver their passengers. These connected to a new outer curtain wall (continuous wall) on the landward sides making the Tower effectively an up-to-date concentric castle (composed of centric rings, usually two or three, of defensive walls) with the White Tower at its center. These major improvements occurred during the reign of Edward I (r. 1272–1307) and it was he who began to use the Tower for other functions such as the Royal Mint where the coinage was made, and the beginnings of the Records Office for the storage of state papers. At times the Tower was surrounded by a moat flooded by the waters of the Thames but this was problematic as the river was tidal at this point and the level could not be controlled; there is now a dry moat.

The War of the Roses, the civil war of the late fifteenth century, saw the

Tower change hands several times as the Crown was wrested from one side to the other until the marriage of Henry Tudor of Lancaster (symbolized by the red rose) and Elizabeth of York (of the white rose) concluded the conflict. Henry Tudor, King Henry VII (r. 1485–1509), was the last monarch to build Royal Apartments at the Tower, against the south wall facing the river. His son Henry VIII (r. 1509–1547) used these on one occasion—the coronation of his second wife Anne Boleyn in 1533—the last time the Tower was used as a royal residence.

The Tower of London, a palace, a fortress, a garrison, the site of the Royal Mint, the Records Office, and the Royal Menagerie (zoo—a polar bear was allowed a regular swim in the moat), earned its fearsome reputation as a prison where the most troublesome of a monarch's subjects were incarcerated and often executed. The list is long, beginning with Ralf Flamard, Bishop of Durham in 1101 and continuing to include Henry VI (r. 1422–1461, 1470–1471); Edward V (r. 1483) and his brother (the Princes in the Tower); the Duke of Clarence (said to have been drowned in a barrel of wine in 1478); Sir Thomas More and Bishop Fisher of Rochester, who were imprisoned and executed in 1535 for disagreeing with Henry VIII, as were two of Henry's wives—Anne Boleyn (1536) and Catherine Howard (1542). The reigns of Edward VI (r. 1547–1553), Mary I (r. 1553–1558), and Elizabeth I (r. 1558–1603) were especially bloody as the country still struggled with the suppression of the Catholic Church and the rise of the Protestant Church of England. The last person to be executed on Tower Green was Elizabeth I's erstwhile favorite Robert Devereux, Earl of Dudley, who lost his head in February 1601. There is a well-known nineteenth-century music hall song that speaks of the ghost of Anne Boleyn walking "with 'er 'ead tucked underneath 'er arm."

During the eighteenth and nineteenth centuries the Tower saw little change except for the construction of large barracks and munitions stores (armories) that replaced some of the unused Royal Apartments. By 1850 the Royal Mint, the Public Records Office, and the Royal Menagerie had moved to new premises outside the Tower and Price Albert oversaw a restoration and "remediaevalisation" under the direction of architect Anthony Salvin. The Tower of London had been opened to visitors from 1660; in 1841 the first guidebook was written, and by 1900 the annual number of visitors had reached half a million. Nowadays over 2.5 million tourists visit the Tower annually, drawn to the historic fortress, the site of bloody executions, the Crown Jewels (the Jewel House has recently been modernized and includes a people conveyor belt that moves visitors past the crowns and regalia, preventing bottlenecks), and the historic "Beefeaters," more correctly called the Yeoman Warders. Their uniforms and duties date from the time of Henry VIII. Strutting across the lawns around the White Tower can be seen six ravens. Ravens took refuge within the Tower during the Great Fire of London of 1666 and the legend developed that the both the White Tower and the monarchy would collapse if the ravens left—six ravens are kept there at all times, with their wings carefully clipped!

The Tower of London, a symbol of royal power from 1066, looks across the river to the **London City Hall** of 1998–2002, a symbol of the people's power in more egalitarian times while connecting them is **Tower Bridge** of 1886–1894, a structure that symbolizes the power and ingenuity of the Industrial Revolution and the British Empire ruled over by the Queen-Empress Victoria (r. 1837–1901).

Further Reading

Historic Royal Palaces. www.hrp.org.uk.
Wessex, Edward The Earl of. *Crown and Country: A Personal Guide to Royal London.* New York: Universe Publishing, 2000.

TRAFALGAR SQUARE, LONDON

Styles: Georgian—Neoclassical, Victorian, and Twentieth Century—Modern
Dates: 1813–1845; 1998–2003
Architects: John Nash and Sir Charles Barry (nineteenth century); Norman Foster (twentieth century)

In 1805, the Emperor Napoleon of France threatened England with attack. The coast facing across the English Channel toward France was prepared for defense with new forts and those who could afford to move their families sent them north away from the threat. War had broken out in 1803 and under Admiral Horatio Nelson (1758–1805), "England's greatest and vainest admiral" (Hibbert), the British Navy had defeated the French at the battles of the Nile and Saint Vincent. On October 12, 1805, a combined French-Spanish fleet lined up against the British fleet, commanded by Nelson, off Cape Trafalgar. On his flagship H.M.S. *Victory,* Nelson ran up the signal, "England expects every man will do his duty" and the last great sea battle between wooden fighting ships commenced. At the end of the day the British were victorious and Napoleon's ships destroyed or captured—England was safe from invasion. Nelson had saved his country but at the cost of his own life. Recklessly dressed in the full dress uniform of an Admiral of the Fleet, he was an easy target for a French sniper as the *Victory* came into close conflict and he was shot, dying in the arms of his Flag Officer, to whom he said his last words: "Kiss me, Hardy." Nelson's body was pickled in brandy so that it could be returned to London for a hero's burial.

The Battle of Trafalgar of 1805 defeated Napoleon's navy and the Battle of Waterloo of 1815 finally defeated his armies, releasing Europe from his

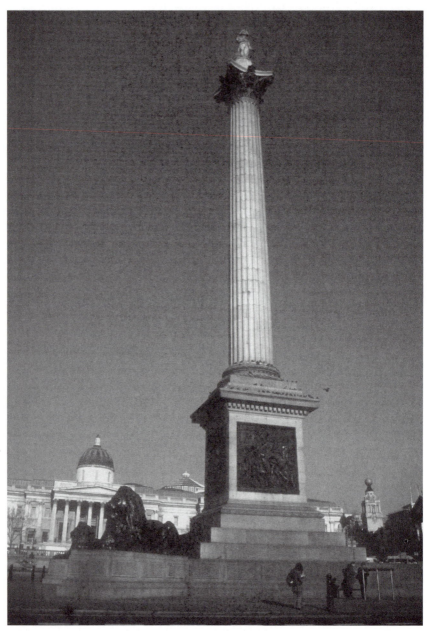

Trafalgar Square. Nelson's Column, the nation's monument to Admiral Horatio Nelson, is at the center of the square with the National Gallery in the background. *Photo by Ian Britton (FreeFoto.com).*

ambition. Britain was safe from invasion and was to rule the seas for over a century—"Rule Britannia, Britannia rule the waves . . ." (words by John Thomson set to music by composer Edward Elgar in the late nineteenth century). In commemoration of the great battles and victories many public buildings were built as memorials: the rebuilt **Buckingham Palace**, begun in 1825, and its gateway, the Marble Arch, celebrate the defeat of Napoleon and in 1826 an Act of Parliament designated that the new, vast public plaza under construction at Charing Cross be called Trafalgar Square.

Charing Cross is at the northern end of Whitehall, the street of government offices that terminates at Parliament Square and **The Houses of Parliament**. It is named Charing Cross because the small village of Charing was the last overnight resting place, en route to Westminster Abbey, of the coffin of Eleanor of Castile, the wife of Edward I (r. 1272–1307), who died in 1290. At the twelve stops made by the funeral procession the king caused a cross to be erected—Charing Cross was the last of twelve crosses. The Cross, situated at the meeting point of several major streets, became a landmark and meeting place; it is from the Cross that distances to and from London are measured. Originally constructed of carved wood, the stone replacement was demolished in 1647 on the orders of Oliver Cromwell and on its site now sits the equestrian statue of Charles I (r. 1625–1649). A copy of the Cross, designed in 1863 by the architect Edward Middleton Barry and carved by Thomas Earp, stands outside Charing Cross Station a short distance eastward from Trafalgar Square.

North of the Charing Cross junction the site of Trafalgar Square was from about 1250 used as the Royal Mews. At first this meant it was the place where the king's hunting birds, hawks and falcons, were kept—the name derived from the mewing noise the birds made when content—but during the reign of Henry VIII (r. 1509–1547) the buildings were converted to stables and the use of the word "mews" for stables dates from this time; the stables at Buckingham Palace are called the Royal Mews. By the end of the eighteenth century the mews covered a huge area comprising the Great Mews, with a central courtyard and pond, on the site of Trafalgar Square; the Crown Stables on the site of the western half of the National Gallery; and the adjoining Green Mews. However, by 1813 they were dilapidated, inconvenient for the royal residences at Carlton House, St. James's Palace or Buckingham House, and indeed stood exactly where the expanding city needed to run a new street to connect the fashionable squares of Mayfair to The City and Westminster. John Nash, the Prince Regent's favorite architect who was designing so much of the new London, including **Regent Street** farther to the west, was commissioned to design a square that would resolve the meeting of all the streets: Whitehall from the south, The Strand from the east, Pall Mall from the west, and St. Martin's Lane from the north (Northumberland Avenue to the southeast was opened up in 1874 and to the southwest Sir Aston Webb's Admiralty Arch of 1911 provided a suitably impressive access to The Mall and Buckingham Palace). Nash proposed a great plaza, with a

new building for the Royal Academy at its center (not built), lined by the National Gallery (1834–1838 by William Wilkins) on the north side, the Royal College of Physicians (1822–1825 by Sir Robert Smirke and now incorporated into Canada House) on the west side, and other public buildings on the east side. On the northeast corner stands the church of **St. Martin-in-the-Fields** (1722–1726 by James Gibbs), which, until the square was created, had been obscured by the Royal Mews and adjoining houses. Nash's plans were approved by Parliament in 1813 but proceeded slowly, and by the time of his disgrace in 1830 (see Buckingham Palace) little had been achieved and it was Sir Charles Barry who laid out the square as it was finally realized in 1840. Barry proposed leveling the site to create a flat plaza with the North Terrace on the higher side providing a base for Wilkins's recently completed National Gallery, which was already thought to be an unsatisfactory design, too weak for such a prominent site. Two flights of stairs descended from the North Terrace to the main level of the square where Barry created two large pools with fountains (these were replaced in 1948; the originals were re-erected in Ottawa, Canada). It was only with some persuasion that Barry was convinced that the design for Trafalgar Square should include the towering memorial to Admiral Lord Nelson, the hero of the great battle. The square is dominated by this monument, Nelson's Column, which has become one of the symbols of London and of Britain.

Nelson's Column was built in 1840–1843 to the designs of an otherwise obscure architect named William Railton (c. 1801–1877) whose only other claim to notice was in 1835 when he was awarded the fourth premium (place) in the competition for the rebuilding of the Houses of Parliament. In 1839 he won a competition sponsored by the Nelson Memorial Committee proposing the "conventional but unexceptional idea of a column surmounted by a statue" (Howard Colvin). The column, made of Devon granite, sits on a large square base and is of the *Corinthian Order* copied from the ancient Temple of Mars Ultor in Rome, the bronze acanthus leaves cast from British cannons. Railton had wanted the column to be 200 feet tall but Smirke and others prevailed in suggesting a lower height of 170 feet. On the square base were placed four bronze—cast from French cannons—relief sculptures depicting Nelson's greatest battles: the Battle of the Nile by W. F. Worthington on the north side; the Bombardment of Copenhagen by Ternouth on the east side; the battle of St. Vincent by M. L. Watson on the west side; and on the south side the Death of Nelson at the Battle of Trafalgar by J. E. Carew. The bronze statue of Nelson atop the column, by Edmund Hodges Baily, seventeen feet high and weighing sixteen tons, was put in place on November 5, 1843. Critics complained that because of the height of the column the statue could not be appreciated and the view of one of England's greatest heroes is not particularly flattering. Criticized, even ridiculed, were the four lions placed diagonally at each corner of the base in 1868. The original sculptor could not complete the commission and it was then awarded to the animal painter Sir Edwin Henry Landseer (1802–1873). He apparently based

his lions on domestic cats and in consequence made the pose much too friendly—the lions are now much loved by children and tourists.

Over the years other statues were added to Trafalgar Square. The equestrian statue of Charles I on the site of the Charing Cross (1633 by Le Sueur), James II (1686 by Grinling Gibbons), and several nineteenth- and twentieth-century generals and admirals. On three of four large plinths at the corners of the square sit George IV (c. 1830 by Chantry and Earle), and Generals Havelock (1861 by Behnes) and Napier (1855 by Adams); the fourth plinth is unoccupied and it is now proposed that this be used for a rotating exhibit of modern sculpture.

This last suggestion is part of a revival of Trafalgar Square that was completed on July 2, 2003. By the 1990s, Trafalgar had become little more than a large traffic circle. Tourists braved speeding cars, black taxis, and double-decker buses to reach the island of paving surrounding Nelson's Column, feed the pigeons, and admire what survived of the grand plans of Nash and Barry. In 1996, Norman Foster won an international competition proposing a master plan he called "World Squares for All" that encompasses Trafalgar Square, Whitehall, Parliament Square, and the Thames (London's river) embankment between Westminster and Hungerford Bridges—the transformation of Trafalgar Square is the first phase of this ambitious plan. Working with a company called Space Syntax that uses computer models to predict traffic and pedestrian movement, Foster redesigned the road system and pedestrian routes confidently closing the north side to traffic to provide an upper piazza connecting the National Gallery to Barry's North Terrace. The terrace was sympathetically altered to include a wide central flight of steps while underneath space was made for a café and public restrooms. The only modern touch is two elevators providing handicapped access to the two levels. The small island around the statue of Charles I was increased in size and is now a fitting base even though it is still surrounded by traffic. The balance has been restored and Trafalgar Square is now a great public piazza with some traffic at its periphery. In the words of Lord Foster: "The transformation of Trafalgar Square is a cause for great celebration. It is the culmination of years of work to improve the heart of Britain's capital, giving it a new lease of life. The improvements recreate this major civic space, turning an undignified traffic roundabout [circle] into a truly public space, to be enjoyed by Londoners and visitors alike. It is the result of a careful balancing act between the needs of traffic and pedestrians, the ceremonial and the everyday and the old and the new."

Further Reading

Davis, Terence. *John Nash: The Prince Regent's Architect*. Newton Abbot, U.K.: David and Charles, Ltd., 1973.

Mansbridge, Michael. *John Nash: A Complete Catalogue*. New York: Rizzoli International, 1991.

TYNTESFIELD, SOMERSET, ENGLAND

Style: Victorian—Gothic Revival
Dates: 1863–1866; 1873–1875
Architects: John Norton and Sir Arthur W. Blomfield

The headline in the *Daily Telegraph* of June 19, 2002, read, "Magical Victorian Mansion saved for nation in £24m deal" (by Will Bennett, Art Sales Correspondent). Tyntesfield, "the spectacular Gothic country house . . . has been sold to the National Trust for £24 million plus a further unspecified amount negotiated in a tax deal between the government and (its) owners." The owners were the nineteen heirs of the 2nd Lord Wraxall, a reclusive bachelor who had died at the age of 73 in 2001. None of the heirs had the means to buy out the others let alone maintain the 43-bedroom mansion and its 2,410-acre estate situated on the outskirts of the city of Bristol. There were fears that the house, virtually unchanged from the late Victorian period and remarkable for the "completeness of the estate, the house and its contents" (Bennett), would be sold, its contents dispersed, and the estate redeveloped. Almost as feared was the sighting of a helicopter landing on the lawn, rumored to contain the pop singer Kylie Minogue coming to view the house. Historians of art and architecture recalled the fate of Mentmore (1850–1855), the Bedfordshire home of Baron Amschel de Rothschild, which equally complete, and despite pleas for its preservation, was sold in 1978 after an auction of the contents. Mentmore was a turning point for the preservation movement, and several houses (none as spectacular as Mentmore) have been saved for the nation. Eager to avoid another Mentmore, the National Heritage Memorial Fund chipped in £17.5 million ($26 million), two anonymous benefactors made donations (£4m and £1m), and the public raised £1.5 million. The government waived duty (tax) on the sale of the house and waived inheritance taxes, allowing the price to be lowered. Tyntesfield has been saved but will take millions of pounds more to repair and prepare for opening.

Tyntesfield is worth saving because it is one of the country's greatest Victorian mansions, typical of the houses built by the nouveau riche manufacturers made wealthy by the Industrial Revolution and the British Empire: Rencomb House, Gloucestershire, was built by a bullion broker; Milner Filed, Yorkshire, by a wool weaver; Rousdon, Devon, by a biscuit (cookie) maker; and Tyntesfield by a guano importer. Guano is the accumulated seabird droppings from uninhabited islands off the coast of the South American countries of Peru, Ecuador, Chile, and Bolivia. In the nineteenth century it was the main fertilizer used until replaced by nitrate of soda, which was imported and sold by the same company. This enterprising and unlikely company was Anthony Gibbs and Sons, established in London in 1809 by a cloth

and wine merchant driven out of the European markets by the Napoleonic Wars. William Gibbs inherited in 1815 and after the death of his brother in 1842 was head of the firm until his death in 1875. It is one of the strengths of the English class system that it is fluid, and those aspiring to enter the upper classes were accepted provided they accepted the mores and norms. Newly rich manufacturers, gruff and unpolished, would buy country estates, build great mansions, and send their sons to the right schools such that the second generation was fully incorporated, even married, into the upper classes—the aristocracy, of course, appreciated the timely injection of money as long as its source was not discussed. The huge, vulgar mansions of the nouveau riche, and the manners of their owners, are often the setting for novels and murder mysteries: Enderby Hall, the fictional neo-Gothic palace of the Abernethie family in Agatha Christie's *After the Funeral*, was built by a manufacturer of "cornplasters and allied foot preparations." Tyntesfield could be the model for the extraordinary house described by Christie.

In 1843, William Gibbs joined the landed classes, buying an estate and small country house called Tyntes Place a few miles west of Bristol. Only minor remodeling took place at first but as Gibbs's income increased to £100,000 and his fortune to £1,500,000 (the equivalent of about $150m today), he decided to entirely remodel the house and renamed it Tyntesfield. The architect John Norton (1823–1904), who grew up in Bristol but maintained his office in London, was consulted in 1863. Work appears to have started by October 1863 and in February 1866, *The Builder* (a widely read architectural magazine) described the house as "just completed," and at a cost of £70,000.

Norton maintained the earlier house, its shape discernible as the central box of the composition. This he raised to three stories—four stories at the center with a steeply pitched pyramid roof. To east and west he added single-story high-roofed wings containing the Library and the Drawing Room, both of which have high ceilings rising within the roofs. Norton, a pupil of Benjamin Ferry (himself a pupil of A.W.N. Pugin), followed the Pugin doctrine that each element of the house should be identifiable and therefore the two wings are of different heights and have different *fenestration* (window types and spacing), that of the Drawing Room being concealed by a *loggia*. Thus, the new south *façade* is asymmetrical but balanced. The reconfigured central block is also not symmetrical, with a large round *oriel* (upper floor bay window) *turret* on its corner that counters the "heavier" drawing room wing. On the east front behind the Library rose a tall, turreted and steep-roofed tower over the entrance porch (this originally contained the smoking room but was reduced in height in 1935) while a long wing extended north and east to end with another turret *corbelled* (cantilevered) off the corner. The west front begins with the massive semi-circular bay window of the Drawing Room and finished with an immense domed *conservatory* nearly as tall as the towers of the house; the conservatory was demolished in 1919. The roofs are covered in a diaper patter of different-colored slates.

William Gibbs and his wife, Matilda Blanche, were deeply religious and supporters of the High Church movement (Church of England—Episcopalian—but with almost as much ritual and splendor as Roman Catholicism). The Gibbs fortune built and endowed many churches and foundations including William Butterfield's chapel at Keble College, Oxford; the Refectory (dining hall) and Library at Keble were built by William Gibbs's sons after his death in 1875. Gibbs employed domestic chaplains at Tyntesfield who lived as High Church celibates in a chaplain's cottage beyond the rose garden. Charlotte M. Yonge, the Victorian novelist, was related to the Gibbs family and she wrote of Tyntesfield, "That beautiful house was like a church in spirit, I used to think so when going up and down the great staircase like a Y. At the bottom, after prayers, Mr. Gibbs in his wheeled chair used to wish everybody goodnight." In 1873–1875, Sir Arthur Blomfield, the architect son of the Bishop of London, was commissioned to design the Chapel attached to the north end of the house, which added to the complexity of steep roofs. Big enough to be a college chapel, it is modeled on the Sainte Chapelle in Paris.

Internally, the rooms are organized around a top-lit staircase hall. The Drawing Room originally had its walls and high ceiling covered with *stenciled* and painted decorations but these have since been eliminated (maybe the National Trust will restore this decorative treatment). The Library, however, completely lined with oak bookshelves and paneling is still evocatively Victorian as is the Billiard Room with its top lighting achieved by *traceried dormer windows* cut into the curved timber *barrel vault*. Although the High Church atmosphere of the house has mellowed over the years, most of the original furniture, elaborately Gothic in style, is still at Tyntesfield.

Houses of the nouveau riche manufacturers, much of whose wealth came from the exploitation of the inventions of the Industrial Revolution, tended to be elaborately up-to-date. Tyntesfield was heated by hot air; gasometers near the kitchen garden supplied gas to light the house, stables, lodges, and the clock-face at the top of the entrance tower; two water-wheels continue to pump water to reservoirs on the hill above the house that supply bathrooms, showers, and fire hydrants. Electricity was installed in the 1880s, as was the hydraulic lift.

Tyntesfield, a house imbued with High Church values, has changed little since the death of William Gibbs in 1875. His son Anthony succeeded and somewhat reduced the piety of the atmosphere, inserting the Billiard Room and increasing the size of the Dining Room to serve large house parties. Anthony Gibbs's son was created Lord Wraxall in 1928 and it is the death of his grandson, the 2nd Lord Wraxall that has led to the recent successful campaign to save Tyntesfield for the nation.

Further Reading

Bennett, Will. "Magical Victorian Mansion Saved for Nation in £24m Deal." *Daily Telegraph*, London, June 19, 2002.

Girouard, Mark. *The Victorian Country House.* New Haven, Conn.; London: Yale University Press, 1979.

National Trust. www.nationaltrust.org.uk/places/tyntesfield/.

WALES. *See* Caernarfon Castle; Cardiff Castle; Erddig Hall; The Parish Church of St. Giles; Portmeirion.

WESTMINSTER ABBEY, THE COLLEGIATE CHURCH OF ST. PETER AT WESTMINSTER, WESTMINSTER, LONDON

Style: Mediaeval—Gothic
Dates: 1045–1065; 1245–1512; 1736–1745
Masons: Henry de Reyns; John of Gloucester; Robert of Beverley (thirteenth century)
Architect: Nicholas Hawksmoor (eighteenth century)

Two great cathedrals dominate London: **St. Paul's Cathedral** in the City of London and Westminster Abbey at Westminster. Westminster Abbey is the most important royal church in London as well as being a church of national importance: most recently, in 2002, Westminster Abbey was the setting for the state funeral service for Her Majesty Queen Elizabeth The Queen Mother and in 1997 for that of Diana, Princess of Wales. Every king and queen since William the Conqueror (r. 1066–1087), who was crowned at Westminster Abbey on Christmas day 1066, has been anointed in the service of coronation at the Abbey. There are only two exceptions: Edward V (r. 1483) and Edward VIII (r. 1936) were not crowned as neither reigned long enough to have a coronation. Westminster Abbey, dating from before the Norman Conquest, is the oldest of Britain's great cathedrals and, being central to the monarchy and the nation, it is one of the most magnificent.

The monarch, who is currently Queen Elizabeth II (r. 1952–), is Supreme

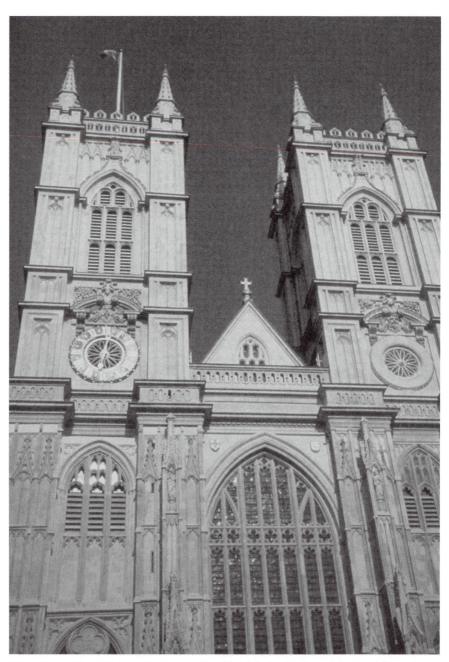

Westminster Abbey. The west façade completed by Nicholas Hawksmoor in the eighteenth century. *Harcourt Index.*

Governor of the Church of England, the leader of the Protestant Anglican Church (Episcopalian Church in the United States), formed by King Henry VIII (r. 1509–1547) in the 1530s. Spiritually, the leaders of the Church of England are the Archbishop of Canterbury (senior archbishop) and the Archbishop of York who oversee the bishops who control the dioceses, the divisions that cover the country. Each diocese has a cathedral church as its central church where the bishop has his throne or cathedra. Most cathedrals are ancient buildings dating back to mediaeval times and often began as abbeys or monasteries. This distinctive building type has a plan that follows a given format with little variation, although in detail each is very different. In a typical abbey, one would find the church building, in plan cruciform, a Latin cross, oriented with the long axis running east to west with the top of the cross to the east. The main entrance is at the west end leading to the nave, the long arm of the cross. Usually, the nave has aisles to each side separated by an arcade of columns and arches. The crossing is the point where the two bars of the cross meet, to north and south are the transepts, also often with aisles, and usually containing secondary chapels, while above is the tower. In mediaeval times the public only had access to the nave and its aisles and possibly the crossing. Beyond the crossing, farther to the east, is the Sanctuary with the High Altar, the focal point of the church. The choir is the area where the monks sat in mediaeval times; its position is flexible though is usually between the crossing and the High Altar, closed off from public view by an elaborately carved *rood screen*. In many abbey churches a Lady Chapel dedicated to the Virgin Mary is situated at the farthest eastern point of the church beyond the High Altar.

On the south side of the church, protected from the north winds by its towering bulk, are the Cloisters. This is a square courtyard surrounded by a wide covered walkway, either open or with large windows to provide a view of the garth, the central garden. Here the monks could exercise, read, meet, or contemplate. The Cloisters were also the main circulation as most of the secondary accommodation was reached off this hallway: the Refectory or Dining Room, Library, Dormitory, Abbot's Lodging, and Chapter House. The Chapter House was usually off the east Cloister, often octagonal, and was the meeting room where abbey and church business was discussed. Beyond the buildings surrounding the Cloisters would be the kitchens, brew house, laundry, infirmary, produce gardens, barns, and storehouses, all surrounded by a protective wall.

Henry VIII confiscated the wealth of the Catholic Church and during the Dissolution of the Monasteries of 1536–1540 evicted all the monks. Many isolated monasteries such as Fountains Abbey in Yorkshire or Valle Crucis in North Wales fell into ruin; many, with extensive lands attached, were given to favorite courtiers or sold by the king and transformed into country mansions such as Woburn Abbey or **Syon House**; those in cities and large towns became cathedrals and parish churches. Westminster Abbey, with its royal associations, became a Royal Peculiar, a church under the direct control of the monarch rather than under a bishop.

Legend says that on the site of Westminster Abbey once stood a Roman temple dedicated to Apollo that was replaced by a church in the second century C.E. In the seventh century a new church was built dedicated to St. Peter, who was said to have miraculously appeared at its consecration. The monastery, established in the tenth century, destroyed by Viking raiders, was rebuilt by King Canute (r. 1016–1035) in about 1035, when a palace was built to the east closer to the River Thames. King Edward the Confessor (r. 1042–1066) had vowed to make a pilgrimage to the tomb of St. Peter in Rome but fearing disorder at home in his absence he petitioned the pope and was allowed instead to build a new church and monastery of St. Peter. Edward gave a tenth of his possessions and income to the new church and by December 28, 1065, Holy Innocents Day, enough had been completed for the building to be consecrated, although building work continued until 1080 fourteen years after the Norman Conquest. Edward's Westminster Abbey was in the Norman style, the first in the country to have a cruciform plan, derived from the church at Jumièges, Normandy.

The tomb of Edward the Confessor is in a small chapel immediately behind the High Altar but that is about all that remains of his monastery, as it was completely rebuilt by Henry III (r. 1216–1272). Work began in 1245 and was nearly to bankrupt the country. Three masons oversaw the design and construction: Henry de Reyns (mason in charge 1245–1253), John of Gloucester (1253–1260), and Robert of Beverley (1260–1285). Work began at the Lady Chapel to the east and by 1285 had reached the west end of the "quire" (choir). The Cloisters and monastic buildings all date from this time; the Chapter House, restored by Sir George Gilbert Scott in 1866–1872, is octagonal with a ribbed *vault* supported on a central column. So delicate are the columns and so large the windows that the room has the feel of a large umbrella overhead with only the gauziest of walls confining the space.

The style is essentially Early English with later Perpendicular in the Henry VII Chapel at the east end and in the western half of the nave (see **The Parish Church of St. Giles**, Wrexham, for an explanation of the styles of English Gothic architecture). The nave is 102 feet high from floor to vault, the highest in England, with the internal elevation composed of an arcade, leading to the aisles (51 feet high), a triforium arcade, with an upper aisle behind (17 feet), and a windowed clerestory (34 feet). Externally, massive pinnacled *buttresses* and a series of *flying buttresses*, double above the aisles, triple above the Cloisters, support this great height.

Westminster Abbey was not completed until the reign of Henry VII (r. 1485–1509) because the intervening years were politically turbulent, particularly during the War of the Roses in the late fifteenth century. Upon his accession Henry VII decided to complete the nave and rebuild the Lady Chapel as a memorial to his uncle Henry VI (r. 1422–1461, 1470–1471). The new Lady Chapel, completed in 1519, is one of the most astounding examples of the late Gothic Perpendicular style with walls seemingly made of glass supporting delicate fan vaulting, of which Washington Irving wrote: "stone

seems, by the winning labor of the chisel, to have been robbed of its weight and density, suspended aloft as if by magic, and the fretted roof achieved with the wonderful minuteness and airy security of a cobweb."

Henry VII's construction completed the nave but the west towers were not built until the eighteenth century, to the designs of Nicholas Hawksmoor. The niches for statues in the lower fifteenth-century *façade* had never been occupied and it was only in 1995 that statues of saints, twentieth-century martyrs, and the traditional virtues of Mercy, Truth, Righteousness, and Peace were added; 1995 was the year a major restoration of Westminster Abbey was completed.

It is hard, in mere words, to convey the majesty of Westminster Abbey: to enter through the west doors and see the seemingly endless nave soaring to the vaulted roof; the choir of rich carved wood breaks the path eastward until the crossing is reached with the High Altar beyond. Pass into the ambulatory that surrounds the Sanctuary; glimpse the tomb of Edward the Confessor, then up the steps into the jewel-like enclosure of the Lady Chapel, the Henry VII Chapel, with its cobweb of vaults overhead. Here one is surrounded by history; ahead the tomb of Henry VII and his queen, Elizabeth of York; to the left that of Elizabeth I (r. 1558–1603), to the right Mary Queen of Scots and William and Mary (r. 1689–1702). Elsewhere throughout the Abbey rest the remains of many monarchs and famous citizens: in Poet's Corner, among many memorials and tombs, are buried poets and authors Dryden, Tennyson, Masefield, Dickens, Sheridan, and Hardy.

Further Reading

Briggs, Martin S. *A Pictorial Guide to Cathedral Architecture*. London: Pitkin Pictorials Ltd., 1963.

Cruikshank, Dan, ed. *Sir Banister Fletcher's A History of Architecture*, 20th ed. Oxford: Architectural Press, 1996.

Wessex, Edward The Earl of. *Crown and Country: A Personal Guide to Royal London*. New York: Universe Publishing, 2000.

Westminster Abbey. www.westminster-abbey.org.

WHITEHALL. *See* The Banqueting House; Number 10 Downing Street.

WINDSOR CASTLE, BERKSHIRE, ENGLAND

Styles: Mediaeval, Gothic, and Georgian—Picturesque/Romantic
Dates: Circa 1080; 1358–1368; 1673–1684; 1823–1828; 1992–1997
Architects: William of Wykeham (fourteenth century); Hugh May (seventeenth century); Sir Jeffry Wyatville (nineteenth century); Giles Downes of the Siddell Gibson Partnership (twentieth century)

William, Duke of Normandy, earned his sobriquet of "the Conqueror" in 1066 when he defeated King Harold at the Battle of Hastings and declared himself King of England. To consolidate the Norman takeover and control the Saxon population, William caused to be built a series of great castles. In the capital **The Tower of London** soon glowered over the city while to guard the western approaches he built Windsor Castle. Surrounded by a vast hunting preserve—now Windsor Great Park—the castle became a favorite residence of the monarchs who built a great palace within its strengthened fortifications. The largest inhabited castle in the world and also continuously inhabited for the longest time, Windsor Castle remains a favorite home of the British royal family, whose family name it provides—Windsor-Mountbatten.

The castle that William I (r. 1066–1087) had built was typical of that time being formed of an artificial mound called a *motte*, on top of which stood the defensive *keep*, the largest and strongest tower of the castle. To protect the entrance to the keep a large courtyard called a *bailey* was usually attached to one side; this courtyard would often contain living and service quarters for day-to-day use. At Windsor there are two baileys created partly because of the site on a long ridge beside, and commanding, a crossing over the River Thames. As the castle developed into a royal residence the two baileys developed as the Lower Ward for secondary functions and the Upper Ward for the accommodation of the monarch and high officials of the court. An aerial photograph readily shows that the mediaeval arrangement survives with the plan being a figure-eight formed by the two baileys connected at the narrow center by the motte and its keep, the Round Tower. Originally built of timber, the castle was rebuilt in stone mostly for Henry II (r. 1154–1189) in about 1170.

The first major change took place during the reign of Edward III (r. 1327–1377) when the Upper Ward was rebuilt as a Gothic Palace celebrating the chivalry of the newly founded knightly Order of the Garter. Twenty-

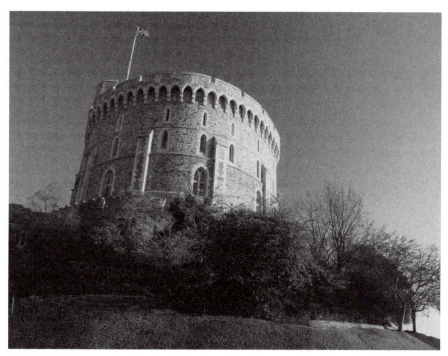

Windsor Castle. The mediaeval shell keep, the Round Tower, atop the motte, heightened by Sir Jeffry Wyatville in the 1820s. *Harcourt Index.*

six of the most illustrious people in the country including the monarch and senior members of the royal family form the membership of the Order. Annual ceremonies to celebrate the Order, its founding, and to induct new members take place each June culminating in a service in St. George's Chapel, the Order's chapel in the Lower Ward, built by Edward IV (r. 1461–1470, 1471–1483) in 1475–1483 in the most extravagant late Gothic style. A great fire in 1992 enabled archaeologists to dissect the mediaeval castle buried within later construction and revealed that the north side of the Upper Ward, designed by William of Wykeham for Edward III, was in fact "the largest, most elaborate, most permanent, most prestigious and most expensive tournament grandstand" (Nicolson). Originally divided into two "teams," led by the King and his heir, Edward, the Black Prince (d. 1376), the members of the Order of the Garter would meet in tournament in the Upper Ward. Typically, a tournament arena would comprise two gates, one for each team, with a grandstand for their audience in between. At Windsor this was recreated in stone with two massive gatehouses, one at each end of a long building containing a banqueting hall and a chapel, each with large windows that provided the grandstand for onlookers. The west gatehouse survives, much changed, as the "State Entrance"; the hall and chapel as the recently restored St. George's Hall; while the east gatehouse disappeared only

to be discovered hidden within later extensions. To the west of this celebration of chivalry William of Wykeham created the Royal Apartments separated into two suites for the King and the Queen. These survive modified and extended as the State Apartments. North of the banqueting hall the Royal Kitchen stood, detached because of the danger of fire; that the current Royal Kitchen is the mediaeval kitchen, still in use some after 600 years and not a nineteenth-century pastiche, was ironically also revealed by the 1992 fire.

As a favorite royal residence Windsor Castle saw continual change as successive tenants made their own imprint on the fabric. A major change occurred 1673–1684 when King Charles II (r. 1660–1685) commissioned Hugh May (1621–1684) to renovate the castle. Keeping the basic form of the mediaeval building, May created within its walls a grand Baroque palace of a splendor to rival that of Versailles. The King's and Queen's apartments were expanded and decorated with oak paneling, intricate carvings by Grinling Gibbons, and painted ceilings by the Italian artist Antonio Verrio. The most astonishing rooms were the redecorated Royal Chapel and St. George's Hall. Although elaborately Classical in style, the subject of the murals, carvings, and painted ceilings referred back to the mediaeval origins of the castle celebrating through allegory and symbolism the rightness of monarchy. Charles I (r. 1625–1649) had been beheaded only a quarter of a century before and Charles II had spent eleven years in exile before the restoration of the monarchy in 1660. Only a fraction of May's work survives; most was destroyed by Sir Jeffry Wyatville in the 1820s causing the present Prince of Wales, Prince Charles to call him "the greatest vandal ever to have worked at Windsor."

Wyatville's name was originally Wyatt (of a prolific architectural family) but his work "mediaevalizing" Windsor for George IV (r. 1820–1830) made him request the change of name to be equally ancient sounding! Beginning in 1824 and eventually costing over £1,027,000, an astronomical sum at that time ($400 million today), Wyatville left no part of the castle unchanged in his fervor to make it picturesque and "authentic." Everything genuinely mediaeval was improved, the Round Tower atop the motte, for example, was doubled in height. The State Apartments were altered and became rooms of ceremony and show, new Private Apartments for the King being formed in the east and south wings of the Upper Ward. Most of Wyatville's designs for the interiors were unfortunate, particularly his enlarged St. George's Hall which combined the old Banqueting Hall and Chapel into a long, narrow, ill-proportioned room. More successful however, were his new Private Apartments particularly the White, Green, and Crimson Drawing Rooms, which together form the most splendid suite of late Georgian interiors in the country. Gilded carvings, marble fireplaces, elaborately swagged, festooned and tasseled curtains, mirrors and paintings, multicolored carpets, and sumptuously upholstered furniture resulted in luxurious rooms of breathtaking extravagance. Relatively austere was Wyatville's Waterloo Chamber, commissioned by George IV to celebrate the defeat of Napoleon,

and lined with portraits of the monarchs of the Grand Alliance. So complete was Wyatville's rebuilding of the castle that little was changed for nearly 200 years.

The anguish of the Queen was evident on the afternoon of November 20, 1992, when she arrived to see for herself the damage done by the massive fire that gutted a large part of the castle. Starting in the Private Chapel in Edward III's east gatehouse, the fire rapidly spread through hidden voids and attics destroying St. George's Hall, the Grand Reception Room, the Crimson Drawing Room, most of the Green Drawing Room, the State Dining Room, numerous service rooms below, and staff accommodation above. Although contained after nine hours the fire burned for fifteen hours; towers acted as chimneys as their floors collapsed and in some areas the temperatures are estimated to have reached 1508 degrees. The Fates were kind, however, as the priceless contents of the rooms were in storage—contractors were rewiring the rooms and installing fire detection and alarm systems. Although considered a disaster when it happened, coming at the end of the Queen's "Annus Horribilis"—the year the marriages of three of her children scandalously dissolved—the fire of 1992 can now be viewed as beneficial. Much more is known about the history of the castle; mediaeval work hidden behind paneling or beneath paint has been restored to view; kitchens and mechanical systems have been modernized; historic rooms, such as the drawing rooms have been restored to their original appearance, and the rebuilt St. George's Hall, the new Lantern Lobby, and Private Chapel are an architectural tour de force. Giles Downes of the Siddell Gibson Partnership was the architect for the new work. The hammerbeam ceiling over St. George's Hall does much to correct its proportions and is the largest construction of its type since Westminster Hall (at the **The Houses of Parliament**) of 1394–1402. Following mediaeval tradition the ceiling is built entirely of hand-finished green (unseasoned) oak with pegged joints rather than the modern "glu-lams" originally suggested by the engineers. The Lantern Lobby (the anteroom between St. George's Hall and the Private Apartments) and the Private Chapel appear Gothic but are also very modern; restrained, however, to fit into this ancient structure. The restoration of Windsor Castle was completed on November 20, 1997, five years after the fire and on the fiftieth anniversary of the queen's marriage. It cost $56 million, most of which was raised by opening **Buckingham Palace** to the public during the summer months.

Further Reading

Montague-Smith, Patrick, and Montgomery-Massingberd, Hugh. *Royal Palaces, Castles and Homes.* London: Country Life Books, 1981.

Nicolson, Adam. *Restoration: The Rebuilding of Windsor Castle.* London: Michael Joseph Ltd. and Royal Collections Enterprises Ltd., 1997.

Robinson, John Martin. *Windsor Castle.* London: Royal Collections Enterprises Ltd., 1997.

Wessex, Edward The Earl of. *Crown and Country: A Personal Guide to Royal London.* New York: Universe Publishing, 2000.

Windsor Castle. British Government. www.royal.gov.uk/output/Page557.asp.

WREXHAM PARISH CHURCH. *See* The Parish Church of St. Giles.

WROTHAM PARK, BARNET, HERTFORDSHIRE, ENGLAND

Style: Georgian—Palladian
Date: 1754
Architect: Isaac Ware

The county of Hertfordshire is the setting for Jane Austen's book *Emma* and Wrotham Park could easily be the home of one of the heroine's aristocratic acquaintances. Its aloof *Palladian* exterior commands a view over a 300-acre *park*, with mature trees and a broad lake, which in turn is surrounded by 2,500 acres of farmland. In Austen's time Hertfordshire was the country, far enough from London to distance it from the fashionable doings of the capital. Today the center of London is only thirty minutes' drive from the gates of Wrotham Park and it is therefore all the more surprising that this house, its park, and estate has survived with little apparent change since its completion in the mid-eighteenth century, still owned by the Byng family for whom it was built.

The architect was Isaac Ware (c. 1707–1766), a protégé and disciple of Lord Burlington the leader of the Palladian movement. Ware, however, looked beyond the strict adherence to the principles of Palladio demanded by Burlington and was influential in moving architectural taste beyond these strictures. His architecture is lighter and more playful than that of Burlington at **Chiswick House** or William Kent (another Palladian architect) at **Holkham Hall** or Horse Guards. Appointed to a position in the Royal Works (i.e., one of the king's architects), Ware was very successful and it is a surprise that the list of buildings he is known to have designed is short, and few survive. Wrotham Park is his most important private commission and in

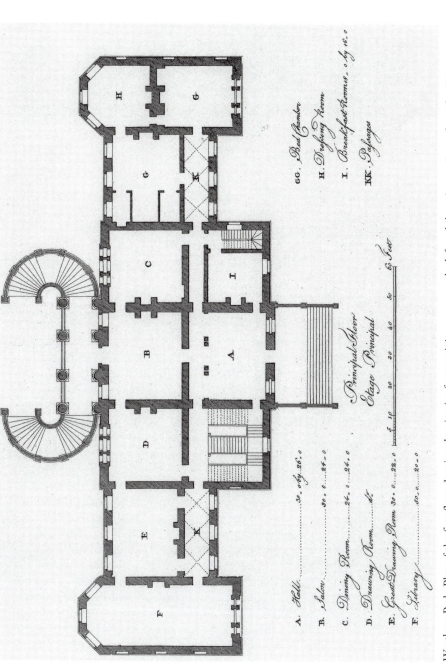

A. Hall 30..0 by 26..0
B. Salon 30..0 .. 24..0
C. Dining Room 24..0 .. 24..0
D. Drawing Room &c
E. Great Drawing Room 30..0 ..22..0
F. Library 30..0 .. 20..0

GG. Bed Chamber
H. Dressing Room
I. Breakfast Rooms .. 0 by 16..0
KK. Passages

Principal Floor
Etage Principal

5 10 20 30 40 50 60 Feet

Wrotham Park. Plan of the first floor showing the circuit of entertaining rooms to the left and the private suite to the right. *Vitruvius Britannicus.*

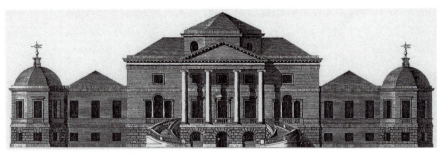

Wrotham Park. The southwest façade to the park. An extra floor was added in the nineteenth century but the house still appears to be composed of distinct pavilions. *Vitruvius Brittanicus.*

his portrait by Andrea Soldi, now in the collection of the Royal Institute of British Architects, he is depicted holding a drawing of the house.

The client for Wrotham was Admiral John Byng, the fourth son of Admiral George Byng, the first Viscount Torrington. Born at Southill, Bedfordshire, in 1704, John Byng followed family tradition and in 1718 obtained a commission in the Royal Navy. A lieutenant in 1724 and a captain in 1727, he served as Governor of Newfoundland from 1742 to 1745 when he was promoted to Rear Admiral. Further promoted to Vice-Admiral and Commander-in-Chief in the Mediterranean in 1747, he was also elected Member of Parliament for Rochester in 1751. Successful and rich beyond the usual expectations of a younger son, John Byng was able to commission Ware to redecorate his London town house at 41 Berkeley Square and, in the early 1750s, a new country house to be called Wrotham Park, at Barnet a few miles northwest of London. Construction began in 1752 and was virtually complete in 1754. Byng's career meant he had little time to enjoy his fine new house. In 1756, Byng was again promoted, this time to Admiral, and returned to the Mediterranean to guard the island of Minorca from the French with whom Britain was again at war—the Seven Years' War of 1756–1763. He arrived to find the island under French attack and when he met with the enemy fleet his own ships were badly damaged in the consequent battle and he retreated to Gibraltar. Minorca surrendered to the French a month later. Unfortunately, copies of the French admiral's dispatches reached London before Byng's own explanation and the British government, wishing to find a scapegoat for their own ill-preparedness and facing a public outcry, had Byng arrested and court-martialed. The trial found him not guilty of cowardice and disaffection but guilty of negligence, for which the Twelfth Article of War mandated the death sentence. Admiral Byng was executed by firing squad on the quarterdeck of H.M.S. *Monarch* on March 14, 1757. Buried at Southill, his monument bears this inscription: "To the Perpetual Disgrace of Public Justice, the Hon. John Byng, Esq., Admiral of the Blue, fell a Martyr to Political Persecution, March 14th, in the year MDCCLVII; when Bravery and Loyalty were insufficient Securities for

the Life and Honour of a Naval Officer." Voltaire had the last word on Admiral Byng, writing soon after, "In this country [Britain] we find it pays to shoot an admiral from time to time to encourage the others."

The house that Isaac Ware designed for Admiral Byng was not large, an extended villa rather than a great mansion. Sited at the top of a southwest-facing slope, the house nestles into the earth so that the garden *façade* is a story taller than the entrance façade where the *basement* is completely concealed. The design follows the *Palladian* ideal of a central block with flanking wings connecting to terminating *pavilions*, in this case strung out in a long line so that all the major rooms enjoy the southwest view of the lake and park and the countryside beyond. A basement extends under the whole house but only the central block had upper floors—the house was essentially single storey over a basement, with a partial attic floor. The central pavilion is of five *bays* with an attached *pediment* on the northeast, entrance façade and, on the southwest front, a four-columned *Ionic portico* approached from the gardens by twin semi-circular flights of stairs. The wings appear as separate elements pushed beside the central block each having pyramidal roofs while each pavilion reaches out to the view with a three-sided canted bay roofed by an eight-sided, faceted dome topped by weather vanes.

Inside, the house demonstrated the transition from the *formal house*, such as **Blenheim Palace**, of earlier in the century, with its separate *apartments* to the more relaxed circuit house of the late eighteenth century. It is a smaller version of **Harewood House**, a house designed only a few years later. At Wrotham the front door leads into a spacious entrance hall with paired columns demarking the cross passage that runs the length of the house. Beyond the Hall is the Salon, which opens up to the portico and the extensive view. To the north of the Salon is the Dining Room, an early example of a room specifically designated for dining, and to the south is a circuit of rooms comprising a Drawing Room, a Great Drawing Room, and the Library. The circuit returns to the Hall via a broad, *vaulted* passageway and the staircase hall where an impressive imperial staircase (a single flight rising to a half-landing, then splitting into two flights) led to the upper floor. The purpose of such a circuit was to allow for large-scale entertaining; guests would be received in the Hall then pass though the sequence of rooms enjoying various amusements such as music, cards, or a buffet while admiring the house and its decoration. Byng, a senior admiral of the Royal Navy and a Member of Parliament, would be expected to host elaborate parties at his new house.

The north wing and pavilion contained two bedrooms and a dressing room. Here the change from the formal house is most apparent with the bedrooms being comparatively remote and private. Byng's bedroom does contain one surprisingly old-fashioned element: the bed is placed in a deep recess, an alcove off the main space of the room, which is almost a small room in itself. An idea of the size of the rooms can be gathered form the illustrations of the house in *Vitruvius Brittanicus—The British Architect*—volume five, published in 1771. The Hall is 30 feet by 26, the Salon 30 by 24,

the Dining Room and Drawing Room 24 by 24, the Great Drawing Room 30 by 22, and the Library 50 by 20. The bedroom is approximately 22 by 20 and the bed recess 10 feet square.

Upon Byng's death, since he had no children, his nephew George Byng inherited the estate. Perhaps fearful of the Navy the family instead distinguished itself in the Army and in the mid-nineteenth century were raised to the peerage as Earls of Strafford, reviving an old and famous title that had died out in the seventeenth century. In 1811, finding the house too small for their needs, an additional floor of rooms was added to the whole building, raising the central block to three floors and the wings and pavilions to two floors, all above the service basement which was extended to the north. These alterations essentially provided extra bedrooms for family, children, servants and guests, as the main floor remained unchanged. Disaster struck in 1883 when a fire broke out on the top floor. Four fire brigades struggled to contain the blaze but their pumps were not powerful enough to reach the flames and the house was burned to the ground. The contents of the main floor were saved and the house was rebuilt almost exactly as before, such that Admiral Byng would hardly realize that the main rooms were not his own.

Solid, and reputedly fireproof, Victorian building technology replaced eighteenth-century methods while the servants' rooms in the basement and attics were brought up to the exacting standards of the era. The Victorian country house is the final stage in the evolution of the relationship between noble owners and their servants. In the mediaeval castle or manor house the household was seen as a community and they all ate together in the Great Hall. As the nobility retreated into private apartments the servants were relegated to a servants' hall in the basement or adjoining wing—the community had become masters and servants (see entries for **Haddon Hall**, **Hardwick Hall**, **Belton House**, and **Blenheim Palace**). In the nineteenth century the number of servants increased with the complexity of the houses and ironically, as the life of the masters became less formal, that of the servants beyond the "green baize door" (the division between masters and servants zones) became much more regimented, departmentalized, and controlled. A search for efficiency meant different functions were given their own spaces and specialized staff with related functions grouped together into departments with appropriate access to the main part of the house via back stairs and inconspicuous doors. Typically, there were four departments administered by senior servants: the steward or butler was the most important servant and under him were the footmen who essentially served the family and guests; the housekeeper with her housemaids cleaned and maintained the house; the cook—or chef in very grand houses—reigned in the kitchen with the support of undercooks, kitchen maids and scullery maids; reporting to the housekeeper but separate was the laundry department with its staff of laundry maids. Special servants such as valets, ladies' maids, and governesses counted as upper servants with the butler, the housekeeper, and the cook. Outside the house were gardeners, coachmen, grooms, stable boys, game-

keepers, and so on. All told, a large house such as **Eaton Hall** or **Chatsworth** needed over 100 servants to run efficiently.

The rebuilding of Wrotham after the fire resulted in the modernization of the servants' areas of the house. An insight into how they look and how they worked can be seen from the 2001 movie *Gosford Park* directed by Robert Altman, which was filmed at Wrotham. Ostensibly a satire on the country house murder mystery—the "whodunit"—the movie is also a commentary on the relationships between a jaded aristocracy and their servants. Set in the 1930s, when such extravagantly run houses were disappearing, the movie depicts the events of a weekend house party hosted by Sir William and Lady Sylvia McCordle. As their guests arrive, most bringing their own servants, we are introduced to the organization of the house and as the film proceeds we see how it works. Some things stand out: the departmental lines are never crossed, with each head—butler, housekeeper, and cook—ruling his or her domain; the visiting servants do not have an identity of their own but are known by their employer's name, and at dinner in the servants' hall they follow the same strict order of precedence; the sexes are strictly separated when unsupervised, with different bedroom corridors for women and men servants—Victorian morality dictated separation of not only the male and female servants but "young ladies" and bachelors; the efficiency of the service area with its long central hallway, tiled walls and floors, and glass partitions allowed oversight and control; and the days were long, arduous, and at the whim of master or mistress, although not without reward—for example, listening to Ivor Novello singing in the drawing room after dinner.

The Strafford title again ended in 1951 with the death of the 5th earl but Wrotham Park is still lived in by a descendant of Admiral Byng, Robert Byng, who endeavors to maintain the house and park much as his unfortunate ancestor envisaged.

Further Reading

Girouard, Mark. *Life in the English Country House: A Social and Architectural History.* New Haven, Conn.; London: Yale University Press, 1978.

Wrotham Park. www.wrothampark.com.

Appendix: The Monarchy, the Peerage, and the Parliament

Much of the historic secular architecture of the British Isles is due to the patronage of the titled aristocracy who effectively ruled the country from the Norman Conquest of 1066 until the early twentieth century, when their power devolved to the democratic parties that rule today. The titled aristocracy is called the Peerage and until recently, most of its members had the inherited right to sit in the House of Lords, the upper chamber of Parliament, approximately equivalent to the Senate in the U.S. Congress. The British House of Commons is the equivalent of the House of Representatives.

The Head of State of the United Kingdom is the reigning monarch—currently Her Majesty Queen Elizabeth II—who is also the Head of the Commonwealth, a voluntary association of fifty-four countries, mostly former colonies. Her Majesty is also Queen of Australia, Canada, New Zealand, and several other countries where she is officially represented by a Governor-General. Until the late seventeenth century, the monarch had full power to rule the country, issuing laws and raising taxes, and constrained only by the precedent of Magna Carta (a result of the barons' revolt of 1215) and memories of the fate of Charles I (he was beheaded) after the Civil War of the 1640s. Since the beginning of the eighteenth century, the powers of the monarchy have been curtailed and the Queen's theoretical powers include appointing prime ministers, approving legislation, and acting as head of the Armed Forces and Governor of the Church of England. As a constitutional monarch, the Queen is politically impartial, bound by rules and conventions. There is no written constitution in Britain and the roles of the monarch, the prime minister, and the government are constantly evolving, as can be seen by recent changes to the membership of the House of Lords and the role of the Lord Chancellor.

Queen Elizabeth II's heir is His Royal Highness, The Prince Charles,

Prince of Wales, whose two children are the Princes William and Henry (Harry). Other members of the royal family carry ducal or princely titles—for example HRH The Duke of York (Prince Andrew), HRH The Duke of Gloucester (Prince Richard), HRH The Princess Alexandra of Kent—which can usually be inherited by their children, although the style "Royal Highness" eventually ceases to apply being held only by children and grandchildren of a monarch.

The basic titles in the British Peerage—excluding those of the royal family—are, in order of rank, Duke, Marquess (or sometimes Marquis), Earl, Viscount, and Baron (or Lord) plus, outside the Peerage, the titles of Baronet and Knight. This order of precedence is recognized in every European country and "derives from the hierarchy of power hacked out by broadswords in misty forests a thousand or more years ago" (Lacey). Titles were awarded by the monarch in return for services rendered either to the Crown or to the public cause—the Dukedom of Wellington was awarded to the general who defeated Napoleon; the Marquessate of Salisbury for political service; the Viscountcy of Rothermere for public service (newspaper publication); a few titles were "earned" by King Charles II's mistresses; and a few were bought by wealthy landowners, merchants, or industrialists from monarchs or prime ministers in need of extra cash.

Duke: This title derives from the Latin *Duces*, Roman high commanders who held territorial responsibilities. Later, the leaders of the barbarian invaders who moved into the Roman Empire took the title. A duke's wife is called a duchess. A duke is addressed formally by his full title preceded by "His Grace."

Marquess: This title derives from the German word for a count (see Earl below), *Graf*. A rank above a *graf*, a *markgraf*, was created, from which margrave, marquis, and marquess are derived. Their superior status was earned because they were allocated particularly difficult frontier lands called marks or marches to capture or protect. A marquess's wife is a marchioness. A marquess is informally addressed as a "Lord" rather than by his formal title, which, when used, is preceded by "the Most Honourable."

Earl: This title derives from the Anglo-Saxon *Eorls* which derives from the Danish *Jarl*, referring to the military viceroys (governors) of shires or counties. The European equivalent is Count (*Conde*, *Conte*, or *Comte*) from the Latin *Comes*, meaning "companion," a term appropriated by the Franks (one of the barbarian tribes) for the outriders escorting a ruler. An earl's wife is a countess. An earl is addressed informally as a "Lord" rather than by his formal title, which, when used, is preceded by "the Right Honourable."

Viscount: Literally the deputy to a count, a vice-count, hence viscount or *vicomte*. A viscount's wife is a viscountess and he is addressed in the same way as an earl.

Baron: This is the lowest-ranking title that gave the holder the right to sit in the House of Lords. In mediaeval times in England, all powerful land-holders were barons (the king theoretically owned all land, and it was only held for the lifetime of its holder, but the desire to pass land and its associated power to children soon prevailed); dukes were members of the royal family. As the title of duke expanded to the aristocracy and other titles were introduced, baron became the lowliest title. In Britain, a baron is never referred to by this title but rather as "Lord" and his wife as "Lady," formally preceded by "the Right Honourable."

Baronet: This title, and that of knight, did not carry the right to a seat in the House of Lords. The title of baronet was created by James I in the early seventeenth century and was effectively for sale to the highest bidders. The title of baronet is hereditary and the holder is called "Sir" and his wife "Lady."

Knight: Although an old sounding designation, knight as a title is comparatively recent. It is similar to baronet with the exception that the title cannot be inherited. The title of knight has been given to leading figures in business, The City, and government.

Peers above the rank of baron often have several subsidiary titles in addition to their principal one, usually indicating those conferred on ancestors. For example, the Duke of Devonshire (**Chatsworth**) is also Marquess of Hartington and Earl of Burlington or the Duke of Westminster (**Eaton Hall**) is also Marquess of Westminster, Earl Grosvenor, and Viscount Belgrave. It is longstanding usage that these subsidiary titles will be conferred as a "courtesy" title upon the eldest son and grandson. Hence, the 11th Duke of Devonshire's (died 2004) eldest son, Peregrine Cavendish, had the title of Marquess of Hartington and, in turn, his son was Earl of Burlington. Only the holder of the principal title had the right to sit on the House of Lords. There are also rules governing how the younger children of peers are addressed, which add to the complexity of the system.

The titles of most peers derive from their estates or the county in which their largest estates were located—the Earls/Dukes of Northumberland (**Alnwick Castle** and **Syon House**) own substantial estates in that county. In the sixteenth and seventeenth centuries, as titles became "vacant" (through lack of an heir or because the holder was attainted and his titles confiscated) they would be allocated to the newest candidate. The Cavendish family, Dukes of Devonshire, have no connections with the county of Devon. In some cases, relatively rare until the twentieth century, family names are retained as the title; eighteenth-century examples are Earl Spencer (**Spencer House**) and Earl Granville.

"Letters Patent" signed by the monarch elevate worthy persons to the ranks of the Peerage and define the rules of inheritance; in most cases, the title is limited to "heirs male" of the first holder of the title. It is under these

circumstances that an obscure person can inherit a title that for many generations has passed from father to son. If that line dies out, an heir is sought among male descendants of the first holder resulting in a distant, possibly unknown, cousin becoming a Lord. It is unusual for "heirs female" and this is usually allowed only in the case of no direct male heir. Thus, the heir to the first Duke of Marlborough (**Blenheim Palace**) was his daughter as there was no son and the Scottish Earldom of Dysart has passed to daughters several times.

The role of the Peerage in the governance of Britain evolved from mediaeval times (**The Houses of Parliament**) and until comparatively recently it was the Peerage with the Lords Spiritual (archbishops and senior bishops) and the Lords of Appeal who constituted the House of Lords. In 1958, the first major change took place when Life Peerages were introduced allowing worthy commoners—often retired government ministers—to be elevated to the House of Lords without creating, in these more democratic times, hereditary titles. A few years later, in 1963, peers were allowed to disclaim a title for life; this was done specifically for the socialist Labour Party member Anthony Wedgewood-Benn, who inherited as Viscount Stansgate, to remain in the House of Commons, and was used by the 14th Earl of Home to become prime minister as Sir Alec Douglas-Home. The disclaimed title can be revived by the next heir.

However, in 1999, the so-called New Labour government of Prime Minister Tony Blair passed the House of Lords Act, which contained major reforms to the Upper House. The prime minister felt that it was an anachronism in a modern society that laws could be promulgated, passed, or rejected by an Upper House composed mainly of people whose rights were inherited, no matter how worthy the original awardee of the title. The first stage of reform removed the rights of all but ninety-two (approximately ten percent) hereditary peers; the ninety-two were elected by the full Peerage. The second stage was to follow within a year or two, once discussions had determined how the Upper House should be selected—whether elected, partly elected/partly appointed, or fully appointed. There is now an impasse and several years later the House of Lords still includes the ninety-two remaining hereditary peers, plus Life Peers, the Lords Spiritual, and the Lords of Appeal. In 2003, Prime Minister Blair, in a reshuffle of his government team, tried to eliminate the ancient role of the Lord Chancellor—"speaker" of the House of Lords—only to discover that a Lord Chancellor is necessary to conduct business in the Upper House. These changes are examples—maybe too hasty and ill-considered—of the evolution of the unwritten constitution by which the government of Britain works.

The House of Commons, the Lower House, also began in mediaeval times (The Houses of Parliament) and until the late nineteenth century was effectively the second house in importance—many Members of Parliament were family members or appointees of peers. The Great Reform Act of 1832 effectively curtailed aristocratic abuses but power did not completely move to

the Lower House until 1910 when a conflict between the two Houses over the budget led to the ascendancy of the House of Commons.

In theory, the Queen invites a senior politician to become prime minister and form a government. The only possible appointee, however, is the leader of the party—currently Conservative, Liberal-Democrat, or Labour—that has won the most seats in the House of Commons in periodic elections. Unlike elections in the United States, where there is a fixed timetable, elections in Britain can be called at any time up to a maximum of five years apart; governments can fall earlier through failing a vote of confidence or the attrition of their majority through by-elections, or a prime minister can call elections because recent successes make reelection likely. The Queen's role is therefore limited to that of a figurehead offering advice and encouragement and occasionally warning to "Her" government—the prime minister meets in private audience with the Queen one evening of nearly every week.

Further Reading

Blunt, Anthony. *Treasures from Chatsworth, The Devonshire Inheritance: A Note on the Use of Hereditary Titles*. London: International Exhibitions Foundation, 1980.

Lacey, Robert. *Aristocrats*. Boston: Little, Brown and Company, 1983.

Glossary

Amphitheater: A circular or oval-shaped space surrounded by tiered seating. The theater in ancient Greek and Roman times was a semi-circle of tiered seating facing a stage and an amphitheater could be described as two theaters placed together. The most famous example is the Colosseum in Rome; major cites of the Roman Empire had an amphitheater for gladiator contests and other entertainments.

Apartments: Suites of rooms, called apartments, set aside for the most important residents or guests in the palaces and houses of kings and nobles throughout Europe in mediaeval through Victorian times. An apartment was often entered through an anteroom that led to a sequence of increasingly private and usually smaller rooms. The queen's private rooms in Buckingham Palace are still called the Queen's Apartment. An American residential apartment would be called a "flat" in Britain.

Apse: A small apse is a semi-circular recess capped by a half-dome suitable for the placement of a statue. On a large scale an apse is the semi-circular or polygonal end of a church or chapel where the altar is placed.

Art Nouveau: An art movement of the late nineteenth and early twentieth centuries that evolved from the Arts and Crafts Movement and strived to be modern, not dependent on period styles of past eras. Initially influencing textile and book design, Art Nouveau spread to furniture, decorative objects, and architecture. Naturalistic forms, attenuated lines, and undulating, wave-like forms, sometimes referred to as whiplash curves, characterize Art Nouveau. In the United States, Louis C. Tiffany is considered to be an Art Nouveau artist.

Avenue: A wide city street lined by regularly spaced rows of trees or a straight drive approaching a country house similarly lined with trees.

Bailey: *See* Motte and Bailey.

Balustrade: A fence-like barrier around a terrace or roof composed of balusters (often curvaceous, vase-like in form) topped by a coping or rail.

Balustraded parapet: *See* Parapet.

Barrel vault: The simplest form of vault made of stone, brick, plaster, or wood used to roof over spaces and passages. A barrel vault is a simple semi-circular vault spanning between two walls. It is also sometimes referred to as a tunnel vault or a wagon vault (because it is a bit like the canvas top of a covered wagon).

Basement: The lowest level of a building at ground level or below ground level that is the base for the main floors above. A basement contains work or living rooms, usually for servants, as opposed to a cellar, which is for storage only.

Battlements: The walkway at the top of a mediaeval castle wall protected by a battlemented or crenellated parapet wall of a stepped, up-down profile. The high pieces, called merlons, provided concealment for defenders while the lower pieces, called embrasures, provided places from which to fire at attackers. Battlements were also used as a decorative motif on churches and later castle-style houses.

Bays: Most buildings have windows and doors regularly spaced and/or aligned vertically. A bay is a vertical array of doors and/or windows with its required surrounding wall surface. A building can therefore be described as being x number of bays wide with bays recessed or projecting. This definition is easily confused with a bay window, an angled or curved projecting window.

Beau ideal: Literally the ideal beauty; the perfection of an idea or concept.

Blind arcades: An arcade is a row of columns connected by arches such as is often seen separating the nave from the aisles of a Gothic church. A blind arcade is formed when an arcade is used decoratively on a wall surface so that there are no openings between the columns.

Bow window: A bay window but semi-circular or curved in plan.

Buttresses: Short walls projecting at ninety degrees from the main wall of a building to provide additional support. Buttresses are a particular feature of Gothic architecture used to reinforce extremely tall and heavy structures with increasingly large windows.

Castellated: In mediaeval times permission to castellate a building allowed an owner to construct towers, turrets, battlements, drawbridges, and other defensive features. The term also refers to such features used decoratively on buildings in later periods.

Cast in situ: Concrete poured in the place needed as opposed to precast concrete produced in a factory and transported to the building site.

Chancel: Derives from the Latin *cancellus*, screen, but came to mean the east end of a church beyond the rood screen reserved for the clergy and choir and where the High Altar was placed. A chancel could be an apse (*see* apse) or, when much larger, an extension of the nave eastward beyond the crossing forming the top part of the cross-like church plan.

Chateau (plural Chateaux): The French word for a castle or later a country house. Large houses in cities and towns are called "Palais" or "Hotel" (from which the modern word derives) while country houses are Chateaux. Thus the palace at Versailles is correctly called the Chateau de Versailles.

Coffering: Recessed ornamental squares or polygons set into ceilings, vaults, or domes.

Conservation rating: Britain has a long-established and complicated rating system to designate and protect historic and architecturally significant buildings. Depending on the rating a building can or cannot be demolished or changed. A Grade I listing also allows owners to claim grants and other financial assistance for maintenance.

Conservatory: A greenhouse or glasshouse for delicate and exotic plants usually attached to a house, often decorative in form and detail. Conservatories became popular in the nineteenth century, famous in literature as places for dalliances or whispered conversations behind rampant foliage.

Corbelled: Imagine trying to create a bridge between two chairs using books. Each book in a stack on each chair would be stepped beyond the one below until the gap was small enough to place one book across the top. This stepping structure is the corbel system and it can be used in many ways to span openings or form cantilevered projections on which to support a beam or statue.

Corinthian order: One of the three main orders of architecture—Doric, Ionic, and Corinthian—created by the ancient Greeks that form the basis of Classical design. An order is a complete design system of form, proportions, and decoration. The Corinthian order is characterized by its elaborate capital (the top of the column) decorated with acanthus leaves and other naturalistic forms.

Cupola: Correctly a small dome atop a circular or polygonal base. Cupola is sometimes used to describe a small windowed structure on top of a large dome or forming a skylight but this is more correctly called a lantern.

Doric order: One of the three main Orders of architecture—Doric, Ionic, and Corinthian—created by the ancient Greeks that form the basis of Classical design. An order is a complete design system of form, proportions, and decoration. Simpler details and heavier proportions characterize the Doric order: it is described as the masculine Order.

Dormer windows: Windows lighting rooms in the roof space of a building that project from the roof surface such that the window itself is vertical rather than parallel to the slope (which would be a skylight).

Enfilade: A French term referring to a sequence of rooms with their doors aligned so that when open a vista is obtained. Particularly used in late seventeenth- and eighteenth-century palaces and houses to create a visual axis and sense of grandeur.

Façade: Architecturally, the face or elevation of a building; similar to "front." For example, when tourists view Buckingham Palace they are looking at

the east façade or east front; an architect, thinking more technically, might call it the east elevation.

Fenestration: The pattern of windows on the façade of a building.

Flying buttresses: A development of the buttress used in Gothic cathedrals and churches. Buttresses against the outer walls would "fly" or arch over the aisle roof to support the higher walls and vaults of the central nave.

Frieze: The horizontal band, usually decorated, below the cornice (crown molding) of an internal wall or between the architrave and cornice forming the structure resting on the columns in the Doric, Ionic, and Corinthian orders.

Fritted: Originally, frit was finely ground material used to glaze bricks but recently the term "fritted" has been used to describe glass that has an applied surface of tiny colored dots that from the outside appear opaque but from the inside are invisible, allowing an unobstructed view. Fritted glass is used to reduce the effects of the sun and can also be seen on some commercial vehicles where advertising appears to cover the outside of the glass.

Gothic revival: Gothic architecture is associated with the mediaeval period that was supplanted by the Renaissance. In the eighteenth century the Picturesque and Romantic movements used Gothic ruins for their effect and then began to build new Gothic structures. This renewed interest in Gothic architecture led to the Battle of the Styles, between Classical and Gothic, and the Gothic Revival of the nineteenth century.

Grille: A pierced screen of metal, wood, or stone separating two spaces. Also a decorative wrought iron screen incorporating gates can be called a grille.

Hipped roof: A roof that slopes up from all sides with hips at the angles between slopes. A gabled roof slopes up from two directions and has triangular gable walls on the other sides.

Ingle-nook fireplace: A fireplace in a recess usually with bench seats to each side, forming a cozy area. Sometimes, in a large room, an arch over the opening to the recess makes it appear that there is an appropriately scaled chimneybreast.

Ionic order: One of the three main Orders of architecture—Doric, Ionic, and Corinthian—created by the ancient Greeks that form the basis of Classical design. An order is a complete design system of form, proportions, and decoration. The Ionic order is characterized by its elaborate capital (the top of the column) decorated with spiral volutes. Compared to the Doric order lighter proportions characterize the Ionic order: it is described as the feminine Order.

Jettied: In timber-framed building construction the structural efficiency of the beams is increased by projecting or cantilevering upper floors beyond lower floors creating a stepped or jettied profile.

Keep: The strongest and largest tower of a castle that evolved from a circular shell keep on top of a motte (*see* motte and bailey), to a square tower

keep within a courtyard and evolved into multiple defensive towers in the later concentric castles.

Lantern: A glazed or windowed structure atop a large dome or roof that allows daylight to enter the building. Sometimes confused with the term "cupola" that correctly refers to the small dome that often caps a lantern.

Loggia: A gallery or walkway open on at least one side to a garden or courtyard and separated by an arcade (columns and arches) or colonnade (columns only). Occasionally, a loggia can refer to a detached garden building.

Mortise and tenon joint: A carpentry joint formed of a projecting piece, the tenon, which fits into a socket, the mortise, used to connect timber members of a truss and also, on a smaller scale, join the front to the sides of drawer.

Motte and bailey: The earliest castle designs featured a tall conical mound—the motte—with defensive keep on top. Walls, attached to the keep, enclosed a courtyard—the bailey—at the base of the motte. Larger castles had two baileys. The keep was only used in the event of an attack; day-to-day accommodation surrounded the bailey(s).

Neoclassical style: In the late eighteenth century archaeological excavations at such places as Pompeii and Herculaneum uncovered more complete remains of Roman buildings, and travel to southern Italy and Greece revealed the true appearance of ancient Greek architecture. Neoclassical designers based their ideas on this newly discovered correct Classical architecture rejecting the incorrect derivations of Palladio, Jones, and Burlington (although their influence was still important) and particularly the excesses of Baroque and Rococo design, seeking instead simpler, rational solutions. The austere Greek Revival style of architecture is a short-lived example of Neoclassical design.

Oriel window: A bay or bow window on an upper floor.

Palladian: In the style of Andrea Palladio (1508–1580), an architect from Vicenza, Italy, famous for his designs for villas, palazzos, and churches that were very influential in England.

Parapet: A low wall at the edge of a structure such as a roof, terrace, or bridge. Parapets often concealed low-pitched roofs giving the impression a building had a flat roof. Often a parapet would be visually lightened by including fence-like balustrades forming a *balustraded parapet*.

Park: In mediaeval times the kings and nobles maintained hunting preserves known as deer parks; the public parks of central London are the remains of such deer parks. In the sixteenth and seventeenth centuries deer parks often surrounded country houses and their formal gardens. In the eighteenth century such landscape designers as Capability Brown reshaped the land and formed vast lakes to create carefully designed parks, which came right up to the house. Nowadays a park may display deer but may also be used to pasture cattle, although fences and gates are carefully concealed.

Parterre: A flat garden of formally laid-out beds with low boxwood hedges that architecturally relates to the façade of a building.

"Pass the port": Nineteenth-century dinner parties were very elaborate and formal. After the dessert the hostess would catch the eye of the ladies signaling their departure to the drawing room, leaving the gentlemen in the dining room. The butler would place a decanter of port (a fortified wine from Oporto in Portugal) on the table and it would be passed from gentleman to gentleman. After several glasses of wine and political, sporting, or ribald conversation the gentlemen would join the ladies for coffee in the drawing room.

Pavilion: An ornamental, sometimes frivolous garden building such as a summer house or gazebo; a building beside a sports field; or, in larger buildings, a projecting center or wing with a distinctive roof.

Pediment: The triangular gable above a portico as seen on the front of Greek and Roman temples, often filled by sculpture or a carved coat of arms. Smaller pediments with an angled or curved profile were placed above doors, windows, or niches.

Pendentive: A curved, triangular structural element that forms the transition between a circular dome over a square or polygonal space.

Piano nobile: Literally the noble floor, the main floor of a building placed above a basement or ground floor.

Pilasters: A column is free standing and usually circular in plan; an attached or engaged column appears to be half contained by a wall but is still circular in plan; while a pilaster is a shallow, flat rectangular pier or column decorating a wall.

Pinnacles: In Gothic architecture the elements atop buttresses that function to add weight and consequently a downward thrust to counter the outward force of the roofs and vaults. Pinnacles give Gothic architecture its characteristic spiky profile; they can also be used as decorative features on parapets or balustrades.

Plinth: A projecting base supporting a column, statue, or building.

Porte cochere: A projecting porch large enough to allow a carriage and horses or an automobile to pass through, providing protected access to the entrance of a building.

Portico: A porch featuring columns at the front of a building either projecting or recessed, often with a pediment above to emphasize the center of a façade and the most important rooms within.

Quatrefoil: A foil is a leaf-shaped form created when two curves adjoin. Usually used in tracery in threes (trefoil) or fours (quatrefoil).

Reredos: A decorated screen or wall placed behind the altar in a church or cathedral.

Rood screen: An elaborate carved wooden screen that separates the chancel from the nave or crossing of a cathedral or church shielding VIPs, the clergy, and choir from the congregation. Only a few rood screens have

survived from mediaeval times as liturgical changes demanded the High Altar be more visible.

Rusticated: Masonry cut to appear as large blocks of stone with each block emphasized by deep, v-shaped joints, giving an appearance of great strength and hence often used for the exterior walls of the ground floor that support the piano nobile. Sometimes imitated in stucco.

Scagliola: Fake marble composed of plaster or cement with marble chips or coloring, invented by the Romans but also used in the seventeenth and eighteenth centuries.

Screens: The entry to a mediaeval manor house led directly into the great hall. To reduce drafts wooden screens formed a lobby and came to support a minstrels' gallery above. The screens comprised three parts, two side screens attached to the walls and a central screen that also blocked the view of the corridor leading to the kitchens. The screens were often elaborately decorated with carved designs and the coat of arms of the owner.

Semi-dome: A half-dome.

Spire: A very tall conical, pyramidal, or polygonal structure that extended the height of a tower or turret, usually seen on a cathedral or church and constructed of stone or of timber covered with lead or shingles.

State rooms: The most important rooms of a palace or mansion, partly set aside as an apartment for the owner or even reserved for distinguished visitors. State rooms contained the best furniture and art works and therefore were also showrooms displaying the wealth and taste of the owner.

Stencil: A metal or card plate with a shape or design cut into it used to create repeating patterns on walls or textiles. Particularly popular in mediaeval times and the nineteenth century.

Tracery: Ornamental stone bands or ribs dividing the upper part of windows in Gothic buildings. Tracery became increasingly complex as Gothic architecture evolved and window sizes grew. It was also often used as a bas-relief decoration of flat wall panels.

Trilithon: A post-and-beam construction composed of two massive, upright stones supporting a third, horizontal stone.

Trophy: A carved wall or parapet decoration often composed of swords, spears, armor, and shields intermingled with flowers and vines, usually installed to commemorate a victory.

Turret: A small, slender tower.

Vault: A stone or brick arched ceiling or roof sometimes copied in timber or plaster. The simplest vault is the barrel or tunnel vault. Two barrel vaults meeting form a cross or groin vault. As Gothic architecture developed vaulting became more complex, concluding with the elaborately decorated fan vaults of the Perpendicular style.

Venetian window: A three-part window with a wider arched central opening. Also often called a Palladian Window but more correctly known as a

Serliana or Serlian. Probably invented by the Italian architect Bramante, c. 1500, it was first published in Serlio's *Architettura* of 1537.

Verandah: Sometimes veranda. Derived from a Hindu word and meaning a covered deck or balcony; a porch in the United States.

Vernacular: Native or indigenous architecture suited to the local society, climate, and terrain, usually built of readily available local materials.

Wattle and daub: Panels made of woven sapling branches inserted between the members of a half-timbered structure, then covered with mud, clay, or plaster and usually given a protective limewash coat, giving a white finish that contrasts with the dark timbers.

Additional Sources for Architectural Definitions

Fleming, John, Honour, Hugh, Pevsner, Nikolaus, and Etherton, David. *The Penguin Dictionary of Architecture*. Harmondsworth, England: Puffin Books (Penguin Books Ltd.), 1991.

Cruikshank, Dan, ed. *Sir Banister Fletcher's A History of Architecture*, 20th ed. Oxford: Architectural Press, 1996.

Bibliography

Allsopp, Bruce, and Clark, Ursula. *English Architecture*. Stocksfield: Oriel Press Ltd., 1979.

Anscombe, Isabelle. *Arts & Crafts Style*. London: Phaidon Press Ltd., 1991.

Aslet, Clive. *The Last Country Houses*. New Haven, Conn.; London: Yale University Press, 1982.

Aslet, Clive, and Powers, Alan. *The National Trust Book of the English House*. Harmondsworth: Penguin Books Ltd., 1986.

Balsan, Consuelo Vanderbilt. *The Glitter and the Gold*. New York: Harper and Brothers, 1952.

Beard, Geoffrey. *The Work of Christopher Wren*. London: Bloomsbury Books, 1982.

Bennett, Will. "Magical Victorian Mansion Saved for Nation in £24m Deal." *Daily Telegraph* (London), June 19, 2002.

Betjeman, John, ed. *Collins Guide to English Parish Churches*. London: William Collins Sons & Co. Ltd., 1958.

Blunt, Anthony. *Treasures from Chatsworth, The Devonshire Inheritance: A Note on the use of Hereditary Titles*. London: International Exhibitions Foundation, 1980.

Borer, Mary Cathcart. *The City of London: A History*. New York: David McKay Company, Inc., 1977.

Briggs, Martin S. *A Pictorial Guide to Cathedral Architecture*. London: Pitkin Pictorials Ltd., 1963.

Brown, Jane. *Lutyens and the Edwardians: An English Architect and His Clients*. London: Viking/Penguin Group, 1996.

Brown, Roderick, ed. *The Architectural Outsiders*. London: Waterstone, 1985.

Bryson, Bill. *Notes from a Small Island*. New York: HarperCollins Publishers, 1995.

Cameron, Robert, and Cooke, Alistair. *Above London*. SanFrancisco: Cameron and Company, 1986.

Cavendish, Deborah, Duchess of Devonshire. *The House, a Portrait of Chatsworth*. London: Macmillan Ltd., 1982.

Coats, Peter. *Great Gardens of the Western World*. London: George Weidenfeld and Nicholson Ltd., 1963.

Colvin, Howard. *A Biographical Dictionary of British Architects: 1600–1840.* London: John Murray, 1978.

Cook, Olive. *The English Country House.* London: Thames and Hudson, 1984.

Cooper, Nicholas. *Houses of the Gentry 1460–1680.* New Haven, Conn.; London: Yale University Press, 1999.

Crook, J. Mordaunt. *William Burges and the High Victorian Dream.* London: John Murray, 1981.

Davey, Peter. *Arts and Crafts Architecture.* London: Phaidon Press Ltd., 1997.

Davis, Terence. *John Nash: The Prince Regent's Architect.* Newton Abbot, U.K.: David and Charles Ltd., 1973.

Deane, Phyllis. *The First Industrial Revolution.* Cambridge: Cambridge University Press, 1980.

de Figueiredo, Peter, and Treuherz, Julian. *Cheshire Country Houses.* Chichester: Phillimore & Co. Ltd., 1988.

Derbyshire, David. "Secrets of Silbury Hill Uncovered." *Daily Telegraph*, February 20, 2002.

Dietsch, Deborah K. "The Lloyd's Building." *Architectural Record*, November 1986.

Dimbleby, Jonathan. *The Prince of Wales: A Biography.* New York: William Morrow and Company, Inc., 1994.

Dinkel, John, with Morley, John. *The Royal Pavilion, Brighton.* Brighton Borough Council, 1990.

Doordan, Dennis P. *Twentieth-Century Architecture.* Englewood Cliffs, N.J.: Prentice Hall, 2002.

Dunster, David. *Architectural Monographs: Edwin Lutyens.* London: Academy Editions/St. Martin's Press, 1986.

Durant, Stuart. *Architectural Monographs No. 19: CFA Voysey.* London: Academy Editions, 1992.

Fairclough, Peter, ed. *Three Gothic Novels* (including Beckford's *Vathek*). Harmondsworth: Penguin Books Ltd., 1983.

Ferriday, Peter, ed. *Victorian Architecture.* London: Jonathon Cape Ltd., 1963.

Field, Leslie. *Bendor, the Golden Duke of Westminster.* London: Weidenfeld and Nicolson, 1983.

FitzGerald, Roger. *Buildings of Britain.* London: Bloomsbury Publishing Plc., 1995.

Fleming, John, Honour, Hugh, Pevsner, Nikolaus, and Etherton, David. *The Penguin Dictionary of Architecture.* Harmondsworth, England: Puffin Books (Penguin Books Ltd.), 1991.

Fletcher, Sir Banister. *Sir Banister Fletcher's A History of Architecture*, 20th ed. Dan Cruikshank, ed. Oxford: Architectural Press, 1996.

Friedman, Joseph. *Spencer House: Chronicle of a Great London Mansion.* London: Zwemmer, 1993.

Girouard, Mark. *Life in the English Country House: A Social and Architectural History.* New Haven, Conn.; London: Yale University Press, 1978.

Girouard, Mark. *The Victorian Country House.* New Haven, Conn.; London: Yale University Press, 1979.

Goldberger, Paul. "The Supreme Court: Modernism Coexists with Classicism in the New Courtyard of the British Museum." *The New Yorker*, January 8, 2001.

Gow, Ian. *Scottish Houses and Gardens from the Archives of Country Life.* London: Aurum Press Limited, 1997.

Hall, Michael. *The English Country House—From the Archives of Country Life, 1897–1939*. London: Mitchell Beazley, 1994.

Harris, John. *The Palladian Revival: Lord Burlington, His Villa and Garden at Chiswick.* New Haven, Conn.; London: Yale University Press, 1994.

Harris, John. *The Palladians*. London: Trefoil Books Ltd., 1981.

Harris, John, and Snodin, Michael, eds. *Sir William Chambers, Architect to George III.* New Haven, Conn.; London: Yale University Press, 1996.

Hart, Sarah. "Queen Elizabeth II Great Court, British Museum, London." *Architectural Record*, March 2001.

Haslam, Richard. *RIBA Drawings Monograph No 2: Clough Williams-Ellis.* London: Academy Editions, 1996.

Hawkes, Jason. *London 360°, Views Inspired by British Airways London Eye.* London: HarperCollins Illustrated, 2000.

Hibbert, Christopher. *The Marlboroughs, John and Sarah Churchill, 1650–1744.* London: Penguin Books Ltd., 2001.

Hibbert, Christopher. *The Story of England*. London: Phaidon Press Ltd., 1992.

Hitchmough, Wendy. *CFA Voysey*. London: Phaidon Press Ltd., 1995.

Hollamby, Edward. *Red House*. London: Architecture Design and Technology Press, 1991.

Jackson-Stops, Gervase. *The English Country House in Perspective*. New York: Grove Weidenfeld, 1990.

Jardine, Lisa. *On a Grander Scale: The Outstanding Life and Tumultuous Times of Sir Christopher Wren*. New York: HarperCollins, 2002.

Jenkins, Simon. *England's Thousand Best Churches*. London: Penguin Books Ltd., 1999.

Jones, Nigel. *Peckforton Castle*. Dissertation submitted at the University of Newcastle-upon-Tyne for the Degree, Bachelor of Architecture, 1977.

Katz, Peter. *The New Urbanism*. New York: McGraw-Hill, Inc., 1994.

Kennerley, Peter. *The Building of Liverpool Cathedral*. Lancaster: Carnegie Publishing, 2004.

Lacey, Robert. *Aristocrats*. Boston: Little, Brown and Company, 1983.

Lancaster, Osbert. *Here, of All Places*. London: Readers Union/John Murray, 1960.

Lee, Christopher. *This Sceptred Isle: 55BC–1901*. London: BBC Books, 1997.

Leigh, Catesby. "All the King's Architects: The Surprising Success of Prince Charles's Anti-Modernist Crusade." *The Weekly Standard*, June 24, 2002.

Lloyd, Nathaniel. *History of the English House*. London: The Architectural Press, 1975.

Macauley, Dr. James. *Glasgow School of Art*. London: Phaidon Press Ltd., 1993.

MacCarthy, Fiona. *William Morris: A Life for Our Time*. New York: Alfred A. Knopf, Inc., 1995.

Mansbridge, Michael. *John Nash: A Complete Catalogue*. New York: Rizzoli International, 1991.

McKean, John. *Architecture in Detail: Crystal Palace*. London: Phaidon Press Ltd., 1994.

Middleton, Robin, and Watkin, David. *History of World Architecture: Neoclassical and 19th Century Architecture/1—The Enlightenment in France and England*. New York: Rizzoli International Publications, 1987.

Middleton, Robin, and Watkin, David. *History of World Architecture: Neoclassical and 19th Century Architecture/2—The Diffusion and Development of Classicism and the Gothic Revival*. New York: Rizzoli International Publications, 1987.

Miller, Keith. "Making the Grade: The Red House." *Daily Telegraph* (London), July 26, 2003.

Montague-Smith, Patrick, and Montgomery-Massingberd, Hugh. *The Country Life Book of Royal Palaces, Castles and Homes Including Vanished Palaces and Historic Houses with Royal Connections.* London: Antler Books Ltd., 1981.

Montague-Smith, Patrick, and Montgomery-Massingberd, Hugh. *Royal Palaces, Castles and Homes.* London: Country Life Books, 1981.

Montgomery-Massingberd, Hugh, and Sykes, Christopher Simon. *Great Houses of England & Wales.* New York: Rizzoli International Publications, Inc., 1994.

Moriaty, Denis, ed. *Alec Clifton-Taylor's Buildings of Delight.* London: Victor Gollancz Ltd., 1988.

Morris, Christopher. *The Illustrated Journeys of Celia Fiennes, 1685–c.1712.* London and Sydney: Macdonald & Co. (publishers) Ltd., 1982.

Morton, Andrew. *Inside Buckingham Palace.* New York: Summit Books, 1991.

Mowl, Timothy, and Earnshaw, Brian. *An Insular Rococo: Architecture, Politics and Society in Ireland and England, 1710–1770.* London: Reaktion Books Ltd., 1999.

Murray, Peter, and Stevens, MaryAnne. *Living Bridges: The Inhabited Bridge, Past, Present and Future.* London: Royal Academy of Arts; New York: Prestel Munich, 1996.

Murray, Peter, and Trombley, Stephen. *Modern British Architecture Since 1945.* London: Frederick Muller Ltd., 1984.

Muthesius, Hermann. *The English House.* St. Albans, U.K.: Granada Publishing Ltd., 1979.

Muthesius, Stefan. *The English Terraced House.* New Haven, Conn.; London: Yale University Press, 1982.

Nicolson, Adam. *Restoration: The Rebuilding of Windsor Castle.* London: Michael Joseph Ltd. and Royal Collections Enterprises Ltd., 1997.

Norwich, John Julius. *Great Architecture of the World.* London: Mitchell Beazley Publishers Limited, 1975.

Nuttgens, Patrick. *The Story of Architecture.* London: Phaidon Press Ltd., 1997.

Palladio, Andrea (translated by Tavenor, Robert, and Schofield, Richard). *The Four Books on Architecture.* Cambridge: The MIT Press, 1997.

Papadakis, Andreas, ed. *Architectural Monographs No. 27: Quinlan Terry, Selected Works.* London: Academy Editions, 1993.

Pearce, David. *The Great Houses of London.* New York: The Vendome Press, 1986.

Pearson, John. *The Serpent and the Stag.* New York: Holt, Rinehart and Winston, 1983.

Penoyre, John, and Ryan, Michael. *The Observer's Book of Architecture.* London: Frederick Warne and Co. Ltd., 1975.

Pierce, Patricia. *Old London Bridge: The Story of the Longest Inhabited Bridge in Europe.* London: Headline Book Publishing, 2001.

Pritchard, T. W. *Elihu Yale, the Great Welsh American.* Wrexham: Wrexham Area Civic Society, 1991.

Quill, Sarah. *Ruskin's Venice: The Stones Revisted.* Aldershot: Ashgate Publishing, 2000.

Rattenbury, Kester. *The Essential Eye.* London: HarperCollins Publishers, 2001.

Richardson, Margaret, and Stevens, MaryAnne. *John Soane Architect.* London: Royal Academy of Arts, 1999.

Risebero, Bill. *The Story of Western Architecture.* Cambridge, Mass.: The MIT Press, 1997.

Robinson, John Martin. *Buckingham Palace.* London: Michael Joseph Ltd. and Royal Collection Enterprises Ltd., 1995.

Robinson, John Martin. *The Latest Country Houses.* London: The Bodley Head Ltd., 1983.

Robinson, John Martin. *Windsor Castle.* London: Royal Collections Enterprises Ltd., 1997.

Ross, Iain, ed. *The Houses of Parliament: History, Art, Architecture.* London: Merrell, 2000.

Rowland, Ingrid D., and Howe, Thomas Noble (translator and commentator/illustrator). *Vitruvius: Ten Books on Architecture.* Cambridge: Cambridge University Press, 1999.

Rykwert, Joseph, and Rykwert, Anne. *Robert and James Adam.* New York: Rizzoli International Publications, Inc., 1985.

Saunders, Ann. *The Art and Architecture of London: An Illustrated Guide.* London: Phaidon Press Ltd., 1996.

Saunders, Matthew. *The Churches of S. S. Teulon.* London: The Ecclesiological Society, 1982.

Smart, C. Murray, Jr. *Muscular Churches: Ecclesiastical Architecture of the High Victorian Period.* Fayetteville: University of Arkansas Press, 1989.

Smith, Edwin, Cook, Olive, and Hutton, Graham. *English Parish Churches.* London: Thames & Hudson Ltd., 1976

Stamp, Gavin. *Edwin Lutyens Country Houses.* New York: The Monacelli Press, Inc., 2001.

Stierlin, Henri. *The Roman Empire, Volume 1: From the Etruscans to the Decline of the Roman Empire.* Cologne: Benedikt Taschen Verlag GmbH, 1996.

Strong, Roy. *Lost Treasures of Britain.* London: Penguin Books Ltd., 1990.

Strong, Roy. *Royal Gardens.* New York: Pocket Books (Simon and Schuster Inc.), 1992.

Strong, Roy, Binney, Marcus, and Harris, John. *The Destruction of the Country House, 1875–1975.* London: Thames & Hudson Ltd., 1974.

Summerson, John. *Architecture in Britain, 1530–1830.* New Haven, Conn.; London: Yale University Press, 1993.

Summerson, Sir John. *Inigo Jones.* London: Penguin Books Ltd., 1966.

Sykes, Christopher Simon. *Private Palaces: Life in the Great London Houses.* New York: Viking Penguin Inc., 1986.

Tavernor, Robert. *Palladio and Palladianism.* London and New York: Thames & Hudson, 1991.

Thurley, Simon. *Hampton Court: A Social and Architectural History.* New Haven, Conn.; London: Yale University Press, 2003.

Tinniswood, Adrian. *Country Houses from the Air.* London: George Weidenfeld & Nicolson Ltd., 1994.

Tinniswood, Adrian. *His Invention So Fertile: A Life of Christopher Wren.* London: Jonathon Cape, 2001.

Tomalin, Claire. *Samuel Pepys: The Unequalled Self.* New York: Vintage Books, 2002.

Trachtenburg, Marvin, and Hyman, Isabelle. *Architecture from Prehistory to Post-Modernism.* Englewood Cliffs, N.J.: Prentice-Hall, 1986.

Wales, HRH The Prince of. *The Garden at Highgrove.* London: Weidenfeld & Nicolson, 2000.

Wales, HRH The Prince of. *A Vision of Britain: A Personal View of Architecture.* London: Doubleday, 1989.

Wales, HRH The Prince of, and Glover, Charles. *Highgrove, Portrait of an Estate.* London: Chapmans, 1993.

Watkin, David. *English Archiecture.* London: Thames & Hudson Ltd., 1979.

Watkin, David. *The Royal Interiors of Regency England—From Watercolors First Published by K. H. Pyne* in 1817–1826 London: The Vendome Press, 1984.

Weinreb, Matthew. *London Architecture, Features and Façades.* London: Phaidon Press Ltd., 1993.

Wessex, Edward The Earl of. *Crown and Country: A Personal Guide to Royal London.* New York: Universe Publishing, 2000.

Wilhide, Elizabeth. *Sir Edwin Lutyens: Designing in the English Tradition.* London: Pavilion Books Ltd., 2000.

Wilkinson and Kennerley. *The Cathedral Church of Christ in Liverpool.* Liverpool: Bluecoat Press, 2003.

Williams, W. Alister. *The Parish Church of St. Giles, Wrexham.* Wrexham: Bridge Books, 2000.

Williamson, Tom. *Polite Landscapes: Gardens and Society in Eighteenth Century England.* Baltimore, Md.: John Hopkins University Press, 1995.

Woodham-Smith, Cecil. *Queen Victoria, from Her Birth to the Death of the Prince Consort.* New York: Alfred A. Knopf, Inc., 1972.

Index

Abbeys. *See* Monasteries

Adam, James (architect), 5, 145

Adam, Robert (architect), 137, 145, 165, 219, 255; Alnwick Castle, 4; Bath, 18, 19; Harewood House, 133–134; Syon House, 273–276; Terraced Houses: Wynn House, Number 20 St. James's Square, 279, 281–282

Adelaide of Saxe-Meiningen (wife of William IV), 168, 233, 234

Adie, George M. (architect), Charters, 63

Ahrends, Peter (architect), 201

Albert, Prince Consort (Prince Albert), 43, 148, 228, 248; Balmoral Castle, 6–7; the Crystal Palace, 88–91; death, 221, 248; marriage to Victoria, 233; the Royal Albert Hall, 220–223; the Tower of London, 290

Albert Memorial, Hyde Park, London, 205, 221, 223

Alberti, Leon Battista (architect), 241

Alexandra of Denmark (wife of Edward VII), 235; Sandringham House, 248, 249, 251

All Souls, Langham Place, London, 219

Allen, Ralph, 16

Alnwick Castle, Northumberland, 1–5

American Institute of Architects (AIA), 62, 200

Anne, Queen, 3, 16, 127, 208, 211, 229, 237; Blenheim Palace, 24, 25–26; St. James's Palace, 233, 235

Anne of Denmark (wife of James I), 10, 208, 257

Anthony Gibbs and Sons (guano/fertilizer importers), 296

Aquae Sulis. *See* Bath, Avon

Archer, Thomas (architect), Chatsworth House, 69

Archigram (architects), 183

Architects Journal, 197

Art Deco, 63, 206

Art Nouveau, 37, 113

Arts and Crafts Movement, 35, 196, 198; at Highgrove, 138; Red House, Bexleyheath, 212–215

Arup (engineers), the Millenium Bridge, London, 179–182

Aslet, Clive, 64

Atkinson, Robert (architect), 225

Atlee, Clement (prime minister), 189

Austen, Jane (writer), 13, 17, 104; *Emma*, 308

Avebury Henge (Avebury Stone Circle), 265, 266

Badminton House, 75

Bage, Charles (architect and engineer), Ditherington Flax Mill, 92

Baker, Sir Herbert (architect), 60

Balmoral Castle, Aberdeenshire, 6–7, 85, 221, 247, 248

Bank of England, London, 253, 256

Banqueting House, Whitehall, London, 8–12, 58, 75, 209, 232, 245, 253

Barfield, Julia (architect), the "London Eye," London, 173–175

Barry, Edward Middleton (architect), 293; The Houses of Parliament, 149

Barry, Sir Charles (architect), 57, 88, 111, 234, 285; Harewood House, 134–135, The Houses of Parliament, London, 146–150; Trafalgar Square, 294

Barry, Sir John Wolfe (engineer), Tower Bridge, 283–284

Bath, Avon: city, 13–19, 111; spa, 19

Battle of Britain, 246

Battle of Hastings (1066), 287, 304

"Battle of the Styles," 147

Beatles, The (pop group), 57, 279

Beckford, William, 18; disgrace and exile, 107; financial embarrassment, 111; Fonthill Abbey, 107–112; reaction to trespasser at Fonthill Abbey, 111; Vathek, 107

Bedford, Duke of, 103, 259

"Beefeaters." See Yeoman Warders

Belgravia, London, 98–99

Belton House, Lincolnshire, 19–24, 105

Belvoir Castle, 116

Bernini (architect and sculptor), 31, 68

"Big Ben." See Houses of Parliament, Westminster, London

Bladud (father of King Lear), 13

Blair, Tony (prime minister), 180, 189; opening of The Millennium Dome, 183

Blenheim, Battle of, 25, 26, 235

Blenheim Palace, Oxfordshire, 24–32, 76, 127, 131, 144, 235

Blomfield, Sir Arthur William (architect), 239; Tyntesfield, 298

Blomfield, Sir Reginald (architect), 60

Blore, Edward (architect), 51; Buckingham Palace, 43

Blow, Detmar (architect), 112

Bodley, George F. (architect), 54, 56

Boleyn, Anne (second wife of Henry VIII), 8, 232, 273, 290; "with 'er 'ead tucked underneath 'er arm," 290

Book of Architecture, A. See Gibbs, James

Boudicca, Queen, 119

"Bowelism" (architectural style), 183

Bowood, Great House, 165

Boyle, Richard. See Burlington, 3rd Earl of (aristocrat and architect)

Boyle's Law, 75

Brettingham, Matthew (architect), Holkham Hall, 140, 145

British Airways, "London Eye," London, 173–175

British Library, London, 34

British Museum, Bloomsbury, London, 32–35, 180; Reading Room, 34

Broadleys, Cumbria, 35–37

Bronte sisters (writers), 78

Brown, Denise Scott (architect), 256

Brown, Lancelot, "Capability" (landscape designer and architect), 5, 100, 133, 276; Blenheim Palace, 25, 31; Chatsworth House, 69, 269

Brownlow, Earls and Barons. See Belton House

Brunel, Isambard Kingdom and Henri Marc (engineers), 285

"Brutalism" (architectural style), 183

Bryson, Bill (writer), 95

Buckingham, Duke of, 38–39, 42

Buckingham House, London, 33, 67, 229, 234, 293. See also Buckingham Palace, London

Buckingham Palace, London, 6, 38–43, 231, 236, 251, 256; and ceremony, 60, 150; East Wing, 43, 228; George IV, 224; official residence of monarch, 186, 247, 283; opened to the public, 307; The Queen's Gallery, 43; The Royal Mews, 293; The Royal State Coach, 228–231. See also Regent's Park and Regent Street, London; St. James's Palace, Pall Mall, London

Builder, The, 285, 297

Burges, William (architect): Cardiff Castle, 48–53; Castell Coch 49, 50

Burlington, 3rd Earl of (aristocrat and architect), 73, 133, 138, 261, 308; Chiswick House, 73–77; Holkham Hall, 138–145

Burlington House, London, 73, 75, 77, 258

Burn William (architect), 112; Eaton Hall, 101

Burne-Jones, Edward (painter), 212

Burnett, Frances Hodgson (writer), 78

Buro Happold (engineers), 34, 35; The Millennium Dome, 183–185

Burton, Decimus (architect), 69

Bush, President George W., 12, 247

Bute, Marquesses of, 48–53

Butler, Samuel (coachmaker), 230

Butterfield, William (architect), 298

Button, Frederick C. (architect), Charters, 63

Byng, Admiral John, Wrotham Park, 310–311

Cabinet, origins of name for government inner circle of ministers or advisors, 30, 130

Caernarfon Castle, Gwynnedd, 44–48

Caesar, Julius, 70–71, 119, 273

Cambridge University, 155, 244

Campbell, Colen (architect), 75, 138, 211; Stourhead, 267

Canaletto, Antonio (painter), 240, 244, 246

Canterbury Cathedral, 94, 157

Canute, King, 302

Capper, Reverend Daniel, 78

Caractacus, King, 49, 119

Cardiff Castle, Cardiff, South Glamorgan, 48–53

Carême, Marie-Antoine (Anton, chef), 227

Carlton House, London, 6, 100, 224, 234, 293; and Buckingham Palace, 40, 41, 42; replaced by Carlton House Terrace, 220, 231. See also Regent's Park and Regent Street, London

Caroline of Ansbach (wife of George II), 127, 233

Carlyle, Thomas (writer), 212

Caro, Sir Anthony (sculptor), the Millennium Bridge, 179–182

Carr, John (architect), Harewood House, 133–134

Casa Malparte, 130

Casina, Clontarf, Co. Dublin, 257

Cast iron, 93, 227

Castell Coch, 49, 50, 51–52

Castle Howard, 26, 127, 131, 132

Castles, design of, 2, 3, 46, 47

Catharine of Aragon (first wife of Henry VIII), 8, 273

Catharine of Braganza (wife of Charles II), 257

Cathedral Church of Christ, St. Peter's Mount, and The Metropolitan Cathedral of Christ the King, Liverpool, Merseyside, 53–58

Cathedrals, design of, 96, 301

Cavendish family. See Chatsworth House, Derbyshire; Hardwick Hall, Derbyshire

Cenotaph, Whitehall, London, 57, 58–62, 177

Centre Pompidou, Paris, 164, 183

Chambers, Sir William (architect), 225; Buckingham House, 39; the Casina, Clontarf, Co. Dublin, 257; the Royal State Coach, 228–231; Somerset House, London, 256–259; *Treatise on Civil Architecture*, 229

Chapel Royal, St. James's Palace, 233, 234

Charing Cross, London, 293

Charles, Prince of Wales (Prince Charles), 5, 207, 240; Buckingham Palace, 38; Clarence House, 234; Earl of Chester, 70; Highgrove 136–138; Investiture at Caernarfon Castle, 44, 46, 48; "Luftwaffe" speech, 201, 204; "monstrous carbuncle" speech, 200–201, 204; Poundbury, 196, 200–204; *A Vision of Britain: A Personal View of Architecture*, 201, 246

Charles I (king), 11, 209, 232, 257; defeat and execution, 12, 67, 233, 306; statue, 293, 295

Charles II (king), 12, 15, 67, 72, 187, 210, 211, 244, 251, 306

Charlotte of Mecklenburg-Strelitz (wife of George III), 39, 42, 234

Charters, Berkshire, 63–65

Chatsworth House, Derbyshire, 66–70, 75, 90, 116, 128, 159, 269, 313; Great Stove, 69, 90, 276; Victoria Regia house, 90

Chaucer, Geoffrey (writer), 51, 213; *Pilgrim's Progress*, 212

Chester, Cheshire: city, 70–72, 160, 190; the Rows, 72

Chippendale, Thomas (cabinet maker), 134

Chiswick House, London, 73–77, 138, 139, 308; contemporary reactions to, 76

Christie, Agatha (writer), 65; *After the Funeral*, 297

Church of England, establishment, 8, 124

Church of St. John the Baptist, Huntley, Gloucestershire, 77–81

Churchill, Sir Winston, 24, 150

Churchill, John, Duke of Marlborough, 235; Blenheim Palace, 25–26

Churchill, Sarah, Duchess of Marlborough, 260; Blenheim Palace, 26, 27, 31; Marlborough House, 235

Cibber, Caius Gabriel (sculptor), 68

Cipriani, Giovanni Battista (painter and engraver), the Royal State Coach, 228–231

Circuit House, planning: Harewood House, 134; Holkham Hall 144; Wrotham Park, 311

City, the (the City of London), 122, 146, 162, 172, 215, 217, 236, 237, 240, 243, 257, 260, 283, 293

Civil War (1642–1651), 3, 233; and the Cavendish family 67; and the Coke family, 139; and the Moreton family, 161; Battle of Naseby, 12; Battle of Rowton Heath, 72

Clanricarde, Marquis of, 135

Clarence House, St. James's Palace, London, 231, 234, 235

Clarendon House, London, 20, 22–23, 99, 105

Claudius, Emperor, 71, 119

Clerk, Simon (mason), King's College Chapel, 157

Coalbrookedale. *See* Iron Bridge, Ironbridge

Coates, Nigel (architect), 185

Coates, Welles (architect), 63

Cockerell, Samuel (architect), 226

Coke, Sir Edward, 139

Coke, Thomas. *See* Leicester, 1st Earl of (first creation)

Coke family. *See* Leicester, Earls of; Holkham Hall, Norfolk

Coke of Norfolk. *See* Leicester, 1st Earl of (second creation)

Coleshill House, 20–22, 99, 105

Commonwealth, 97, 139, 187, 233. *See also* Interregnum

Commonwealth Secretariat, 236

Company of Coachmakers, the Worshipful, 229

Connell, Amyas (architect), 64

Constantine (emperor), 47

Constantinople, 47

Cornwall, Duchy of, 137, 201, 203

Cottman, John Sell (artist), 162

Country Life, 177, 203

Courtauld Institute of Art, 259

Couse, Kenton, Number 10 Downing Street, 188

Coventry Cathedral, Coventry, West Midlands, 82–85

Coward, Sir Noel (playwright and writer): *Blithe Spirit*, 199; *Private Lives*, 247

Cowper, Charles Spencer, 247–248

Crace, Frederick, and Son (interior designers and cabinet makers), 225, 227

Craigievar Castle, Aberdeenshire, 85–87

Cromwell, Oliver, 12, 97, 187, 194, 233, 293

Crown Jewels, 290

Crystal Palace, Hyde Park, London, 88–91, 165, 220, 223, 276; and the Arts and Crafts Movement, 214; Great Stove, Chatsworth House,

69, 276; and the Industrial Revolution, 35; influence of Iron Bridge, 154;

Cubitt, Thomas (developer and contractor), 6, 7, 249

Cundy, Thomas (architect), Syon House, 276

da Sangallo, Giuliano (architect), 209

Darby, Abraham, III (iron master), 92; The Iron Bridge at Ironbridge, 151–154

David (king of Scotland), 2

Davies, Robert (of the Davies brothers, ironworker), 100, 103, 191

de Colechurch, Peter, London Bridge, 166–169

De La Warr Pavilion, Bexhill-on-Sea, 65

de l'Orme, Philibert (architect), 130

de Medici, Lorenzo, 209

de Reyns, Henry (mason), Westminster Abbey, 302

Deanery Garden, Sonning, 177. *See also* Lutyens, Sir Edwin (architect), Lutyens Country Houses

Dennys, John (architect), Eaton Hall, 102–103

Derby House, London, 260

Devonshire, Dukes of, 75, 77; Devonshire House, London, 260. *See also* Chatsworth House, Derbyshire

Diana, Princess of Wales, 136, 233, 240, 299; Spencer family, 260, 263

Dickens, Charles (writer), 78, 168; tomb, 303

Dining Room (as a designated room), 275

Dissolution of the Monasteries, 8, 66, 82, 128, 187, 237, 273, 301

Ditherington Flax Mill, Shrewsbury, Shropshire, 92–94

Divine Right of Monarchs, 11

"Dome, The." *See* Millennium Dome, Greenwich, London

Doomsday Book, 108, 133

Dorchester, 201. *See* Poundbury

Downes, Giles (architect), Windsor Castle, 307

Downing, Sir George, 187

Downing Street. *See* Number 10 Downing Street

Downton Castle, 153

Duany, Andres (architect), 202

Duchêne, Achille (landscape architect), Blenheim Palace, 31

Ducie, 2nd Earl of, 79, 80

Dulwich Picture Gallery, London, 256

Durham Cathedral Church of Christ and Blessed Mary the Virgin, Durham, 56, 94–98, 191

Earp, Thomas (sculptor), 80, 293

Eaton Hall, Cheshire, 72, 98–103, 105, 158, 313

Edgar, King, 15

Edis, Colonel Sir Robert W. (architect), Sandringham House, 250

Edisbury, Joshua, 104

Ednaston Manor, 178. *See also* Lutyens, Sir Edwin (architect), Lutyens Country Houses

Edward I (king), 44–45, 71, 195, 293

Edward II (king), 47

Edward III (king), 304, 305

Edward IV (king), 33, 157, 305

Edward V (king), 290, 299

Edward VI (king), 49, 66, 290

Edward VII (king), 43, 54, 188, 235; Sandringham House, 247–251

Edward VIII (king), 24, 48, 299

Edward the Confessor (king), 146, 287, 302

Eleanor of Castile (queen, wife of Edward I), 45, 293

Elgin Marbles, 32–33, 34

Elizabeth I (queen), 10, 16, 88, 129, 187, 232, 290; tomb, 303

Elizabeth II (queen), 43, 186, 204, 228, 236, 283; "Annus Horribilis," 307; Balmoral Castle, 6; at Coventry Cathedral, 85; at Hampton Court Palace, 127; at the Iron Bridge, 154; jubilees, 229, 230, 240; at Liverpool Cathedral, 56; opening Lloyd's of London, 164; opening London Bridge, 169; opening London City Hall, 172; opening of

The Millennium Bridge, 180–182; opening of The Millennium Dome, 183; opening of the Queen Elizabeth Great Court, British Museum, 34; at Sandringham House, 247, 250; Supreme Governor of the Church of England, 299–301; fire at Windsor Castle, 307

Elizabeth of York (queen, wife of Henry VII), 123, 290; tomb, 303

Elliot, George (writer), 78

Eltham Palace, 64–65

Ely, Reginald (mason), King's College Chapel, 157

Ely Cathedral, 94

Enfilade. See Formal House

England: Council for the Protection of Rural England, 197; union with Scotland, 2, 86–87

English Heritage, 77, 93

Erddig Hall, Wrexham, 104–106

Erith, Raymond (architect), Number 10 Downing Street, 189

Eton College, 155

Evelyn, John (diarist), 22, 244

Ferry, Benjamin (architect), 297

Fishbourne Roman Villa, 120

Flax, plant and products, 92

Flitcroft, Henry, Stourhead, 267–269

Follies, 138, 198; sham castles, 3

Fontana, Carlo (architect), 237

Fonthill Abbey, Wiltshire, 18, 107–112; collapse, 111–112; influence on Houses of Parliament, 147

Fonthill House, 112

Fonthill Splendens, 108, 109

Forbidden City, Beijing, China, 286

Fordyce, John, Surveyor-General of Land Revenue, 216

Foreign Office, London, 147, 188, 205

Formal House planning; Blenheim Palace, 27–30; Chatsworth House, 68; Stourhead, 267; transition to Circuit House, 133; Wynn House, 282; Wrotham Park, 311

Foster, Sir Norman (Lord Foster of Thames Bank, architect), 164, 174, 176; the British Museum, 34–35;

London City Hall, 169–173; the Millennium Bridge, 179–182; Trafalgar Square, 295

Fountains Abbey, Yorkshire, 301

Fowke, Captain Francis (Royal Engineers architect), The Royal Albert Hall, 220–223

Fowler, Charles (architect), 276

Fox Henderson and Co. (engineers and contractors), 90

France: the Bastille, Paris, 286; Carcassone, 44; Centre Pompidou, Paris, 164, 183; the Eiffel Tower, Paris, 173, 283; French Revolution, 78, 235; Normandy, 97; Paris, 17, 32, 41, 42, 60, 68, 146, 164, 173; Seine River, 213; St. Chapelle, Paris, 298; ties with Scotland, 7; Tuileries Palace, Paris, 41; Vaux-le-Vicomte, 68; Chateau of Versailles, 126, 211, 286, 306

Frankenstein, 108

Gandon, James (architect), 281

Garden Suburbs, 270

Gateshead Millennium Bridge, 182

George, Sir Ernest (architect), 176

George I (king), 233, 237, 239

George II (king), 33, 123, 127, 229, 233

George III (king), 42, 234; architectural student, 39, 229, 257; illness and "madness," 217, 224; library, 33; the Royal State Coach, 229, 230

George IV (king), 217, 230, 234; Buckingham Palace, 40, 42; the Royal Pavilion, Brighton, 224–228; statue, 295; Windsor Castle, 306–307. See also Prince Regent

George V (king), 48, 60; Balmoral Castle, 6; Buckingham Palace, 43; at Liverpool Cathedral, 56; Princess Royal (daughter), 135; Sandringham House, 247, 251; Silver Jubilee, 206; unveiling of The Cenotaph, 62

George VI (king), 43, 150; Balmoral Castle, 6; Royal State Coach, 230; Sandringham House, 247, 251

Germany, 63; Berlin Reichstag, 172;

Luftwaffe, 201, 204; Neuch-
wanstein Castle, 49
Gibberd, Sir Frederick (architect), 57
Gibbons, Grinling (sculptor and wood
carver), 26, 27, 295, 306
Gibbs, James (architect), 75, 157; *A
Book of Architecture*, 236, 237; influ-
ence on American architecture,
236–237, 239; St. Martin-in-the-
Fields, 236–239, 294
Girouard, Mark (architectural writer), 22
Glamis Castle, 87
Glasgow School of Art, Glasgow, La-
narkshire, 112–115
Glorious Revolution, The (1688), 3, 15,
67
Goodhart-Rendel, Sir Harry Stuart (ar-
chitect and writer), 78, 79
Gosford Park (2001 movie directed by
Robert Altman), 313
Gothic architecture: development of
pointed arch, 96–97; styles 56, 96–
97, 191–193
Gothic novel, 107–108
Gothic Revival, 56, 57; Fonthill Abbey,
107–112; Houses of Parliament,
146–150; Red House, Bexleyheath,
212–215
Grand Chartreuse (Switzerland), 109
Grand Tour, 139, 237
Graves, Michael (architect), 176, 255
Gray, Colonel Sir George, Spencer
House, 261–262
Great Exhibition (1851), 69, 214, 220,
248; The Crystal Palace, London,
88–91
Great Fire of London, 72, 162, 168,
215, 239, 240–244, 257; London
building codes, 277
Great Hall: description and use, 117–
118; Hardwick hall, 130; kitchen,
buttery and pantry, 118; mediaeval
hall house, 30, 86; minstrel's
gallery, 117; planning, 117–118; re-
duction in importance, 20, 130; re-
treat from by nobility, 30, 118;
screens passage, 117–118
Great International Exhibition (1862),
80

Greater London Authority, 169
Greenwich, University of, 211
Greenwich Mean Time, 211. *See also*
Prime Meridian, Greenwich
Greenwich Palace, London, 208
Grimshaw, Sir Nicholas, and Partners
(architects), 19, 172
Grosvenor Estates, 103, 217, 282. *See
also* Westminster, Dukes of; Eaton
Hall, Cheshire
Grosvenor family. *See* Eaton Hall;
Grosvenor Estates; Westminster,
Dukes of
Grosvenor House, London, 260
Grosvenor Square, London, 17, 98,
260, 279
Gummow, Benjamin (architect), Eaton
Hall, 101
Gundulf, Bishop of Rochester (architect),
the Tower of London, 286–289
Gwynne, Nell (mistress of Charles II),
251

Haddon Hall, Derbyshire, 116–118,
159
Hadrian, Emperor, 1; Hadrian's Wall,
119–122
Hadrian's Wall, Bowness-on-Solway to
Wallsend-on-Tyne, Cumbria,
Northumberland, and Tyne and
Wear, 1, 119–122
Hammerbeam roof, 150
Hampton Court Palace, London, 12,
68, 105, 122–127, 200, 211; and
Henry VIII, 8; *Paolo Cortese's de
Cardinalatu*, 123, 124
Hardwick, Bess of, 66, 159. *See also*
Hardwick Hall, Derbyshire
Hardwick, Thomas (architect), 218
Hardwick Hall, Derbyshire, 22, 30,
128–132, 159, 209; and Chatsworth
House, 66, 67, 69; innovative plan-
ning, 20, 30
Hardy, Thomas (writer), 201; tomb,
303
Harewood House, Yorkshire, 132–135
Harlech Castle, 195
Harold Goodwinson, King, 287, 304
Harry Potter and the Sorcerer's Stone, 5

Hart of Bristol (mason), The Parish Church of St Giles, Wrexham, 194

Hawksmoor, Nicholas (architect), 233; Blenheim Palace, 25, 27; The Queen's House and The Royal Naval Hospital, Greenwich, London, 211; Westminster Abbey, 303

Hearst, William Randolph, 107

Heathcote, Ilkley, 177. See also Lutyens, Sir Edwin (architect); Lutyens Country Houses

Henge, 263. See also Stonehenge, Wiltshire

Henrietta Maria of France (wife of Charles I), 209, 257

Henry II (king), 155, 304

Henry III (king), 302

Henry V (king), 273

Henry VI (king), 155, 156, 208, 290

Henry VII (king), 123, 157, 193, 194, 290; Henry VII Chapel, Westminster Abbey, 302–303; tomb, 303

Henry VIII (king), 72, 117, 155, 157, 216; Church of England, 301; death, 257, 273; Hampton Court Palace, 8, 123, 124–126; political and religious upheavals, 66, 78, 128, 168, 187, 237, 240, 301; The Royal Mews, 293; St. James's Palace, 232; The Tower of London, 290; Whitehall Palace, 8–10

Herland, Hugh (carpenter), 150

High and Over, 64

"High Tech" (architectural style): Lloyd's of London, 162–166; Millennium Dome, The, 183–185

Highgrove, Tetbury, Gloucestershire, 136–138

Hill, Oliver (architect and designer), 64, 85

Hoare, Henry, II (amateur garden designer), Stourhead, 267–269

Holkham Hall, Norfolk, 75, 138–145, 308

Hollamby, Edward (architect), 215

Holland, Hannen and Cubitts Ltd. (contractors), 62

Holland, Henry (architect): The Royal Pavilion, Brighon, 224; Spencer House, 262

Homewood, Knebworth, 178. See also Lutyens, Sir Edwin (architect); Lutyens Country Houses

Honeyman and Keppie (architects), 113, 114

Hooke, Robert (scientist), 244

Hoover factory, 65

Horeau, Hector (architect), 90

Horse Guards, London, 8, 75, 187, 308

Horta, Victor (architect), 113

Hotel de Salm, Paris, 41

Houses of Parliament, Westminster, London, 8, 58, 146–150, 169, 173, 186, 283; "Big Ben," 149, 204, 283; relationship to Fonthill Abbey, 111, 147; St. Steven's Chapel, 149, 150; State Opening of Parliament, 149–150, 247; Westminster Hall, 12, 150

Howard, Catharine (fifth wife of Henry VIII), 126, 290

Hudson, Edward (Country Life), 177

Humbert, Albert Jenkins (architect), Sandringham House, 249

Hunstanworth, 80

Hyde Park, London, 60, 69, 88, 260; The Albert Memorial, 223

Imperial War Graves Commission, 60, 62, 176

India, New Delhi, 60, 176

Industrial Revolution, 42, 88, 92, 214, 224, 296. See also The Iron Bridge, Ironbridge

Interregnum, 67. See also Commonwealth

Iron Bridge, Ironbridge, Coalbrookedale, Shropshire, 88, 92, 151–154, 227

Irving, Washington (writer), 302–303

Italy: Capri, 130; Casa Malaparte, Capri, 130; Colosseum, Rome, 222; Florence, 19; Milan, 56; Palazzo Chieracati, Vicenza, 261; the Pantheon, Rome, 268, 274; Poggio a Caiano, 209; Portofino, 195; River Tiber, Rome, 275; St. Peter's Basilica, Rome, 56, 302; Veneto, 73–74; Venice, 73–74; Vicenza, 73–74,

261; Villa Alemrico-Capra (Villa Rotonda), 74, 76

Jacobite Rebellion, 122
Jacobsen, Hugh Newell (architect), 176
James I (king), 38, 208, 257; Gunpowder Plot, 187; Union of England and Scotland, 2, 86; Whitehall Palace, 10, 11
James II (king), 12, 15, 67; statue, 295
James VI (king of Scotland). *See* James I (king)
"Jardin Anglais" (English Garden), Stourhead, 269
Jeckyll, Gertrude (landscape and garden designer), 61; Lutyens Country Houses, 176–178
Jeckyll, Thomas (architect), 248
Jefferson, President Thomas, 75
Jellicoe, Sir Geoffrey Alan (landscape and garden designer), 250
Jerome, Jennie (Lady Randolph Spencer-Churchill), 24–25
Jetty construction, 72, 160, 277
John, King, 2, 53, 167
John of Gloucester (mason), Westminster Abbey, 302
Johnson, Ben (playwright), 10
Johnson, Philip (architect), 255
Jolwynds, 64
Jones, Inigo (architect), 22, 251, 257; the Banqueting House, Whitehall, 7–12; influence on Chiswick House, 75, 76, 77; influence on Holkham Hall, 142, 143; the Queen's Chapel, St. James's Palace, 232; the Queen's House and the Royal Naval Hospital, Greenwich, 208–211; St. Paul's Cathedral, 240–241, 245
Jones, Sir Horace (architect), Tower Bridge, 284
J. Rothschild Group, 260, 263
Judd, Rolfe (architect), Spencer House, 263

Katharine of Braganza (wife of Charles II), 16
Keble College, Oxford, 298

Keck, Anthony (architect), Highgrove, 136–138
Kedleston Hall, 145
Keeping Up Appearances (television program), 272
Kelly, Felix (painter), 138
Kelmscott Manor, 215
Kennedy, President John F., 69
Kent, William (architect), 8, 127, 261; Chiswick House, 73–77; Holkham Hall, 138–145; Number 10 Downing Street, 188; St. James's Palace, 233
Kew: Palm House, 69, 88, 276; Royal Botanical Gardens, 273
King's College, London, 258
King's College Chapel, Cambridge, 155–158, 193
Kings Weston, 26
Kipling, Rudyard (writer), 58
Knight, Payne, 153
Knights Hospitallers of St. John of Jerusalem, 123
Kohn Pedersen Fox (architects), 172
Kremlin, Moscow, Russia, 286
Krier, Leon (architect and architectural theorist), Poundbury, 202

Ladies' Army and Navy Club, 263
Lageurre, Louis (painter), 27, 38, 235
Lake Havasau City, Arizona, 166, 169
Lami, Eugène (painter), 234
Lancaster House, St. James's Palace, London, 231, 233, 234
Landseer, Sir Edwin (painter and sculptor), 176, 294–295
Lascelles family. *See* Harewood House, Yorkshire
Le Corbusier (architect), 64, 103, 164
Leases, property ownership and rental arrangements, 282
Leicester, Earls of, Holkham Hall, 138–145
Leicester, 1st Earl of (first creation), Holkham Hall, 138–145
Leicester, 1st Earl of (second creation), Coke of Norfolk, 144–145
Lin, Maya (architect), 58, 60
Lincoln Cathedral, 94

Lincoln's Inn Fields, London, 251
Little Moreton Hall, Cheshire, 159–162
Little Ridge (Fonthill Park), 112
Little Thakeham, 178. *See also* Lutyens, Sir Edwin (architect); Lutyens Country Houses
Liverpool: the Cathedral Church of Christ, St. Peter's Mount, 53–58; Herculaneum Docks, 279–280; the Metropolitan Cathedral of Christ the King, 53–58; terraced house in, 279–281
Livingstone, Ken (mayor of London), 171, 172
Lloyd's of London, London, 162–166, 184; Lloyd's insurance market, 163
Londinium, 166, 287
London, The City of. *See* City, the (the City of London)
London Bridge, London, 166–169, 180, 243
London City Hall, London, 169–173, 286, 291
"London Eye," London, 173–175
Londonderry House, London, 260
Long Gallery, 118, 130–131, 161
Longleat House, 130
Lorrain, Claude (painter), *Coast View of Delos with Aeneas*, 268
Louis XIV (king of France), 5, 25, 30, 67, 126
Louvre Museum, Paris, 32, 34, 42, 68, 126
Lubetkin, Bertold (architect), 63
Lundenwic, 166
Lutyens, Sir Edwin (architect), 36, 37, 255; the Cenotaph, 58–62; Lutyens Country Houses, 176–178; Metropolitan Cathedral of Christ the King, Liverpool, 57

Macbeth, 87
Mackintosh, Charles Rennie (architect), 36; Glasgow School of Art, 112–115
Mackintosh School of Architecture, 115
Macmillan, Harold (prime minister), 69
Magnus Maximus (emperor), 47

Malaparte, Curzio (writer), 129
Manners family. *See* Rutland, Dukes of; Haddon Hall
Mansart, J. H. (architect), 17, 23
Marble Hill, 138
Margam Abbey Orangery, 137
Margaret of Anjou (wife of Henry VI), 208
Marks, David (architect), The "London Eye," 173–175
Marlborough, Dukes of, 79. *See also* Blenheim Palace, Oxfordshire
Marlborough House, St. James's Palace, London, 136, 231, 234, 235, 250
Marleybone Park, London, 216, 217
Martin, Elias (Swedish painter), 153
Marriner, Sir Neville (musician), 239
Marx, Karl, *Das Kapital*, 34
Mary (queen of Scots), tomb, 303
Mary I (queen), 66, 232, 290
Mary II (queen, co-ruler with William III): accession to throne, 67; Hampton Court Palace, 123, 126–127; preferred residences, 12, 210–211; The Royal Naval Hospital, Greenwich, 211; tomb, 303
Mary of Modena (wife of James II), 16
Mary of Teck (Queen Mary, wife of George V), 43, 56, 150, 235–236, 251
May, Hugh (architect), Windsor Castle, 306
Mayfair, London, 98, 251, 293
Menai Strait (Wales), 46
Mendelsohn, Erich (architect), 65
Mentmore, Bedfordshire, 296
Millennium Bridge, London, 173, 179–182
Millennium Dome, Greenwich, London, 34, 173, 180, 183–185
Mitford, Nancy, 259
Modern Movement, 63–65, 212
Monasteries, planning, 301
Moneo, Rafael (architect), 256
Montagu House, London, 33
Monticello, 75
Mordaunt Crook, J. (architectural writer), 50
More, Sir Thomas, 290

Morris, William (designer), 35; Morris, Marshall, Faulkner and Co., 214; Red House, Bexleyheath, 212–215

Motte and bailey castle, 2, 46, 47, 49, 304

Munstead Wood, 61, 178. *See also* Lutyens, Sir Edwin (architect); Lutyens Country Houses

Napoleon (emperor), 38, 41, 247, 291–293, 306

Napoleon III (emperor), 220

Napoleonic Wars, 78, 92, 108, 111; Battles of Trafalgar and Waterloo, 291, 306

Nash, Beau (social arbiter), 16, 17

Nash, John (architect), 18; All Souls, Langham Place, 219; Buckingham Palace, 40–43; Clarence House, St. James's Palace, 234; downfall and disgrace, 42–43, 226; Regent's Park and Regent Street, London, 215–220, 234; The Royal Pavilion, Brighton, 224–228; Trafalgar Square, 291–295

National Coal Board, 106

National Gallery, London, 34, 201, 236, 293, 294

National Trust: Erddig Hall, 104–106; Little Moreton Hall, 159–162; Red House, Bexleyheath, 212–215; Stourhead, 267–269; Tyntesfield, 296–298

National Trust for Scotland, 87; Craigievar Castle, 85–87

Navy Board, 258

Nelson, Admiral Horatio, 109; battles and death, 291, 295; Nelson's Column, Trafalgar Square, 236, 256, 295; statue atop column, 294

Neoclassical style, 33, 113, 133, 137, 145; the Casina, Clontarf, Co. Dublin, 257. *See also* Buckingham Palace, London; Harewood House, Yorkshire; Somerset House; Syon House, Middlesex

Nero, Emperor, 49

Neuchwanstein Castle (Germany), 49

New Towns, 270

Newbery, Francis H. (painter), 113–114

Norman Conquest, 96. *See also* William I (king)

Northern Marches, 1

Northumberland, Dukes of: Alnwick Castle, 1–5: Northumberland House, 274, 276; Syon House, 273–276

Norton, John (architect), Tyntesfield, 297

Number 10 Downing Street, 61, 186–189

Number 20 St. James's Square. *See* Wynn House

Order of the Garter, 304–305

Osborne House, Isle of Wight, 6, 221, 248

Oxford University, 155, 244

Paine, James (architect), 145; Alnwick Castle, 4; Chatsworth House, 69

Palladian Movement/Palladianism, 198, 308. *See also* Chiswick House, London; Harewood House, London; Holkham Hall, Norfolk; Spencer House, Green Park, London; Stourhead, Wiltshire; Wrotham Park, Barnet, Hertfordshire

Palladio, Andrea (architect), 11, 22, 177, 308; influence on Chiswick House, 73–74, 75, 76, 77; influence on Holkham Hall, 142, 143; influence in Inigo Jones, 10, 209; influence on The Queen's Chapel, St. James's Palace, 232; influence on Spencer House, 261; influence on Sir John Vanbrugh, 26; influence on St. Paul's Cathedral, 241

Paolo Cortese's de Cardinalatu. See Hampton Court Palace, London

Parish Church of St. Giles, Wrexham, 56, 104, 190–195

Parthenon, Athens, 32–33, 60, 146, 283

Paxton, Sir Joseph (gardener, architect and engineer), 165, 220; Chatsworth House, the Great Stove, 69, 90, 276; Crystal Palace, 88–91, 276; "tablecloth" enclosure system, 90

Pei, I. M. (architect), 34
Pennethorne, Sir James (architect), 258;
 Buckingham Palace, 43
Penshurst Place, Kent, 118
Percier and Fontaine (architects), 41
Perrault, Claude (architect), 42
Piano, Renzo (architect), 164, 172,
 183
Picts and Scots, 119, 122
Picturesque Movement, 138, 161;
 Stourhead, 268
Piper, John (painter), 84
Pitt, William, the Younger (prime min-
 ister), 188
Pitzhanger Manor, Ealing, London,
 253, 256
Pius XI (Pope), 57
Placentia, Palace of, Greenwich, 208, 210
Plater-Zyberk, Elizabeth (architect), 202
Ponte Vecchio (Florence), 19
Pope, Alexander (writer), 26–27
Pope, John Russell (architect), The
 British Museum, 34
Porden, William (architect), 225, 226;
 Eaton Hall, 100, 101
Portmeirion, Gwynnedd, 195–200
Poundbury, Dorchester, Dorset, 196,
 200–204; planning principles, 202–
 203
Pratt, Sir Roger (architect), 19–24, 99,
 178
Pre-Raphaelites (art movement), 50,
 213
Prescott, John (deputy prime minister),
 203
Prime Meridian, Greenwich, 183, 211
Prince Regent, 40, 100, 217, 234, 293;
 the Royal Pavilion, Brighton, 224–
 228. See also George IV (king)
Prince of Wales. See Charles, Prince of
 Wales (Prince Charles)
Prisoner, The, 199
Pritchard, Thomas Farnolls (architect),
 92; Iron Bridge at Ironbridge, 151–
 154
Public Telephone Kiosks, 204, 207
Pugin, Augustus Welby Northmore (ar-
 chitect), 36, 51, 57, 79, 213, 297;
 The Houses of Parliament, 148

Pugin, Edward Welby (architect), 57
Punch, 91

Queen's Chapel, St. James's Palace,
 London, 10, 232
Queen's Gallery. See Buckingham
 Palace, London
Queen's House, Greenwich, London,
 10, 75. See also Queen's House and
 the Royal Naval Hospital, Green-
 wich, London
Queen's House and the Royal Naval
 Hospital, Greenwich, London,
 208–211
Queen Mother (Queen Elizabeth), 87,
 150, 234, 256, 259, 299

Railton, William (architect), Nelson's
 Column, Trafalgar Square, 294
Real Tennis, 9
Red House, Bexleyheath, Kent, 35,
 212–215
Regent's Park and Regent Street, Lon-
 don, 18, 41, 215–220, 226, 234,
 256
Rennie, John (engineer), London
 Bridge, 168
Rennie, Sir John (engineer), London
 Bridge, 168
Repton, Humphrey (landscape de-
 signer), 217, 226
Restoration of the monarchy, 67, 306
Ricci, Sebastiano (painter), 39
Richard II (king), 150
Richard III (king), 157
Richard of Farnham (mason/architect),
 Durham Cathedral, 97
Ripley, Thomas (architect), 211
Robert of Beverley (mason), Westmin-
 ster Abbey, 302
Robinson, William (architect), 257
Rodgers, Richard (Lord Rodgers of
 Riverside, architect), 172, 174;
 Lloyd's of London, 162–166; The
 Millennium Dome, 183–185
Roman Empire: Londinium, 166; mod-
 ern city names derived from "cas-
 trum," 71, 119–120; Pax Romanum,
 71, 119; Roman Army, 71; Roman

Britain, 13, 49, 70–71, 119–120, 122; Temple of Fortuna Virilis, Rome, 143

Romantic Movement: Fonthill Abbey, 107–112; Stourhead, 268

Rosetta Stone, 32

Rossetti, Dante Gabriel (painter), 212

Rotonda, Villa (Vicenza), 74, 76

Rowling, J. K. (writer), 5

Royal Academy of Arts, 253, 257, 258

Royal Albert Hall, South Kensington, London, 220–223

Royal Botanical Gardens. *See* Kew, Royal Botanical Gardens

Royal Institute of British Architects (RIBA), 62, 78, 310; disagreement with Prince Charles, 200–201; first Gold medal recipient, 253

Royal Lodge, Windsor Great Park, 40

Royal Mews, Charing Cross, London, 293. *See also* Buckingham Palace, London; Royal State Coach

Royal Mint, 289

Royal Naval College, 6, 211

Royal Naval Hospital, Greenwich, London. *See* Queen's House and the Royal Naval Hospital, Greenwich, London

Royal Observatory, Greenwich, London, 211

Royal Pavilion, Brighton, Sussex, 6, 40, 100, 217, 224–228

Royal Society for the Encouragement of Arts, Manufactures and Commerce (the Royal Society), 88, 258

Royal State Coach, Royal Mews, Buckingham Palace, 228–231

Rubens, Sir Peter Paul (painter), 11, 158

Ruskin, John (author and critic), 36, 79, 212, 213

Rutland, Dukes of. *See* Haddon Hall, Derbyshire

Rysbrack, John Michael (Jan Michiel, sculptor), 268

St. Cuthbert, 96, 97

St. George, James (military engineer), Caernarfon Castle, 46

St. George's Chapel, Windsor Castle, 193, 305

St. Giles's Church, Wrexham. *See* Parish Church of St. Giles, Wrexham

St. James's Palace, Pall Mall, London, 10, 12, 40, 231–236, 261, 293; Court of St. James, 39, 231

St. James's Park, London, 41, 186, 187, 215, 220, 260; and Buckingham House, 38, 39; and St. James's Palace, 231, 233; and Whitehall Palace, 9, 11

St. John the Baptist, Church of, Huntley, 77–81

St. John's Chapel, Tower of London, London, 289

St. Marleybone Church, London, 218

St. Martin-in-the-Fields, Trafalgar Square, London, 75, 236–239, 294; Academy of St. Martin-in-the-Fields, 239; influence on American architecture, 236–237, 239

St. Mary Magdalene, Sandringham, 251

St. Pancras Station, London, 205

St. Paul's Cathedral, London, 39, 180, 215, 240–246, 299; Great Fire of London, 277; Great Model, 245; and Inigo Jones, 10; and Prince Charles, 201; Royal events, 229, 231; and Sir Christopher Wren, 126; Warrant Design, 245

St. Peter's Basilica, Rome, 56

St. Stephen Walbrook, London, 237, 244

Salisbury Cathedral, 94, 97

Salisbury Plain, 263

Salmon, F. Cuthbert and Christine (Salmon and Salmon Architects), 85

Salutation, 178. *See* Lutyens, Sir Edwin (architect); Lutyens Country Houses

Salvin, Anthony (architect), Alnwick Castle, 4–5; The Tower of London, 290

Samwell, William (architect), Eaton Hall, 99, 100

Sandringham House, Norfolk, 247–251; St. Mary Magdalene, 251

Sanmicheli, Michele (architect), 177

Saunders, Matthew (architectural writer), 79

Saxons, 15

Scamozzi, Vincenzo (architect), 10, 74, 75, 76, 208, 209

Schinkel, Karl Friedrich von (architect), 33

Scotland: Antonine Wall, 113, 121; Balmoral Castle, 6–7; Craigievar Castle, 85–87; description by Prince Albert, 6; geography, 112–113; Glasgow School of Art, 112–115; Hill House, Glasgow, 113; relations with England, 1–2; Royal Museum of Scotland, Edinburgh, 221; Scottish Baronial style, 7, 112, 113; ties with France, 7; tower houses, 86, 113; union with England, 2, 86–87; Willow Tea Rooms, Glasgow, 113

Scott, Adam Gilbert (architect), 57

Scott, Colonel H. Y. Darracott (Royal Engineers architect), The Royal Albert Hall, 220–223

Scott, Sir George Gilbert (architect), 147, 205; The Albert Memorial, 223; Westminste Abbey, 302

Scott, Sir Giles Gilbert (architect), 256; The Cathedral Church of St. Peter's Mount, 53–56; Public Telephone Kiosks, 204–207

Scott, Sir Walter (writer), 4

Seaside, Florida, 196, 202

Seaton Delaval, 26

Segontium, 47

Septimus Severus, Emperor, 121

Serlio, Sebastiano (architect), 130

Servants: role in household, 20–22, 130; Victorian household, 312–313

Seven Years' War, 229, 310

Severn, River, 151

Seymour, Edward (duke of Somerset), 257, 273

Seymour, Jane (third wife of Henry VIII), 273

Sezincote, 225

Shakespeare, William (playwright), 87

Shaw, Richard Norman (architect), 36, 54, 176, 196, 199

Shelley, Mary (writer), 108

Shepherd, Vincent (architect), Alnwick Castle, 4

Shrewsbury, Earl of (George Talbot), 129

Siddell Gibson Partnership (architects). *See* Downes, Giles (architect)

Silbury Hill, 266

Simpson, John (architect), the Queen's Gallery, Buckingham Palace, 43

Simpson, Wallis Warfield, 24

Smirke, Sir Robert (architect), 147, 234, 294; the British Museum, 33, 35

Smirke, Sydney (architect), The British Museum, 34

Smith, William (architect), Balmoral Castle, 7

Smithsonian Institution, Washington, D.C., 3, 32

Smythson, Robert (architect), Hardwick Hall, 128–132

Soane, Sir John (architect), 11, 147, 205; Bank of England, London, 253, 256; *Description* (of the Soane Museum), 255; Dulwich Picture gallery, 256; Number 10 Downing Street, 188; Pitzhanger Manor, 253, 256; The Soane Museum, 251–256

Soane Museum, The, 251–256; simplified development history, 254

Society of Antiquaries, 258

Soldi, Andrea (painter), 310

Somerset House, the Strand, London, 253, 256–259; Duke of Somerset, 257; Old Somerset House, 9, 130, 209, 240, 257; reference to the United States of America, 259

South Sea Bubble, 140

Southwark, London, 166, 167

Spence, Sir Basil (architect), Coventry Cathedral, 82–85

Spencer family, 260. *See also* Spencer House, Greenpark, London

Spencer, John (1st Earl Spencer), 260

Spencer House, Green Park, London, 259–263

Stafford House, St. James's Palace, London. *See* Lancaster House, St. James's Palace, London

Stamp, Gavin (architectural writer), 177

Stanton, William (master-mason), 23

State Apartment: Blenheim Palace, 27–30; Buckingham Palace, 42; development from mediaeval hall house, 30; *enfilade*, 30; Hardwick hall, 130–131; layout in formal house, 30, 68; use as indicator social standing, 30

State Centre (planning device), 20, 22

Stevenage Development Corporation (new town), 197

Stirling, James (architect), 176; Stirling Prize, 182

Stokesay Castle, 118

Stonehenge, Wiltshire, 263–266

Stourhead, Wiltshire, 75, 138, 267–269

Strand, London, 122, 215, 236, 256, 257, 293

Strawberry Hill, Twickenham, London, 4

Street, George Edmund (architect), 213

Stripped Classicism (architectural style), 206

Stuart, James "Athenian" (architect), 211; Spencer House, 262

Suburban Semi-Detached Houses, 212, 269–272

Sullivan, Louis (archtect), 172

Summerson, Sir John (architectural writer), 10, 18, 262

Sustainable architecture, 171–172

Sutherland, Graham (artist), 84

Synchonous lateral excitation, 181–182

Syon House, Middlesex, 273–276, 301

Talman, William (architect): Buckingham House, 38; Chatsworth House, 67, 68, 69

Tate Modern (art gallery), London, 180, 205

Taylor, Sir Robert (architect), Number 10 Downing Street, 188

Taymouth Castle, 6

Telford, Thomas (engineer), 92

Tennyson, Lord Alfred (poet), 36, 212; tomb, 303

Terraced Houses, 276–282

Terry, Quinlan (architect), Number 10 Downing Street, 189

Teulon, Samuel Sanders (architect): career, 79–80; Church of St. John the Baptist, Huntley, 77–81; death, 80–81; Hunstanworth, 80; influence on Suburban Semi-detached Houses, 271; Sandringham House, 248, 249

Thames, River, London, 215, 240; the Great Fire, 243; Greenwich, 183, 208; the Houses of Parliament, 146; London Bridge, 166–169; the "London Eye," 173–175; the "main street" of London, 122; Somerset House, 256, 257, 258; The Tower of London, 286–291; Tower Bridge, 283–286; traveling west, upriver, 73, 122; Whitehall Palace, 9

Thatcher, Margaret (prime minister), 169, 189

Thomas, William Broderick (garden designer), 250

Thompson, Alexander "Greek" (architect), 113

Thornhill, Sir James (painter), 27

Tijou, Jean (ironworker), 68, 100, 191

Tortworth Court, 79, 80

Tower Bridge, London, 170, 180, 208, 283–286, 291. *See also* Tower of London

Tower of London, 47, 157, 170, 256, 286–291, 304; the Bloody Tower, 289; built for William I, 146; prisoners and executions, 126, 232, 257, 290; the White Tower, 287–289. *See also* Tower Bridge, London

Trafalgar Square, London, 8, 58, 204, 236, 256, 291–295; connection to Regent Street, 217

Trollope, Anthony (writer), 78, 94

Tudor dynasty, 49, 67, 157. *See also* Henry VII (king); Henry VIII

(king); Edward VI (king); Mary I (queen); Elizabeth I (queen)
Turner, J.M.W. (painter), 107, 147
Turner, Richard (architect), 88, 90
Tyntesfield, Somerset, 296–298

UNESCO World Heritage Site, 19, 32, 98, 154
United States of America: Brooklyn Bridge, New York, NY, 180; the Capitol, Washington, D.C., 283; embassy in London, 282; emigration to, 54; Golden Gate Bridge, San Francisco, CA, 180, 182; Guggenheim Museum, New York, NY, 172; Harvard University, 187; influence of Palladio, 75; Kentlands, MD, 202; Lake Havasau City, AZ, 166, 169; Monticello, 75; reference to at Somerset House, London, 259; San Simeon, CA, 107; Seaside, FL, 196, 202; Stillwater, OK, 85; trade with, 54, 92, 279; Washington, D.C., 3, 32, 60, 146, 186; White House, Washington, D.C., 186; Yale University, 106

Valle Crucis Abbey, Denbighshire, 193, 301
van der Rohe, Mies (architect), 164
Vanbrugh, Sir John (architect), 9, 211, 233, 255; Blenheim Palace, 25, 26, 27, 235; bridge at Blenheim Palace, 31; epitaph, 31; influence on Sir Edwin Lutyens, 176–178
Vanderbilt, Consuelo, 31
Vardy, John (architect), 233; Spencer House, 261–262
Venerable Bede, 98
Venturi, Robert (architect), 256
Vernon, Dorothy, 116
Verrio, Antonio (painter), 68, 306
Victoria, Queen, 228, 230, 233, 235, 248; Balmoral Castle, 6–7, 85; Buckingham Palace, 43; The Crystal Palace, 88–91; death of Albert, 221, 248; jubilees, 43, 78, 283; marriage to Albert, 233, 234; open-

ing of Houses of Parliament, 148; opinion of Stafford (later Lancaster) House, 234; Queen Victoria Memorial, 231; The Royal Albert Hall, 221, 222; Victorian era, 78, 80
Violett-le-Duc (architect), 51
Vision of Britain: A Personal View of Architecture A (HRH Prince Charles), 201
Vitruvius, Marcus Pollio (architect and engineer), 11, 73–74
Vitruvius Britannicus, 311
Voltaire, François-Marie Arouet de (writer), comment about Admiral John Byng, 311
Voysey, Charles F. A. (architect), 176, 196; Broadleys, 35–37

Wakely, Shelagh (artist), 223
Wales: Caernarfon Castle, 44–48; Campaign for the Protection of Rural Wales; 197; Cardiff Castle, 48–53; Castell Coch, 49, 50, 51–52; castles built during conquest by Edward I, 45, 46; coal mining, 105; Erddig Hall, 104–106; Menai Strait, 46; Parish Church of St. Giles, Wrexham, 190–195; Prescelly Hills, Pembrokeshire, 264; Seven Wonders of Wales, 191; Wrexham, 104, 190–195; Wynnstay, Denbighshire, 281
Wales, Prince of, Arthur, 117; and Caernarvon Castle, 44–48. See also Charles, Prince of Wales (Prince Charles)
Wallis, Gilbert and Partners (architects), 63, 64, 65
Walpole, Horace, 4, 76, 260
Walpole, Sir Robert (prime minister), 188, 235
War of the Roses, 3, 49, 155, 157, 289, 302
War of the Spanish Succession, 25
Ware, Isaac (architect), portrait, 310; Wrotham Park, 308–313
Wastell, John (mason), King's College Chapel, 157, 158

Waterhouse, Sir Alfred (architect), 34, 221; Eaton Hall 101–102

Waterloo, Battle of, 38

Watkins-Wynn, Sir Watkin. See Wynn House

Waugh, Evelyn (writer), 63

Webb, John (architect), 11, 22, 262; the Queen's House and The Royal Naval Hospital, Greenwich, London, 208–211; Syon House, 274

Webb, Philip (architect), 35; Red House, Bexleyheath, 212–215

Webb, Sir Aston (architect), 293; Buckingham Palace, 43

Webb, Thomas (architect), Erddig Hall, 104

Wells Cathedral, 95

West End, London, 260

Westminster, City of, 122, 256, 293

Westminster, Dukes of, 72, 78, 158, 259; Eaton Hall, 98–103

Westminster, Palace of. See Houses of Parliament, Westminster, London

Westminster Abbey, the Collegiate Church of St. Peter at Westminster, Westminster, London, 60, 146, 149, 193, 229, 299–303; Henry VII Chapel, 302–303

Westminster Hall. See Houses of Parliament, Westminster, London

Whitehall Palace, London, 8–12, 126, 149, 186, 209, 237; destruction, 232

Wilkins, William (architect), 157, 294

William I (king), 99, 108, 117, 133, 150, 286; coronation, 299; curfew, 243; Durham Cathedral, 96; the Norman Conquest, 1, 44, 49, 240; the Tower of London, 146, 287; Windsor Castle, 287, 304

William II (king, "The Rufus"), 150, 167

William III (king, William of Orange, co-ruler with Mary II): accession to throne, 67; Hampton Court Palace, 123, 126–127; preferred residences, 12, 210–211; The Royal Naval Hospital, Greenwich, 211; tomb, 303

William IV, 43, 168, 228, 229, 233, 234

William, Prince, 48, 234

William of Wykeham (mason), Windsor Castle, 305

William the Conqueror. See William I (king)

Williams-Ellis, Sir Clough (architect), country houses, 197; Portmeirion, 195–200

Winde, Captain William (architect): Belton House, 23; Buckingham House, 38

Windermere, Lake, 35, 36, 37

Windsor Castle, Berkshire, 155, 175, 251, 304–308; and Elizabeth II, 247; and George IV, 6, 224, 228; and William I, 287; death of Prince Albert, 248; fire of 1992, 307; motte and bailey design, 47; restoration, 127, 307; St. George's Chapel, 193, 305

Wise, Henry (landscape designer), Blenheim Palace, 25, 31

Woburn Abbey, Bedfordshire, 301

Wollaton Hall, 130

Wolrich, John (mason), King's College Chapel, 157

Wolsey, Cardinal Thomas, 232, 257; and Hampton Court Palace, 8, 123, 124

Wood, John, the elder (architect), Bath, 16, 17, 18

Wood, John, the younger (architect), Bath, 17, 18

World War I, 56, 58, 62, 69, 105, 205, 260

World War II, 34, 43, 54, 58, 69, 82, 87, 102, 105, 189, 196, 218, 219, 246, 271

Wordsworth, William (poet), 36

Worsley, Giles (architectural writer), 170–171, 203

Wraxall, 2nd Lord of. See Tyntesfield, Somerset

Wren, Sir Christopher (architect), 22, 26, 31, 176, 255; City Churches, 239, 240, 244; Hampton Court Palace, 105, 123, 126–127; Marlborough House, St. James's Palace,

235; The Queen's House and The Royal Naval Hospital, Greenwich, London, 208–211; St. James's Palace, 233, 234; St. Paul's Cathedral, 215, 240–246; St. Stephen Walbrook, 237, 244; "Wrennaissance," influence on Sir Edwin Lutyens, 178
Wrexham Parish Church. *See* Parish Church of St. Giles, Wrexham
Wright, Frank Lloyd (architect), 172, 199
Wrotham Park, Barnet, Hertfordshire, 76, 308–313
Wyatt, Benjamin (architect), 234
Wyatt, James (architect), 24, 147, 276; character and death, 111; Erddig Hall, 105; Fonthill Abbey, 107–112; nickname "The Destroyer," 109
Wyatt, Matthew Digby (architect), 51

Wyatt, Philip (architect), 234
Wyatville, Sir Jeffry (architect), 233, 306; Chatsworth House, 69; Windsor Castle, 306–307
Wynn House, Number 20 St. James's Square, London, 281–282

Yale, Elihu, 106, 191; grave and epitaph, 194–195
Yale University, 106, 191
Yeoman Warders, 290
Yevele, Henry (mason), 97; Westminster Hall, 150
Yonge, Charlotte M. (writer), 298
York House, St. James's Palace, London. *See* Lancaster House, St. James's Palace, London
York Minster, 95, 132, 277
Yorke family. *See* Erddig Hall, Wrexham
Yorkshire, 132, 177

About the Author

NIGEL R. JONES is Associate Professor of Architecture of Oklahoma State University, where he teaches design studio, perspective, and the history of Greek and Roman architecture and English Renaissance and Early American architecture, and also serves as Academic Advisor to the undergraduate Bachelor of Architecture program.